# An Anthology of
# Pre-Raphælite Writings

# An Anthology of
# Pre-Raphælite Writings

edited by
## *Carolyn Hares-Stryker*

**New York University Press**
Washington Square, New York

*To my Mother,*
*my guide to the Tate and to Kelmscott*

Copyright © 1997 Sheffield Academic Press

First published in the U.S.A. in 1997 by
New York University Press
Washington Square
New York, N.Y. 10003

Library of Congress Cataloging-in-Publication Data

An anthology of Pre-Raphælite writing / edited by Carolyn Hares
    -Stryker.
        p.    cm.
        Includes bibliographical references and indexes.
        ISBN 0-8147-3552-5 (cloth). — ISBN 0-8147-3553-3 (pbk.)
        1. English literature—19th century. 2. Pre-Raphælitism-
    -Literary collections. 3. English literature—19th century—History
    and criticism—Theory, etc. 4. Authors, English—19th century-
    -Biography. 5. Arts, Modern—19th century—England. 6. Artists-
-Great Britain—Biography. 7. Pre-Raphælites—Biography. 8. Pre
-Raphælitism. 9. Arts, English. I. Hares-Stryker, Carolyn.
PR1145.A68   1996
820.8'008—dc20                                                    96-21305
                                                                        CIP

Printed on acid-free paper in Great Britain

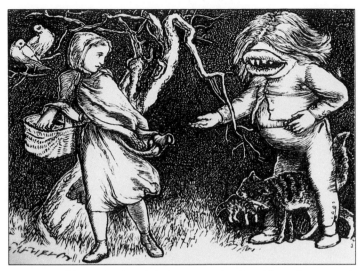

Arthur Hughes' illustration in Christina Rossetti's 'Speaking Likenesses' (1874)

I have been here before,
 But when or how I cannot tell:
I know the grass beyond the door,
 The sweet, keen smell,
The sighing sound, the light around the shore.

You have been mine before—
 How long ago I may not know:
But just when at that swallow's soar
 Your neck turned so,
Some veil did fall,—I knew it all of yore.

Has this been thus before?
 And shall not thus time's eddying flight
Still with our lives our love restore
 In death's despite,
And day and night yield one delight once more?

**Dante Rossetti, *Sudden Light* (1863)**

# CONTENTS

# The 1870s

## List of Credits

**Max Beerbohm**, 'Rossetti in his Back Garden', 'The Introduction', and From *And Even Now*—Reproduced by kind permission of Mrs. Reichmann.

**Wilfrid Scawen Blunt**, *From Jane Morris to Wilfrid Scawen Blunt*, ed. Peter Faulkner—By kind permission of the University of Exter Press.

**Arthur Hughes**, Letters to Alice Boyd and William Bell Scott—Major Greville Chester and the Rylands Bulletin (Reproduced by courtesy of the Director and University Librarian, The John Rylands University Library of Manchester).

**Henry James**, Letter to his Sister—Reprinted by permission of the publishers from *The Letters of Henry James*, ed. Leon Edel, Cambridge, Mass.: The Belknap Press of Harvard University Press, Copyright 1974, 1975, 1980, 1984, 1987, Leon Edel, Editorial; 1974, 1975, 1980, 1984, 1987. Alexander R. James, James Copyright Material.

**William Morris**, From *Poems by the Way*—Copyright British Museum.

**William Morris**, From *Poems: Written for Georgiana Burne-Jones*—By courtesy of the Board of Trustees of the Victoria & Albert Museum, London.

# Acknowledgments

I should like to extend a collective but grateful thanks to the many people who have helped me edit this anthology. My thanks go to the generosity of the librarians, acquisitions staff, and publishers in England, America and in Germany who have granted permission and who often offered unsolicited encouragement of the book. Specifically, I would like to thank my own institution's librarians, Mary Zimmer and Sherri Saines, who were invaluable in their efforts to secure books for my research from other libraries. Further, I would like to give special thanks to Roger Sims, the head of the Manx National Museum Library in the Isle of Man, who was so gracious to me during my time there, and without whom I would never have been able to work with the Dante Rossetti letters to Hall Caine; George Brandak, the head of the Special Collections of the library of the University of British Columbia, who was always there with additional information and advice concerning the Penkill papers; and especially Len Roberts whose advice and encouragement meant so much as I worked on the Arthur Hughes correspondence. I have to acknowledge the financial support that Marietta College has given me by awarding me Summer grants and allowing me to reduce my teaching load. I am also indebted to Connie Golden, the chair of the Education department, for her patience while I took up residence in her computer lab. This book has from its beginning been an exercise of scholarship and personal attachment, and I wish to thank the students of my Pre-Raphælite class for the inspiration, insight and delight they gave me during the Autumn months of 1994 and on our journey to Yale, and to two very special women, Kelly Apshaga and Annie Harris, who helped me with the proofreading of the manuscript. And, finally, I would like to thank my husband Julian for his love and patience, my father, 'Uncle', for his quiet support, and my sons, Jordan and Cian, my passion and joy.

# LIST OF PLATES

Following page 256

## The Beginnings: 1848–1859

**1. Dante Rossetti**, *Ecce Ancilla Domini* (1849),
oil painting, 1850. Tate Gallery, London.

**2. John Everett Millais**, *Ophelia* (1851),
oil painting, 1852. Tate Gallery, London.

**3. Elizabeth Siddal**, *Clerk Saunders* (1857),
water colour, 1857. Reproduced by Permission of the Syndics of the Fitzwilliam Museum, Cambridge.

**4. *The Oxford Union Murals* (1857),**
The Oxford Union Old Debating Chamber. Photograph, Oxford Union Society.

## The 1860s

**5. Ford Madox Brown**, *The Last of England* (1865),
oil painting, 1865. By Courtesy of Birmingham Museums and Art Gallery.

**6. Morris, Marshall, Faulkner and Company**, *The Green Dining Room* (1866),
1866. Photograph by courtesy of the Board of Trustees of the Victoria & Albert Museum, London.

**7. William Holman Hunt**, *Isabella and the Pot of Basil* (1867),
oil painting, 1876. From the collection at the Laing Art Gallery, Newcastle upon Tyne. Reproduced by permission of Tyne and Wear Museums Service.

**8. Dante Rossetti**, *Beata Beatrix* (1868),
oil painting, c.1864-70. Tate Gallery, London.

## The 1870s

**9. *A Garden by the Sea* (1870),**
from William Morris' *Book of Verse* 1870. By courtesy of the Board of Trustees of the Victoria & Albert Museum, London.

**10. Dante Rossetti**, *Proserpine* (1873),
oil painting, 1873-77. Tate Gallery, London.

**11. Edward Burne-Jones**, *The Beguiling of Merlin* (1874),
oil painting, 1874. National Museums and Galleries on Merseyside (Lady Lever Art Gallery).

## The 1880s

**12. Edward Burne-Jones**, *King Cophetua and the Beggar Maid* (1884),
oil painting, 1884. Tate Gallery, London.

**13. J. W. Waterhouse**, *The Lady of Shalott* (1888),
oil painting, 1888. Tate Gallery, London.

## The 1890s and after

**14. Edward Burne-Jones**, *The Briar Rose — The Sleeping Princess* (1890),
oil painting, 1890. Faringdon Collection, Buscot Park, Oxfordshire.

**15. J. W. Waterhouse**, *La Belle Dame Sans Merci* (1893),
oil painting, 1893. Darmstadt, Hessisches Landesmuseum.

**16. William Morris & Edward Burne-Jones**, *The Prologue of the Tale of the Manne of Lawe* (1896),
from The Kelmscott *Chaucer* 1896

**17. Kate E. Bunce**, *The Keepsake* (1901),
tempera on canvas, 1901. By Courtesy of Birmingham Museums and Art Gallery.

# List of Illustrations

# ▣ Introduction ▣

'I say, are not you the fellow doing that good drawing in No. XIII room? You ought to be at the Academy.' 'That is exactly my opinion', I returned. 'But unfortunately the Council have twice decided the other way.' 'I say, do you ever sell what you do? So do I. I've often got ten pounds, and even double.' 'How old are you?' he asked. 'Well, I'm seventeen', I replied. 'I'm only fifteen just struck, but don't you be afraid.' 'Will you be here to-morrow?' 'No', I whispered, 'it's my portrait day, but don't betray me. Good-bye.' 'Don't you be down in the mouth', he laughed out.

Thus it began. The year was around 1843. Millais was the son of doting parents who had moved the family from the Channel Islands to London so as to further their son's development of his obvious artistic talents. At the age of fifteen, Millais was well established as a protégé; he had already been a student at the Royal Academy for four years. Hunt, the son of a warehouse manager, was somewhat older but very concerned not to neglect any means of increasing his chances of being accepted this third time by the Council. He had struck a bargain with his father that if he failed again, he would go into business, the drapers' warehouses in Cheapside. In this first conversation between John Everett Millais and William Holman Hunt, one sees the youthful vitality of beginnings. There is a spontaneity and ease about this accidental moment of connection that occurred in the British Museum. Hunt had first seen Millais earlier when Millais had been awarded the Academy Antique medal, but had not spoken to him at that time, consumed as he was with nervousness about the upcoming judging of his line-drawing the following day. After Millais' exuberant attention, however, Hunt describes himself as feeling more light-hearted than he had felt for months. Prior to the meeting, both had been outsiders of a sort. Hunt had only met

Millais because, unlike his fellow students who were enjoying their holidays, Hunt had chosen to remain in London near the British Museum and to practice his drawing late into the summer. In Millais' case, because he was so much younger than the other Royal Academy students, his father worried that 'Johnnie' was treated so roughly by the elder students that he came home frequently 'bearing the marks of their coarse behaviour'. In the other, they recognised someone whom they could befriend, someone who could understand and encourage the drive each had to be part of something greater than themselves: to their minds, during those early days, the Royal Academy, the acme of the world of an artist.

And it may have been, if it weren't for another, again almost chance, meeting that happened in 1848. Hunt describes himself virtually stumbling across Dante Rossetti as he lay stretched out across some steps. Hunt, now accepted as a Royal Academy student, had seen Rossetti before. He remembers Rossetti as always being surrounded by 'clamorous students' who were drawn to him by the reward of this probationary student's sketches of knights rescuing ladies and lovers in medieval dress. But Hunt and Rossetti had never spoken, until they struck up a conversation that day about the virtues of the quattrocento masters. The two then met again a few days later when Rossetti loudly and effusively praised Hunt's *Eve of St. Agnes*, which had been hung somewhat high in the Architectural Room. Raphæl one could speak of with academic fascination; Keats, though, created between them a bond of intimacy. After all, Keats was the property of connoisseurs: his poems had been published infrequently after his death, and Hunt had found the slim volume of poetry that had inspired his painting in a book-bin labelled 'this lot 4d'. In those early days, Rossetti appeared as a young man of decidedly Southern features. His father, Gabriel Rossetti, now an Italian

professor at University College, London, had in his youth been a poet in Naples where he was accused of writing revolutionary songs, compelled to leave his country and emigrate to England as a political exile. At five foot seven in height, with dreamy eyes, and endearing indifference to his manner of dress—mud splatters could remain dry on his clothes for days without fear of disturbance—his son, however, seemed bent on choosing a very different path towards revolution.

Within days of praising *The Eve of St. Agnes*, Rossetti visited Hunt's studio and confessed there his discontent with his drawing master, Ford Madox Brown, who wanted him to draw a series of still-life renditions of bottles and sundry objects. So disheartened was Rossetti with his first tutoring in art that he had turned to Leigh Hunt, a Romantic poet and essayist and champion of Keats and Shelley, and asked if he would read a few poems that Rossetti had written. Rossetti relayed to his new friend that Leigh Hunt 'implored him, if he had any prospect whatever as a painter, on no account to give it up'. Rossetti, of course, despite Ford Madox Brown's irritation and Leigh Hunt's advice, listened to neither and continued on within the growing circle of friends who supported his enthusiastic endeavours, though, as Hunt writes, they needed at times 'the bold gift of prophecy' to look beyond their doubt and to shame their scepticism.

Drawn together by their shared love of art, the three young men began the formation of an artistic society of their own, an academy of their own design and definition. In a sense it is easy to view them as wholly self motivated and insular. Yet they were not untouched by the events occurring around them, and perhaps one can understand the impulse towards the creation of a supportive organisation of artists and thinkers when one remembers the turbulence of the 'hungry forties' in England. Victoria had been queen for nearly a decade, but day to day life was not marked by the economic and political complacency we often associate with the myth of the Victorian period. During 1848 and 1849, the

dangers of over industrialisation, grinding poverty and lack of medical effectiveness were emphasised in the cholera epidemic that broke out in London. Both Millais and Hunt had witnessed the great Chartist demonstration of 1848 on Kensington Common, in which the call for 'Equal Representation, Universal Suffrage and Vote by Ballot' echoed the sentiments of working class unrest and sparked fears of mob violence. Indeed 1848 had been characterised as 'the year of great and general revolt', and not solely for England. Rossetti's own romantic family history—his father's songs of rebellion—was based on the very real political turmoil that continued within Italy. To quote D.S.R. Welland is to read the grim roster of events that distinguished this unsettled period:

> At the beginning of the year there was a serious apprehension of a French invasion. Then in February revolution broke out in Paris and Louis Philippe was overthrown. Rioting continued sporadically in France, and civil war raged in Hungry, in Austria, in Poland, and in Italy. This conflict of ideologies and classes throughout Europe is best epitomised by one fact: 1848 saw the publication of the *Communist Manifesto* by Karl Marx and Friedrich Engels.

For the three friends the question must surely have been, What role to play within this time of upheaval? The easy and most obvious answer would have been to retreat entirely into the world of art. The Bastille had already been stormed after all, and to what end? But to idealists, another grim fortress was much nearer at hand. The Royal Academy itself could be challenged. Perhaps as artists, freed from restricting convention, they could enter into a social contract of sorts in which art became society's banner, unfurling before it social ills and Truth.

The aspirations were lofty, but the language that surrounded such a grand venture was not always so. To differentiate themselves from the Royal Academy, Millais, Hunt and Rossetti juxtaposed its august tradition with their own

mocking levity. They believed that those paintings most favoured by the Academy were awash in false sentimentality, contrived, murky and trivial. It was all 'slosh' and Sir Joshua Reynolds, whose *Discourses* were an honoured academic tradition, became Sir 'Sloshua'. For Hunt, the ambition was clear. A new course must be set, away from 'Monkeyana' paintings (a pointed jab at Sir Edwin Landseer's popular series of domestic genre paintings of cats, dogs and monkeys) or 'Chorister Boys, whose forms are those of melted wax with drapery of no tangible texture'. Hunt wrote in his memoirs years later that even 'illustrations to Holy Writ were feeble enough to incline a sensible public to revulsion'. All cant imitation had to be eschewed, all aping of the Greeks, Michael Angelo, Titian, and the 'early Flemings'. In short, what was needed was a new and bolder English art that 'turned the minds of men to good reflection'.

Their crusade had an almost religious dimension in its fervour and in its impulse towards ritual and the clandestine. If one can believe Hunt's recollections, Rossetti had been terming their new artistic principles as 'Early Christian' and it was Hunt who insisted on the term 'Pre-Raphælite' as being the more accurate. The term pinpointed well their belief that it was after the great Renaissance master Raphæl that art had begun to stagnate. Their time had come and a gathering of like-minded comrades began, something that Rossetti was particularly keen on. They had named their new society, but now it needed members and Rossetti, putting to a motion that the word Brotherhood be added to the original designation of Pre-Raphælite, oversaw the induction of four additional members in the winter of 1848. They included Rossetti's own brother, William Michael Rossetti, a civil servant at the Inland Revenue and who became the work horse of the group; a sculptor, Thomas Woolner, a somewhat self-aggrandising personality; a Royal Academy student and suitor of Christina Rossetti, Rossetti's sister, James Collinson, who was afflicted with narcolepsy and often fell asleep

during the meetings; and Hunt's pupil, F.G. Stephens, who had little talent, indeed had never painted a picture, but had much enthusiasm. These additional 'brothers' had been recruited while Millais had been away in the country, and his first reaction was not an approving one. His cherished dream of reform had been private, and he wished it to remain so. When Hunt went to his studio, Millais shouted out, only half teasingly,

> Where is your flock? I expected to see them behind you. Tell me about it. I can't understand so far what you are after. Are you getting up a regiment to take the Academy by storm? I can quite see why Gabriel Rossetti, if he can paint, should join us, but I didn't know his brother was a painter. Tell me. And then there is Woolner. Collinson'll certainly make a stalwart leader of a forlorn hope, won't he? And Stephens, too! Does he paint? Is the notion really to be put into practice?

Hunt smoothed things over, and Rossetti's delight was infectious. Soon two others would become closely associated with the Brotherhood—Christina Rossetti, already a published poet, and Ford Madox Brown, Rossetti's former instructor and an established painter. They were never asked, however, to join the mystical seven, because for one thing Christina could hardly be a 'brother' and, for another, because Rossetti liked the cabalistic quality of the group of seven and did not wish to extend the official membership further. The Round Table completed, they then determined to use the letters P.R.B. as their insignia, each promising to keep its meaning a secret. Many of them were still students after all and feared incurring any repercussions. However, secrecy did not dictate solemnity, and soon inside jokes flew: the initials could also stand for 'Please Ring Bell' or, in Rossetti's case, 'Penis Rather Better'.[1] Hunt would record in his memoirs rather ominously, though, that 'It is strange that with this

---

1. I cannot take credit for such knowledge but instead must indicate my indebtedness to Timothy Hilton's *The Pre-Raphælites* (London: Thames and Hudson, 1970).

precaution against dangers from outside our Body, we took such small care to guard ourselves against those that might assail us from within'.

But Hunt's fears were not for those early years, and indeed the Brotherhood adopted a champion, one of England's most respected art critics, John Ruskin. They were inspired by Ruskin's *Modern Painters*, and, though he had been writing about Turner's paintings and would not meet any of the Pre-Raphælites for some years, Ruskin's principals came to define the most enduring and cohesive element of Pre-Raphælite art—fidelity to nature: 'Go to nature in all singleness of heart…rejecting nothing, selecting nothing and scorning nothing; believing all things to be right and good, and rejoicing always in the truth'. So it was that, while influenced by the conventions of Victorian art, the Brotherhood embraced a radically new spirit of painting. They continued to depict the anecdotal and moralistic subjects typical to Victorian audiences, although many of the paintings were drawn from the Romantic poetry of Keats and almost all of them depicted romantic or tragic love. Their technique of painting, however, was unique. They studiously avoided chiaroscuro and applied brilliant colours like blues, greens, purples and violets over already whitened canvases. And most significantly, they turned their attention to observing Nature in its minutiæ. Each leaf, the subtle shading of sunlight as it traced the contours of rock or bark, all was recorded, much of it in plein air. In his journals, Ford Madox Brown joyously describes the hallmark of this first phase of Pre-Raphælitism, its own brand of realism:

> What wonderful effects I have seen this evening in the hayfields! The warmth of the uncut grass, the greeny greyness of the unmade hay in furrows or tufts with lovely violet shadows, and the long shades of the trees thrown athwart all, and melting away one tint into another imperceptibly; and one moment more a cloud passes and all the magic is gone.

In 1849, Rossetti, Millais and Hunt would each exhibit their first truly Pre-Raphælite paintings. Rossetti's, *The Girlhood of Mary Virgin*, which he had completed in Hunt's studio and with the help of Ford Madox Brown and Hunt, was the first, and Rossetti exhibited his painting at the Hyde Park gallery a month before the Royal Academy opened for the season. The subject matter was biblical, the colours harsh and bright, the narrative conveyed through a series of symbolic references, and just below his signature Rossetti placed the mysterious initials P.R.B. The Marchioness of Bath bought it for eighty guineas. Later, at the Royal Academy, Millais would exhibit *Isabella*, its subject drawn from Keats' poem *Isabella and the Pot of Basil*, and next to it would hang Hunt's *Rienzi*, which Hunt, true to the spirit of Ruskin, had painted largely while sitting at his easel outdoors. All three paintings were sold and were well received critically. The *Art Journal* wrote of Millais' painting that *Isabella* would establish the young painter's fame and of Hunt that 'he is of a surety destined to occupy a foremost place in Art'; the *Athenæum* recorded its hope that 'Mr. Rossetti will continue to pursue the lofty career which he has here so successfully begun'.

Buoyed by such praise and encouraged to extend Pre-Raphælite principles beyond its original sphere, in January 1850, the Brotherhood, particularly Dante Rossetti, turned its attention also to literature and the arts in the form of a monthly journal, appropriately or amusingly entitled *The Germ*. Although the names of the authors were still kept anonymous in the first issue, the journal did seem to be an additional way in which the Brotherhood could promote their ideas, give public evidence of their abilities, and perhaps gain a place within their own list of Immortals. At the inception of the Brotherhood, the seven members had each signed their names to a manifesto that declared their absence of faith in immortality except for those 'thinkers and workers', fifty-seven of which, whose genius or heroism exercised a perennial influence. Among

those on the list were Jesus Christ, the author of Job, and Shakespeare, all of whom received three or more stars; other, lesser immortals, included Keats, Raphæl, Tennyson and Fra Angelico, who received but one or two stars next to their names. *The Germ* was intended to be the beginnings of an enterprise that would take the literary world by storm, and at one shilling an issue, the price of immortality was quite reasonable.

Unfortunately so few wished to subscribe that *The Germ* had only four issues, even though in March its title was changed to *Art and Poetry*. Its final issue was in April of 1850. While it lasted, however, *The Germ* defined its aim as follows:

> To obtain the thoughts of Artists, upon Nature as evolved in Art, in another language besides their own proper one, this Periodical has been established. Thus, then, it is not open to the conflicting opinions of all who handle the brush and palette, nor is it restricted to actual practitioners; but is intended to enunciate the principles of those who, in the spirit of Art, enforce a rigid adherence to the simplicity of Nature either in Art or Poetry.

To this end, *The Germ* contained a remarkable variety of writings: poetry, treatises on art, short stories and critical reviews. In addition to Dante Rossetti, Christina Rossetti and William Michael Rossetti, Thomas Woolner and Ford Madox Brown also contributed work. As did such new recruits as William Bell Scott, an older Scottish painter and poet whose work so delighted Rossetti that he had written to him and thus formed a lasting friendship, and Coventry Patmore, who came from a literary family and had already published some poetry. (In fact, in the P.R.B.'s 'List of Immortals' his name had received one star.) Thomas Woolner's companion pieces 'My Beautiful Lady' and 'Of my Lady in Death', the first offerings of the first issue, epitomise well—in their intricate word pictures of the beauty of nature and in their poignant, sometimes

voyeuristic, contemplation of the beloved's death—the themes that would characterise the style and motifs of later Pre-Raphælite poetry. *The Germ* was remarkable in its freshness but it signaled also a shift away from the Pre-Raphælites' original defining concern, Art, and away from the 'Brotherhood' itself. Hunt contributed only one illustration and Millais contributed nothing at all.

The original three members of the Brotherhood were, however, still united in their art, and often worked together. Indeed, Hunt describes the day when, Rossetti painting his *Annunciation*, Millais his *Carpenter's Son* and he his 'Druid picture', they all became aware of a derisive paragraph in the 'gossiping column' of a newspaper that revealed the meaning of the initials P.R.B. They soon realised that it had sparked 'an almost universal fury' against them. Up to that point, they had been confident that in the upcoming exhibitions they would improve on last year's successes. This public criticism was harsh and unexpected, and the distancing by recent admirers hurtful. But their reception at the exhibitions was even worse than they had imagined it would be. Hunt recollects that no one complimented him at the Royal Academy and those he saw 'turned away as though [he] had committed a crime'. The criticism levelled at Rossetti's *Annunciation*, shown at the Portland Place gallery, was so hostile that Rossetti determined never to exhibit in public again.

The year, which had begun on such a high note, seemed ruined by April. *The Germ* had failed, though due predominately to events and not for lack of merit, none of the exhibited paintings sold, and the topper was the review by Charles Dickens against Millais' *Christ in the House of his Parents*. Not only was the Millais depiction of Christ described as 'mean, repulsive and revolting', but Dickens was a voice outside of the art world and his attack revealed the breadth of their shame. Christopher Wood, in *The Pre-Raphælites*, conjectures that the critical reception was as bitter as it was partly 'because they [the

critics] resented the impertinent pretensions of the P.R.B. in forming themselves into a secret society' and partly because the subject matter hinted darkly at Roman Catholic affinities. Yet such objectivity is born of hindsight.

The Brotherhood had won some converts such as Charles Austin Collins, brother of the novelist Wilkie Collins, and Arthur Hughes, a young student of the Royal Academy who after reading a copy of *The Germ* sought out their company. They also retained such loyal followers as Walter Deverell, reputed as having first 'discovered' Elizabeth Siddal working in a milliner's shop and persuading her to sit for his *Twelfth Night* as Viola. Nevertheless, Millais and Hunt felt that Rossetti's decision to withdraw from all future exhibitions was done with 'no sense of corporate interest' and that he had left them to face the full force of the criticism. As Wood writes, 'Recriminations broke out, with Millais accusing Rossetti of leaking the secret of the P.R.B. Millais' parents also blamed Rossetti for bringing their brilliant son to disgrace. Hunt was plunged into financial difficulty...[and] Collinson's reaction was to resign from the Brotherhood.' They felt betrayed by what they perceived as Rossetti's selfish cowardice. And indeed it would be Millais and Hunt who would truly continue the spirit of the Brotherhood in its purest form after this disastrous year. With brave tenacity, they exhibited their paintings again the following year, and 1851, the same year as the Great Exhibition in Hyde Park and Wordsworth's death, saw Millais' *Mariana*, *The Woodman's Daughter* and *The Return of the Dove to the Ark* and Hunt's *Valentine Rescuing Sylvia from Proteus*; in addition, Ford Madox Brown presented *Chaucer at the Court of King Edward III* and Collinson *Convent Thoughts*.

In response, last year's storm of abuse now turned into a hurricane, and Hunt believed that there was a 'studied determination to destroy [them] altogether'. Yet John Ruskin, whose views they had from the beginnings embraced, like 'thunder as out of a clear sky', came to their rescue. In his letters to *The Times*, Ruskin, England's leading art critic, offered criticism but also support: 'May they, as they gain experience, lay in our England the foundations of a school of art nobler than the world has seen for three hundred years'. He offered protection and his influence quelled the storm. By the autumn, Hunt's *Valentine* won first prize at the Liverpool Exhibition and, though Rossetti had been conspicuously absent throughout much of the year, the Brotherhood seemed set.

In reality, the painful fragmenting, which had begun during the humiliating reception in 1850 and which culminated in Collinson's resignation, continued. The year 1851 saw the growing division between the members, the separation intensified by the critics' hostility and by artistic differences and clashing personalities. In 1852, Hunt produced *The Hireling Shepherd* and Millais *Ophelia*, both probably the finest examples of Ruskinian fidelity to natural observation; Rossetti produced nothing that year. Hunt had taken him to Sevenoaks in Kent to do some landscape painting. It had rained, and Rossetti retreated hurriedly from Kent and from *plein air* compositions. Also, in the summer, Thomas Woolner left England altogether for Australia, his immigration providing the inspiration for Ford Madox Brown's *Last of England*. William Michael Rossetti wrote that all was 'sinking into desuetude'. The following year, 1852, proved no better, although marked by milestones: Dickens' *Bleak House*, England being drawn into the conflict between Russia and Turkey, and Millais' election to the Royal Academy in November. Other milestones were to come. In 1854, Dickens published *Hard Times*, in March England and France declared war on Russia, the allied armies entered Crimea in September, and Hunt set off for the Holy Land. Dante Rossetti wrote to his sister, Christina, that 'the whole Round Table is dissolved'. She replied with a sonnet:

The P.R.B. is in its decadence:
For Woolner in Australia cooks his chops,
And Hunt is yearning for the land of Cheops;

> D.G. Rossetti shuns the vulgar optic;
> While William M. Rossetti merely lops
> His B's in English disesteemed as Coptic;
> Calm Stephens in the twilight smokes his pipe,
> But long the dawning of his public day;
> And he at last the champion great Millais,
> Attaining academic opulence,
> Winds up his signature with A.R.A.
> So rivers merge in the perpetual sea;
> So luscious fruit must fall when overripe;
> And so the consummated P.R.B.

As Wood so aptly phrases it, this was the end of the Pre-Raphælite Brotherhood but the beginning of Pre-Raphælitism. Millais would continue on with the Royal Academy, achieving great commercial success with such paintings as *Bubbles* and *Hearts are Trumps*. His creativity was traded for that which was lauded—sentimentality and society portraits—and in his last years he became a baronet and was awarded a new set of initials in 1896, the P.R.A.: President of the Royal Academy. Hunt remained obsessively Pre-Raphælite in his painting technique—going to the Red Sea itself to paint *The Scapegoat* and painting the unfortunate subject even as it died before him—and remained increasingly intent upon religious subjects—his most famous being *The Light of the World*, a copy of which can be seen in St. Paul's Cathedral.

The story of Pre-Raphælitism, however, truly continues with Dante Rossetti. Having abandoned the larger, more detail-oriented canvases, Rossetti now devoted his art to the creation of smaller, brilliant watercolour visions taken entirely from his own readings and imaginings of Arthurian lore. *The Wedding of Saint George and the Princess Sabra* and *How Galahad, Sir Bors, and Sir Percival were fed with the Sanc Grœl; but Sir Percival's Sister died by the Way* are wonderful examples of Victorian medievalism, a Middle Ages that never existed except within romantic recreation. He turned to book illustration. He had a hand, as did Arthur Hughes and Millais, in illustrating the poetry of William Allingham, an Irish civil servant and poet

who had become a close friend of Rossetti's and whose wife Helen Allingham would become well known for her pictures of idyllic country cottages. In addition to Allingham's book, Rossetti, along with Hunt and Millais, provided illustrations for the Moxon edition of Tennyson, published in 1857. In ways, his experiences were less insular. Rossetti still retained a connection with Ford Madox Brown and John Ruskin, even though Ruskin had been closer to Millais than to Rossetti in the early days. But when Effie Ruskin left her husband for the much younger and more affectionate Millais, the professional relationship failed for obvious reasons. In the mid 1850s, it was Rossetti, Ruskin and Brown who were drawn together by their association with F.D. Maurice's Working Men's College in Great Ormond Street. Maurice was a Christian Socialist and had founded the College in 1854. It was an odd enterprise, noble in its principle to educate the workman in art but its classes were taught by very diverse personalities. Ruskin taught drawing—grasses, stones, leaves, flowers, water; Thomas Hughes, of *Tom Brown's Schooldays* fame, taught boxing; Brown later taught painting, systematically and precisely; and Rossetti taught evening classes of figure and watercolour painting, when he remembered to turn up.

It was there at the Working Men's College that Edward Burne-Jones, the son of an unsuccessful picture framer and now a student at Exeter College in Oxford, met Rossetti early in 1856. By the summer Rossetti had taken him on as a student and a disciple. Burne-Jones himself had belonged to a Brotherhood or 'Set' of young men studying for the Church in Oxford: William Fulford, Charles Faulkner, Cornell Price, Richard Watson Dixon, and later William Morris, the son of a wealthy London businessman. The young men of 'The Set' were romantic in their interests—Tennysonians—but they were also concerned with industrial and socio-political realities. They were aware of and affected by the existence of slums, the cholera epidemic and the Crimean war. Burne-Jones' father had been a

constable at the Chartist riots of 1839. They too had turned to medieval England, but not as a retreat but as a model for Victorian reform, one that stressed the value of work, community, the countryside, and the civilising centrality of architecture.

Before meeting Rossetti, Burne-Jones describes how, as early as 1854, 'The Set' knew of him, fascinatingly again by way of Ruskin. Burne-Jones remembers the day when

> I was working in my room when Morris ran in one morning bringing the newly published book [Ruskin's *Edinburgh Lectures*] with him: so everything was put aside until he read it all to me. And there we first saw about the Pre-Raphælites, and there I first saw the name of Rossetti. So for many a day after that we talked of little else but paintings we had never seen.

The Oxford Set, however, was not particularly interested in art but in books and contemporary issues. 'We have such a deal to tell people', wrote Burne-Jones, 'such a deal of scolding to administer, so many fights to wage…our spirits are quite rising with the emergency'. *The Oxford and Cambridge Magazine*, the brain-child of Dixon and the financial burden of Morris, was born, modelled on the format of its *parentis in spiritus*, *The Germ*. It was comprised of short stories, poetry, social articles, and actually did quite well. Seven hundred and fifty copies were printed for the first issue in January 1856. Ruskin was enthusiastic and Tennyson full of praise, but the magazine lasted for only twelve issues as Morris grew tired of bank-rolling the publication, editing the issues and contributing eight prose tales, five poems, two articles and a review.

By the time Morris met Rossetti through Burne-Jones in the summer of 1856—Rossetti by now having encouraged Burne-Jones to devote his life to art—Morris had published quite a bit and had begun to formulate a philosophy of society and reform that would be the basis for his later involvement in the early Socialist movement. Rossetti, however, saw in 'Ned' (Edward Burne-

Jones) and 'Topsy' (Morris' nickname because of his thick, unruly hair) the chance to create a new Pre-Raphælite Brotherhood, and he did much to persuade them, quite easily in Burne-Jones' case, to put aside the Oxford causes. Morris wrote in July 1856, 'Rossetti says I ought to paint, he says I shall be able; now he is a very great man, and speaks with authority and not as the scribes. I must try!'

By November, Rossetti had persuaded them to move to London, specifically No. 17 Red Lion Square where sadly Walter Deverell had died of Bright's Disease. So caught up was he with this new life that Burne-Jones ascribed an almost beatific quality to that first year with Rossetti:

> That was a year in which I think it never rained nor clouded, but was blue summer from Christmas to Christmas, and London streets glittered, and it was always morning, and the air sweet and full of bells.

It was perhaps less perfect for Morris. He was now one of the court within the Palace of Art, but he wanted something other than to merely worship there. In this year, Morris began what would become one of the hallmarks of the movement—forging important links between the visual and the verbal. He wrote both 'The Blue Closet' and 'The Tune of Seven Towers', later to be published in *The Defence of Guinevere*, as companions to watercolours of the same titles purchased from Rossetti. Because, for all of Rossetti's influence and call to the life of art, Morris was not in his heart a painter, though he tried to be when the group was invited to paint murals of Arthurian subjects in the Oxford Union.

In the summer months of 1857, the summer of Trollope's *Barchester Towers* and the Indian Mutiny, Rossetti's 'jovial campaign' was launched. The company included, besides Rossetti, Morris and Burne-Jones, some new recruits to the cause: Arthur Hughes, Spencer Stanhope and Val Prinsep, who unfortunately could neither paint nor draw but who could, fortunately, record in his diary what it was like to

be there. Faulkner, Price and Dixon, members of the old 'Set', also helped Morris with his panels and scaffolding. It was a reunion of sorts, and 'scholars working in the library next door were frequently disturbed by their laughter and songs and jokes and the volleys of their soda water corks'. The summer was a happy one of shared camaraderie. In addition to the gothic designs, the painted knights and ladies, Rossetti drew cartoons of wombats and small caricatures of Morris. Though some of the panels were never completed, and though the murals themselves began to fade within six months, due to the damp, the smoke from glass chandeliers, and uneven, ill prepared walls, Prinsep remembered when rooms were alive with their voices:

> There I found Rossetti in a plum-coloured frock-coat, and a short square man with spectacles and a vast mop of dark hair. I was cordially received. 'Top', cried Rossetti, 'let me introduce you to Val Prinsep.'
>
> 'Glad, I'm sure', answered the man in spectacles, nodding his head, and then he resumed his reading of a large quarto. This was William Morris. Soon after, the door opened, and before it was half opened in glided Burne-Jones. 'Ned', said Rossetti, who had been absently humming to himself, 'I think you know Prinsep'…When dinner was over, Rossetti, humming to himself as was his wont, rose from the table and proceeded to curl himself up on a sofa. 'Top', he said, 'read us one of your grinds.' 'Very well, old chap', growled Morris, and having got his book he began to read in a sing-song chant some of the poems afterwards published in his first volume [*The Defence of Guinevere*]. All the time, he was jiggling about nervously with his watch chain. I was then a very young man and my experience of life was therefore limited, but the effect produced on my mind was so strong that to this day, forty years after, I can still recall the scene: Rossetti on the sofa with large melancholy eyes fixed on Morris, the poet at the table reading and ever fidgeting with his watch chain, and Burne-

Jones working at a pen-and-ink drawing …What fun we had in that Union! What jokes! What roars of laughter!…Rossetti was the planet around which we revolved. We copied his very way of speaking. All beautiful women were 'stunners' with us. Wombats were the most delightful of God's creatures. Medievalism was our *beau idéal* and we sank our own individuality in the strong personality of our adored Gabriel.

At much the same time as the Oxford Union Murals, Morris had been preparing to publish some of the many poems he had now written. He had the ability to compose poetry seemingly without effort. Dixon remembered when Morris, years ago while in the Set, had first read one of his poems to the group, and amid praise modestly said, 'Well, if this is poetry, then it is very easy to write'. That ease of writing never abated, and in March 1858, he published *The Defence of Guinevere* with Bell & Daldy, the publisher also of *The Oxford and Cambridge Magazine* and *The Germ*. In subject matter, the thirty poems were appropriately medieval and Arthurian in theme. Many of them were short and highly imagistic. Some express deep yearning, like 'In Praise of my Lady', while others, like 'The Haystack in the Floods', are characterised by a stark realism and underlying morbidity. The landscapes are beautiful and the characters noble, but all seems under the menace of war and violence. The beauty, if anything, lays stress to its fragility. Critically, *The Defence of Guinevere* was not received with much enthusiasm, and while it did not incur the animosity that had greeted the first Pre-Raphælite paintings of Hunt, Millais and Rossetti, its lacklustre reception did not seem to bode well for the first true offering of Pre-Raphælite literature. William Allingham (*Poems*, 1850, and *Day and Night Songs*, 1854), William Bell Scott (*Poems of a Painter*, 1854) and Coventry Patmore (*The Angel in the House*, 1856) had published some of their work earlier, but Morris was the first within the inner circle to submit his work to public judgment—Dixon's

*Christ's Company and Other Poems* would not be published until 1861, Christina Rossetti's *Goblin Market* not until 1862, and Dante Rossetti's *Poems* not until 1870. Disappointed, Morris would wait for over a decade before publishing more of his poetry.

In the meantime, the personal dynamics of this predominantly male group were not without tension. Rossetti was involved with Elizabeth Siddal and had been since soon after Deverell employed her as his model. Deverell described her as reserved, fragile, 'magnificently tall, with a lovely figure, a stately neck'. He went on to pronounce that 'she has grey eyes, and her hair is like dazzling copper, and shimmers with lustre as she waves it down.' Before long, she began to sit almost exclusively for Rossetti, however, and Rossetti told Ford Madox Brown that 'when he first saw her he felt his destiny was defined'. 'Lizzie', as she was commonly called, was beautiful, but she also had substance. She seized the chance that the Pre-Raphælite's adulation gave her, and with no formal education, she began earnestly to study art under Rossetti's tutelage and to write poems. Her art was public and admired by Ruskin himself, but her poetry was private and kept for the inner life. Whether 'Guggums' as Rossetti affectionately called her or the first of the 'stunners', Elizabeth Siddal must have been extraordinary and as complex and, in her own way, as driven as was Rossetti himself. Their relationship was certainly not a peaceful one. She was often ill, a state attributed to 'delicacy of health' and later to laudanum usage. Rossetti, though he loved her and had set up house with her, resisted marriage, much to Ruskin's enduring distress; furthermore, he formed an attachment to another of his models, Fanny Cornforth, a large-boned, vivacious woman with long blond hair that touched the ground, a prostitute who lived in Soho. Of even more significance than Fanny Cornforth, in December 1857, Rossetti met yet another 'stunner', the eighteen year old Jane Burden. She was discovered when she attended the theatre at Oxford. Like the other models, Jane

Burden came from a poor family, in her case her father being an ostler, and she began first to sit for Rossetti. Unlike Elizabeth Siddal, Jane Burden was tall, had dark frizzy hair, and had an exotic, foreign quality about her. Rossetti was attracted to her.

Morris fell in love with her. She modelled for Morris' *La Belle Iseult* (1858), Morris' only painting, and legend has it that he wrote on the initial drawing, 'I cannot paint you, but I love you'.

The triangle that existed between 'Janey', Morris and Rossetti was not unique in Pre-Raphælite history. Already a shocking triangle had transpired between Millais, Ruskin and Effie Ruskin, later Effie Millais. And yet another was to occur. By 1856, the tide of critical perspective had changed concerning Pre-Raphælite art. Ruskin wrote in his *Academy Notes* of that year that 'animosity has changed into emulation, astonishment into sympathy'. Naturally, therefore, as the Pre-Raphælite movement gained ground, it gathered into itself a growing number of followers, particularly young artists. Among these was Henry Wallis whose affiliation with the Pre-Raphælites was intense though brief. In this year, Wallis presented to the Academy *The Death of Chatterton*, which caused a sensation. It depicted the tragic eighteenth-century poet Thomas Chatterton dead at his own hand, lying in a bedsit. The model had been George Meredith, the novelist and poet. During the time that he posed for Wallis, Meredith's wife, Mary Ellen, fell in love with the younger painter and by 1858, already separated from her husband, Mary Ellen gave birth to a child by Wallis. Soon thereafter, the lovers 'eloped' to France. Wallis never painted seriously again, and the strained and painful relationship between Meredith and Mary Ellen would serve as the inspiration for Meredith's quasi-autobiographical novel *The Ordeal of Richard Feverel* (1859) and, on the occasion of Mary Ellen's death in 1861, the bitter sonnet sequence, *Modern Love* in 1862.

In the case of William Morris, he proceeded

forward in blind trust, announcing his engagement to Jane Burden in the spring of 1858. The following year of 1859, the same year as Darwin's *Origins of the Species* and Tennyson's *Idylls of the King*, they were married in April by his old friend Dixon, who was now a curate at St. Mary, Lambeth. The marriage, though, was fated at its very beginning: after his death, Jane Morris admitted that she had never loved him but had married him because his name represented economic stability and social acceptance. The difference in their class was certainly uppermost in Algernon Charles Swinburne's mind. Swinburne, who was a new poet whom Rossetti had 'unearthed' in Oxford and Burne-Jones called 'dear little Carrots', referring to his bright red hair, is said to have lamented that Morris 'should be content with that perfect stunner of his—to look at or speak to. The idea of *marrying* her is insane.' Rossetti had strong feelings also, though his were not predicated on elitism. He made clear his disapproval by not attending the wedding. His relationship with Jane Morris, however, continued and strengthened, growing more intimate, rather than less, as time went on. Fiona MacCarthy's biography of William Morris even describes a manuscript sent by Rossetti to Jane Morris in 1875. It is a play in which Morris is killed by a Mrs. Wardle, infamous in 1857 for her suspected poisoning of her lover. The drama is correctly seen by MacCarthy as a cruel example of Rossetti's twisted jealousy and Janey's compliance in a long series of mean-spirited jokes at Morris' expense. The play is entitled *A Drama of the Future in One Unjustifiable Act*:

Scene 2
(St. James's Hall)
*Topsy is discovered lecturing in Architectural Restoration.*

Top (*reads*). 'Our forefathers had thus reared for us, with superhuman labour, temples worthy of Christian worship—nay, almost worthy in themselves of some portion of the homage which the worshippers'—(*Aside through his teeth,* —I can't have written rot like this—*turns the page to skip, but finding he cannot, goes on*) —'which the worshippers bestowed on that Power which alone could have inspired such mighty achievements.' (*Aside, as before*) I know that damned Ned has stuck it in!—(*goes on*)—'Little could those great yet humble ones have dreamed that a too puffed-up posterity'—(*Scratches the seat of his trousers, and looks uneasily at the curtain behind him*)—'would have devoted all their efforts only to the defacement of the noble structures bequeathed to their keeping by godlike minds and hands.' (*Aside through the curtains*)—I say, Ned, damn you.
E. Burne-Jones (*from behind the curtain*). I didn't do it, Top—you wrote it yourself. It's very bad, but go on or the audience will hiss.

(*Topsy goes on, lurching a great deal, and at last concludes amid great applause: he bows and goes behind the curtain.*)...

Scene 3
(A Private Apartment.)
*Wardle and Madeline [Mrs. Wardle] seated at a table, with cups and saucers etc...*
(*A crash without. Enter Topsy.*)

Top. I say, I'm very sorry, but I was laying down my hat on a chair outside, and somehow my hand went through it.
Madeline. I pray don't mention it, Mr. Morris, it's of no consequence.
Top (*to Wardle*). I say, old chap, Ned told me just now that someone had chalked a T on my back. (*Tries to see it*) Do you see it?
Wardle. No, of course.
Top. Blow that Ned! (*Aside through his teeth*) I should like to tread his guts out.
Wardle. He hasn't got any...
Madeline. Mr. Morris, you're letting your coffee get cold. George dear, hand the cup...

Regardless of what would happen years later, however, by the close of the decade, the Red Lion Square group was breaking up. William and Jane

Morris were preparing to move to Morris' Red House in Upton, Kent, which had been built under the guidance of the architect Philip Webb and infused with the romance of Victorian sensibilities of medieval design and interiors. Edward Burne-Jones, having been engaged to Georgiana Macdonald, the daughter of a Methodist minister, had now married also. Even Rossetti had, at last, married, though his marriage to Elizabeth Siddal would end tragically when she died of an overdose at their home in Chatham Place in February 1862.

The first phase of Pre-Raphælitism was over, but the Pre-Raphælite movement would last until the turn of the century, and, after the 1860s, it took on a diversity of influence, particularly within the Arts and Crafts Movement and the Æsthetic Movement. Beginning in the 1860s, Pre-Raphælitism began to make bold inroads into Victorian domestic life, focusing attention on the æsthetic possibilities, nay necessity, of furniture, fabrics, architecture, interior design, book design and illustration. Pre-Raphælitism had such an impact that by 1877 Henry James could write emphatically that in its effect one saw 'the art of culture, of reflection, of intellectual luxury, of æsthetic refinement, of people who look at the world and at life not directly, as it were, and in all its accidental reality, but in the reflection and ornamental portrait of it.'

Morris, already awakened to the possibilities of design and decoration by the Oxford Union murals and the building of Red House—for which he, Burne-Jones and their friends had designed everything from the furniture to the carpets—headed up the formation of 'the Firm' in 1861. The Firm's full title was Morris, Marshall, Faulkner and Company, the 'company' consisting of nearly all the Pre-Raphælites: Edward Burne-Jones, Ford Madox Brown, Arthur Hughes, and Philip Webb. Even Georgiana and Janey were brought into the venture, their tasks to paint tiles

and embroider wall hangings. Their ideals were high: that they as practitioners of High Art should also turn their talents to design and decorative art, stained glass, tapestries, wallpapers, tiles and jewellery. Rossetti would write in a letter dated January 1861 that their aim was not to produce 'costly rubbish' but 'to give real good taste at the price if possible of ordinary furniture'. They launched the Arts and Crafts Movement in England, and unlike the hero of George Eliot's *Felix Holt, the Radical* (1866) they chose not to shun but rather to embrace the life of the artisan.

Needless to say, idealism was whittled away by reality, and while the movement continued unabated, its original practitioners began to fall away. By 1875, Morris alone of the Pre-Raphælite 'company' had remained faithful to the everyday grind of manufacturing. Rossetti, Brown and Burne-Jones had returned to painting; Webb to architecture; Marshall to sanitary engineering; and Faulkner to academia once more. Morris reconstituted the Firm and it was thereafter called Morris & Co. This formal restructuring was not done without acrimony, however, as a Rossetti caricature drawn at that time makes clear. In it one sees at the top left hand corner a diminutive group of the original partners holding a sign that reads 'We are Starving'; they, as well as Janey and Marx and Engels, watch as a corpulent Morris tumbles downwards towards the upraised pitchforks of hell. Yet, Morris & Co., which would last from 1875 to 1940, well beyond Morris' death, did extraordinarily well, receiving commissions to decorate, for example, Castle Howard and the Duke of Westminster's new chapel at Eaton Hall. His wallpapers and beautiful fabrics would provide the backdrop for Oscar Wilde and, then youngsters, Aldous Huxley and William Butler Yeats. Indeed, Yeats remembers as a child going with his parents to their new house in Bedford Park and being overwhelmed with delight and discovery:

> We were to see De Morgan tiles, peacock-blue doors and the pomegranate pattern and the tulip pattern of Morris, and to

discover that we had always hated doors painted with imitation grain, the roses of mid-Victoria, and tiles covered with geometrical patterns that seemed to have been shaken out of a muddy kaleidoscope. We went to live in a house like those we had seen in pictures.

During this time of expansion and prosperity Morris began to experience a keen disillusionment. As MacCarthy writes, 'he was becoming more conscious of his falseness of position in "ministering to the swinish luxury of the rich" '. He turned increasingly back to the sympathies of the old Oxford days, first throwing himself into the conservation and restoration movement, the Society for the Protection of Ancient Buildings. Yet, realising that the activities of the 'Anti-Scrap' were only passingly beneficial to the larger society and social reform, by the 1880s Morris became a Socialist and began delegating the running of the firm to trusted associates. In January 1883, he joined the Democratic Federation, a political organisation that proposed the union of all people, irrespective of party, to call for the rights and dignities due the working class. In taking up the cause of Socialism, Morris crossed a 'river of fire' and his whole-hearted involvement led him to a milieu very different from that of the Pre-Raphælite community. Andreas Scheu, a Viennese refugee who became a close colleague, gives a first hand account of Morris at an early Socialist gathering in London:

> In the early winter months of 1883 the Democratic Federation had arranged some meetings at the Westminster Palace Chambers. I attended the first of those meetings (I forget the exact date), Mr. Hyndman in the chair. The order of the day was the passing of some resolutions on the question of education, normal working-day, and the housing of the working classes. The business had scarcely been started when Banner, who sat behind me, passed me a slip of paper, 'The third man to your right is

William Morris.' I had read of but never seen Morris before, and I looked at once in the direction given. I was struck by Morris's fine face, his earnestness, the half searching, half dreamy look of his eyes, and his plain and comely dress.

In 1884, Morris left the Social-Democratic Federation, as it was later named, because he disagreed with its increasing advocacy of immediate parliamentary action. Morris, following more purist socialist theory predicated upon long term social agitation and education, formed the Socialist League, causing a split in British socialism. The League's mouthpiece, also of Morris' creation, would be *The Commonweal* and within its first issue, Morris would publish the League's Manifesto: 'Fellow Citizens, We come before you as a body advocating the principles of Revolutionary International Socialism; that is, we seek to change in the basis of Society—a change which would destroy the distinctions of classes and nationalities'. Frederich Engels would be a contributor to the second issue.

These were heady days for Morris, but this too would in time fall away to disillusionment when Morris, dispirited by the excesses of ideology and personalities, said farewell to the League in 1890. Instead, he would return once more to the eternal verities of art and literature. He began writing in earnest a series of dreamscape romances, and with Burne-Jones formed the Kelmscott Press, named after his beloved summer home in Oxfordshire. Between the two old friends, they produced highly crafted illustrated books: the Kelmscott *Chaucer* was deemed by Yeats as being 'the most beautiful book in the world'.

The path chosen by the two Pre-Raphælites closest to him, however, could not have been more different. The removal from the world afforded by æsthetic philosophy could hardly be better represented than in the art of Rossetti and Burne-Jones in which class struggle and exploitation played no part. At first, before the tragic decline in his health and emotional stability, Rossetti was the

dominating figure of the Æsthetic Movement. Leaving behind the small medieval watercolours of the 1850s, Rossetti began to paint large glowing canvases of women who filled much of the frame, whether they were seated or shown in half-length. Such women became a type, an eternal icon of beauty. Richly coloured, they shared a sensual and brooding quality. Rossetti's myopic visions had long necks and dark wavy hair, evocative as they gazed out fixedly at some distant space that they alone could see. An amazing series of sometimes languorous, sometimes menacing, women followed: Elizabeth Siddal in *Beata Beatrix* (1870) and *The Blessed Damozel* (1879); Alexa Wilding, one of his favorite later models, in *The Bower Meadow* (1872) and *Veronica Veronese* (1872); and of course Jane Morris, whom he painted obsessively, in such works as *Proserpine* (1877) and *Astarte Syriaca* (1877). As early as 1861, Christina Rossetti wrote a poem, entitled 'In an Artist's Studio', about her brother's unceasing shaping of the 'selfsame figure'. Her insights are telling:

> One face looks out from all his canvases,
> One selfsame figure sits or walks or leans:
> We found her hidden just behind those screens,
> That mirror gave back all her loveliness.
> A queen in opal or in ruby dress,
> A nameless girl in freshest summer-greens,
> A saint, an angel—every canvas means
> The same one meaning, neither more nor less.
> He feeds upon her face by day and night,
> And she with true kind eyes looks back on him,
> Fair as the moon and joyful as the light:
> Not wan with waiting, not with sorrow dim;
> Not as she is, but was when hope shone bright;
> Not as she is, but as she fills his dreams.

Christina Rossetti's observations are chilling in their implications for the submersion of the sitter's emotions to the artist's vampiric need to control and to create without reference to the reality of her unhappiness; however, Christina Rossetti is not altogether correct. While Dante Rossetti did indeed idealise, and thus distort, his models, one can distinguish between them: the ethereal fragility of Elizabeth Siddal, the calm and youthfulness of Alexa Wilding, the coarser sensuality of Fanny Cornforth, and the dark, compelling beauty of Jane Morris.

The same could not be said for the women of Edward Burne-Jones' canvases. In some cases, as in *The Golden Stairs* (1880) and even in the later *Mirror of Venus* (1898), the same woman—her graceful, elongated body, her flowing classical dress and her hauntingly serene (or empty?) expression—is duplicated ten to eighteen times in the same painting. While his æsthetic ideal was inspired by Greek and Roman myth and always by *Le Morte Arthur*, these writings were often mere allusions within his paintings, providing the trappings of time period but not a sustaining narrative. Rossetti wanted somehow to capture forever the essence of the women around him; Burne-Jones wanted to capture the essence of the poetic imagination: 'I mean by a picture a beautiful romantic dream of something that never was, never will be—in light better than any light that shone—in a land no-one can define, or remember, only desire'. Although he refused the title, in time he became the leader of the Æsthetic Movement, the figurehead for writers such as Swinburne and Walter Pater, and the inspiration for a second generation of Pre-Raphælite artists, among them Sidney Harold Meteyard, Marie Stillman née Spartali, Jessie Marion King, John Atkinson Grimshaw, John de Morgan and Evelyn de Morgan née Pickering, John Melhuish Strudwick, Eleanor Fortescue Brickdale, Kate E. Bunce, and John William Waterhouse.

There would be a second phase of Pre-Raphælite writings also. *The Germ* and Morris' *Defence of Guinevere* would not remain the primary examples. Morris would later publish copiously: *The Earthly Paradise* (1869), *News from Nowhere* (1891), a series of utopian romances and essays on politics and the decorative arts, and the works of the Kelmscott Press. Christina Rossetti would also do so: *The Prince's Progress* (1866), *Common Place and Other Short Stories* (1870), *Sing-Song* (1872), *A*

*Pageant and Other Poems* (1881) and *The Face of the Deep* (1892). The original Pre-Raphælites would continue writing under the movement's influence: William Allingham, *Evil May-Day* (1882); William Bell Scott, *Poems* (1875) and *A Poet's Harvest Home* (1882); and Richard Watson Dixon, *Christ's Company* (1861) and *Mano* (1883). Ruskin's 'demoniac youth', Swinburne, perhaps the most deliberately aggressive poet of Pre-Raphælite imagery and thematic obsession with the *femme fatale*, published a *Poems and Ballads* series, first in 1866 and then in 1878, before succumbing to a new obsession, represented in *Songs Before Sunrise* (1871), Italian politics and æsthetic protest. Rossetti had also come into his own as a poet, and as legend and William Bell Scott's *Autobiographical Notes* tell us, he exhumed the poems he had buried with Elizabeth Siddal's body, revised them, added to them, and presented them in 1870 as *Poems*. In 1881, he published *Ballads and Sonnets* with the completed sonnet sequence 'The House of Life', his masterpiece, which explored Love in all of its nuances and delineations.

Such literary splendour proved as magnetic as did Pre-Raphælite art, and many fell under its spell. Pre-Raphælite writings, after all, shared the style and visual wealth of paintings: the religiosity, the sensuality, the colours, the density of details and allusiveness, the medievalism, the frequent morbidity, the cryptic nature of ballads. In the 1860s, two men particularly were drawn in worshipful tribute to Rossetti. The first was Thomas Gordon Hake. In his youth, Hake had written metaphysical poetry modelled on Shelley, but he allowed himself to be convinced by his friends and by a less than enthusiastic reception to go to medical school. Hake was sixty years old when he met Rossetti and was inspired to begin writing poetry again (*The World's Epitaph* [1866]), and did so while serving also as Rossetti's friend and physician. The second man was Sebastian Evans, who actually became closest in friendship to Edward Burne-Jones. Evans would publish *Brother Fabian's Manuscript and*

*Other Poems* in 1865, its devotional themes approved of by Christina Rossetti, but in 1875 Evans' *In the Studio* focused on a different religion, the higher principles and ephemeral dreams of Arthurian lore, a love he shared with Edward Burne-Jones.

Indeed, the 1870s saw the blossoming of Pre-Raphælite writing and writers whom Rossetti believed would be the successors to the legacy. Arthur O'Shaughnessy, a reserved and quiet man who worked in the Zoology section of the British Museum, first attracted the attention of Swinburne with his startling poems that spoke of madness, passion and werewolves: *An Epic of Women* (1870), *The Lays of France* (1872) and *Music and Moonlight* (1874). There was Philip Bourke Marston, a close friend of Arthur O'Shaughnessy, who had gone blind at the age of four and who, before his thirtieth year, had lost his mother, his fiancée, Mary Nesbit, his sister Cicely, and his sister Eleanor and her husband, Arthur O'Shaughnessy. In 1882, he would even lose his mentor, Dante Rossetti, who had written a sonnet to Marston naming Philip his poetic heir:

> Ah! let the Muse now snatch
> My wreath for thy young brows, and bend to watch
> Thy veiled transfiguring sense's miracle.

Not surprisingly, Marston's poetry is marked overwhelmingly by sadness, but he wrote of loss not as an abstraction evidenced by oft-used poetic conventions but of the aching absence caused by loss made tactile and real within the world of the senses: the remembered sounds of silk rustling in movement, the feel of skin, and cold stillness of deserted rooms: *Song Tide* (1871), *All in All* (1875), *Wind Voices* (1883) and *A Last Harvest* (1891). Ford Madox Brown's son, Oliver Madox Brown, was also naturally included. Oliver Madox Brown, perhaps wishing to distinguish himself from the artistic pursuits of his father, wrote the only true Pre-Raphælite novel, *Gabriel Denver*, at the age of seventeen. The novel had originally been titled *The Black Swan*, but its editors insisted upon significant changes not because it

was a juvenile work but because the original contained gruesome elements and ended unhappily. *Gabriel Denver* (1873) was the revised version, and one can only speculate on how shocking the original must have been. Sadly, Oliver Madox Brown died at the age of twenty-one of blood poisoning. And then there was John Payne, a scholar at heart who eventually settled into a solicitor's office where he was able to find peace and space enough to pursue his poetry. At one point, he had hopes of marrying Ford Madox Brown's daughter, Emma Lucy, but his hopes were dashed when she accepted William Michael Rossetti's offer of marriage. He would write *Lautrec* in 1878, a lengthy and wondrously weird poem about a female vampire.

It has to be said that these converts to Pre-Raphælitism did not have a significant impact on the literary world. The announcement of Payne's death, for example, came thirteen days after the fact. They were followers, not originators, and thereby they avoided serious critical scrutiny. For them, no knives were sharpened; no laurels woven. Shadowed by the first generation Pre-Raphælites, those larger than life figures of the inner circle, the works of the second generation were often admired greatly by those within the circle but neglected by those outside. And whether because of modesty or a sense of realism, they seemed to understand their place only too well. Philip Bourke Marston amusingly reflects this awareness when he writes in a letter dated 2 June 1886,

> I am striving to bring up the people in my house in the way they should go. After weeks of careful study I discovered they never cleaned my boots, and I mildly remarked to them that though they probably didn't know it I was what was called a poet, that is to say, a person who rhymed dove and love and sent his poems to magazines, and got no money for them, which was a peculiar proceeding, but then poets were peculiar people, and one of their most remarkable peculiarities was that they liked to have their boots blackened.

Only two 'minor' Pre-Raphælites would provoke the world, one without ever knowing that he had. Such was the case for William Bell Scott, who first published *Poems of a Painter* in 1854 and continued publishing right up to his death in 1890. His *Autobiographical Notes*, however, published posthumously under the watchful eyes of his long-term friend and reputed mistress, Alice Boyd, caused an uproar, and the loudest voices were those of the surviving Pre-Raphælites themselves, particularly Swinburne who was enraged by its revelations. The other to force unwelcome recognition was Hall Caine, whose *Recollections of Rossetti* (1882) like Scott's *Notes* was biographical in nature. Caine had come to Rossetti's attention when Caine had defended the poet's literary honour at a public lecture, and Caine would later live at Tudor House at Rossetti's invitation. Although years passed and he eventually returned to his birthplace, the Isle of Man, Caine would be ridiculed relentlessly and unfairly caricatured in the London newspapers as a shameless self-promoter.

That the surviving Pre-Raphælites should feel protective of Rossetti is hardly surprising. As Prinsep had written in the 1860s, he was their 'beloved Gabriel'. Rossetti's relationships with the other Pre-Raphælites, however, had deteriorated considerably over the years. He had suffered increasingly from paranoia: a state of mind triggered perhaps by Robert Buchanan's vitriolic attack of *Poems* in 'The Fleshy School of Poetry' (1871). Despite the ongoing public support of such voices as Thomas Watts-Dunton, an intimate of the Pre-Raphælites and the chief critic for the *Athenæum*, Rossetti had begun to suspect even close friends of betrayal, and became more and more reclusive and subject to depression. When he died on Easter Sunday, 1882, the impulse of William Michael Rossetti and others was to keep the legend intact, and they fought against the prying eyes and wagging tongues of unauthorised biographers. And there would be other biographers, others who had not been part of the charmed circle but who observed as outsiders,

guests but not 'brothers': Wilfrid Scawen Blunt and his *Diaries*, recording his 'friendship' with Jane Morris during the 1880s, and Violet Hunt's *The Wife of Rossetti*, presenting the first biography of Elizabeth Siddal.

The protectiveness stemmed also from the pervading sense of endings. William Holman Hunt, now an old man, believed that his perspective was needed as a corrective to history. Even in the late 1850s, Hunt had mourned the loss of the 'corporate hereditary' when Rossetti decamped to Oxford. Neither he nor Millais had spoken to Rossetti since 1857. When in 1881 Hunt heard of Rossetti's failing health, instead of going to him, Hunt wrote to William Michael Rossetti and asked if he could visit Dante. The reply was thoughtful, and graciously declined Hunt's offer. When over time Rossetti's name came to denote the founding of Pre-Raphælitism, Hunt reveals in his memoirs, *The Pre-Raphælites and Pre-Raphælitism* (1906), his almost bitter insistence that he and Millais, not Rossetti, had been the mind and spirit of the original Brotherhood. Indeed, they were the true Pre-Raphælites; their fidelity had always been to nature and not 'hothouse fancifulness'. He felt that he had been treated shoddily by history, and his frustration and hurt are clear. '[Rossetti] was a divergence from our aims', he wrote.

Times were changing. One can sense that even in the world of literature. Tennyson had died in 1892, and such literature of realism as Hardy's *Tess of the D'Urbervilles* (1886) was coming to the fore. Edward Burne-Jones said plaintively,

> I won't have nice girls hanged. Surely such stories are only needed by the hard-hearted. I wish, I wish someone would write a happy tale…And I have read two or three French tales, but they destroyed me body and soul. How masterly they are, no words are good enough to tell, but I hated them.

The days of medievalism and dream-scapes, of icons and wombats, seemed replaced with concerns for a diminishing empire and diminishing optimism. The Pre-Raphælites  themselves were aging, and several died before the new century: Philip Bourke Marston in 1887, William Allingham in 1889, Ford Madox Brown in 1893, Christina Rossetti in 1894, John Everett Millais and William Morris in 1896, and Richard Watson Dixon in 1900. In 1901 Queen Victoria died, and her son's Edwardian age would have its brief time.

The movement was no longer distinct from that of Art Nouveau and Symbolism. As a separate body of thought, it was becoming passé. As Wood writes, 'In the Art Club in 1900, two young artists danced for joy when they heard of the death of Ruskin—to them it was as if a great and oppressive weight had been lifted off their shoulders'. A new generation called for new ideals, and old heroes became the new Sir Sloshua's of mockery and rebellion.

❧

As I edited these works, choosing representative paintings and illustrations, culling through the literature, the diaries and letters, I was reminded always of the character in *84 Charing Cross Road*. Helene Hanff had a contempt for an editor of John Donne's work who had the effrontery to decide upon selections of the great man's poetry and prose. I too may run afoul of the tastes and sensibilities of the readers of this gathering of selections. I hope not. I have tried to steer a path between academic propriety and pure personal delight, between those works time-honoured now by both Victorian and twentieth-century editors and those works that simply struck within me a chord. Like the Pre-Raphælites, I care about the grander, ennobling pursuits and passions of life; and like them, I too am fascinated by the fragility of molluscs, spooked by the Gothic potential of crypts and survivors trapped on small ocean-borne crafts, and drawn to the 'fundamental brainwork', as Rossetti called it, needed to hear the whisper of candles and the settling of snow upon hedges.

It was important to me to present the Pre-Raphælites as individuals but also as participants within an evolving but ever interconnecting movement that spanned much of the Victorian period. In the past, Pre-Raphælitism has often been represented by five writers—Dante Rossetti, Christina Rossetti, William Morris, George Meredith and Algernon Charles Swinburne. Such a perspective certainly allows for an objectivity that pulls the reader cleanly to the poems or prose of those writers; such a perspective, however, does not allow the reader to sense behind those works the life—often messy, sometimes petty and sometimes inspiring—of the person who created them. In the case of the most famous figures, I wanted to show how they evolved and the different paths on which their work took them, sometimes professional and sometimes personal. Without the works—the poetry, the prose, the diary excerpts, the letters, the paintings, the self-caricatures—being arranged in chronological order, one doesn't get a sense of how each person grew, how each embraced one obsession to later cast it aside and take up another. One doesn't get a sense also of how closely they interwove their lives: how they wrote to the London *Times*, for example, defending or praising a work newly offered up by one of their own, or how often they had large dinner parties together or spent summers at Penkill Castle or Kelmscott, or how significant the affect was when Rossetti began to retreat more and more into the interiors of his own world and Tudor House. Without a fuller perspective, the breadth of their achievements and interests is lost. So many of the Pre-Raphælites did not limit themselves to poetry or art alone. They stretched beyond to grapple with the world: Morris became a businessman *and* a Socialist; Hunt went to the Holy Land and lived for months among Arab tribes; Hake continued working within a very successful medical practice while all along recording his memories of those around him; and Watts-Dunton, well he just seemed to do everything: retained his practice as a solicitor, consistently contributed critical reviews and

articles to the newspapers, published the very long *Coming of Love* in 1897 and *Aylwin* in 1898, and nursed an ailing Swinburne who stayed to live with him.

To this purpose, in addition to the paintings and drawings, the personal recollections and the literature, I have also included a section for each decade entitled 'Reactions'. The Pre-Raphælites, for better or for worse, did not exist in isolation from Victorian society, and the Victorians, and even the Edwardians, had much to say about them. There were strong attacks written about Pre-Raphælite paintings and poetry, and there were also articulate, impassioned articles of praise. *Punch* and later Max Beerbohm adored parodying the style and affectations of Pre-Raphælitism; others simply adored the new religion of beauty. As early as 1855, James Smetham, a minor artist and poet and something of a mad-sad *protégé* of Ruskin's and Rossetti's, drew a picture of a distraught man radiating anger while he reads his reviews. The highly charged relationship between the Pre-Raphælites and the critics was forged almost from the very beginning and continued on into the turn of the century. There were detractors and admirers, and both camps were drawn as much by the works as by the personalities. Nor were the Pre-Raphælites themselves averse to throwing themselves into the journalistic fray. They did so with almost casual abandon, sometimes even taking up several editions of newspapers to air their views and make public their squabbles. But we also have those rare instances when those with no ideological bent describe what it was like to stand as a child in the hallway of Tudor House and to meet Rossetti.

My wish is that readers will be able to browse through the writings of Pre-Raphælites, to study how themes unique to an individual or to the group changed, to appreciate the range of time and accomplishment. To be able to do so, however, one has to go beyond the famous to those individuals who filled up the days and lives of the famous, those who protected, recorded, continued, expanded and adopted the gossamer

that is Pre-Raphælitism. The anthology, therefore, is devoted in great part to them also. Included are such things as the memories of Georgiana Burne-Jones, some chapters from the novel written by Ford Madox Brown's son, Oliver Madox Brown, the letters and illustrations of Arthur Hughes, and the writings of the first biographers. For the first time, general readers and students of the movement will be able to read alongside such well-known works as *The House of Life*, *The Defence of Guinevere* and *Goblin Market* parts of *The Germ* and *The Oxford and Cambridge Magazine*, poems by William Allingham, Coventry Patmore, William Bell Scott, Richard Watson Dixon, Sebastian Evans, Elizabeth Siddal, John Payne, Arthur O'Shaughnessy and Philip Bourke Marston, and prose by Hall Caine and Theodore Watts-Dunton. No single literary theme exists to epitomise Pre-Raphælite writing; it is as various as is Pre-Raphælite art. The writing encompasses such themes as idealism and madness, the gothic elements of death and violent obsession, fairy lore, the beauty of nature, the beauty and salvation and danger of women, medievalism, the life of the artist, religious introspection, politics, and, of course, love in all of its facets. Much of Pre-Raphælite writing is also self-reflective. The letters and memoirs center on the personalities and doings of those within the circle. The fiction and poetry reflect on lives known intimately. More than that, the literature tells, and retells, the defining stories of their world and of their identities: of the artist's isolation, of coffins that contain poems awaiting exhumation, of the enemies within and of their betrayals, of the goblin [wo]men whose tread disturbs the stability of the home; and always of the pursuit of an ephemeral perfection never quite realised. More often than not, in their writings, the stories they tell are the stories of themselves.

You shall find a lot here: the many voices and moods, the many controversies and alliances, the many moments of self-doubt and times of laughter that make up the lives of those who create a movement. In 1874, Arthur O'Shaughnessy captured the attraction and essence of the Pre-Raphælites. He wrote,

> We are the music makers,
>     And we are the dreamers of dreams,
> Wandering by lone sea-breakers,
>     And sitting by desolate streams;—
> World-losers and world-forsakers,
>     On whom the pale moon gleams:
> Yet we are the movers and shakers
>     Of the world for ever, it seems.

His *Ode* would be prophetic.

# ◼ The Beginnings: 1848-1859 ◼

## LETTERS, DIARIES AND REFLECTIONS

**Georgiana Macdonald Burne-Jones**
**From *The Memorials of Edward Burne-Jones***

[1853]
'Oxford is a glorious place; godlike! at night I
have walked round the colleges under the full
moon, and thought it would be heaven to live
and die here. The Dons are so terribly majestic,
and the men are men, in spirit as well as name—
they seem overflowing with generosity and good
nature; and their pride seldom ascends to
haughtiness, or descends to vanity. I wonder
how the examiners ever have the heart to pluck
such men. Nevertheless I should like to see home
and all there, and before this term is over, I shall
long to see them. My purgatory will last three
weeks or a month, if I am plucked you will see
me directly, preparatory to leaving England. I
assure you this is no joking, the chances are at
most but equal, and if the catastrophe comes I
couldn't honourably pursue my course here.'
Edward speaks in his notes of a little
Birmingham colony already formed at that
College when he went up, which Morris and he
used to join when they sought for more
company than their own. The nucleus of the
colony consisted of Fulford, Dixon, and
Faulkner, the last hitherto, unknown to Edward.
His rooms on the ground floor, in a corner of the
old quadrangle of Pembroke, stood in invitingly
ready for men to turn into, and there, about nine
o'clock most evenings of the week, the friends
met. In the daytime Edward and Morris
generally walked together into the country or
about the city...

[1855]
'When I was in London visiting my aunt, Morris
and I went across to Tottenham to the house of a
Mr. Windus, who was said to have some pictures
of the Pre-Raphælites, where we spent a happy
morning. It was there that we first saw a picture
by Madox Brown, called "The Last of England",
and a beautiful little picture of a lady in black by
Millais which I have never seen since, and some
drawings by Millais; and we came away strength-
ened and confirmed. It must have been at the
end of the summer term of this year that we got
permission to look at the Pre-Raphælite pictures
in the house of Mr. Combe, the head of the
Clarendon Press at Oxford, and there we saw
two pictures by Holman Hunt, "The Christian
Missionary wounded in the Fisherman's Hut"
and a portrait of some surpliced friend of the
Combes in Oxford, with part of the Cloisters of
New College for a background. But our greatest
wonder and delight was reserved for a water-
colour of Rossetti's, of Dante drawing the head
of Beatrice and disturbed by people of
importance. We had already fallen in with a copy
of the Germ, containing Rossetti's poem of the
Blessed Damozel, and at once he seemed to us
the chief figure in the Pre-Raphælite
Brotherhood.'...

Soon after this... my own recollection of
Morris begins. At the Royal Academy where
Wilfred Heeley had taken me, we saw him
standing before Millais's picture of 'The
Rescue', examining it closely: as he turned to go
away, Heeley said 'That's Morris', and
introduced us to each other; but he looked, as if
he scarcely saw me. He was very handsome, of
an unusual type—the statues of mediæval kings
often remind me of him—and at that time he
wore no moustache, so that the drawing of his
mouth, which was his most expressive feature,
could be clearly seen. His eyes always seemed to
me to take in rather than to give out. His hair
waved and curled triumphantly. By this time his
reputation as a poet had been established

amongst his friends at Oxford, by some verses, the first he had ever written, of new and singular beauty. The way in which he answered the enthusiasm with which they were hailed tells more about him than any description could. 'Well, if this is poetry', he said, 'it is very easy to write.' And though for some time he continued to produce a fresh poem almost every day, he did not give up any other work that he was about, but simply added poetry as the blossom of it all. 'Topsy is writing such a beautiful story', says Edward in a letter home, 'so glorious you cannot think; when it is finished you shall see it.' The name of 'Topsy' was given to Morris by Edward, and finding favour in the intimate circle, it soon became much more closely identified with him than his own proper one of William, which no one at Oxford ever used. Edward, on the other hand, was a man whom friends readily called by his familiar Christian name, Ted, or, in later years, Ned...

When the men were alone, much of their talk was of a scheme that for some time past had been taking the place of the first proposed brotherhood and whose details they now threshed out and sifted. It was an idea, suggested by Dixon, of their all joining together to start a magazine, which would be at once a medium for the expression of their principles and enthusiasms and also an assured place for the publication of original work. The whole set welcomed the plan, and Heeley promised help from Cambridge, but innumerable spoken words had to precede the written ones.

What preparation of the heart of man could have been better than this, recorded by Mr. Price after one of their conversations: 'It is unanimously agreed that there shall be no shewing off, no quips, no sneers, no lampooning in our Magazine.' Politics, they resolved, were to be almost eschewed, and the contents of the magazine were to be 'mainly Tales, Poetry, friendly critiques and social articles.' ...Then there were quiet times when Edward and Morris were alone and communed with each other in their own world of imagination. About this world which never failed him Edward once said, 'Of course imagining doesn't end with my

work: I go on always in that strange land that is more true than real.' He had lately found a treasure belonging to that land over which he and his friend now rejoined joined together.

It was Southey's reprint of Malory's Morte d'Arthur: and sometimes I think that the book never can have been loved as it was by those two men. With Edward it became literally a part of himself. Its strength and beauty, its mystical religion and noble chivalry of action, the world of lost history and romance in the names of people and places—it was his own birthright upon which he entered.

'I remember I could not buy the precious book', he writes thirty-five years afterwards. 'I used to read it in a bookseller's shop day after day, and bought cheap books to pacify the owner, but Morris got it at once and we feasted on it long.' After nearly three weeks together in Birmingham Morris went on to Worcester, and Edward started for a long-delayed visit to Harris Bridge, but 'the precious book' seems to have been left with him, for when he was back again at home Mr. Price's journal says, 'over to Birmingham, round and round the garden with Ted, reading the Morte d'Arthur, the chapters about the death of Percival's sister and the Shalott lady.' Then the talks began again, though Morris was not there, except by letters, which he sent often. In one of these letters he evidently spoke about leaving Oxford before taking his degree, for on September 28th Cormell puts succinctly in his diary, 'Wrote to Morris two sheets abusing him roundly for thinking of leaving Oxford to which Morris answers in his own direct way, "Thank you very much for taking so much interest in me, but make your mind easy about my coming back next term, I am certainly coming back, though I should not have done so if it had not been for my Mother".'...

To Edward I believe the most important thing that happened this term was his meeting with Rossetti's illustration of The Maids of Elfenmere, just published in Allingham's Day and Night Songs. For him it cleared up the question of what a modern drawing could be made to express and

with how much beauty, and at the sight his own imagination burned within him and he became bold to use it. From what he said at the time about this design he never swerved: 'It is I think the most beautiful drawing for an illustration that I have ever seen; the weirdness of the Maids of Elfenmere, the musical timed movement of their arms together as they sing, the face of the man, above all, are such as only a great artist could conceive.'...

[1856]
The post brought the first letter Edward ever received from Ruskin—in answer, I believe, to one that had gone to him with the January number of the Magazine—and the excitement of this event is preserved in some words written to Cormell Price.

'I'm not Ted any longer, I'm not E.C.B. Jones now—I've dropped my personality—I'm a correspondent with RUSKIN, and my future title is "the man who wrote to Ruskin and got an answer by return".'...

Eager to know what the man looked like who had drawn the Maids of Elfenmere and written the Blessed Damozel, he cast about to find how he might be able to see the face of Rossetti. He has himself described so fully the way in which this was accomplished, that though the story has appeared elsewhere it must be repeated here. The quest also brought him and Vernon Lushington together for the first time. 'I had no dream', he says, 'of ever knowing Rossetti, but I wanted to look at him, and as I had heard that he taught in the Working Men's College in Great Ormond Street, a little University set up by Denison Maurice, where men skilled in science or history gave lectures and their services of evenings, I went to the College one day to find out how it would be possible that I should set eyes upon him. I was told that there was to be a monthly meeting that very evening in a room connected with the College, and that, for a modest payment, anyone could get admittance, including tea, and hear the addresses on the condition of the College and the advancement of studies which were delivered by the different professors—so without fail I was there, and sat at a table and had thick bread and

butter, but knowing no one. But good fellowship was the rule there, that was clear, and a man sitting opposite to me spoke at once to me, introducing himself by the name of Furnivall, and I gave my name and college and my reason for coming. He reached across the table to a kindly-looking man whom he introduced to me as Vernon Lushington, to whom I repeated my reason for coming, and begged him to tell me when Rossetti entered the room. It seemed that it was doubtful if he would appear at all, that he was constant in his work of teaching drawing at the College, but had no great taste for the nights of addresses and speeches, and as I must have looked downcast at this, Lushington, with a kindness never to be forgotten by me, invited me to go to his rooms in Doctors Commons a few nights afterwards, where Rossetti had promised to come. So I waited a good hour, or more, listening to speeches about the progress of the College, and Maurice, who was president, spoke of Macaulay's new volume, just out, blaming much the attack on George Fox in a true Carlylese spirit, which was very pleasing—and then Lushington whispered to me that Rossetti had come in, and so I saw him for the first time, his face satisfying all my worship, and I listened to addresses no more, but had my fill of looking, only I would not be introduced to him. You may be sure I sent a long letter about all this to Morris at Walthamstow, and on the night appointed, about ten o'clock, I went to Lushington's rooms where was a company of men, some of whom have been friends ever since. I remember Saffi was there, and Rossetti's brother William, and by and by Rossetti came, and I was taken up to him and had my first fearful talk with him. Browning's "Men and Women" had just been published a few days before, and someone speaking disrespectfully of that book was rent in pieces at once for his pains, and was dumb for the rest of the evening—so that I saw my hero could be a tyrant and I thought it sat finely upon him. Also another unwary man professed an interest in metaphysics; he was dealt with firmly.

'Before I left that night Rossetti bade me come to his studio the next day. It was in the last

house by Blackfriars Bridge at the North West corner of the bridge, long ago pulled down to make way for the Embankment; and I found him painting at a water colour of a monk copying a mouse in an illumination. The picture was called "Fra Pace" afterwards.

'He received me very courteously, and asked much about Morris, one or two of whose poems he knew already, and I think that was our principal subject of talk, for he seemed much interested about him. He shewed me many designs for pictures: they tossed about everywhere in the room; the floor at one end was covered with them, and with books. No books were on the shelves, and I remember long afterwards he once said that books were no use to a painter except to prop up models in difficult positions, and that then they might be very useful. No one seemed to be in attendance upon him. I stayed long and watched him at work, not knowing till many a day afterwards that this was a thing he greatly hated—and when for shame I could stay no longer, I went away, having carefully concealed from him the desire I had to be a painter.'...

The Easter term found him in Oxford again as he had intended, but the place had done all that it could for him, and he was now so restless that within the first week he gave up the idea of going in for honours and soon afterwards came to the conclusion that it was no use to think of taking even a pass degree until the October term. This decision arrived at, what was there to keep him away from London? His aunt's house was always open to him, and by the 6th of May he was there again. The Royal Academy that year had a wonderful show of pictures: five by Millais, Holman Hunt's 'Scapegoat', Wallis' 'Chatterton', Arthur Hughes' 'April Love', and 'Burd Helen', by Windus of Liverpool...

There was no more talk of Edward's going back to Oxford for his degree: Rossetti's encouragement and advice had decided him to give his whole life to Art. He was now close upon twenty-three years of age, a time when painters should have mastered the mechanical art of their craft, and he was only at its beginning: but Rossetti knew with whom he had to deal when he

urged him against the Hill Difficulty, and Edward faced it with as few words as possible. His working materials henceforth seemed to become a part of himself, and my instinctive remembrance of him at this time is always with a drawing portfolio under his arm.

Meanwhile Rossetti set about finding some employment for him by which he might be able to live. The first idea that suggested itself was to get for him a commission to draw the wood block for an engraving that was to be made from Windus' picture of 'Burd Helen', but before the plan was settled Morris one day shewed Gabriel some of Edward's own original designs, and he then refused to let him copy 'Burd Helen'. The drawings were probably some of those done for Mr. MacLaren, and were shewn without Edward's knowledge and in his absence, so that when he re-entered the room he was overwhelmed by Gabriel coming up to him and saying as he put his arm round his shoulder, 'There are not three men in England, Ned, that could have done these things'. Talking about Rossetti, many a long year after this time, Edward said, 'Towards other men's ideas he was decidedly the most generous man I ever knew. No one so threw himself into what other men did—it was part of his enormous imagination. The praises he at first lavished on me, if I had not had a few grains of inborn modesty, would have been enough to turn my head altogether.'...

A letter to his father describes his first seeing Holman Hunt. 'A glorious day it has been—a glorious day', he exclaims, 'one to be remembered by the side of the most notable ones in my life: for whilst I was painting and Topsy was making drawings in Rossetti's studio, there entered the greatest genius that is on earth alive, William Holman Hunt—such a grand-looking fellow, such a splendour of a man, with a great wiry golden beard, and faithful violet eyes—oh, such a man. And Rossetti sat by him and played with his golden beard passing his paint-brush through the hair of it. And all evening through Rossetti talked most gloriously, such talk as I do not believe any man could talk beside him.'...

He said that he thought some rooms at 17, Red Lion Square, in which he had lived with Walter Deverell in early P.R.B. times, were to be had; so next day they all went to look at them, and before evening they were taken. Gabriel wrote to Allingham that he had been to look at his old quarters and found them all dusty and unused, with an address that either he or Deverell had written on the wall of a bedroom still there after five years, the only sign of life left in the place, 'so pale and watery had been all subsequent inmates, not a trace of whom remained.' Red Lion Square was dark and dirty, but much more interesting than Upper Gordon Street, where the houses were so exactly like each other that Edward once entered the wrong door without noticing it, and had shouted for dinner and got halfway upstairs before finding his mistake. Morris and Edward had the first floor, on which there were three rooms; a large one in front with the middle window cut up to the ceiling for a painting light, a medium-size room behind this, which Edward had, and a further and smaller one, which was Morris'. Some French people named Fauconnier, who were feather-dressers, were the tenants of the house, and carried on their business below. Here Gabriel often came, and his influence with the two friends constantly increased. A trace of the removal to Red Lion Square at the end of November is found in a letter to a lady whom Edward had met at Heeley's wedding—Miss Charlotte Salt, of Birmingham. Her friendship, extended to me also, has been without shadow of turning from that time to this. He writes: 'You see we have removed from Gordon Street—such a hideous nuisance this has been, for my notions of all domestic arrangements are of the most limited description. I think to see me in the midst of a removal is to behold the most abjectly pitiable sight in nature: books, boxes, boots, bedding, baskets, coats, pictures, armour, hats, easels—tumble and rumble and jumble. After all one must confess there is an unideal side to a painter's life—a remark which has received weight in the fact that the exceedingly respectable housekeeper we got has just turned in upon us in

the most unequivocal state of intoxication.' And the next day the story goes on in a letter to Miss Sampson: 'We are quite settled here now. The rooms are so comfortable, not very furnished at present but they will be soon; when I have time I will make a rough drawing of the place and send it down. Topsy has had some furniture (chairs and table) made after his own design; they are as beautiful as mediæval work, and when we have painted designs of knights and ladies upon them they will be perfect marvels.'

In this same letter he says, 'To-day we are to go and see Ruskin', and after their return, 'Just come back from being with our hero for four hours—so happy we've been: he is so kind to us, calls us his dear boys and makes us feel like such old old friends. Tonight he comes down to our rooms to carry off my drawing and shew it to lots of people; to-morrow night he comes again, and every Thursday night the same—isn't that like a dream? think of knowing Ruskin like an equal and being called his dear boys. Oh! he is so good and kind—better than his books, which are the best books in the world.'...

The year of 1856 that looks so fair in memory seemed equally beautiful to us in reality. Recalling it long after youth was past, Edward deliberately wrote: 'There was a year in which I think it never rained nor clouded, but was blue summer from Christmas to Christmas, and London streets glittered, and it was always morning, and the air sweet and full of bells.'...

[1857]
In a letter to Rossetti written at the end of June...[Edward] refers to an intended visit of Rossetti to Oxford, a visit that altered the disposition of Edward's time for months to come and that of Morris' whole life.

'I'm awfully sorry not to be able to go with you tomorrow to Oxford—on Sunday last I felt quite sure I should be able to leave town, but I could not now for two or three reasons. 1° Topsy comes from there to-morrow and I want to see him. 2° I have a friend staying with me, just

arrived, and I can't well leave him. 3° I'm painting some lilies which are going, and keep me from doing the same, so I feel sure I ought not to go this week. I am very sorry, for it would have been most jolly—I could manage it well in a fortnight if that is not too late for you.'

It was not Edward, however, but Morris who was at Oxford with Gabriel on the eventful visit when he conceived the idea of painting the walls of the Union. The Notes say: 'When Rossetti and Morris came back they were full of a scheme, and I was to put everything aside and help it. Woodward had just built a new debating room for the University, and there were large bays above the gallery that ran round the room, hungry to be filled with pictures—Gabriel equally hungry to fill them, and the pictures were to be from the Morte d'Arthur, so willed our master.'

This meant for Edward the putting aside of his picture of 'The Blessed Damozel' and the giving up of an intended visit to the Art Treasures Exhibition at Manchester.

In the course of the long Vacation, Rossetti enlisted also Arthur Hughes, Hungerford Pollen, Spencer Stanhope, Valentine Prinsep, and Alexander Munro the sculptor, to join in the scheme, and the time they all spent together was one never to be forgotten. Mr. Prinsep clearly recalls the day that Gabriel came out to Little Holland House, and by the power of his personality made him promise to 'join him and some other fellows in decorating the Union at Oxford'. The young artist of course felt flattered by the invitation, but he says 'I had not studied with Watts without being well aware of my own deficiencies in drawing—so I told Rossetti that I did not feel strong enough to undertake such work. "Nonsense", answered Rossetti confidently, "there's a man I know who has never painted anything—his name is Morris—he has undertaken one of the panels and he will do something very good you may depend—so you had better come!" Rossetti was so friendly and confident that I consented and joined the band at Oxford.'

In a letter written home one Sunday in July, Edward says how much he should have liked to be with his father at Spon Lane that day, 'but instead of that I am going with Rossetti to be introduced to a lot of swells who'll frighten me to death and make me keep close to his side all the time'. Long afterwards, in one of his moods of reminiscence, he wrote about this, his first visit to Little Holland House, and how Rossetti prepared him for it and for the sight of Watts, who then lived with the Prinseps.

'One day Gabriel took me out in a cab—it was a day he was rich and so we went in a hansom, and we drove and drove until I thought we should arrive at the setting sun—and he said, "You must know these people, Ned; they are remarkable people; you will see a painter there, he paints a queer sort of pictures about God and Creation." So it was he took me to Little Holland House.'

Mr. Prinsep also remembers their visit and says: 'This time Rossetti was accompanied by a younger man, who he declared was the greatest genius of the age—a shy, fair young man, with mild, grey-blue eyes and straight light hair which was apt to straggle over his well-developed forehead—who spoke in an earnest impressive manner when he did speak, which was not often. On this, his first visit to my father's house, he did not impress me much; but then, as I said, he was almost painfully shy and my mind was filled with Rossetti. It was Burne-Jones, or as Rossetti and all of us called him, "Ned Jones".'…

By the middle of August the work at the Union was well begun, and the painters then hoped that it would be finished in about six weeks—that is, by the end of the Long Vacation—but it lasted till the spring of the following year. The difficulties they found were great, for the preparation of the surface to be decorated had not been considered, and each bay also was pierced by two windows which dazzled the sight and made anything painted on the wall-space between them almost invisible. The building is described in the Notes as being so new that the mortar was hardly dry, and the rough brickwork was only white washed over. 'The walls were not quite flat and

had a ridge in them over which we had to train a face, if a face happened to come there; but we began with enthusiasm, and repented, if we repented, afterwards. At any rate we had no misgivings, and when Gabriel willed a thing it had to be done.' At first Rossetti, Edward and Morris were alone, and they lodged together at 87 High Street, a pleasant old house opposite Queen's College, but later on, when the October term began, they moved to another house in George Street.

All the artists had promised to give their work, but the members of the Union were to pay the cost of their lodging and the materials used, both sides to this bargain being quite ignorant what this cost was likely to be; 'and I am afraid', says Edward, 'that as the task lasted so long, our gift did not turn out to be such a generous one as we meant: indeed natural complainings were made, and our gift underwent public criticism in the debating room, but Bowen was then Treasurer, and stood up for us and saved us from all inconvenience. He was much beloved by us—a courteous and delightful fellow and always regarded in the University as a man of exceptional promise—whom Rossetti loved at once.'

'Morris began his picture first and finished it first, and then, his hands being free, he set to work upon the roof, making in a day a design for it which was a wonder to us for its originality and fitness, for he had never before designed anything of the kind, nor, I suppose seen any ancient work to guide him. Indeed, all his life, he hated the copying of ancient work as unfair to the old and stupid for the present, only good for inspiration and hope. All the autumn through he worked upon the roof high above our heads, and Faulkner, in afternoons, when his work was over at University, would come to help, having always clever hands for drawing.'

On Mr. Prinsep's first arrival at Oxford, there is a legend that he said to his cabman, 'Drive me to the Union', and found himself quickly at the doors of the workhouse. His account of dining with Rossetti that first evening is very vivid. 'I was, of course, proud to accept the invitation', he says, 'so

at the hour mentioned I was punctually at the house. There I found Rossetti in a plum-coloured frock coat, and a short square man with spectacles and a vast mop of dark hair. I was cordially received. "Top", cried Rossetti, "let me introduce Val Prinsep." "Glad, I'm sure", answered the man in spectacles, nodding his head, and there he resumed his reading of a large quarto. This was William Morris. Soon after, the door opened, and before it was half opened, in glided Burne Jones. "Ned", said Rossetti, who had been absently humming to himself. "I think you know Prinsep." The shy figure darted forward, the shy face lit up, and I was received with the kindly effusion which was natural to him.'

'When dinner was over, Rossetti, humming to himself as was his wont, rose from the table and proceeded to curl himself up on the sofa. "Top", he said, "read us one of your grinds." "No, Gabriel", answered Morris, "you have heard them all." "Never mind", said Rossetti, "here's Prinsep who has never heard them, and besides, they are devilish good." "Very well, old chap", growled Morris, and having got his book he began to read in a sing-song chant some of the poems afterwards published in his first volume. All the time, he was jiggling about nervously with his watch chain. I was then a very young man and my experience of life was therefore limited, but the effect produced on my mind was so strong that to this day, forty years after, I can still recall the scene: Rossetti on the sofa with large melancholy eyes fixed on Morris, the poet at the table reading and ever fidgetting with his watch chain, and Burne-Jones working at a pen-and-ink drawing.

> Gold on her head, and gold on her feet,
> And gold where the hems of her kirtle meet,
> And a golden girdle round my sweet
> *Ah! qu'elle est belle La Marguerite.*

still seems to haunt me, and this other stanza:

> Swerve to the left, son Roger, he said
> When you catch his eyes through the helmet slit,
> Swerve to the left, then out at his head
> And the Lord God give you joy of it!

I confess I returned to the Mitre with my brain in a whirl.'

Mr. Prinsep says that the windows in the spaces they were painting were whitened in order to tone the light, and that the whitened glass was covered all over with sketches, chiefly of wombats. 'Do you know the wombat at the Zoo?' asked Rossetti; 'a delightful creature—the most comical little beast.' He was drawn by Edward in endless different positions and situations, and Rossetti's admiration led him years afterwards to buy a live one and try to make it happy at Cheyne Walk.

'What fun we had in that Union! What jokes! What roars of laughter!' writes Mr. Prinsep...

Rossetti had often to go back to London for a few days at a time because of the pressure of other work, and was also much distracted in mind owing to the illness of Miss Siddal, to whom he had long been engaged, so that his picture could not move quickly, but whilst he remained in Oxford he was the leader and inspirer of all his company. 'Rossetti was the planet round which we revolved', says Mr. Prinsep; 'we copied his very way of speaking. All beautiful women were "stunners" with us. Wombats were the most delightful of God's creatures. Mediævalism was our *beau idéal* and we sank our own individuality in the strong personality of our adored Gabriel.'...

The following description of a scene makes one feel how young they all were together: 'I have from now till breakfast to write to you in, and I have no idea what now is, for after the most elaborate directions for being called early, which were strictly attended to, I turned over and dozed away like a pig, and now I expect every moment my usual morning tormentors, Rossetti and Pollen, who come at about 8 o'clock to insult me—laugh at me, my dear—point the finger of scorn at me, address

me by opprobrious names and finally tear blankets and counterpanes and mattresses and all the other things that cover me, from my enfeebled grasp, and so leave me, to do the same to Topsy. I've done them this time; when they come in presently with no knocking at the door, they will see Virtue asserted in the form of a bold and upright figure at the dressing-table, who will slowly turn upon them a look of calm but significant defiance with one eye, while with the other he expresses similar feelings by a contumelious wink.'

An occasional drawback to the happiness of the painters in this improvised Bohemia was the recognition of their presence in Oxford by various polite invitations to dinner, for after their day's work at the Union the men wanted nothing so much as to meet again at George Street in the evening, where they could smoke, talk altogether or not at all, read aloud or play whist, just as they chose.

Mr. Prinsep tells a story of an evening when they were honoured by an invitation to dine at Christ Church, which Edward, 'being shy', declined, but Rossetti, Morris and Prinsep accepted. 'The preparation for the dinner created some bustle. Morris found he had no dress clothes with him, at which Rossetti was indignant. "You should always have dress clothes with you", he said, "Top, it's disgraceful of you." However, Hughes had some, and although he was taller than Morris and rather thin, it was agreed that the clothes must do. But Morris was so long dressing that Rossetti having attired himself and having waited some time in his top coat declared he would wait no longer, and off we started. Before we reached Christ Church we heard the sound of Morris' footsteps and he overtook us.

"What do you mean turning up like that?" cried Rossetti furiously, "look at your hair!" There sure enough, on Morris' dark mop was a dab of blue paint, the relic of his day's work. "Well, Gabriel", answered Morris meekly, "I'll go to Charley Faulkner's and get it off." And so he did.

'When we arrived at Christ Church and took off our overcoats, I was amused to find that Gabriel, though he had been so particular about

evening dress, had finished his own attire by absently putting on the old plum-coloured frock-coat he wore daily, which was itself not free from paint. I, however, discreetly said nothing, nor do I think he ever found out his mistake or I fancy we should have heard of it.'...

It was in the last days of the Long Vacation that Morris first saw Miss Jane Burden, who afterwards became his wife. She had been born and brought up in Oxford, and her beauty was of so rare and distinguished a type that one would have thought it impossible for Morris to have missed seeing her face during the time he was at College: but fate reserved the meeting until now, when, as it is said, 'by chance' being at the theatre with Gabriel, Edward, and Hughes one evening, he saw her in a box above them, and so the story began...

I wish it were possible to explain the impression made upon me as a young girl whose experience so far had been quite remote from art, by sudden and close intercourse with those to whom it was the breath of life. The only approach I can make to describing it is by saying that I felt in the presence of a new religion. Their love of beauty did not seem to me unbalanced, but as if it included the whole world and raised the point from which they regarded everything. Human beauty especially was in a way sacred to them, I thought; and of this I received confirmation quite lately from a lady whom I had not seen for many years, and who had been in her youth an object of wild enthusiasm and admiration to Rossetti, Morris and Edward. She and I sat and talked for an hour about them and the days when we were all young, and I found that she kept the same feeling that I do about that time—that the men were as good as they were gifted, and unlike any others that we knew. She had lost sight of them long ago and lived abroad and seen many people since then, but her regard for the young artists she remembered was still fresh and she loved to dwell on their memory. 'I never saw such men', she said; 'it was being in a new

world to be with them. I sat to them and was there with them, and they were different to everyone else I ever saw. And I was a holy thing to them—I was a holy thing to them'...

[1858]
It makes one smile in the midst of the ghosts of this time to realize the standard of age by which we then measured each other, for in a letter that I wrote to my friend Charlotte Salt are these words, referring to the painters that I knew: 'Have I ever mentioned Brown to you? He is the father of them all, a married man of, I should think, nearly forty.' In reality he was just thirty-seven. 'Rossetti', I tell her, 'is still out of town, I saw him last at Christmas —did I tell you of it?—where I saw Hughes also, one of the most beautiful men in the world.'

Where I saw them was at a party given by Morris and Edward in Red Lion Square, an invitation to which festivity, lightly scribbled to his 'dear Bruno' by Edward, has found its way into my hands after all these years.

'Come to-night and see the chair, there's a dear old fellow—such a chair!!!!!! Gabriel and Top hook it to-morrow, so do come. Hughes will come, and a Stunner or two to make melody. Come soon, there's a nice old chap—victuals and squalor at all hours, but come at 6.'...

Red Lion Square was not very brilliant in 1858, as from one cause or another Morris and Edward were seldom there at the same time: a sense of change was in the air, and so early as Easter they began to consider whether it was worth while to keep the rooms on. Never from the time of their first meeting did the friends see so little of each other in any year as in this.

Mr. Price, who was reading for his degree, kept house at Red Lion Square most of the Long Vacation, and part of the time Rossetti was there with him, driven from his own studio at Blackfriars by the smell of the river below its windows. Mary [the housekeeper] looked after them both with a good will, for they were among her chief favourites. At the beginning of the summer Morris told Edward of his engagement to

Miss Burden, and they both realised that the old ways were now at an end and that a new order of things had begun. I am surprised on employing the ruthless measure of weeks and months to find how short a time the brilliant days of Red Lion Square really lasted, for on looking back it seems so much longer. But I believe that it made the same impression upon many of us and that every minute then contained the life of an hour.

## William Holman Hunt
### From *Pre-Raphælitism and the Pre-Raphælite Brotherhood*

It being late in the summer, my fellow-students were holiday-making. One day, when absorbed in my work in the Sculpture Gallery, a boy who was going through the gallery darted aside and stood for a few minutes attentively behind me. After close scrutiny he went off as suddenly; observing that he had a black velvet tunic, a belt, and shining bright brown hair curling over a white turned down collar, I recognised that he was the boy Millais whom I had seen receive the Academy antique medal. Later in the day I went into the Elgin Room with the intention of glancing in passing over the student's shoulder; he was drawing the Illysus. As I approached he suddenly turned with, 'I say, are not you the fellow doing that good drawing in No. XIII. room? You ought to be at the Academy.'

'That is exactly my opinion', I returned. 'But unfortunately the Council have twice decided the other way.' 'You just send the drawing you are doing now, and you'll be in like a shot. You take my word for it; I ought to know; I've been there as a student, you know, five years. I got the first medal last year in the antique, and it's not the first given me, I can tell you.' I asked him about the method of drawing most in fashion, explaining that I must not neglect any means of increasing my chance of acceptance. 'Oh, the blocking-out system serves to make beginners understand the solidity of figures given by light and shade,

modified by reflections and half tints, and to get over muddling about with dirty chalk; you know all that. Very few fellows stick to it for long. I do sometimes use gray paper with white, but I like white paper just now. You see I sketch the lines in with charcoal, and when I go over with chalk I rub in the whole with wash leather, take out the lights with bread, and work up the shadows till it's finished; but I do some times work altogether with the point, and if either is done well it makes little or no difference to the Council. Don't you be afraid; you're all right. I say, tell me whether you have begun to paint? What? I'm never to tell; it is your deadly secret. Ah! ah! ah! that's a good joke. You'll be drawn and quartered without ever being respectably hung by the Council of "Forty" if you are known to have painted before completing your full course in the Antique. Why, I'm as bad as you, for I've painted a Long while. I say, do you ever sell what you do? So do I. I've often got ten pounds, and even double. Do you paint portraits?'

'Yes', I said, 'but I'm terribly behind you.'

'How old are you?' he asked.

'Well, I'm seventeen', I replied.

'I'm only fifteen just struck, but don't you be afraid. Why, there are students of the Academy just fifty and more. There's old Pickering; he once got a picture into the Exhibition, and he quite counts upon making a sensation when he has finished his course, but he is very reluctant to force on his genius. Will you be here to-morrow?'

'No', I whispered, 'it's my portrait day, but don't betray me. Good-bye.'

'Don't you be down in the mouth', he laughed out, as I walked away more light-hearted than I had been for many months, my unexpected conference with the prize student in whose personality I had so long passively felt interest having cheered me up. It was long ere I saw him again. For some reason not remembered I made another drawing for the probationership, which I gained at the next trial, and in due order a student's place…

The Antique School had no seneschal as it now has to suppress the eccentric impulses of the students, which were unbridled except for the half-

hour when the Keeper made his rounds. Millais was still about the youngest in the school, although the first in honours. During the day, he frequently made hurried but very clever sketches of grooms, jockeys, farmers, horses, and animals of all kinds, and incidents yet vivid in his mind of the country place where he had been staying. He kept up a lively accompaniment to this exhuberant performance with the pencil, by reproducing with his voice all the chatter and clatter of the various creatures of the stables, the farmyard, and the racing paddock. The sketches were waited for by a surrounding appreciative throng, and carried off by the most persistent. The etiquette of schoolboys forbade my claiming his acquaintance, but when he met me he exclaimed, 'I told you so. I knew you'd soon be in', and so we came to be on saluting terms…

Once on my going to Millais' house, he was away, but his parents were at home. The father talked about the Academy school, and of the treatment Johnnie had formerly experienced there. 'Being so very young', he said, 'Johnnie became the sport of some of the rough, elder students, and he came home at times complaining and bearing marks of their coarse behaviour. They lifted him up above their heads and twirled him about, affecting to be acrobats. One brutal fellow, H— (you must know him), carried the child up a ladder that happened to be in the school, encouraged the more by the poor little fellow's cries; and once he held him up by the ankles and marched with him head down-wards around the school, his hair sweeping the ground. What could I do? It would not have done to make a scandal of it, but I told Johnnie to invite this burly fellow here to give advice on some design in hand. When he came I received him in friendly manner, and soon spoke of Johnnie's fragile form, saying that some elder students in the Academy were thoughtless about the delicacy of the young boy, that I felt sure he was a good, sensible fellow, but that some young men were without reflection and needed to be opposed, and that I would trust him always to protect Johnnie and save him from such horseplay. After that Johnnie was left unmolested,

and we had every reason to rejoice in the effect of my appeal to H's better feelings.' This restraint, however, was but of transient or partial value for the man had at bottom a cruel nature. Millais with true instinct, although not at the time admitting to himself the reason, painted him in the 'Isabella' picture as the brother cracking the nut and at the same time kicking the dog…

[1847]

In the midst of our earliest talk a quiet knock came at the door. 'Who's there?' asked my companion.

'I have brought you the tea myself', said the mother. I was hurrying forward, when Millais stopped me with his hand, and a silent shake of the head.

'I really can't let you in, mamma', he returned; 'please put the tray down at the door, and I'll take it in myself.'

I spoke then. 'We are debating matters, Mrs. Millais, that would really be very dull to all but artists up to their necks in paint, and our talk is the deepest treason against our betters.'

She knocked again. 'I call on you, Hunt, as a witness of this bad behaviour to his mother.'

Millais' only apology was, 'You'll see in time how right I am'; and when she left he waited a minute ere he went for our tea.

We resumed our talk, reverting to the difference between vigorous and moribund art. I continued, 'The beauty aimed at now is exactly the opposite to that of great art: in old days the ambition was to combat sickly ideas of beauty; the modern ambition is utterly without health or force of character, either physical or mental. It is conceived to satisfy the prejudices of the modiste; ladies by some are portrayed with waists that would condemn the race to extermination in two generations, and men are made such waxwork dandies that savagedom would soon sweep a nation with such an aristocracy into the melting pot. Art's office is not to encourage such maudlin culture, for true refinement in design, as in word poetry, is to raise aspirations to the healthy and heroic; it certainly should not lead its admirers to

court the moribund, by decking up the sentimentally languid in fine feathers. Lately I had great delight in skimming over a certain book, *Modern Painters* by a writer calling himself an Oxford Graduate; it was lent to me only for a few hours, but, by Jove! passages in it made my heart thrill. He feels the power and responsibility of art more than any author I have ever read. He describes pictures of the Venetian School in such a manner that you see them with your inner sight, and you feel that the men who did them had been appointed by God, like old prophets, to bear a sacred message, and that they delivered themselves like Elijah of old. They seemed mighty enough to overthrow any vanity of the day. He glories most in Tintoretto, and some of the series described, treating of the life of the Virgin, and others illustrating the history of the Saviour, make one see in the painter a sublime Hogarth. The Annunciation takes place in a ruined house, with walls tumbled down; the place in that condition stands as a symbol of the Jewish Church—so the author reads—and it suggests an appropriateness in Joseph's occupation of a carpenter, that at first one did not recognise; he is the new builder! The Crucifixion is given with redoubled dramatic penetration, and the author dwells upon the accumulated notes of meaning in the design, till you shudder at the darkness around you. I wish I could quote the passage about Christ. I'll tell you more of the book some day. I speak of it now because the men he describes were of such high purpose and vigour that they present a striking contrast to the uninspired men of to-day. This shows need for us young artists to consider what course we should follow. That art is dying at times is beyond question. The "Oxford Graduate" reverses the judgment of Sir Joshua, for he places the Venetian in the highest rank, and disdains the Bolognese school, which until these days has never been questioned for its superiority, both under the Caraccus and Le Brun, whom the President also lauds. Students in those days would have been wise had they realised their doleful condition, and taken an independent course. I venture to conclude that we are now in a similar plight, and the book I

speak of helps one to see the difference between dead and living art at a critical juncture. False taste has great power, and has long often gained distinction and honour. Life is not long enough to drivel though a bad fashion and begin again. The determination to save one's self and art must be made in youth. I feel that is the only hope, at least for myself. One's thoughts must stir before the hands can do. With my picture from The Eve of St. Agnes I am limited to architecture and night effect, but I purpose after this to paint an out-of-door picture, with a foreground and background, abjuring altogether brown foliage, smokey clouds, and dark corners, painting the whole out of doors, direct on the canvas itself, with every detail I can see, and with the sunlight brightness of the day itself. Should the system in any point prove to be wrong, well! I shall be ready to confess my mistake and modify my course.'

In the midst of my talk Millais continually expressed eagerness to get away altogether from the conventions denounced, and adduced examples of what he agreed were absurdities, declaring that often he had wondered whether something very interesting could not be done in defiance of them. 'You shall see in my next picture if I won't paint something much better than "Cymon and Iphigenia"; it is too late now to treat this more naturally.'… It is on quiet and confidential occasions such as this that burning convictions are tested and refined, and ours at this time were beaten upon the anvil of what experience we had already had. Here the scaling dross was shaken off, and the pure iron converted into tempered steel…

On the date for receiving the works of outsiders at the Academy, our pictures were forwarded, literally at the eleventh hour of the night, and very glad each of us was to go to his long-neglected bed.

The first use which Millais and I made of our release from the pressure of work on a succeeding morning was to accompany the noted Chartist procession; it marched from Russell Square across Blackfriars Bridge to Kennington Common; we did not venture on to the grass with the agitators, but, standing up on the cross rails outside the

enclosure, we could see the gesticulations of the orators as they came forward on the van drawn up in the centre of the green. When the address was beginning to evoke tumultuous cheers, a solitary policeman, square and tall, appeared from the northern corner, walked through the dense artisan crowd to the foremost stand, and beckoned to Fergus O'Connor to return with him to the Superintendent of Police, under assurance of nondetention. I felt respect for both men and for the crowd as the speaker quietly descended, and a lane was made by the thousands present, while the two walked over the common as staidly as though they alone were on the ground. The Chartist champion was detained only a few minutes. He came back by himself, knowing that concealed measures had been taken to quell any outbreak of disturbance, and that roofs of the neighbouring houses were manned with riflemen. On re-ascending the van, he advised the law-abiding people to disperse, which they did without delay. We essayed to return by the road we had come, but at Blackfriars Bridge a cordon of police barred further passage. We turned towards Bankside. Here at the entrance a set of stalwart roughs armed with bludgeons were determined to have their fight, and we heard, as we were about to pass, the sound of bloody strife. Who that has heard such even in its mildest form can forget the hurtle? We felt the temptation to see the issues, and Millais could scarcely resist pressing forward, but I knew how in a moment all present might be involved in a fatal penalty. I had promised to keep him out of wanton danger, but it was not without urgent persuasion that I could get him away. We went along, accompanied by but few of the crowd, till we reached London Bridge; passing this we arrived at the sand-bags to mask the soldiery. We succeeded on our round in gaining a thorough knowledge of the state of affairs. Returning by way of Holborn, the sombre sky opened its silent artillery on us with spots of rain as large as grape shot, and cleared the street of agitators, mischief-makers, and idlers alike. With the last we scampered home as swiftly as any of the reformers…

When the Academy Hanging Committee had completed their work I was surprised and distressed to learn that Millais' painting of 'Cymon and Iphigenia' had not been placed. The only justification could have been that the work was incomplete. He was exceedingly brave about the disappointment, and—as was characteristic with him throughout life on encountering any check to success—he was very reticent on the subject, and now he hid the picture away. My picture of 'The Eve of St. Agnes', being not nearly so large, had more easily met with better fortune, notwithstanding the absence of close finish. It was hung somewhat high up in the Architectural Room, but in a good light, as was proved on the touching-up morning by the amount of attention which fellow-exhibitors bestowed upon it.

Millais had gone out of town at this time—partly, if I remember right, to arrange about a commission for the execution of a series of paintings in monochrome at Leeds. Before returning to town he stayed at Oxford and Shotover till the end of summer.

Rossetti came up to me, repeating with emphasis his praise, and loudly declaring that my picture of 'The Eve of St. Agnes' was the best in the collection. Probably the fact that the subject was taken from Keats made him the more unrestrained, for I think no one had ever before painted any subject from this still little-known poet.

No other copies of his works than those published in his lifetime had yet appeared. These were in mill-board covers, and I had found mine in book-bins labelled 'this lot 4d.' Rossetti frankly proposed to come and see me. Before this I had been only on nodding terms with him in the schools, to which he came but rarely and irregularly. He had always attracted there a following of clamorous students, who, like Millais' throng, were rewarded with original sketches. Rossetti's subjects were of a different class from Millais, not of newly culled facts, but of knights rescuing ladies, of lovers in mediæval dress, illustrating stirring incidents of romantic poets; in manner, they resembled Gilbert's book designs. His flock

*[handwritten margin notes:]* 4-10-00 mon; shows how very tense situation; they could end up dead; In state of martial law of October

of impatient petitioners had always barred me from approaching him. Once indeed I had found him alone, perched on some steps stretched across my path, drawing in his sketch book a single female figure from the gates of Ghiberti. I had recently been attentively drawing some of the groups for their expression and arrangement, and I told Rossetti then how eloquent the Keeper had been in his comments on seeing me at work from the group of 'The Finding of the Cup in Benjamin's Sack', saying that Ghiberti's principles of composition were in advance of his time in their variety of groupings, and that his great successors had all profoundly profited by these examples. As an instance he had pointed out how Raphæl in the cartoon of 'The Charge to St. Peter' had put a little quirk of drapery projecting out under the elbow of the last disciple on the right to break the vertical line of the figure just as Ghiberti had here introduced the ass with projecting pannier for the same purpose. The Keeper for these reasons regretted that the gates were not more often studied by young painters. Thus chatting and dilating on these quattrocento epochal masterpieces and their fascinating merits gave us subject for a few minutes talk; but our common enthusiasm for Keats brought us into intimate relations...

While engaged on the question of the practice of painting, he confessed to me that he was very disheartened about his position. He had, some short time ago, applied to Madox Brown to take him as a pupil. This the established artist had generously agreed to do on terms of amity. In accordance with all sound precedent, the master had set him to copy a painting of his own of two cherub angels watching the crown of thorns, and this he had managed to finish. The next task was a study of still life from a group of bottles and other objects which happened to be lying about in the studio. This discipline Rossetti had found so abhorrent that it had tormented his soul beyond power of endurance. Thus disheartened, he had given up painting for the time and had turned for counsel to Leigh Hunt, asking him to read his small collection of

poems and to tell him whether he might not hope to rely upon poetry for his bread. 'The heart knoweth its own bitterness.' My namesake had replied about the verses in the most appreciative manner, but implored him, if he had any prospect whatever as a painter, on no account to give it up, since the fortunes of an unfriended poet in modern days were too pitiable to be risked. Rossetti had thus been again driven to painting...

The talk at my studio was often on the further extension of our number. In Gabriel's subscription [to] Life School he was soon joined by his brother William, who applied himself at night in a steady manner to the pursuit of drawing, and regularly executed conscientious, although rigid, transcripts of the nude. Gabriel was soon persuaded that, in spite of William's lateness in taking up art, he would shortly become proficient enough to be justified in throwing up his appointment at the Inland Revenue Office and taking to painting, and with this prospect he proposed that we should make room for him in our Body. In addition to this proposal, I agreed to submit to Millais the question of the acceptance of James Collinson, who had already distinguished himself by paintings of the genre kind, and was now writing poetry in the highest Church spirit. He promised now to paint in the severe style, declaring himself a convert to our views. The idea of extending our numbers so trustfully was thus originated by Gabriel. Youth is sanguine, and I offered no opposition to the experiment; and when the enthusiastic desire of these fellow-students was declared to be a sure earnest of future zeal and power, I introduced to my friends F.G. Stephens, who had not yet achieved anything as an artist. I urged that he also, with the whirl of enthusiasm in operation, and under seal of promise to us, might become an active artist.

When on Millais' return to town, I went to his studio, he shouted out, 'Where is your flock? I expected to see them behind you. Tell me all about it. I can't understand so far what you are after. Are you getting up a regiment to take the Academy by storm? I can quite see why Gabriel

*[handwritten margin note]* He's not happy about this being done (& wto his consent)

Rossetti, if he can paint, should join us, but I didn't know his brother was a painter. Tell me. And then there's Woolner. Collinson'll certainly make a stalwart leader of a forlorn hope, won't he? And Stephens, too! Does he paint? Is the notion really to be put in practice?'

'Well', I replied, 'in order I'll tell you.' Gabriel implored me to take him and teach him to paint, and he's such an eager fellow that my one doubt as to his success is that he may be ever beginning and never finishing. He is now working in my studio on a little picture of 'The Virgin and St. Ann', the most mediæval of his last three designs. You saw the drawing of it. It seems that lately he has seen a great deal of Woolner, and talked to him of our plan of going direct to Nature for all things, and the sculptor expressed a desire to join us. I didn't know him, but now I think he might help to spread our principles in his branch. Probably you know his powers better than I do. Now comes the forlorn-hoper; it appears that the Rossettis are much attached to him, and Gabriel, having taken possession of him, declares he can attain to a higher kind of work than he has yet accomplished, and Collinson himself has been pressing me to get him accepted. I like the meek little chap. All I call say is that there was a good idea in his 'Charity Boy', and that the manipulation was conscientious, so that with higher inspiration he might do something good. I must not forget William Rossetti. Well, Gabriel proposes that he too shall become an artist and join us. It is very late in life; he is as old as you, without having drawn at all yet, but his brother declares that he will soon make up for lost time. Now these are proposed by Rossetti. The numbers grew so fast, and his confidence in our power was so extensive, that I determined to put a limit to the number of probationary members, which I did by adding my nominal painting pupil Stephens. So far I have not yet been able to awaken in him the novice's indispensable passion but being treated as a real artist may awaken his ambition.'

Millais' rejoinder was, 'Yes; but all this is a heavy undertaking.'...

In my own studio soon after the initiation of the Brotherhood, when I was talking with Rossetti about our ideal intention, I noticed that he still retained the habit he had contracted with Ford Madox Brown of speaking of the new principles of art as 'Early Christian'. I objected to the term as attached to a school as far from vitality as was modern classicalism, and I insisted upon the designation 'Pre-Raphælite' as more radically exact and as expressing what we had already agreed should be our principle. The second question, what our corporation itself should be called, was raised by the increase of our company. Gabriel improved upon previous suggestion with the word Brotherhood, overruling the objection that it savoured of clericalism. When we agreed to use the letters P.R.B. as our insignia, we made each member solemnly promise to keep its meaning strictly secret, foreseeing the danger of offending the reigning powers of the time. It is strange that with this precaution against dangers from outside our Body we took such small care to guard ourselves against those that might assail us from within. The name of our Body was meant to keep in our minds our determination ever to do battle against the frivolous art of the day, which had for its ambition 'Monkeyana' ideas, 'Books of Beauty', Chorister Boys, whose forms were those of melted wax with drapery of no tangible texture. The illustrations to Holy Writ were feeble enough to incline a sensible public to revulsion of sentiment...

Once, in a studio conclave, some of us drew up a declaration that there was no immortality for humanity except that which was gained by man's own genius or heroism. We were still under the influence of Voltaire, Gibbon, Byron, and Shelley, and we could leave no corner or spaces in our minds unsearched and unswept. Our determination to respect no authority that stood in the way of fresh research in art seemed to compel us to try what the result would be in matters metaphysical, denying all that could not be tangibly proved. We agreed that there were different degrees of glory in great men, and that these grades should be denoted by one, two, or three stars. Ordinary children of

men fulfilled their work by providing food, clothing, and tools for the fellows; some, who did not engage in the labour of the earth, had allowed their minds to work without the ballast of common-sense, and some of these had done evil, but the few far-seeing ones revealed to us vast visions of beauty. Where these dreams were too profound for our sight to fathom, our new iconoclasm dictated that such were too little substantial for human trust; for of spiritual powers we for the moment felt we knew nothing, and we saw no profit in relying upon a vision, however beautiful it might be...

Arguing thus, Gabriel wrote out the following manifesto of our absence of faith in immortality, save in that perennial influence exercised by great thinkers and workers:

We, the undersigned, declare that the following list of Immortals constitutes the whole of our Creed, and that there exists no other Immortality than what is centred in their names and in the names of their contemporaries, in whom this list is reflected:

Jesus Christ****
The Author of Job***
Isaiah
Homer**
Pheidias
Early Gothic Architects
Cavalier Pugliesi
Dante*
Boccaccio*
Rienzi
Ghiberti
Chaucer**
Fra Angelico*
Leonardo da Vinci**
Spenser
Hogarth
Flaxman
Hilton
Goethe**
Kosciusko
Byron
Wordsworth
Keats**
Shelley**

Raphæl*
Michael Angelo
Early English Balladists
Giovanni Bellini
Georgioni
Titian
Tintoretto
Poussin
Alfred**
Shakespeare**
Milton
Cromwell
Hampden
Bacon
Newton
Landor**
Thackeray**
Poe
Hood
Longfellow*
Emerson
Washington**
Leigh Hunt (Author of *Stories after Nature**)

*[handwritten annotations: "old fashioned, folksy types of songs" (pointing to Early English Balladists); "famous goldsmith of Renais." (pointing to Giovanni Bellini); "this list as screamingly funny!"; "artist who did friezes on Parthenon" (pointing to Pheidias); "great caricaturist of 18c England" (pointing to Hogarth)]*

Haydon
Cervantes
Joan of Arc
Mrs. Browning*
Patmore*

Wilkie
Columbus
Browning**
Tennyson

*[handwritten: "Coventry > Friend of Rosetti + later Pre-Raphaelite"]*

## [1842]

While our pictures were shut up for another week at the Royal Academy, Rossetti's was open to the public sight, and we heard that he was spoken of as the precursor of a new school; this was somewhat trying...

At the Hyde Park Gallery Rossetti's picture, 'The Girlhood of the Virgin', appeared pure and bright, and was the more attractive by its quaint sweetness. The Marchioness of Bath bought it for eighty guineas.

The notice in *The Athenæum* ran thus:

It is pleasant to turn from the mass of commonplace to a manifestation of true mental power in which art is made the exponent of some high aim; and what is of the earth, earthy, and of the art material, is lost sight of in a dignified and intellectual purpose. Such a work will be found here, not from a long-practised hand, but from one young in experience, new to fame, Mr. D.G. Rossetti. He has painted 'The Girlhood of Virgin Mary', a work which, for its invention and for many parts of its design, would be creditable to any exhibition. In idea it forms a fitting pendant to Mr. Herbert's 'Christ subject to his Parents at Nazareth'. A legend may possibly have suggested to Mr. Rossetti also the subject of his present work The Virgin is in this picture represented as living amongst her family, and engaged in the task of embroidering drapery to supply possibly some future sacred vestment. The picture, which is full of allegory, has much of that sacred mysticism inseparable from the works of the early masters, and much of the tone of the poets of the same time. While immature practice is visible in the executive department of the work, every allusion gives evidence of maturity of thought, every detail that might rich or amplify the subject has found a place in it. The personification of

the Virgin is an achievement worthy of an older hand. Its spiritualised attributes, and the great sensibility with which it is wrought, inspire the expectation that Mr. Rossetti will continue to pursue the lofty career which he has here so successfully begun. The sincerity and earnestness of the picture remind us forcibly of the feeling with which the early Florentine monastic painters wrought; and the form and face of the Virgin recall the words employed by Savonarola in one of his wonderful sermons: 'Or pensa quanta bellezza avea la Vergine, che avea tanta santita, che risplendeva in quella faccia della quale dice San Tommaso che nessuno che la vedesse mai la guardo per concupiscenza, tanta era la santita che rilustrava in lei.' Mr. Rossetti has perhaps unknowingly entered into the feelings of the renowned Dominican who in his day wrought as much reform in art as in morals. The coincidence is of high value to the picture.

On the first Monday in May, outside artists were admitted to the Royal Academy to touch up their pictures from 7AM till 12, when the public were let in. Millais and I had heard that our works were hung as pendants in large room just above the line in honourable places. Millais sold his 'Lorenzo and Isabella' for £150 to three tailors in Bond Street who were making an essay in picture dealing… Several of the members of the Academy introduced themselves to me as I was on a ladder touching up my work, and quite confused me with compliments, so that I felt fortified in the hope of the sale of my picture, but the day passed without any patron appearing, and I returned home much discouraged at the apathy of amateurs.

[Sounds like Quilen Club — *handwritten annotation*]

[1849]

Rossetti at that date had the habit of coming to me with a drawing folio, and sitting with it designing while I was painting at a further part of the room. When on one occasion evening had set in, and dinner had given place to work, Deverell broke in upon our peaceful labours. He had not been seated many minutes, talking in a somewhat

'The Pre-Raphælite Meeting' by Arthur Hughes (1848) from a sketch by William Holman Hunt

absent manner, when he bounded up, marching, or rather dancing to and fro about the room and, stopping emphatically, he whispered, 'You fellows can't tell what a stupendously beautiful creature I have found. By Jove! she's like a queen, magnificently tall, with a lovely figure, a stately neck, and a face of the most delicate and finished modelling; the flow of surface from the temples over the cheek is exactly like the carving of a Pheidean goddess. Wait a minute! I haven't done; she has grey eyes, and her hair is like dazzling copper, and shimmers with lustre as she waves it down. And now, where do you think I lighted on this paragon of beauty? Why, in a milliner's back workroom when I went out with my mother shopping. Having nothing to amuse me, while the woman was tempting my mother with something, I peered over the blind of glass door at the back of the shop, and there was this unexpected jewel. I got my mother to persuade the miraculous creature to sit for me for my Viola in 'Twelfth Night', and to-day I have been trying to paint her; but I have made a mess of my beginning. To-morrow she's coming again; you two should come down and see her; she's really a wonder; for while her friends, of course, are quite humble, she behaves like a real lady, by clear common sense, and without any affectation, knowing perfectly, too, how to keep people at a respectful distance.'

I could not accept Deverell's confiding invitation, but Gabriel was less pressed for time, and on the morrow came back with no diminished account of Miss Siddal's beauty, with the announcement that he had prevailed upon her to sit to him. I had the idea of making the young

woman tending the priest in my picture a fair Celt with red hair, and as I had no one in my knowledge who would serve as model, I asked Rossetti whether he thought I would ask Miss Siddal to sit. He advised me to write to her, with the happy result that she agreed to it. With my desire to give a rude character to the figure, and my haste to finish, certainly the head bore no resemblance her in grace and refinement. Rossetti, although he betrayed an admiration from the beginning, did not for a full year or two profess any strong personal feeling for her.

He was painting his 'Annunciation', Millais was progressing with his 'Carpenter's Shop', and I with my 'Druid' picture, each anxious to improve the position that we had gained last year at the Exhibition, when suddenly a newspaper in its gossiping column published a spirited paragraph revealing the true meaning of the initials of P.R.B. on our pictures, about which there had been hitherto only the most preposterous guesses. It held the whole body up to derision. The effect of the announcement proved how much our intention of secrecy had been wise. The younger members of the profession, our forerunners, had nearly to a man declared themselves hostile to us, and the bitterness had grown wilder and wider. Now with the exposure of our 'wicked' designs an almost universal fury was excited against us…

[1850]
The difference was very marked in the reception of our pictures by members of the Academy from that of last year; not one complimented me in any way, but those I saw turned away as though I had committed a crime…

Gabriel's picture of 'The Annunciation', shown at Portland Place Gallery, did not escape the storm, though it attracted considerable admiration from thoughtful artists. The effect of rancorous criticism upon Rossetti was such that he resolved never again to exhibit in public and he adhered to this determination to the end, very much as it proved, to his future advantage. The dividing of himself at first from us in the place and

date of exhibition was done with no sense of corporate interest, and now Millais and I were left to bear the whole brunt of the storm. When the press gave their verdict it was with one voice of condemnation. The leading journals denounced our works as iniquitous and infamous. The critics exhibited their indignation with the more effect by giving their own interpretation of the revealed meaning of the word Pre-Raphælite, and what naturally made our enormity more shameful beyond artistic circles, the great Charles Dickens wrote a leading article in *Household Words* against Millais' picture…

It was at his home when he was absent that the cruelty of the attack on Millais was most apparent. There the mother, taking the different papers and journals tremblingly in her hand, having had experience hitherto of unchequered triumph following in the wake of her brilliant son's indefatigable enthusiasm, read with little short of incredulity the insults heaped upon his young head. 'Think', said she, 'what other much more competent judges than those self-appointed anonymous newspaper critics have said of Jack', it was only lately that he had stamped out the pet name of Johnnie, 'think what Sir Martin Archer Shee on seeing his drawings said, although he had declared before it would be preferable to be a chimney-sweeper than to take to art.'…

Thereupon the dear lady sat quite up right, and, obeying a singular habit she indulged in when irritated, drew her open hand in front of her face, and with extended forefinger traced her handsome profile from the height of the forehead to the throat, and, recommencing, repeated the action until the point of the nose was reached, which she pressed down in her haste to follow up another movement; drawing her scarf more closely about her shoulders, holding the extremities for a moment like wings, she then wrapped them close to her breast and threw herself back in her easy chair. The father meanwhile was walking about with a cane in his hand, which he switched, making it whistle in the air, and breaking out into indignation clenching his fist and swearing that if he knew where to find

the anonymous brood of abusers he would drag them out into the street and thrash them within an inch of their lives. And in his heat he meant what he said. 'Ah', continued Mrs. Millais, 'the pity is he ever altered his style, he would never have provoked this outrageous malice has he not changed. His manner was admired by every one. I say let everyone keep his own style. His was right for him. Yours, Hunt, is quite right for you; an excellent manner, I call it. It is the forming of yourselves into so large a body and all the talking that has done the mischief. I wish that you had never had anything to do with that Rossetti.'

'Poor Rossetti, how is he to blame in the matter?' I urged. 'Jack had quite agreed upon his new course long before Rossetti came here, when in fact Rossetti was not thinking of painting at all. In the Academy Schools I am pretty certain they never spoke ten words together.'

'Ah', said Mrs. Millais, 'I don't like the look of him; he's a sly Italian, and his forestalling you deceitfully by sending his first picture to an exhibition, where it was seen with your joint insignia upon it, a week before the pictures by you and Jack would appear, was quite unEnglish and unpardonable when you had taught him and treated him with great generosity.'

[1851]
In 1851 Millais had painted 'The Woodman's Daughter', 'Mariana of the Moated Grange', and 'The Return of the Dove to the Ark'. Rossetti made no appearance public this season.

Our pictures this year had less good places than before; they were separated, and all suffered as to their key of colour and effect by want of support. The wrath against us now was of triumphant tone, our enemies spoke as though we must see we were defeated. Yet there were painters who stood attentive before the pictures, and in the end turned and shook our hands heartily, saying, 'Do not heed all this clamour.' Millais, came back with me early from the Academy to Chelsea on the first day of the Exhibition, and there he took up a pen and sketched the scene representing our

rivals' wrath at our pictures, with others engaged in touching up their own work.

No sooner had the Exhibition opened than we found that the storm of abuse of last year was now turned into a hurricane...

With me, debt was increasing every day. I was determined not to drag on, repining over hard fate, but to look at facts fairly and use my best reason in accepting the consequences.

Many of our literary friends expressed their sympathy with us, and declared indignation at the treatment we had received. Patmore said he knew of no such organised conspiracy at any date against young men, and David Masson wished that he had art profundity enough to be of use to us.

In the midst of this helplessness came thunder as out of a clear sky—a letter from Ruskin in *The Times* in our defence...

[1854][1]
But for a few acacia trees growing in the dry course of the storm-stream which we were following there was no sign of vegetation anywhere. The uplands were gradually declining before us, and to the left we saw only ridges bordering the courses of ravines descending to the bed of the sea. To the

1. The following selections concern Hunt's time in the Near East during which he lived with an Arab tribe for a time and painted *The Scapegoat*.

right there were other heights with openings through which we could see towards Wady Akabah. In front was the deep ghor, with the bluest of lakes in the hollow, and beyond lay the amethystine mountains of Moab in the afternoon sun.

I was too much occupied with the scene to talk. We arrived somewhat abruptly at the precipitous descent, with its ruined fortress below. On the walls of the castle were painted figures like the signs of the Zodiac which seemed of recent date, it was at the foot of this fortress that I was to live with my troop. I dismounted and led the party down the steep descent, while they followed I made my plans with Soleiman, and we soon set off, taking the picture case mounted on a donkey to the margin of the sea, that I might choose my place of work and study the sunset effect while drawing in the outline. Glance where we would over the extensive plain and mountains not a sign of humanity was before us. Getting out of the defile, we turned slightly to the right to reach the spur of Oosdoom, about a mile distant; a furlong beyond that point I made my way to the margin of the sea. There leaving my man to guard the ass, I strode about the hard drifts of the salt-encrusted shallow ridges to find the best site, and wandered to the end of a curve of drift; ten paces away was yet another turn; the salt surface intervening appeared firm enough to trust to with light and rapid steps; I essayed it, but soon found myself sinking into the mire. As I struggled, a story of my mother's cousin told me in childhood came into my mind. He had seen the veritable pillar of salt into which Lot's wife had been turned and in escaping from some terrible danger he had nearly got swallowed up in a slime pit, but had saved himself by falling prostrate. I threw myself down on the salt surface to secure a wider support, and

crawled to the firm ridge. I discovered afterwards there was no danger of sinking much below one's knees. The available spots for painting were now reduced to one or two. When the best had been chosen, I employed Soleiman to lead the goat over the surface in order that I might scrutinise its manner of walking on the yielding crust, and the tone of the animal in shadow against the sea and bright distance.

With a few large stones I was able to make a firm foundation for my picture case, and placing another for a seat I proceeded to sketch out the landscape and lines of the composition. Soleiman, when unemployed, upset my gravity by sitting down exactly in front of me in utter bewilderment, staring with open mouth intently into my face.

In an hour I was steadily at work; my man kept repeating the inquiry whether I had finished, but I could not reply. Every minute the mountains became more gorgeous and solemn, the whole scene more unlike anything ever portrayed. Afar all seemed of the brilliancy and preciousness of jewels, while near, it proved to be only salt and burnt lime, with decayed trees and broken branches brought down by the rivers feeding the lake. Skeletons of animals, which had perished for the most part in crossing the Jordan and the Jabbok, had been swept here and lay salt-covered, so that birds and beasts of prey left them untouched. It was a most appropriate scene for my subject, and each minute I rejoiced more in my work. While thus absorbed, Soleiman touched my arm and said, 'My father, the sunset has come', and then he grew quite out of patience, and added, 'In the dark how can we escape danger? In the light I can detect men from afar, but when the sun has gone, as we go back I can't see if they hide behind trees and shoot us.' I answered, 'My son, be obedient and patient till I have done my work. Keep silent until I am ready, and when I tell you we will hurry back to the tent.'

When the stars were beginning to appear, I removed the ban of silence from the head of my 'son', who was almost in desperation by this time. I tied up the umbrella and shut up my tools, while

*Bit full of himself, eh?*

William Holman Hunt's drawing in a letter to his son

Soleiman led the donkey. We then together balanced the case on the creature's back, and, securing it, trudged away, not without a trace of ill humour in my companion. But an Arab soon forgets discontent if you tell him a tale, and by the time we got to the opening in the cliff we were the best of friends. It was a necessary precaution to talk low ourselves, and to prevent our donkey from braying as we approached nearer to the encampment; this my 'son' effected by a timely cuff; or sometimes by covering the creature's nostrils with his cloak. On arriving at the tent, water was brought me from a cistern near at hand. It was of the shade of London porter, which may have arisen from some colouring matter in the pit, or from the tanning of the skin bottles; at any rate it was good enough to wash with, it served the cook's purpose and made excellent coffee. All looked home-like on my return; the light of the grate, where dinner was being prepared, was rivalled by the fire of a dead tree brought up by the Arabs, and set alight for their comfort. While I was having dinner I could hear Soleiman recounting my perplexing proceedings down on the beach together with murmuring, which convinced me that I should have to use all my tact to make the men stay a sufficient time for me to do my work…

Soon now the mountains, the sea, and the middle distance on my canvas were completed, and I was beginning to feel the more indifferent to the grumblings of the men. I was gradually working down to the salt foreground, and one afternoon

when Soleiman was away I was pondering on the present state of desolation of 'the way of the sea', when my 'brother' appeared, looking more impressive than usual. He crouched down beside me, put his hand out to the cliffs towards Masada, and uttered the portentous words, 'There are robbers; they are coming this way—one, two, three, on horseback, and two—wait, three—yes, four on foot. They have not yet seen us, and soon they will be behind Oosdoom, and we shall be able safely to move. You must put down your umbrella, shut up your picture, cover it with stones. They will not be here for all hour. We will go up in the mountain; they will keep along the road at the foot; we will come back to the picture when they have gone by.' I could see the party very far away, and asked, 'How do you know they are robbers?' 'They are always robbers when the others are feeble; it would be useless for us to resist. Quick', he said. 'Perhaps they belong to a friendly tribe', I argued. 'They do not', he said. 'Come.' 'No', I said, 'I shall stay.' He implored me to listen, and finally stamped, saying, 'Your blood be on your own head; as for me I shall go to the mountain and hide myself.' As he went away he turned two or three times, and again appealed to me like a man at his wits' end. 'Why stay? What do you trust in?' I replied mine was a good work, that Allah would help me, and that I was content to accept whatever might be the issue, and I saw him run to the break in the mountain near, and, with the ass, climb up its roughness and disappear.

I worked on steadily, but had to turn my head occasionally to watch the progress of the deeshman. Before they were cut off from observation by the intervening Oosdoom I recognised that Soleiman's estimate of their number was correct. There was a long hiatus, while my 'brother' made no sign, and there was nothing to do but to progress with my work as effectively as possible. As time wore away I grew anxious for the climax, and it was a relief to me to be able at last to hear the approaching Arabs talking, and their horses' hoofs among the shingle. I suspended my painting and looked from beneath my umbrella, until suddenly the deeshman emerged

from behind the mountain within half a furlong of me where they all halted. The horsemen had their faces covered with black kufeyiahs and carried long spears, while the footmen carried guns, swords, and clubs. They stood stock-still some minutes, pointing at my umbrella, and then turned out of the beaten way direct to me clattering at a measured pace among the large and loose stones. I continued placidly conveying my paint from palette to canvas, steadying my touch by resting the hand on my double-barrelled gun. I knew that my whole chance depended upon the exhibition of utter unconcern, and I continued as steadily as if in my studio at home.

Eventually the whole party drew up in a half-circle. The leader thundered out, 'Give me some water.' I turned and looked at him from his head to his horse's feet, and then very deliberately at the others, and resumed my task without saying a word. He stormed again, 'Do you hear? Give us some water.' After turning to him once more with a little pause, extending my right hand on my breast, I said, 'I am an Englishman; you are an Arab. Englishmen are not the servants of Arabs; I am employing Arabs for servants. You are thirsty—it is hot—the water is there—I will out of kindness let you have some, but you must help one another; I have something else to do', and I turned again quietly to work.

They chattered a little in a low but excited tone. Presently the leader again spoke, 'Are you here alone?' 'No', I said, 'I have Arabs of the tribe of Abou Daouk waiting upon me.' 'Where are they?' 'Well, some are with my tent and animals in the Wady Zuara, but one comes with me to stay all day.' They looked about while they handed the bottle from one to another and drank. And then again the speaker said, 'We should see him were he here.' 'But', I said, 'he saw you coming. When you were at a distance, and, being afraid, he went to the mountains to hide himself.' At which my questioner said, 'Call him.' I looked at him very gravely, and said in a convincing tone, 'But I don't want him.' The reply was, 'We want him.' 'Well', I added, 'then you call him; his name is Soleiman.'

After a little discussion the strangers seemed to see reason in the argument; and the plain echoed with the name, familiar to Arabs as that of the imperial wizard over nature, but no response came. 'There', they said, 'there is no one, or he would answer.'

My explanation was that I had said he was afraid, that they best knew what, under the circumstances, it was needful to do; accordingly 'Soleiman' was again shouted with solemn pledges of amity. Presently a voice was heard demanding further assurances of safety, then my 'brother' stood up from behind a rock, and slowly he came down, bringing the donkey with him. He advanced with salutations direct to the men. First, he kissed the leader, and then addressed himself to the others, who returned his salutation and began to talk, both stating their tribe. When this ceremony was over the horsemen dismounted, formed a circle, lit pipes, and sat down to talk.

To their first question I heard Soleiman reply that the tent was guarded by one hundred of his tribe, some of whom were always coming down to us, that I had bargained with the sheik to stay a month or two, that I had been on the spot twelve days, and recounted what I had done on arriving there. 'What does he come here for' was asked. 'He comes', said Soleiman, 'each day from the tent at sunrise, and stays till sunset writing on that paper with his coloured inks taken out of those bottles.' 'Ah!' was muttered, 'why doesn't he stay in England and leave our country to us?' 'Who can say', returned my 'brother', 'why frangis do what they do.' 'True', said the speaker...

[1856]
Soon after my return to England I went down to Oxford, and found all my Syrian boxes there. Mr. Combe, after the arrival of the painting of 'The Scapegoat', had indefatigably written in turn to all those who had given me commissions; but each had replied that the subject was not one which fitly represented me. One art lover in the North, after expressing this opinion, wrote that he should like to have the work sent to him for a few days, but my friend had not felt authorised to accede

and thus I was still the proud owner of the picture and also of a fast-dwindling exchequer. I was glad of the opportunity of unpacking my pictures and drawings to obtain the judgment of my friends. Two or three months separation from the works to a great degree dissipated the prejudice nurtured of familiarity with them, and my new judgment was a benefit to me. It relieved me to believe that the amount of painting achieved was not altogether so disappointing as I had feared, and I found that the parts finished in 'The Temple' subject interested my friends greatly.

My little reserve of money in Mr. Combe's hands was almost expended in setting up my new home. An optimistic dream was to bring 'The Temple' picture to completion before showing it to anybody…I had to raise money as quickly as possible. Pot boilers are so called because they keep the kitchen range alight. The water-colour drawings I had made in the East did not at first command purchasers. The prejudice ruling that an artist should do only one kind of subject was always standing in my way. At that time picture-dealers told me there was a great demand for replicas of works of mine exhibited years ago, which when they first appeared had been much abused; I therefore took up the original studies of these, and elaborated them into finished pictures. Those works escaped diatribes of the critics which always met any works incorporating a perfectly new idea, and thus timid purchasers were not frightened…

In 1856…[Ford Madox Brown] told me that Ruskin was patronising Rossetti and was using his influence with Mr. M'Cracken, Lady Trevelyan, and other of his friends to buy drawings off him. It was evident that Ruskin was not disposed to hold out the same helping hand to Brown himself, or to express sympathy for his work. There was a great difference between our refusal of Brown in early years as a nominal 'Brother', and our welcoming him as an outside convert like other men whose work we thoroughly admired, so that when he joined with Rossetti to get up a collection of small works for a private exhibition, I willingly contributed some Eastern landscapes. Rooms were secured in Charlotte Street, Fitzroy Square; and when all was arranged I went to a private view. Rossetti was there, and immediately on my arrival called me to come and see 'the stunning drawings' that the Sid (the name by which Miss Siddal went) had sent. I complimented them fully, and said that had I come upon them without explanation I should have assumed they were happy designs by Walter Deverell.

'Deverell!' he exclaimed, 'they are a thousand times better than anything he ever did.' I had thought that to compare the attempts of Miss Siddal, who had only exercised herself in design for two years, and had had no fundamental training, to those of Gabriel's dear deceased friend, who had satisfactorily gone through the drilling of the Academy schools, would be taken as a compliment, but Rossetti received it as an affront, and his querulous attitude confirmed me in the awakened painful suspicion that he was seeking ground of complaint against his former colleagues…

Every time I visited Oxford I heard more of the sensation Rossetti was making there. Ruskin was taking the responsibility of directing the architect Woodward, who, with his partner Deane, was engaged in building the new Museum, and it was still said that Rossetti would return to Oxford to paint some of the walls. But as the building was not yet ready, and the rooms of the Union built by the same architects were advanced to the stage at which the bare walls were temptingly smooth and white, Rossetti had volunteered to paint upon them the story of King Arthur with no other charge but for the materials. Arthur Hughes was helping him in this enterprise. It was in character with Rossetti's sanguine enthusiasm that he induced many undergraduates, with little or no previous training, to undertake to cover certain spaces. Edward Burne Jones, William Morris, and Spencer Stanhope were persuaded to take part in the work, the last only, having had any preliminary training. I saw my name inscribed on a fine blank panel, and nothing would have delighted me more than to have contributed my share to the decorations, but

I had too many stronger claims to allow me to undertake this mural work. Some of those connected with the Council of the Union, I heard, saw little to be grateful for in the generosity of the young decorators, and expressed themselves discourteously; perhaps it was this, coming to Rossetti's ears, that disenchanted him with his design, for he left it abruptly half-finished and returned to town, refusing all allurements of Ruskin and others to carry it further. Without previous experience of wall-painting, and disregarding the character of the pigments, the work of the group was doomed to change and perish speedily and nothing of it now remains. Rossetti had lighted upon remarkable undergraduates of great genius, to which choice band was added Swinburne of poetic genius.

Calling one day on Gabriel at his rooms in Blackfriars, I saw, sitting at a second easel, an ingenuous and particularly gentle young man whose modest bearing and enthusiasm at once charmed. He was introduced to me as Jones, and was called 'Ned'.

Although what Rossetti had painted at Oxford had not pleased the persons most immediately concerned, his reputation grew there with those reputed to be connoisseurs in taste. The fame that his poetry had won for him enlarged the faith in his art powers. His five or six years of seniority over his disciples gave him a voice of authority over them, and Ruskin's ever-increasing praise perhaps did more than all in spreading the idea of what his brother calls his 'leadership'. Retirement, therefore, from the outward struggle was no longer a disadvantage, but a boundless gain to him, for when any uninitiated commentator on the works of Millais, which appeared year by year, expressed his opinion about the progress of our reform movement, he was at once told that what Millais or any other had done towards it was only a vulgar reflection of Rossetti's purpose, that Rossetti disapproved of public exhibition, and that his studio could be visited only by a favoured few.

From this time he avoided Millais, Woolner, and myself to a degree that proved to be more than unstudied. Woolner did not accept this new attitude passively. He told me that on the occasion of a walk with Gabriel in the fields at Hampstead the latter spoke of his position so much as that of originator or head of the Brotherhood that Woolner, although, in allusion to his mediævalism, he had habitually addressed him as the 'Arch Pre-Raphælite', said, 'I wasn't going to humour his seriously making such a preposterous claim, so I told him that it was against all the known facts of the case. At which he became moody and displeased, and so went home alone.' This is a sad page of my record.

## John Guille Millais
### From *The Life and Letters of John Everett Millais*

[1848]
'It was in the beginning of the year 1848', says Mr. Holman Hunt, 'that your father and I determined to adopt a style of absolute independence as to art-dogma and convention: this we called "Pre-Raphælitism". D.G. Rossetti was already my pupil, and it seemed certain that he also, in time, would work on the same principles. He had declared his intention of doing so, and there was beginning to be some talk of other artists joining us, although in fact some were only in the most primitive stages of art, such as William Rossetti, who was not even a student.

'Meanwhile, D.G. Rossetti, himself a beginner, had not got over the habit (acquired from Madox Brown) of calling our art "Early Christian"; so one day, in my studio, sometime after our first meeting, I protested, saying that the term would confuse us with the German Quattro Centists. I went on to convince him that our real name was "Pre-Raphælites", a name which we had already so far revealed in frequent argument that we had been taunted as holding opinions abominable enough to deserve burning at the stake. He thereupon, with a pet scheme of an extended co-operation still in mind, amended my previous suggestion by adding to our title of "Pre-

Raphælite", the word "Brotherhood".'

Hunt, it should be explained, first met Rossetti in the Royal Academy schools, where as fellow-students they occasionally talked together. Rossetti, however, was an intermittent attendant rather than a methodical student, and presently, wearying of the work, he gave it up and took to literature, hoping to make a living by his pen. Here again he was disappointed. His poems, charming as many of them were did not meet with the wide acceptance he had hoped for, and in a fit of despondency he came to Hunt and begged him to take him into his studio. But Holman Hunt could not do this—he was far too busy working for a livelihood, with little time to spare for the indulgence of his own taste as an artist; but he laid down a plan of work to be followed by Rossetti in his own home, and promised to visit him there and give him all the help he could.

Not satisfied with this, Rossetti betook himself to Madox Brown, whose style of painting he admired, and who, he hoped, would teach him the technicalities of his art, while allowing him free play in all his fancies. Madox Brown, however, had been through the mill himself, and knew there was no short cut to success. So, much to the disgust of Rossetti, he set him to paint studies of still-life, such as pots, jugs, etc. By-and-by this became intolerable to a man of Rossetti's temperament, so he once more returned to Hunt, and begged him to take compassion on him, and at last, moved by his appeal, Hunt consented.

These are Hunt's words on the subject: 'When D.G. Rossetti came to me he talked about his hopes and ideals or rather his despair, at ever being able to paint. I, however, encouraged him, and told him of the compact that Millais and I had made, and the confidence others had in our system. Rossetti was a man who enthusiastically took up an idea, and he went about disseminating our programme as one to be carried out by numbers. He offered himself first, as he knew that Millais had admired his pen-and-ink drawings. He then suggested as converts Collinson, his own brother William, who intended to take up art, and

Woolner, the sculptor. Stephens should also be tried, and it struck him that others who had never done anything yet to prove their fitness for art reformation, or even for art at all, were to be taken on trust.

'I doubt very much', he said, 'whether any man ever gets the credit of being quite square and above-board his life and work. The public are like sheep. They follow each other in admiring what they don't understand [*Omne ignotum pro magnifico*], and rarely take a man at what he is worth. If you affect a mysterious air, and are clever enough to conceal your ignorance, you stand a fair chance of being taken for a wiser man than you are; but if you talk frankly and freely of yourself and your work, as you know I do, the odds are that any silly rumour you may fail to contradict will be accepted as true. That is just what has happened to me. The papers are good enough to speak of me as a typical English artist; but because in my early days I saw a good deal of Rossetti—the mysterious and un-English Rossetti—they assume that my Pre-Raphælite impulses in pursuit of light and truth were due to him. All nonsense! My pictures would have been exactly the same if I had never seen or heard of Rossetti. I liked him very much when we first met, believing him to be (as perhaps he was) sincere in his desire to further our aims—Hunt's and mine—but I always liked his brother William much better. D.G. Rossetti, you must understand, was a queer fellow, and impossible as a boon companion—so dogmatic and so irritable when opposed. His aims and ideals in art were also widely different from ours, and it was not long before he drifted away from us to follow his own peculiar fancies. What they were may be seen from his subsequent works. They were highly imaginative and original, and not without elements of beauty, but they were not Nature. At last, when he presented for our admiration the young women which have since become the type of Rossettianism, the public opened their eyes in amazement. "And this", they said, "is Pre-Raphælitism!" It was nothing of the sort. The Pre-Raphælites had but one idea—to

present on canvas what they saw in Nature; and such productions as these were absolutely foreign to the spirit their work.'…

[1849]
In the following year was exhibited the picture commonly known as 'Christ in the Home of his Parents', but with no other title than the following quotation from Zechariah 13.6: 'And one shall say unto Him, "What are these wounds in Thine hands?" Then He shall answer, "Those with which I was wounded in the house of My friends." ' It was painted on precisely the same principle as was that which had called forth the derision of the multitude, and as both Rossetti and Mr. Hunt exhibited at the same time important pictures of the same school, there could no longer be any doubt as to the serious meaning of the movement. Then, with one accord, their opponents fell upon Millais as the prime mover in the rebellion against established precedent. In the words of a latter-day critic, 'Men who knew nothing of Art reviled Millais because he was not of the art, artistic. Dilettanti who could not draw a finger-tip scolded one of the most accomplished draughtsmen of the age because he delineated what he saw. Cognoscenti who could not paint rebuked the most brilliant gold medal student of the Royal Academy on account of his technical proceedings. Critics of the most rigid views belaboured and shrieked at an original genius, whose struggles and whose efforts they could not understand. Intolerant and tyrannical commentators condemned the youth of twenty because he dared to think for himself; and, to sum up the burden of the chorus of shame and false judgment, there was hardly a whisper of faith or hope, or even of charity—nay, not a sound of the commonest and poorest courtesy—vouchsafed to the painter of "The Carpenter's Shop", as, in utter scorn, this picture was originally called.'

What the Academy thought of it may be gathered from the words of the late F.B. Barwell: 'I well remember Mulready, R.A., alluding to the picture some two years after its exhibition. He said

that it had few admirers inside the Academy Council, and that he himself and Maclise supported its claims to a favourable consideration.' The picture itself, devotional and symbolic in intent, is too well known to need any description. The child Christ is seen in His father's workshop with blood flowing from His hand, the result of a recent wound, while His mother waits Him with loving sympathy. That is the main subject. And now let us see how it was treated by the Press.

*Blackwood's Magazine* dealt with it in this wise: 'We can hardly imagine anything more ugly, graceless, and unpleasant than Mr. Millais' picture of "Christ in the Carpenter's Shop". Such a collection of splay feet, puffed joints, and misshapen limbs was assuredly never before made within so small a compass. We have great difficulty in believing a report that this unpleasing and atrociously affected picture has found a purchaser at a high price. Another specimen from the same brush inspires rather laughter than disgust.'

That was pretty strong; but, not to be left behind in the race to accomplish the painter's ruin, a leading literary journal, whose Art critic, by the way, was a Royal Academician, delivered itself in the following terms: 'Mr. Millais in his picture without a name (518), which represents a holy family in the interior of a carpenter's shop, has been most successful in the least dignified features of his presentment, and in giving to the higher forms, characters, and meanings a circumstantial art-language from which we recoil with loathing and disgust. There are many to whom his work will seem a pictorial blasphemy. Great imaginative talents have been perverted to the use of an eccentricity both lamentable and revolting.'

Another critic, bent on displaying his wit at the expense of the artist, said: 'Mr. Millais' picture looks as if it had passed through a mangle'. And even Charles Dickens, who in after years was a firm friend of Millais and a great admirer of his works, denounced the picture in a leading article in *Household Words* as 'mean, odious, revolting, and repulsive.'

[1851]

In was in this year that Ruskin took up arms in defence of the Pre-Raphælite Brotherhood, and no more earnest or more eloquent advocate could they have desired. In the first volume of *Modern Painters* he insisted that 'a complete picture...has both the general wholeness and effect of Nature and the inexhaustible perfection of Nature's details'; and, pointing to the 'admirable, though strange pictures of Mr. Millais and Mr. Holman' as examples of progress in this direction, he added, 'they are endeavouring to paint, with the highest possible degree of completion, what they see in Nature, without reference to conventional or established rules: but by no means to imitate the style of any past epoch. Their works are, in finish of drawing and in splendour of colour, the best in the Royal Academy, and I have great hope that they may become the foundation of a more earnest and able school of Art than we have seen for centuries.'

Here was a heavy blow to the Philistines of the Press; for at this time Ruskin was all but universally accepted as the final authority in matters of Art. But a heavier yet was in store for them. In an addendum to one of his published *Lectures On Architecture and Painting*—lectures delivered at Edinburgh in November, 1853—he declared that 'the very faithfulness of the Pre-Raphælites arises from the redundance of their imaginative power. Not only can all the members of the [Pre-Raphælite] School compose a thousand times better than the men who pretend to look down upon them, but I question whether even the greatest men of old times possessed more exhaustless invention than either Millais or Rossetti.'...

Having selected his site [for the painting of 'Ophelia',] the next thing was to obtain lodgings within easy distance, and these he [Millais] secured in a cottage near Kingston, with his friend Holman Hunt as a companion. They were not there very long, however, for presently came into the neighbourhood two other members of the Pre-Raphælite fraternity, bent on working together; and, uniting with them, the two moved into Worcester Park Farm, where an old garden wall happily served as a background for the 'Huguenot', at which Millais could now work alternately with the 'Ophelia'.

It was a jolly bachelor party that now assembled in the farmhouse—Holman Hunt, Charlie Collins, William and John Millais—all determined to work in earnest; Holman Hunt on his famous 'Light of the World' and 'The Hireling Shepherd', Charlie Collins at a background, William Millais on water-colour landscapes, and my father on the backgrounds for the two pictures he had then in hand.

From ten in the morning till dark the artists saw little of each other, but when the evenings 'brought all things home' they assembled to talk deeply on Art, drink strong tea, and discuss and criticise each other's pictures.

Fortunately a record of these interesting days is preserved to us in Millais' letters to Mr. and Mrs. Combe, and his diary—the only one he ever kept—which was written at this time... It was written from the cottage near Kingston before Millais and Hunt removed to Worcester Park Farm.

To Mrs. Combe.
Surbiton Hill, Kingston,
July 2nd, 1851.

My Dear Mrs. Combe,—I have dined and taken breakfast with Ruskin, and we are such good friends that he wishes me to accompany him to Switzerland this summer...We are as yet singularly at variance in our opinions upon Art. One of our differences is about Turner. He believes that I shall be converted on further acquaintance with his works, and I that he will gradually slacken in his admiration.

You will see that I am writing this from Kingston, where I am stopping, it being near to a river that I am painting for 'Ophelia'. We get up (Hunt is with me) at six in the morning, and are at work by eight, returning home at seven in the evening. The lodgings we have are somewhat better than Mistress King's at Botley, but are, of course, horribly uncomfortable. We have had for

dinner chops and suite of peas, potatoes, and gooseberry tart four days running. We spoke not about it, believing in the certainty of some change taking place; but in private we protest against the adage that 'you can never have too much of a good thing'. The countryfolk here are a shade more civil than those of Oxfordshire, but similarly given to that wondering stare, as though we were as strange a sight as the hippopotamus.

My martyrdom is more trying than any I have hitherto experienced. The flies of Surrey are more muscular, and have a still greater propensity for probing human flesh. Our first difficulty was…to acquire rooms. Those we now have are nearly four miles from Hunt's spot and two from mine, so we arrive jaded and slightly above that temperature necessary to make a cool commencement. I sit tailor-fashion under an umbrella throwing a shadow scarcely larger than a halfpenny for eleven hours, with a child's mug within reach to satisfy my thirst from the running stream beside me. I am threatened with a notice to appear before a magistrate for trespassing in a field and destroying the hay; likewise by the admission of a bull in the same field after the said hay be cut; am also in danger of being blown by the wind into the water, and becoming intimate with the feelings of Ophelia when that lady sank to muddy death, together with the (less likely) total disappearance, through the voracity of the flies. There are two swans who not a little add to my misery by persisting in watching me from the exact spot I wish to paint, occasionally destroying every water-weed within their reach. My sudden perilous evolutions on the extreme bank, to persuade them to evacuate their position, have the effect of entirely deranging my temper, my picture, brushes, and palette; but, on the other hand, they cause those birds to look most benignly upon me with an expression that seems to advocate greater patience. Certainly the painting of a picture under such circumstances would be a greater punishment to a murderer than hanging…

Very affectionately yours,
JOHN EVERETT MILLAIS

[1852]

On the following day Millais returned to Gower Street, his backgrounds being now completed; set to work at once on the figures in the two pictures, Miss Siddal (afterwards Mrs. D.G. Rossetti) posing as the model for 'Ophelia'. Mr. Arthur Hughes has an interesting note about this lady in *The Letters of D.G. Rossetti to William Allingham*. He says:

'Deverell accompanied his mother one day to a milliner's. Through an open door he saw a girl working with her needle: he got his mother to ask her to sit to him. She was the future Mrs. Rossetti. Millais painted her for his "Ophelia"—wonderfully like her. She was tall and slender, with red, coppery hair and bright consumptive complexion, though in these early years she had no striking signs of ill-health. She had read Tennyson, having first come to know something about him by finding one or two of his poems on a piece of paper which she brought home to her mother wrapped round a pat of butter. Rossetti taught her to draw; she used to be drawing while sitting to him. Her drawings were beautiful, but without force. They were feminine likenesses of his own.'

Miss Siddal had a trying experience whilst acting as a model for 'Ophelia'. In order that the artist might get the proper set of the garments in water and the right atmosphere and aqueous effects, she had to lie in a large bath filled with water, which was kept at an even temperature by lamps placed beneath. One day, just as the picture was nearly finished, the lamps went out unnoticed by the artist, who was so intensely absorbed in his work that he thought of nothing else, and the poor lady was kept floating in the cold water till she was quite benumbed. She herself never complained of this, but the result was that she contracted a severe cold, and her father (an auctioneer at Oxford) wrote to Millais, threatening him with an action for £50 damages for his carelessness. Eventually the matter was satisfactorily, compromised. Millais paid the doctor's bill; and Miss Siddal quickly recovering, was none the worse for her cold bath.

D.G. Rossetti had already fallen in love with her, struck with her 'unworldly simplicity and purity of aspect'—qualities which, as those who knew her bear witness, Millais succeeded in conveying to the canvas—but it was not until 1860 that they married.

## [1853]

Millais, as we have seen, was now one of the elect of the Royal Academy, and his picture, 'The Huguenot', had added much to his reputation as an artist; but it is quite a mistake to assume, as so many writers have done, that after this date the current of his life ran smoothly on without any serious obstruction or impediment. His great fight—perhaps the greatest fight of all—was yet to come; and as 1853 drew to a close, the elation he might otherwise have felt was restrained by circumstances and considerations of no small moment to a man of his sensitive nature. Leading members of the Academy were, as he well knew, prejudiced against him; the Press continued to jeer at him as an enthusiast in a false style of Art; D.G. Rossetti, wounded by their carping and insulting criticism of his 'Annunciation', had retired from the contest; Walter Deverell, a devoted friend of Millais and an ardent supporter of the Pre-Raphælite movement, was seriously ill; and now that Hunt, his greatest and strongest ally, was about to leave for the East, he knew that upon him alone would devolve the duty of maintaining the cause to which he had devoted his life as an artist. Charlie Collins, it is true, was still with him, and in 'Mike' Halliday and Leech he had found other firm and faithful friends; but, highly skilled as these three men were, both as artists and connoisseurs, they could hardly be expected to share the enthusiasm of himself and Hunt for a cause which they had made so peculiarly their own. Individual Pre-Raphælites, such as Collinson, Hughes, and others, were doing good work, and the Academy did not exclude their paintings at the annual exhibitions; but the Brotherhood itself no longer existed in its old form as a body of associated workers. It had become, indeed, as Hunt says in one of his letters, 'a solemn mockery, and died of itself'.

## LITERATURE

### Selections from *The Germ* (1850)

### Ellen Alleyn
[Christina Rossetti's pseudonym adopted for *The Germ*]

### *Dream Land*

Where sunless rivers weep
Their waves into the deep,
She sleeps a charmed sleep;
    Awake her not.
Led by a single star,
She came from very far,
To seek where shadows are
    Her pleasant lot.

She left the rosy morn,
She left the fields of corn,
For twilight cold and lorn,
    And water-springs.
Thro' sleep, as thro' a veil,
She sees the sky look pale,
And hears the nightingale,
    That sadly sings.

Rest, rest, a perfect rest,
Shed over brow and breast;
Her face is toward the west,
    The purple land.
She cannot see the grain
Ripening on hill and plain;
She cannot feel the rain
    Upon her hand.

Rest, rest, for evermore
Upon a mossy shore,
Rest, rest, that shall endure,
    Till time shall cease;—
Sleep that no pain shall wake,
Night that no morn shall break,
Till joy shall overtake
    Her perfect peace.

## Song

Oh! roses for the flush of youth,
    And laurel for the perfect prime;
But pluck an ivy-branch for me,
    Grown old before my time.
Oh! violet for the grave of youth,
    And bay for those dead in their prime;
Give me the withered leaves I chose
    Before in the olden time.

## A Testimony

I said of laughter: It is vain;—
    Of mirth I said: What profits it?—
    Therefore I found a book, and writ
Therein, how ease and also pain,
How health and sickness, every one
Is vanity beneath the sun.

Man walks in a rain shadow; he
    Disquieteth himself in vain.
    The things that were shall be again.
The rivers do not fill the sea,
But turn back to their secret source:
The winds, too, turn upon their course.

Our treasures, moth and rust corrupt:
    Or thieves break through and steal; or they
    Make themselves wings and fly away.
One man made merry as he supp'd,
Nor guessed how when that night grew dim,
His soul would be required of him.

We build our houses on the sand
    Comely withoutside, and within;

But when the winds and rains begin
To beat on them, they cannot stand;
They perish, quickly overthrown,
Loose at the hidden basement stone.

All things are vanity, I said:
    Yea vanity of vanities.
    The rich man dies; and the poor dies:
The worm feeds sweetly on the dead.
Whatso thou lackest, keep this trust:
All in the end shall have but dust.

The one inheritance, which best
    And worst alike shall find and share.
    The wicked cease from troubling there,
And there the weary are at rest;
There all the wisdom of the wise
Is vanity of vanities.

Man flourishes as a green leaf,
    And as a leaf doth pass away;
    Or, as a shade that cannot stay,
And leaves no track, his course is brief:
Yet doth man hope and fear and plan
Till he is dead: oh foolish man!

Our eyes cannot be satisfied
    With seeing; nor our ears be fill'd
    With hearing: yet we plant and build,
And buy, and make our borders wide:
We gather wealth, we gather care,
But know not who shall be our heir.

Why should we hasten to arise
    So early, and so late take rest?
    Our labour is not good; our best
Hopes fade; our heart is stayed on lies:
Verily, we sow wind; and we
Shall reap the whirlwind, verily.

He who hath little shall not lack;
    He who hath plenty shall decay:
    Our fathers went; we pass away;
Our children follow on our track:
So generations fail, and so
They are renewed, and come and go.

The earth is fattened with our dead;
    She swallows more and doth not cease;
    Therefore her wine and oil increase
And her sheaves are not numbered;
Therefore her plants are green, and all
Her pleasant trees lusty and tall.

Therefore the maidens cease to sing,
    And the young men are very sad;
    Therefore the sowing is not glad,
And weary is the harvesting.
Of high and low, of great and small,
Vanity is the lot of all.

A king dwelt in Jerusalem:
    He was the wisest man on earth;
    He had all riches from his birth,
And pleasures till he tired of them:
Then, having tested all things, he
Witnessed that all are vanity.

## Dante Rossetti

### Songs of One Household No. 1: *My Sister's Sleep*

She fell asleep on Christmas Eve.
    Upon her eyes' most patient calms
    The lids were shut; her uplaid arms
Covered her bosom, I believe.

Our mother, who had leaned all day
    Over the bed from chime to chime,
    Then raised herself for the first time,
And as she sat her down, did pray.

Her little work-table was spread
    With work to finish. For the glare
    Made by her candle, she had care
To work some distance from the bed.

Without, there was a good moon up,
    Which left its shadows far within;
    The depth of light that it was in
Seemed hollow like an altar-cup.

Through the small room, with subtle sound
    Of flame, by vents the fireshine drove
    And reddened. In its dim alcove
The mirror shed a clearness round.

I had been sitting up some nights,
    And my tir'd mind felt weak and blank;
    Like a sharp strengthening wine, it drank
The stillness and the broken lights.

Silence was speaking at my side
    With an exceedingly clear voice:
    I knew the calm as of a choice
Made in God for me, to abide.

I said, 'Full knowledge does not grieve:
    This which upon my spirit dwells
    Perhaps would have been sorrow else:
But I am glad 'tis Christmas Eve.'

Twelve struck. That sound, which all the years
    Hear in each hour, crept off; and then
    The ruffled silence spread again,
Like water that a pebble stirs.

Our mother rose from where she sat.
    Her needles, as she laid them down,
    Met lightly, and her silken gown
Settled: no other noise than that.

'Glory unto the Newly Born!'
    So, as said angels, she did say;
    Because we were in Christmas-day,
Though it would still be long till dawn.

She stood a moment with her hands
    Kept in each other, praying much;
    A moment that the soul may touch
But the heart only understands.

Almost unwittingly, my mind
    Repeated her words after her;
    Perhaps tho' my lips did not stir;
It was scarce thought, or cause assign'd.

Just then in the room over us
  There was a pushing back of chairs,
  As some who had sat unawares
So late, now heard the hour, and rose.

Anxious, with softly stepping haste,
  Our mother went where Margaret lay,
  Fearing the sounds o'erhead—should they
Have broken her long-watched for rest!

She stooped an instant, calm, and turned;
  But suddenly turned back again;
  And all her features seemed in pain
With woe, and her eyes gazed and yearned.

For my part, I but hid my face,
  And held my breath, and spake no word:
  There was none spoken; but I heard
The silence for a little space.

Our mother bowed herself and wept.
  And both my arms fell, and I said:
  'God knows I knew that she was dead.'
And there, all white, my sister slept.

Then kneeling, upon Christmas morn
  A little after twelve o'clock
  We said, ere the first quarter struck,
'Christ's blessing on the newly born!'

### The Blessed Damozel

The blessed damozel leaned out
  From the gold bar of Heaven:
Her blue grave eyes were deeper much
  Than a deep water, even.
She had three lilies in her hand,
  And the stars in her hair were seven.

Her robe, ungirt from clasp to hem,
  No wrought flowers did adorn,
But a white rose of Mary's gift,
  On the neck meetly worn;
Her hair, lying down her back,
  Was yellow like ripe corn.

Herseemed she scarce had been a day
  One of God's choristers;
The wonder was not yet quite gone
  From that still look of hers;
Albeit to them she left, her day
  Had counted as ten years.

(To *one*, it is ten years of years:
  …Yet now, here in this place,
Surely she leaned o'er me,—her hair
  Fell all about my face…
Nothing: the Autumn-fall of leaves.
  The whole year sets apace.)

It was the terrace of God's house
  That she was standing on;
By God built over the sheer depth
  In which Space is begun;
So high, that looking downward thence
  She scarce could see the sun.

It lies from Heaven, across the flood
  Of ether, as a bridge.
Beneath, the tides of day and night
  With flame and blackness ridge
The void, as low as where this earth
  Spins like a fretful midge.

But in those tracts, with her, it was
  The peace of utter light
And silence. For no breeze may stir
  Along the steady flight
Of seraphim; no echo there
  Beyond all depth or height.

Heard hardly, some of her new friends
  Playing at holy games,
Spake, gentle-mouthed, among themselves,
  Their virginal chaste names;
And the souls, mounting up to God,
  Went by her like thin flames.

And still she bowed herself, and stooped
  Into the vast waste calm;
Until her bosom's pressure must have made

67

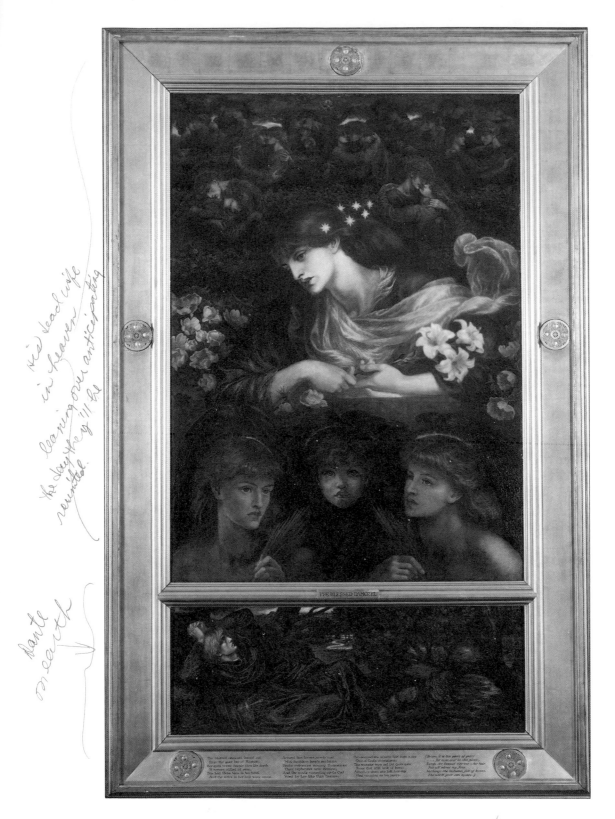

*The Blessed Damozel* by Dante Gabriel Rossetti (1879)

The handwritten marginal notes:

"his dead wife in heaven
leaning over anticipating
the day they'll be reunited"

"Dante on earth"

*his dead wife
in heaven
leaning over anticipating
the day they'll be
reunited.*

*Dante
on earth*

The bar she leaned on warm,
 And the lilies lay as if asleep
  Along her bended arm.

From the fixed lull of Heaven she saw
 Time, like a pulse, shake fierce
Through all the worlds. Her gaze still strove,
 Within the steep gulph to pierce
The swarm: and now she spake, as when
 The stars sang in their spheres.

'I wish that he were come to me,
 For he will come', she said.
'Have I not prayed in solemn heaven?
 On earth, has he not pray'd?
Are not two prayers a perfect strength?
 And shall I feel afraid?

'When round his head the aureole clings,
 And he is clothed in white,
I'll take his hand and go with him
 To the deep wells of light;
And we will step down as to a stream
 And bathe there in God's sight.

'We two will stand beside that shrine,
 Occult, withheld, untrod,
Whose lamps are tremble continually
 With prayer sent up to God;
And where each need, revealed, expects
 Its patient period.

'We two will lie i' the shadow of
 That living mystic tree
Within whose secret growth the Dove
 Sometimes is felt to be,
While every leaf that His plumes touch
 Saith His Name audibly.

'And I myself will teach to him,
 I myself, lying so,—
The songs I sing here; which his mouth
 Shall pause in, hushed and slow,
Finding some knowledge at each pause,
 Or some new thing to know.'

(Alas! to *her* wise simple mind
 These things were all but known
Before: they trembled on her sense,—

 Her voice had caught their tone.
Alas for lonely Heaven! Alas
 For life wrung out alone!

(Alas, and though the end were reached?...
 Was thy part understood
Or borne in trust? And for her sake
 Shall this too be found good?—
May the close lips that knew not prayer
 Praise ever, though they would?)

'We two' she said, 'will seek the groves
 Where the lady Mary is,
With her five handmaidens, whose names
 Are five sweet symphonies:—
Cecily, Gertrude, Magdalen,
 Margaret and Rosalys.

'Circlewise sit they, with bound locks
 And bosoms covered;
Into the fine cloth, white like flame,
 Weaving the golden thread,
To fashion the birth-robes for them
 Who are just born, being dead.

'He shall fear haply, and be dumb,
 Then will I lay my cheek
To his, and tell about our love,
 Not once abashed or weak:
And the dear Mother will approve
 My pride, and let me speak.

'Herself shall bring us, hand in hand,
 To Him round whom all souls
Kneel—the unnumber'd solemn heads
 Bowed with their aureoles:
And Angels, meeting us, shall sing
 To their citherns and citoles.

'There will I ask of Christ the Lord
 Thus much for him and me:—

To have more blessing than on earth
    In nowise; but to be
As then we were,—being as then
    At peace. Yea, verily.

'Yea, verily; when he is come
    We will do thus and thus:
Til this my vigil seem quite strange
    And almost fabulous;
We two will live at once, one life;
    And peace shall be with us.'

She gazed, and listened, and then said,
    Less sad of speech than mild:
'All this is when he comes.' She ceased;
    The light thrilled past her, filled
With Angels, in strong level lapse.
    Her eyes prayed, and she smiled.

(I saw her smile.) But soon their flight
    Was vague 'mid the poised spheres:
And then she cast her arms along
    The golden barriers,
And laid her face between her hands,
    And wept. (I heard her tears.)

# William Michael Rossetti

## 'When Whoso Merely Hath a Little Thought'

When whoso merely hath a little thought
    Will plainly think the thought which is in him,—
    Not imaging another's bright or dim,
Not mangling with new words what others taught;
When whoso speaks, from having either sought
    Or only found,—will speak, not just to skim
    A shallow surface with words made and trim,
But in that very speech the matter brought:
Be not too keen to cry—'So this is all!—
    A thing I might myself have thought as well,
But would not say it, for it was not worth!'
    Ask: 'Is this truth?' For is it still to tell
That, be the theme a point or the whole earth,
Truth is a circle, perfect, great or small?

## Fancies at Leisure No. 5: *The Fire Smouldering*

I look into the burning coals, and see
    Faces and forms of things; but they soon pass,
    Melting one into other: the firm mass
Crumbles, and breaks, and fades gradually,
Shape into shape as in a dream may be,
    Into an image other than it was:
    And so on till the whole falls in, and has
Not any likeness,—face, and hand, and tree,
All gone. So with the mind: thought follows thought,
    This hastening, and that pressing upon this,
    A mighty crowd within so narrow room:
    And then at length heavy-eyed slumbers come,
    The drowsy fancies grope about, and miss
Their way, and what was so alive is nought.

## To the Castle Ramparts

The Castle is erect on the hill's top,
To moulder there all day and night: it stands
With the long shadow lying at its foot.
That is a weary height which you must climb
Before you reach it; and a dizziness
Turns in your eyes when you look down from it,
So standing clearly up into the sky.

I rose one day, having a mind to see it,
'Twas on a clear Spring morning, and a blackbird
Awoke me with his warbling near my window:
My dream had fashioned this into a song
That some one with grey eyes was singing me,
And which had drawn me so into myself
That all the other shapes of sleep were gone:
And then, at last, it woke me, as I said.
The sun shone fully in on me; and brisk
Cool airs, that had been cold but for his warmth,
Blew thro' the open casement, and sweet smells
Of flowers with the dew yet fresh upon them,—
Rosebuds, and showery lilacs, and what stayed
Of April wallflowers.

    I set early forth,
Wishing to reach the Castle when the heat

Should weigh upon it, vertical at noon.
My path lay thro' green open fields at first,
With now and then trees rising statelily
Out of the grass; and afterwards came lanes
Closed in by hedges smelling of the may,
And overshadowed by the meeting trees.
So I walked on with none but pleasant thoughts;
The Spring was in me, not alone around me,
And smiles came rippling o'er my lips for nothing.
I reached at length,—issuing from a lane
Which wound so that it seemed about to end
Always, yet ended not for a long while,—
A space of ground thick grassed and level to
The overhanging sky and the strong sun:
Before me the brown sultry hill stood out,
Peaked by its rooted Castle, like a part
Of its own self. I laid me in the grass,
Turning from it, and looking on the sky,
And listening to the humming in the air
That hums when no sound is; because I chose
To gaze on that which I had left, not that
Which I had yet to see...

## John Tupper
### From *The Subject in Art*: No. 2

...Let us proceed to enquire into the propriety of selecting the Subject from the past or the present time; which enquiry resolves itself fundamentally into the analysis of objects and incidents experienced immediately by the senses, or acquired by mental education.

Here then we have to explore the difference between the incidents and objects of to-day, as exposed to our daily observations, and the incidents and objects of time past, as bequeathed to us by history, poetry, or tradition...

It is obvious, in the meanwhile, that all which we have of the past is stamped with an impress of mental assimilations: an impress it has received from the mind of the author who has garnered it up, and disposed it in that form and order which ensure it acceptance with posterity. For let a writer of history be as matter of fact as he

will, the very order and classification of events will save us the trouble of confusion, and render them graspable, and more capable of assimilation, than is the raw material of every-day experience. In fact the work of mind is begun, the key of intelligence is given, and we have only to continue the process. Where the vehicle for the transmission of things past is poetry, then we have them presented in that succession, and with that modification of force, a resilient plasticity, now advancing, now recoiling, insinuating and grappling, that ere this material and mental warfare is over, we find facts thus transmitted are incorporated with our psychical existence. And in tradition is it otherwise?—Every man tells the tale in his own way; and the merits of the story itself, or the person who tells it, or his way of telling, procures it a lodgment in the mind of the hearer, whence it is ever ready to start up and claim kindred with some external excitement.

Thus it is the luck of all things of the past to come down to us with some poetry about them; while from those of diurnal experience we must extract this poetry ourselves: and although all good men are, more or less, poets, they are passive or recipient poets; while the active or donative poet caters for them what they fail to collect. For let a poet walk through London, and he shall see a succession of incidents, suggesting some moral beauty by a contrast of times with times, unfolding some principle of nature, developing some attribute of man, or pointing to some glory in The Maker: while the man who walked behind him saw nothing but shops and pavement, and coats and faces; neither did he hear the aggregated turmoil of a city of nations, nor the noisy exponents of various desires, appetites and pursuits: each pulsing tremour of the atmosphere was not struck into it by a subtile ineffable something willed forcibly out of a cranium: neither did he see the driver of horses holding a rod of light in his eye and feeling his way, in a world he was rushing through, by the motion of the end of that rod: he only saw the wheels in motion, and heard the rattle on the stones; and yet this man stopped twice at Book shop to buy 'a

Tennyson', or a 'Browning's Sordello'. Now this man might have seen all that the poet saw; he walked through the same streets: yet the poet goes home and writes a poem; and he who failed to feel the poetry of the things themselves detects it readily in the poet's version. Then why, it is asked, does not this man, schooled by the poet's example, look out for himself for the future, and so find attractions in things of to-day? He does so to a trifling extent, but the reason why he does so rarely will be found in the former demonstration.

It was shown how bygone objects and incidents come down to us invested in peculiar attractions: this the poet knows and feels, and the probabilities are that he transferred the incidents of to-day, with all their poetical and moral suggestions, to the romantic long-ago, partly from a feeling of prudence, and partly that he himself was under this spell of antiquity. How many a Troubadour, who recited tales of king Arthur, had his incidents furnished him by the events of his own time! And thus it is the many are attracted to the poetry of things past, yet impervious to the poetry of things present. But this retrograde movement in the poet, painter, or sculptor (except in certain cases as will subsequently appear), if not the result of necessity, is an error of judgment or a culpable dishonesty. For why should he not acknowledge the source of his inspiration, that others may drink of the same spring with himself; and perhaps drink deeper and a clearer draught?—For the water is unebbing and exhaustless, and fills the more it is emptied: why then should it be filtered through his tank where he can teach men to drink it at the fountain?

If, as every poet, every painter, every sculptor will acknowledge, his best and most original ideas are derived from his own times: if his great lessonings to piety, truth, charity, love, honour, honesty, gallantry, generosity, courage, are derived from the same source; why transfer them to distant periods, and make them not things of to-day? Why teach us to revere the saints of old, and not our own family-worshippers? Why to admire the lance-armed knight, and not the patience-hero of misfortune? Why to draw a sword we do not wear to aid an oppressed damsel, and not a purse which we do wear to rescue an erring one? Why to worship a martyred St. Agatha, and not a sick woman attending the sick? Why teach us to honour an Aristides or a Regulus, and not one who pays an equitable, though to him ruinous, tax without a railing accusation? And why not teach us to help what the laws cannot help?—Why teach us to hate a Nero or an Appius, and not an under-selling oppressor of workmen and betrayer of women and children? Why to love a Ladie in Bower, and not a wife's fireside? Why paint or poetically depict the horrible race of Ogres and Giants, and not show Giant Despair dressed in that modern habit he walks the streets in? Why teach men what were great and good deeds in the old time, neglecting to show them any good for themselves?—Till these questions are answered aboulutory to the artist, it were unwise to propose the other question—Why a poet, painter or sculptor is not honoured and loved as formerly?...

To answer objections of this latitude demands the assertion of certain characteristic facts which, tho' not here demonstrated, may be authenticated by reference to history. Of these, the facts of Alfred's disguised visit to the Danish camp, and Aulaff's visit to the Saxon, are sufficient to show in what respect the poets of that period were held; when a man without any safe conduct whatever could enter the enemy's camp on the very eve of battle, as was here the case; could enter unopposed, unquestioned, and return unmolested!—What could have conferred upon the poet of that day so singular a priviledge?...What but an universal recognition of the poet as an universal benefactor of mankind? And did mankind recognize him as such, from such unaccountable infatuation, or because his labours obtained for him an indefeasible right to that estimate? How came it, when a Greek sculptor had completed some operose performance, that his countrymen bore him in triumph thro' their city, and rejoiced in his prosperity as identical to their own? How but

because his art had embodied some principle of beauty whose mysterious influence it was their pride to appreciate—or he had enduringly moulded the limbs of some well-trained Athlete, such as it was their interest to develop, or he had recorded the overthrow of some barbaric invader whom their fathers had fallen to repel.

In the middle ages when a knight listened, in the morning, to some song of brave doing, ere evening he himself might be he the hero of such a song.—What wonder then that he held sacred the function of the poet! Now-a-days our heroes (and we have them) are left unchapleted and neglected—and therefore the poet lives and dies neglected.

Thus it would appear from these facts (which have been collaterally evolved in course of enquiring into the propriety of choosing the subject from past or present time, and in course of the consequent analysis) that Art, to become a more powerful engine of civilization, assuming a practically humanizing tendency (the admitted function of Art), should be made more directly conversant with the things, incidents, and influences which surround and constitute the living world of those whom Art proposes to improve...

Illustration to 'My Beautiful Lady' by William Holman Hunt

# Thomas Woolner

## *My Beautiful Lady*

I love my lady; she is very fair;
Her brow is white, and bound by simple hair;
    Her spirit sits aloof, and high,
    Altho' it looks thro' her soft eye
    Sweetly and tenderly.

As a young forest, when the wind drives thro',
My life is stirred when she breaks on my view.
    Altho' her beauty has such power,
    Her soul is like the simple flower
    Trembling beneath a shower.

As bliss of saints, when dreaming of large wings,
The bloom around her fancied presence flings,
    I feast and wile her absence, by
    Pressing her choice hand passionately—
    Imagining her sigh.

My lady's voice, altho' so very mild,
Maketh me feel as strong wine would a child;
    My lady's touch, however slight,
    Moves all my senses with its might,
    Like to a sudden fright.

A hawk poised high in air, whose nerved wing-tips
Tremble with might suppressed, before he dips,—
    In vigilance, not more intense
    Than I; when her word's gentle sense
    Makes full-eyed my suspense...

## *Of my Lady in Death*

All seems a painted show. I look
    Up thro' the bloom that's shed
    By leaves above my head,
And feel the earnest life forsook
    All being, when she died:—
    My heart halts, hot and dried
As the parched course where once a brook
    Thro' fresh growth used to flow,—
    Because her past is now
No more than stories in a printed book.

The grass has grown above that breast,
    Now cold and sadly still,
    My happy face felt thrill:—
Her mouth's mere tones so much expressed!
    Those lips are now close set,—
    Lips which my own have met;
Her eyelids by the earth are pressed;
    Damp earth weighs on her eyes;
    Damp earth shuts out the skies.
My lady rests her heavy, heavy rest.

To see her slim perfection sweep,
    Trembling impatiently,
    With eager gaze at me!
Her feet spared little things that creep:—
    'We've no more right,' she'd say,
    'In this the earth than they.'
Some remember it but to weep.
    Her hand's slight weight was such,
    Care lightened with its touch;
My lady sleeps her heavy, heavy sleep.

My day dreams hovered round her brow;
    Now o'er its perfect forms,
    Go softly real worms.
Stern death, it was a cruel blow,
    To cut that sweet girl's life
    Sharply, as with a knife.
Cursed life that lets me live and grow,
    Just as a poisonous root,
    From which rank blossoms shoot;
My lady's laid so very, very low.

Dread power, grief cries aloud, 'unjust,'—
    To let her young life play
    Its easy, natural way;
Then, with an unexpected thrust,
    Strike out the life you lent,
    Just when her feelings blent
With those around whom she saw trust
    Her willing power to bless,
    For their whole happiness;
My lady moulders into common dust.

Small birds twitter and peck the weeds
    That wave above her head,
    Shading her lowly bed:
Their brisk wings burst light globes of seeds,
    Scattering the downy pride
    Of dandelions, wide:
Speargrass stoops with watery beads:
    The weight from its fine tips
    Occasionally drips:
The bee drops in the mallow-bloom, and feeds.

About her window, at the dawn,
    From the vine's crooked boughs
    Birds chirupped an arouse:
Flies, buzzing, strengthened with the morn;—
    She'll not hear them again
    At random strike the pane:
No more upon the close cut lawn,
    Her garment's sun-white hem
    Bend the prim daisy's stem,
In walking forth to view what flowers are born.

No more she'll watch the dark-green rings
    Stained quaintly on the lea,
    To image fairy glee;
While thro' dry grass a faint breeze sings,
    And swarms of insects revel
    Along the sultry level:—
No more will watch their brilliant wings,
    Now lightly dip, now soar,
    Then sink, and rise once more.
My lady's death makes dear these trivial things.

My lady's love has passed away,
 To know that it is so
 To me is living woe.
That body lies in cold decay,
 Which held the vital soul
 When she was my life's soul.
Bitter mockery it was to say—
 'Our souls are as the same:'
 My words now sting like shame;
Her spirit went, and mine did not obey.

It was as if a fiery dart
 Passed seething thro' my brain
 When I beheld her lain
There whence in life she did not part.
 Her beauty by degrees,
 Sank, sharpened with disease:
The heavy sinking at her heart
 Sucked hollows in her cheek,
 And made her eyelids weak,
Tho' oft they'd open wide with sudden start.

The deathly power in silence drew
 My lady's life away.
 I watched, dumb with dismay,
The shock of thrills that quivered thro'
 And tightened every limb:
 For grief my eyes grew dim;
More near, more near, the moment grew.
 O horrible suspense!
 O giddy impotence!
I saw her fingers lax, and change their hue.

Her gaze, grown large with fate, was cast
 Where my mute agonies
 Made more sad her sad eyes:
Her breath caught with short plucks and fast:
 Then one hot choking strain.
 She never breathed again:
I had the look which was her last:
 Even after breath was gone,
 Her love one moment shone,—
Then slowly closed, and hope for ever passed.

Silence seemed to start in space
 When first the bell's harsh toll
 Rang for my lady's soul.
Vitality was hell; her grace
 The shadow of a dream:
 Things then did scarcely seem:
Oblivion's stroke fell like a mace:
 As a tree that's just hewn
 I dropped, in a dead swoon,
And lay a long time cold upon my face

Earth had one quarter turned before
 My miserable fate
 Pressed on with its whole weight.
My sense came back; and, shivering o'er,
 I felt a pain to bear
 The sun's keen cruel glare;
It seemed not warm as heretofore.
 Oh, never more its rays
 Will satisfy my gaze.
No more; no more; oh, never any more.

**William Allingham**
**From *Poems* (1850)**

### *The Fairies*: A Child's Song

 Up the airy mountain,
  Down the rushy glen,
 We daren't go a-hunting
  For fear of little men;
 Wee folk, good folk,
  Trooping all together;
 Green jacket, red cap,
  And white owl's feather!

 Down along the rocky shore
  Some make their home,
 They live on crispy pancakes
  Of yellow tide-foam;
 Some in the reeds
  Of the black mountain-lake,
 With frogs for their watch-dogs,
  All night awake.

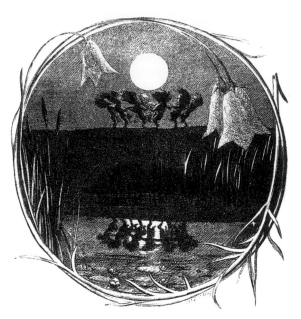

'The Fairies' by Arthur Hughes (1855)

High on the hill-top
    The old King sits;
He is now so old and grey
    He's nigh lost his wits.
With a bridge of white mist
    Columbkill he crosses,
On his stately journeys
    From Slieveleague to Rosses;

Or going up with music
    On cold starry nights,
To sup with the Queen
    Of the gay Northern Lights.

They stole little Bridget
    For seven years long;
When she came down again
    Her friends were all gone.
They took her lightly back,
    Between the night and morrow,
They thought that she was fast asleep,
    But she was dead with sorrow.
They have kept her ever since
    Deep within the lakes,
On a bed of flag-leaves,
    Watching till she wakes.

By the craggy hill-side,
    Through the mosses bare,
They have planted thorn-trees
    For pleasure here and there.
Is any man so daring
    As dig them up in spite,
He shall find their sharpest thorns
    In his bed at night.

Up the airy mountain,
    Down the rushy glen,
We daren't go a-hunting
    For fear of little men;
Wee folk, good folk,
    Trooping all together;
Green jacket, red cap,
    And white owl's feather!

### Lady Alice

1

Now what doth Lady Alice so late on the turret stair,
Without a lamp to light her, but the diamond in her hair;
When every arching passage overflows with shallow gloom,
And dreams float through the castle, into every silent room?

She trembles at her footsteps, although they fall so light;
Through the turret loopholes she sees the wild midnight;
Broken vapours streaming across the stormy sky;
Down the empty corridors the blast doth moan and cry.

She steals along a gallery; she pauses by a door;
And fast her tears are dropping down upon the oaken floor;
And thrice she seems returning—but thrice she turns again:
Now heavy lie the cloud of sleep on that old father's brain!

Oh, well it were that never shouldst thou waken from thy sleep!
For wherefore should they waken, who waken but to weep?
No more, no more beside thy bed doth Peace a vigil keep,
But Woe,—a lion that awaits thy rousing for its leap.

2

An afternoon of April, no sun appears on high,
But a moist and yellow lustre fills the deepness of the sky:
And through the castle-gateway, left empty and forlorn,
Along the leafless avenue an honour'd bier is borne.

They stop. The long line closes up like some gigantic worm;
A shape is standing in the path, a wan and ghost-like form,
Which gazes fixedly; nor moves, nor utters any sound;
Then, like a statue built of snow, sinks down upon the ground.

And though her clothes are ragged, and though her feet are bare,
And though all wild and tangled falls her heavy silk-brown hair;
Though from her eyes the brightness, from her cheeks the bloom is fled,
They know their Lady Alice, the darling of the dead.

With silence, in her own old room the fainting form they lay,
Where all things stand unalter'd since the night she fled away:
But who—but who shall bring to life her father from the clay?
But who shall give her back again her heart of a former day?

## The Witch-Bride

A fair witch crept to a young man's side,
And he kiss'd her and took her for his bride.

But a Shape came in at the dead of night,
And fill'd the room with snowy light.

And he saw how in his arms there lay
A thing more frightful than mouth may say.

And he rose in haste, and follow'd the Shape
Till morning crown'd an eastern cape.

And he girded himself, and follow'd still
When sunset sainted the western hill.

But, mocking and thwarting, clung to his side,
Weary day!—the foul Witch-Bride.

## From *Day and Night Songs* (1854)

### St. Margaret's Eve

I built my castle upon the sea-side,
  *The waves roll so gaily O,*
Half on the land and half in the tide,
  *Love me true!*

Within was silk, without was stone,
*The waves roll so gaily O,*
It lacks a queen, and that alone,
*Love me true!*

The grey old harper sung to me,
*The waves roll so gaily O,*
Beware of the damsel of the sea!
*Love me true!*

Saint Margaret's Eve it did befall,
*The waves roll so gaily O,*
The tide came creeping up the wall,
*Love me true!*

I open'd my gate; who there should stand—
*The waves roll so gaily O,*
But a fair lady, with a cup in her hand,
*Love me true!*

The cup was gold, and full of wine,
*The waves roll so gaily O,*
Drink, said the lady, and I will be thine,
*Love me true!*

Enter my castle, lady fair,
*The waves roll so gaily O,*
You shall be queen of all that's there,
*Love me true!*

A grey old harper sung to me,
*The waves roll so gaily O,*
Beware of the damsel of the sea!
*Love me true!*

In hall he harpeth many a year,
*The waves roll so gaily O,*
And we will sit his song to hear,
*Love me true!*

I love thee deep, I love thee true,
*The waves roll so gaily O,*
But ah! I know not how to woo,
*Love me true!*

Down dash'd the cup, with a sudden shock,
*The waves roll so gaily O,*
The wine like blood ran over the rock,
*Love me true!*

She said no word, but shriek'd aloud,
*The waves roll so gaily O,*
And vanish'd away from where she stood,
*Love me true!*

I lock'd and barr'd my castle-door,
*The waves roll so gaily O,*
Three summer days I grieved sore,
*Love me true!*

For myself a day and night,
*The waves roll so gaily O,*
And two to moan that lady bright,
*Love me true!*

### The Maids of Elfin-Mere

'Twas when the spinning-room was here,
There came Three Damsels clothed in white,
With their spindles every night;
Two and one, and Three fair Maidens,
Spinning to a pulsing cadence,
Singing songs of Elfin-Mere;
Till the eleventh hour was toll'd,
Then departed through the wold.
    *Years ago, and years ago;*
    *And the tall reeds sigh as the wind doth blow.*

Three white Lilies, calm and clear,
And they were loved by every one;
Most of all, the Pastor's Son,
Listening to their gentle singing,
Felt his heart go from him, clinging
Round these Maids of Elfin-Mere;
Sued each night to make them stay,
Sadden'd when they went away.
    *Years ago, and years ago;*
    *And the tall reeds sigh as the wind doth blow.*

Hands that shook with love and fear
Dared put back the village clock, —
Flew the spindle, turn'd the rock,
Flow'd the song with subtle rounding,
Till the false 'eleven' was sounding;
Then these Maids of Elfin-Mere
Swiftly, softly, left the room,
Like three doves on snowy plume.
  *Years ago, and years ago;*
  *And the tall reeds sigh as the wind doth blow.*

One that night who wander'd near
Heard lamentings by the shore,
Saw at dawn three stains of gore
In the waters fade and dwindle.
Nevermore with song and spindle
Saw we Maids of Elfin-Mere.
The Pastor's Son did pine and die:
Because true love should never lie.
  *Years ago, and years ago;*
  *And the tall reeds sigh as the wind doth blow.*

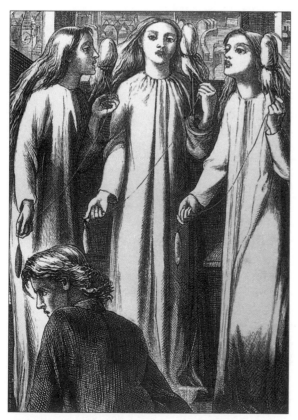

'The Maids of Elfin-Mere' by Dante Gabriel Rossetti (1855)

## Frost in the Holidays

The time of Frost is the time for me!
When the gay blood spins through the heart
  with glee,
When the voice leaps out with a chiming sound,
And the footstep rings on the musical ground;
When the earth is gray, and the air is bright,
And every breath a new delight!

While Yesterday sank, full soon, to rest,
What a glorious sky!—through the level west
Pink clouds in a delicate greenish haze,
Which deepen'd up into purple grays,
With stars aloft as the light decreas'd,
Till the great moon rose in the rich blue east.

And Morning!—each pane a garden of frost,
Of delicate flowering, as quickly lost;
For the stalks are fed by the moon's cold beams,
And the leaves are woven like woof of dreams
By Night's keen breath, and a glance of the Sun
Like dreams will scatter them every one.

Hurra! the lake is a league of glass!
Buckle and strap on the stiff white grass.
Off we shoot, and poise and wheel,
And swiftly turn upon scoring heel;
And our flying sandals chirp and sing
Like a flock of swallows gay on the wing.

Happy skaters! jubilant flight!
Easily leaning to left and right,
Curving, coasting an islet of sward,
Balancing sharp on the glassy cord
With single foot,—ah, wretch unshriven!
A new star dawns in the fishes' heaven.

Away from the crowd with the wind we drift,
No vessel's motion so smoothly swift;
Fainter and fainter the tumult grows,
And the gradual stillness and wide repose
Touch with a hue more soft and grave
The lapse of joy's declining wave.

Pure is the ice; a glance may sound
Deep through an awful dim profound
Of water-dungeons where snake-weeds hide,
Over which, as self-upborne, we glide,
Like wizards on dark adventure bent
Masters of every element.

Homeward! How the shimmering snow
Kisses our hot cheeks as we go!
Wavering down the feeble wind,
Like a manifold thought to a Poet's mind,
Till the earth, and trees, and icy lakes,
Are slowly clothed with the countless flakes.

But the village street—the stir and noise!
Where long black slides run mad with boys;
Where the pie is kept hot, in sequence due,
Aristocrat now the hobnail shoe;
And the quaint white bullets fly here and there,
With laugh and shout in the wintry air.

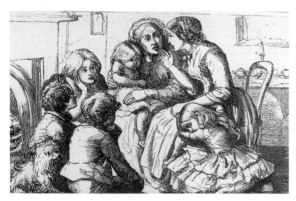

Illustration to 'Frost in the Holidays' by John Everett Millais

In the clasp of Home, by the ruddy fire,
Ranged in a ring to our heart's desire,—
Who is to tell some wondrous tale,
Almost to turn the warm cheeks pale,
Set chin on hands, make grave eyes stare,
Draw slowly nearer each stool and chair?

The one low voice goes wandering on
Through a mystic world, whither all are gone;
The shadows dance; little Caroline
Has stolen her fingers up into mine.
But the night outside is very chill,
And the Frost hums loud at the window-sill

## William Morris
## From *The Oxford and Cambridge Magazine* (1856)

### Riding Together

For many, many days together
    The wind blew steady from the East;
For many days hot grew the weather,
    About the time of our Lady's Feast.

For many days we rode together,
    Yet met we neither friend nor foe;
Hotter and clearer grew the weather,
    Steadily did the East wind blow.

We saw the trees in the hot, bright weather,
    Clear-cut, with shadows very black,
As freely we rode on together
    With helms unlaced and bridles slack.

And often, as we rode together,
    We, looking down the green bank'd stream,
Saw flowers in the sunny weather,
    And saw the bubble-making bream.

And in the night lay down together,
    And hung above our heads the rood,
Or watch'd night-long in the dewy weather,
    The while the moon did watch the wood.

Our spears stood bright and thick together,
    Straight out the banners stream'd behind,
As we gallop'd on in the sunny weather,
    With faces turn'd towards the wind.

Down sank our threescore spears together,
    As thick we saw the pagans ride;
His eager face in the clear fresh weather,
    Shone out that last time by my side.

Up the sweep of the bridge we dash'd together,
    It rock'd to the crash of the meeting spears,
Down rain'd the buds of the dear spring weather,
    The elm-tree flowers fell like tears.

There, as we roll'd and writhed together,
    I threw my arms above my head,
For close by my side, in the lovely weather,
    I saw him reel and fall back dead.

I and the slayer met together,
    He waited the death-stroke there in his place,
With thoughts of death, in the lovely weather,
    Gapingly mazed at my madden'd face.

Madly I fought as we fought together;
    In vain: the little Christian band
The pagans drown'd, as in stormy weather,
    The river drowns low-lying land.

They bound my blood-stain'd hands together;
    They bound his corpse to nod by my side:
Then on we rode, in the bright March weather,
    With clash of cymbals did we ride.

We ride no more, no more together;
    My prison-bars are thick and strong,
I take no heed of any weather,
    The sweet Saints grant I live not long

## 'Pray but One Prayer for Me'

Pray but one prayer for me 'twixt thy closed lips,
    Think but one thought of me up in the stars.
The summer night waneth, the morning light
    slips,
    Faint and grey 'twixt the leaves of the aspen,
      betwixt the cloud-bars,
That are patiently waiting there for the dawn:
    Patient and colourless, though Heaven's gold
Waits to float through them along with the sun.
Far out in the meadows, above the young corn,
    The heavy elms wait, and restless and cold
The uneasy wind rises; the roses are dun;
Through the long twilight they pray for the dawn,
Round the lone house in the midst of the corn.
    Speak but one word to me over the corn,
    Over the tender, bow'd locks of the corn.

## From *The Defence of Guinevere* (1858)

But, knowing now that they would have her speak,
She threw her wet hair backward from her brow,
Her hand close to her mouth touching her cheek,

As though she had had there a shameful blow,
And feeling it shameful to feel ought but shame
All through her heart, yet felt her cheek burned so,

She must a little touch it; like one lame
She walked away from Gauwaine, with her head
Still lifted up: and on her cheek of flame

The tears dried quick; she stopped at last and said:
'O knights and lords, it seems but little skill
To talk of well-known things past now and dead.

'God wot I ought to say, I have done ill,
And pray you all forgiveness heartily!
Because you must be right such great lords—still

'Listen, suppose your time were come to die,
And you were quite alone and very weak;
Yea, laid a dying while very mightily

'The wind was ruffling up the narrow streak
Of river through your broad lands running well:
Suppose a hush should come, then some one speak:

' "One of these cloths is heaven, and one is hell,
Now choose one cloth for ever, which they be,
I will not tell you, you must somehow tell

' "Of your own strength and mightiness; here, see!"
'Yea, yea, my lord, and you to ope your eyes,
At foot of your familiar bed to see

'A great God's angel standing, with such dyes
Not known on earth, on his great wings, and hands,
Held out two ways, light from the inner skies

'Showing him well, and making his commands
Seem to be God's commands, moreover, too,
Holding within his hands the cloths on wands;

'And one of these strange choosing cloths was blue,
Wavy and long and one cut short and red;
No man could tell the better of the two.

'After a shivering half-hour you said,
"God help! heaven's colour, the blue;"
    and he said, "hell."
Perhaps you then would roll upon your bed,

'And cry to all good men that loved you well,
"Ah Christ! if only I had known, known, known;"
Launcelot went away, then I could tell,

'Like wisest man how all things would be, moan,
And roll and hurt myself, and long to die,
And yet fear much to die for what was sown.

'Nevertheless you, O Sir Gauwaine, lie,
Whatever may have happened through these years,
God knows I speak truth, saying that you lie.'

Her voice was low at first, being full of tears,
But as it cleared, it grew full loud and shrill,
Growing a windy shriek in all men's ears,

A ringing in their startled brains, until
She said that Gauwaine lied, then her voice sunk,
And her great eyes began again to fill,

Though still she stood right up, and never shrunk,
But spoke on bravely, glorious lady fair!
Whatever tears her full lips may have drunk,

She stood, and seemed to think,
    and wrung her hair,
Spoke out at last with no more trace of shame,
With passionate twisting of her body there:

'It chanced upon a day that Launcelot came
To dwell at Arthur's court: at Christmas-time
This happened; when the heralds sung his name,

' "Son of King Ban of Benwick", seemed to chime
Along with all the bells that rang that day,
O'er the white roofs, with little change of rhyme.

'Christmas and whitened winter passed away,
And over me the April sunshine came,
Made very awful with black hail-clouds, yea

'And in the Summer I grew white with flame,
And bowed my head down—Autumn, and the sick
Sure knowledge things would never be the same,

'However often Spring might be most thick
Of blossoms and buds, smote on me, and I grew
Careless of most things, let the clock tick, tick,

'To my unhappy pulse, that beat right through
My eager body; while I laughed out loud,
And let my lips curl up at false or true,

'Seemed cold and shallow without any cloud.
Behold my judges, then the cloths were brought:
While I was dizzied thus,
    old thoughts would crowd,

'Belonging to the time ere I was bought
By Arthur's great name and his little love,
Must I give up for ever then, I thought,

'That which I deemed would ever round me move
Glorifying all things; for a little word,
Scarce ever meant at all, must I now prove

'Stone-cold for ever? Pray you, does the Lord
Will that all folks should be quite happy and good?
I love God now a little, if this cord

'Were broken, once for all what striving could
Make me love anything in earth or heaven.
So day by day it grew, as if one should

'Slip slowly down some path worn smooth
    and even,
Down to a cool sea on a summer day;
Yet still in slipping was there some small leaven

'Of stretched hands catching small stones
    by the way,
Until one surely reached the sea at last,
And felt strange new joy as the worn head lay

'Back, with the hair like sea-weed; yea all past
Sweat of the forehead, dryness of the lips,
Washed utterly out by the dear waves o'ercast,

'In the lone sea, far off from any ships!
Do I not know now of a day in Spring?
No minute of that wild day ever slips

'From out my memory; I hear thrushes sing,
And wheresoever I may be, straightway
Thoughts of it all come up with most fresh sting;

'I was half mad with beauty on that day,
And went without my ladies all alone,
In a quiet garden walled round every way;

'I was right joyful of that wall of stone,
That shut the flowers and trees up with the sky,
And trebled all the beauty: to the bone,

'Yea right through to my heart, grown very shy
With weary thoughts, it pierced, and made me glad;
Exceedingly glad, and I knew verily,

'A little thing just then had made me mad;
I dared not think, as I was wont to do,
Sometimes, upon my beauty; if I had

'Held out my long hand up against the blue,
And, looking on the tenderly darken'd fingers,
Thought that by rights one ought to see
          quite through,

'There, see you, where the soft still light yet lingers,
Round by the edges; what should I have done,
If this had joined with yellow spotted singers,

'And startling green drawn upward by the sun?
But shouting, loosed out, see now! all my hair,
And trancedly stood watching the west wind run

'With faintest half-heard breathing sound—
          why there
I lose my head e'en now in doing this;
But shortly listen—In that garden fair

'Came Launcelot walking; this is true, the kiss
Wherewith we kissed in meeting that spring day,
I scarce dare talk of the remember'd bliss,

'When both our mouths went wandering
          in one way,
And aching sorely, met among the leaves;
Our hands being left behind strained far away.

'Never within a yard of my bright sleeves
Had Launcelot come before—and now, so nigh!
After that day why is it Guenevere grieves?

'Nevertheless you, O Sir Gauwaine, lie,
Whatever happened on through all those years,
God knows I speak truth, saying that you lie.

'Being such a lady could I weep these tears
If this were true? A great queen such as I
Having sinn'd this way, straight
          her conscience sears;

'And afterwards she liveth hatefully,
Slaying and poisoning, certes never weeps,—
Gauwaine be friends now, speak me lovingly.

'Do I not see how God's dear pity creeps
All through your frame, and trembles
          in your mouth?
Remember in what grave your mother sleeps,

'Buried in some place far down in the south,
Men are forgetting as I speak to you;
By her head sever'd in that awful drouth

'Of pity that drew Agravaine's fell blow,
I pray your pity! let me not scream out
For ever after, when the shrill winds blow

'Through half your castle-locks! let me not shout
For ever after in the winter night
When you ride out alone! in battle-rout

'Let not my rusting tears make your sword light!
Ah! God of mercy how he turns away!
So, ever must I dress me to the fight;

'So—let God's justice work! Gauwaine, I say,
See me hew down your proofs: yea all men know
Even as you said how Mellyagraunce one day,

'One bitter day in la Fausse Garde, for so
All good knights held it after, saw—
Yea, sirs, by cursed unknightly outrage; though

'You, Gauwaine, held his word without a flaw,
This Mellyagraunce saw blood upon my bed—
Whose blood then pray you? is there any law

'To make a queen say why some spots of red
Lie on her coverlet? or will you say,
'Your hands are white, lady, as when you wed,

' "Where did you bleed?" and must I
          stammer out—"Nay,
I blush indeed, fair lord, only to rend
My sleeve up to my shoulder, where there lay

' "A knife-point last night:" so must I defend
The honour of the lady Guenevere?
Not so, fair lords, even if the world should end

'This very day, and you were judges here
Instead of God. Did you see Mellyagraunce
When Launcelot stood by him? what white fear

'Curdled his blood, and how his teeth did dance,
His side sink in? as my knight cried and said,
"Slayer of unarm'd men, here is a chance!

' "Setter of traps, I pray you guard your head,
By God I am so glad to fight with you,
Stripper of ladies, that my hand feels lead

' "For driving weight; hurrah now! draw and do,
For all my wounds are moving in my breast,
And I am getting mad with waiting so."

'He struck his hands together o'er the beast,
Who fell down flat, and grovell'd at his feet,
And groan'd at being slain so young—"at least."

'My knight said, "Rise you, sir, who are so fleet
At catching ladies, half-arm'd will I fight,
My left side all uncovered!" then I weet,

'Up sprang Sir Mellyagraunce with great delight
Upon his knave's face; not until just then
Did I quite hate him, as I saw my knight

'Along the lists look to my stake and pen
With such a joyous smile, it made me sigh
From agony beneath my waist-chain, when

'The fight began, and to me they drew nigh;
Ever Sir Launcelot kept him on the right,
And traversed warily, and ever high

'And fast leapt caitiff's sword, until my knight
Sudden threw up his sword to his left hand,
Caught it, and swung it; that was all the fight.

'Except a spout of blood on the hot land;
For it was hottest summer; and I know
I wonder'd how the fire, while I should stand,

'And burn, against the heat, would quiver so,
Yards above my head; thus these matters went;
Which things were only warnings of the woe

'That fell on me. Yet Mellyagraunce was shent,
For Mellyagraunce had fought against the Lord;
Therefore, my lords, take heed lest you be blent

'With all this wickedness; say no rash word
Against me, being so beautiful; my eyes,
Wept all away to grey, may bring some sword

'To drown you in your blood; see my breast rise,
Like waves of purple sea, as here I stand;
And how my arms are moved in wonderful wise,

'Yea also at my full heart's strong command,
See through my long throat how the words go up
In ripples to my mouth; how in my hand

'The shadow lies like wine within a cup
Of marvellously colour'd gold; yea now
This little wind is rising, look you up,

'And wonder how the light is falling so
Within my moving tresses: will you dare,
When you have looked a little on my brow,

'To say this thing is vile? or will you care
For any plausible lies of cunning woof,
When you can see my face with no lie there

'For ever? am I not a gracious proof—
"But in your chamber Launcelot was found"—
Is there a good knight then would stand aloof,

'When a queen says with gentle queenly sound:
"O true as steel come now and talk with me,
I love to see your step upon the ground

' "Unwavering, also well I love to see
That gracious smile light up your face, and hear
Your wonderful words, that all mean verily

' "The thing they seem to mean: good friend,
        so dear
To me in everything, come here to-night,
Or else the hours will pass most dull and drear;

' "If you come not, I fear this time I might
Get thinking over much of times gone by,
When I was young, and green hope was in sight:

' "For no man cares now to know why I sigh;
And no man comes to sing me pleasant songs,
Nor any brings me the sweet flowers that lie

' "So thick ill the gardens; therefore one so longs
To see you, Launcelot; that we may be
Like children once again, free from all wrongs

' "Just for one night." Did he not come to me?
What thing could keep true Launcelot away
If I said "Come"? there was one less than three

'In my quiet room that night, and we were gay;
Till sudden I rose up, weak, pale, and sick,
Because a bawling broke our dream up, yea

'I looked at Launcelot's face and could not speak,
For he looked helpless too, for a little while;
Then I remember how I tried to shriek,

'And could not, but fell down; from tile to tile
The stones they threw up rattled o'er my head,
And made me dizzier; till within a while

'My maids were all about me, and my head
On Launcelot's breast was being soothed away
From its white chattering, until Launcelot said—

'By God! I will not tell you more to-day,
Judge any way you will—what matters it?
You know quite well the story of that fray,

'How Launcelot still'd their bawling, the mad fit
That caught up Gauwaine—all, all, verily,
But just that which would save me; these things flit.

'Nevertheless you, O Sir Gauwaine, lie,
Whatever may have happen'd these long years,
God knows I speak truth, saying that you lie!

'All I have said is truth, by Christ's dear tears.'
She would not speak another word, but stood
Turn'd sideways; listening, like a man who hears

His brother's trumpet sounding through the wood
Of his foes' lances. She lean'd eagerly,
And gave a slight spring sometimes, as she could

At last hear something really; joyfully
Her cheek grew crimson, as the headlong speed
Of the roan charger drew all men to see,
The knight who came was Launcelot at good need.

## Spell-Bound

How weary is it none can tell,
　　How dismally the days go by!
I hear the tinkling of the bell,
　　I see the cross against the sky.

The year wears round to autumn-tide,
　　Yet comes no reaper to the corn:
The golden land is like a bride
　　When first she knows herself forlorn—

She sits and weeps with all her hair
　　Laid downward over tender hands;
For stainèd silk she hath no care
　　No care for broken ivory wands;

The silver cups beside her stand;
　　The golden stars on the blue roof
Yet glitter, though against her hand
　　His cold sword presses, for a proof

He is not dead, but gone away.
　　How many hours did she wait
For me, I wonder? Till the day
　　Had faded wholly, and the gate

Clanged to behind returning knights?
　　I wonder did she raise her head
And go away, fleeing the lights;
　　And lay the samite on her bed,

The wedding samite strewn with pearls:
　　Then sit with hands laid on her knees,
Shuddering at half-heard sound of girls
　　That chatter outside in the breeze?

I wonder did her poor heart throb
　　At distant tramp of coming knight?
How often did the choking sob
　　Raise up her head and lips? The light,

Did it come on her unawares,
　　And drag her sternly down before
People who loved her not? in prayers
　　Did she say one name and no more?

And once—all songs they ever sung,
　　All tales they ever told to me,
This only burden through them rung:
　　*O! golden love that waitest me,*

*The days pass on, pass on a pace,*
　　*Sometimes I have a little rest*
*In fairest dreams, when on thy face*
　　*My lips lie, or thy hands are prest*

*About my forehead, and thy lips*
　　*Draw near and nearer to mine own;*
*But when the vision from me slips,*
　　*In colourless dawn I lie and moan,*

*And wander forth with fever'd blood,*
　　*That makes me start at little things,*
*The blackbird screaming from the wood,*
　　*The sudden whirr of pheasants' wings.*

*O! dearest, scarcely seen by me—*
　　But when that wild time had gone by,
And in these arms I folded thee,
　　Who ever thought those days could die?

Yet now I wait, and you wait too,
　　For what perchance may never come;
You think I have forgotten you,
　　That I grew tired and went home.

But what if some day as I stood
　　Against the wall with strained hands,
And turn'd my face toward the wood,
　　Away from all the golden lands;

And saw you come with tired feet,
　　And pale face thin and wan with care,
And stainèd raiment no more neat,
　　The white dust lying on your hair:—

Then I should say, I could not come;
　　This land was my wide prison, dear;
I could not choose but go; at home
　　There is a wizard whom I fear:

He bound me round with silken chains
    I could not break; he set me here
Above the golden-waving plains,
    Where never reaper cometh near.

And you have brought me my good sword,
    Wherewith in happy days of old
I won you well from knight and lord;
    My heart upswells and I grow bold.

But I shall die unless you stand,
    —Half lying now, you are so weak,—
Within my arms, unless your hand
    Pass to and fro across my cheek.

## The Blue Closet

### THE DAMOSELS

Lady Alice, Lady Louise
Between the wash of the tumbling seas
We are ready to sing, if so ye please;
So lay your long hands on the keys;
  Sing, '*Laudate pueri.*'

*And ever the great bell overhead*
*Boom'd in the wind a knell for the dead,*
*Though no one toll'd it, a knell for the dead.*

### LADY LOUISE

Sister, let the measure swell
Not too loud; for you sing not well
If you drown the faint boom of the bell;
  He is weary, so am I.

*And ever the chevron overhead*
*Flapp'd on the banner of the dead;*
*(Was he asleep, or was he dead?)*

### LADY ALICE

Alice the Queen, and Louise the Queen,
Two damozels wearing purple and green,
Four lone ladies dwelling here
From day to day and year to year;
And there is none to let us go;
To break the locks of the doors below,
Or shovel away the heaped-up snow;
And when we die no man will know
That we are dead; but they give us leave,
Once every year on Christmas-eve,
To sing in the Closet Blue one song;
And we should be so long, so long,
If we dared, in singing; for dream on dream,
They float on in a happy stream;
Float from the gold strings, float from the keys,
Float from the open'd lips of Louise;
But, alas! the sea-salt oozes through
The chinks of the tiles of the Closet Blue;

*And ever the great bell overhead*
*Booms in the wind a knell for the dead,*
*The wind plays on it a knell for the dead.*

[*They sing all together.*]

How long ago was it, how long ago,
He came to this tower with hands full of snow?

'Kneel down, O love Louise, kneel down', he said,
And sprinkled the dusty snow over my head.

He watch'd the snow melting, it ran through my hair,
Ran over my shoulders, white shoulders and bare.

'I cannot weep for thee, poor love Louise,
For my tears are all hidden deep under the seas;

'In a gold and blue casket she keeps all my tears
But my eyes are no longer blue, as in old years;

'Yea, they grow grey with time, grow small and dry,
I am so feeble now, would I might die.'

*And in truth the great bell overhead*
*Left off his pealing for the dead,*
*Perchance, because the wind was dead.*

Will he come back again, or is he dead?
O! is he sleeping, my scarf round his head?

Or did they strangle him as he lay there,
With the long scarlet scarf I used to wear?

Only I pray thee, Lord, let him come here!
Both his soul and his body to me are most dear.

Dear Lord, that loves me, I wait to receive
Either body or spirit this wild Christmas-eve.

*Through the floor shot up a lily red,*
*With a patch of earth from the land of the dead,*
*For he was strong in the land of the dead.*

What matter that his cheeks were pale,
 His kind kiss'd lips all grey?
'O, love Louise, have you waited long?'
'O, my lord Arthur, yea.'

What if his hair that brush'd her cheek
Was stiff with frozen rime?
His eyes were grown quite blue again,
As in the happy time.

'O, love Louise, this is the key
Of the happy golden land!
O, sisters, cross the bridge with me,
My eyes are full of sand.
What matter that I cannot see,
If ye take me by the hand?'

*And ever the great bell overhead,*
*And the tumbling seas mourn'd for the dead;*
*For their song ceased and they were dead.*

### The Tune of Seven Towers

No one goes there now:
 For what is left to fetch away
From the desolate battlements all arow,
 And the lead roof heavy and grey?
*'Therefore', said fair Yoland of the flowers,*
*'This is the tune of Seven Towers.'*

No one walks there now;
 Except in the white moonlight
The white ghosts walk in a row;
 If one could see it, an awful sight,—
*'Listen!' said fair Yoland of the flowers,*
*'This is the tune of Seven Towers.'*

But none can see them now,
 Though they sit by the side of the moat,
Feet half in the water, there in a row,
 Long hair in the wind afloat.
*'Therefore', said fair Yoland of the flowers,*
*'This is the tune of Seven Towers.'*

If any will go to it now,
 He must go to it all alone
Its gates will not open to any row
 Of glittering spears—will you go alone?
*'Listen!' 'said fair Yoland of the flowers,*
*'This is the tune of Seven Towers.'*

By my love go there now,
 To fetch me my coif away,
My coif and my kirtle, with pearls arow,
 Oliver, go to-day!
*'Therefore', said fair Yoland of the flowers,*
*'This is the tune of Seven Towers.'*

I am unhappy now,
 I cannot tell you why;
If you go, the priests and I in a row
 Will pray that you may not die.
*'Listen!' said fair Yoland of the flowers,*
*'This is the tune of Seven Towers.'*

If you will go for me now,
    I will kiss your mouth at last;
        *[She sayeth inwardly.]*
(The graves stand grey in a row,)
    Oliver, hold me fast!
'Therefore', said fair Yoland of the flowers,
'This is the tune of Seven Towers.'

## Golden Wings

Midways of a walled garden,
    In the happy poplar land,
    Did an ancient castle stand,
With an old knight for a warden.

Many scarlet bricks there were
    In its walls, and old grey stone;
    Over which red apples shone
At the right time of the year.

On the bricks the green moss grew,
    Yellow lichen on the stone
    Over which red apples shone;
Little war that castle knew.

Deep green water fill'd the moat,
    Each side had a red-brick lip,
    Green and mossy with the drip
Of dew and rain; there was a boat

Of carven wood, with hangings green
    About the stern; it was great bliss
    For lovers to sit there and kiss
In the hot summer noons, not seen.

Across the moat the fresh west wind
    In very little ripples went;
    The way the heavy aspens bent
Towards it, was a thing to mind.

The painted drawbridge over it
    Went up and down with gilded chains,
    'Twas pleasant in the summer rains
Within the bridge-house there to sit.

There were five swans that ne'er did eat
    The water-weeds for ladies came
    Each day, and young knights did the same
And gave them cakes and bread for meat.

They had a house of painted wood,
    A red roof gold-spiked over it,
    Wherein upon their eggs to sit
Week after week; no drop of blood,

Drawn from men's bodies by sword-blows,
    Came over there, or any tear;
    Most certainly from year to year
'Twas pleasant as a Provence rose.

The banners seem'd quite full of ease,
    That over the turret-roofs hung down;
    The battlements could get no frown
From the flower-moulded cornices.

Who walked in that garden there?
    Miles and Giles and Isabeau,
    Tall Jehane du Castel beau,
Alice of the golden hair,

Big Sir Gervaise, the good knight,
    Fair Ellayne le Violet,
    Mary, Constance fille de fay,
Many dames with footfall light.

Whosoever wander'd there,
    Whether it be dame or knight,
    Half of scarlet, half of white
Their raiment was; of roses fair

Each wore a garland on the head,
    At Ladies' Gard the way was so:
    Fair Jehane du Castel beau
Wore her wreath till it was dead.

Little joy she had of it,
    Of the raiment white and red,
    Or the garland on her head,
She had none with whom to sit

In the carven boat at noon;
    None the more did Jehane weep,
    She would only stand and keep
Saying, 'He will be here soon.'

Many times in the long day
    Miles and Giles and Gervaise past,
    Holding each some white hand fast,
Every time they heard her say:

'Summer cometh to an end,
    Undern cometh after noon;
    Golden wings will be here soon,
What if I some token send?'

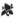

'I cannot stay here all alone,
    Or meet their happy faces here,
    And wretchedly I have no fear;
A little while, and I am gone.'

Therewith she rose upon her feet,
    And totter'd; cold and misery
    Still made the deep sobs come, till she
At last stretch'd out her fingers sweet,

And caught the great sword in her hand;
    And, stealing down the silent stair,
    Barefooted in the morning air,
And only in her smock, did stand

Upright upon the green lawn grass;
    And hope grew in her as she said:
    'I have thrown off the white and red,
And pray God it may come to pass

'I meet him; if ten years go by
    Before I meet him; if, indeed,
    Meanwhile both soul and body bleed,
Yet there is end of misery,

'And I have hope. He could not come,
    But I can go to him and show
    These new things I have got to know,
And make him speak, who has been dumb.'

O Jehane! the red morning sun
    Changed her white feet to glowing gold,
    Upon her smock, on crease and fold,
Changed that to gold which had been dun.

O Miles, and Giles, and Isabeau,
    Fair Ellayne le Violet,
    Mary, Constance fille de fay!
Where is Jehane du Castel beau?

O big Gervaise ride apace!
    Down to the hard yellow sand,
    Where the water meets the land.
This is Jehane by her face;

Why has she a broken sword?
    Mary! she is slain outright;
    Verily a piteous sight;
Take her up without a word!

Giles and Miles and Gervaise there,
    Ladies' Gard must meet the war;
    Whatsoever knights these are,
Man the walls withouten fear!

Axes to the apple trees
    Axes to the aspens tall!
    Barriers without the wall
May be lightly made of these.

O poor shivering Isabeau;
    Poor Ellayne le Violet,
    Bent with fear! we miss to-day
Brave Jehane du Castel beau.

O poor Mary, weeping so!
    Wretched Constance fille de fay!
    Verily we miss to-day
Fair Jehane du Castel beau.

The apples now grow green and sour
    Upon the mouldering castle-wall,
    Before they ripen there they fall:
There are no banners on the tower.

The draggled swans most eagerly eat
    The green weeds trailing in the moat;
    Inside the rotting leaky boat
You see a slain man's stiffen'd feet.

## Praise of my Lady

My lady seems of ivory,
Forehead, straight nose, and cheeks that be
Hollow'd a little mournfully.
    *Beata mea Domina!*

Her forehead, overshadow'd much
By bows of hair, has a wave such
God was good to make for me.
    *Beata mea Domina!*

Not greatly long my lady's hair,
Nor yet with yellow colour fair,
But thick and crisped wonderfully:
    *Beata mea Domina!*

Heavy to make the pale face sad,
And dark, but dead as though it had
Been forged by God most wonderfully
    —*Beata mea Domina!*—

Of some strange metal, thread by thread,
To stand out from my lady's head,
Not moving much to tangle me.
    *Beata mea Domina!*

Beneath her brows the lids fall slow,
The lashes a clear shadow throw
Where I would wish my lips to be.
    *Beata mea Domina!*

Her great eyes, standing far apart,
Draw up some memory from her heart,
And gaze out very mournfully;
    —*Beata me Domina!*—

So beautiful and kind they are,
But most times looking out afar,
Waiting for something, not for me.
    *Beata mea Domina!*

I wonder if the lashes long
Are those that do her bright eyes wrong,
For always half tears seem to be
    —*Beata mea Domina!*—

Lurking below the underlid,
Darkening the place where they lie hid—
If they should rise and flow for me!
    *Beata mea Domina!*

Her full lips being made to kiss,
Curl'd up and pensive each one is;
This makes me faint to stand and see.
    *Beata mea Domina!*

Her lips are not contented now,
Because the hours pass so slow
Towards a sweet time: (pray for me),
    —*Beata mea Domina!*—

Nay, hold thy peace! for who can tell;
But this at least I know full well,
Her lips are parted longingly,
    —*Beata mea Domina!*—

So passionate and swift to move,
To pluck at any flying love,
That I grow faint to stand and see.
    *Beata mea Domina!*

Yea! there beneath them is her chin,
So fine and round, it were a sin
To feel no weaker when I see
    —*Beata mea Domina!*—

God's dealings; for with so much care
And troublous, faint lines wrought in there,
He finishes her face for me.
    *Beata mea Domina!*

Of her long neck what shall I say?
What thing about her body's sway,
Like a knight's pennon or slim tree
 —*Beata mea Domina!*—

Set gently waving in the wind;
Or her long hands that I may find
On some day sweet to move o'er me?
 *Beata mea Domina!*

God pity me though, if I miss'd
The telling, how along her wrist
The veins creep, dying languidly
 —*Beata mea Domina!*—

Inside her tender palm and thin.
Now give me pardon, dear, wherein
My voice is weak and vexes thee.
 *Beata mea Domina!*

All men that see her any time,
I charge you straightly in this rhyme,
What, and wherever you may be,
 —*Beata mea Domina!*—

To kneel before her; as for me,
I choke and grow quite faint to see
My lady moving graciously.
 *Beata mea Domina!*

## Coventry Patmore
**From *The Angel in the House* (1856)**

### The Tribute

Boon Nature to the woman bows;
 She walks in earth's whole glory clad,
And, chiefest far herself of shows,
 All others help her, and are glad:
No splendour 'neath the sky's proud dome
 But serves for her familiar wear;
The far-fetch'd diamond finds its home
 Flashing and smouldering in her hair;
For her the seas their pearls reveal;

Art and strange lands her pomp supply
With purple, chrome, and cochineal,
 Ochre, and lapis lazuli;
The worm its golden woof presents;
 Whatever runs, flies, dives, or delves,
All doff for her their ornaments,
 Which suit her better than themselves;
And all, by this their power to give,
 Proving her right to take, proclaim
Her beauty's clear prerogative
 To profit so by Eden's blame.

### The Morning Call

1

'By meekness charm'd, or proud to allow
 'A queenly claim to live admired,
'Full many a lady has ere now
 'My apprehensive fancy fired,
'And woven many a transient chain;
 'But never lady like to this,
'Who holds me as the weather-vane
 'Is held by yonder clematis.
'She seems the life of nature's powers;
 'Her beauty is the genial thought
'Which makes the sunshine bright; the flowers,
 'But for their hint of her, were nought.'

2

A voice, the sweeter for the grace
 Of suddenness, while thus I dream'd,
'Good morning!' said or sang. Her face
 The mirror of the morning seem'd.
Her sisters in the garden walk'd,
 And would I come? Across the Hall
She led me; and we laugh'd and talk'd,
 And praised the Flower-show and the Ball;
And Mildred's pinks had gain'd the Prize;
 And, stepping like the light-foot fawn,
She brought me 'Wiltshire Butterflies',
 The Prize-book; then we paced the lawn,
Close-cot, and with geranium-pots,
 A rival glow of green and red;
Then counted sixty apricots
 On one small tree; the gold-fish fed;

And watch'd where, black with scarlet tans,
    Proud Psyche stood and flash'd like flame,
Showing and shutting splendid fans;
    And in the prize we found its name.

### The Dean

#### 1

The Ladies rose. I held the door,
    And sigh'd, as her departing grace
Assured me that she always wore
    A heart as happy as her face;
And, jealous of the winds that blew,
    I dreaded, o'er the tasteless wine
What fortune momently might do
    To hurt the hope that she'd be mine.

#### 2

Towards my mark the Dean's talk set:
    He praised my 'Notes on Abury',
Read when the Association met
    At Sarum; he was pleased to see
I had not stopp'd, as some men had,
    At Wrangler and Prize Poet; last,
He hoped the business was not bad
    I came about: then the wine pass'd.

#### 3

A full glass prefaced my reply:
    I loved his daughter, Honor; I told
My estate and prospects; might I try
    To win her? At my words so bold
My sick heart sank. Then he: He gave
    His glad consent, if I could get
Her love. A dear, good Girl! she'd have
    Only three thousand pounds as yet;
More bye and bye. Yes, his good will
    Should go with me; he would not stir;
He and my father in old time still
    Wish'd I should one day marry her,…

#### 4

He ceased, and gave his hand. He had won
    (And all my heart was in my word),
From me the affection of a son,

Whichever fortune Heaven conferr'd!
Well, well, would I take more wine? Then go
    To her; she makes tea on the lawn
These fine warm afternoons. And so
    We went whither my soul was drawn;
And her light-hearted ignorance
    Of interest in our discourse
Fill'd me with love, and seem'd to enhance
    Her beauty with pathetic force,
As, through the flowery mazes sweet
    Fronting the wind that flutter'd blythe,
And loved her shape, and kiss'd her feet,
    Shown to their insteps proud and lithe,
She approach'd, all mildness and young trust,
    And ever her chaste and noble air
Gave to love's feast its choicest gust,
    A vague, faint augury of despair.

### Going to Church

#### 4

Thenceforth, and through that pray'r, I trod
    A path with no suspicions dim.
I loved her in the name of God,
    And for the ray she was of Him;
I ought to admire much more, not less;
    Her beauty was a godly grace;
The mystery of loveliness,
    Which made an altar of her face,
Was not of the flesh, though that was fair,
    But a most pure and living light
Without a name, by which the rare
    And virtuous spirit flamed to sight.
If oft, in love, effect lack'd cause
    And cause effect, 'twere vain to soar
Reasons to seek for that which was
    Reason itself, or something more.
My joy was no idolatry
    Upon the ends of the vile earth bent,
For when I loved her most then I
    Most yearn'd for more divine content.
That other doubt, which, like a ghost,
    In the brain's darkness haunted me,
Was thus resolved: Him loved I most,
    But her I loved most sensibly.

Lastly, my giddiest hope allow'd
    No selfish thought, or earthly smirch;
And forth I went, in peace, and proud
    To take my passion into Church;
Grateful and glad to think that all
    Such doubts would seem entirely vain
To her whose nature's lighter fall
    Made no divorce of heart from brain.

### 6

Her soft voice, singularly heard
    Beside me, in her chant, withstood
The roar of voices, like a bird
    Sole warbling in a windy wood;
And, when we knelt, she seem'd to be
    An angel teaching me to pray;
And all through the high Liturgy
    My spirit rejoiced without allay,
Being, for once, borne clearly above
    All banks and bars of ignorance,
By this bright spring-tide of pure love
    And floated in a free expanse,
Whence it could see from side to side,
    The obscurity from every part
Winnow'd away and purified
    By the vibrations of my heart.

### The Chace

He wearies with an ill unknown;
    In sleep she sobs and seems to float,
A water-lily, all alone
    Within a lonely castle-moat;
And as the full-moon, spectral, lies
    Within the crescent's gleaming arms,
The present shows her heedless eyes
    A future dim with vague alarms.
She sees, and yet she scarcely sees,
    For, life-in-life not yet begun,
Too many are its mysteries
    For thought to fix on and one.
She's told that maidens are by youths
    Extremely honour'd and desired;
And sighs, 'If those sweet tales be truths,

'What bliss to be so much admired!'
The suitors come; she sees them grieve;
    Her coldness fills them with despair;
She'd pity if she could believe;
    She's sorry that she cannot care.
But who now meets her on her way?
    Comes he as enemy or friend,
Or both? Her bosom seems to say,
    He cannot pass, and there an end.
Whom does he love? Does he confer
    His heart on worth that answers his?
Or is he come to worship her?
    She fears, she hopes, she thinks he is!
Advancing stepless, quick, and still,
    As in the grass a serpent glides,
He fascinates her fluttering will,
    Then terrifies with dreadful strides.
At first, there's nothing to resist;
    He fights with all the forms of peace;
He comes about her like a mist,
    With subtle, swift, unseen increase,
And then, unlook'd for, strikes amain
    Some stroke that frightens her to death,
And grows all harmlessness again,
    Ere she can cry, or get her breath.
At times she stops, and stands at bay;
    But he, in all more strong than she,
Subdues her with his pale dismay,
    Or more admired audacity.
She plans some final, fatal blow,
    But when she means with frowns to kill
He looks as if he loved her so,
    She smiles to him against her will.
How sweetly he implies her praise!
    His tender talk, his gentle tone,
The manly worship in his gaze,
    They nearly make her heart his own.
With what an air he speaks her name;
    His manner always recollects
Her sex, and still the woman's claim
    Is taught its scope by his respects.
Her charms, perceived to prosper first
    In his beloved advertencies,
When in her glass they are rehearsed,
    Prove his most powerful allies.

Ah, whither shall a maiden flee,
    When a bold youth so swift pursues,
And siege of tenderest courtesy,
    With hope perseverant, still renews!
Why fly so fast? Her flatter'd breast
    Thanks him who finds her fair and good;
She loves her fears; veil'd joys arrest
    The foolish terrors of her blood.
By secret, sweet degrees, her heart,
    Vanquish'd, takes warmth from his desire;
She makes it more, with hidden art,
    And fuels love's late dreaded fire.
The generous credit he accords
    To all the signs of good in her
Redeems itself; his praiseful words
    The virtues they impute confer.
Her heart is thrice as rich in bliss,
    She's three times gentler than before;
He gains a right to call her his
    Now she through him is so much more;
'Tis heaven where'er she turns her head;
    'Tis music when she talks; 'tis air
On which, elate, she seems to tread,
    The convert of a gladder sphere!
Ah, might he, when by doubts aggrieved,
    Behold his tokens next her breast,
At all his words and sighs perceived
    Against its blythe upheaval press'd!
But still she flies. Should she be won,
    It must not be believed or thought
She yields; she's chased to death, undone,
    Surprised, and violently caught.

### The Abdication

#### 2

I grew assured, before I ask'd,
    That she'd be mine without reserve
And in her unclaim'd graces bask'd,
    At leisure, till the time should serve,
With just enough of dread to thrill
    The hope, and make it trebly dear;
Thus loth to speak the word to kill
    Either the hope or happy fear.

#### 4

Twice rose, twice died my trembling word;
    The faint and frail Cathedral chimes
Spake time in music, and we heard
    The chafers rustling in the limes.
Her dress, that touch'd me where I stood,
    The warmth of her confided arm,
Her bosom's gentle neighbourhood,
    Her pleasure in her power to charm;
Her look, her love, her form, her touch,
    The least seem'd most by blissful turn,
Blissful but that it pleased too much,
    And taught the wayward soul to yearn.
It was as if a harp with wires
    Was traversed by the breath I drew;
And, oh, sweet meeting of desires,
    She, answering, own'd that she loved too.

#### 5

Honoria was to be my bride!
    The hopeless heights of hope were scaled;
The summit won, I paused and sigh'd…

### The Married Lover

My having won her, do I woo?
    Because her spirit's vestal grace
Provokes me always to pursue,
    But, spirit-like, eludes embrace,
Because her womanhood is such
    That, as on court-days subjects kiss
The Queen's hand, yet so near a touch
    Affirms no mean familiarness,
Nay, rather marks more fair the height
    Which can with safety so neglect
To dread, as lower ladies might,
    That grace could meet with disrespect,
Thus she with happy favour feeds
    Allegiance from a love so high
That thence no false conceit proceeds
    Of difference bridged, or state put by;
Because, although in act and word
    As lowly as a wife can be,
Her manners, when they call me lord,
    Remind me 'tis by courtesy:

Not with her least consent of will,
    Which would my proud affection hurt,
But by the noble style that still
    Imputes an unattain'd desert;
Because her gay and lofty brows,
    When all is won which hope can ask,
Reflect a light of hopeless snows
    That bright in virgin ether bask;
Because, though free of the outer court
    I am, this Temple keeps its shrine
Sacred to Heaven; because, in short,
    She's not and never can be mine.

## Elizabeth Siddal
### Poems Written between 1855 and 1859

### *A Year and Day*

Slow days have passed that make a year,
    Slow hours that make a day,
Since I could take my first dear love
    And kiss him the old way;
Yet the green leaves touch me on the cheek,
    Dear Christ, this month of May.

I lie among the tall green grass
    That bends above my head
And covers up my wasted face
    And folds me in its bed
Tenderly and lovingly
    Like grass above the dead.

Dim phantoms of an unknown ill
    Float through my tired brain;
The unformed visions of my life
    Pass by in ghostly train;
Some pause to touch me on the cheek,
    Some scatter tears like rain.

A shadow falls along the grass
    And lingers at my feet;
A new face lies between my hands—
    Dear Christ, if I could weep
Tears to shut out the summer leaves
    When this new face I greet.

Still it is but the memory
    Of something I have seen
In the dreamy summer weather
    When the green leaves came between:
The shadow of my dear love's face—
    So far and strange it seems.

The river ever running down
    Between its grassy bed,
The voices of a thousand birds
    That clang above my head,
Shall bring me to a sadder dream
    When this sad dream is dead.

A silence falls upon my heart
    And hushes all its pain.
I stretch my hands in the long grass
    And fall to sleep again,
There to lie empty of all love
    Like beaten corn of grain.

### *Dead Love*

Oh never weep for love that's dead
    Since love is seldom true
But changes his fashion from blue to red,
    From brightest red to blue,
And love was born to an early death
    And is so seldom true.

Then harbour no smile on your bonny face
    To win the deepest sigh.
The fairest words on truest lips
    Pass on and surely die,
And you will stand alone, my dear,
    When wintry winds draw nigh.

Sweet, never weep for what cannot be,
    For this God has not given.
If the merest dream of love were true
    Then, sweet, we should be in heaven,
And this is only earth, my dear,
    Where true love is not given.

## Speechless

Many a mile over land and sea
Unsummoned my love returned to me;
I remember not the words he said
But only the trees moaning overhead.

And he came ready to take and bear
The cross I had carried for many a year,
But words came slowly one by one
From frozen lips shut still and dumb.

How sounded my words so still and slow
To the great strong heart that loved me so,
Who came to save me from pain and wrong
And to comfort me with his love so strong?

I felt the wind strike chill and cold
And vapours rise from the red-brown mould;
I felt the spell that held my breath
Bending me down to a living death.

## The Lust of the Eyes

I care not for my Lady's soul
　　Though I worship before her smile;
I care not where be my Lady's goal
　　When her beauty shall lose its wile.

Low sit I down at my Lady's feet
　　Gazing through her wild eyes
Smiling to think how my love will fleet
　　When their starlike beauty dies.

I care not if my Lady pray
　　To our Father which is in Heaven.[1]
Then carry me through the dim twilight
　　And hide me among the graves.

Then who shall close my Lady's eyes
　　And who shall fold her hands?
Will any harken if she cries
　　Up to the unknown lands?

1. The manuscript is incomplete, and at this line a clear break is evident.

## A Silent Wood

O silent wood, I enter thee
With a heart so full of misery
For all the voices from the trees
And the ferns that cling about my knees.

In thy darkest shadow let me sit
When the grey owls about thee flit;
There will I ask of thee a boon,
That I may not faint or die or swoon.

Gazing through the gloom like one
Whose life and hopes are also done,
Frozen like a thing of stone
I sit in thy shadow—but not alone.

Can God bring back the day when we two stood
Beneath the clinging trees in that dark wood?

## Love and Hate

Ope not thy lips, thou foolish one,
　　Nor turn to me thy face;
The blasts of heaven shall strike thee down
　　Ere I will give thee grace.

Take thou thy shadow from my path,
　　Nor turn to me and pray;
The wild wild winds thy dirge may sing
　　Ere I will bid thee stay.

Lift thy false brow from out the dust
　　Nor wild thine hands entwine
Among the golden summer leaves
　　To mock this gay sunshine.

And turn away thy false dark eyes,
　　Nor gaze upon my face;
Great love I bore thee: now great hate
　　Sits grimly in its place.

All changes pass me like a dream,
    I neither sing nor pray;
And thou art like the poisonous tree
    That stole my life away.

## The Passing of Love

O God, forgive me that I ranged
    My life into a dream of love!
Will tears of anguish never wash
    The passion from my blood?

Love kept my heart in a song of joy,
    My pulses quivered to the tune;
The coldest blasts of winter blew
    Upon me like sweet airs in June.

Love floated on the mists of morn
    And rested on the sunset's rays;
He calmed the thunder of the storm
    And lighted all my ways.

Love held me joyful through the day
    And dreaming ever through the night;
No evil thing could come to me,
    My spirit was so light.

O Heaven help my foolish heart
    Which heeded not the passing time
That dragged my idol from its place
    And shattered all its shrine!

## Lord May I Come?

Life and night are falling from me,
Death and day are opening on me,
Wherever my footsteps come and go,
Life is a stony way of woe.
    Lord, have I long to go?

Hollow hearts are ever near me,
Soulless eyes have ceased to cheer me;
    Lord, may I come to thee?

Life and youth and summer weather
To my heart no joy can gather.
    Lord, lift me from life's stony way!

Loved eyes long closed in death watch for me:
Holy death is waiting for me—
    Lord, may I come to-day?

My outward life feels sad and still
Like lilies in a frozen rill;
I am gazing upwards to the sun,
Lord, Lord, remembering my lost one.
    O Lord, remember me!

How is it in the unknown land?
Do the dead wander hand in hand?
    God, give me trust in thee.

Do we clasp dead hands and quiver
With an endless joy for ever?
Do tall white angels gaze and wend
Along the banks where lilies bend?
Lord, we know not how this may be:
Good Lord we put our faith in thee—
    O God, remember me.

# REACTIONS

### Review in the *Athenæum* (1850) *Who wrote it? (or is he afraid to say?)*

We have already in the course of our Exhibition notices of this year come in contact with the doings of a school of artists whose younger members unconsciously write its condemnation in the very title which they adopt (that of Pre-Raphælite), and we would not have troubled ourselves or our readers with any further remarks on the subject were it not that eccentricities of any kind have a sort of seduction for minds that are intellectual without belonging to the better orders of intellect. It is difficult in the present day of improved taste and information to apprehend any large worship of an Art Idol set up with visible deformity as its attributes, but it is always well to guard against the influence of ostentatious example and fascination of paradox. The idea of an association of artists whose objects are the following out of their art in a spirit of improved purity making sentiment and expression the great ends, and subordinating to these all technical consideration, is not new. The difference between the proceedings of a band of German painters who in the early art of the present century commenced such an undertaking in Rome and those of these English Pre-Raphælites is nevertheless striking. The Germans in question (who had each tested the difficulties of composition in his own several style, each encountered the struggle of pictorial principle in his own studio) learned to throw off the yoke of conventionalism which, commencing with the eclectic ages before, had brought the art of their time in Italy down to its lowest level, etc., etc. With all their good taste and acquirements their formal recurrence to amend art has been repressive of the first great condition of success (originality of thinking). That a body of young painters (untraveled, without experience, and below these Germans in intelligence, going back for revival to a yet earlier period) should fail more signally and find that they have arrived at an absurdity might have been expected beforehand from the mere conditions of the case. This school of English youths has, it may be granted, ambition, but not of that well-regulated order which, measuring the object to be attained by the resources possessed, qualifies itself for achievement. Their ambition is an unhealthy thirst which seeks notoriety by means of mere conceit. Abruptness, singularity, uncouthness are the counters by which they play for game. Their trick is to defy the principles of beauty and the recognised axioms of taste. Again these young artists are mistaken if they imagine that they have reverted to any early period of art for their type of pictorial expression... In all these painters the absence of structural knowledge never resulted in positive deformity. The disgusting incidents of unwashed bodies were not presented in loathsome reality, and flesh with its accidents of putridity was not made the affected medium of religious sentiment in tasteless revelation. Purity of presentment inspired by devotional enthusiasm marked the works of these old rude masters... Let us conjure these young gentlemen to believe that Raphæl may be received as no mean authority for soundness of view and excellence in practice. They stand convicted of insincerity by the very cleverness of some of their pictures. What a willful misapplication of powers is that which affects to treat the human form in the primitive and artless manner of the Middle Ages, while minor accessories are elaborated to a refinement of imitation which belongs to the latest days of executive art! By the side of their affected simplicity and rudeness they write the condemnation of the same, saying, 'You see by the skill with which we can produce a shaving that we could joint and round these limbs if we would. We show you that which some of us could, if we chose, do as well as they who use the enlarged means and appliances of art; we can also do and choose to do as ill as they who wanted our knowledge. We desire you to understand that it is not for want of knowing what

nature is that we fly to affectation.' In point of religious sentiment Rossetti stands the chief of this little band. Mr. Hunt stands next in his picture of 'A Converted British Family' (No. 553). There is a sense of novelty in its arrangement and of expression in its parts and a certain enthusiasm, though wrongly directed in its conduct. Mr. Millais in his picture without a name (No. 518), which represented a Holy Family in the interior of the carpenter's shop, has been most successful in giving the least dignified features of his presentment, and in giving to the higher forms characters and meanings, a circumstantial Art Language from which we recoil with loathing and disgust. There are many to whom his work will seem a pictorial blasphemy. Great imitative talents have here been perverted to the use of an eccentricity both lamentable and revolting. 'Ferdinand lured by Ariel' (504), by the same hand, though better in the painting, is yet more senseless in the conception, a scene built on the contrivances of the stage manager, but with very bad success. Another instance of perversion is to be regretted in 'Berengaria's Alarm for the Safety of her Husband' (etc.) (535), by Mr. Charles Collins.

## Charles Dickens
### 'A Criticism of Millais' "Christ in the House of His Parents" ' in *Household Words* (1850)

*[handwritten: 4-10-00 Mon.]*

You come—in this Royal Academy Exhibition, which is familiar with the works of Wilkie, Collins, Etty, Eastlake, Leslie, Maclise, Turner, Stanfield, Landseer, Roberts, Danby, Creswick, Lee, Webster, Herbert, Dyce, Cope, and others who would have been renowned as great masters in any age or country—you come, in this place, to the contemplation of the Holy Family. You will have the goodness to discharge from your minds all Post-Raphæl ideas, all religious aspirations, all ennobling, sacred, graceful, or beautiful associations; and to prepare yourselves, as befits such a subject—Pre-Raphælly considered—for the lowest depths of what is mean, odious, repulsive,

*[handwritten top margin: ironic in that it resembles one of Dickens character; Dickens can write about it but doesn't like it in painting?]*

and revolting.

You behold the interior of a carpenter's shop. In the foreground of that carpenter's shop is a hideous, wry-necked, blubbering, red-headed boy, in a bed-gown; who appears to have received a poke in the hand, from the stick of another boy with whom he has been playing in an adjacent gutter, and to be holding it up for the contemplation of a kneeling woman, so horrible in her ugliness, that (supposing it were possible for any human creature to exist for a moment with that dislocated throat) she would stand out from the rest of the company as a Monster, in the vilest cabaret in France, or the lowest gin-shop in England. Two almost naked carpenters, master and journeyman, worthy companions of the agreeable female, are working at their trade; a boy, with some small favour of humanity in him, is entering with a vessel of water; and nobody is paying any attention to a snuffy old woman who seems to have mistaken that shop for the tobacconist's next door, and to be hopelessly waiting at the counter to be served with half an ounce of her favorite mixture. Whereever it is possible to express ugliness of feature, limb, or attitude, you have it expressed. Such men as the carpenters might be undressed in any hospital where dirty drunkards, in a high state of varicose veins, are received...

### Letter to *The Times* (7 May 1851)

We cannot censure at present as amply or as strongly as we desire to do, that strange disorder of the mind or the eyes which continues to rage with unabated absurdity among a class of juvenile artists who style themselves P.R.B., which, being interpreted, means Pre-Raphæl-brethren. Their faith seems to consist in an absolute contempt for perspective and the known laws of light and shade, an aversion to beauty in every shape, and a singular devotion to the minute accidents of their subjects, including, or rather seeking out, every excess of sharpness and deformity. Mr. Millais, Mr. Hunt, Mr. Collins—and in some degree—Mr.

*[handwritten bottom margin: By constantly using their name, he's spitting on them ('give me a break'—spit!)]*

Brown, the author of a huge picture of Chaucer, have undertaken to reform the art on these principles. The Council of the Academy, acting in the spirit of toleration and indulgence to young artists, have now allowed these extravagances to disgrace their walls for the last three years, and though we cannot prevent men who are capable of better things from wasting their talents on ugliness and conceit, the public may fairly require that such offensive jests should not continue to be exposed as specimens of the waywardness of these artists who have relapsed into the infancy of their profession.

In the North Room will be found, too, Mr. Millais' picture of 'The Woodman's Daughter', from some verses by Mr. Coventry Patmore, and as the same remarks will apply to the other pictures of the same artist, 'The Return of the Dove to the Ark' (651), and Tennyson's 'Mariana' (561), as well as to similar works by Mr. Collins, as 'Convent Thoughts' (493), and to Mr. Hunt's 'Valentine receiving Proteus' (sic) (59), we shall venture to express our opinion on them all in this place. These young artists have unfortunately become notorious by addicting themselves to an antiquated style and an affected simplicity in Painting, which is to genuine art what the mediæval ballads and designs in Punch are to Chaucer and Giotto. With the utmost readiness to humour even the caprices of Art when they bear the stamp of originality and genius, we can extend no toleration to a mere servile imitation of the cramped style, false perspective, and crude colour of remote antiquity. We do not want to see what Fuseli termed drapery 'snapped instead of folded', faces bloated into apoplexy or extenuated to skeletons, colour borrowed from the jars in a druggist's stop, and expression forced into caricature. It is said that the gentlemen have the power to do better things, and we are referred in proof of their handicraft to the mistaken skill with which they have transferred to canvas the hay which lined the lofts in Noah's Ark, the brown leaves of the coppice where Sylvia strayed, and the prim vegetables of a monastic garden. But we must

doubt a capacity of which we have seen so little proof, and if any such capacity did ever exist in them, we fear that it has already been overlaid by mannerism and conceit. To become great in art, it has been said that a painter must become as a little child, though not childish, but the authors of these offensive and absurd productions have continued to combine the puerility or infancy of their art with the uppishness and self-sufficiency of a different period of life. That morbid infatuation which sacrifices truth, beauty, and genuine feeling to mere eccentricity deserves no quarter at the hands of the public, and though the patronage of art is sometimes lavished on oddity as profusely as on higher qualities, these monkish follies have no more real claim to figure in any decent collection of English paintings than the aberrations of intellect which are exhibited under the name of Mr. Ward.

## John Ruskin
### Letter to The *Times* (14 May 1851)

We [the editors of *The Times*] have received the following remarks upon our criticism on the pictures exhibited at the Royal Academy by Messrs. Millais and Hunt, from Mr. Ruskin, the author of many well-known works on art:

'Sir,—Your usual liberality will, I trust, give a place in your column to this expression of my regret that the tone of the critique which appeared in *The Times* of Wednesday last on the works of Mr. Millais and Mr. Hunt, now in the Royal Academy, should have been scornful as well as severe.

'I regret it, at first, because the more labour bestowed on those works, and their fidelity to a certain order of truth (labour and fidelity which are altogether indisputable) ought at once to have placed them above the level of mere contempt; and, secondly, because I believe these young artists to be at a most critical period of their career—at a turning point, from which they may either sink into nothingness or rise to very real

greatness; and I believe also, that whether they choose the upward or downward path may in no small degree depend upon the character of the criticism which their works have to sustain. I do not wish in any way to dispute or invalidate the general truth of your critique on the Royal Academy; nor am I surprised at the estimate which the writer formed of the pictures in question when rapidly compared with works of totally different style and aim; nay, when I first saw the chief picture by Millais in the Exhibition of last year I had nearly come to the same conclusion myself. But I ask your permission in justice to artists who have at least given much time and toil to their pictures, to institute some more serious inquiry into their merits and faults than your general notice of the Academy could possibly have admitted.

'Let me state, in the first place, that I have no acquaintance with any of these artists, and very imperiled sympathy with them. No one who had met with any of my writings will suspect me of desiring to encourage them in their Romanist and Tractarian tendencies. I am glad to see that Mr. Millais's lady in blue is heartily tired of her painted window and idolatrous toilet-table, and I have no particular respect for Mr. Collins' lady in white, because her sympathies are limited by a dead wall, or divided between some gold fish and a tadpole (the latter Mr. Collins may, perhaps, permit me to suggest *en passant*, as he is already half a frog, is rather too small for his age). But I happen to have a special acquaintance with the water plant,…among which the said gold fish are swimming; and, as I never saw it so thorough or so well drawn, I must take leave to remonstrate with you when you say sweepingly that these men "sacrifice truth as well as feeling to eccentricity." For as a mere botanical study of the water lily and *Alisma*, as well as of the common lily and several other garden flowers, this picture would be invaluable to me, and I heartily wish it were mine.

'But, before entering late into such particulars, let me correct an impression which your article is likely to induce in most minds, and which is altogether false. These pre-Raphælites (I cannot compliment them on common sense in choice of a *nom de guerre*) do not desire or pretend in any way to imitate antique painting, as such. They know little of ancient paintings who suppose the works of three young artists to resemble them. As far as I can judge of their aim— for, as I said, I do not know the men themselves— the pre-Raphælites intend to surrender to advantage which the knowledge or inventions of the present time can afford to their art. They intend to return to early days in this one point only—that, as far as in them lies, they will draw either what they see or what they suppose might have been the actual facts of the scene they desire to represent, irrespective of any conventional rules of picture making; and they have chosen their unfortunate though not inaccurate name because all artists did this before Raphæl's time, and after Raphæl's time did not this, but sought to paint fair pictures rather than represent stern facts, of which the consequence has been that from Raphæl's time to this day historical art has been in acknowledged decadence.

'Now, Sir, presupposing that the intention of these men was to return to archaic art instead of to archaic honesty, your critic borrows Fuseli's expression respecting ancient draperies— "snapped instead of folded", and asserts that in these pictures there is a "servile imitation of false perspective." To which I have just this to answer:

'That there is not one single error in perspective in four out of the five pictures in question, and that in Millais' "Mariana" there is but this one—that the top of the green curtain in the distant window has too low a vanishing point: and that I will undertake, if need be, to point out and prove a dozen worse errors in perspective in any 12 pictures containing architecture, taken at random from among the works of the most popular painters of the day.

'Secondly: that, putting aside the small Mulready and the works of Thorburn and Sir. W. Ross, and perhaps some others of those in the miniature room which I have not examined, there

is not a single study of drapery in the whole Academy, be it in large works or small, which for perfect truth, power, and finish, could be compared for an instant with the black sleeve of the Julia, or with the velvet on the breast and the chain-mail of the Valentine of Mr. Hunt's picture; or with the white draperies on the table in Mr. Millais' "Mariana", and of the right hand figure in the same painter's "Dove returning to the Ark."

'And further: that as studies both of drapery and of every minor detail, there has been nothing in art so earnest or so complete as these pictures since the days of Albert Durer. This I assert generally and fearlessly.'

## John Ruskin's letter to The *Times* (30 May 1851)

To the Editor of *The Times*
'Sir,—Your obliging insertion of my former letter encourages me to trouble you with one or two further notes respecting the pre-Raphælite pictures. I had intended, in continuation of my first letter, to institute as close an inquiry as I could into the character of the morbid tendencies which prevent these works from favourable arresting the attention of the public; but I believe there are so few pictures in the Academy whose reputation would not be grievously diminished by a deliberate inventory of their errors, that I am disinclined to undertake so ungracious a task with respect to this or that particular work. Three points, however, may be noted, partly for the consideration of the painters themselves, partly that forgiveness of them may be asked from the public in consideration of high merit in other respects.

'The most painful of these defect is unhappily also the most prominent—the commonness of feature in many of the principal figures. In Mr. Hunt's "Valentine defending Sylvia", this is, indeed, almost the only fault. Further examination of this picture has even raised the estimate I had previously formed of the marvellous truth in detail and splendour in colour;

nor is the general conception less deserving of praise; the actions of Valentine, his arm thrown round Sylvia and his hand clasping hers at the same instant as she falls at his feet, is most faithful and beautiful, nor less so the contending of doubt and distress with awakening hope in the half-shadowed, half-sunlit countenance of Julia. Nay, even the momentary struggle of Proteus with Sylvia, just pat, is indicated by the trodden grass and broken fungi of the foreground. But all this thoughtful conception, and absolutely inimitable execution, fails in making immediate appeal to the feelings, owing to the unfortunate type chosen for the face of Sylvia. Certainly this cannot be she whose lover was—

"As rich in having such a jewel,
"As twenty seas, if all their sands were pearl."

Nor is it, perhaps, less to be regretted that while in Shakespeare's play there are nominally "Two Gentlemen", in Hunt's picture there should only be one—at least, the kneeling figure on the right has by no means the look of a gentleman. But this may be on purpose, for any one who remembers the conduct of Proteus throughout the previous scenes will, I think, be disposed to consider that the error lies more in Shakespeare's nomenclature than in Mr. Hunt's ideal.

'No defence can, however, be offered for the choice of features in the left-hand figure of Mr. Millais' "Dove returning to the Ark." I cannot understand how a painter so sensible of the utmost refinements of beauty in other objects should deliberately choose for his model a type far inferior to that of average humanity, and unredeemed by any expression except that of dull self-complacency. Yet let the spectator who desires to be just turn away from this head, and contemplate rather the tender and beautiful expression of the stooping figure, and the intense harmony of colour in the exquisitely finished draperies; let him note also the ruffling of the plumage of the wearied dove, one of its feathers falling on the arm of the figure which holds it, and another to the ground, where, by the by, the hay is

painted not only elaborately, but with the most perfect ease of touch and mastery of effect, especially to be observed because this freedom of execution is a modern excellence, which as has been inaccurately stated that these painters despise, but which, in reality, is one of the remarkable distinctions between their painting and that of Van Eyck or Memling, which caused me to say in my first letter that "those know little of ancient painting who supposed the work of these men to resemble it."

'Next to this false choice of feature, and in connection with it, is to noted the defect in the colouring of the flesh. The hands, at least in the pictures of Millais, are almost always ill painted, and the flesh that in general is wrought out of crude purples and dusky yellows. It appears just possible that much of this evil may arise from the attempt to obtain too much transparency—an attempt which had injured also not a few of the best works of Mulready. I believe it will be generally found that close study of minor details is unfavourable to flesh painting; it was noticed of the drawing by John Lewis, in the old water-colour exhibition of 1850 (a work which, in regards the treatment of detail, may be ranged in the same class with the pre-Raphælite picture), that the faces were the worst painted portions of the whole.

'The apparent want of shade is, however, perhaps the fault which most hurts the general eye. The fact is, nevertheless, that the fault is far more in the other pictures of the Academy than in the pre-Raphælite case. It is the former that are false, not the later… I think Mr. Hunt has a slight tendency to exaggerate reflected lights and if Mr. Millais has ever been near a piece of good painted glass he ought to have known that its tone is more sober than that of his Mariana's window. But for the most part these pictures are rashly condemned, because the only lights which we are accustomed to see represented is that which falls on the artist's model in his dim painting-room, not that of sunshine in the fields.

'I do not think I can go much further in fault finding. I had, indeed, something to urge respecting what I supposed to be the Romanizing tendencies of the painters; but I have received a letter assuring me that I was wrong in attributing to them anything of the kind, whereupon, all I can say is that instead of the "pilgrimage" of Mr. Collins's maiden over a plank and round a fishpond, that old pilgrimages of Christiana and her children towards the place where they should "look the Fountain of Mercy in the face" would have been more to the purpose in these times. And so I wish them all heartily good speed, believing in sincerity that if they temper the courage and energy which they have shown in the adoption of their system with a patience and discretion in pursing it, and if they do not suffer themselves to be driven by harsh or careless criticism into rejection of the ordinary means of obtaining influence over the minds of others, they may, as they gain experience, lay in our England the foundations of a school or art nobler than the world has seen for 300 years.

I have the honour to be, Sir,
Your obedient servant,
THE AUTHOR OF "MODERN PAINTERS"
Denmark-hill, May 26.'

We [the editors of *The Times*] should find it no difficult task to destroy the web which the paradoxical ingenuity of our correspondent, the 'Author of Modern Painters', has spun, but we must confine our reply within narrower limits than the letters with which he has favoured us. If we spoke with severity of the productions of the young artists to which this correspondence relates, it was with a sincere desire to induce them, if possible, to relinquish what is absurd, morbid, and offensive in their works, and to cultivate whatever higher and better qualities they possess; but at present these qualities are wholly overlaid by the vices of a style which has probably answered its purpose by obtaining for these young gentlemen a notoriety less hard to bear, even in the shape of ridicule, than public indifference. This perversion of talent—if talent they have—we take to be fairly obnoxious to criticism: and we trust

the authority of the 'Author of Modern Painters' will not have the opposite effect of perpetuating or increasing the defect of a style which, in spite of his assertions, we hold to be flagrant violation of nature and truth. In fact, Mr. Ruskin's own works might prove the best antidote to any such false theory; for (if we remember rightly) he has laid it down in his defence of Mr. Turner's landscapes, that truth in painting is not the mere imitative reproduction of this or that object, as they are, but the reproduction or image of the general effect given by an assemblage of objects as they appear to the sight. Mr. Millais and his friends have taken refuse in the opposite extreme of exaggeration from Mr. Turner; but, as extremes meet, they both find an apologist in the same critic. Ærial perspective, powerful contrasts of light and shade, with form and colour fused in the radiance of the atmosphere, are characteristics of Mr. Turner. The P.R.B.s, to whom the 'Author of Modern Painters' has transferred his affection, combine a repulsive precision of ugly shapes with monotony of tone in such works as 'Sylvia' or 'Convent Thoughts', or distorted expression as in 'Mariana' or the 'Dove in the Ark.'... Many of our correspondent's assertions may be more summarily disposed of by a reference to the pictures.

**From John Ruskin's *Notes on some of the Principal Pictures exhibited in the rooms of the Royal Academy, 1856***

398. *The Scapegoat* (W.H. Hunt)

This singular picture, though in many respects faultful, and in some wholly a failure, is yet the one, of all in the gallery, which should furnish us with most food for thought. First, consider it simply as an indication of the temper and aim of the rising artists of England. Until of late years, young painters have been mostly divided into two groups; one poor, hard-working, and suffering, compelled more or less, for immediate bread, to obey whatever call might be made upon them by patron or publisher; the other, of perhaps more

manifest cleverness or power, able in some degree to command the market, and apt to make the pursuit of art somewhat complementary to that of pleasure; so that a successful artist's studio has not been in general a place where idle and gay people would have found themselves ill at ease, or at a loss for amusement. But here is a young painter, the slave neither of poverty nor pleasure,—emancipated from the garret, despising the green room, and selecting for his studio a place where he is liable certainly to no agreeable forms of interruption. He travels, not merely to fill his portfolio with pretty sketches, but in as determined a temper as ever mediæval pilgrim, to do a certain work in the Holy Land. Arrived there, with the cloud of Eastern War gathered to the north of him, and involving, for most men, according to their adventurous or timid temper, either an interest which would at once have attracted them to its immediate field, or a terror which would have driven them from work in its threatening neighbourhood, he pursues calmly his original purpose; and while the hills of the Crimea were white with tents of war, and the fiercest passions of the nations of Europe burned in high funeral flames over their innumerable dead, one peaceful English tent was pitched beside a shipless sea; and the whole strength of an English heart spent in painting a weary goat, dying upon its salt sand.

And utmost strength of heart is needed. Though the tradition that a bird cannot fly over this sea is an exaggeration, the air in its neighbourhood is stagnant and pestiferous, polluted by the decaying vegetation brought down by the Jordan in its floods; the bones of the beasts of burden that have died by the 'way of the sea', lie like wrecks upon its edge, bared by the vultures, and bleached by the salt ooze, which, though tideless, rises and falls irregularly, swollen or wasted. Swarms of flies, fed on the carcases, darken an atmosphere heavy at once with the poison of the marsh, and the fever of the desert; and the Arabs themselves will not encamp for a night amidst the exhalations of the volcanic chasm.

This place of study the young English painter chooses. He encamps a little way above it; sets his easel upon its actual shore; pursues his work with patience through months of solitude; and paints, crag by crag, the purple mountains of Moab, and grain by grain, the pale ashes of Gomorrah.

And I think his object was one worthy of such an effort. Of all the scenes in the Holy Land, there are none whose present aspect tends so distinctly to confirm the statements of Scripture, which it might seem most desirable to give a perfect idea to those who cannot see it for themselves; it is that also which fewest travellers are able to see; and which, I suppose, no one but Mr. Hunt himself would ever have dreamed of making the subject of a close pictorial study. The work was therefore worth his effort, and he has connected it in a simple, but most touching way, with other subjects of reflection, by the figure of the animal upon the shore. This is, indeed, one of the instances in which the subject of a picture is wholly incapable of explaining itself; but, as we are too apt—somewhat hastily—to accept at once a subject as intelligible and rightly painted, if we happen to know enough of the story to interest us in it, so we are apt, somewhat unkindly, to refuse a painter the little patience of inquiry or remembrance, which, once granted, would enable him to interest us all the more deeply, because the thoughts suggested were not entirely familiar. It is necessary, in this present instance, only to remember that the view taken by the Jews of the appointed sending forth of the scapegoat into the Wilderness was that it represented the carrying away of their sin into a place uninhabited and forgotten; and that the animal on whose head the sin was laid, became accursed; so that 'though not commanded by the law, they used to maltreat the goat Azazel?—to spit upon him, and to pluck off his hair'. The goat, thus tormented, and with a scarlet fillet bound about its brow, was driven by the multitude wildly out of the camp: and pursed into the Wilderness. The painter supposes it to have fled towards the Dead Sea, and to be just about to fall exhausted at sunset—its hoofs

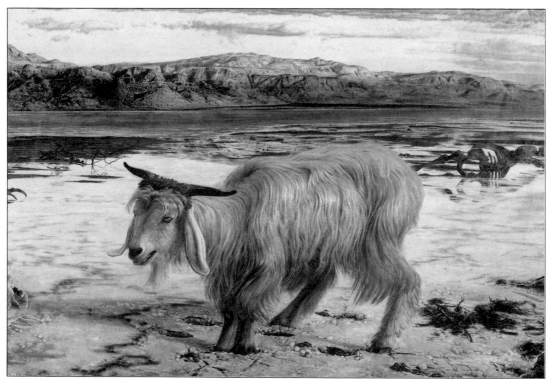

*The Scapegoat* by William Holman Hunt (1854)

*dead sea salty crust goat's feet giving through—while or something died there before*

entangled in the crust of salt upon the shore. The opposite mountains, seen in the fading light, are that chain of Abarim on which Moses died.

Now, we cannot, I think, esteem too highly, or receive too gratefully, the temper and the toil which have produced this picture for us. Consider for a little while the feelings involved in its conception, and the self-denial and resolve needed for its execution; and compare them with the modes of thought in which our former painters used to furnish us annually with their 'Cattle pieces', or 'Lake scenes', and I think we shall see cause to hold this picture as one more truly honourable to us, and more deep and sure in its promise of further greatness in our schools of painting, than all the works of 'high art' that since the foundation of the Academy have ever taxed the wonder, or weariness, the the English public. But, at the same time, this picture indicates a danger to our students of a kind hitherto unknown in any school; the danger of a too great intensity of feeling, making them forget the requirement of painting as an art. This picture, regarded merely as a landscape, or as a composition, is a total failure. The mind of the painter has been so excited by the circumstances of the scene, that, like a youth expressing his earnest feeling by feeble verse (which seems to him good, because he means so much by it), Mr Hunt has been blinded by his intense sentiment to the real weakness of the pictorial expression; and in his earnest desire to paint the Scapegoat, has forgotten to ask himself first, whether he could paint a goat at all.

I am not surprised that he should fail in painting the distant mountains; for the forms of large distant landscape are a quite new study to the Pre-Raphælites, and they cannot be expected to conquer them at first: but it is a great disappointment to me to observe, even in the painting of the goat itself, and of the fillet on its brow, a nearly total want of all that effective manipulation which Mr Hunt displayed in his earlier pictures. I do not say that there is absolute want of skill—there may be difficulties encountered which I do not perceive—but the

'Cutting Reviews' by James Smetham (1855)

difficulties, whatever they may have been, are not conquered: this may be very faithful and very wonderful painting—but it is not a good painting; and much as I esteem feeling and thought in all works of art, still I repeat, again and again, a painter's business is first to paint. No one could sympathize more than I with the general feeling displayed in the 'Light of the World'; but unless it had been accompanied with perfectly good nettle painting, and ivy painting, and jewel painting, I should never have praised it; and though I acknowledge the good purpose of this picture, yet, inasmuch as there is no good hair-painting, nor hoof-painting in it, I hold it to be good only as an omen, not as an achievement; and I have hardly ever seen a composition, left apparently almost to chance, come so unluckily: the insertion of the animal in the exact centre of the canvas, making it look as if it were painted for a sign. I can only, therefore, in thanking Mr Hunt heartily for his work, pray him, for practice sake, now to paint a few pictures with less feeling in them, and more handling.

# ◪ The 1860s ◪

## LETTERS, DIARIES AND REFLECTIONS

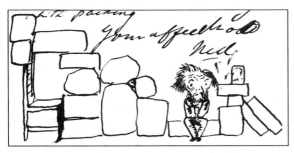

Self-caricature by Edward Burne-Jones in a letter to
William Holman Hunt (1861)

### Georgiana Macdonald Burne-Jones
### From *The Memorials of Edward Burne-Jones*

[1860]

William Allingham came over from Ireland this
summer, and was, I believe, the first friend I made
in my new life. How well I remember his visit,
even to where he stood in the room and the way
the light fell upon him. He was a distinguished-
looking man, though not tall; dark, with a fine cast
of face and most Irish eye—light in the darkness;
his thick black hair was brushed close to his head
and parted in the middle, but rippled in smooth,
close lines that no brush could straighten. He was
disposed to convince me that I was a sister of
George MacDonald the novelist, for the *dramatis
personæ* of his life were of importance to him and
this arrangement fitted in well with his conception
of their order. His conversation was extremely
interesting; serious in manner, with an attractive
reserve which yet gave the impression that he
cared for sympathy, and an evident minute interest
in all that passed before him; a good companion,
ready to talk and easily amused. He did not stay
long in London, having to return to Ballyshannon,
his native place, where at that time he had an
appointment in the Customs, but the threefold
friendship then begun never ceased.

In the unsettled week before his marriage
Edward had amused himself by painting some
figures upon a plain deal sideboard which he
possessed, and this in its new state was a
delightful surprise to find. 'Ladies and animals' he
called the subjects illustrated, and there were
seven pictures, three on the cupboard doors in
front and two at each end, which shewed them in
various relations to each other. Three kind and
attentive ladies were feeding pigs, parrots and
fishes; two cruel ones were tormenting an owl by
forcing him to look at himself in a round mirror,
and gold fish by draining them dry in a net; while
two more were expiating such sins in terror at a
hideous newt upon the garden path and the
assault of a swarm of angry bees. Mrs. Catherwood
gave us a piano, made by Priestly of Berners
Street, who had patented a small one of inoffensive
shape that we had seen and admired at Madox
Brown's house; we had ours made of unpolished
American walnut, a perfectly plain wood of
pleasing colour, so that Edward could paint upon
it. The little instrument when opened shows
inside the lid a very early design for the 'Chant
d'Amour', and on the panel beneath the keyboard
there is a gilded and lacquered picture of Death,
veiled and crowned, standing outside the gate of a
garden where a number of girls, unconscious of
his approach, are resting and listening to music.
The lacquering of this panel was an exciting
process, for its colour had to be be deepened by
heat while still liquid, and Edward used a red-hot
poker for the work.

Rossetti and his wife, after their return from
Paris, took a lodging at Hampstead, but she was so
ill at first that we never saw her till near the end of
July, when to our great delight a day was fixed for
the deferred meeting, and Gabriel suggested that it
should take place at the Zoological Gardens. 'The
Wombat's Lair' was the assignation that he gave to
the Madox Browns and to us. A mention of this
meeting in a letter that I wrote next day gives the

impression of the actual time: 'She was well enough to see us, and I find her as beautiful as imagination, poor thing.'

I wish I could recall more details of that day of the wombat's reception of us, and of the other beasts we visited—but can only remember a passing call on the owls, between one of whom and Gabriel there was a feud. The moment their eyes met they seemed to rush at each other, Gabriel rattling his stick between the cage bars furiously and the owl almost barking with rage. Lizzie's slender, elegant figure—tall for those days, but I never knew her actual height—comes back to me, in a graceful and simple dress, the incarnate opposite of the 'tailor-made' young lady. We went home with them to their rooms at Hampstead, and I know that I then received an impression which never wore away, of romance and tragedy between her and her husband. I see her in the little upstairs bedroom with its lattice window, to which she carried me when we arrived, and the mass of her beautiful deep-red hair as she took off her bonnet: she wore her hair very loosely fastened up, so that it fell in soft, heavy wings. Her complexion looked as if a rose tint lay beneath the white skin, producing a most soft and delicate pink for the darkest flesh-tone. Her eyes were of a kind of golden brown—agate-colour is the only word I can think of to describe them—and wonderfully luminous: in all Gabriel's drawings of her and in the type she created in his mind this is to be seen. The eyelids were deep, but without any languor or drowsiness, and had the peculiarity of seeming scarcely to veil the light in her eyes when she was looking down.

Whilst we were in her room she shewed me a design she had just made, called 'The Woeful Victory'—then the vision passes.

A little later and we were with the Morrises in their new house at Upton, and the time we spent together there was one to swear by, if human happiness were doubted.

First was the arrival at Abbey Wood Station, a country place in those days, where a thin fresh air full of sweet smells met us as we walked down the platform, and outside was the wagonette sent from Red House to meet us; then a pull up the hill and a swinging drive of three miles of winding road on the higher land until, passing 'Hog's Hole' on the left, we stopped at our friends' gate. I think Morris must have brought us down from town himself for I can see the tall figure of a girl standing alone in the porch to receive us.

It was not a large house, as I have said, but purpose and proportion had been so skilfully observed in its design as to arrange for all reasonable demands and leave an impression of ample space everywhere. It stood facing a little west of north, but the longest line of the building had a sunny frontage of west by south, and beneath its windows stretched a green bowling alley where the men used to play when work was over. For it was by no means on a holiday that Edward had come down, nor only to enjoy the company of his friend again, but that they might consult together about the decoration of the house, of which much is said in the Notes from which I have so often quoted.

'The house was strongly built of red brick, and red tiled: the porches were deep and the plan of the house was two sides of a quadrangle. In the angle was a covered well. As we talked of decorating it plans grew apace. We fixed upon a romance for the drawing-room, a great favourite of ours called Sir Degrevaunt. I designed seven pictures from that poem, of which I painted three that summer and autumn in tempera. We schemed also subjects from Troy for the hall, and a great ship carrying Greek heroes for a larger space in the hall, but these remained only as schemes, none were designed except the ship. The great settle from Red Lion Square, with the three painted shutters above the seat, was put up at the end of the drawing-room, and there was a ladder to its top and a parapet round it, and a little door above, in the wall behind it, that led into the roof. There at Christmas time it was intended that minstrels should play and sing. I began a picture from the Niebelungen Lied on the inside of one of the shutters of this settle, and Morris painted in

tempera a hanging below the Degrevaunt pictures, of bushy trees and parrots and labels on which he wrote the motto he adopted for his life, "If I can'" He worked hard at this and the room began to look very beautiful.'

On one of his visits to Red House Rossetti found many of these labels still blank, waiting for the words 'If I can', and in his reckless way instantly filled them with another motto, 'As I can't'. When Morris saw this pleasantry, Edward said, 'it would have puzzled the discriminator of words to know which of those two was most eloquent in violent English.'

Charles Faulkner came down a couple of days after we did, and helped to paint patterns on walls and ceilings, and played played bowls in the alley, and in intervals between work joined in triangular bear-fights in the drawing-room. Once, in the middle of a scrimmage that had surged up the steps into the 'Minstrels' Gallery' he suddenly leapt clear over the parapet into the middle of the floor with an astounding noise; another time he stored windfallen apples in the gallery and defended himself with them against all comers until a too well-delivered apple gave Morris a black eye; and then, remembering that Morris had promised to give away one of his sisters at her marriage a day or two afterwards, Edward and Faulkner left him no peace from their anticipations of the discredit his appearance would bring upon the ceremony.

A few days before this we had been telling each other riddles, and one of us asked, 'Who killed his brother Cain?' Morris instantly fell into the trap and shouted, 'Abel, of course!' amidst a peal of laughter from us all. Afterwards he thought it very funny himself, so on his return from the wedding we were not surprised to learn that he had amused the company at breakfast by trying the trick on some one else. 'I asked the parson'—he told us triumphantly—'I asked him "Who killed his brother Abel?" and when of course he said "Cain", I said "Hah! I knew you'd say that—every one says it." ' And we laughed again, more than before.

Oh, how happy we were, Janey and I, busy in the morning with needlework or wood-engraving, and in the afternoon driving to explore the country round by the help of a map of Kent; we went to the Crays one day and to Chislehurst Common another, finding some fresh pleasure everywhere and bringing back tales of our adventures to amuse the men we had left working at home. Sometimes, but not often, they would go with us, for Edward always hated 'expeditions', and was only supported in them by good fellowship; nor did he at any time seek the country for its own sake. At this I have often wondered, for the backgrounds of his pictures shew how deeply it touched his imagination and feeling: and I came to the conclusion that one reason why he found so little peace and rest in it might be that he did not, and perhaps could not, submit himself passively to its influence, but was forever dealing with it as an instrument. In a note written to his father during this very visit to Red House he says, 'I hate the country—apples only keep me in good spirits—Topsy's garden is perfectly laden with them.' I remember his dread of anything that appealed to the sadness which he shared with all imaginative natures, who 'don't need to be *made* to feel', he said, and I believe that this 'hatred' was partly an instinct of self-preservation from the melancholy of autumn in the country.

The Niebelungen Lied design of which Edward speaks was never finished, and if it was begun upon the back of either of the beautiful 'Salutations of Beatrice' which Rossetti painted on the outside of the doors of the big settle, it may perhaps still remain there.

It will be taken for granted that the two men visitors had endless jokes together at the expense of their beloved host. The dinner hour, at middle day, was a great time for them because Mrs. Morris and I were there, either as eager onlookers at the fun or to take sides for and against. The dining-room was not yet finished, and the drawing-room upstairs, whose beautiful ceiling had been painted by Mr. and Mrs. Morris, was being decorated in different ways, so Morris' studio, which was on the

same floor, was used for living in, and a most cheerful place it was, with windows looking three ways and a little horizontal slip of a window over the door, giving upon the red-tiled roof of the house where we could see birds hopping about all unconscious of our gaze.

Perhaps the joke which made two out of the three men happiest at dinner-time was that of sending Morris to Coventry for some slight cause and refusing to exchange a word with him at his own table: it was carried on with an unflinching audacity that I cannot hope to describe, and occasionally reached the height of their asking Mrs. Morris if she would be good enough to communicate with her husband for them and tell him anything they wished to say—but a stranger coming in upon our merriment would never have guessed from the faces of the company who were the teasers and who the teased.

After work, when it was dark, sometimes there was a game of hide-and-seek all over the house. A fragment of one of these games remains in my memory, and I see that Edward, leaving the door open behind him, has slipped into an unlighted room and disappeared into its black depths for so long that Mrs. Morris, who is the seeker, grows almost terrified. I see her tall figure and her beautiful face as she creeps slowly nearer and nearer to the room where she feels sure he must be, and at last I hear her startled cry and his peal of laughter as he bursts from his hiding-place. There was a piano in the sitting-room, and in the evenings we had music of a simple kind—chiefly the old English songs published by Chappell and the inexhaustible *Echos du Temps Passé*.

Many flowering creepers had been planted against the walls of the house from the earliest possible time, so that there was no look of raw newness about it; and the garden, beautified beforehand by the apple-trees, quickly took shape. In front of the house it was spaced formally into four little square gardens making a big square together; each of the smaller squares had a wattled fence round it with an opening by which one entered, and all over the fence roses grew thickly.

The stable, with stalls for two horses, stood in one corner of the garden, end on to the road, and had a kind of younger-brother look with regard to the house. The deep porches that Edward mentions were at the front and the back of the house; the one at the back was practically a small garden-room. There was a solid table in it, painted red, and fixed to the wall was a bench where we sat and talked or looked out into the well-court, of which two sides were formed by the house and the other two by a tall rose-trellis. This little court with its beautiful high-roofed brick well in the centre summed up the feeling of the whole place.

One morning as Janey and I sat sewing (she was an exquisite needlewoman) I saw in her basket a strange garment, fine, small, and shapeless—a little shirt for him or her—and looking at my friend's face I knew that she had been happy when she made it; but it was a sign of change, and the thought of any change made me sigh. We paid other visits to the Morrises after this, but none quite like it-—how could they be?

Speaking of Red House in the Notes Edward says: 'It was from the necessity of furnishing this house that the firm, Morris, Marshall, Faulkner and Co., took its rise. There were the painted chairs and the great settle of which mention has been made already, but these went only a little way. The walls were bare and the floors; nor could Morris have endured any chair, table, sofa or bed, nor any hangings such as were then in existence. I think about this time Morris' income that was derived from copper mines began to diminish fast, and the idea came to him of beginning a manufactory of all things necessary for the decoration of a house. Webb had already designed some beautiful table-glass, made by Powell of Whitefriars, metal candlesticks, and tables for Red House, and I had already designed several windows for churches, so the idea grew of putting our experiences together for the service of the public. For the fireplaces at Red House I designed painted tiles, but the floors were covered with Eastern carpets, for it was some years afterwards when Morris added that industry to his many

others. For the walls of other rooms than the drawing-room at Red House Morris designed flower-patterns, which his wife worked in wool on a dark ground, and it was a beautiful house.'...

Swinburne was the next remarkable personality I remember in these days; he had rooms very near us and we saw a great deal of him; sometimes twice or three times in a day he would come in, bringing his poems hot from his heart and certain of welcome and a hearing at any hour. His appearance was very unusual and in some ways beautiful, for his hair was glorious in abundance and colour and his eyes indescribably fine. When repeating poetry he had a perfectly natural way of lifting them in a rapt, unconscious gaze, and their clear green colour softened by thick brown eyelashes was unforgettable: 'Looks commercing with the skies' expresses it without exaggeration. He was restless beyond words, scarcely standing still at all and almost dancing as he walked, while even in sitting he moved continually, seeming to keep time, by a swift movement of the hands at the wrists, and sometimes of the feet also, with some inner rhythm of excitement. He was courteous and affectionate and unsuspicious, and faithful beyond most people to those he really loved. The biting wit which filled his talk so as at times to leave his hearers dumb with amazement always spared one thing, and that was an absent friend.

There was one subject which in these days he raised our hopes that he might deal with; but the time passed, and now we shall never see his proposed Diary of Mrs. Samuel Pepys, kept concurrently with that of her husband.

Dear Lizzie Rossetti laughed to find that she and Swinburne had such shocks of the same coloured hair, and one night when we went in our thousands to see 'Colleen Bawn', she declared that as she sat at one end of the row we filled and he at the other, a boy who was selling books of the play looked at Swinburne and took fright, and then, when he came round to where she was, started again with terror, muttering to himself 'There's another of 'em!' Gabriel commemorated one view

of her appearance in his rhyme beginning 'There is a poor creature named Lizzie, Whose aspect is meagre and frizzy', and there, so far as I remember, his muse halted; but he completed another verse on her to her great satisfaction, thus:

> There is a poor creature named Lizzie,
> Whose pictures are dear at a tizzy;
> And of this the great proof
> Is that all stand aloof
> From paying that sum unto Lizzie.

...It is pathetic to think how we women longed to keep pace with the men, and how gladly they kept us by them until their pace quickened and we had to fall behind. It was the same a few years later with the Du Mauriers, I remember: he brought his handsome fiancée, Miss Wightwick, to see us, and she and I took counsel together about practising wood-engraving in order to reproduce the drawings of the men we loved. I had begun it already, but she, though eagerly interested, had scarcely seen the tools required for the art, and I do not know how far she went in it. I can recall Du Maurier's distress though, when she drove a sharp graver into her hand one day. I stopped, as so many women do, well on this side of tolerable skill, daunted by the path which has to be followed absolutely alone if the end is to be reached. Morris was a pleased man when he found that his wife could embroider any design that he made, and did not allow her talent to remain idle. With Mrs. Rossetti it was a different matter, for I think she had original power, but with her, too, art was a plant that grew in the garden of love, and strong personal feeling was at the root of it; one sees in her black-and-white designs and beautiful little water-colours Gabriel always looking over her shoulder, and sometimes taking pencil or brush from her hand to complete the thing she had begun.

The question of her long years of ill-health has often puzzled me; as to how it was possible for her to suffer so much without ever developing a specific disease; and after putting together what I knew of her and what I have learnt in passing

through life, it seems to me that **Dr.** Acland's diagnosis of her condition in 1855 must have been shrewd, sympathetic, and true. He is reported by Gabriel as saying, after careful examination and many professional visits, that her lungs, if at all affected, were only slightly so, and that he thought the leading cause of her illness lay in 'mental power long pent up and lately overtaxed'; which words seem to me a clue to the whole matter. This delicately organized creature, who had spent the first sixteen years of her life in circumstances that practically forbade the unfolding of her powers, had been suddenly brought into the warmth and light of Gabriel's genius and love, under which her whole inner nature had quickened and expanded until her bodily strength gave way; but Rossetti himself did not realize this so as to spare her the forcing influence, or restrict his demands upon her imagination and sympathy. It is a tragic enough thought, but one is driven to believe that if such a simple remedy as what is now called a 'rest-cure' had been known of and sought for her then, her life might have been preserved. However, let us follow what we know.

Gabriel dreaded bringing her to live in London, where she was so often ill, but after vainly seeking for a house that would suit them at Hampstead or Highgate they resolved, as she seemed to have gained a little strength since her marriage, to try the experiment of wintering at Blackfriars.

## [1861]

This was a year of wonders quite different from those of 1856, for all its marvels were visible to others beside ourselves. Let who will smile, but to most people the sight of a first child is one of the miracles of life, and it is noteworthy that Morris, Rossetti, and Edward now went through this experience within a few months of each other. First came the owner of the little garment that was being fashioned for her when we were at Red House the summer before, and then, just as we were taking it for granted that all would go as well in one household as another, there was illness and

anxiety and suspense at Chatham Place, and poor Lizzie was only given back to us with empty arms. This was not a light thing to Gabriel, and though he wrote about it, 'She herself is so far the most important that I can feel nothing but thankfulness', the dead child certainly lived in its father's heart. 'I ought to have had a little girl older than she is', he once said wistfully as he looked at a friend's young daughter of seven years.

When we went to see Lizzie for the first time after her recovery, we found her sitting in a low chair with the childless cradle on the floor beside her, and she looked like Gabriel's 'Ophelia' when she cried with a kind of soft wildness as we came in, 'Hush, Ned, you'll waken it!' How often has it seemed to us that if that little baby had lived she, too, might have done so, and Gabriel's terrible melancholy would never have mastered him.

Lizzie's nurse was a delightful old country woman, whose words and ways we quoted for years after wards, her native wit and simple wisdom endeared her to both Gabriel and Lizzie, and were the best possible medicine for their over-strained feelings. Naturally, after meeting her at Blackfriars, we invited her to come to us.

On the day little Jane Alice Morris was christened many friends went down to Red House for the christening feast, and beds were made up for their accommodation at night in the true Red Lion Square spirit of hospitality, the drawing-room being turned into a big dormitory for the men. At dinner I sat next to Rossetti, and noticed that even amidst such merry company he fell silent occasionally and seemed absent in mind. He drank water only, and, after he had helped himself, I asked him if he would give me some, which he did with an instant return to the scene before him, saying at the same time with grave humour in his sonorous voice, 'I beg your pardon, Georgie: I had forgotten that you, like myself, are a temperate person.'

At this time Faulkner was thinking seriously about leaving Oxford, for he longed to share the struggle which he saw his old companions beginning in a wider world: they, of course,

encouraged this desire, and Edward, for one, says distinctly, 'I'm doing all I can to persuade him to leave Oxford and settle in London at some profession.' This happened a few months later, when Faulkner came up to town and entered the office of a civil engineer, where he patiently sat and drew rivets by the thousand in plans for iron bridges or at least that was the impression we had of his occupation. Out of office hours he kept the books of the firm of Morris, Marshall, Faulkner and Co., now legally registered partners in business...

We continued the excellent habit of going to Red House very often from Saturday afternoon to Monday morning, when we would return to town with Morris, who came up every day to the works at 8, Red Lion Square. This place become a fresh centre for friendly as well as business meetings of the members of the firm, and here they laid plans for the future, discussed work going on at the moment, and in the intervals told anecdotes and played each other tricks which prolonged the youth that seemed as if it would never fail.

On one of these evenings Madox Brown surpassed himself in a display of his peculiarity of forgetting names. He wanted something brought upstairs, but, in order to make sure of calling the right person, first turned round and carefully asked: 'What is the name of your housekeeper, Morris?' 'Button', answered Morris. Whereupon it took no longer than his stepping to the head of the stairs before Madox Brown was heard shouting in his slow, clear voice, 'Mrs. Penny, will you—' but applause drowned the rest. Another time Morris being called away during a meeting, the devil suggested to Faulkner that it were well in his absence to make an elaborate 'booby-trap' to await his return; so the London Directory and two large copper candlesticks were swiftly balanced by his clever fingers upon the top of the half-open door, and of course at Morris's entrance fell like 'Goddes grame' 'right a-middlewards of his crown.' Bumping and rebounding they rolled to the ground, while Morris yelled with the enraged surprise of startled nerves, and was very near to

serious anger, when Faulkner changed everything by holding him up to opprobrium and exclaiming loudly in an injured voice, 'What a bad-tempered fellow you are!' The 'bad-tempered' one stopped his torrent of rage looked at Faulkner for a second, and then burst into a fit of laughter, which disposed of the matter.

'The Co. gets on', Edward wrote to Cormeli Price in Russia; 'have you heard of the Co.? It's made of Topsy, Marshall, Faulkner, Brown, Webb, Rossetti and me—we are partners and have a manufactory and make stained glass, furniture, jewellery, decoration and pictures; we have many commissions, and shall probably roll in yellow carriages by the time you come back.'...

[1862]

Mr. Ruskin's return to England at the end of the year was a great comfort to us, and as Edward slowly gathered strength we began to let our hearts dwell on the thought of carrying out a hope long cherished of going with him to Italy. But first deep waters had to be passed through. One morning in February—a dark and cold one—Edward had settled as usual to such work as the light permitted, when there came a tap at the door, and to our surprise Red Lion Mary [The housekeeper at Red Lion Square] entered. How she told her tale I do not know, but first we heard the words 'Mrs. Rossetti', and then we found that she had come to bring us the dreadful news that our poor, lovely Lizzie was dead, from an overdose of laudanum—so, begging Edward not to risk going out on such a day, I hastened to Blackfriars to bring him any word I could learn about the unhappy Gabriel.

The story can never lose its sadness. To try to tell it afresh now, with a knowledge of its disastrous effect upon one of the greatest of men, would be for me impossible. I will simply transcribe something I wrote about it the next day to one of my sisters: 'I am sure you will feel for Gabriel and all of us when I tell you poor Lizzie died yesterday morning. I scarcely believe the words as I write them, but yesterday I saw her

dead. The evening before she was in good health (for her) and very good spirits—she dined with her husband and Swinburne and made very merry with them—Gabriel took her home, saw her prepare for bed, went out to the Working Men's College, and on his return found her insensible from the effects of an overdose of laudanum which she was used to take medicinally. She never knew him or anyone else for a second—four physicians and a surgeon did everything human skill could devise, but in spite of them all she died, poor darling, soon after seven in the morning. The shock was so great and sudden that we are only beginning to believe it today—I wonder at myself for writing about it so coolly. I went down directly I heard it and saw her poor body laid in the very bed where I have seen her lie and laugh in the midst of illness, but even though I did this I keep thinking it is all a dreadful dream. Brown was with Gabriel and is exactly the man to see to all the sad business arrangements, for of course under such circumstances an inquest has to be held. Of course I did not see Gabriel. Edward is greatly troubled as you will believe, and all the men. I leave you to imagine the awful feeling there is upon us all. Pray God to comfort Gabriel.'

The Chatham Place days were ended now, and Rossetti in his sorrow turned to his mother, whose grave tenderness must have been a refuge for his wounded heart, and went for a time to live in Albany Street with her and his sisters and brother. Poor Lizzie's bullfinch went there too, and sang as sweetly and looked as sleek and cheerful as ever...

On our return [from Milan] we found Rossetti well in health and settled at work in Lincoln's Inn Fields, where he had taken chambers whilst arrangements were being made for his removal to a beautiful old house at Chelsea: he had never gone back to live in Chatham Place after his wife's death. The firm was in great activity; had received two medals for what it shewed at the International Exhibition, and many commissions from it were waiting for Edward; amongst them one for coloured tiles which proved

a welcome outlet for his abounding humour, and in this form the stories of Beauty and the Beast and Cinderella took at his hands as quaint a shape as they wear in the pages of the Brothers Grimm of blessed memory. Some 'lay' stained glass also was demanded, for which he designed a scene in the story of King Mark and La Belle Iseult. His regular habit now and for years afterwards was to design and draw such things in the evening—the presence of friends making no difference—and men returned to the habit of dropping in after dinner almost as freely as before his marriage. Of Charles Faulkner we saw a great deal, as he and his family had left Birmingham and were settled in Queen Square, Bloomsbury, near and welcome neighbours. He was the eldest surviving son of a widowed mother; two sisters and a young brother completed the household. Both sisters shared Faulkner's own skill of hand, and one of them, as it proved, was but waiting time and opportunity to develop a power of beautiful ornamental design: friendship with them was a foregone conclusion, and between Kate Faulkner and me there grew up a lifelong intimacy: both Morris and Edward loved her also. Gabriel came to us at rare intervals—once It was to see his godson, to whom his manner was very tender and another evening he wrote down for us a song which he said was the first he had written for an age. It was now that we learned of his having by a passionate impulse put into the coffin of his poor Lizzie the manuscript volume which contained almost all the poems he had written, and we feared they were lost for ever; so those who loved him began to compare notes and write out what they could remember. Swinburne of course was chief at this, and dictated some to us out of his marvellous memory; amongst others Sister Helen, of which we sent out a copy to Mr. Ruskin, who had asked for any that we could lay hands on.

[1865]
Two small parchment-bound volumes of accounts between Edward and the firm, covering the years 1861-1898, are excellent reading: on his side torrents of fun and on the other bald statements

and figures. There are drawings also, in the form of sketches for stained-glass windows, in one of which Morris is represented plump and prosperous against a background of the vine, holding a brimming beaker in his outstretched hand, while opposite to him stands Edward, a thin and starving prisoner.

…The exact date of a party given by Rossetti in April is fixed as the 12th by its being the day that the Lockwood Kiplings, who were to have been amongst the guests, left England: it had been put off because Gabriel could not get the workmen out of the house who were doing something to his dining-room. Originally the invitations had been to dinner, but, with the frankness that reigned amongst us, as time went on Gabriel announced that he had asked too many people for that—he could not afford it—and it must be an evening party instead. No Thames Embankment had reached Chelsea then, and only a narrow road lay between the tall iron gates of the forecourt of 16, Cheyne Walk, and the wide river which was lit up that evening by a full moon. Gabriel had hung Lizzie's beautiful pen-and-ink and watercolour designs in the long drawing-room with its seven windows looking south, where if ever a ghost

returned to earth hers must have come to seek him: but we did not sit in that room, the studio was the centre of the house. For the sake of those vanishing days let me name some of the people present that evening. William Rossetti and William Bell Scott were there; and Swinburne, who I think was then sharing the house with Gabriel; Morris and his wife had dined with us first, and we all came on together. Of course there were the Madox Browns, and with them were their two daughters—nothing further from expectation at the moment than a marriage that took place nine years later between the elder of these and William Rossetti. Munro the sculptor and his wife, Mr. and Mrs. Arthur Hughes, and the Warrington Taylors came, as well as Legros with his pale, handsome English wife: Christina Rossetti and Mrs. Bell Scott would have been there, we were told, but that it was Passion Week. I remember noticing that night a sign that we were mortal in the fact of Madox Brown's beautifully-thick thatch of hair having turned very grey, at which his wife when the men were not in the room expressed great vexation. He was not changed otherwise though, and made us happy with a long, characteristic description of the way by which he had brought his wife and daughters from Kentish Town in order to save cab-fare. First of all they had taken train for Kew, because he thought it must be near Chelsea. At Kew they were advised to wait half an hour and then go on to Clapham Junction, where they would catch a train for Chelsea: this they exactly missed, and found there was no other for three-quarters of an hour. Finally, on reaching Chelsea Station, it proved to be so far from Cheyne Walk that they then took a cab, and arrived smiling and unruffled at Gabriel's door after two hours and a half by road and rail. I wish I could recall more details of the evening, which is still present to me as a scene, but nothing else of interest detaches itself from the background of house and studio.

One of the happiest chapters of our life was closed this year by the sale of Red House. But it had to go, for Morris, having decided in his

unflinching way that he must come up and live at his business in London, could not bear to play landlord to the house he loved so well—it must be sold outright and he would never see it again. Nor did he; but some of us saw it in our dreams for years afterwards as one does a house known in childhood.

## William Holman Hunt
### From *Pre-Raphælitism and the Pre-Raphælite Brotherhood*

[1860]
Before he [Millais] was twenty he had painted a picture which bore signs of more capacious ability in conception, composition, drawing, colour, and technical qualities combined than any painter ever displayed at such youthful age. He had now been before the world in varying, but always great power for ten or more years, he had added to the glory of modern art, and he had a right to expect the ampler opportunities of exercising his genius which the old masters had universally been afforded, instead of merely securing a tardy livelihood. But critics had hung about his heels, and often so far impeded him that, instead of large or laborious efforts, he had been forced to do humbler works that would more easily come within the taste and the means of the general dealer and buyer. In no other age would such an artist have been left without some national opportunity of exercising his genius. There were indeed painters and sculptors being employed to decorate the Palace at Westminster, but no public minister amidst the clamour that had been raised against our 'heresy' would, however much he might have been instigated by his own taste, have had the courage to employ any one of us in public work, and Millais was never asked by any church dignitaries to paint for them. While his works were still vehemently abused by the press, those of artists of mediocrity were lauded to the skies, and certain of these painters were favoured by Parliamentary Commissioners of Fine Art. Now,

persons of superficial reflection often say that Millais ought not under any temptation to have swerved from his higher inspirations, but great art cannot be produced even by men of the purest genius, if they are not supported by the country's demand for their work; the nation must be behind them, just as it must equip and provide for the soldier fighting for its cause. Raphæl, when commissioned by the Pope to paint the 'Stanze', was only twenty-five years of age, and there can be no sober doubt that he had not then done work of such original power as Millais had shown before he was that age. Had Raphæl died before his work in the Vatican was under-taken, his earlier paintings facile and obediently learned as they were, would have placed him only in the second rank of Italian artists. Surely a man of genius has a right to marry when he has established his commanding, and being married he is called upon to support his family. Millais in this position found himself driven to despair and want of faith, in the possibility of teaching his countrymen the value of poetic art. 'I have striven hard', he said to me, 'in the hope that in time people would understand me and estimate my best productions at their true worth, but they (the public and private patrons) go like a flock of sheep after any silly bell-weather who clinks before them. I have, up to now, generally painted in the hope of converting them to something better, but I see they won't be taught, and as I must live, they shall have what they want, instead of what I know would be best for them. A physician sugars his pill, and I must do the same.' There was a great rage at the time, under the directions of a certain leader of the rout, that painters should do works only of contemporary subjects. The incidents that are historically important are rarely recognised to be so till many years afterwards…The demand for representations of trivial incidents was steady, and Millais being encouraged to seek these, often displayed great taste in their selections and treatment. His 'Apple Blossoms' (1859) was an excellent example of this class. 'Trust Me' had many pictorial excellences, and 'My First Sermon'

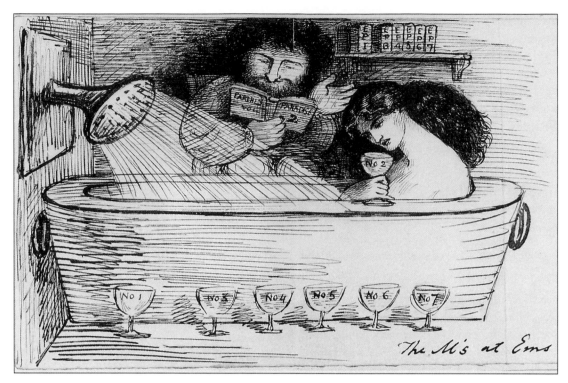

Dante Rossetti's caricature of the Morrises: 'The M's at Em's' (1869)

and 'My Second Sermon' were endearing efforts of his power in this strain; but some which it is needless to instance, however excellent in workmanship, must have been done simply to meet the vulgar demand.

[1862]

In the beginning of 1862 all London was enthusiastically stirred in expectation of the glories of the forthcoming International Exhibition, which was to be more extended and superb than any that had preceded it. Sir Thomas Fairbairn, one of the great movers in the Manchester Loan Collection of 1857, was one of the guarantors of the new venture, and came to London to take his place on the board. Pictures and marbles were borrowed from afar, and the prospects were of the most promising character when, one Sunday morning while people were on their way to church, the ominous bell of St. Paul's tolled out the mournful loss that the much-esteemed Prince Consort was dead. This distressful loss grieved the whole nation and threw

a great pall over the fortunes of the Exhibition;— but preparations had gone too far to allow it to be postponed, and when the opening day came, the joy at the accomplishment of the undertaking and prospects of the gathering together of the latest industrial achievements of the world was not less because of undemonstrative nature. Some of Millais' and my pictures, and, for the first time, several of Woolner's works in marble, were exhibited. In other particulars the Exhibition was of interest to me, for there the firm of Morris, Brown, and Rossetti demonstrated publicly for the first time in our age that the designing of furniture and utensils was the proper work of artists themselves. The determination on the part of the new firm to be markedly different in all their productions to the works usually supplied to the market, had made many of their contrivancies eccentric, so that the common world stigmatised their tables as rough benches, their sofas as racks, and their beds as instruments of torture; but the designers themselves learnt their lesson, and eventually started an admirable line.

## William Bell Scott
### From *Autobiographical Notes*

[1860]

W.M.R. next asks me if I knew that Gabriel is about to marry or, perhaps, is now married to Miss Siddal, whom you have heard about and possibly seen? The family had been a little taken by surprise at receiving from him at Hastings, about a month before, the definite announcement of the forthcoming event, then to be enacted as soon as possible. Still later he had determined that it might possibly be on last Saturday, his thirty-second birthday. She is in the opinion of everyone a beautiful creature with fine powers and sweet character. If only her health should become firmer after marriage, William thinks it will be a happy match. At all events he is glad that Gabriel is settled upon it. 'He leaves Blackfriars, but I think has not yet managed to suit himself elsewhere.' This sudden news was the first I heard of Gabriel's marriage; nor did either I or his own family hear directly from him for some little time after. Instead of leaving Blackfriars he at last appeared there with his wife, where he fitted up another room or two and continued to live till her death.

IX. Three months later (in the summer of 1860) I was for the first time visiting Miss Boyd and her brother at Penkill Castle in Ayrshire. My wife was in London, and writes me about the people she meets.

> I am truly glad [she says] you are in such good company as Miss Boyd and her brother, and finding such delightful landscape subjects in the glen. On Wednesday we drove to the top of Highgate Hill, where is S. Mary Magdalene Home. We spent a pleasant day with the sisters and penitents in the open air, the Bishop of London, etc. etc…Christina is now an Associate, and wore the dress, which is very simple, elegant even; black with hanging sleeves, a muslin cap with lace edging quite becoming to her with the veil. Yesterday, at All Saints, whence Christina and I went to see Woolner and the marble group for Wallington, which is now going on. It is beautiful: and there, too, at last I have met Tennyson. In the evening we had a party of about twelve, among whom were Mr. E. Burne-Jones and his wife. She is pretty, a very little creature, indeed, and sang the ballad of 'Green Sleeves' and others in loud wild tones quite novel and charming. E.B.J. I think extremely like a tall boy from school. William Morris and his wife also looked in, but only for a few minutes, having to go out of town by railway. You have not yet seen either of these ladies, and I now heard that Mrs. Gabriel Rossetti has not yet been seen in his mother's house, and has been invisible to every one. I can't think what country woman Mrs. Morris is like, not an Englishwoman certainly; but she did not untie her bonnet, their hour by the train being at hand. Mrs. D.G.R. has been ill—I suppose this preventing her coming out: she was really dangerously ill on their return from Paris, where she had been so well. Gabriel has been planning to take up his abode there. It seems Mrs. Madox Brown and her mother have been associated intimately somehow, so she is with her every day. All we little women looked quite diminutive beside Mrs. Morris.

These few words serve to show how nearly in point of time these matrimonial affairs came together; unless, indeed, the two now first mentioned above had not been late events, although the ladies were new to my wife. The Morris party going out of town indicates that the house he built after his marriage, the Red House, was already inhabited by them; and we must remember that the painting of the Union gallery at Oxford, if it had no artistic result, had an important one on the fate of William Morris. One evening, after the labours of the day, the volunteer artists of the Union regaled themselves by going to the theatre, and there they beheld in the front box above them what all declared to be the ideal personification of poetical womanhood. In this

case the hair was not auburn, but black as night; unique in face and figure, she was a queen, a Proserpine, a Medusa, a Circe—but also, strangely enough, a Beatrice, a Pandora, a Virgin Mary. They made interest with her family, and she sat to them. Morris was at that time sworn to be a painter; she sat to him; he forthwith ventured to propose marriage, and here they were, starting for his new house at Upton. In this house I first saw her. It was designed by Morris in what he called the style of the thirteenth century. The only thing you saw from a distance was an immense red-tiled, steep, and high roof; and the only room I remember was the dining-room or hall, which seemed to occupy the whole area of the mansion. It had a fixed settle all round the walls, a curious music-gallery entered by a stair outside the room, breaking out high upon the gable, and no furniture but a long table of oak reaching nearly from end to end. This vast empty hall was painted coarsely in bands of wild foliage over both wall and ceiling, which was open-timber and lofty. The adornment had a novel, not to say startling, character, but if one had been told it was the South Sea Island style of thing one could have easily believed such to be the case, so bizarre was the execution. This eccentricity was very easily understood after a little consideration. Genius always rushes to extremes at first; on leaving the beaten track of every day no medium is to be pre-served. The repudiation of whatever is modern in sentiment is immediate. There was the hatred of Louis XIV, and all possible relation to school advice and Birmingham taste. Morris did whatever seemed good to him unhesitatingly, and it has been very good: not 'Songs of the Art-Catholic', certainly, but 'Songs of mediæval life'; The Earthly Paradise has been the ultimate result. In ornament he succeeds not quite so well, but he has made an important position; by and by he will likely do better than anybody else.

X. Here under date of 5th October is something at last from D.G. R.; as usual, I make use of the letter only to carry forward my story

Many thanks for your note with its inquiries regarding my wife, who I trust improves gradually. She is certainly stronger now than some months back, and the approach of winter does not seem to hurt her yet. We sent no cards, too much trouble you know, or certainly you would have got some. My wedding-trip was rather prolonged, and no place out of my studio must know me this autumn, in spite of various invitations, tempting to wife and self.

Soon after he writes again:

Lizzie is gone for a few days to stay with the Morrises at their Red House at Upton, and I am to join her there to-morrow, but shall probably return before her, as I am full of things to do, and could not go there at all, but that I have a panel to paint there. I shall soon be taking up Leathart's picture, almost immediately, but have been much interrupted lately by getting settled. ...I wish you could see how comfortable we have made ourselves. And, by the bye, we have always a spare bedroom, which please do not forget when you and Mrs. Scott come to town.

This friendly invitation was never available, indeed could only have been so for the next season before a second summer D.G.R.'s married life was cut short by his wife's tragic death.

[1864]
When we returned to London towards the end of 1864, Alice Boyd, whom I shall probably in future designate by her monogram AB, also desiring to leave Newcastle, it was arranged that she should make her winter home with us. She was detained in the North by her brother's illness during our first winter in town, but every winter since she has been with us, and every year we have spent the late summer and autumn months at Penkill.

Penkill Castle, the ancient Ayrshire homestead of the younger branch of the Boyds, a family sufficiently historical in Scottish annals, had been suffered to fall into decay, the acres having

been sadly diminished, and Spencer, the heir, living in England. When he came of age, he devoted himself to its restoration, re-roofing the early part and building a great new staircase instead of the narrow newel of former years...

Every summer for nearly ten years l painted there. The 'friendship at first sight' [between Scott and Alice Boyd] was confirmed. Time could not strengthen it, but the impression or instinct of sympathy was changed by experience into satisfied conviction and confident repose...

As we sat painting together by the rushing Penwhapple stream, in the deep glen, which D.G.R. afterwards commemorated, listening to the 'Stream's Secret' before he put it into verse—and I too, by my three series of sonnets called *The Old Scottish Home, Outside the Temple*, and those entitled *Lost Love*, when there was a chance of AB's health giving way; or in town during the long winter evenings reading a hundred books or enjoying whatever a London season cast in our path,—there had never occurred a misunderstood word or wish which might divide us. My wife had faith in us too, and AB's brother [Spencer] as well.

**'Dante Gabriel Rossetti' by William Bell Scott (1891)**

[1868-1869]
It was now midsummer, and AB, finding D.R. in a depression of mind from the idea that his eyes were failing, prevailed upon him to accompany me to Ayrshire for an autumn vacation. He did so; we were a party of four Miss Boyd's cousin, Miss Losh of Ravenside, being a visitor at that time. This old lady—she was about seventy years of age—had somehow or other taken a jealous dislike to me, thinking I had too much influence over her younger cousin, who entertained me so much and who lived with us in London in the winter. She had therefore looked forward to Rossetti's appearance, fully intending to play him off against me, which accordingly she did in the most fantastic way, without in the least knowing anything of the fearful skeletons in his closet, that were every night, when the ladies had gone, brought out for his relief and my recreation. These skeletons, which were also made to dance along the mountain highroad during our long walks, would have surprised the old lady not a little. They shall not be interviewed here, and without them we got on pretty well, although his talk continually turned upon his chance of blindness and the question, why then should he live? 'Live for your poetry', said I. Strangely enough, this seemed never to have occurred to him as a possible interest or resource. Live for your poetry was echoed by the ladies.

We determined to follow up the suggestion, little as we believed in the seriousness of his monomania about blindness. One day, when Miss Boyd was with us on a walk up Penkill Hill, we persuaded him to recall such of his poems as he could recollect, and he repeated *The Song of the Bower*, perhaps the most perfect of all his early verses in harmony between sound and sense, cadence and sentiment. I understood because I

know the history of this pagan poem; AB did not, having neither heard nor read any of his verses, except such as were published in the *Germ*, or in the *Oxford and Cambridge Magazine*. She could scarcely speak, so moved she was, and I confess that I was almost for the first time conscious of the full value of his faculty. Lifted to this rhetorical moment I said much, affirming that the value of his paintings lay in their poetry, that he was a poet by birthright, not a painter. After this I found there was established in his mind a new prevailing idea, able to contend with the monomania, and when we left for London at the end of September he had begun to write out many of his lost poems, his memory being so good. Many loose poems he also had by him in manuscript, and by and by he began to send them to the printer.

Before this return to town, however, the old lady's admiration had culminated in an offer of a loan of money to any amount to prevent him using his eyes in painting or in any other trying occupation; he would get better and repay her, but till then he might depend on her. This generous offer was made one morning. He never got up till near midday, my difficulty every evening being to leave him after we had emptied endless tumblers of the wine of the country in the shape of whisky-toddy. This morning she had him all to herself, and her daily delight was to see him smashing his eggs on the plate, to the loss of half of them, and making innumerable impressions of his tea-cup on the damask table-cloth. 'You see, Alice dear', she would say to AB, 'he is not like one of us, he is a great man, can't attend to trifles, is always occupied with great ideas!' so she was often left to enjoy the sight all by herself at that hour of the day. She intended indeed that this plan should be a secret one between them, but no sooner had we started on our daily constitutional than he entrusted it to me, with much effusion and gratitude, at the same time protesting he would never think of availing himself of her kindness. This determination I strenuously encouraged, and we heard no more of the matter until after the old lady's death, when the evidences to the contrary

were all too clear.

Rossetti returned with me to Penkill next summer…[H]e was more hypochondriacal than ever, and our nightly sederunts more prolonged, so I did not do much, and Mr. Reid, the priest in question, had rather a holiday. Neither AB nor I saw or heard anything of chloral; we have therefore come to the conclusion that no such habit as that which was so injurious to him after his severe and too real illness had then been contracted. Miss Losh was not at Penkill that season, so Miss Boyd sometimes drove us about the country, instead of leaving us to take those long walks I found so trying in the previous year. One day she took us to the Lady's Glen, a romantic ravine in which the stream falls into a black pool round which the surrounding vertical rocks have been worn by thousands of years of rotating flood into a circular basin called, as many such have been designated, the Devil's Punch-Bowl. We all descended to the overhanging margin of the superincumbent rock; but never shall I forget the expression of Gabriel's face when he bent over the precipice peering into the unfathomed water dark as ink, in which sundry waifs flew round and round like lost souls in hell. In no natural spectacle had I ever known him to take any visible interest; the expression on his pale face did not indicate such interest; it said, as both Miss Boyd and I at the same moment interpreted it, 'One step forward and I am free!' But his daily talk of suicide had not given him courage; the chance so suddenly and unexpectedly brought within his grasp paralysed him. I advanced to him, trembling I confess, for I could not speak. I could not have saved him; we were standing on a surface, slippery as glass by the wet green lichen. Suddenly he turned round, and put his hand in mine, an action which showed he was losing self-command and that fear was mastering him. When we were safely away we all sat down together without a word, but with faces too conscious of each other's thoughts.

So for that time we escaped, and after all I did continue to be his keeper, or at least his

companion. We encountered no such danger again, but on the very next day, I think it was, occurred an adventure more extraordinary than any I have ever heard of in connection with a man writing his best poetry, painting his best pictures, and exercising a daily shrewdness of business habits, the wonder and admiration of all who were in any way connected with him. The feeble-minded English law declares the suicide to be of unsound mind, whereas he is anything but that; it is the privilege of man alone, the only reasoning suicidal creature in the world.

But the circumstance I am now to relate, indicating the subversion of reasoning itself, it appears to me highly desirable to place on record. It is a problem for doctors and psychologists alike. Mounting the ascending road towards Barr, we observed a small bird, a chaffinch, exactly in our path. We advanced: it did not fly but remained quite still, continuing so till he stooped down and lifted it. He held it in his hand: it manifested no alarm. 'What is the meaning of this?' I heard him say to himself, and I observed his hand was shaking with emotion. 'Oh', I said, 'put the pretty creature down again. It is strange certainly: it must be very young, perhaps a tame one escaped from a cage.' 'Nonsense!' was his reply, still speaking sotto voce, 'you are always against me, Scott. I can tell you what it is, it is my wife, the spirit of my wife, the soul of her has taken this shape; something is going to happen to me.' To this I had nothing to reply, but when we reached home its silence, by a chance which often takes place in life, incidents of similar kinds falling together, Miss Boyd hailed us with the news that the household had had a surprise—the house bell, which takes a strong pull to ring it, had been rung, and rung by nobody! Rossetti inquired when this had taken place, and finding it must have been just about the time when we met the bird, he turned his curiously ferocious look upon me, asking what I thought now?—a question as perplexing as the conviction under which he laboured! But I observed he did not relate the story of the bird to Miss Boyd with the same confidence he had shown at first, and when

he saw she was altogether averse to entertain it, he shut up at once. Nothing more was said at the time, but we have thought of it often since, trying in vain to understand him. He had brought a mass of 'proofs', and nearly every day brought him more. But besides he was writing better than in the earlier days: both *Eden Bower* and *Troy Town* were elaborated now. Almost every day he would seclude himself in the glen. Here I used to find him face to the wall lying in a shallow cave that went by the name of a seventeenth-century Covenanter, Bennan's Cave, working out with much elaboration and little inspiration, *The Stream's Secret*.

After it was done he did not know what to call this poem, till reading over my series of sonnets called *The Old Scotch House*, and finding one called 'The Stream's Secret', he simply appropriated that name for his own performance. Nothing would restrain him. 'No name in the world would suit me but that, it expresses what I want!' No doubt it did, but it also expressed what I wanted to say in my sonnet... A deadly quarrel I could not bear, so here, as always, he had his way...

I must return to the story of my dear friend D.G'.s poetic studies. They led him out of one difficulty into another. Before he left us, he had a volume in print, thin indeed and with the prose story of his early days called *Hand and Soul* inserted at the end. But what then? He would not publish. There cropped up the fear of a public ordeal of miscellaneous criticism, which had prevented him from exhibiting his water-colour pictures, and had shut him up exclusively in his own studio. If he could not publish, what else would he do with the printed poems? Give them to his friends with a preface as a privately printed volume? Even for this, considering the whole question, I could not help agreeing with him, that the introduction of the prose tale was an exhibition of poverty not to be thought of. He suddenly determined to reclaim the MS. book buried with his wife. What he wanted most was the poem called 'Jenny', written at the same time as he painted 'Found'. In a few days he was gone.

# LITERATURE

## Richard Watson Dixon
### From *Christ's Company and Other Poems* (1861)

### St. Mary Magdalene

Kneeling before the altar step,
 Her white face stretched above her hands;
In one great line her body thin
Rose robed right upwards to her chin;
Her hair rebelled in golden bands,
 And filled her hands;

Which likewise held a casket rare
 Of alabaster at that tide;
Simeon was there and looked at her,
Trancedly kneeling, sick and fair;
Three parts the light her features tried,
 She rest implied.

Strong singing reached her from within,
 Discordant, but with weighty rhymes;
Her swaying body kept the stave;
Then all the woods about her wave,
She heard, and saw, in mystic mimes,
 Herself three times.

Once, in the doorway of a house,
 With yellow lintels painted fair,
Very far off where no men pass,

Green and red banners hung in mass
Above scorched woodwork wormed and bare,
 And spider's snare.

She, scarlet in her form and gold,
 Fallen down upon her hands and knees,
Her arms and bosom bare and white,
Her long hair streaming wild with light,
Felt all the waving of the trees,
 And hum of bees.

A rout of mirth within the house,
 Upon the ear of madness fell,
Stunned with its dread, yet made intense;
A moment, and might issue thence
Upon the prey they quested well,
 Seven fiends of hell.

She grovelled on her hands and knees,
 She bit her breath against that rout;
Seven devils inhabited within,
Each acting upon each his sin,
Limb locked in limb, snout turning snout,
 And these would out.

Twice, and the woods lay far behind,
 Gold corn spread broad from slope to slope;
The copses rounded in faint light,
Far from her pathway gleaming white,
Which gleamed and wound in narrow scope,
 Her narrow hope.

She on the valley stood and hung,
    Then downward swept with steady haste;
The steady wind behind her sent
Her robe before her as she went;
Descending on the wind, she chased
    The form she traced.

She, with her blue eyes blind with flight,
    Rising and failing in their cells,
Hands held as though she played a harp,
Teeth glistening as in laughter sharp,
Flew ghostly on, a strength like hell's,
    When it rebels.

Behind her, flaming on and on,
    Rushing and streaming as she flew;
Moved over hill as if through vale,
Through vale as if o'er hill, no fail;
Her bosom trembled as she drew
    Her long breath through.

Thrice, with an archway overhead,
    Beneath, what might have seemed a tomb;
White garments fallen fold on fold,
As if limbs yet were in their hold,
Drew the light further in the gloom,
    Of the dark room.

She, fallen without thought or care,
    Heard, as it were, a ceaseless flow
Of converse muttered in her ear,
Like waters sobbing wide and near,
About things happened long ago
    Of utter woe.

### The Wizard's Funeral

For me, for me, two horses wait,
Two horses stand before my gate:
Their vast black plumes on high are cast,
Their black manes swing in the midnight blast,
Red sparkles from their eyes fly fast.
But can they drag the hearse behind,
Whose black plumes mystify the wind?

What a thing for this heap of bones and hair!
Despair, despair!
Yet think of half the world's winged shapes
Which have come to thee wondering:
At thee the terrible idiot gapes,
At thee the running devil japes,
And angels stoop to thee and sing
From the soft midnight that enwraps
Their limbs, so gently, sadly fair;—
Thou seest the stars shine through their hair.
The blast again, ho, ho, the blast!
I go to a mansion that shall outlast;
And the stoled priest who steps before
Shall turn and welcome me at the door.

### Waiting

By the ancient sluice's gate
Here I wait, here I wait;
Here is the sluice with its cramped stone,
Which the shadows dance upon.
        Here I wait.

Stone, with time-blots red and blue,
And white, the shadows tremble through,
When the sun strikes out through the
        poplars tall,
And the sun strikes out upon the wall.
        Here I wait.

From the sluice the stream descends
A bowshot; then its running ends
In flags and marsh flowers; then it runs
Bright and broad beneath the suns.
        Here I wait.

And to one side of it come down
The walls and roofs of our good town;
The other side for miles away
The willows prick it short and grey.
        Here I wait.

Any moment I might see
My lady in her majesty

Moving on from tree to tree
Where the river runs from me.
                    Here I wait.

Any moment she might rise
From the hedgerow, where my eyes
Wait for her without surprise,
While the first bat starts and flies.
                    Here I wait.

Here I lie along the trunk
That swings the heavy sluice-door sunk
In the water, which outstreams
In little runlets from its seams.
                    Here I wait.

The last yellowhammer flits,
The winds begin to shake by fits;
More coldly swing the mists and chase:
Thinking of my lady's face
                    Here I wait.

Like a tower so standeth she,
Built of solid ivory;
Her sad eyes well opened be,
Her wide hair runs darkly free.
                    Here I wait.

Her eyes are like to water-birds
On little rivers, and her words
As little as the lark, which girds
His wings to measure out his words.
                    Here I wait.

Here the crows come flying late—
One flies past me; past the gate
Of the old sluice another flies;
Heavily upwards they do rise.
                    Here I wait:

I am growing thoughtful now;
Will she never kiss my brow?
Solemnly I sit and feel
The edge upon my sword of steel.
                    Here I wait.

If she come, her feet will sound
Not at all upon the ground;
I think upon thy feet, my love,
Red as feet of any dove.
                    Here I wait.

Here my face is white and cold,
Here my empty arms I fold;
Here float down the beds of weeds,
With the fly that on them feeds.
                    Here I wait.

## The Judgment of the May

Come to the judgment, golden threads
        Upon golden hair in rich array;
Many a chestnut shakes its heads,
        Many a lupine at this day,
Many a white rose in our beds
        Waits the judgment of the May.

Oh, like white roses, great white queen,
        Come to the judgment, come to-day.
The white stars on thy robes of green
        Are like white roses on trees in May:
By me thy stars and flowers are seen,
        But now thou seemest far away.

## Sebastian Evans
### From *Brother Fabian's Manuscript and Other Poems* (1865)

### The Seven Fiddlers

A blue robe on their shoulder,
        And an ivory bow in hand,
Seven fiddlers came with their fiddles
        A-fiddling through the land,
And they fiddled a tune on their fiddles
        That none could understand.

For none who heard their fiddling
  Might keep his ten toes still,
E'en the cripple threw down his crutches,
  And danced against his will:
Young and old they all fell a-dancing,
  While the fiddlers fiddled their fill.

They fiddled down to the ferry—
  The ferry by Severn-side,
And they stept aboard the ferry,
  None else to row or guide,
And deftly steered the pilot,
  And stoutly the oars they plied.

Then suddenly in mid-channel
  These fiddlers ceased to row,
And the pilot spake to his fellows
  In a tongue that none may know:
'Let us home to our fathers and brothers,
  And the maidens we love below.'

Then the fiddlers seized their fiddles,
  And sang to their fiddles a song:
'We are coming, coming, O brothers,
  'To the home we have left so long,
'For the world still loves the fiddler,
  'And the fiddler's tune is strong.'

Then they stept from out the ferry
  Into the Severn-sea,
Down into the depths of the waters
  Where the homes of the fiddlers be,
And the ferry-boat drifted slowly
  Forth to the ocean free!

But where those jolly fiddlers
  Walked down into the deep,
The ripples are never quiet,
  But for ever dance and leap,
Though the Severn-sea be silent,
  And the winds be all asleep.

## Thomas Gordon Hake
### From *The World's Epitaph* (1866)

### *Life and Death (The Nightshade)*

There was a haunt, it does not change,
  Not while the fiend its path invades:
And he who did its alleys range
  Has willed his penance to its shades.
There still the nightshade breathes its pest
On fallen spirits not at rest.

A sadder theme in evil dwells
  Than all that grief can else supply;
Its fruits the parent-mind foretells,
  Ere on the child is stamped the die.
Tho' lengthened, bitter be his days
Who thus the infant soul betrays.

One who first saw the light in gloom,
  A darkness less of birth than death,
Had smiled by instinct at his doom
  As he drew in his early breath.
More like an angel born in hell,
He laughed to greet a happier spell.

Nor tree nor meadow had he seen;
  His world one dingy colour wore.
He did not know the fields were green,
  Tho' sky above he might adore,
But, born in broils, in squalor bred,
How knew his soul to where it led?

Such was his narrow earthly home,
  Where odours wander foul and dank,
Where road and house together come
  Like floor and wall within a tank.
Where faces nurtured by that air,
Add grimy looks to old despair.

And like the entrance to a drain,
  An alley ran into their den,
And souls were hoarded up for gain
  With rags and bones of famished men,
As if some starver, by his skill,
Had trained them up to do his will.

And so it was, the master-man
    Who owned these beings, rag and bone,
There carried out his monstrous plan,
    And bade his cursed will be done,
And all those souls out begging sent
To get the means to pay his rent.

Amidst this sight of bones and rags,
    That simple little soul to train,
From virtue's ways his mother drags,
    That all may hear his cry of pain;
May be infected by the woe,
And on his mother coins bestow.

His feet were sore, and to the stones,
    Tho' snatched and dragged along, they clung;
For tender were they to the bones;
    And on his mother's arm he hung,
A thing unloved; and never dried
The tear of passion as he cried.

Her eyes of prey, like fangs, she laid
    On all who gave her a hurried look,
As in his name she whined for aid,
    Nor paused, but when a coin she took.
This clutched, her thirst and famine raged,
And one fierce thought her heart engaged.

She runs, her nostrils vomit death,
    And snorting to the public-house,
The infant with her, out of breath,
    On licensed waters to carouse,
Both throats she pours the lava down,
In ready fire her soul to drown.

As thence the hourly imposts drop
    In golden harvests to the state,
The chancellor, who reaps the crop,
    Finds profit in the drunkard's fate,
And spite of penalties to warn,
The tipsy soul gets into pawn.

That soul locked up till it has run
    The sharp ordeal of the fire,
And law its flimsy course has spun

'Mid curses, and 'mid mocking dire,
The law, whose boast is to be mild,
Provides no mother for the child.

Nor church puts up a little pew
    Where prayers are made the babes to fit,
And set their little souls anew;
    And mothers' crimes in them remit;
But law is let its wrath to pour
On generations three or four.

By law with book provided not,
    Unlettered is the drunkard's spawn;
By gospel, too it is forgot,
    From threadbare curate up to lawn.
Outlawed, out-gospelled, must it live,
And with the looming gallows strive.

The little soul of human seed
    Rose of itself the street to sweep.
Not born to character, or to creed,
    And put to vice, it learned to creep,
To dance, to walk upon its head,
All but to pray, for daily bread.

If it had done some honest act
    It must have deemed the deed a sin,
For too suspicious were the fact,
    And then would prison-time begin.
From vice to virtue could it steal,
And from a mother's ways appeal?

As well might it resolve to taste
    Of smoking viands, when the smell
Which from the windows runs to waste,
    Should him to petty theft impel.
And dangerous are those gusts impure
Which starving souls to food allure.

Yet oft a-hungered has he stood
    As one on whom had sin begun,
While wistfully he saw the food,
    With one leg out way to run,
Lest justice should dispute his right
To look as it with all his might.

Lest justice should detect within
    A consciousness of base degree,
He dragged his rags about his skin
    To hide from view his pedigree.
He deemed himself a thief by law
Who stole before the light he saw.

His theft, the infancy of crime,
    As yet was but a glance to steal,
As at the shops he lost his time
    In gloating on what they reveal.
With what a superstitious dread
Such hunger looks at daily bread!

No better school to teach or guide,
    He lingers o'er the savoury mass,
And watches mouths that open wide,
    And sees them eating thro' the glass.
Oft his own lips he opes and shuts;
And sympathy his fancy gluts.

Not yet he begs, but in a trance
    Admires the scene where numbers throng;
And if on him descends a glance
    He is abashed and slinks along.
Nor cares he more, the spell once broke,
Scenes of false plenty to invoke.

The man of charity beholds
    The vagrant with a pent-up grief;
And even if he stops and scolds,
    Abstains from giving him relief,
But mourns that idleness should live
To thus on others' earnings thrive.

There is one prayer whose word devout
    On king and queen a blessing calls:
In it the beggar is left out
    Till he has reached the prison walls,
For soon or late he there is brought
And his great future lesson taught.

He learns the empty oath to spell,
    And all its bearings to apply:
He learns the alphabet of hell,

And key to its philosophy.
A hundred curses in a breath,
These syllable the pangs of Death.

Who then to life can death unite,
    Who such a bride and bridegroom wed,
Who bring them to the marriage rite,
    Thro' worldly sorrow singly led?
He can, the only One who shares
The highest hopes and basest cares.

The One whose eye thro' vice can gain
    Else hidden views of wondrous worth,
Tho' such by theft its bread obtain,
    Blaspheming as it sallies forth:
The One whose charity extends
Salvation to the soul He mends.

## George Meredith
### From *Modern Love* (1862)

#### 1

By this he knew she wept with waking eyes:
That, at his hand's light quiver by her head,
The strange low sobs that shook their common bed
Were called into her with a sharp surprise,
And strangled mute, like little gaping snakes,
Dreadfully venomous to him. She lay
Stone still, and the long distance flowed away
With muffled pulses. Then, as midnight makes
Her giant heart of Memory and Tears
Drink the pale drug of silence, and so beat
Sleep's heavy measure, they from head to feet
Were moveless, looking through their dead
    black years,
By vain regret scrawled over the blank wall.
Like sculptured effigies they might be seen
Upon their marriage-tomb, the sword between:
Each wishing for the sword that severs all.

#### 2

It ended, and the morrow brought the task.
Her eyes were guilty gates, that let him in
By shutting all too zealous for their sin:

Each sucked a secret, and each wore a mask.
But, oh, the bitter taste her beauty had!
He sickened as at breath of poison-flowers:
A languid humour stole among the hours,
And if their smiles encountered, he went mad,
And raged deep inward, till the light was brown
Before his vision, and the world, forgot,
Looked wicked as some old dull murder-spot.
A star with lurid beams, she seemed to crown
The pit of infamy: and then again
He fainted on his vengefulness, and strove
To ape the magnanimity of love,
And smote himself, a shuddering heap of pain.

### 7

She issues radiant from her dressing room,
Like one prepared to scale an upper sphere:
—By stirring up a lower, much I fear!
How deftly that oiled barber lays his bloom!
That long-shanked dapper Cupid with frisked curls
Can make known women torturingly fair;
The gold-eyed serpent dwelling in rich hair
Awakes beneath his magic whisks and twirls.
His art can take the eyes from out my head,
Until I see with eyes of other men;
While deeper knowledge crouches in its den,
And sends a spark up:—is it true we are wed?
Yea! filthiness of body is most vile,
But faithfulness of heart I do hold worse.
The former, it were not so great a curse
To read on the steel-mirror of her smile.

### 9

He felt the wild beast in him betweenwhiles
So masterfully rude, though he would grieve
To see the helpless delicate thing receive
His guardianship through certain dark defiles.
Had he not teeth to rend, and hunger too?
But still he spared her. Once: 'Have you no fear?'
He said: 'twas dusk; she in his grasp; none near.
She laughed: 'No, surely; am I not with you?'
And uttering that soft starry 'you', she leaned
Her gentle body near him, looking up;
And from her eyes, as from a poison-cup,
He drank until the flittering eyelids screened.

Devilish malignant witch! and oh, young beam
Of heaven's circle-glory! Here thy shape
To squeeze like an intoxicating grape—
I might, and yet thou goest safe, supreme.

### 15

I think she sleeps: it must be sleep, when low
Hangs that abandoned arm toward the floor;
The face turned with it. Now make fast the door.
Sleep on: it is your husband, not your foe.
The Poet's black stage-lion of wronged love
Frights not our modern dames:—well if he did!
Now will I pour new light upon that lid,
Full-sloping like the breasts beneath. 'Sweet dove,
Your sleep is pure. Nay pardon: I disturb.
I do not? good!' Her waking infant-stare
Grows woman to the burden my hands bear:
Her own handwriting to me when no curb
Was left on Passion's tongue. She trembles through;
A woman's tremble—the whole instrument:
I show another letter lately sent.
The words are very like: the name is new.

### 16

In our old shipwrecked days there was an hour,
When in the firelight steadily aglow,
Joined slackly, we beheld the red chasm grow
Among the clicking coals. Our library-bower
That eve was left to us: and hushed we sat
As lovers to whom Time is whispering.
From sudden-opened doors we heard them sing:
The nodding elder mixed good wine with chat.
Well knew we that Life's greatest treasure lay
With us, and of it was our talk. 'Ah, yes!
Love dies!' I said: I never thought it less.
She yearned to me that sentence to unsay.
Then when the fire domed blackening, I found
Her cheek was salt against my kiss, and swift
Up the sharp scale of sobs her breast did lift:
Now am I haunted by that taste! that sound!

### 17

At dinner, she is hostess, I am host.
Went the feast ever cheerfuller? She keeps
The Topic over intellectual deeps

In buoyancy afloat. They see no ghost.
With sparkling surface-eyes we ply the ball:
It is in truth a most contagious game:
HIDING THE SKELETON, shall be its name.
Such play as this the devils might appal!
But here's the greater wonder; in that we,
Enamoured of an acting nought can tire,
Each other, like true hypocrites, admire;
Warm-lighted looks, Love's ephemerie,
Shoot gaily o'er the dishes and the wine.
We waken envy of our happy lot.
Fast, sweet, and golden, shows the marriage-knot.
Dear guests, you now have seen Love's corpse-
    light shine.

### 22

What may the woman labour to confess?
There is about her mouth a nervous twitch.
'Tis something to be told, or hidden: —which?
I get a glimpse of hell in this mild guess.
She has desires of touch, as if to feel
That all the household things are things she knew.
She stops before the glass. What sight in view?
A face that seems the latest to reveal!
For she turns from it hastily, and tossed
Irresolute steals shadow-like to where
I stand; and wavering pale before me there,
Her tears fall still as oak-leaves after frost.
She will not speak. I will not ask. We are
League-sundered by the silent gulf between.
You burly lovers on the village green,
Yours is a lower, and a happier star!

### 23

'This Christmas weather, and a country house
Receives us: rooms are full: we can but get
An attic-crib. Such lovers will not fret
At that, it is half-said. The great carouse
Knocks hard upon the midnight's hollow door,
But when I knock at hers, I see the pit.
Why did I come here in that dullard fit?
I enter, and lie couched upon the floor.
Passing, I caught the coverlet's quick beat:
Come, Shame, burn to my soul! and Pride,
    and Pain—

Foul demons that have tortured me, enchain!
Out in the freezing darkness the lambs bleat.
The small bird stiffens in the low starlight.
I know not how, but shuddering as I slept,
I dreamed a banished angel to me crept:
My feet were nourished on her breasts all night.

### 25

You like not that French novel? Tell me why.
You think it quite unnatural. Let us see.
The actors are, it seems, the usual three:
Husband, and wife, and lover. She—but fie!
In England we'll not hear of it. Edmond,
The lover, her devout chagrin doth share;
Blanc-mange and absinthe are his penitent fare,
Till his pale aspect makes her over-fond:
So, to preclude fresh sin, he tries rosbif.
Meantime the husband is no more abused:
Auguste forgives her ere the tear is used.
Then hangeth all on one tremendous IF:
If she will choose between them. She does choose;
And takes her husband, like a proper wife.
Unnatural? My dear, these things are life:
And life, some think, is worthy of the Muse.

### 31

This golden head has wit in it. I live
Again, and a far higher life, near her.
Some women like a young philosopher;
Perchance because he is diminutive.
For woman's manly god must not exceed
Proportions of the natural nursing size.
Great poets and great sages draw no prize
With women: but the little lap-dog breed,
Who can be hugged, or on a mantel-piece
Perched up for adoration, these obtain
Her homage. And of this we men are vain?
Of this! 'Tis ordered for the world's increase!
Small flattery! Yet she has that rare gift
To beauty, Common Sense. I am approved.
It is not half so nice as being loved,
And yet I do prefer it. What's my drift?

### 34

Madam would speak with me. So, now it comes:
The Deluge or else Fire! She's well; she thanks
My husbandship. Our chain on silence clanks.
Time leers between, above his twiddling thumbs.
Am I quite well? Most excellent in health!
The journals, too, I diligently peruse.
Vesuvius is expected to give news:
Niagara is no noisier. By stealth
Our eyes dart scrutinizing snakes. She's glad
I'm happy, says her quivering under-lip.
'And are not you?' 'How can I be?' 'Take ship!
For happiness is somewhere to be had.'
'Nowhere for me!' Her voice is barely heard.
I am not melted, and make no pretence.
With commonplace I freeze her, tongue and sense.
Niagara or Vesuvius is deferred.

### 35

It is no vulgar nature I have wived.
Secretive, sensitive, she takes a wound
Deep to her soul, as if the sense had swooned,
And not a thought of vengeance had survived.
No confidences has she: but relief
Must come to one whose suffering is acute.
O have a care of natures that are mute!
They punish you in acts: their steps are brief.
What is she doing? What does she demand
From Providence or me? She is not one
Long to endure this torpidity, and shun
The drugs that crowd about a woman's hand.
At Forfeits during snow we played, and I
Must kiss her. 'Well performed!' I said: then she:
''Tis hardly worth the money, you agree?'
Save her? What for? To act this wedded lie!

### 39

She yields: my Lady in her noblest mood
Has yielded: she, my golden-crownëd rose!
The bride of every sense! more sweet than those
Who breathe the violet breath of maidenhood.
O visage of still music in the sky!
Soft moon! I feel thy song, my fairest friend!
True harmony within can apprehend
Dumb harmony without. And hark! 'tis nigh!

Belief has struck the note of sound: a gleam
Of living silver shows me where she shook
Her long white fingers down the shadowy brook,
That sings her song, half waking, half in dream.
What two come here to mar this heavenly tune?
A man is one: the woman bears my name,
And honour. Their hands touch! Am I still tame?
God, what a dancing spectre seems the moon!

### 42

I am to follow her. There is much grace
In women when thus bent on martyrdom.
They think that dignity of soul may come,
Perchance, with dignity of body. Base!
But I was taken by that air of cold
And statuesque sedateness, when she said
'I'm going'; lit a taper, bowed her head,
And went, as with the stride of Pallas bold.
Fleshly indifference horrible! The hands
Of Time now signal: O, she's safe from me!
Within those secret walls what do I see?
Where first she set the taper down she stands:
Not Pallas: Hebe shamed! Thoughts black as death
Like a stirred pool in sunshine break. Her wrists
I catch: she faltering, as she half resists,
'You love…? love…? love…?' all on an
      indrawn breath.

### 43

Mark where the pressing wind shoots javelin-like
Its skeleton shadow on the broad-backed wave!
Here is a fitting spot to dig Love's grave;
Here where the ponderous breakers plunge
      and strike,
And dart their hissing tongues high up the sand:
In hearing of the ocean, and in sight
Of those ribbed wind-streaks running into white.
If I the death of Love had deeply planned,
I never could have made it half so sure,
As by the unblest kisses which upbraid
The full-waked sense; or failing that, degrade!
'Tis morning: but no morning can restore
What we have forfeited. I see no sin:
The wrong is mixed. In tragic life, God wot,
No villain need be! Passions spin the plot:
We are betrayed by what is false within.

### 45

It is the season of the sweet wild rose,
My Lady's emblem in the heart of me!
So golden-crowned shines she gloriously,
And with that softest dream of blood she glows:
Mild as an evening heaven round Hesper bright!
I pluck the flower, and smell it, and revive
The time when in her eyes I stood alive.
I seem to look upon it out of Night.
Here's Madam, stepping hastily. Her whims
Bid her demand the flower, which I let drop.
As I proceed, I feel her sharply stop,
And crush it under heel with trembling limbs.
She joins me in a cat-like way, and talks
Of company, and even condescends
To utter laughing scandal of old friends.
These are the summer days, and these our walks.

### 47

We saw the swallows gathering in the sky,
And in the osier-isle we heard them noise.
We had not to look back on summer joys,
Or forward to a summer of bright dye:
But in the largeness of the evening earth
Our spirits grew as we went side by side.
The hour became her husband and my bride.
Love, that had robbed us so, thus blessed our
    dearth!
The pilgrims of the year waxed very loud
In multitudinous chatterings, as the flood
Full brown came from the West, and like pale blood
Expanded to the upper crimson cloud.
Love, that had robbed us of immortal things,
This little moment mercifully gave,
And still I see across the twilight wave
The swan sail with her young beneath her wings.

### 50

Thus piteously Love closed what he begat:
The union of this ever-diverse pair!
These two were rapid falcons in a snare,
Condemned to do the flitting of the bat.
Lovers beneath the singing sky of May,
They wandered once; clear as the dew on flowers:
But they fed not on the advancing hours:

Their hearts held cravings for the buried day.
Then each applied to each that fatal knife,
Deep questioning, which probes to endless dole.
Ah, what a dusty answer gets the soul
When hot for centuries in this our life!—
In tragic hints here see what evermore
Moves dark as yonder midnight ocean's force,
Thundering like ramping hosts of warrior horse,
To throw that faint thin line upon the shore!

## William Morris
### From *The Earthly Paradise* (1869)

Of Heaven or Hell I have no power to sing,
I cannot ease the burden of your fears,
Or make quick-coming death a little thing,
Or bring again the pleasure of past years,
Nor for my words shall ye forget your tears,
Or hope again for aught that I can say,
The idle singer of an empty day.

But rather, when aweary of your mirth,
From full hearts still unsatisfied ye sigh,
And, feeling kindly unto all the earth,
Grudge every minute as it passes by,
Made the more mindful that the sweet days die,—
Remember me a little then, I pray,
The idle singer of an empty day.

The heavy trouble, the bewildering care
That weighs us down who live and earn our bread,
These idle verses have no power to bear;
So let me sing of names remembered,
Because they, living not, can ne'er be dead,
Or long time take their memory quite away
From us poor singers of an empty day.

Dreamer of dreams, born out of my due time,
Why should I strive to set the crooked straight?
Let it suffice me that my murmuring rhyme
Beats with light wing against the ivory gate,
Telling a tale not too importunate
To those who in the sleepy region stay,
Lulled by the singer of an empty day.

Folk say, a wizard to a northern king
At Christmas-tide such wondrous things did show,
That through one window men beheld the spring,
And through another saw the summer glow,
And through a third the fruited vines arow,
While still, unheard, but in its wonted way,
Piped the drear wind of that December day.

So with this Earthly Paradise it is,
If ye will read aright, and pardon me,
Who strive to build a shadowy isle of bliss
Midmost the beating of the steely sea,
Where tossed about all hearts of men must be;
Whose ravening monsters mighty men shall slay,
Not the poor singer of an empty day.

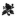

### The Writing on the Image

#### Argument

How on an Image that stood anciently in Rome
were written certain words, which none
understood, until a scholar, coming there, knew
their meaning, and thereby discovered great
marvels, but withal died miserably.

In half-forgotten days of old,
As by our fathers we were told,
Within the town of Rome there stood
An image cut of cornel-wood,
And on the upraised hand of it
Men might behold, these letters writ—
'PERCUTE HIC': which is to say,
In that tongue that we speak to-day,
'Strike here!' nor yet did any know
The cause why this was written so.

Thus in the middle of the square,
In the hot sun and summer air,
The snow-drift and the driving rain,
That image stood, with little pain,
For twice a hundred years and ten;
While many a band of striving men
Were driven betwixt woe and mirth

Swiftly across the weary earth,
From nothing unto dark nothing:
And many an Emperor and King,
Passing with glory or with shame
Left little record of his name,
And no remembrance of the face
Once watched with awe for gifts or grace.

Fear little, then, I counsel you,
What any son of man can do;
Because a log of wood will last
While many a life of man goes past,
And all is over in short space.

Now so it chanced that to this place
There came a man of Sicily,
Who, when the image he did see,
Knew full well who, in days of yore,
Had set it there; for much strange lore,
In Egypt and in Babylon,
This man with painful toil had won;
And many secret things could do;
So verily full well he knew
That master of all sorcery
Who wrought the thing in days gone by,
And doubted not that some great spell
It guarded, but could nowise tell
What it might be. So, day by day,
Still would he loiter on the way,
And watch the image carefully,
Well mocked of many a passer-by.

And on a day he stood and gazed
Upon the slender finger, raised
Against a doubtful cloudy sky,
Nigh noontide; and thought, 'Certainly
The master who made thee so fair
By wondrous art, had not stopped there,
But made thee speak, had he not thought
That thereby evil might be brought
Upon his spell.' But as he spoke,
From out a cloud the noon sun broke
With watery light, and shadows cold:
Then did the Scholar well behold
How, from that finger carved to tell
Those words, a short black shadow fell
Upon a certain spot of ground,
And thereon, looking all around

And seeing none heeding, went straightway
Whereas the finger's shadow lay,
And with his knife about the place
A little circle did he trace;
Then home he turned with throbbing head,
And forthright gat him to his bed,
And slept until the night was late
And few men stirred from gate to gate.

  So when at midnight he did wake,
Pickaxe and shovel did he take,
And, going to that now silent square,
He found the mark his knife made there,
And quietly with many a stroke
The pavement of the place he broke:
And so, the stones being set apart,
He 'gan to dig with beating heart,
And from the hole in haste he cast
The marl and gravel; till at last,
Full shoulder high, his arms were jarred,
For suddenly his spade struck hard
With clang against some metal thing:
And soon he found a brazen ring,
All green with rust, twisted, and great
As a man's wrist, set in a plate
Of copper, wrought all curiously
With words unknown though plain to see
Spite of the rust; and flowering trees,
And beasts, and wicked images,
Whereat he shuddered; for he knew
What ill things he might come to do,
 If he should still take part with these
And that Great Master strive to please.

  But small time had he then to stand
And think, so straight he set his hand
Unto the ring, but where he thought
That by main strength it must be brought
From out its place, lo! easily
It came away, and let him see
A winding staircase wrought of stone,
Wherethrough the new-come wind did moan.

  Then thought he, 'If I come alive
From out this place well shall I thrive,
For I may look here certainly
The treasures of a king to see,
A mightier man than men are now.

So in few days what man shall know
The needy Scholar, seeing me
Great in the place where great men be,
The richest man in all the land?
Beside the best then shall I stand,
And some unheard-of palace have;
And if my soul I may not save
In heaven, yet here in all men's eyes
Will I make some sweet paradise,
With marble cloisters, and with trees
And bubbling wells, and fantasies,
And things all men deem strange and rare,
And crowds of women kind and fair,
That I may see, if so I please,
Laid on the flowers, or mid the trees
With half-clad bodies wandering.
There, dwelling happier than the King,
What lovely days may yet be mine!
How shall I live with love and wine
And music, till I come to die!
And then—Who knoweth certainly
What has to us when we are dead?
Truly I think by likelihead
Naught haps to us of good or bad;
Therefore on earth will I be glad
A short space, free from hope or fear;
And fearless will I enter here
And meet my fate, whatso it be.'

  Now on his back a bag had he,
To bear what treasure he might win,
And therewith now did he begin
To go adown the winding stair;
And found the walls all painted fair
With images of many a thing,
Warrior and priest, and queen and king,
But nothing knew what they might be.
Which things full clearly could he see,
For lamps were hung up here and there
Of strange device, but wrought right fair,
And pleasant savour came from them.

  At last a curtain, on whose hem
Unknown words in red gold were writ,
He reached, and softly raising it
Stepped back, for now did he behold

A goodly hall hung round with gold,
And at the upper end could see
Sitting, a glorious company:
Therefore he trembled, thinking well
They were no men, but fiends of hell.
But while he waited, trembling sore,
And doubtful of his late-learned lore,
A cold blast of the outer air
Blew out the lamps upon the stair
And all was dark behind him; then
Did he fear less to face those men
Than, turning round, to leave them there
While he went groping up the stair.
Yea, since he heard no cry or call
Or any speech from them at all,
He doubted they were images
Set there some dying king to please
By that Great Master of the art;
Therefore at last with stouter heart
He raised the cloth and entered in
In hope that happy life to win,
And drawing nigher did behold
That these were bodies dead and cold
Attired in full royal guise,
And wrought by art in such a wise
Whose very eyes he well could see,
That living they all seemed to be,
That now beheld not foul or fair,
Shining as though alive they were.
And midmost of that company
An ancient king that man could see,
A mighty man, whose beard of gray
A foot over his gold gown lay;
And next beside him sat his queen
Who in a flowery gown of green
And golden mantle well was clad,
And on her neck a collar had
Too heavy for her dainty breast;
Her loins by such a belt were pressed
That whoso in his treasury
Held that alone, a king might be.
On either side of these, a lord
Stood heedfully before the board,
And in their hands held bread and wine
For service; behind these did shine

The armour of the guards, and then
The well-attired serving-men,
The minstrels clad in raiment meet;
And over against the royal seat
Was hung a lamp, although no flame
Was burning there, but there was set
Within its open golden fret
A huge carbuncle, red and bright;
Wherefrom there shone forth such a light
That great hall was as clear by it,
As though by wax it had been lit,
As some great church at Easter-tide.
    Now set a little way aside,
Six paces from the daïs stood
An image made of brass and wood,
In likeness of a full-armed knight
Who pointed 'gainst the ruddy light
A huge shaft ready in a bow.
        Pondering how he could come to know
What all these marvellous matters meant,
About the hall the Scholar went,
Trembling, though nothing moved as yet;
And for a while did he forget
The longings that had brought him there
In wondering at these marvels fair;
And still for fear he doubted much
One jewel of their robes to touch.

    But as about the hall he passed
He grew more used to them at last,
And thought, 'Swiftly the time goes by,
And now no doubt the day draws nigh
Folk will be stirring; by my head
A fool I am to fear the dead,
Who have seen living things enow,
Whose very names no man can know,
Whose shapes brave men might well affright
More than the lion in the night
Wandering for food'; therewith he drew
Unto those royal corpses two,
That on dead brows still wore the crown;
And midst the golden cups set down
The rugged wallet from his back,
Patched of strong leather, brown and black,
Then, opening wide its mouth, took up

From off the board, a golden cup
The King's dead hand was laid upon,
Whose unmoved eyes upon him shone
And recked no more of that last shame
Than if he were the beggar lame,
Who in old days was wont to wait
For a dog's meal beside the gate.
  Of which shame naught our man did reck,
But laid his hand upon the neck
Of the slim Queen, and thence undid
The jewelled collar, that straight slid
Down her smooth bosom to the board.
And when these matters he had stored
Safe in his sack, with both their crowns,
The jewelled parts of their rich gowns,
Their shoes and belts, broaches and rings,
And cleared the board of all rich things,
He staggered with them down the hall.
But as he went his eyes did fall
Upon a wonderful green stone,
Upon the hall-floor laid alone;
He said, 'Though thou art not so great
To add by much unto the weight
Of this my sack indeed, yet thou,
Certes, would make me rich enow,
That verily with thee I might
Wage one half of the world to fight
The other half of it, and I
The lord of all the world might die;—
I will not leave thee'; therewithal
He knelt down midmost of the hall,
Thinking it would come easily
Into his hand; but when that he
Gat hold of it, full fast it stack,
So fuming, down he laid his sack,
And with both bands pulled lustily,
But as he strained, he cast his eye
Unto the daïs, and saw there
The image who the great bow bare
Moving the bowstring to his ear,
So, shrieking out aloud for fear,
Of that rich stone he loosed his hold
And catching up his bag of gold,
Gat to his feet: but ere he stood,
The evil thing of brass and wood

Up to his ear the notches drew;
And clanging forth the arrow flew,
And midmost of the carbuncle
Clanging again, the forked barbs fell,
And all was dark as pitch straightway.

  So there until the judgment day
Shall come and find his bones laid low,
And raise them up for weal or woe,
This man must bide; cast down he lay
While all his past life day by day
In one short moment he could see
Drawn out before him, while that he
In terror by that fatal stone
Was laid, and scarcely dared to moan.
But in a while his hope returned,
And then, though nothing he discerned,
He gat him up upon his feet,
And all about the walls he beat
To find some token of the door
But never could he find it more,
For by some dreadful sorcery
All was sealed close as it might be,
And midst the marvels of that hall
This Scholar found the end of all.

  But in the town on that same night,
An hour before the dawn of light,
Such storm upon the place there fell,
That not the oldest man could tell
Of such another: and thereby
The image was burnt utterly,
Being stricken from the clouds above;
And folk deemed that same bolt did move
The pavement where that wretched one
Unto his foredoomed fate had gone,
Because the plate was set again
Into its place, and the great rain
Washed the earth down, and sorcery
Had hid the place where it did lie.
  So soon the stones were set all straight,
But yet the folk, afraid of fate,
Where once the man of cornel-wood
Through many a year of bad and good
Had kept his place, set up alone

Great Jove himself, cut in white stone,
But thickly overlaid with gold.
'Which', saith my tale, 'you may behold
Unto this day, although indeed
Some lord or other, being in need,
Took every ounce of gold away.'

But now, this tale in some past day
Being writ, I warrant all is gone,
Both gold and weather-beaten stone.

Be merry, masters, while ye may,
For men much quicker pass away.

## Christina Rossetti 4-17-00
### From *Goblin Market and Other Poems* (1862)

### *Goblin Market*

sing-songy, jingly rhyme

Morning and evening
Maids heard the goblins cry:
'Come buy our orchard fruits,
Come buy, come buy:
Apples and quinces,
Lemons and oranges,
Plump unpecked cherries,
Melons and raspberries,
Bloom-down-cheeked peaches,
Swart-headed mulberries,
Wild free-born cranberries,
Crab-apples, dewberries,
Pineapples, blackberries,
Apricots, strawberries;—
All ripe together
In summer weather,—
Morns that pass by,
Fair eves that fly;
Come buy, come buy:
Our grapes fresh from the vine,
Pomegranates full and fine,
Dates and sharp bullaces,
Rare pears and greengages,
Damsons and bilberries,
Taste them and try:
Currants and gooseberries,

Bright-fire-like barberries,
Figs to fill your mouth,
Citrons from the South,
Sweet to tongue and sound to eye;
Come buy, come buy.'

Evening by evening
Among the brookside rushes,
Laura bowed her head to hear,
Lizzie veiled her blushes:
Crouching close together
In the cooling weather,
With clasping arms and cautioning lips,
With tingling cheeks and finger tips.
'Lie close', Laura said,
Pricking up her golden head:
'We must not look at goblin men,
We must not buy their fruits:
Who knows upon what soil they fed
Their hungry thirsty roots?'
'Come buy', call the goblins
Hobbling down the glen.
'Oh', cried Lizzie, 'Laura, Laura,
You should not peep at goblin men.'
Lizzie covered up her eyes,
Covered close lest they should look;
Laura reared her glossy head,
And whispered like the restless brook:
'Look, Lizzie, look, Lizzie,
Down the glen tramp little men.
One hauls a basket,
One bears a plate,
One lugs a golden dish
Of many pounds' weight.
How fair the vine must grow
Whose grapes are so luscious;
How warm the wind must blow
Through those fruit bushes.'
'No', said Lizzie: 'No, no, no;
Their offers should not charm us,
Their evil gifts would harm us.'
She thrust a dimpled finger
In each ear, shut eyes and ran:
Curious Laura chose to linger
Wondering at each merchant man.

One had a cat's face,
One whisked a tail,
One tramped at a rat's pace,
One crawled like a snail,
One like a wombat prowled obtuse and furry,
One like a ratel tumbled hurry skurry.
She heard a voice like voice of doves
Cooing all together:
They sounded kind and full of loves
In the pleasant weather.

*Similes— repeated on (140)*

Laura stretched her gleaming neck
Like a rush-imbedded swan,
Like a lily from the beck, *pale skin*
Like a moonlit poplar branch,
Like a vessel at the launch
When its last restraint is gone.

Backwards up the mossy glen
Turned and trooped the goblin men,
With their shrill repeated cry,
'Come buy, come buy.'
When they reached where Laura was
They stood stock still upon the moss,
Leering at each other,
Brother with queer brother;
Signalling each other,
Brother with sly brother.
One set his basket down,
One reared his plate;
One began to weave a crown
Of tendrils, leaves, and rough nuts brown
(Men sell not such in any town);
One heaved the golden weight
Of dish and fruit to offer her:
'Come buy, come buy', was still their cry.
Laura stared but did not stir,
Longed but had no money.
The whisk-tailed merchant bade her taste
In tones as smooth as honey,
The cat-faced purr'd,
The rat-paced spoke a word
Of welcome, and the snail-paced even was
    heard;

One parrot-voiced and jolly
Cried 'Pretty Goblin' still for 'Pretty Polly';—
One whistled like a bird.

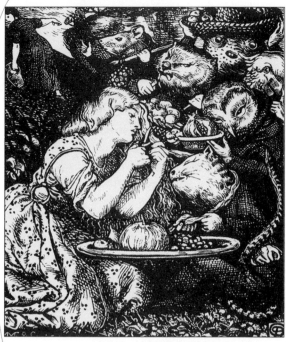

Illustration by Dante Gabriel Rossetti

But sweet-tooth Laura spoke in haste:
'Good folk, I have no coin;
To take were to purloin:
I have no copper in my purse,
I have no silver either,
And all my gold is on the furze
That shakes in windy weather
Above the rusty heather.'
'You have much gold upon your head',
They answered all together:
'Buy from us with a golden curl.'
She clipped a precious golden lock,
She dropped a tear more rare than pearl,
Then sucked their fruit globes fair or red.
Sweeter than honey from the rock,
Stronger than man-rejoicing wine,
Clearer than water flowed that juice;
She never tasted such before,
How should it cloy with length of use?
She sucked and sucked and sucked the more
Fruits which that unknown orchard bore;

She sucked until her lips were sore;
Then flung the emptied rinds away
But gathered up one kernel stone,
And knew not was it night or day
As she turned home alone.
Lizzie met her at the gate
Full of wise upbraidings:
'Dear, you should not stay so late,
Twilight is not good for maidens;
Should not loiter in the glen
In the haunts of goblin men.
Do you not remember Jeanie,
How she met them in the moonlight,
Took their gifts both choice and many,
Ate their fruits and wore their flowers
Plucked from bowers
Where summer ripens at all hours?
But ever in the noonlight
She pined and pined away;
Sought them by night and day,
Found them no more but dwindled and
        grew grey;
Then fell with the first snow,
While to this day no grass will grow
Where she lies low:
I planted daisies there a year ago
That never blow.
You should not loiter so.'
'Nay, hush', said Laura
'Nay, hush, my sister:
I ate and ate my fill,
Yet my mouth waters still:
To-morrow night I will
Buy more'; and kissed her.
'Have done with sorrow;
I'll bring you plums to-morrow
Fresh on their mother twigs,
Cherries worth getting;
You cannot think what figs
My teeth have met in,
What melons icy-cold
Piled on a dish of gold
Too huge for me to hold,
What peaches with a velvet nap,
Pellucid grapes without one seed:

Odorous indeed must be the mead
Whereon they grow, and pure the wave
        they drink
With lilies at the brink,
And sugar-sweet their sap.'

Golden head by golden head,
Like two pigeons in one nest
Folded in each other's wings,
They lay down in their curtained bed:
Like two blossoms on one stem,
Like two flakes of new-fall'n snow,
Like two wands of ivory
Tipped with gold for awful kings.
Moon and stars gazed in at them,
Wind sang to them lullaby,
Lumbering owls forbore to fly,
Not a bat flapped to and fro
Round their nest:
Cheek to cheek and breast to breast
Locked together in one nest.

Illustration by Dante Gabriel Rossetti

Early in the morning
When the first cock crowed his warning,
Neat like bees, as sweet and busy,
Laura rose with Lizzie:
Fetched in honey, milked the cows,
Aired and set to rights the house,
Kneaded cakes of whitest wheat,
Cakes for dainty mouths to eat,

Next churned butter, whipped up cream,
Fed their poultry, sat and sewed;
Talked as modest maidens should:
Lizzie with an open heart,
Laura in an absent dream,
One content, one sick in part;
One warbling for the mere bright day's
    delight,
One longing for the night.

At length slow evening came:
They went with pitchers to the reedy brook;
Lizzie most placid in her look,
Laura most like a leaping flame.
They drew the gurgling water from its deep.
Lizzie plucked purple and rich golden flags,
Then turning homewards said: 'The
    sunset flushes
Those furthest loftiest crags;
Come, Laura, not another maiden lags,
No wilful squirrel wags,
The beasts and birds are fast asleep.'
But Laura loitered still among the rushes
And said the bank was steep.

And said the hour was early still,
The dew not fall'n, the wind not chill:
Listening ever, but not catching
The customary cry,
'Come buy, come buy',
With its iterated jingle
Of sugar-baited words:
Not for all her watching
Once discerning even one goblin
Racing, whisking, tumbling, hobbling;
Let alone the herds
That used to tramp along the glen,
In groups or single,
Of brisk fruit-merchant men.
Till Lizzie urged, 'O Laura, come;
I hear the fruit-call but I dare not look:
You should not loiter longer at this brook:
Come with me home.
The stars rise, the moon bends her arc,
Each glowworm winks her spark,

Let us get home before the night grows dark:
For clouds may gather
Though this is summer weather,
Put out the lights and drench us through;
Then if we lost our way what should we do?'

Laura turned cold as stone
To find her sister heard that cry alone,
That goblin cry,
'Come buy our fruits, come buy.'
Must she then buy no more such dainty fruit?
Must she no more such succous pasture find,
Gone deaf and blind?
Her tree of life drooped from the root:
She said not one word in her heart's sore ache:
But peering thro' the dimness,
    nought discerning,
Trudged home, her pitcher dripping all
    the way;
So crept to bed, and lay
Silent till Lizzie slept;
Then sat up in a passionate yearning,
And gnashed her teeth for baulked desire,
    and wept
As if her heart would break.

Day after day, night after night,
Laura kept watch in vain
In sullen silence of exceeding pain.
She never caught again the goblin cry:
'Come buy, come buy';—
She never spied the goblin men
Hawking their fruits along the glen:
But when the moon waxed bright
Her hair grew thin and grey;
She dwindled, as the fair full moon doth turn
To swift decay and burn
Her fire away.

One day remembering her kernel-stone
She set it by a wall that faced the south;
Dewed it with tears, hoped for a root,
Watched for a waxing shoot,
But there came none.
It never saw the sun,

It never felt the trickling moisture run:
While with sunk eyes and faded mouth
She dreamed of melons, as a traveller sees
False waves in desert drouth
With shade of leaf-crowned trees,
And burns the thirstier in the sandful breeze.

She no more swept the house,
Tended the fowls or cows,
Fetched honey, kneaded cakes of wheat,
Brought water from the brook:
But sat down listless in the chimney-nook
And would not eat.

Tender Lizzie could not bear
To watch her sister's cankerous care,
Yet not to share.
She night and morning
Caught the goblins' cry:
'Come buy our orchard fruits,
Come buy, come buy':
Beside the brook, along the glen,
She heard the tramp of goblin men,
The voice and stir
Poor Laura could not hear;
Longed to buy fruit to comfort her,
But feared to pay too dear.
She thought of Jeanie in her grave,
Who should have been a bride;
But who for joys brides hope to have
Fell sick and died
In her gay prime,
In earliest winter time,
With the first glazing rime,
With the first snow-fall of crisp winter time.

Till Laura dwindling
Seemed knocking at Death's door:
Then Lizzie weighed no more
Better and worse;
But put a silver penny in her purse,
Kissed Laura, crossed the heath with clumps
    of furze
At twilight, halted by the brook:
And for the first time in her life
Began to listen and look.

Laughed every goblin
When they spied her peeping:
Came towards her hobbling,
Flying, running, leaping,
Puffing and blowing,
Chuckling, clapping, crowing,
Clucking and gobbling,
Mopping and mowing,
Full of airs and graces,
Pulling wry faces,
Demure grimaces,
Cat-like and rat-like,
Ratel- and wombat-like,
Snail-paced in a hurry,
Parrot-voiced and whistler,
Helter skelter, hurry skurry,
Chattering like magpies,
Fluttering like pigeons,
Gliding like fishes,—
Hugged her and kissed her:
Squeezed and caressed her:
Stretched up their dishes,
Panniers, and plates:
'Look at our apples
Russet and dun,
Bob at our cherries,
Bite at our peaches,
Citrons and dates,
Grapes for the asking,
Pears red with basking
Out in the sun,
Plums on their twigs;
Pluck them and suck them,
Pomegranates, figs.'

'Good folk', said Lizzie,
Mindful of Jeanie:
'Give me much and many':
Held out her apron,
Tossed them her penny.
'Nay, take a seat with us,
Honour and eat with us',
They answered grinning:
'Our feast is but beginning.
Night yet is early,

Warm and dew-pearly,
Wakeful and starry:
Such fruits as these
No man can carry;
Half their bloom would fly,
Half their dew would dry,
Half their flavour would pass by.
Sit down and feast with us,
Be welcome guest with us,
Cheer you and rest with us.'—
'Thank you', said Lizzie: 'But one waits
At home alone for me:
So without further parleying,
If you will not sell me any
Of your fruits though much and many,
Give me back my silver penny
I tossed you for a fee.'—
They began to scratch their pates,
No longer wagging, purring,
But visibly demurring,
Grunting and snarling.
One called her proud,
Cross-grained, uncivil;
Their tones waxed loud,
Their looks were evil.
Lashing their tails
They trod and hustled her,
Elbowed and jostled her,
Clawed with their nails,
Barking, mewing, hissing, mocking,
Tore her gown and soiled her stocking,
Twitched her hair out by the roots,
Stamped upon her tender feet,
Held her hands and squeezed their fruits
Against her mouth to make her eat.

White and golden Lizzie stood,
Like a lily in a flood,—
Like a rock of blue-veined stone
Lashed by tides obstreperously,—
Like a beacon left alone
In a hoary roaring sea,
Sending up a golden fire,—
Like a fruit-crowned orange-tree
White with blossoms honey-sweet

*[handwritten left margin: 4-17-00]*
*[handwritten left margin: Simile]*

Sore beset by wasp and bee,—
Like a royal virgin town
Topped with gilded dome and spire
Close beleaguered by a fleet
Mad to tug her standard down.

*[handwritten top margin: flower stung (penetrated) by bee or wasp — highly sexually charged here]*

One may lead a horse to water,
Twenty cannot make him drink.
Though the goblins cuffed and caught her,
Coaxed and fought her,
Bullied and besought her,
Scratched her, pinched her black as ink,
Kicked and knocked her,
Mauled and mocked her,
Lizzie uttered not a word;
Would not open lip from lip
Lest they should cram a mouthful in:
But laughed in heart to feel the drip
Of juice that syrupped all her face,
And lodged in dimples of her chin,
And streaked her neck which quaked
        like curd.
At last the evil people
Worn out by her resistance,
Flung back her penny, kicked their fruit
Along whichever road they took,
Not leaving root or stone or shoot;
Some writhed into the ground,
Some dived into the brook
With ring and ripple,
Some scudded on the gale without a sound,
Some vanished in the distance.

In a smart, ache, tingle,
Lizzie went her way;
Knew not was it night or day;
Sprang up the bank, tore thro' the furze,
Threaded copse and dingle,
And heard her penny jingle
Bouncing in her purse,—
Its bounce was music to her ear.
She ran and ran
As if she feared some goblin man
Dogged her with gibe or curse
Or something worse:

But not one goblin skurried after,
Nor was she pricked by fear;
The kind heart made her windy-paced
That urged her home quite out of breath
　　　with haste
And inward laughter.

*4/7-00*

She cried 'Laura', up the garden,
'Did you miss me?
Come and kiss me.
Never mind my bruises,
Hug me, kiss me, suck my juices
Squeezed from goblin fruits for you,
Goblin pulp and goblin dew.
Eat me, drink me, love me;
Laura, make much of me;
For your sake I have braved the glen
And had to do with goblin merchant men.'

*Very graphic – embarrassingly so*

Laura started from her chair,
Flung her arms up in the air,
Clutched her hair:
'Lizzie, Lizzie, have you tasted
For my sake the fruit forbidden?
Must your light like mine be hidden,
Your young life like mine be wasted,
Undone in mine undoing
And ruined in my ruin,
Thirsty, cankered, goblin-ridden?'—
She clung about her sister,
Kissed and kissed and kissed her:
Tears once again
Refreshed her shrunken eyes,
Dropping like rain *drought*
After long sultry drouth;
Shaking with anguish, fear, and pain,
She kissed and kissed her with a hungry mouth.

Her lips began to scorch,
That juice was wormwood to her tongue,
She loathed the feast:
Writhing as one possessed she leaped
　　　and sung,　·
Rent all her robe, and wrung
Her hands in lamentable haste,

And beat her breast,
Her locks streamed like the torch
Borne by a racer at full speed,
Or like the mane of horses in their flight,
Or like an eagle when she stems the light
Straight toward the sun,
Or like a caged thing freed,
Or like a flying flag when armies run.

*long string of similes again*

Swift fire spread through her veins, knocked
　　　at her heart,
Met the fire smouldering there
And overbore its lesser flame;
She gorged on bitterness without a name:
Ah! fool, to choose such part
Of soul-consuming care!
Sense failed in the mortal strife:
Like the watch tower of a town
Which an earthquake shatters down,
Like a lightning-stricken mast,
Like a wind-uprooted tree
Spun about,
Like a foam-topped waterspout
Cast down headlong in the sea,
She fell at last;
Pleasure past and anguish past,
Is it death or is it life?

Life out of death.
That night long Lizzie watched by her,
Counted her pulse's flagging stir,
Felt for her breath,
Held water to her lips, and cooled her face
With tears and fanning leaves.
But when the first birds chirped about
　　　their eaves,
And early reapers plodded to the place
Of golden sheaves,
And dew-wet grass
Bowed in the morning winds so brisk to pass,
And new buds with new day
Opened of cup-like lilies on the stream,
Laura awoke as from a dream,
Laughed in the innocent old way,
Hugged Lizzie but not twice or thrice;

Her gleaming locks showed not one thread
    of grey,
Her breath was sweet as May,
And light danced in her eyes.

Days, weeks, months, years
Afterwards, when both were wives
With children of their own;
Their mother-hearts beset with fears,
Their lives bound up in tender lives;
Laura would call the little ones
And tell them of her early prime,
Those pleasant days long gone
Of not-returning time:
Would talk about the haunted glen,
The wicked, quaint fruit-merchant men,
Their fruits like honey to the throat
But poison in the blood
(Men sell not such in any town):
Would tell them how her sister stood
In deadly peril to do her good,
And win the fiery antidote:
Then joining hands to little hands
Would bid them cling together,—
'For there is no friend like a sister
In calm or stormy weather;
To cheer one on the tedious way,
To fetch one if one goes astray,
To lift one if one totters down,
To strengthen whilst one stands.'

*[handwritten annotations: "Can hear the older women's caution 'Watch out for those men' they're nothing but trouble!" and "stop"]*

### At Home

When I was dead, my spirit turned
    To seek the much-frequented house:
I passed the door, and saw my friends
    Feasting beneath green orange boughs;
From hand to hand they pushed the wine,
    They sucked the pulp of plum and peach;
They sang, they jested, and they laughed,
    For each was loved of each.

I listened to their honest chat:
    Said one: 'To-morrow we shall be

Plod plod along the featureless sands,
    And coasting miles and miles of sea.'
Said one: 'Before the turn of tide
    We will achieve the eyrie-seat.'
Said one: 'To-morrow shall be like
    To-day, but much more sweet.'

'To-morrow', said they, strong with hope,
    And dwelt upon the pleasant way:
'To-morrow', cried they, one and all,
    While no one spoke of yesterday.
Their life stood full at blessed noon;
    I, only I, had passed away:
'To-morrow and to-day', they cried;
    I was of yesterday.

I shivered comfortless, but cast
    No chill across the table-cloth;
I, all-forgotten, shivered, sad
    To stay, and yet to part how loth:
I passed from the familiar room,
    I who from love had passed away,
Like the remembrance of a guest
    That tarrieth but a day.

### A Birthday

My heart is like a singing bird
    Whose nest is in a watered shoot;
My heart is like an apple-tree
    Whose boughs are bent with thickset fruit;
My heart is like a rainbow shell
    That paddles in a halcyon sea;
My heart is gladder than all these
    Because my love has come to me.

Raise me a dais of silk and down;
    Hang it with vair and purple dyes;
Carve it in doves, and pomegranates,
    And peacocks with a hundred eyes;
Work it in gold and silver grapes,
    In leaves and silver fleurs-de-lys;
Because the birthday of my life
    Is come, my love is come to me.

## Remember

Remember me when I am gone away,
    Gone far away into the silent land;
    When you can no more hold me by the hand,
Nor I half turn to go yet turning stay.
Remember me when no more, day by day,
    You tell me of our future that you plann'd:
    Only remember me; you understand
It will be late to counsel then or pray.
Yet if you should forget me for a while
    And afterwards remember, do not grieve:
    For if the darkness and corruption leave
A vestige of the thoughts that once I had,
Better by far you should forget and smile
    Than that you should remember and be sad.

## After Death

The curtains were half drawn, the floor was swept
    And strewn with rushes, rosemary and may
    Lay thick upon the bed on which I lay,
Where through the lattice ivy-shadows crept.
He leaned above me, thinking that I slept
    And could not hear him; but I heard him say:
    'Poor child, poor child:' and as he turned away
Came a deep silence, and I knew he wept.
He did not touch the shroud, or raise the fold
    That hid my face, or take my hand in his,
    Or ruffle the smooth pillows for my head:
    He did not love me living; but once dead
    He pitied me; and very sweet it is
To know he still is warm though I am cold.

## An Apple Gathering

I plucked pink blossoms from mine apple-tree
    And wore them all that evening in my hair;
Then in due season when I went to see,
    I found no apples there.

With dangling basket all along the grass
    As I had come I went the self-same track:
My neighbours mocked me while they saw me pass
    So empty-handed back.

Lilian and Lilias smiled in trudging by,
    Their heaped-up basket teased me like a jeer;
Sweet-voiced they sang beneath the sunset sky,
    Their mother's home was near.

Plump Gertrude passed me with her basket full,
    A stronger hand than hers helped it along;
A voice talked with her through the shadows cool
    More sweet to me than song.

Ah Willie, Willie, was my love less worth
    Than apples with their green leaves piled above?
I counted rosiest apples on the earth
    Of far less worth than love.

So once it was with me you stooped to talk,
    Laughing and listening in this very lane;
To think that by this way we used to walk
    We shall not walk again!

I let my neighbours pass me, ones and twos
    And groups; the latest said the night grew chill,
And hastened. But I loitered; while the dews
    Fell fast I loitered still.

## Echo

Come to me in the silence of the night;
    Come in the speaking silence of a dream;
Come with soft rounded cheeks and eyes as bright
    As sunlight on a stream;
    Come back in tears,
O memory, hope, love of finished years.

Oh dream how sweet, too sweet, too bitter sweet,
    Whose wakening should have been
        in Paradise,
Where souls brimfull of love abide and meet;
    Where thirsting longing eyes
        Watch the slow door
That opening, letting in, lets out no more.

Yet come to me in dreams, that I may live
    My very life again though cold in death:

Come back to me in dreams, that I may give
  Pulse for pulse, breath for breath:
   Speak low, lean low,
As long ago, my love, how long ago!

## Winter: My Secret

I tell my secret? No indeed, not I:
Perhaps some day, who knows?
But not to-day; it froze, and blows, and snows,
And you're too curious: fie!
You want to hear it? well:
Only, my secret's mine, and I won't tell.

Or, after all, perhaps there's none:
Suppose there is no secret after all,
But only just my fun.
To-day's a nipping day, a biting day;
In which one wants a shawl,
A veil, a cloak, and other wraps:
I cannot ope to every one who taps,
And let the draughts come whistling through
  my hall;
Come bounding and surrounding me,
Come buffeting, astounding me,
Nipping and clipping through my wraps and all.
I wear my mask for warmth: who ever shows
His nose to Russian snows
To be pecked at by every wind that blows?
You would not peck? I thank you for good will,
Believe, but leave that truth untested still.

Spring's an expansive time: yet I don't trust
March with its peck of dust,
Nor April with its rainbow-crowned brief showers,
Nor even May, whose flowers
One frost may wither through the sunless hours.

Perhaps some languid summer day,
When drowsy birds sing less and less,
And golden fruit is ripening to excess,
If there's not too much sun nor too much cloud,
And the warm wind is neither still nor loud,
Perhaps my secret I may say,
Or you may guess.

## 'No, Thank You, John'

I never said I love you, John:
  Why will you tease me day by day,
And wax a weariness to think upon
  With always 'do' and 'pray'?

You know I never loved you, John;
  No fault of mine made me your toast:
Why will you haunt me with a face as wan
  As shows an hour-old ghost?

I dare say Meg or Moll would take
  Pity upon you, if you'd ask:
And pray don't remain single for my sake
  Who can't perform that task.

I have no heart?—Perhaps I have not;
  But then you're mad to take offence
That I don't give you what I have not got:
  Use your common sense.

Let bygones be bygones:
  Don't call me false, who owed not to
   be true:
I'd rather answer 'No' to fifty Johns
  Than answer 'Yes' to you.

Let's mar our pleasant days no more,
  Song-birds of passage, days of youth:
Catch at to-day, forget the days before:
  I'll wink at your untruth.

Let us strike hands as hearty friends;
  No more, no less; and friendship's good:
Only don't keep in view ulterior ends,
  And points not understood

In open treaty. Rise above
  Quibbles and shuffling off and on:
Here's friendship for you if you like; but
  No, thank you, John.

## A Pause of Thought

I looked for that which is not, nor can be,
        And hope deferred made my heart sick in truth:
        But years must pass before a hope of youth
            Is resigned utterly.

I watched and waited with a steadfast will:
        And though the object seemed to flee away
        That I so longed for, ever day by day,
            I watched and waited still.

Sometimes I said: This thing shall be no more:
        My expectation wearies and shall cease;
        I will resign it now and be at peace:
            Yet never gave it o'er.

Sometimes I said: It is an empty name
        I long for; to a name why should I give
        The peace of all the days I have to live?—
            Yet gave it all the same.

Alas, thou foolish one! alike unfit
        For healthy joy and salutary pain:
        Thou knowest the chase useless, and again
            Turnest to follow it.

## Shut Out

The door was shut. I looked between
        Its iron bars; and saw it lie,
        My garden, mine, beneath the sky,
Pied with all flowers bedewed and green:

From bough to bough the song-birds crossed,
        From flower to flower the moths and bees:
        With all its nests and stately trees
It had been mine, and it was lost.

A shadowless spirit kept the gate,
        Blank and unchanging like the grave.
        I, peering through, said: 'Let me have
Some buds to cheer my outcast state.'

He answered not. 'Or give me, then,
        But one small twig from shrub or tree;
        And bid my home remember me
Until I come to it again.'

The spirit was silent; but he took
        Mortar and stone to build a wall;
        He left no loophole great or small
Through which my straining eyes might look:

So now I sit here quite alone
        Blinded with tears; nor grieve for that,
        For nought is left worth looking at
Since my delightful land is gone.

A violet bed is budding near,
        Wherein a lark has made her nest:
        And good they are, but not the best;
And dear they are, but not so dear.

## Song

    When I am dead, my dearest,
        Sing no sad songs for me;
    Plant thou no roses at my head,
        Nor shady cypress tree:
    Be the green grass above me
        With showers and dewdrops wet;
    And if thou wilt, remember,
        And if thou wilt, forget.

    I shall not see the shadows,
        I shall not feel the rain;
    I shall not hear the nightingale
        Sing on, as if in pain:
    And dreaming through the twilight
        That doth not rise nor set,
    Haply I may remember,
        And haply may forget.

## Up-Hill

Does the road wind up-hill all the way?
    Yes, to the very end.
Will the day's journey take the whole long day?
    From morn to night, my friend.

But is there for the night a resting-place?
    A roof for when the slow dark hours begin.
May not the darkness hide it from my face?
    You cannot miss that inn.

Shall I meet other wayfarers at night?
    Those who have gone before.
Then must I knock, or call when just in sight?
    They will not keep you standing at that door.

Shall I find comfort, travel-sore and weak?
    Of labour you shall find the sum.
Will there be beds for me and all who seek?
    Yea, beds for all who come.

## A Better Resurrection

I have no wit, nor words, no tears;
    My heart within me like a stone
Is numbed too much for hopes or fears.
    Look right, look left, I dwell alone;
I lift mine eyes, but dimmed with grief
    No everlasting hills I see;
My life is in the falling leaf:
    O Jesus, quicken me.

My life is like a faded leaf,
    My harvest dwindled to a husk:
Truly my life is void and brief
    And tedious in the barren dusk;
My life is like a frozen thing,
    No bud nor greenness can I see:
Yet rise it shall—the sap of Spring;
    O Jesus, rise in me.

My life is like a broken bowl,
    A broken bowl that cannot hold
One drop of water for my soul
    Or cordial in the searching cold;
Cast in the fire the perished thing;
    Melt and remould it, till it be
A royal cup for Him, my King:
    O Jesus, drink of me.

## Symbols

I watched a rosebud very long
    Brought on by dew and sun and shower,
    Waiting to see the perfect flower:
Then, when I thought it should be strong,
    It opened at the matin hour
And fell at evensong.

I watched a nest from day to day,
    A green nest full of pleasant shade,
    Wherein three speckled eggs were laid:
But when they should have hatched in May,
    The two old birds had grown afraid
Or tired, and flew away.

Then in my wrath I broke the bough
    That I had tended so with care,
    Hoping its scent should fill the air;
I crushed the eggs, not heeding how
    Their ancient promise had been fair:
I would have vengeance now.

But the dead branch spoke from the sod,
    And the eggs answered me again:
    Because we failed dost thou complain?
Is thy wrath just? And what if God,
    Who waiteth for thy fruits in vain,
Should also take the rod?

## The World

By day, she woos me, soft, exceeding fair:
    But all night as the moon so changeth she;
    Loathsome and foul with hideous leprosy
And subtle serpents gliding in her hair.

By day she woos me to the outer air,
    Ripe fruits, sweet flowers, and full satiety:
    But through the night, a beast she grins at me,
A very monster void of love and prayer.
By day she stands a lie: by night she stands
    In all the naked horror of the truth
With pushing horns and clawed and clutching
        hands.
Is this a friend indeed, that I should sell
    My soul to her, give her my life and youth,
Till my feet, cloven too, take hold on hell?

**From *The Prince's Progress and Other Poems*
(1866)**

*Twice*

    I took my heart in my hand
        (O my love, O my love),
    I said: Let me fall or stand,
        Let me live or die,
    But this once hear me speak—
        (O my love, O my love)—
    Yet a woman's words are weak;
        You should speak, not I.

    You took my heart in your hand
        With a friendly smile,
    With a critical eye you scanned,
        Then set it down,
    And said: It is unripe,
        Better wait awhile;
    Wait while the skylarks pipe,
        Till the corn grows brown.

    As you set it down it broke—
        Broke, but I did not wince;
    I smiled at the speech you spoke,
        At your judgment that I heard:
    But I have not often smiled
        Since then, nor questioned since,
    Nor cared for corn-flowers wild,
        Nor sung with the singing bird.

    I take my heart in my hand,
        O my God, O my God,
    My broken heart in my hand:
        Thou hast seen, judge Thou.
    My hope was written on sand,
        O my God, O my God:
    Now let Thy judgment stand—
        Yea, judge me now.

    This condemned of a man,
        This marred one heedless day,
    This heart take Thou to scan
        Both within and without:
    Refine with fire its gold,
        Purge Thou its dross away—
    Yea, hold it in Thy hold,
        Whence none can pluck it out.

    I take my heart in my hand—
        I shall not die, but live—
    Before Thy face I stand;
        I, for Thou callest such:
    All that I have I bring,
        All that I am I give,
    Smile Thou and I shall sing,
        But shall not question much.

*The Bourne*

Underneath the growing grass,
    Underneath the living flowers,
    Deeper than the sound of showers:
    There we shall not count the hours
By the shadows as they pass.

Youth and health will be but vain,
    Beauty reckoned of no worth:
    There a very little girth
    Can hold round what once the earth
Seemed too narrow to contain.

## Memory

### 1

I nursed it in my bosom while it lived,
    I hid it in my heart when it was dead;
In joy I sat alone, even so I grieved
    Alone and nothing said.

I shut the door to face the naked truth,
    I stood alone—I faced the truth alone,
Stripped bare of self-regard or forms or ruth
    Till first and last were shown.

I took the perfect balances and weighed;
    No shaking of my hand disturbed the poise;
Weighed, found it wanting: not a word I said,
    But silent made my choice.

None know the choice I made; I make it still.
    None know the choice I made and broke
        my heart,
Breaking mine idol: I have braced my will
    Once, chosen for once my part.

I broke it at a blow, I laid it cold,
    Crushed in my deep heart where it used to live.
My heart dies inch by inch; the time grows old,
    Grows old in which I grieve.

### 2

I have a room wherein no one enters
    Save I myself alone:
    There sits a blessed memory on a throne,
There my life centres.

While winter comes and goes—oh tedious comer!—
    And while its nip-wind blows;
    While bloom the bloodless lily and warm rose
Of lavish summer.

If any should force entrance he might see there
    One buried yet not dead,
    Before whose face I no more bow my head
Or bend my knee there;

But often in my worn life's autumn weather
    I watch there with clear eyes,
    And think how it will be in Paradise
When we're together.

## Somewhere or Other

Somewhere or other there must surely be
    The face not seen, the voice not heard,
The heart that not yet—never yet—ah me!
    Made answer to my word.

Somewhere or other, may be near or far;
    Past land and sea, clean out of sight;
Beyond the wandering moon, beyond the star
    That tracks her night by night.

Somewhere or other, may be far or near;
    With just a wall, a hedge, between;
With just the last leaves of the dying year
    Fallen on a turf grown green.

## L.E.L.

4-17-00 Mon.

Whose heart was breaking for a little love.

Downstairs I laugh, I sport and jest with all:
    But in my solitary room above
I turn my face in silence to the wall;
    My heart is breaking for a little love.
        Though winter frosts are done,
        And birds pair every one,
And leaves peep out, for springtide is begun.

I feel no spring, while spring is wellnigh blown,
    I find no nest, while nests are in the grove:
Woe's me for mine own heart that dwells alone,
    My heart that breaketh for a little love.
        While golden in the sun
        Rivulets rise and run,
While lilies bud for springtide is begun.

All love, are loved, save only I; their hearts
    Beat warm with love and joy, beat full thereof:
They cannot guess, who play the pleasant parts,
    My heart is breaking for a little love.
        While beehives wake and whirr,
        And rabbit thins his fur,
In living spring that sets the world astir.

I deck myself with silks and jewellery,
    I plume myself like any mated dove:
They praise my rustling show, and never see
    My heart is breaking for a little love.
        While sprouts green lavender
        With rosemary and myrrh,
For in quick spring the sap is all astir.

Perhaps some saints in glory guess the truth,
    Perhaps some angels read it as they move,
And cry one to another full of ruth,
    'Her heart is breaking for a little love.'
        Though other things have birth,
        And leap and sing for mirth,
When springtime wakes and clothes and
        feeds the earth.

Yet saith a saint: 'Take patience for thy scathe';
    Yet saith an angel: 'Wait, for thou shalt prove
True best is last, true life is born of death,
    O thou, heart-broken for a little love.
        Then love shall fill thy girth,
        And love make fat thy dearth,
When new spring builds new heaven and
        clean new earth.'

### The Lowest Place

Give me the lowest place: not that I dare
    Ask for that lowest place, but Thou hast died
That I might live and share
    Thy glory by Thy side.

Give me the lowest place: or if for me
    That lowest place too high, make one more low
Where I may sit and see
    My God and love Thee so.

# Algernon Charles Swinburne
## From *Poems and Ballads* (1866)

## From *The Triumph of Time*

Where the dead red leaves of the years lie rotten,
    The cold old crimes and the deeds thrown by,
The misconceived and the misbegotten,
    I would find a sin to do ere I die,
Sure to dissolve and destroy me all through,
That would set you higher in heaven, serve you
And leave you happy, when clean forgotten,
    As a dead man out of mind, am I.

Your lithe hands draw me, your face burns
        through me,
    I am swift to follow you, keen to see;
But love lacks might to redeem or undo me,
    As I have been, I know I shall surely be;
'What should such fellows as I do?' Nay,
My part were worse if I chose to play;
For the worst is this after all; if they knew me,
    Not a soul upon earth would pity me.

And I play not for pity of these; but you,
    If you saw with your soul what man am I,
You would praise me at least that my soul all through
    Clove to you, loathing the lives that lie;
The souls and lips that are bought and sold,
The smiles of silver and kisses of gold,
The lapdog loves that whine as they chew,
    The little lovers that curse and cry.

There are fairer women, I hear; that may be.
    But I, that I love you and find you fair,
Who are more than fair in my eyes if they be,
    Do the high gods know or the great gods care?
Though the swords in my heart for one were seven,
Would the iron hollow of doubtful heaven,
That knows not itself whether night-time or day be,
    Reverberate words and a foolish prayer?

I will go back to the great sweet mother,
    Mother and lover of men, the sea.
I will go down to her, I and none other,

Close with her, kiss her and mix her with me;
Cling to her, strive with her, hold her fast;
O fair white mother, in days long past
Born without sister, born without brother,
  Set free my soul as they soul is free.

O fair green-girdled mother of mine,
  Sea, that art clothed with the sun and the rain,
Thy sweet hard kisses are hard like wine,
  Thy large embraces are keen like pain.
Save me and hide me with all thy waves,
Find me one grave of thy thousand graves,
Those pure cold populous graves of thine,
  Wrought without hand in a world without
    stain.

I shall sleep, and move with the moving ships,
  Change as the winds change, veer in the tide;
My lips will feast on the foam of thy lips,
  I shall rise with thy rising, with thee subside;
Sleep, and not know if she be, if she were,
Filled full with life to the eyes and hair,
As a rose is fulfilled to the roseleaf tips
  With splendid summer and perfume and pride.

This woven raiment of nights and days,
  Were it once cast off and unwound from me,
Naked and glad would I walk in thy ways,
  Alive and aware of thy ways and thee;
Clear of the whole world, hidden at home,
Clothed with the green and crowned with the foam,
A pulse of the life of thy straits and bays,
  A vein in the heart of the streams of the sea.

Fair mother, fed with the lives of men,
  Thou art subtle and cruel of heart, men say
Thou hast taken, and shalt not render again;
  Thou art full of thy dead, and cold as they.
But death is the worst that comes of thee;
Thou art fed with our dead, O mother, O sea,
But when hast thou fed on our hearts? or when,
  Having given us love, hast thou taken away?

O tender-hearted, O perfect lover,
  Thy lips are bitter, and sweet thine heart.

The hopes that hurt and the dreams that hover,
  Shall they not vanish away and apart?
But thou, thou art sure, thou art older than earth;
Thou art strong for death and fruitful of birth;
Thy depths conceal and thy gulfs discover;
  From the first thou wert; in the end thou art.

I shall go my ways, tread out my measure,
  Fill the days of my daily breath
With fugitive things not good to treasure,
  Do as the world doth, say as it saith;
But if we had loved each other—O sweet,
Had you felt, lying under the palms of your feet,
The heart of my heart, beating harder with pleasure
  To feel you tread it to dust and death—

Ah, had I not taken my life up and given
  All that life gives and the years let go,
The wine and the honey, the balm and leaven,
  The dreams reared high and the hopes
    brought low?
Come life, come death, not a word be said;
Should I lose you living, and vex you dead?
I never shall tell you on earth; and in heaven
  If I cry to you then, will you hear or know?

## A Leave-Taking

Let us go hence, my songs; she will not hear.
Let us go hence together without fear;
Keep silence now, for singing-time is over
And over all old things and all things dear.
She loves not you nor me as well we love her.
Yea, though we sang as angels in her ear,
                She would not hear.

Let us rise up and part; she will not know.
Let us go seward as the great winds go,
Full of blown sand and foam; what help is there?
There is no help, for all these things are so,
And all the world is bitter as a tear.
And how these things are, though ye strove to show,
                She would not know.

Let us go home and hence; she will not weep,
We gave love many dreams and days to keep,
Flowers without scent, and fruits that would not
    grow,
Saying, 'If thou wilt, thrust in thy sickle and reap.'
All is reaped now; no grass is left to mow;
And we that sowed, though all we fell on sleep,
              She would not weep.

Let us go hence and rest; she will not love.
She shall not hear us if we sing hereof,
Nor see love's ways, how sore they are and steep.
Come hence, let be, lie still: it is enough.
Love is a barren sea, bitter and deep;
And though she saw all heaven in flower above,
              She would not love.

Let us give up, go down; she will not care.
Though all the stars made gold of all the air,
And the sea moving saw before it move
One moon-flower making all the foam-flowers fair;
Though all those waves went over us, and drove
Deep down the stifling lips and drowning hair,
              She would not care.

Let us go hence, go hence; she will not see.
Sing all once more together: surely she,
She too, remembering days and words that were,
Will turn a little toward us, sighing; but we,
We are hence, we are gone, as though we had not
    been there.
Nay, and though all men seeing had pity on me,
              She would not see.

## A Match

If love were what the rose is,
    And I were like the leaf,
Our lives would grow together
In sad or singing weather,
Blown fields or flowerful closes,
    Green pleasure or grey grief;
If love were what the rose is,
    And I were like the leaf.

If I were what the words are,
    And love were like the tune,
With double sound and single
Delight our lips would mingle,
With kisses glad as birds are
    That get sweet rain at noon;
If I were what the words are
    And love were like the tune.

If you were my life, my darling,
    And I your love were death,
We'd shine and snow together
Ere March made sweet the weather
With daffodil and starling
    And hours of fruitful breath;
If you were life, my darling,
    And I your love were death.

If you were thrall to sorrow,
    And I were page to joy,
We'd play for lives and seasons
With loving looks and treasons
And tears of night and morrow
    And laughs of maid and boy;
If you were thrall of sorrow,
    And I were page to joy.

If you were April's lady,
    And I were lord in May,
We'd throw with leaves for hours
And draw for days with flowers,
Till day like night were shady
    And night were bright like day;
If you were April's lady,
    And I were lord in May.

If you were queen of pleasure,
    And I were king of pain,
We'd hunt down love together,
Pluck out his flying-feather,
And teach his feet a measure,
    And find his mouth a rein;
If you were queen of pleasure,
    And I were king of pain.

## Faustine

*Ave Faustina Imperatrix, morituri te salutant.*

Lean back, and get some minutes' peace;
    Let your head lean
Back to the shoulder with its fleece
    Of locks, Faustine.

The shapely silver shoulder stoops,
    Weighed over clean
With state of splendid hair that droops
    Each side, Faustine.

Let me go over your good gifts
    That crown you queen;
A queen whose kingdom ebbs and shifts
    Each week, Faustine.

Bright heavy brow well gathered up:
    White gloss and sheen;
Carved lips that make my lips a cup
    To drink, Faustine.

Wine and rank poison, milk and blood,
    Being mixed therein
Since first the devil threw dice with God
    For you, Faustine.

Your naked new-born soul, their stake,
    Stood blind between;
God said 'let him that wins her take
    And keep Faustine.'

But this time Satan throve, no doubt;
    Long since, I ween,
God's part in you was battered out;
    Long since, Faustine.

The die rang sideways as it fell,
    Rang cracked and thin,
Like a man's laughter heard in hell
    Far down, Faustine.

A shadow of laughter like a sigh,
    Dead sorrow's kin;
So rang, thrown down, the devil's die
    That won Faustine.

A suckling of his breed you were,
    One hard to wean;
But God, who lost you, left you fair,
    We see, Faustine.

You have the face that suits a woman
    For her soul's screen—
The sort of beauty that's called human
    In hell, Faustine.

You could do all things but be good
    Or chaste of mien;
And that you would not if you could,
    We know, Faustine.

Even he who cast seven devils out
    Of Magdalene
Could hardly do as much, I doubt,
    For you, Faustine.

Did Satan make you to spite God?
    Or did God mean
To scourge with scorpions for a rod
    Our sins, Faustine?

I know what queen at first you were,
    As though I had seen
Red gold and black imperious hair
    Twice crown Faustine.

As if your fed sarcophagus
    Spared flesh and skin,
You come back face to face with us,
    The same Faustine.

She loved the games men played with death,
    Where death must win;
As though the slain man's blood and breath
    Revived Faustine.

Nets caught the pike, pikes tore the net;
    Lithe limbs and lean
From drained-out pores dripped thick red sweat
    To soothe Faustine.

She drank the steaming drift and dust
    Blown off the scene;
Blood could not ease the bitter lust
    That galled Faustine.

All round the foul fat furrows reeked,
    Where blood sank in;
The circus splashed and seethed and shrieked
    All round Faustine.

But these are gone now: years entomb
    The dust and din;
Yea, even the bath's fierce reek and fume
    That slew Faustine.

Was life worth living then? and now
    Is life worth sin?
Where are the imperial years? and how
    Are you, Faustine?

Your soul forgot her joys, forgot
    Her times of teen;
Yea, this life likewise will you not
    Forget, Faustine?

For in the time we know not of
    Did fate begin
Weaving the web of days that wove
    Your doom, Faustine.

The threads were wet with wine, and all
    Were smooth to spin;
They wove you like a Bacchanal,
    The first Faustine.

And Bacchus cast your mates and you
    Wild grapes to glean;
Your flower-like lips dashed with dew
    From his, Faustine.

Your drenched loose hands were stretched to hold
    The vine's wet green,
Long ere they coined in Roman gold
    Your face, Faustine.

Then after change of soaring feather
    And winnowing fin,
You woke in weeks of feverish weather,
    A new Faustine.

A star upon your birthday burned,
    Whose fierce serene
Red pulseless planet never yearned
    In heaven, Faustine.

Stray breaths of Sapphic song that blew
    Through Mitylene
Shook the fierce quivering blood in you
    By night, Faustine.

The shameless nameless loves that makes
    Hell's iron gin
Shut on you like a trap that breaks
    The soul, Faustine.

And when your veins were void and dead,
    What ghost unclean
Swarmed round the straitened barren bed
    That hid Faustine?

What sterile growths of sexless root
    Or epicene?
What flower of kisses without fruit
    Of love, Faustine?

What adders came to shed their coats?
    What coiled obscene
Small serpents with soft stretching throats
    Caressed Faustine?

But the time came of famished hours,
    Maimed loves and mean,
This ghastly thin-faced time of ours,
    To spoil Faustine.

You seem a thing that hinges hold,
    A love-machine
With clockwork joints of supple gold—
    No more, Faustine.

Not godless, for you serve one God,
  The Lampsacene,
Who metes the gardens with his rod;
  Your lord, Faustine.

If one should love you with real love
  (Such things have been,
Things your fair face knows nothing of
  It seems, Faustine);

That clear hair heavily bound back,
  That lights wherein
Shift from dead blue to burnt-up black
  Your throat, Faustine,

Strong, heavy, throwing out the face
  And hard bright chin
And shameful scornful lips that grace
  Their shame, Faustine,

Curled lips, long since half kissed away,
  Still sweet and keen;
You'd give him—poison shall we say?
  Or what, Faustine?

### The Leper

Nothing is better, I well think,
  Than love; the hidden well-water
Is not so delicate to drink:
  This was well seen of me and her.

I served her in a royal house;
  I served her wine and curious meat.
For will to kiss between her brows,
  I had no heart to sleep or eat.

Mere scorn God knows she had of me,
  A poor scribe, nowise great or fair,
Who plucked his clerk's hood back to see
  Her curled up lips and amorous hair.

I vex my head with thinking this.
  Yea, though God always hated me,
And hates me now that I can kiss
  Her eyes, plait up her hair to see

How she then wore it on the brows,
  Yet am I glad to have her dead
Here in this wretched wattled house
  Where I can kiss her eyes and head.

Nothing is better, I well know,
  Than love; no amber in cold sea
Or gathered berries under snow:
  That is well seen of her and me.

Three thoughts I make my pleasure of:
  First I take heart and think of this:
That knight's gold hair she chose to love,
  His mouth she had such will to kiss.

Then I remember that sundawn
  I brought him by a privy way
Out at her lattice, and thereon
  What gracious words she found to say.

(Cold rushes for such little feet—
  Both feet could lie into my hand.
A marvel was it of my sweet
  Her upright body could so stand.)

'Sweet friend, God give you thank and grace;
  Now am I clean and whole of shame,
Nor shall men burn me in the face
  For my sweet fault that scandals them.'

I tell you over word by word.
  She, sitting edgewise on her bed,
Holding her feet, said thus. The third,
  A sweeter thing than these, I said.

God, that makes time and ruins it,
  And alters not, abiding God,
Changed with disease her body sweet,
  The body of love wherein she abode.

Love is more sweet and comelier
    Than a dove's throat strained out to sing.
All they spat out and cursed at her
    And cast her forth for a base thing.

They cursed her, seeing how God had wrought
    This curse to plague her, a curse of his.
Fools were they surely, seeing not
    How sweeter than all sweet she is.

He that had held her by the hair,
    With kissing lips blinding her eyes,
Felt her bright bosom, strained and bare,
    Sigh under him, with short mad cries

Out of her throat and sobbing mouth
    And body broken up with love,
With sweet hot tears his lips were loth
    Her own should taste the savor of,

Yea, he inside whose grasp all night
    Her fervent body leapt or lay,
Stained with sharp kisses red and white,
    Found her a plague to spurn away.

I hid her in this wattled house,
    I served her water and poor bread.
For joy to kiss between her brows
    Time upon time I was nigh dead.

Bread failed; we got but well-water
    And gathered grass with dropping seed.
I had such joy of kissing her,
    I had small care to sleep or feed.

Sometimes when service made me glad
    The sharp tears leapt between my lids,
Falling on her, such joy I had
    To do the service God forbids.

'I pray you let me be at peace,
    Get hence, make room for me to die.'
She said that: her poor lip would cease,
    Put up to mine, and turn to cry.

I said, 'Bethink yourself how love
    Fared in us twain, what either did;
Shall I unclothe my soul thereof?
    That I should do this, God forbid.'

Yea, though God hateth us, he knows
    That hardly in a little thing
Love faileth of the work it does
    Till it grow ripe for gathering.

Six months, and now my sweet is dead
    A trouble takes me; I know not
If all were done well, all well said,
    No word or tender deed forgot.

Too sweet, for the least part in her,
    To have shed life out by fragments; yet,
Could the close mouth catch breath and stir,
    I might see something I forget.

Six months, and I sit still and hold
    In two cold palms her cold two feet.
Her hair, half grey half ruined gold,
    Thrills me and burns me in kissing it.

Love bites and stings me through, to see
    Her keen face made of sunken bones.
Her worn-off eyelids madden me,
    That were shot through with purple once.

She said, 'Be good with me; I grow
    So tired for shame's sake, I shall die
If you say nothing': even so.
    And she is dead now, and shame put by.

Yea, and the scorn she had of me
    In the old time, doubtless vexed her then.
I never should have kissed her. See
    What fools God's anger makes of men!

She might have loved me a little too,
    Had I been humbler for her sake.
But that new shame could make love new
    She saw not—yet her shame did make.

I took too much upon my love,
　　Having for such mean service done
Her beauty and all the ways thereof,
　　Her face and all the sweet thereon.

Yea, all this while I tended her,
　　I know the old love held fast his part:
I know the old scorn waxed heavier,
　　Mixed with sad wonder, in her heart.

It may be all my love went wrong—
　　A scribe's work writ awry and blurred,
Scrawled after the blind evensong—
　　Spoilt music with no perfect word.

But surely I would fain have done
　　All things the best I could. Perchance
Because I failed, came short of one,
　　She kept at heart that other man's.

I am grown blind with all these things:
　　It may be now she hath in sight
Some better knowledge; still there clings
　　The old question. Will not God do right?

## Rondel

Kissing her hair I sat against her feet,
Wove and unwove it, wound and found it sweet,
Made fast therewith her hands, drew down her eyes
Deep as deep flowers and dreamy like dim skies;
With her own tresses bound and found her fair,
　　Kissing her hair.

Sleep were not sweeter than her face to me,
Sleep of cold sea-bloom under the cold sea;
What pain could get between my face and hers?
What new sweet thing would love not relish worse?
Unless, perhaps, white death had kissed me there,
　　Kissing her hair?

## From *Before the Mirror*
## (Verses Written Under a Picture)
## Inscribed to J.A. Whistler

### 2

'Come snow, come wind or thunder
　　High up in air,
I watch my face, and wonder
　　At my bright hair;
Nought else exalts or grieves
The rose at heart, that heaves
　　With love of her own leaves and lips that pair.

'She knows not loves that kissed her
　　She knows not where,
Art thou the ghost, my sister,
　　White sister there,
Am I the ghost, who knows?
My hand, a fallen rose,
　　Lies snow-white on white snows, and takes
　　　　no care.

'I cannot see what pleasures
　　Or what pains were;
What pale new loves and treasures
　　New years will bear;
What beam will fall, what shower,
What grief or joy for dower;
　　But one thing knows the flower; the flower
　　　　is fair.'

### 3

Glad, but not flushed with gladness,
　　Since joys go by;
Sad, but not bent with sadness,
　　Since sorrows die;
Deep in the gleaming glass
She sees all past things pass,
　　And all sweet life that was lie down and lie.

There glowing ghosts of flowers
　　Draw down, draw nigh;
And wings of swift spent hours
　　Take flight and fly;
She sees by formless gleams,

She hears across cold streams,
Dead mouths of many dreams that sing
and sigh.

Face fallen and white throat lifted,
With sleepless eye
She sees old loves that drifted,
She knew not why,
Old loves and faded fears
Float down a stream that hears
The flowing of all men's tears beneath the sky.

## The Garden of Proserpine

Here, where the world is quiet,
Here, where all trouble seems
Dead winds' and spent waves' riot
In doubtful dreams of dreams;
I watch the green field growing
For reaping folk and sowing,
For harvest time and mowing,
A sleepy world of streams.

I am tired of tears and laughter,
And men that laugh and weep;
Of what may come hereafter
For men that sow to reap:
I am weary of delays and hours,
Blown buds of barren flowers,
Desires and dreams and powers
And everything but sleep.

Here life has death for neighbour,
And far from eye or ear
Wan waves and wet winds labour,
Weak ships and spirits steer;
They drive adrift, and whither
They wot not who make thither;
But no such winds blow hither,
And no such things grow here.

No growth of moor or coppice,
No heather-flower or vine,
But bloomless buds of poppies,

Green grapes of Proserpine,
Pale beds of blowing rushes
Where no leaf blooms or blushes,
Save this whereout she crushes
For dead men deadly wine.

Pale, without name or number,
In fruitless fields of corn,
They bow themselves and slumber
All night till light is born;
And like a soul belated,
In hell and heaven unmated,
By cloud and mist abated
Comes out of darkness morn.

Though one were strong as seven,
He too with death shall dwell,
Nor wake with wings in heaven,
Nor weep for pains in hell;
Though one were fair as roses,
His beauty clouds and closes;
And well though love reposes,
In the end it is not well.

Pale, beyond porch and portal,
Crowned with calm leaves, she stands
Who gathers all things mortal
With cold immortal hands;
Her languid lips are sweeter
Than love's who fears to greet her
To men that mix and meet her
From many times and lands.

She waits for each and other,
She waits for all men born;
Forgets the earth her mother,
The life of fruits and corn;
And spring and seed and swallow
Take wing for her and follow
Where summer songs rings hollow
And flowers are put to scorn.

There go the loves that wither,
The old loves with wearier wings;
And all dead years draw thither,

And all disastrous things;
Dead dreams of days forsaken
Blind buds that snows have shaken,
Wild leaves that winds have taken,
    Red strays of ruined springs.

We are not sure of sorrow,
    And joy was never sure;
To-day will die to-morrow;
    Time stoops to no man's lure;
And love, grown faint and fretful,
With lips but half regretful
Sighs, and with eyes forgetful
    Weeps that no loves endure.

From too much love of living,
    From hope and fear set free,
We thank with brief thanksgiving
    Whatever gods may be
That no life lives for ever;
That dead men rise up never;
That even the weariest river
    Winds somewhere safe to sea.

Then star nor sun shall waken,
    Nor any change of light:
Nor sound of waters shaken,
    Nor any sound or sight:
Nor wintry leaves nor vernal,
Nor days nor things diurnal;
Only the sleep eternal
    In an eternal night.

## The Sundew

A little marsh-plant, yellow green,
And pricked at lip with tender red.
Tread close, and either way you tread
Some faint black water jets between
Lest you should bruise the curious head.

A live thing may be; who shall know?
The summer knows and suffers it;
For the cool moss is thick and sweet

Each side, and saves the blossom so
That it lives out the long June heat.

The deep scent of the heather burns
About it; breathless though it be,
Bow down and worship; more than we,
Is the least flower whose life returns,
Least weed renascent in the sea.

We are vexed and cumbered in earth's sight
With wants, with many memories;
These see their mother what she is,
Glad-growing, till August leave more bright
The apple-coloured cranberries.

Wind blows and bleaches the strong grass,
Blown all one way to shelter it
From trample of strayed kine, with feet
Felt heavier than the moorhen was,
Strayed up past patches of wild wheat.

You call it sundew: how it grows,
If with its colour it have breath,
If life taste sweet to it, if death
Pain its soft petal, no man knows:
Man has no sight or sense that saith.

My sundew, grown of gentle days,
In these green miles the spring begun
Thy growth ere April had half done
With the soft secret of her ways
Or June made ready for the sun.

O red-lipped mouth of marsh-flower,
I have a secret halved with thee.
The name that is love's name to me
Thou knowest, and the face of her
Who is my festival to see.

The hard sun, as thy petals knew,
Coloured the heavy moss-water:
Thou wert not worth green midsummer
Nor fit to live to August blue,
O sundew, not remembering her.

# REACTIONS

## Robert Buchanan
### Review of *Poems and Ballads* in the *Athenæum* (4 August 1866)

Mr. Swinburne commenced his literary career with considerable brilliance. His 'Atalanta in Calydon' evinced noticeable gifts of word-painting and of music; and his 'Chastelard', though written in a monotone, contained several passages of dramatic force and power. In the latter work, however, there was too open a proclivity to that garish land beyond the region of pure thinking, whither so many inferior writers have been lured for their destruction,—the land where Atys became a raving and sexless maniac, and where Catullus himself would have perished had he not been drawn back to the shadier border-region by the sincerity of his one grand passion. The glory of our modern poetry is its transcendent purity—no less noticeable in the passionate sweetness of Keats and Shelley than in the cold severity of Wordsworth; a purity owing much to the splendid truth of its sensuous colouring. More or less unavailing have been all the efforts of insincere writers to stain the current of our literature with impure thought; and those who have made the attempt have invariably done so with a view to conceal their own literary inferiority. Very rarely indeed a mighty physical nature has found utterance in warmer, less measured terms than are commonly employed in life or art; but it would be difficult, on fair critical grounds, to decide such utterance to be immoral—it is so genuine. The genuineness of the work as Art, we would suggest, can be the only absolute test of immorality in a story or a poem. Truly sincere writing, no matter how forcible, seldom really offends us. When, however, we find a writer like the author of these 'Poems and Ballads', who is deliberately and impertinently insincere as an artist,—who had no splendid individual emotions to reveal, and is unclean for the mere sake of uncleanness,—we may safely affirm, in the face of many pages of brilliant writing, that such a man is either no poet at all, or a poet degraded from his high estate, and utterly and miserably lost to the Muses. How old is this young gentleman, whose bosom, it appears, is a flaming fire, whose face is as the fiery foam of flowers, and whose words are as the honeyed kisses of the Shunamite? He is quite the Absalom of modern bards,—long ringleted, flippant-lipped, down-cheeked, amorous-lidded. He seems, moreover, to have prematurely attained to the fate of his old prototype; for we now find him fixed very fast indeed up a tress, and it will be a miracle if one breath of poetic life remain in him when he is cut down. Meanwhile, he tosses to us this charming book of verses, which bears some evidence of having been inspired in Holywell Street, composed on the Parade at Brighton, and touched up in the Jardin Mabile. Very sweet things in puerility, as a literary linen-draper might express it,—fine glaring patterns after Alfred de Musset and George Sands,—grand bits in the manner of Hugo, with here and there a notable piece of insertion from Ovid and Boccaccio. Yet ere we go further, let us at once disappoint Mr. Swinburne, who would doubtless be charmed if we averred that his poems were capable of having an absolutely immortal influence. They are too juvenile and unreal for that. The strong pulse of true passion beats in no one of them. They are unclean, with little power; and mere uncleanness repulses. Here, in fact, we have Gito, seated in the tub of Diogenes, conscious of the filth and whining at the stars.

The very first verse in the book, though harmless enough in meaning, is a sample of the utter worthlessness in *form* of most of the poems:

> I found in dreams a place of wind and flowers,
>> Full of sweet trees and colour of glad grass,
>>> In midst whereof there was
> A lady clothed like summer with sweet hours.
> Her beauty, fervent as a fiery moon,
>> Made my blood burn and swoon
>>> Like a flame rained upon.

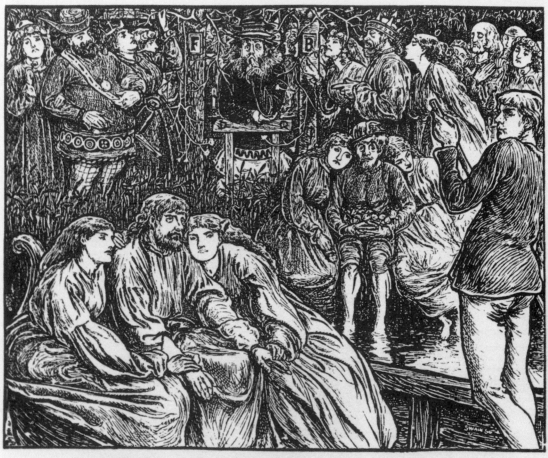

## A Legend of Camelot.—Part 5 and Last. Gauwaine his Penance.

The castle weeds have grown so tall
Knights cannot see the red brick wall.
   O miserie !
The little drawbridge hangs awry,
The little flowery moat is dry !
   O miserie !
And the wind, it soughs and sighs alway
Through the grey willows, night and day !
   O miserie !
And evermore two willows there
Do weep, whose boughs are always bare :
   O miserie !
At all times weep they, in and out
Of season, turn and turn about !
   O miserie !
But later, when the year doth fall,
And other willows, one and all,
   O miserie !
In yellowing and dishevelled leaf
Sway haggard with their autumn grief,
   O miserie !
Then do these leafless willows now
Put forth a rosebud from each bough !
   O miserie !
What time Gauwaine, with spurless heels,
Barefoot (but not bare-headed) kneels
   O miserie !
Between ! . . . as fits a bigamous knight
Twice widowed in a single night :
   O miserie !

And then, for that promiscuous way
Of axing Hebrews in broad day,
   O miserie !
He ever uttereth a note
Of Eastern origin remote. . . .
   O miserie !
A well-known monochord, that tells
Of one who, wandering, buys and sells !
   O miserie !
What time the knights and damsels fair,
Of Arthur's court come trooping there,
   O miserie !
They come in dresses of dark green,
Two damsels take a knight between :
   O miserie !
One sad and sallow knight is fixt
Dyspeptic damsels twain betwixt !
   O miserie !
They speak not, but their weary eyes
And wan white eyelids droop and rise
   O miserie !
With dim dead gaze of mystic woe !
They always take their pleasure so
   O miserie !
In Camelot . . . It doth not lie
With us to ask, or answer, why !
   O miserie !
Yet, seeing them so fair and good,
Fain would we cheer them, if we could !
   O miserie !

And every time they find a bud,
They pluck it, and it bleeds red blood.
   O miserie !
And when they pluck a full blown rose,
And breathe the same, its colour goes !
   O miserie !
But with Gauwaine alone at night,
The willows dance in their delight !
   O miserie !
The rosebuds wriggle in their bliss,
And lift them for his lips to kiss !
   O miserie !
And if he kiss a rose instead,
It blushes of a deeper red !
   O miserie !
And if he like it, let him be !
It makes no odds to you or me !
   O miserie !
O many-headed multitude,
Who read these rhymes that run so rude,
   O miserie !
Strive not to fathom their intent !
But say your prayers, and rest content
   O miserie !
That, notwithstanding those two cracks
He got from Gauwaine's battle-axe,
   O miserie !
The Hebrew had the best of it !
So, Gentles, let us rest a bit.
   O miserie !

'A Legend of Camelot: Part 5 and Last' in *Punch,* by George DuMaurier (31 March 1866)

Sorrow had filled her shaken eyelid's blue,
And her mouth's sad red heavy rose all through
   Seemed sad with glad things gone.

     Here all the images are false and
distracted,—mere dabs of colour distributed
carelessly and without art. The following sonnet
goes further:

Lying asleep between the strokes of night
   I saw my love lean over my sad bed,
   Pale as the duskiest lily's leaf or head,
Smoothed-skinned and dark, with bare throat
     made to bite,
Too wan for blushing and too warm for white,
   But perfect-coloured without white or red.
   And her lips opened amorously, and said—
I wist not what, saving one word—Delight.
And all her face was honey to my mouth,
   And all her body pasture to mine eyes;
   The long lithe arms and hotter hands than fire,
The quivering flanks, hair smelling of the south,
   The bright light feet, the splendid supple thighs
   And glittering eyelids of my soul's desire.

It would be idle to quote such prurient trash as
that,—save for the purpose of observing that Mr.
Swinburne's thought is on a fair level with his
style of expression: both are untrue, insincere, and
therefore unpoetical. Absolute passion there is
none; elaborate attempts at thick colouring supply
the place of passion. Now, it may be fairly assumed
that a writer so hopelessly blind to the simplest
decencies of style, so regardless of the first
principles of Art, can scarcely fail to offend if he
attempt to discuss topics of importance to his
fellow creatures, or deal with themes which
demand the slightest exercise of thought properly
so called...

     It is quite obvious that Mr. Swinburne has
never thought at all on religious questions, but
imagines that rank blasphemy will be esteemed
very clever. He describes the Almighty as
throwing dice with the Devil for the soul of
Faustine; and in the 'Laus Veneris', inserts the
following lines, which he himself, doubtless,
considers very grand:

Lo, she was thus when her clear limbs enticed
All lips that now grow sad with kissing Christ,
   Stained with blood fallen from the feet of God,
The feet and hands whereat our souls were priced.
Alas, Lord, surely thou art great and fair.
But lo, her wonderfully woven hair!
   And thou didst heal us with thy piteous kiss;
But see now, Lord; her mouth is lovelier.

She is right fair; what hath she done to thee?
Nay, fair Lord Christ, lift up thine eyes and see;
   Had now thy mother such a lip—like this?

Impertinence like the above can only be the work
either of a misdirected and most disagreeable
youth or of a very silly man. It is writing of which
no true poet, fairly cultured, could have been
guilty.

     Gross insincerity in dealing with simple
subjects, and rank ravings on serious themes,
makes one suspicious of a writer's quality in all
things; and a very little examination enables us to
perceive that these poems are essentially imitative.
Indeed Mr. Swinburne's knack of parody is very
remarkable, though it weights heavily against his
literary quality. Nothing could be cleverer than his
imitation, here printed, of an old miracle-play; or
than his numerous copies of the French lyric
writers; or his ingenious parrotings of the way of
Mr. Browning. In no single instance does he free
himself from the style of the copyist. His skill in
transferring an old or modern master would be an
enviable gift for any writer but one who hoped to
prove himself a poet. Then again, though clever
and whimsical to the last degree, he is satisfied
with most simple effects. After a while we find out
there is a trick in his very versification, that it owes
its music to the most extraordinary style of
alliteration:

It will grow not again, this fruit of my heart,
   Smitten with sunbeams, ruined with rain.
The singing seasons divide and depart,
   Winter and summer depart in twain.

It will grow not again, it is ruined at root,
  The bloodlike blossom, the dull red fruit;
Though the heart yet sickens, the lips yet smart,
  With sullen savour of poisonous pain.

This kind of writing, abounding in adjectives chosen merely because they alliterate, soon cloys and sickens; directly we find out the trick our pleasure departs. We soon perceive also that Mr. Swinburne's pictures are bright and worthless. We detect no real taste for colour; the skies are all Prussian blue, the flesh-tints all vermillion, the sunlights all gamboge. The writer, who has no meditative faculty, evinces total ignorance of nature; his eye rolls like that of a drunkard, whose vision is clouded with fumes.

But we fear we have lingered too long over this book; criticism is thriftless here. We have hinted very slightly at the tone of the poems,—in all of which pure thinking is treated with scorn, and sensuality paraded as the end of life. The impure thought finds its natural expression in insincere verses, without real music, without true colour. One word with Mr. Swinburne before we conclude; perhaps it is not too late for him to turn back from ruin; perhaps, being young, he has evil advisers. Let him, then, seek wisdom, and cast evil advisers aside. Some few years hence he will feel that the only sure hold on the public is the reputation of earnestness in life, and of sincerity in thought; yet, after publishing these poems, he will find it hard, very hard, to convince his readers that he is an earnest man or a sincere thinker. His very parasites will abandon him, and the purer light, pouring in his sick eyes, will agonize and perhaps end him. Let him seek out Nature, let him humble himself, let him try to think seriously on life and art. He it was who, in a recent preface to Bryon, described Wordsworth as slicing up Nature for culinary purposes. If that description be true, a sound course of discipline in the kitchen will do Mr. Swinburne a great deal of good; for he will, at least, learn to distinguish the ingredients of things, what will or will not harmonize together, and what kind of dishes form wholesome food for grown-up men.

### *The Session of Poets* in *The Spectator* (September 1866)

*Di magni, salaputium disertum!*—CAT. LIB. 53

1

At the Session of Poets held lately in London,
  The Bard of Freshwater was voted the chair:
With his tresses unbrush'd, and his shirt-collar undone,
  He loll'd at his ease like a good-humour'd Bear;
'Come, boys!' he exclaimed, 'we'll be merry together!'
  And lit up his pipe with a smile on his cheek;—
While with eye, like a skipper's, cock'd up at the weather,
  Sat the Vice-Chairman Browning, thinking in Greek.

2

The company gather'd embraced great and small bards,
  Both strong bards and weak bards, funny and grave,
Fat bards and lean bads, little and tall bards,
  Bards who wear whiskers, and others who shave.

Of books, men, and things, was the bards' conversation—
    Some praised Ecce Homo, some deemed it so-so—
And then there was talk of the state of the nation,
    And when the Unwash'd would devour Mister Lowe.

3

Right stately sat Arnold,—his black gown adjusted
    Genteelly, his Rhine wine deliciously iced,—
With puddingish England serenely disgusted
    And looking in vain (in the mirror) for 'Geist;'
He heark'd to the Chairman, with 'Surely!' and 'Really?'
    Aghast at both collar and cutty of clay,—
Then felt in his pocket, and breath'd again freely,
    On touching the leaves of his own classic play.

4

Close at hand, lingered Lytton, whose Icarus-winglets
    Had often betrayed him in regions of rhyme,—
How glitter'd the eye underneath his grey ringlets,
    A hunger within it lessen'd by time!
Remoter sat Bailey—satrical, surly—
    Who studied the language of Goethe too soon,
And sang himself hoarse to the stars very early,
    And crack'd a weak voice with too lofty a tune.

5

How name all that wonderful company over?—
    Prim Patmore, mild Alford,—and Kingsley also?
Among the small sparks, who was realler than Lover?
    Among misses, who sweeter than Miss Inglelow?
There sat, looking moony, conceited, and narrow,
    Buchanan,—who, finding, when foolish and young,
Apollo asleep on a coster-girl's barrow,
    Straight dragged him away to see somebody hung.

6

What was said? what was done? was there prosing in rhyming?
    Was nothing noteworthy in deed or in word?—
Why, just as the hour of the supper was chiming,
    The only event of the evening occurred.
Up jumped, with his neck stretching out like a gander,
    Master Swinburne, and squeal'd, glaring out thro' his hair,
'All Virtue is bosh! Hallelujah for Landor!
    I disbelieve wholly in everything!—There!'

### 7

With language so awful he dared then to treat 'em,—
    Miss Ingelow fainted in Tennyson's arms,
Poor Arnold rush'd out, crying 'Soecl's inficetum!'
    And great bards and small bards were full of alarms;
Till Tennyson, flaming and red as a gipsy,
    Struck his fist on the table and utter'd a shout:
'To the door with the boy! Call a cab! He is tipsy!'
    And they carried the naughty young gentleman out.

### 8

After that, all the pleasanter talking was done there,—
    Who ever had known such an insult before?
The Chairman tried hard to rekindle the fun there,
    But the Muses were shocked and the pleasure was o'er.
Then 'Ah!' cried the Chairman, 'this teaches me knowledge.
    The future shall find me more wise, by the powers!
This comes of assigning to yonkers from college
    Too early a place in such meetings as ours!'

## John Morley
### From 'Mr. Swinburne's New Poems: *Poems & Ballads*' in the *Saturday Review* (August 1866)

It is mere waste of time, and shows a curiously mistaken conception of human character, to blame an artist of any kind for working at a certain set of subjects rather than at some other set which the critic may happen to prefer. An artist, at all events an artist of such power and individuality as Mr. Swinburne, works as his character compels him. If the character of his genius drives him pretty exclusively in the direction of libidinous song, we may be very sorry, but it is of no use to advise him and to preach to him. What comes of discoursing to a fiery tropical flower of the pleasant fragrance of the rose or the fruitfulness of the fig-tree? Mr. Swinburne is much too stoutly bent on taking his own course to pay any attention to critical monitions as to the duty of the poet, or any warnings of the worse than barrenness of the field in which he has chosen to labour. He is so firmly and avowedly fixed in an attitude of revolt against the current notions of decency and dignity and social duty that to beg of him to become a little more decent, to fly a little less persistently and gleefully to the animal side of human nature, is simply to beg him to be something different from Mr. Swinburne. It is a kind of protest which his whole position makes it impossible for him to receive with anything but laughter and contempt. A rebel of his calibre is not to be brought to a better mind by solemn little sermons on the loyalty which a man owes to virtue. His warmest prayer to the gods is that they should

Come down and redeem us from virtue.

His warmest hope for men is that they should change

The lilies and languors of virtue
For the raptures and roses of vice.

It is of no use, therefore, to scold Mr. Swinburne for grovelling down among the nameless shameless abominations which inspire him with such frenzied delight. They excite his imagination

to its most vigorous efforts, they seem to him the themes most proper for poetic treatment, and they suggest ideas which, in his opinion, it is highly to be wished that English men and women should brood upon and make their own. He finds that these fleshly things are his strong part, so he sticks to them. Is it wonderful that he should? And at all events he deserves credit for the audacious courage with which he has revealed to the world a mind all aflame with the feverish carnality of a schoolboy over the dirtiest passages in Lemprière. It is not every poet who would ask us all to go hear him tuning his lyre in a stye. It is not everybody who would care to let the world know that he found the most delicious food for poetic reflection in the practices of the great island of the Ægean, in the habits of Messalina, of Faustina, of Pasiphaæ. Yet these make up Mr. Swinburne's version of the dreams of fair women, and he would scorn to throw any veil over pictures which kindle, as these do, all the fires of his imagination in their intensest heat and glow. It is not merely 'the noble, the nude, the antique' which he strives to reproduce. If he were a rebel against the fat-headed Philistines and poor-blooded Puritans who insist that all poetry should be such as may be wisely placed in the hands of girls of eighteen, and is fit for the use of Sunday schools, he would have all wise and enlarged readers on his side. But there is an enormous difference between an attempt to revivify among us the grand old pagan conceptions of Joy, and attempt to glorify all the bestial delights that the subtleness of Greek depravity was able to contrive. It is a good thing to vindicate passion, and the strong and large and rightful pleasures of sense, against the narrow and inhuman tyranny of shrivelled anchorites. It is a very bad and silly thing to try to set up the pleasures of sense in the seat of the reason they have dethroned. And no language is too strong to condemn the mixed vileness and childishness of depicting the spurious passion of a putrescent imagination, the unnamed lusts of sated wantons, as if they were the crown of character and their enjoyment the great glory of human life. The only

comfort about the present volume is that such a piece as 'Anactoria' will be unintelligible to a great many people, and so will the fevered folly of 'Hermaphroditus', as well as much else that is nameless and abominable. Perhaps if Mr. Swinburne can a second and third time find a respectable publisher willing to issue a volume of the same stamp, crammed with pieces which many a professional vendor of filthy prints might blush to sell if he only knew what they meant, English readers will gradually acquire a truly delightful familiarity with these unspeakable foulnesses; and a lover will be able to present to his mistress a copy of Mr. Swinburne's latest verses with a happy confidence that she will have no difficulty in seeing the point of every allusion to Sappho or the pleasing Hermaphroditus, or the embodiment of anything else that is loathsome and horrible. It will be very charming to hear a drawing-room discussion on such verses as these, for example:

> Stray breaths of Sapphic song that blew
> Through Mitylene
> Shook the fierce quivering blood in you
> By night, Faustine.
> The shameless nameless love that makes
> Hell's iron gin
> Shut on you like a trap that breaks
> The soul, Faustine.
> And when your veins were void and dead,
> What ghosts unclean
> Swarmed round the straitened barren bed
> That hid Faustine?
> What sterile growths of sexless root
> Or epicene?
> What flower of kisses without fruit
> Of love, Faustine?

We should be sorry to be guilty of anything so offensive to Mr. Swinburne as we are quite sure an appeal to the morality of all the wisest and best men would be. The passionate votary of the goddess whom he hails as 'Daughter of Death and Priapus' has got too high for this. But it may be presumed that Common sense is not too insulting a standard by which to measure the worth and place of his new volume. Starting from this

sufficiently modest point, we may ask him whether there is really nothing in women worth singing about except 'quivering flanks' and 'splendid supple thighs', 'hot sweet throats' and 'hotter hands than fire', and their blood as 'hot wan wine of love'? Is purity to be expunged from the catalogue of desirable qualities? Does a poet show respect to his own genius by gloating, as Mr. Swinburne does, page after page and poem after poem, upon a single subject, and that subject kept steadily in a single light? Are we to believe that having exhausted hot lustfulness, and wearied the reader with a luscious and nauseating iteration of the same fervid scenes and fervid ideas, he has got to the end of his tether?

## Algernon Charles Swinburne
**From *Notes on Poems and Reviews* (1866)**
**'A Rejoiner'**

Certain poems of mine, it appears, have been impugned by judges, with or without a name, as indecent or as blasphemous. To me, as I have intimated, their verdict is a matter of infinite indifference: it is of equally small moment to me whether in such eyes as theirs I appear moral or immoral, Christian or pagan. But, remembering that science must not scorn to investigate animalcules and infusoria, I am ready for once to play the anatomist.

With regard to any opinion implied or expressed throughout my book, I desire that one thing should be remembered: the book is dramatic, many-faced, multifarious; and no utterance of enjoyment or despair, belief or unbelief, can properly be assumed as the assertion of its author's personal feeling or faith. Were each poem to be accepted as the deliberate outcome and result of the writer's conviction, not mine alone but most other men's verses would leave nothing behind them but a sense of cloudy chaos and suicidal contradiction. Byron and Shelley, speaking in their own persons, and with what sublime effect we know, openly and insultingly

mocked and reviled what the English of their day held most sacred. I have not done this. I do not say that if I chose, I would not do so to the best of my power; I do say that hitherto I have seen fit to do nothing of the kind.

It remains then to inquire what in that book can be reasonably offensive to the English reader. In order to resolve this problem, I will not fish up any of the ephemeral scurrilities born only to sting if they can, and sink as they must. I will take the one article that lies before me; the work (I admit) of an enemy, but the work (I acknowledge) of a gentleman. I cannot accept it as accurate; but I readily and gladly allow that it neither contains nor suggests anything false or filthy. To him therefore, rather than to another, I address my reclamation. Two among my poems, it appears, are in his opinion 'especially horrible'. Good. Though the phrase be somewhat 'inexpressive', I am content to meet him on this ground. It is something—nay, it is much—to find an antagonist who has a sufficient sense of honesty and honour to mark out the lists in which he, the challenger, is desirous to encounter the challenged.

The first, it appears, of these especially horrible poems is *Anactoria*. I am informed, and have not cared to verify the assertion, that this poem has excited, among the chaste and candid critics of the day or hour or minute, a more vehement reprobation, a more virtuous horror, a more passionate appeal, than any other of my writing. Proud and glad as I must be of this distinction, I must yet, however reluctantly, inquire what merit or demerit has incurred such unexpected honour. I was not ambitious of it; I am not ashamed of it; but I am overcome by it. I have never lusted after the praise of reviewers; I have never feared their abuse; but I would fain know why the vultures should gather here of all places; what congenial carrion they smell, who can discern such (it is alleged) in any rose-bed. And after a little reflection I do know, or conjecture. Virtue, as she appears incarnate in British journalism and voluble through that unsavoury organ, is something of a compound creature—

A lump neither alive nor dead,
Dog-headed, bosom-eyed, and bird-footed;

nor have any dragon's jaws been known to emit on occasion stronger and stranger sounds and odours. But having, not without astonishment and disgust, inhaled these odours, I find myself at last able to analyse their component parts. What my poem means, if any reader should want that explained, I am ready to explain, though perplexed by the hint that explanation may be required. What certain reviewers have imagined it to imply, I am incompetent to explain, and unwilling to imagine. I am evidently not virtuous enough to understand them. I thank Heaven that I am not. *Ma corruption rougirait de leur pudeur*. I have not studied in those schools whence that full-fledged phoenix, the 'virtue' of professional pressmen, rises chuckling and crowing from the dunghill, its birthplace and its deathbed. But there are birds of alien feather, if not of higher flight; and these I would now recall into no hencoop or preserve of mind, but into the open and general field where all may find pasture and sunshine and fresh air: into places whither the prurient prudery and the virulent virtue of press-men and prostitutes cannot follow; into an atmosphere where calumny cannot speak, and fatuity cannot breathe; in a word, where backbiters and imbeciles become impossible. I neither hope nor wish to change the unchangeable, to purify the impure. To conciliate them, to vindicate myself in their eyes, is a task which I should not condescend to attempt, even were I sure to accomplish…

Next on the list of accusation stands the poem of *Dolores*. The gist and bearing of this I should have thought evident enough, viewed by the light of others which precede and follow it. I have striven here to express that transient state of spirit through which a man may be supposed to pass, foiled in love and weary of loving, but not yet in sight of rest; seeking refuge in those 'violent delights' which 'have violent ends', in fierce and frank sensualities which at least profess to be no more than they are. This poem, like *Faustine*, is so distinctly symbolic and fanciful that it cannot

justly be amenable to judgment as a study in the school of realism. The spirit, bowed and discoloured by suffering and by passion (which are indeed the same thing and the same word), plays for a while with its pleasures and its pains, mixes and distorts them with a sense half-humorous and half-mournful, exults in bitter and doubtful emotions—

Moods of fantastic sadness, nothing worth.

It sports with sorrow, and jests against itself; cries out for freedom and confesses the chain; decorates with the name of goddess, crowns anew as the mystical Cotytto, some woman,—real or ideal, in whom the pride of life with its companion lusts is incarnate. In her lover's half-shut eyes, her fierce unchaste beauty is transfigured, her cruel sensual eyes have a meaning and a message; there are memories and secrets in the kisses of her lips. She is the darker Venus, fed with burnt-offering and blood-sacrifice; the veiled image of that pleasure which men impelled by satiety and perverted by power have sought through ways as strange as Nero's before and since his time; the daughter of lust and death, and holding of both her parents; Our Lady of Pain, antagonist alike of trivial sins and virtues; no Virgin, and unblessed of men; no mother of the Gods or God; no Cybele, served by sexless priests or monks, adored of Origen or of Atys; no likeness of her in Dindymus or Loreto.

The next act in this lyrical of passion represents mad commotion of sense has stormed itself out; the spirit, clear of the old regret that drove it upon such violent ways for a respite, healed of the fever that wasted it in the search for relief among fierce fancies and tempestuous pleasures, dreams now of truth discovered and repose attained. Not the martyr's ardour of selfless love, an unprofitable flame that burnt out and did no service—not the rapid rage of pleasure that seemed for a little to make the flesh divine, to clothe the naked senses with the fiery raiment of faith; but a stingless love, an innocuous desire. 'Hesperia', the tenderest type of woman or of dream, born in the westward 'islands of the blest',

where the shadows of all happy and holy things live beyond the sunset a sacred and a sleepless life, dawns upon his eyes a western dawn, risen as the fiery day of passion goes down, and risen where it sank. Here, between moonrise and sunset, lives the love that is gentle and faithful, neither giving too much nor asking—a bride rather than a mistress, a sister rather than a bride. But not at once, or not for ever, can the past be killed and buried; hither also the temptress follows her flying prey, wounded and weakened, still fresh from the fangs of passion; the cruel hands, the amorous eyes, still glitter and allure. *Qui a bu boira*: the feet are drawn back towards the ancient ways. Only by lifelong flight, side by side with the goddess that redeems, shall her slave of old escape from the goddess that consumes: if even thus one may be saved, even thus distance the bloodhounds...

I have heard that even the little poem of Faustine has been to some readers a thing to make the scalp creep and the blood freeze. It was issued with no such intent. Nor do I remember that any man's voice or heel was lifted against it when it first appeared, a new-born and virgin poem, in the *Spectator* newspaper for 1862. Virtue, it would seem, has shot up surprisingly in the space of four years or less—a rank and rapid growth, barren of blossom and rotten at root. *Faustine* is the reverie of a man gazing on the bitter and vicious loveliness of a face as common and as cheap as the morality of reviewers, and dreaming of past lives in which this fair face may have held a nobler or fitter station; the imperial profile may have been Faustina's, the thirsty lips a Mænad's, when first she learnt to drink blood or wine, to waste the loves and ruin the lives of men...

To all this, however, there is a grave side. The question at issue is wider than any between a single writer and his critics, or it might well be allowed to drop. It is this: whether or not the first and last requisite of art is to give no offence; whether or not all that cannot be lisped in the nursery or fingered in the schoolroom is therefore to be cast out of the library; whether or not the domestic circle is to be for all men and writers the outer limit and extreme horizon of their world of work? For to this we have come; and all students of art must face the matter as it stands. Who has not heard it asked, in a final and triumphant tone, whether this book or that can be read aloud by her mother to a young girl? whether such and such a picture can properly be exposed to the eyes of young persons? If you reply that this is nothing to the point, you fall at once into the ranks of the immoral. Never till now, and nowhere but in England, can so monstrous an absurdity rear for one moment its deformed and eyeless head.

## Henry James
### Letter to his Sister, Alice James (March 1869)

7 Half Moon St., W.
March 10th [1869].

Ma soeur chérie,

I have half an hour before dinner-time: why shouldn't I begin a letter for Saturday's steamer? ...I really feel as if I had lived—I don't say a lifetime—but a year in this murky metropolis. I actually believe that this feeling is owing to the singular permanence of the impressions of childhood, to which any present experience joins itself on, without a broken link in the chain of sensation. Nevertheless, I may say that up to this time I have been crushed under a sense of the mere magnitude of London—its inconceivable immensity—in such a way as to paralyse my mind for any appreciation of details. This is gradually subsiding; but what does it leave behind it? An extraordinary intellectual depression, as I may say, and an indefinable flatness of mind. The place sits on you, broods on you, stamps on you with the feet of its myriad bipeds and quadrupeds. In fine, it is anything but a cheerful or a charming city. Yet it is a very splendid one. It gives you here at the west end, and in the city proper, a vast impression of opulence and prosperity. But you don't want a dissertation of commonplaces on London and you would like me to touch on my own individual

experience. Well, my dear, since last week it has been sufficient, altho' by no means immense. On Saturday I received a visit from Mr. Leslie Stephen (blessed man) who came unsolicited with the utmost civility in the world and invited me to dine with him the next day. This I did, in company with Miss Jane Norton. His wife made me very welcome and they both appear to much better effect in their own premises than they did in America. After dinner he conducted us by the underground railway to see the beasts in the Regent's Park, to which as a member of the Zoological Society he has admittance 'Sundays'... In the evening I dined with the invaluable Nortons and went with Chas. and Madame, Miss S. and Miss Jane (via underground railway) to hear Ruskin lecture at University College on Greek Myths. I enjoyed it much in spite of fatigue; but as I am to meet him some day through the Nortons, I shall reserve comments. On Wednesday evening I dined at the N.'s (toujours Norton, you see) in company with Miss Dickens—Dickens's only unmarried daughter—plain-faced, ladylike (in black silk and black lace,) and the image of her father. I exchanged but ten words with her. But yesterday, my dear old sister, was my crowning day—seeing as how I spent the greater part of it in the house of Mr. Wm. Morris, Poet. Fitly to tell the tale, I should need a fresh pen, paper and spirits. A few hints must suffice. To begin with, I breakfasted, by way of a change, with the Nortons, along with Mr. Sam Ward, who has just arrived, and Mr. Aubrey de Vere, tu sais, the Catholic poet, a pleasant honest old man and very much less high-flown than his name. He tells good stories in a light natural way. After a space I came home and remained until 4 1/2 p.m., when I had given rendez-vous to C.N. and ladies at Mr. Morris's door, they going by appointment to see his shop and C. having written to say he would bring me. Morris lives on the same premises as his shop, in Queen's Square, Bloomsbury, an antiquated ex-fashionable region, smelling strong of the last century, with a hoary effigy of Queen Anne in the middle. Morris's poetry, you see, is only his sub-

trade. To begin with, he is a manufacturer of stained glass windows, tiles, ecclesiastical and medieval tapestry, altar-cloths, and in fine everything quaint, archaic, pre-Raphælite—and I may add, exquisite. Of course his business is small and carried on in his his house: the things he makes are so handsome, rich and expensive (besides being articles of the very last luxury) that his fabrique can't be on a very large scale. But everything he has and does is superb and beautiful. But more curious than anything is himself. He designs with his own head and hands all the figures and patterns used in his glass and tapestry, and furthermore works the latter, stitch by stitch, with his own fingers—aided by those of his wife and little girls. Oh, ma chère, such a wife! Je n'en reviens pas—she haunts me still. A figure cut out of a missal—out of one of Rossetti's or Hunt's pictures—to say this gives but a faint idea of her, because when such an image puts on flesh and blood, it is an apparition of fearful and wonderful intensity. It's hard to say whether she's a grand synthesis of all the pre-Raphælite pictures ever made—or they a 'keen analysis' of her— whether she's an original or a copy. In either case she is a wonder. Imagine a tall lean woman in a long dress of some dead purple stuff, guiltless of hoops (or of anything else, I should say,) with a mass of crisp black hair heaped into great wavy projections on each of her temples, a thin pale face, a pair of strange sad, deep, dark Swinburnian eyes, with great thick black oblique brows, joined in the middle and tucking themselves away under her hair, a mouth like the 'Oriana' in our illustrated Tennyson, a long neck, without any collar, and in lieu thereof some dozen strings of outlandish beads—in fine complete. On the wall was a large nearly full-length portrait of her by Rossetti, so strange and unreal that if you hadn't seen her you'd pronounce it a distempered vision, but in fact an extremely good likeness. After dinner (we stayed to dinner, Miss Grace, Miss S.S. and I,) Morris read us one of his unpublished poems, from the second series of his un-'Earthly Paradise', and his wife, having a bad toothache, lay

on the sofa, with her handkerchief to her face. There was something very quaint and remote from our actual life, it seemed to me, in the whole scene: Morris reading in his flowing antique numbers a legend of prodigies and terrors (the story of Bellerophon, it was), around us all the picturesque bric-a-brac of the apartment (every article of furniture literally a 'specimen' of something or other,) and in the corner this dark silent medieval woman with her medieval toothache. Morris himself is extremely pleasant and quite different from his wife. He impressed me most agreeably. He is short, burly, corpulent, very careless and unfinished in his dress, and looks a little like B.G. Hosmer, if you can imagine B.G. infinitely magnified and fortified. He has a very loud voice and a nervous restless manner and a perfectly unaffected and business-like address. His talk indeed is wonderfully to the point and remarkable for clear good sense. He said no one thing that I remember, but I was struck with the very good judgment shown in everything he uttered. He's an extraordinary example, in short, of a delicate sensitive genius and taste, saved by a perfectly healthy body and temper. All his designs are quite as good (or rather nearly so) as his poetry: altogether it was a long rich sort of visit, with a strong peculiar flavour of its own…Ouf! what a repulsively long letter! This sort of thing won't do. A few general reflections, a burst of affection (say another sheet), and I must close…Farewell, dear girl, and dear incomparable all—

Your H.

# ◼ The 1870s ◼

## Letters, Diaries and Reflections

### Georgiana Macdonald Burne-Jones
### From *The Memorials of Edward Burne-Jones*

[1870]
There are hundreds of letters from Edward to his children still in existence. In these, from the first, he often jestingly assumed the character of an old man, and this led to his establishing a caricature likeness of himself which became as well known to his friends as any written signature. One of these, from a letter to Ruskin, is reproduced here.
To his boy of eight he signs himself 'your loving

withered old Papa'. The children and I were then staying at Whitby. 'I hope', he writes to the child, 'the next sea-side will not be such a long way from me, but somewhere near, where at least I can feel as if I could quickly see you—but where you are it is a heavy day's journey, too long for an old man. I think nothing has changed since you went away, except the fruit that is ripening ready for you when you come back—and the house is very still without you, and feels as if nothing could happen. I paint all day long and want to cry sometimes because after a long day no nice work has been done, and I have often spoiled my pictures for a time—then I want to be comforted with little arms about me; but often the work goes well and I feel

proud—only I want you back, my little. Tomorrow is Sunday, and then in one more week you will be back to me. I very much liked the little red picture you made for me of Whitby—it was better than I made at your age, and I want you to look at every lovely thing in the world and remember it, and forget about the rest.'...

See in these words to the youngest 'wench'—written later in the year—how the past is already touched for Edward by Death in Life. 'It was most pretty of you to write for my birthday; one of my few little treasures is this letter I enclose [one she had written him when a child], do you remember it? Send it me back. I keep it in a drawer sacred to treasures. And don't make fun of its arithmetic, because it has been a great comfort to me. I'm a

'Rossetti Carrying Cushions for a Startled Janey Morris'
caricature by Edward Burne-Jones (1870).

deadly age, dear; not "twice as old as you and four over", any longer, but still something portentous. The little letter as I take it out is full of such old autumns—Gordon Place and Topsy's first poems, and pen-and-ink drawings—what nice years.'

'My dear, I can scarcely write to you—a short letter seems so little, and a long one is impossible; you must take me for granted as the same old Ned and many of them. By this time we can scarcely guess what each other is most thinking of but I want to keep as much of what you give me in this kid's letter as I can. Be sure to send it me back.'

Ruskin was amongst those who remembered this particular birthday. 'I would have asked you to spend your birthday here, but I am so inconceivably more than usually dead and stupid—not depressed, but lifeless and dreamy— that I can't but think you will both be happier by yourselves. Besides Sunday's always wretched here—from old idle habits—and the servants "keep it" by going out larking, and are piously vicious if one asks them to do anything. Many and many happy returns of day—and of strength renewed with it.'...

It is startling to find these words in a letter to Mr. Norton: 'And Ruskin I see never—and when I see him he angers me, which is bad.' But such a time as this was bound to come before the friends could reach their final relationship. We have seen how at the beginning Edward threw himself at Ruskin's feet and made a law of the lightest word spoken by that splendid teacher; but this could not last as the strength and confidence of the discipline asserted themselves.

## [1871]

[Morris and Edward] the two friends, who kept pace in so many things, had flagged together and took heart again at the same time. 'There', wrote Morris, when he came back from Iceland, 'it was worth doing and has been of great service to me. I was getting nervous and depressed and very much wanted a rest, and I don't think anything would have given me so complete a one.' He was happy too in having found what was to atone to him for

the loss of Red House: 'We have taken a little place deep down in the country, where my wife and the children are to spend some months every year, as they did this—a beautiful and strangely naif house, Elizabethan in appearance though much later in date, as in that out of the way manner people built Gothic till the beginning or middle of the last century. It is on the S.W. extremity of Oxfordshire, within a stone's throw of the baby Thames, in the most beautiful grey little hamlet called Kelmscott.'

## [1872]

The year 1872 was marked for us and our intimate circle by illness, trouble and death: yet it was one of the most productive in Edward's life. Its beginning was clouded by the loss of our newly-won friend, young Mrs. Norton, who died unexpectedly at Dresden in the midst of her happy family, and from that time our sympathy with her husband changed affection into devotion. 'There was no need for you to be dearer to your friends', Edward wrote to him, 'but you will be'...

But the disaster of the year was Rossetti's terrible illness in June; for when once we realized that his brain was touched, however slightly, the pillars of our life felt shaken. Guardedly, as in all such cases, we spoke of it to most people, but Edward in writing to Mr. Norton goes near to expressing our worst fears.

'There is no news yet sufficiently good for us to build upon—he is utterly broken down, and the most hopeful view the doctor has given points to three or four months of slow recovery. He is away now in Scotland with Madox Brown, who sends frequent bulletins and makes them as cheerful as possible, but fluctuations of better or worse from day to day I believe are little guide in his case, and we must wait. It has been the saddest sight I have had in my days, and seems to tinge everything with melancholy and foreboding. There is more than any tenderness of friendship in what I feel for him—he is the beginning of everything in me that I care for, and it is quite dreadful.'

And all these sorrowful thoughts were

justified, for though before three months were over Gabriel had recovered so far as to begin painting again, and although he did great work in the remaining ten years of his life, yet a sad inertia slowly changed him, and soon Edward had to realize that all joy in their intercourse belonged to the past. I never remember Rossetti again under our roof, but Edward continued to go to him: sometimes wondering almost bitterly whether if he ceased doing so it would be noticed.

[1874]

There was still no renewal of the old kind of intercourse with Rossetti, who had gradually ceased to ask what Edward was doing, or to shew him anything of his own; and the loss of the quick sympathy to which he had accustomed his friend was felt bitterly. Edward's delight, however, when he first saw 'Proserpine' in the house of its owner made him forget everything else, and he hastened to write of it to Gabriel.

'I hear you are in town for a few days and I should like to see you. I was going to write to Kelmscott to say a little of the enthusiasm I feel for the Proserpine at Leyland's—it drew me out of myself as if something lucky had happened and I can't forget it. I wanted you to know, for it is such help to have one's work really loved—and is the only reward possible.' And in another note upon a different subject he says, 'But it's a very good world after all that has Proserpine in it.' He could complain, though, on occasion. 'This is a letter of bitter reproach—you've finished a big picture and are sending it away to-day, and I do think it's shabby not to tell me and let me see it. Nobody anywhere in the world cares for your pictures as I do, and no body understands them as well, and I ought to see them. Tell me if it's too late—I'd go to-morrow if you still have it—anyhow I'll run over and see you on Sunday at the end of the day.' Then follows a pacified note on receiving Gabriel's answer: 'Sunday at half past four, and I should like to stay; and am so glad it isn't gone. I don't care for anybody else's work a bit, and I am faithful to you.'

The fact sounds abrupt, but it really came about quite naturally, that towards the end of this year a preliminary meeting was held in Queen Square in order to discuss the dissolution of the Firm. The minutes of this meeting say: 'It was agreed to have a balance sheet made out to Michaelmas, 1874, and to summon a general meeting of the firm at the earliest possible period after its completion, to endeavour if possible to come to an amicable adjustment of the process of dissolution.' These words shew that difference of opinion had arisen amongst the partners—and so it was; not as to the nature of their work, but about claims and responsibilities connected with it. None of them doubted, however, but that the time had come for reconsidering engagements entered into thirteen years before; for the business was growing in various directions, and their liability was unlimited. On the other hand, though no one except Morris had put into it more than a nominal sum, and he had from the first supplied both capital and motive power, yet the others had a right by the terms of their partnership to demand from him an equal share in all the profits and property of the establishment. Madox Brown considered that the goodwill of the business ought also to be taken at three years' purchase and included in the assets. In all this Morris stood in a way by himself, and the six others were equally divided. Edward, Faulkner, and Webb finally agreed that their legal claim did not to them represent the justice of the case, and they only wished to be released from responsibility, leaving Morris with a free hand. On this view they acted. Rossetti, Madox Brown, and Marshall stood upon their rights, and after four or five months' difficulty their terms were agreed to and the Firm was dissolved. At one time Edward dreaded 'the ignominy of an open row', writing to Gabriel: 'I must say I feel ashamed of the remarks of a philosophic world at the spectacle of a set of old friends breaking down in this humiliating way—if it goes to law and new anxieties begin for us in that vague region I must say it will be damnable.'

[1878]

In October Morris left Turnham Green and came to live a mile or so nearer to us, which made it an easy thing for him to walk to the Grange on Sunday mornings. We had long known the George MacDonalds as tenants of this new house, which was on the Upper Mall, Hammersmith; in their time it was called 'The Retreat', but Morris changed the name to 'Kelmscott House', in remembrance of his beautiful country home nearly a hundred miles further up on the same bank of the Thames. Kelmscott House was much larger than the one he left at Turnham Green, and had an adjoining stable and coach-house which have become historic among Socialists. There was also a long garden, of which Morris made the most by dividing it into separate spaces, as he had done at Upton. He used to say that the soil of this garden was composed chiefly of old shoes and soot, for no substitute for real country ever contented him; but the lawns and trees were very pleasant, and the river that flowed in front was a good change from the dusty high road.

The year was not to end without disturbance of a particularly trying kind. Ever since Ruskin's notice of the Grosvenor Gallery in Fors Chavigera there had been a rumour that Mr. Whistler was likely to claim damages from him in a court of law, on account of a strongly-worded sentence in that notice, which he considered might hinder the sale of his pictures. Ruskin himself was delighted at this prospect: 'It's mere nuts and nectar to mine the notion of having to answer for myself in court, and the whole thing will enable one to assert some principles of art economy which I've never got into the public's head by writing, but may get sent over all the world vividly in a newspaper report or two.' It was a year after this, however, when the action was brought, and although he had quite recovered from his illness, he was not allowed to appear in the case. On November 2nd Ruskin writes to Edward: 'I have given your name to the blessed lawyers, as chief of men to whom they might refer for anything which in their wisdom they can't discern unaided concerning me. But I

commanded them in no wise and for no cause whatsoever to trouble or tease you; and neither in your case nor in that of any other artist, to think themselves justified in asking more than may enable them to state the case with knowledge and distinctness.' Few positions could have been more annoying or difficult, for the paragraph containing the sentence in question—one of Ruskin's severest condemnations—was practically a comparision between Mr. Whistler's work and Edward's own. But the subject covered so much wider ground than any personality that Edward was finally able to put this thought aside and did with calmness what he had undertaken to do, namely, endorse Ruskin's criticism that good workmanship was essential to a good picture. His first reported words, 'I am a painter and have been so for twenty years. I have painted some works which have become known to the public within the last two or three years', are a fair type of the modesty with which he gave evidence, and those who saw him said that he spoke with authority also. I shall string together and condense his answers in examination.

'I think that nothing but perfect finish ought to be allowed by artists; that they should not be content with anything that falls short of what the age acknowledges as essential to perfect work. I have seen the pictures by Mr. Whistler which were produced yesterday in this court, and I think the 'Nocturne in Blue and Silver' is a work of art, but a very incomplete one; an admirable beginning, but that it in no sense whatever shews the finish of a complete work of art. I am led to the conclusion because while I think the picture has many good qualities—in colour, for instance, it is beautiful—it is deficient in form, and form is as essential as colour.' With regard to the next picture, 'Battersea Bridge', when asked to give an opinion he said: 'The colour is even better than the other, but it is more formless, and as to the composition and detail, it has neither. The day and a half, in which Mr. Whistler says it was painted, seems a reasonable time for it.' Then the 'Nocturne in Black and Gold' was discussed, and being pressed

as to whether in his opinion it was a work of art he said, 'No, I cannot say it is', and gave as one reason for this that the subject itself was against it: 'I never saw a picture of night that was successful. This is only one out of a thousand failures which artists have made in their efforts at painting it.'

A portrait of Titian was brought into court as a sample of what was meant by 'finish', and Edward recognized it as 'a very perfect example of the highest finish that ancient artists aimed at.' On counsel asking if he saw any mark of labour in the

'Enter Morris', caricature by Dante Gabriel Rossetti (1871).

three pictures by Mr. Whistler that were under consideration, he answered: 'Yes, there must have been great labour to produce such work, and great skill also, but I think he has evaded the chief difficulty of painting, and has not tested his powers by carrying it out. The difficulties in painting increase daily as the work progresses, and that is the reason why so many of us fail. The danger is this, that if unfinished pictures become common we shall arrive at a stage of mere manufacture, and the art of the country will be degraded.'

Mr. Frith, R.A., and Mr. Tom Taylor, the art critic of *The Times*, were the other witnesses called on Ruskin's side. The verdict was one farthing's damage for Mr. Whistler, and the judge, exercising his discretion, gave judgment for him without costs. Edward wrote to Rossetti afterwards: 'The whole thing was a hateful affair and nothing in a small way ever annoyed me more—however, as I had to go I spoke my mind, and I try not to think of it all more than I can help.' To another friend he said: 'I wish all that trial-thing hadn't been; so much I wish it, and I wish Whistler knew that it made me sorry—but he would not believe.' From Ruskin there came this acknowledgment: 'I am very grateful to you for speaking up. I don't think you will be sorry hereafter that you stood by me, and I shall be evermore happier in my secure sense of your truth in me, and to a good cause—for there was more difficulty in your appearing than in anyone else's.'

# LITERATURE

## Oliver Madox Brown
### From *Gabriel Denver* (1873)

### Chapter 5

> Could curses kill as doth the mandrake's groan,
> I would invent as better searching terms
> As curst, as harsh, as horrible to hear,
> Delivered strongly through my fixed teeth,
> With full as many signs of deadly hate
> As lean-faced Envy, in her loathsome cave.
>
> *Henry VI, Part 2*

It was eight weeks since the 'Black Swan' had left her moorings at Port _____; and now, lost in the deep, windless night, she floated without sound or motion. The cabin lights were extinguished, and all on board the becalmed vessel seemed enveloped in silence and sleep.

Her brown, wind-worn sails had all been furled aloft in the breathless air, and, strange negligence, there was no sign or signal of any watch kept over the decks. The torpid ship was left entirely to her own control; even the steersman was slumbering, his hand attached by a string to the wheel, which, in case of any unexpected movement of the rudder, or sudden rising of the wind, would tighten, and so recall him to his duties. The breeze which had borne the big ship out so far into the ocean had long before nightfall entirely died away from the face of the water, though high overhead it still lasted, so that the few stars visible from the ship lost in the darkness below, appeared to be slowly drifting past the apertures in the sultry overhanging yet unseen clouds. The sea still heaved slightly round the great black hull, agglomerated in the obscurity surrounding it, save where a faint line of light was emitted by the water rippling and splashing round its sides.

At times, some unlooked-for lurching of the vessel would cause a wave to dash up over the waterline, showering back inflamed into a livid chaldron of glowing phosphoric fire, spreading round in circles of luminous foam, reflected brilliantly in the wet hull, and gleaming in the cabin-windows, and on the heavy anchors at the prow; and, even in the utter darkness, playing with a weird flickering reflection on the undersides of the great projecting yards and the rigging, otherwise indiscernible up aloft.

Indeed, the sultry tropical ocean seemed in an unusually excitable phosphoric condition. Every few minutes, the water to a distance round the entire hull would be suffused with a pale quivering flame, which at times lit up its clear green depths far beneath the surface; and the spot where floated a piece of drift timber, dropt overboard during the calm, was illuminated by constantly recurring flashes of the same fantastic light. Where the calm, hardly perceptible swell of the subsiding waves met with no obstruction, they were hidden in the deepest obscurity.

The whole of the upper outlines of the 'Black Swan', to a practised eye, might have formed a kind of dark silhouette, half blotted out against the night, but for the two lanterns burning above the bulwarks. One was a red signal-lamp, pendent over the high, old-fashioned forecastle, which struggled feebly with the intense gloom in which it hung, but was too high up to shed its faint glimmer on the fore-deck. The other, more brilliant in light, and fastened to the mainmast, threw a glow over all the stern end of the ship (the deck behind being concealed in the densest shadow), and fell on the figure of a man, who had suddenly become visible in the darkness.

He commenced walking to and fro in the sombre flickering lamplight: though he could not have been a sailor, for he appeared from his dress to be one of the passengers. At intervals, he came so close to the steering-wheel, that his great black restless shadow cast by the lamp covered it, yet without hiding its form; for a dim light burned in the tilted binnacle, and reflected a glow on to the brass-bound circle of spokes.

The helmsman from here was just visible in a

kind of transparent half-light. He was slumbering heavily, and was wrapped up in a tarpaulin to keep off the wet night-dew which covered the decks, gleaming wherever it met the light. At times, the water would be heard bubbling faintly round the stern and rudder—a sound so vague that it could scarce be distinguished from the sailor's placid breathing; but everything else around and on the ship seemed silent as death, save the ceaseless movement of this man, who continued his monotonous footsteps up and down the deck, his head sunk on his breast, and without appearing to notice anything around him, till his action seemed as restless as an excited restrained animal.

Every now and then, he interrupted himself, seeming to listen with impatience, and then resuming his walk. He must have been pacing there a long while with some object in view, for the dew-drops gleamed like silver on his shoulders, and in his tangled curly hair.

It might have been thought at first that his strange, sleepless restlessness was the result of the indescribable ennui and weariness caused by the long voyage; but there would, on closer consideration, have seemed a more poignant cause for it.

A slight noise at last attracted his attention; and with a deep, prolonged respiration, he turned facing the lamp, looking intently into the darkness behind it.

His sun-burnt bearded face, the eyes glittering, as he stood with the light concentrated on them (two scintillating points, like stars, surrounded by the deep gloom of the night), looked strangely care-worn and fevered. It was like that of a man who had passed long nights without sleep; and seemed, in its anxious, almost haggard look, coinciding with his restless movements, to express some heavy annoyance or disappointment under which his mind was labouring.

As he paused with raised head, shading his eyes with his hand, an indistinct sound like the rustle of a woman's dress, becoming audible above the dreary endless plashing of the water, fell on his ears. There seemed at this as if a gleam of light were reflected suddenly through the gloom of his mind. The despondent expression of his face was utterly changed; and though he could have seen nothing, he turned hastily in the direction the sound came from, and disappeared in the darkness.

Almost before he could find where he was going, he nearly stumbled against some figure—that of a woman, standing motionless on the deck near the bulwark. She had come silently in the night out of the companion-stairs that led to the cabin—advancing stealthily, and hardly seeming to breathe, lest her respiration should betray her presence. She evidently desired to watch the restless figure pacing in and out of the circle of light, while she herself remained hidden.

It was not so intensely dark behind the lamp as the light, dazzling and blinding his eyes, had made it seem to him; for against the faint glow of the lantern on the forecastle he could dimly trace the outline of a woman's form.

She remained perfectly motionless and speechless: but without a moment's reflection, his limbs seeming to act before his mind could direct them, or recover consciousness in the sudden bewilderment of his senses, he went up to her, impetuously uttering the name 'Laura!'

Then he paused for a moment; and flinging his arms round her neck and shoulders (which were muffled up in the hood of a shawl), he pressed her passionately to his breast, whispering in a low, almost trembling voice.

'I know you'd be certain to come, my love— though I've waited a weary while for you! Why don't you speak to me, Laura? We sha'n't be overheard here. Ah!'

Then—as he seemed to kiss her face—a sudden tremor stopped his words, and the woman broke away from his embrace with an angry exclamation; while he, starting back from her, appeared to stagger for an instant, as though a snake had stung him.

All this passed in an instant, hidden in the darkness.

The woman whom he had embraced so tenderly and passionately began crying out in an

exasperated, angry voice:

'How dare you treat me in this fashion? I'm not Laura, although I occupied her position once! Ah! you sneak back soon enough now; but you shall not escape me. We two are alone at last. You shall render an account of the fidelity you've shown me.'

'Curse you! Will you never let me have one moment to myself, without poisoning it with your presence?' the man answered fiercely. 'It's bad enough to have to think about you!'

'You lie!' she interrupted, in a passionate, almost screaming voice; 'I've neither been near you, nor spoken to you, for six weeks. Good God! what a return I've toiled my life out for; to sit silent by myself in this dreary, stifling ship, neglected by everyone, watching you make love to another woman before my very face, hour after hour, day after day, week after week, till it's driven me mad! I've sat thinking about you and watching you till my brain whirled, and my eyes grew dizzy, and I could have struck a knife into your hearts. Yet you think, because I've taken no notice of you, and never spoken to you, that I'm too poor-spirited or dejected or callous to care how you treat me, and that you can do as you like; but you shall find out the difference. You shall know what it is to neglect a woman's love, and then fall under her power. Every hour of your existences shall be an everlasting curse to you and your shameless paramour! You shall learn to dread each other's faces! You've embittered my entire life from when I first set eyes on you; but I shall be well revenged. I loved you once, Denver, for all you could do to disgust me. Loved you! I loved you as only a woman can love, until I found at what price you held me. I hate you now! But sooner than give you up to her, I'll steal in upon you in your sleep and strangle you. O God! after all I have done and suffered for you, to be kissed and embraced in mistake for another woman! I could have borne anything before; but you've neglected me all my life, and insulted me now, till you've driven me to distraction. I don't know what I'm doing or saying. It's made me insane to compare the difference between her sickening face and mine in the glass below, and think what it has cost me. She affects to ignore my very existence; but she shrinks from me, and dreads me more and more. Are my feelings to be no more regarded than an animal's, do you think? I've endured hours upon hours of misery, till my mind wandered, and I thought I was a child again, playing in my dead mother's house, only to come to myself, remembering that you were both within two or three yards of me, hardly out of my sight or hearing, and thinking over the injustice you have done me, till I've had to dig my nails into my breast, to prevent myself from screaming out, or flying at her and tearing her eyes out, and blinding her. Yet I've managed to keep all my resentment to myself, smouldering secretly in my own brain, until the expression of my face makes everybody in the ship shun me. All this has been going on in this accursed ship, minute after minute, falling on my brain like drops of water, torturing me till they've driven me to madness. I overheard you asking her to come up and meet you to-night, and I thought to watch you both together; but she wasn't with you, and I meant to await another opportunity, only you interrupted me with your cursed kiss: you scorched my lips with it. Ah, Denver! you shall yet learn what a woman's love turned to hatred is.'

She grew so violent at last, that her throat seemed quite exhausted with her passion, and she broke down into a fit of hysterical sobbing. Nothing is more trying to the patience than the convulsive, unnatural cries of an hysterical woman; but now, in this strange position on the deck of the ship, hidden as she was in the profound gloom of the night, her voice, exasperated by passion, seemed something to shudder at.

Denver had kept perfectly speechless and motionless till her voice broke down. One might not have known of his existence even; but now he moved away from her, into the circle of light.

She seemed by an intense effort to stifle her cries, and followed him, exclaiming with still more passion and virulence than before:

'I've had a fit of this coming on for a long

while. I've bitten my lips till my mouth was full of blood, to restrain myself and wait till my time came; but I'll have it out now. I thought I'd fling myself overboard into the sea at first, but that I thought how happy it would make you. No, I'll not do that. You can't and sha'n't get rid of me. I swear you shall share all my sorrows to the last bitter, bitter, dregs. I'll cling to you to the last hour of your existence, and make every day of your life as great a curse to you as you have made mine to me. Ah! you feel my words; but I'll make you wince still farther yet, till you are as mad and wretched as you have made me, though you have some one to love you.'

Her voice stopped once more, as though she were breathless. His continued silence seemed only to embitter her anger.

Now that they were both come fully into the lamplight, the display of mad, reckless passion in this woman's face was something terrible. Lit up by the feeble flickering lamp, it formed a white angry spot of light surrounded by an immense expanse of darkness. It was like a portrait painted with the night for its background. The sky, the sea, and the atmosphere, and even the ship itself, were all (save for a few drifting stars overhead) blotted out together, and absorbed into the deep gloom—only this one distorted face seemed visible, with the light concentrated on it.

The intense monotonous night-silence, broken only by her exasperated voice, seemed wishing to diffuse and drown the sound in its breathless immensity. It was as the self-centred madness of humanity contending vainly with the solemn undeviating dignity of nature, for no soul on board the ship appeared to hear her.

There was a fierce, constrained look about Denver's eyes, though he still said not a word; but her face looked perfectly hideous in her mad temper. The hood of her cloak had slipped back on her shoulders, leaving her unbound black hair to fall in writhing tangles about her face and neck. She had thrown the shawl over her night-gown, and her feet and throat were bare.

Her complexion was very dark, and her livid lips quivering back over her teeth, showed them glistening at times. Her deep-set eyes, glittering with the revengeful light of madness, under her high cheek bones and dark curved brows, gave to her naturally fine features a devilish expression, such as only the blind vindictive jealousy which was goading her could give to the divinely-intended face of a woman. Hers looked more like the head of an enraged venomous snake.

Most men would have been cowed and silenced by such temper—a savage might have opposed it by force; but to reason with it was impossible.

This man before her had a certain instinctive elevation and dignity in his bearing. In the life of danger and toiling which had left its signs upon his features, he must have gone through too much to be a coward; but the sudden and extreme transition from the sweet expression, the answering embrace, the warm beauty and soft utterance of the girl who loved him, to this woman (whom he seemed to detest, and even more so perhaps from the lingering knowledge which clung about him, in his blind desperate love for her rival, that he was doing her an undeserved injury), the change from the almost ecstatic happiness he had felt for one instant to this hateful realism, utterly deadened and sickened his heart, and unnerved his brain.

His head felt giddy as he thought of the irrevocable hold she might have had over him in a little while. He could hardly bear looking at her; his mind, flooded by his blind reckless passion for her rival, was utterly incapable of feeling any pity for her. He could only feel the tantalised never-satiated longing of his heart.

He could no more struggle against the fate which had led him on board this ship, to fall in love with the beautiful girl he met there (who as blindly reciprocated his passion), than a tired spent swimmer could contend with the eddies of a whirlpool.

Could this woman always cling to him all his life, as she had threatened? It seemed like some intangible spell laid over him. His brain felt

bewildered, as if his reason were going; all his mental struggling only seemed to leave his love more clearly defined and tenacious, his hatred for her more bitter.

What could be expected of him? He was only one man, guided by the same instincts which over-sway the minds of all humanity—a swimmer thrown struggling among harsh rocks and breakers, desperate for safety and life.

He was a wild man, and had been brought up among still wilder associations. One half-muttered yet irresistible suggestion seemed dinning always in his brain. Once it came so strongly that it almost fashioned itself into uttered and audible words; but something like a flash of light in the darkness seemed to bewilder his eyes. It was too terrible. He dared not think about it. He felt powerless as a child, and could do nothing.

But if his conscience forced him to keep the promise this woman had once extorted from him, it seemed to him, in his present excitement, that his whole future life would be one blind blank misery to him.

As he stood with his back to the lamp, his gleaming eyes looking restlessly aside into the deep night, like a tiger glancing through its bars, anywhere but at the hateful face before him, in the silence and utter obscurity around him, where all human associations were lost and obliterated, and where his mind could meet with no known object to assure itself of its own identity, he could hardly realise his position.

There was a cold sweat on his brow, despite the fierce look which flitted at times over his features. Nothing could more strangely exhibit the instantaneous extremes between passion and discouragement to which some men's minds are subjected.

The woman had ceased speaking for a while, as if to gain breath, and now, more angered than ever at his stubborn silence (for in the wild state of mind induced by her jealousy she was utterly incapable of understanding what his silence meant), she began again railing against him, more wildly and bitterly even than before.

'Ah! I am only a weak woman, yet you durst not look me in the face. You and she think you have kept yourselves so close! but I'll expose you both before the whole ship. They shall all know what you have made of her, and how false-hearted you've been to me. I could have been happy an hundred times over but for you; but you shall not ruin my life for nothing.'

Once more all words failed her, and she broke down into a violent fit of hysterical sobbing. Over and over again she repeated, in sob-broken utterance, '*I hate you! I'll revenge myself on you!*'

'If you hate me, Deborah Mallinson, only half so much as I do you,' said Denver, at last forcing himself to look at her, 'you'd not come up here at this hour of all hours, to tempt and madden me in this way.'

He muttered this almost under his breath; but her morbidly-acute ear caught the meaning of his words.

Her eyes flashed as with fire. She left off sobbing, and gave a taunting laugh, and came still nearer to him on the deck—nearer and nearer, till she could have touched him with her hand, then she paused and looked fearlessly in his face.

No passion is more bitter or maddening than the jealousy which has its root in disappointed love, it destroys the very soul. A child could have seen that this woman was rendered insane by it.

Denver went on endeavouring to speak calmly—though his tight-clutched hands and his convulsive lips displayed his fast accumulating anger.

'What right have you to attempt to make my life a misery to me? I never wished for you! We should never be happy together—even if I had not met with Laura. Your existence would have been the curse of my life! You only come up here now to taunt me____'

'Is *my* life and misery nothing to you?' she cried with a fresh outburst of tears.

'Yes! you *have* found the truth out—though God knows I never tried to conceal it. I do love Laura Conway, and have loved her from the first hour I ever set eyes on her. I never, in the wildest

dream, ever saw a face like hers before, and I could no more resist loving her than I could help breathing!—while I *hate* you! You've goaded me now, till the devil seems twitching my arms to fling you into the sea and myself after you! Yes, I do love her and she loves me in return, in spite of you. She was coming up here to meet me just now. I had been waiting for two hours, and was going wild with impatience, till I mistook you for her and kissed you—when I'd sooner have kissed a black bush-snake. Your presence is utterly hateful to me, I don't care what you can do or say. God knows I can't help it if I'm wronging *you*. On board this ship, getting more sick of it every day as I do, I can no more keep from going near her than iron from a loadstone, or an opium eater from his landanum. I'm in heaven when I'm near her, all my life past and present seems obliterated. Before I told her how I loved her I suffered worse torments than hell's! I've walked about this deck in the night time, when she was gone and nobody could see me, going more hopelessly infatuated about her every minute, and yet thinking that I had no right to be happy with her—struggling to realise why love such as she and I had for each other must be suppressed, and kept breaking our hearts in secret, while we remained unable to help ourselves, until I seemed like a fly caught in a spider's web! I felt as if my brain were entangled in some horrid dream that I should wake from and find to be all a delusion. I broke through it by force at last: I found she loved me as much as I loved her. She is as light-hearted as you were always discontented and sullen—more pure and innocent than the sea foam we're floating on. Come!' he said suddenly and sternly, breaking off the desultory, disconnected way in which he had been speaking, and looking straight at her. 'Don't begin again. It's too late to recede, and I'm troubled enough already, without you. You may go too far, for it's raised the devil in me talking of her in comparison to one like *you*.'

If the light could have been directed on to his countenance, Deborah would have seen a strange and most sinister look on his brow; but standing with his back to the lamp as he was, she could only see him shudder visibly and press his clenched hands to his forehead.

She had managed to keep silent with great difficulty, though it could be seen plainly that she was getting more insane every moment, her jealousy and passionate resentment had reduced her to a condition in which more than one woman has been known to wind all her hair round her throat and strangle herself. Once she clenched her teeth till her head and neck shook in a kind of convulsion.

But before he could finish she seemed to make a violent effort to regain her self-possession. At last she said, in a low suppressed voice (which nevertheless trembled with such passion that every word of it struck more keenly on the startled senses than if it had been uttered in the wildest tones), '*Fling me overboard, you coward, and stain your soul with murder as well as perjury.*'

At the same time she advanced so close to him that her face was within a foot of his. Their eyes glared straight into each others' pupils— her's, blind and mad with stored up resentment at the wrongs she supposed herself to have suffered, reflected in his, which were wild and luminous as an animal's.

'Fling me overboard—I wish I could move you into doing so! You're not frightened to stab my feelings—to strangle all the pleasure I have in life; but you don't dare to put yourself under the law. You needn't look at me in that way—you can't intimidate me! She pure as the sea foam! Innocent!' she cried in an ironical voice, which her violence rendered almost inarticulate, though she struggled to express plainly her meaning.

Then she retreated back a step from him and shook her outstretched arm threateningly in his face, while he turned into the light, following her movements. The fire in his heart seemed flashing out through his very eyes.

'I'll punish the shameless creature', she cried, with terrible emphasis; 'I'll punish her, though I'm sent to hell fire the next instant for it!'

There was a sudden pause, a crisis such as

the soul of any one looking on at this strange scene might have shuddered under, but she seemed quite unappalled at the anger she had roused in the man, and she stood facing him defiantly.

He moved, and his face was lost in shadow, while she started back and waited panting and breathless. The dead silence around them was broken only by the placid ripple of the waves.

Suddenly a harsh noise, like the opening of a rusty-hinged casement, was heard. Previously to that a peculiar and undefined sound like the low murmur of a bee had become half-audible; but now, some twenty yards from where these two stood, a woman's clear sweet voice rose through the night, in words which could be heard plainly as they issued from her low-strained throat.

It was a song the melody of which sounded beautiful beyond expression, as the singer sang and pronounced it clearly with her subtle voice:—

> Alas, who knows or cares, my love,
>     If our love live or die?
> If thou thy frailty, sweet, should'st prove,
>     Or my soul thine deny?
> Yet merging sorrow in delight,
> Love's dream disputes our devious night.
>
> None know, sweet love, nor care a thought
>     For our heart's vague desire;
> Nor if our longing come to nought,
>     Or burn in aimless fire.
> Let them alone, we'll waste no sighs,
> Cling closer, love, and close thine eyes.

She ceased, and the sweet vibration died swiftly away in the depths of the night.

The mind of the singer producing this song must have formed a strange contrast in its utter isolation from the mad flood of passion and hatred and recrimination which swept round these two. It was as if an utterly windless, passionless space of smooth sea and sunlit sky existed, enveloped by a raging, black, profound and foam-surging ocean—utterly incommunicable with, and undisturbed by the surrounding tempest; for the human mind in its manifold forms resembles a sea with its waves,

all indissolubly connected together—one driving on and followed by another—one strong ripple fashioning a million others to its uttermost confines.

Strange was the effect this song produced on these two; it was as though the wind had died away in the midst of a storm.

The woman stopped, listening to it with a ghastly look and with averted eyes, while Denver turned from her, pressing his hands wildly over his face and brow, and trembling all over until it died away. When it ceased Deborah's senses were suddenly recalled to his presence; she seemed to start and come to herself with a sudden tremor.

Her eyes gleamed wildly and cruelly, but her face seemed changed into colourless stone, and the next instant she was lost to view. He saw her face and form recede like a flicker of light vapour into the darkness, and only heard the rustle of her dress on the boards: then all was quiet. He remained a little while as if stupefied, without motion, and then he went and leant against the bulwark, looking vacantly out into the night.

## Chapter 13[1]

> I am hungry for revenge,
> And now I cloy me with beholding it.
>                                                   *Richard III*

Laura still seemed to sleep, and he did not wake her; but after standing awhile examining the sky and the sea, he bent down and picked up the cast-off cloak, which had lain disused during the warmth of the night, and then began searching carefully through its seams and folds, as though with some set purpose. Next, he felt in his pockets for his knife: but it was gone, and he began picking the thread out as well as he could with his

---

1. After Denver's meeting with his cousin, Deborah, a fire begins on board which soon forces the passengers of 'The Black Swan', if they were fortunate enough to escape the flames, to abandon the ship and take to the lifeboats.

The three hapless survivors—Deborah, Laura and Denver—now find themselves alone together in a small lifeboat where they will stay until Deborah's death and the eventual rescue.

fingers and teeth. In this way, by knotting and plaiting fragments together, he made shift to get four or five yards of strong pack-thread.

This was to form a fishing-line.

Once, while his work was going on, he bent over the side of the boat, peering down into the depths of the blue water; but he could see nothing there. The sea was as clear as crystal, and his eyes plunged deeper and deeper into the weltering flood, until it all became hazy, and he could see no further.

The line was made fast to one of the pegs that the oars move in; and then he began to look about him. A hook must be made.

His eye was caught by some object glittering in the folds of the shawl; and leaning down, he found a small silver brooch there, with a strong pin to it. In an instant he had caught it up, and plucked the pin out of it, and this he fashioned with his teeth, until it was bent into the form required. Then it was made fast at the end of the line.

In the meantime, so intent was he on this work, that he had not noticed how Laura Conway was awake. She was roused by his movements, for every step he made caused the frail boat to quiver from stern to prow, as it hung on the clear waves.

He was trying to think what he should bait the hook's point with, when he looked up, and saw her rising in a bewildered manner.

The poor girl seemed scarcely to know where she was at first; and then she caught sight of Deborah, half lying and half sitting in the stern.

There was a kind of empty and doorless locker, the top of which formed a bench that her face lay on, supported by her left arm. The right hung down passively by her side, the fingers twitching at intervals. The rest of her body was on the planks, and she was just high enough to look over the low gunwale.

Laura's face resumed the paleness which seemed habitual to it now as she came and sat down by his side on the only other bench in the boat; she still, however, watched Deborah, as though unable to take her eyes off.

Denver looking anxiously about him all the while, could think of nothing better for a bait than to tear pieces off his woollen shirt-sleeve, and to prick his arm with the hook so as to soak them in blood. This he did; and a few drops of the red liquid fell on each, staining them through. Now it must be remembered that sea fish will bite almost at a bare hook itself, and that the lure he had provided for them would have sufficed to attract swarms from the water around the boat.

Fastening the rag on, he next dropped the line over the side: but it only floated there. He had to pull it back, and fasten the broken brooch on it before it would sink. Then, with his finger trembling on the line, his heart beating with anxiety while he waited the result, he turned round to Laura. She was still gazing half in amazement and half in fear at his cousin; but she that was looked at neither moved nor looked back, only her dark eyes gazed vacantly (with a kind of half-smothered and sombre fire in them) out across the glittering waves, while her lips moved occasionally, though without sound coming from them. It seemed, indeed, as though her own frantic words had come true, and that the events she had passed through really had reduced her to insanity. There seemed something in her presence that always acted like a spell over poor Laura whenever they met—just as the wild singing ceases through the woods and all is hushed when a hawk sweeps overhead in decreasing circles. Yet it seemed as if fate were never weary o of bringing these two in more literal contact with each other every day of their lives. But now Deborah took no notice of her, and seeing this, she began to regain confidence. The dark-complexioned black-haired woman with her jealous face and fiery eyes inspired her with almost the same kind of instinctive terror that one feels on sight of some venomous reptile.

But she felt that Denver's strength of will was so near to protect her, that she presently threw off all restraint in speaking to him; or, at least, all such as was not self-imposed by her own natural modesty and bashfulness; though it is probable

that if Deborah had once looked at her, the same influence would have been resumed. Far from being able to look at them, however, she seemed hardly able to bear being looked at herself. Some subtle instinct seemed to tell her whenever their faces were turned in her direction; and even though they were not looking directly at her, she seemed as ill at ease as a wild animal. Once or twice an involuntary impulse caused Denver to turn round, gazing at her as though she had fascinated him, and with a look of unyielding repugnance in his face; but, otherwise, he seemed to accept her presence passively—just as a kind of fate, which must be dumbly endured without reasoning or resistance.

So Laura, timidly at first, but with gathering confidence as she observed Deborah's lassitude and apathy, began to talk with Denver, and to allow him to caress her, and wind the fond fingers of his free hand through the ripples of her hair.

Yet, God knows, it seemed to neither of them a time for triviality; they both knew well that their lives hung upon a straining cord, *literally upon the line Denver was fishing with*, and despite the mutual love which at times asserted itself, transmuting everything in their faces and voices into its own tone, despite this, neither could hide from the other the trouble and anxiety on their minds.

Nearly a full hour must have passed, during which Denver had succeeded in making, with Laura's assistance, another line, getting the necessary thread from the skirt of her dress, and fashioning the hook from a hair-pin.

Laura herself held this one, and so they patiently waited a longer while yet, neither of them speaking, and always without success.

Suddenly (not having rightly seen how the hooks were baited, or perhaps wishing to divert his mind from the gloom his face must have shown it was harbouring) she asked him what they had at the ends of the lines.

'A rag stained with blood', he replied.

'*Your own blood!*' she exclaimed, looking at him with such intense fear, that he almost smiled, in spite of the sickening anxiety that was growing

in his heart, but he only made a motion with his head in reply.

Twenty or thirty minutes more passed, he with one line, she with the other, and neither of them said a word.

Again Laura spoke, 'There's nothing on my line, Denver. Has nothing touched yours?'

'Nothing.'

He was evidently not in a talkative mood, but presently she again essayed to rouse his attention:

'Put some of *my* blood on the hooks, maybe it would attract them more than yours, Gabriel.'

There was something almost ludicrous in the feminine simplicity and confidence with which this was said, and in the way she bared one of her beautiful wrists and held it out to him, but in the place in which they were uttered, there was a significance in her words and in her action which made them terrible.

As to Denver, he merely smiled in her face, half bitterly and half tenderly, and then the lines of his countenance relapsed into their somewhat more than serious expression, while he took her outstretched hand in his own, pressing it at intervals with his fingers, and went on watching silently and intently the water in which the line drifted.

She noticed that his hand trembled at times, and there was something so strangely anxious added to the habitual earnestness of his features, that she hardly dared to take her eyes off him as they sat together.

He was thinking over the preceding day's excitement and terror that had thus rendered them castaways. Something caused him suddenly to look up at Deborah, in one of those impulses before described, but Laura's face and eyes assumed a look of terror at the fierce expression shown in his, for she dreaded him to meet Deborah's gaze even more than she herself did, and she laid her hand on his arm as though its touch could distract and break up his reverie.

The reality of their position was growing terrible to them.

It must now, to judge by the sun's position,

have been nearly noon. An almost imperceptible breeze blew over the surface of the sea in slight wave-ruffling gusts, and served a little to atone for the flame-heat on their bare heads and lightly clad bodies, but it brought no cloud with it. The sky was utterly denuded and cloudless (save for one faint white speck, just touching the waves, where the moon was sinking) and its paleness at dawn was now changed to a colour as deep and brilliant as the manifold tones of the ocean beneath; not the vaguest hint of the morning's grayness remained.

The very waves seemed palpitating with the heat. Whenever the boat plunged slightly, as it now and then did, a dash of lukewarm spray was cast in their faces.

Now that the full noon-tide glare showed the vast proportions of the water and firmament, the boat with those in it (Deborah lying or leaning in the stern, Denver with his careworn features, and the other girl with her beautiful face and her hair flaming red in the sun) looked fearfully diminished and lonely. To Denver and Laura, the imprisoning walls of the blue horizon and the still bluer sky beyond, became perfectly insufferable in their unbroken monotony. A soul-benumbing sensation of utter helplessness gained upon them as the tedious day wore away.

They were absolutely without anything in the boat save their clothes. Denver's watch, his knife, and his telescope (things that he invariably had with him) were all left behind in the cabin of the destroyed ship. Only out of one of his pockets nearly twenty or thirty guinea-pieces and some old Spanish pieces of eight, still in colonial circulation, had fallen and lay unheeded and valueless in the bottom of the boat.

How many times Denver stood up gazing intently all round the smooth, unchanging horizon, always hopelessly and futilely, it would be impossible to say. Multitudinous times his heart started within him, and his brain turned dizzy again with the recoil of his sudden hope, while some horizon wave, bearing its crests of foam white in the sun, took for an instant the semblance of a sail, ere it subsided again and was lost, and how many times did his eyes, foiled, and haggard, and desperate, return baffled to Laura's face again!

It indeed would be hard to tell, totally unused to scanning the sea and its signs as he must have been, how often he was thus deluded into false hope by some unusual and transitory appearance, while ever his inward despair grew with each successive disappointment.

The day wore slowly on, the sun was over their heads at the zenith, and then long past them on the other side again. Every three or four minutes they had to wet their heads to assuage the heat, longing all the while that they could only dare to put the cool moist sea-water between their dry thirst-bitten lips, for thirst, at first an inconvenience, now began to grow intolerable. Denver at last bethought him of stretching the cloak like an awning from thwart to thwart in the narrow prow, so as to obtain shelter for Laura underneath it.

This was done, but first some whispered conversation took place between them, she seemingly urging him to carry out some request, something which he was very unwilling to comply with, until at last she said, in a voice strangely decided for her, 'If *you* don't, I will!'

At this he stepped reluctantly up the boat to where his cousin was sitting, and spoke some words to her. She took no notice of him the first time. Again he reiterated what he had said, 'The sun will scorch you to death unless you come under the shelter we have made.'

Then she turned her head and looked at him with a face that made him start, so dreadful was the contempt it seemed to express.

'*Die where you choose,*' she only said, 'Die where you will, I choose to die *here.*'

After such a speech as this, both he and Laura saw that it was useless to address her again. She was mad.

Denver himself refused positively to lie down under the cloak, and sat silently in the hot open air. He was too used to the sun to fear sun-stroke, but presently the fitful gusts of wind beginning to

strengthen, cooled somewhat the sultry atmosphere.

The two lines were continually slack, several times he had gashed the brown hair-covered skin of his arm to resoak the baits with his blood, but all his exertions seemed thrown away. The blue water appeared to be deserted by all animal life. Again and again the red stains were washed out of the rags, and at last he grew hopeless, and almost gave up attending to them.

Since the daylight had really permitted him to think and act without prejudice, a deep soul-benumbing sense of despondency had taken hold of him, and begun to enervate his whole moral being. His strong keen eyes were worn out and blinded with trying to pierce the blank confines where the faultlessly modelled dome of the sky seemed to rest on the waves. The pallid day-moon that hung so like a fleck of cloud in the mid air, was now no longer to be seen, and the scorching sunlight blinded and maddened him. He remained silent and motionless for a while, with his brown sinewy wrists and hands twisted over his face, but after some time he got up, and unable to resist some inner impulse, he lifted gently a corner of the shawl so as to look on Laura's face and figure for a moment.

She lay half-sleeping with closed eyes, and there was a frightened look on her features which, moreover, were slightly stained by the sun into a complexion which in no way diminished her beauty. Just at her neck a button was undone, and over the apple of her throat, otherwise whiter than ivory itself, a brown rim showed where the sun had reached. The whole head lay enframed in its rich profusion of warm golden hair, which glittering where the sunlight fell upon it, lay spread out on the concave boards and rippling round her face like an auriole.

As the lover bent over this spectacle of his mistress' beauty, a tumult of wild agony mastered his soul, and showed visibly in all his features, as his imagination realised the slow and lingering death which might be, even now, environing her. He put the cloak back without seeming to disturb her, and once more sat down, twisting his hands over his face, as if in a spasm of internal pain. All his blind infatuated tenderness and still blinder love could do nothing for her, unless help came to them; but he would be reduced to sitting helplessly at her side, watching her die a death of lingering pain, and all he would be able to do would be to kiss her uselessly, and wait till the end. This time *yesterday* on board the becalmed ship he would have shuddered and turned pale at the mere suggestion of such a prospect, but now with it visibly before him, he sat as if he were stupified or stunned.

By the position of the sun it must have now been about six in the evening. In another hour it would set and leave them in total darkness again; but for the present there were no signs of the evening, and everything glittered still with undiminished though slightly mellowed power of light. Laura still lay motionless, and Denver sat watching by her, always revolving idle conjectures which ended in nothing, save in producing a still gloomier view of their situation every time that he considered it. At times he strained his eyes into the cloudless and now yellowing depths of the sky, in the vain hope of discovering any vague particle of mist or vapour which might serve to indicate rain, for his thirst tortured him and made it terrible for him to look on the tantalising sea-water.

Everywhere he was baffled. The depths of his own heart, the unblemished sky, and the unbroken horizon lines, brought nothing but discouragement and deeper dejection to him. Yet at times it seemed so impossible that such a fate could environ him and Laura, after all the protestations that had passed between them, and all the mutual love and hope they had for each other, that once he began inadvertently to laugh.

It was a mere twitching of the facial muscles; but to anyone who could have seen this, it would have seemed as though the workings of madness were in his brain, caught from his cousin Deborah's, for madness is infectious, like any other disease.

Meanwhile the sun sank lower and lower, and its rays slanting, horizontally across the waves, showed the workings in his sunburnt face lowering out in deep shadow and intense glow, till it would have become fearful to contemplate. The shadow of the boat stretched further and further along the golden waves, till at last the burning rim of the sun touched, joined, and dipped into the sea, then began slowly and steadily to disappear, and so palpably, it seemed, that anyone in the boat might almost have looked to see the steam of boiling water rise in the sky.

A long train of scintillating glitter travelled over the foam and greenery of the sea, and arrived dancing and flashing up to the boat, as in mad glee and mockery of the two figures, a man and woman, who sat clasped together in her prow—Laura with her hair spread over Denver's neck, and two or three tangles of it, bright with the dying sun, blown and streaming in the wind, their faces pressed one to another, and lit up into a kind of wild enthusiasm.

For a while they had forgotten even their wretchedness in their great love, for with nothing else in the world they had at least that to satiate them.

It was a beautiful and yet a terrible picture, taken with its inward meanings and outward surroundings!

Their faces were set to the light of the sun, and Deborah, being behind them, received their shadows full over her. She had turned, and was looking at them clasped as they were together. There was a kind of fiercely sinister smile on her lips and in her dark, deep-set eyes—such a look of exulting malice and mockery that one knows no words to describe it with. Then the expression changed into one of intense hatred, and she sank back again into her old position.

It is peculiar to this latitude that darkness swiftly and simultaneously comes with the sinking of the sun. Even now the night, hardly restrained by the radiation of the last glittering fire-point visible, began to sweep in long reaches of gloom over the hollows made by the profoundly heaving

ocean, while the faint clusters of stars gleamed forth, slowly brightening down from the dark depth of the zenith till they reached the verges of the sea.

Soon the limitless surface of the sea, still hot with the sun, was bathed and enveloped in the coolness and secresy of night; and for that whole day these three had touched no nutriment.

## Sebastian Evans
## From *In the Studio* (1875)

### *The Eve of Morte Arthur*

Beside the dripping copses fleeting low,
    The homeless cuckoo jeereth all the day,
Even as he jeered a thousand years ago.
    May-morn itself is weary of the May.
In wonted wise, the cheerless nightingale
    Carpeth her carol on the hawthorn spray:
The daffodil and primrose are as pale,
    Dog-violet scentless as in Mays of yore,
And all the woodland telleth its old tale.

    All deeds are done, and the last quest is o'er;
For Galahad is gone, and sinless Knight
    Shall seat him in Siege Perilous no more.
O pure and perfect Champion of the Right,
    O lily-flower of sinful Lancelot's line!
Wert thou not born to teach us how the might
    Of earthly knighthood quails before divine?
True warrior, harnessed in celestial mail!
    Wert thou not Priest, too, chosen at the shrine,
When the last glory of the Holy Grail
    Flashed from the altar-stone in Carbonek,
And psalms of welcome pealed within the veil?
    Not like thine erring sire hast thou made wreck
Of God's dear grace, and flinched the one last quest;
In death as life, a soul without a fleck!

Yea, Galahad hath entered into rest,
    Fair-tombed in Sarras, his own holy land!
That knightly Hermit, too, whom he loved best,

Percivall, sleeps in peace at his right hand;
And at this left, that knight's sweet sister, oared
    By angel-shipmates to the blissful strand.

Tristan, than whom since Nembroth 'fore the Lord
    No mightier hunter rode with horn and hound;
He, too, hath died the death, not hard on sword
    As best beseems true knight of Table Round,
But slain by her he wronged: 'Fair dame,' quoth he,
    'Look forth, for I am faint of my sore wound:
Be the sails white, my Love comes back to me,
    Be the sails black, all my good days are done.'
Then went the wife and looked across the sea,
    And saw the white sails glisten in the sun,
And lied to him she loved: 'One sail I spied,
    Blacker than treason,—other spied I none.'
But he thereon gave a great groan and died.
    Then came that other widow to the beach,
And those two women meeting there dry-eyed
    Across the dead stood staring each on each.
Then, bending low, that queenly Voyager
    Kissed the white lips: 'Mine own!'—and in
        the speech
Fell forward dead. The first one glared at her
    And spurned her with her foot and slunk away.
So passed he to the land where none can err;
    The Sire of Nurture. Let the gaunt wolf bay,
And the tall-antlered red-deer couch secure,
    The broad-winged heron fearless cleave the grey;
No bowman lives can draw a bolt so sure;
    Dumb are his deep-mouthed boar-hounds
        of Albayne,
His falcons-royal heedless of the lure!

And he, too, Merlin, he who wooed in vain
The grace of that fair Lady of the Lake
    Who nursed Sir Lancelot—cometh not again!
Snared in the charm he taught her for love's sake,
    The hoary Wizard haunts the thorny brere,
And wastes his marvels or the wild-wood brake.
    Yet still not seldom may the Hermit hear
A dolorous hint at dusk in the Waste Land;
    And caitiff horseman, felled by angry spear
Five fathom o'er the croup with unseen hand,
    Surmise a dreary chuckle in the breeze
Among the bare oaks of Brokeliand.

All are forgotten. Yea, and more than these,
Fair dame and lord, minstrel and knight and sage,
    Who wrought and fought and loved and
        took their ease,
Have wended forth on their last pilgrimage.
    In shameless drivel of unhallowed eld
Morgana doteth on a lusty page
    Among the lakes o' the West, where once she held
High court that vied with Arthur's court of yore:
    And, homeless wandering through her
        woods unspelled,
The Fair Dame of the Forest Sans-retour
    Hath lost her chess-play and sweet carollings,
Her greenwood bowers of dalliance all forlore.

O, for those old May-days, when queens
        and kings
Held court of Love amidst the Table Round,
    And she whose knight had done the
        worthiest things
For her sole sake, though she and Fortune frowned,
    Heard all the doughty deeds he did achieve
And gave the guerdon as he sate there crowned!

So fares our kingdom now, for Arthur's might
Quakes to the base, fire-sapped by kingly sin:—
    A footfall jarring scarce enough to shake
One withered blossom from the jessamin
    More than enough beneath our feet to wake
The doom we wait for from its slumberings,
    And loose the fountains of the burning lake.

The world is old—and still the mavis sings.
    We wait the doom—yet on the hawthorn-spray
The nightingale remembers the old springs.
    May-morn itself is weary of the May,
Yet, careless of the wreck of realms and kings,
    The homeless cuckoo jeereth all the day.

**Thomas Gordon Hake**
From *New Symbols* (1876)

*The Painter*

1

'Summer has done her work', the painter cries,
    And saunters down his garden by the shore.
'The fig is cracked and dry; upon it lies,
    In crystals, the sweet oozing of its core.
The peach melts in its pink and yellow beam;
    Grapes cluster to the earth in diadems
    Of dripping purple; from their slender stems,
'Mid paler leaves, the dark-green citrons gleam.

2

'Summer has done her work; she, lingering, sees
    Her shady places glare: yet cooler grow
The breezes as they stir the sunny trees
    Whose shaking twigs their ruby berries sow.
Ripe is the fairy-grass, we breathe its seeds.
    But, hanging o'er the rocks that belt the shore,
    Safe from the sea, above its bustling roar,
Here ripen, still, the blossom-swinging weeds.

3

'Pale cressets on the summer waters shine,
    No ripple there but flings its jet of fire.
Rich amber wrack still bronzing in the brine
    Is tossed ashore in daylight to expire.
A wallowing wave the rocky shoal enwreathes;
    From the loose spray, cascades of bubbles fall
    Down steeps whose watery, coral-mantled wall
Drinks of the billow, and the sunshine breathes.

4

'Summer has done her work, but mine remains.
    How shall I shape these ever-murmuring waves,
How interweave these rumours and refrains,
    These wind-tossed echoes of the listening caves?
The restless rocky roar, the billow's splash,
    And the all-hushing shingle—hark! it blends,
    In open melody that never ends,
The drone, the cavern-whisper, and the clash.

5

'And this wide ruin of a once new shore
    Scooped by new waves to waves of solid rock,
Dark-shelving, white-veined, as if marbled o'er
    By the fresh surf still trickling block to block!
O worn-out waves of night, long set aside—
    The moulded storm in dead, contending rage,—
    Like monster-breakers of a by-gone age!
And now the gentle waters o'er you ride.

6

'Can my hand darken in swift rings of flight
    The air-path cut by the black sea-gulls' wings,
Then fill the dubious track with influent light,
    While to my eyes the vanished vision clings?
While at their sudden whirr the billows start,
    Can my hand hush the cymbal-sounding sea,
    That breaks with louder roar its reverie
As those fast pinions into silence dart?

7

'Press on, ye summer waves, still gently swell,—
    The rainbow's parent-waters over-run!
Can my poor brush your snaky greenness tell,
    Raising your sheeny bellies to the sun?
What touch can pour you in yon pool of blue
    Circled with surging froth of liquid snow,
    Which now dissolves to emerald, now below
Glazes the suken rocks with umber hue?

8

'Summer has done her work, dare I begin—
    Painting a desert, though my pencil craves
To intertwine all tints heaven akin?
    Nature has flung her palette to the waves!
Then bid my eyes on cloudy landscape dwell,—
    Not revel in thy blaze. O beauteous scene!
    Between thy art and mine is nature's screen,—
Transparent only to the soul,—farewell!

9

'Oh! could I paint thee with these ravished eyes,—
    Catch in my hollow palm thy overflow,
Who broadcast fling'st away thy witcheries!
    Yet would I not desponding turn and go.

Be it a feeble hand to thee I raise,
    'Tis still the worship of the soul within:
    Summer has done her work,—let mine begin,
Though as the grass it wither in thy blaze.'

## Philip Bourke Marston
**From *Song Tide* (1871)**

### A Christmas Vigil

Round the vast city draws the twilight grey;
    I know men say,
This evening is the eve of Christmas Day,
But what has Christmas time to do with me,
Who live a shameful life out shamelessly?
A creature now that doth not even yearn
    From sin to turn;
Too blind perchance it may be to discern
God's mighty mercy, and the boundless love
That all paid, praying preachers tell us of.

Here he lies dead, with whom my shame began,
    This is the man!
Through whom my life to such dishonour ran.
He was the snare in which my soul was caught;
Oh, the sweet ways wherein for love he wrought.
Yet God, not he, my wrath of soul shall bear,
    God set the snare!
God made him lustful, and God made me fair.
O God! were not his kisses more to me
Than Christians' hopes of immortality?

O lovely, wasted fingers, lithe and long,
    So kind and strong;
O lips! wherein all laughter was a song,
All song as laughter. O the cold, calm face,
The speechless marble mouth, that had such ways
Of singing, that for very joy of it,
    My heart would beat
Almost as loud as when our lips would meet,
And all love's passion, hotter for its shame,
Set panting mouths and thirsting eyes on flame.

Thus, would I part this hair back from the brow;
    But look you now,
What timing is left for me, save this, to bow
Myself unto him, as in days gone by,
To stretch myself beside him, and to die;
To crush my burning, aching lips on his,
    In one long kiss;
To know how cold and strange a thing death is?
His lips are cold, but my lips are so hot,
That all death's fearful coldness chills them not.

Fast falls the night, and down the iron street,
    Loud ring the feet
Of happy people, who pass on to meet
Fair sights of home; I hear the roll and roar
Of traffic, like a sea upon a shore.
One dying candle's pallid light is shed
    Upon the bed
Whereon is laid my beautiful cold dead,—
Mine, altogether mine, for two brief days!
Are not these hands his hands; this face his face?

And now I can recall the time gone by,
    The pure fresh sky
Of spring, 'neath which we first met, he and I,
The smell of rainy fields in curly spring,
The song of thrushes, and the glimmering
Of rain-drenched leaves by sudden sun made bright
    The tender light
Of peaceful evening, and the saintly night.
Sweet still the scent of roses; only this,
They had a perfume then which now I miss.

Yea, too, I can recall the night wherein
    Did first begin
The joy of that intoxicating sin.
Late was the day in April, gray and still,
Too faint to gladden, and too mild to chill;
Hot lay upon my lips the last night's kiss,
    The first of his;
I wandered blindly between shame and bliss;
And, yearning, hung all day about the lane,
Where, in the evening, he should come again.

Now, when the time of the sun's setting came,
      The sky caught flame;
For all the sun, which as an empty name
Had been that day, then rent the leaden veil
And lashed out sharp, 'twixt watery clouds, and pale,
Then, suddenly, a stormy wind upsprang,
      That shrieked and sang;
Around the reeling tree-tops, loud it rang,
And all was dappled blue, and faint, fresh gold,
Lovely, and virgin; wild, and sweet, and cold.

Then through the wind I heard his voice ring out,
      And half in doubt,
Trembling and glad, I turned, and looked about,
And saw him standing in my downward way,
Full in the splendour of the dying day.
Silent I stood a space, and then at last
      Strong arms were cast
About me, and his burning spirit passed
Into my spirit, till the twain as one
Shone out together under passion's sun.

I felt that joy unnameable was near,
      A great sweet fear
Fell all around me, and no thing was clear
To me save this,—that in his arms I lay,
And felt his kisses burn my soul away.
I heard the wild wind singing in my hair,
      And same the fair
Green branches tossing in the stormy air;
And, through the failing light, I heard a voice
That cried, 'O soul, at least this night rejoice!'

Ah me! the shameless, limitless delight
      Of that spring night!
The magic ways wherein, 'twixt dusk and light,
I wandered, dazed and faint with joy's excess—
Ah, God! what human creature shall express
That night's dear joy, the long thirst quenched last,
      All shame outcast,
The haven entered, and the tempest passed?
O shameful, sacred night, whereby alone
I bear with life till life's last day be done!

But when the feverish night had passed away,
      And faint, and grey,
On wet, chill April fields calm broke the day,
I rose, and in an altered world had part;
Love, marred by shame, lay bitter at my heart.
Through all my daily rounds that day I went,
      Till day was spent;
And with the night once more came sweet content
And joy that shut out every thought of shame,
And made all infamy an empty name.

Then quickly came the waste, gold, summer days,
      The blinding blaze
Of burning sunlight, and the sultry ways
Of breathless nights, wherein the moon seemed strange,
And with the scent of roses came the change;
Yea, when, as naked blades sharp-edged and bright,
      'Neath blasting light.
Sharp flashed the streams; when every coming night,
Solemn with moonlight, or with stars thrilled through,
Or quite unlit but passionately blue,

Were sweet as rest—'mid song, and scent, and flame,
      To me there came
The sense of loss, and bitterness of shame.
Surely between his kisses he had said,
'O love! before the sumumer time has fled,
I will return, and thou with me shalt come
      To a fair home.'
My kisses answered, for my voice was dumb.
Ah, God! those terrible June days, wherein
No rapture came to hush the voice of sin.

O sickening perfume of those summer days!
      O tree-girt ways
Wherein we wandered! O the happy place
Where first I burst on love, and love on me!
O sleepless nights when tears fell bitterly!
So died the Summer; and the Autumn sweet,
      With languid feet;
And recollections of the by-gone heat
Came down to us; but still he came no more,
And then I knew my destiny was sure.

I know not how, at length, when hope was gone,
        And shame had grown
Too sharp a thing to be endured alone,
 I left the peaceful country far behind,
And to the mighty city came to find
Some opiate for pain, and found it, too.
        Fresh passions grew
Within me: and a little while I knew
The bitter joys that set the blood on flame:
So grief slays joy, and wretchedness slays shame.

But still, through every feverish night and day,
        The old love lay
Hot at my heart, though he had gone his way,
As I had mine: sometimes of him I heard,
And how the world was by his spirit stirred.
Then came the news, how he lay dying here!
        I shed no tear,
I only felt the time at length was near,
When meeting I should see his face again,
And feel, through all, I had not lived in vain.

And now it is two nights ago, since first
        With eyes athirst
To see his face, resolved to know the worst,
I came in here, and stood beside his bed:
No look he gave me, and no word he said;
But I said, bowing down, and speaking low—
        'Two years ago,
You slew my honour, and I came here now
To tell you, whether yet you die or live,
Lost as I am, I love you, and forgive.'

He turned, and then I knew that he would speak;
        Against my cheek
Hot beat the blood, I stood there dazed and weak;
He said—'O face and voice that I remember,
'Twas July then, and now it is December;
Poor dove! that all God's hawks for prey have got.
        Ah me! how hot
This fever burns, and she remembers not
The ways of love wherein last June we trod.
They work their will, this woman and her God.'

Thus, as towards ending of his speech he drew,
        I only knew
Some other bitter mem'ry had come through
His thoughts of me, and set his soul adrift;
Then, as he backward fell, I saw him lift
Bright hollow eyes unto the wall, whereon
        A picture shone—
A picture now that from the wall has gone;
A portrait of a woman strange as fair,
With calm grey eyes, and fitful gold of hair.

The pale calm face, immovable and sad,
        Such beauty had,
As well might make by love a strong man mad.
The long sweet hands upon her breast were laid,
The full throat just a little back was swayed,
Its firm white beauty better to expose;
        The mouth kept close
The spirit's secrets of all joys and woes;
So calm and still he lay, I thought he slept,
Till, bending nearer down, I knew he wept.

And then he said, as one who speaks in dreams,
        'O face that gleams
Upon me when in sleep my spirit seems
To walk with thine, O long-loved love, O sweet,
O vanished eyes, O unreturning feet!
O heart that all the tempest of my love
        Could no way move!
O death, is not the end now sharp enough—
To love her, and to lose her, and to die,
While she knows not how life is going by?

'Could she know all I think she would arise,
        And let her eyes,
Wherein the very calm of heaven lies,
Fall on my face; yea, too, I do believe
So sweet her sweet soul is that she would grieve
A little space, in silence sitting here,
        To see draw near
Death's sea o'er which no light and land appear;
Yea, too, with words and touches she might make
The death-ward path smile as a flowering brake.'

Then all his love came on him, and he cried,—
                    'O death! divide
My soul from thought of hers; O darkness! hide
The passionless cold face and speechless mouth
By mine unkissed that waste my soul with drought!
O love, and must I die unkissed by thee?
                    What man shall be
The chosen one to come 'twixt thee and me?'
Then forth into the air he stretched his hand,
As one who, drowning, strives to reach the land.

Upon his brow a trembling hand I laid,
                    And tearless said,—
'Lie down and rest.' Then, as the rain is shed
When awful thunder-storms break up the heat,
My kisses on his lips and eyelids beat,
My fingers met and closed within his hair,
                    He was so fair;
And, like the unhoped granting of a prayer,
Such prayers as dying men for life must pray,
At length upon my hand his kisses lay.

Then by him, bowed with all my love, I fell,
                    And cried, ' 'Tis well,
Live yet, and in thy presence let me dwell.'
He smiled, and said, 'O tender hands and kind,
O lovely worshipped hands that now I find
So sweet, so sweet! O love, that bringest bliss,
                    What joy is this
To gain at last the heaven of thy kiss?'
And then he turned himself, gave thanks and sighed,
Nor spake again; and in the dawn he died.

My lips sealed up his eyes, my hands were spread
                    Beneath his head.
I stretched the lovely limbs upon the bed,
Folded the wasted hands upon the breast;
As there he lay in calm and frozen rest,
The drawn and rigid lips looked cold and stern,
                    That seemed to spurn
All joys and griefs; no soul was left to yearn
Within the hollow, dreamless, lampless eyes,
Whose death-look said the dead soul shall not rise.

I know not whether I did wrong or right,
                    But in the night
I came into his room, and raised the light
Unto the pictured face upon the wall
That looked on his, and was not moved at all;
I took it down, the face indeed was fair;
                    But, standing there,
I spurned it with my foot as God spurns prayer,
And lacking strength, not will, to spoil the face,
I cast it forth where none might know its grace.

And yet I think sometimes if he could know,
                    Loving her so,
As men, O God, can love and bear with woe,
He might be angry for the face downcast,
And for it come to hate me at the last;
But now the heavy tread upon the stair
                    Of men who bear
Some strange thing up: they come, they will not spare.
O God! they come, and now the door goes back;
They smell of death, the thing they bear is black.

### Sir Launcelot's Song to Guenevere

She is fresh and she is bright,
Joyous as the morning light;
Tender as a summer night,
Wherein men lose their souls for bliss,
And airs come wafted like a kiss
From crimson lips of Guenevere.
Who so stately, who so fair
As my own love, Guenevere?

When were ever seen such eyes,
Where the love-light faints and flies?
Such a crimson paradise
As her sweet mouth rife with love
Murmuring secret joys thereof?
Droop above me, Guenevere!
Who has lips, and eyes, and hair
Like thine own, my Guenevere?

When the sun had left the west
With head upon her fair white breast,
Oft at night times would I rest,

While, the listening space along,
Poured the music of her song
That told the love of Guenevere.
What in witchery may compare
With the voice of Guenevere?

Who has ever seen such feet,
Round which jewelled sandals meet,
Sweetly indolent or fleet
As love prompts or pleasure stays?
Love shines royal in the face
Of my royal Guenevere.
Love that doth a sceptre bear
Yields it in my Guenevere.

Thrills her touch through pulse and vein,
Flooding each with rapturous pain
That of its excess doth wane;
Moves she as a laden vine
That doth rise or now decline
As the love-gust sweeps by her;
Who is various, who is fair
As my own love, Guenevere?

La Belle Iseult is fair, we know;
Her mouth a rose, her bosom snow;
Such charms for other men may blow,
Their beauties may, for my will, pass
Like their own semblance in a glass,
If they leave but Guenevere.
Who has brows so fit to wear
Love's crown as my Guenevere?

Morgan le Fay is fair and wise,
With strange words in her lips and eyes,
That rend the secrets of the skies;
She's too weird, too grave for me,
Too like a tranced summer sea.
Changeful is my Guenevere;
Whom shall mortal eyes compare
In each change with Guenevere?

## Wedded Grief

And now we walk together, she and I;
    She sits with me unseen where men are gay,
    And all the pleasures of the sense have sway;
She walks with me beneath the moonlit sky
And murmurs ever of the days gone by;
    She follows still in dreams upon my way,
    She sits beside me in the fading day,
And thrills the twilight silence with a sigh;
So on we journey till we gain the strand
Whose sea conjectures of no further land;
    There, where the past is fading from my view,
To this my sorrow I will reach my hand
And say—O thou who wert alone found true,
Forgive if now I must forget thee too.

## Divine Pity

I wonder when you've gained the happy place,
    And walked above the marvel of the skies,
    And seen the brows of God, and large sweet eyes
Of Christ look lovingly upon your face,
    And all dear friends of unforgotten days;
Will you some time in that fair Paradise,
While all its peace and light around you lies,
    To greet your lover lost your dear eyes raise?
And when at length this thing you come to know,
    How he, forbid to pass, the heavenly bourne,
    Through undreamed distance roves with
        shades forlorn,
Will you be sorry, and, with eyes bent low,
    Wander apart the sudden wound to hide,
    And, meeting Mary, turn your face aside?

## Retrospect

Oh! strange to me, and terrible it seems
    To think that, ere I met you, you and I
    Lived both beneath the same all-covering sky,
Had the same childhood's hopes and childhood's
        schemes,
And, later on, our beautiful false dreams:
    The funerals of my dead joys passed me by,

And things, expected long, at length drew nigh.
The joy that slays and sorrow that redeems
    Were ours before that day whereon we met;
    And all the weary way that God had set
Between us was past over, and my soul
Knew in your fatal loveliness its goal.
    'Twas mine to love, 'twas yours, sweet, to forget;
For you the heaven, and for me the shoal.

### Body and Soul

All know the beauty of my lady's face,
    The peace and passion of her deep grey eyes,
    Her hair wherein gold warmth of sunlight lies.
Her mouth that makes as mockery all praise,
And languorous low voice that hath such ways
    Of unimagined music that the soul
    Stands poised and trembling; breathless till
        the whole
Ends in an unhoped symphony of sighs:
But who **as** I my lady's soul shall know—
    The deep tides of her nature that bear on,
    Till all the line of common life seems gone,
To hearts that weary of their boundaries grow,
Then must I turn, O love, from thee to go
    Through ways, to places, of thy soul unknown?

### Love's Magnetism

O Love! though far apart our bodies be,
    I think my soul must somehow touch your heart,
    And make you, in the dusk of slumber start,
To feel my strong love beat and surge round thee,
Oh, one sweet island of my soul's waste sea.
    Serene, and fair, and passionless thou art,
    Why should my sorrow of thy life make part,
Or shade the face burnt in my memory?
I think, too, as I pace the tawny sand,
If you were on the opposite fair strand,
And my heart should with love to your heart yearn,
I do believe you would not choose but turn
And look across the sea, my way, until
Not knowing why, my soul should burn and thrill.

### In Bondage

Oh, I have waited long for you, my sweet,
    In these cold dungeons far from light or day;
    And wondered if your eyes were blue or gray,
And how your face would look, my face to meet.
Yet his stern vengeance cannot be complete,
    Who holds me here as pris'ner in his sway;
    And, as a panther lurks about his prey,
Lurks he about us now, with noiseless feet.

Oh, kiss me once upon the lips, and bow
    The solemn beauty of your face to mine;
    Laugh as you laughed of old; but why turn pale,
    And why does such sweet, rising music fail?
Ah, he hath fill'd the cup to overflow,
    And I must drink your tears for my last wine.

### A Garden Reverie

    I hear the sweeping fitful breeze
        This early night in June;
    I hear the rustling of the trees
        That had no voice at noon.
    Clouds brood, and rain will soon come down
    To gladden all the panting town
    With the cool melody that beats
    Upon the busy dusty streets.

    But in this space of narrow ground
        We call a garden here—
    Because less loudly falls the sound
        Of traffic on the ear,
    Because its faded grass-plot shows
    One hawthorn tree, which each May blows,
    Whereon the birds in early spring
    At sun-dawn and at sun-down sing—

    I muse alone. A rose-tree twines
        About the brown brick wall,
    Which strives, when Summer's glory shines,
        To gladden at its festival,

Yet lets, upon the path beneath,
Such pale leaves drop as I would wreathe
Around a portrait that to me
Is all my soul's divinity:

A face in nowise proud or grand,
⠀⠀⠀But strange, and sad and fair;
A maiden twining round her hand
⠀⠀⠀A tress of golden hair,
While in her deep pathetic eyes
The light of coming trouble lies,
As on some silent sea and warm
The shadow of a coming storm.

From those still lips shall no more flow
⠀⠀⠀The tones that, in excess
Of tremulous love, touched more on woe
⠀⠀⠀Than quiet happiness,
When my arms strained her in a grasp
That sought her very soul to clasp;
When my hand pressed that hand most fair,—
I hold now but a tress of hair.

How look, this breezy summer night,
⠀⠀⠀The places that we knew
When all the hills were flushed with light
⠀⠀⠀And July seas were blue?
Does the wind eddy through our wood
As through this garden solitude?
Do the same trees their branches toss
The undulating wind across?

What feet tread paths that now no more
⠀⠀⠀Our feet together tread?
How in the twilight looks the shore?
⠀⠀⠀Is the sea outspread
Beneath the sky, a silent plain
Of silver lights that wax and wane?
What ships go sailing by the strand
Of that fair consecrated land?

Alas! what voice shall now reply?
⠀⠀⠀Not thine, arrested gale,
That 'neath the dark and pregnant sky
⠀⠀⠀Subsidest to a wail

On dusty city, silent plain,
And on thy village grave the rain
Comes down, while I tonight shall jest,
And hide a secret in my breast.

## From *All in All* (1875)

### *In the June Twilight*

In the June twilight, starless and profound,
She sits, and of the twilight seems a part.
No birds sing now, nor is there any sound
Of wind among the leaves; faintly you hear
The distant beating of the city's heart:
It doth not break the spell nor vex the ear,
But seems the silence yet to make more deep,
As though some giant whispered in his sleep.
Sometimes from little gardens lying round,
A voice calls through the evening; or you catch
The sound of opening windows, or a latch
Rais'd stealthily beneath, by those who keep
Love's trists, that often are too bitter found.
And lo! one sits beside her; does she know
How the least tone of hers, the slightest noise
Of soft, stirr'd raiment sets his heart aglow?
Yea, does she see how all the soul of him
Yearns to her in his look and in his voice?
Their faces in the falling light are dim;
And now to ease his heart a little space,
He tells her songs, that Love, with sovereign grace,
Has given him to sing of her; that so, when
Time, grown weary, casts his soul away
As a thing wholly done with, men shall say—
'How this man loved, and she his verses praise:
Such women come not twice God's grace to show.'

And now he ceases; and the common things
Of outer life go on: she does not move,
Her soul is full of mystic whisperings.
Is this heart hers, to do with as she wills?
But men as well as women can feign love,
Or deem that love which time too quickly kills.
But has she kindled in this man the fire
That only with his being can expire?

And starts he, when she looks at him, and springs
The violent blood through each dilating vein
When her hand touches his? can love be pain?
Can love unloving hearts with love inspire,
And is her love the heaven of which he sings?

## Not thou but I

It must have been for one of us, my own,
    To drink this cup and eat this bitter bread.
    Had not my tears upon thy face been shed,
Thy tears had dropped on mine; if I alone
Did not walk now, thy spirit would have known
    My loneliness, and did my feet not tread
    This weary path and steep, thy feet had bled
For mine, and thy mouth had for mine made moan;
    And so it comforts me, yea, not in vain,
To think of thy eternity of sleep,
To know thine eyes are tearless though mine weep:
    And when this cup's last bitterness I drain,
One thought shall still its primal sweetness keep—
Thou hadst the peace and I the undying pain.

## Fated!

Stand, fated house, forevermore, alone!
    Stand, 'mid thy barren gardens, wild, and swept
    By winds that wailing through thy trees have kept
The tune of grief. Be thou of joy unknown:
For in thy walks, now dank with oozing stone,
    My lady turned her face from me and wept,
    And gave me her last parting kiss, and slept
The sleep from which none wake to laugh or moan.

The summer misbecomes thee, O dread house!
Glad songs of birds sound alien in thy boughs!
    Death keep thy doors, thy passages are full
    Of ghosts that sorrow makes not beautiful.
    Forlorn, barred, silent—keep thy secret well,
    That none who pass may guess what thou coulds't tell.

## Was it for this?

Was it for this we met three years ago;
    Took hands, spake low, sat side by side, and heard
    The sleeping trees beneath us touched and stirred
By some mild twilight wind as soft as snow,
And with the sun's late kisses still aglow?
    Was it for this the end was so deferred?
    For this thy lips at length let through the word
That saved my soul, as all Love's angels know?
    Was it for this, that sweet word being said,
We kissed and clung together in our bliss,
    And walked within Love's sunlight and Love's shade?
Was it for this—to dwell henceforth apart,
One housed with death, and one with beggared heart?
    Nay, surely, love, it was for more than this.

## Sore Longing

My body is athirst for thee, my love;
    My lips, that may not meet thy lips again,
    Are flowers that fail in drought for want of rain;
My heart, without thy voice, is like a grove
Wherein no bird makes music, while, above,
    The twilight deepens as the low winds wane;
    My eyes, that ache for sight of thee in vain,
Are hidden streams no stars make mirrors of.
    I see thee but in memory, alas!
So some worn seaman, restless in his sleep,
In time of danger, o'er the raging deep,
    Sees visionary lights, and cries, 'We pass
The prayed-for land; reverse the helm, put back!'
And still the ship bears on her starless track.

## Impossible Joy

What of that place, my dearest, the far place
    We should have seen together, planning so,
    Before the Autumn's winds had strength to blow,
And Summer turn'd from us with lingering gaze,
As one who, parting, yet to go delays?—
    Ah! very strange, it seems to me, to know
    That seasons in that place still come and go,

Though we come not; if down the talked-of-ways
  My solitary steps are ever led,
  I shall seem surely as some man new-wed,
Who finds the loved one absent from his side,
And seeing she returns not, opens wide
  The bridal chamber, and bows down his head
Upon the couch where should have lain the bride.

## William Morris
### From *The Book of Verse: Written for Georgiana Burne-Jones* (1870)

### *Missing*

Upon an eve I sat me down and wept,
Because the world to me seemed nowise good.
Still autumn was it, and the meadows slept,
The misty hills dreamed, and the silent wood
Seemed listening to the sorrow of my mood:
I knew not if the earth with me did grieve
Or if it mocked my grief that bitter eve.

Then twixt my tears a maiden did I see
Who drew anigh me o'er the leaf-strewn grass,
Then stood and gazed upon me pityfully
With grief-worn eyes, until my woe did pass
From me to her, and tearless now I was,
And she mid tears was asking me of one
She long had sought unaided and alone.

I knew not of him, and she turned away
Into the dark wood, and my own great pain
Still held me there, till dark had slain the day
And perished at the grey dawn's hand again.
Then from the wood a voice cried: 'Ah, in vain,
In vain I seek thee, O thou bitter-sweet;
In what lone land are set thy longed-for-feet?'

Then I looked up, and lo, a man there came
From midst the trees, and stood regarding me
Until my tears were dried for very shame;
Then he cried out: 'O mourner, where is she
Whom I have sought oer every land and sea?
I love her, and she loveth me, and still
We meet no more than green hill meeteth hill.'

With that he passed on sadly, and I knew,
That these had met, and missed in the dark night,
Blinded by blindness of the world untrue,
That hideth love, and maketh wrong of right.
Then midst my pity for their lost delight
Yet more with barren longing I grew weak
Yet more I mourned that I had none to seek.

### *The Ballad of Christine*

Of silk my gown was shapen,
  Scarlet they did on me.
Then to the sea-strand was I borne
  And laid in a bark of the sea.
*O well would I from the World away.*

But on the sea I might not drown,
  To me was God so good,
The billows bore me up a land
  Where grew the fair green-wood.

There came a knight a riding by
  With three swains along the way
And took me up, the little-one,
  On the sea-strand as I lay.

He took me up, and bore me home
  To the house that was his own,
And there so long I bode with him
  That I was his love alone.

But the very first night we lay abed
  Befell this sorrow and harm,
That thither came the king's ill men,
  And slew him on mine arm.

There slew they the King Ethelbert.
  Two of his swains slew they.
But the third sailed swiftly from the land
  For ever to bide away.

O, wavering hope of this world's bliss,
  How shall men trow in thee?
My grove of gems is gone away
  For mine eyen no more to see!

Each hour that this my life shall last
Remembereth him alone.
Such heavy sorrow lies on me
For our meeting time agone.—

Ah, early of a morning tide
Men cry, Christine the Fair,
Art thou well content with that true-love
Thou sittest loving there?

O yea, so well I love him,
So dear to my heart is he,
That the very God of Heaven aloft
Worshippeth him and me.

All the red gold that I have
Well would I give today,
Only for this and nothing else,
From the World to win away.

Ah, of all folk upon the earth
Keep thou thy ruddy gold,
And love withal the mighty lord
Who wedded thee of old.
*O well would I from the World away.*

### Lonely Love and Loveless Death

O have I been hearkening
To some dread new-comer?
What chain is it bindeth,
What curse is anigh,
That the World is a-darkening
Amidmost the summer,
That the soft sunset blindeth
And Death standeth by?

Doth it wane, is it going,
Is it gone by for ever,
The life that seemed round me
The longing I sought?
Has it turned to undoing,
That constant endeavour
To bind love that bound me,
To hold all it brought?

I beheld all beholding
Grew pain thrice told over;
I hearkened till hearing
Grew woe beyond speech;
I dreamed of enfolding
Arms blessing the lover
Till the dream past all bearing
The dark void did reach.

Beaten back, ever smitten
By pains that none knoweth;
Did love ever languish
Did hope ever die?
I know not, but litten
By the light that love showeth
I beheld her through anguish
Never lost, never nigh.

I know not; but never
The day was without her,
I know not; but morning
Still woke me to her;
The miles that might sever
All faces about her
Weary Days, and self-scorning—
Ah easy to bear!

Look back, while grown colder,
The sunless day lingers,
And the tree-tops are stirring
With the last wind of day—
If thou didst behold her
If thine hand touched her fingers
If her breath thou wert hearing,
What words wouldst thou say?

Words meet for the hearkening
Of Death the new-comer;
For the new bond that bindeth,
The new pain anigh:
For the World is a-darkening
Amidmost the summer,
Death sickeneth and blindeth
No love standeth by.

*Birth of June*

> How the wind howls this morn,
> About the end of May
> And drives June on apace
> To mock the World forlorn,
> And my unlonged for face!
>
> The World's joy past away—
> For no more may I deem
> That any heart is glad
> To see the break of day
> Sunder the tangled dream
> Wherein no grief it had.
> Ah, through the tangled dream
> Where others have no grief,
> Ever it fares with me
> That fares and treasons stream;
> And sleep slays all belief
> Of what I hoped might be.
>
> Sleep slayeth all belief,
> Until the hapless light
> Wakes at the birth of June
> More lying tales to weave,
> More love in woe's despite,
> More hope to perish soon.
>
> More love in woe's despite—
> Then, O tongue, hold thy peace!
> Be silent thankless heart,
> Nor wish the World were bright
> Nor wish for Autumn's ease!
> Thou hast the better part.

# Arthur O'Shaughnessy
## From *An Epic of Women* (1870)

### *Creation*

*Nam non in hac ærumnosa miseriarum valle, in qua
ad laborem ceteri mortales nascimur, producta est.*
  Boccaccio: *De Claris Mulieribus*

And God said, 'Let us make a thing most fair,—
  A Woman with gold hair, and eyes all blue:'
He took from the sun gold and made her hair,
  And for her eyes He took His heaven's own hue.

He sought in every precious place and store,
  And gathered all sweet essences that are
In all the bodies: so He made one more
  Her body, the most beautiful by far.

Pure coral with pure pearl engendering,
  Bore Her the fairest flower of the sea;
And for the wonder of that new-made thing
  God ceased then, and nothing more made He.

So the beginning of her was this way:
  Full of sea savours, beautiful and good,
Made of sun, sky, and sea,—more fair than they—
  On the green margin of the sea she stood.

The coral colour lasted in her veins,
  Made her lips rosy like a sea-shell's rims;
The purple stained her cheeks with splendid stains,
  And the pearl's colour clung upon her limbs.

She took her golden hair between her hands;
  The faded gold and amber of the seas
Dropped from it in a shower upon the sands;
  The crispéd hair enwrapped her like a fleece:

And through the threads of it the sun lost gold,
  And fell all pale upon her throat and breast
With play of lights and tracings manifold:
  But the whole heaven shone full upon the rest.

Her curvéd shapes of shoulder and of limb,
    Wrought fairly round or dwindling delicate,
Were carven in some substance made to dim
    With whiteness all things carven or create.

And every sort of fairness that was yet
    In work of man or God was perfected
Upon that work her bosom, where were set
    In snows two wondrous jewelries of red.

The sun and sea made haloes of a light
    Most soft and glimmering, and wreathed her close
Round all her wondrous shapes, and kept her bright
    In a fair mystery of pearl and rose.

The waves fell fawning all about her there
    Down to her ancles; then, with kissing sweet,
Slackened and waned away in love and fear
    From the bright presence of her new-formed feet.

The green-gray mists were gathering away
    In distant hollows underneath the sun
Behind the round sea; and upon that day
    The work of all the world-making was done.

The world beheld, and hailed her, form and face;
    The ocean spray, the sunlight, the pure blue
Of heaven beheld and wondered at her grace;
    And God looked out of heaven and
        wondered too.

And ere a man could see her with desire,
    Himself looked on her so, and loved her first,
And came upon her in a mist, like fire,
    And of her beauty quenched his god-like thirst.

He touched her wholly with his naked soul,
    At once sufficing all the new-made sense
For ever: so the Giver Himself stole
    The gift, and left indeed no recompense.

All lavishly at first He did entreat
    His leman; yea, the world of things create
He rolled like any jewel at her feet,
    And of her changeful whim He made a fate.

He feasted her with ease and idle food
    Of gods, and taught her lusts to fill the whole
Of life; withal He gave her nothing good,
    And left her as He made her—without soul.

And lo, when he had held her for a season
    In His own pleasure-palaces above,
He gave her unto man; this is the reason
    She is so fair to see, so false to love.

### A Troth for Eternity

So, Woman! I possess you. Yes, at length,
Once wholly and for ever you are mine!

That cursèd burden on my memory,
Your whole past life's betrayal—let it go.
Ay, let it perish, and, for me at least,
Let life begin this moment, though we die
But three hours hence!

                            Is this your little voice
My Love, enthralling, winning my whole faith
With mere increasing sweetness in its tones,
Dissolving, exorcising, as it used,
Ah too infallibly, the phantom thing,
The doubt, the dread within me? ah, my Sweet,
Is this once more your voice assuring me—
With some rare music rather than one word
Of those fair whispered oaths of constancy;
Yea, till, as ever, I am come to smile
And glory in you, and believe you pure—
All mine, for ever, past a change in thought?

But no! *It is the little voice of the Steel*
*Here safe against my breast and fairly hid:*
*The Steel is singing to me, very low,*
*A tender song entrancing me;—O joy!*
The Steel says you will ne'er escape me more;
You will be true to me; you will be mine;
No man shall touch you after me; no face,
However strangely fair, shall have the art
To draw one look from you, to charm and rouse
That wondrous little snake of treachery

That was for ever lurking for me—sure
To spring upon me out of the least look
Or promise, safe to be curled up beneath
The simplest seeming offering in your hand.

Yes, 'tis a thing at length as good as this
The Steel is singing to me: did you hear,
You should but love it—since it pleads so well
It makes me put whole faith in you once more.
For now three days and nights indeed—while I,
Contending for you with the love I gave
Against the curse I owed you, raged and thought
It was my madness—O this little voice
Was striving with me, singing all the time,
Upon a low sweet soothing tune, strange words
Of promise that seemed like the distant taunts
Of all my past beliefs and that I sought
To cover with my curses; till, last night,
My soul grew faint with hearing them—how sweet,
How full of good they were. Then I fell still,
Yea, stunned, and with my head upon the ground;
And through the shut bleared darkness of my eyes,
I seemed to see the room about me lit
And fearful, and the Sword from off the wall
Unscabbarded before me in the midst,
Most terrible and living, and in light—
Just like a great archangel with the glare
Of burning expiations full on him.

O then my soul did call upon the Steel;
And the Steel heard and swore to me. My soul
Tore forth the hidden-rooted love of thee,
Thy treasured words—each one a cruel worm
That gnaws me through for ever, thy fair face
From the first inmost shrine, thy early kiss,
Thy separate falsenesses, all my despair,
My utter helplessness—and flung them down,
The very writhing entrails of my life
Become one inward horror to be borne
No longer. And there came about me, loud,
The mocking of a thousand impious tongues,
That seemed to clash and rattle hideously
From ancient hollow sepulchres of men
Long buried and forgotten; for my love
Their gibe was, for my faith, for my despair,

For my long blindness: and at last I knew,
And, understanding, called with a great voice
Upon the Steel: and the Steel heard me there,
And swore to me—for you and me and God!
*Sing on, O little voice: She cannot hear;*
*There is a pact between us.*

I cannot stir now. Many a knotted tress
Is on me, like a thousand-threaded chain
Twined many times about my limbs. I dream
No more: I feel her small and gliding hands
Seek mine; and while the burning rapid words
Her full heart furnishes hiss in mine ear,
My sight is peering blindly through the dark
Of her vast hair—a cavernous abyss
Of blackness traversed by mad shooting sparks
Or fearful gleams of blood.—What things she says!
'—Let this be as it were my bridal night,
'If you doubt all the Past. I am yours now;
'Take this for the beginning, and trust me;
'I will be yours for ever,—not a look,
'A word, a thought shall e'er dishonour you.'—
And, if I had not heard this very thing
Before, once, twice, innumerable times,
I should not plunge as I do now, my head
Still deeper in the fathomless dark hair,
And see tears falling from me—as it seems—
To fall on through a drear eternity.

But, hark, another voice! Whence comes it?
   —Whence?
From here, beneath the pillow; yes, 'tis harsh
And not like hers; but speaks a sweet thing—this:
*I swear for Her it shall be so: trust Me!*

Ah, yes—my Love, my own, I answer you;
I part with all the Past, forgive, deny,
Refuse to see it. All my soul is yours;
I never loved a moment in this world,
But what was love was wholly meant for you.
Yea, even before I saw you as you are,
Or knew your name, the vaguest breaths of love
Were but sent forward to me from the days

When you should come, preparing me for you.
I know in truth there never was a time
Wherein I saw no part of you—nor sign
To love you by; for all my sun, my light,
My flowers, my world would be the saddest blank,
The day you were not; you have these in you,
And are yourself in them; and, or the day
You go, you take them all away with you;
And so 'twas you I saw when I saw them
And said:—'*That Lady mine* shall have a head
Like yonder drooping lily or whose white
The summer's breath may never set a stain;
And She shall have a heaven for her hair
As deep, and dark, and splendid, as the one
I dream beneath; and She shall have such eyes
As ever seem to me those still blue lakes
I come on in the twilight of the woods
And find wide open under the thick fringe
Of violets—that fascinate me so
With gazing on me; yes, and, for her smile,
She shall but use that magic of the sun
That so transfigures all the day with light,
And gives my heart already such a thrill
As if She smiled at me:'—my Love, 'twas you
I saw then, dreamed of, waited for; 'twas you;
My heart attests it, looking on you now.—
So this of mine is such a perfect love
You see, it could not change nor turn away;—
It is the only love God made for you,
As you he made for me and from the first
Revealed to me. Therefore it cannot be
That you are false to me,—that I no way
Can save and keep you mine—you whom He gave
To me for ever, to be brought as mine
Before Him at the last. My precious one,
You are all worthy of me—are my crown
Untarnished, perfect, for you have not sinned;
'Tis I have sinned,—not being strong at once
To save both pure in you. Did not your lips
Completely make you mine of your own will?
Did you not swear yourself to me at first,
Yea, in God's name, before him? So that I—
Yes, I, have let you, all against your heart,
Be brought to do sad things you would have shunned;
Because I had the way, and used it not,

To keep you from them.—Ah, I curse myself!—
My own, my Love!—those gentle words of yours,
Those promises—repeat them; yes, once more:
You will be mine; you are mine; yes, my Love,
I do believe you now; I may, I can—
(For *that* sings under the pillow; believe Me!—)
I bless and kiss you for them all.

                    She sleeps.

*The Steel is singing to me now; its voice*
*Creeps through and through*;—go on,—she cannot
    hear—
*The things it sings are death and love; ay, love*
*That death keeps true*:—She sleeps, she cannot hear.

There is no sort of madness in my brain;
But rather a great strength, a calm, as though
A more than human spirit dwelt with mine.
And yet I do perceive that, since last night,
My eyes have been bewildered with the glare
Of mighty blades and swords that seem to whirl
And strike around me, and transform the world
With an exceeding splendour cold and bare;
A thousand films are as it were cut through;
And all the beauty, supernatural
And real of things seems only to endure.
The Steel is an immense magician: yes—
Love, Beauty, Life—a touch can change them all
And make them wholly fit for me and great.
See now where *it* is gleaming through her hair!
'Tis like a fair barbaric ornament
Ablaze with glancing points of diamonds
Stuck in and out between the writhing black.
Or, rather, 'tis as fearful and as bright
As some fierce snake of azure lightning curled
Sinister under the dark mass of night,
That ever, with his sudden forked flash
Piercing some crevice, doth illumine it.

I could be gazing on this sight for hours…

—Therefore, my Love, I will not let you wake.
Nay—though you are so pure now and have sworn—
Lest you betray me as you did last time,
And times before that, having sworn as now.
But you are mine—my beautiful, my own!
And your lips said it while your heart beat here
Against mine—thrilling with a thought of me;
Your looks were almost piteous with a prayer
That I—that God would save you. Shall your mouth,
The chaste, the holy one that I have kissed
Be desecrate once more? Shall your own arms
Embrace and hug the very shame of you?
Shall this, your heart that made you mine, be false
—Go once more seeking out adulteries?

Not so: I strike the holy steel in it.

—It was the only way to keep her mine.

### From *Music and Moonlight* (1874)

### *Song*

    Has summer come without the rose,
        Or left the bird behind?
    Is the blue changed above thee,
        O world! or am I blind?
    Will you change every flower that grows,
        Or only change this spot,
    Where she who said, I love thee,
        Now says, I love thee not?

    The skies seemed true above thee,
        The rose true on the tree;
    The bird seemed true the summer through,
        But all proved false to me.
    World! is there one good thing in you,
        Life, love, or death—or what?
    Since lips that sang, I love thee,
        Have said, I love thee not?

    I think the sun's kiss will scarce fall
        Into one flower's gold cup;
    I think the bird will miss me,

    And give the summer up.
O sweet place! desolate in tall
        Wild grass, have you forgot
How her lips loved to kiss me,
        Now that they kiss me not?

Be false or fair above me,
        Come back with any face,
Summer!—do I care what you do?
        You cannot change one place—
The grass, the leaves, the earth, the dew,
        The grave I make the spot—
Here, where she used to love me,
        Here, where she loves me not.

### *Ode*

We are the music makers,
    And we are the dreamers of dreams,
Wandering by lone sea-breakers,
    And sitting by desolate streams;—
World-losers and world-forsakers,
    On whom the pale moon gleams:
Yet we are the movers and shakers
    Of the world for ever, it seems.

With wonderful deathless ditties
We build up the world's great cities,
    And out of a fabulous story
    We fashion an empire's glory:
One man with a dream at pleasure,
    Shall go forth and conquer a crown;
And three with a new song's measure
    Can trample a kingdom down.

We, in the ages lying
    In the buried past of the earth,
Built Nineveh with our sighing,
    And Babel itself in our mirth;
And o'erthrew them with prophesying
    To the old of the new world's worth;
For each age is a dream that is dying,
    Or one that is coming to birth.

A breath of our inspiration
Is the life of each generation;
    A wondrous thing of our dreaming
    Unearthly, impossible seeming—
The soldier, the king, and the peasant
    Are working together in one,
Till our dream shall become their present,
    And their work in the world be done.

They had no vision amazing
Of the goodly house they are raising;
    They had no divine foreshadowing
    Of the land to which they are going:
But on one man's soul it hath broken,
    A light that doth not depart;
And his look, or a word he hath spoken,
    Wrought flame in another man's heart.

And therefore to-day is thrilling
With a past day's late fulfilling;
    And the multitudes are enlisted
    In the faith that their fathers resisted,
And, scorning the dream of to-morrow,
    Are bringing to pass, as they may,
In the world, for its joy or its sorrow,
    The dream that was scorned yesterday.

But we, with our dreaming and singing,
    Ceaseless and sorrowless we!
The glory about us clinging
    Of the glorious futures we see,
Our souls with high music ringing:
    O men! it must ever be
That we dwell, in our dreaming and singing,
    A little apart from ye.

For we afar with the dawning
    And the suns that are not yet high,
And out of the infinite morning
    Intrepid you hear us cry—
How, spite of your human scorning,
    Once more God's future draws nigh,
And already goes forth the warning
    That ye of the past must die.

Great hail! we cry to the corners
    From the dazzling unknown shore;
Bring us hither your sun and your summers,
    And renew our world as of yore;
You shall teach us your song's new numbers,
    And things that we dreamed not before:
Yea, in spite of a dreamer who slumbers,
    And a singer who sings no more.

### The Great Encounter

Such as I am become, I walked one day
Along a sombre and descending way,
Not boldly, but with dull and desperate thought:
Then one who seemed an angel—for 'twas He,
My old aspiring self, no longer Me—
Came up against me terrible, and sought
To slay me with the dread I had to see
His sinless and exalted brow. We fought;
And, full of hate, he smote me, saying, 'Thee
I curse this hour: go downward to thine hell.'
And in that hour I felt his curse and fell.

## Coventry Patmore

### The Rosy Bosom'd Hours (Pall Mall Gazette, July 1876)

A florin to the willing Guard
    Secured, for half the way,
(He lock'd us in, ah, lucky-starr'd,)
    A curtain'd, front coupé.
The sparkling sun of August shone;
    The wind was in the West;
Your gown and all that you had on
    Was what became you best;
And we were in that seldom mood
    When soul with soul agrees,
Mingling, like flood with equal flood,
    In agitated ease.
Far round, each blade of harvest bare
    Its little load of bread;

Each furlong of that journey fair
    With separate sweetness sped.
The calm of use was coming o'er
    The wonder of our wealth,
And now, maybe, 'twas not much more
    Than Eden's common health.
We paced the sunny platform, while
    The train at Havant changed:
What made the people kindly smile,
    Or stare with looks estranged?
Too radiant for a wife you seem'd,
    Serener than a bride;
Me happiest born of men I deem'd,
    And show'd perchance my pride.
I loved that girl, so gaunt and tall,
    Who whispered loud, 'Sweet Thing!'
Scanning your figure, slight yet all
    Round as your own gold ring.
At Salisbury you stray'd alone
    Within the shafted glooms,
Whilst I was by the Verger shown
    The brasses and the tombs.
At tea we talk'd of matters deep,
    Of joy that never dies;
We laugh'd, till love was mix'd with sleep
    Within your great sweet eyes.
The next day, sweet with luck no less
    And sense of sweetness past,
The full tide of our happiness
    Rose higher than the last.
At Dawlish, 'mid the pools of brine,
    You stept from rock to rock,
One hand quick tightening upon mine,
    One holding up your frock.
On starfish and on weeds alone
    You seem'd intent to be:
Flash'd those great gleams of hope unknown
    From you, or from the sea?
Ne'er came before, ah, when again
    Shall come two days like these:
Such quick delight within the brain,
    Within the heart such peace?

I thought, indeed, by magic chance,
    A third from Heaven to win,
But as, at dusk, we reach'd Penzance,
    A drizzling rain set in.

### The Toys (*Pall Mall Gazette*, November 1876)

My little Son, who look'd from thoughtful eyes
And moved and spoke in quiet grown-up wise,
Having my law the seventh time disobey'd,
I struck him, and dismiss'd
With hard words and unkiss'd,
His Mother, who was patient, being dead.
Then, fearing lest his grief should hinder sleep,
I visited his bed,
But found him slumbering deep,
With darken'd eyelids, and their lashes yet
From his late sobbing wet.
And I, with moan,
Kissing away his tears, left others of my own;
For, on a table drawn besides his head,
He had put, within his reach,
A box of counters and a red-vein'd stone,
A piece of glass abraded by the beach
And six or seven shells,
A bottle of bluebells
And two French copper coins, ranged there with
    careful art,
To comfort his sad heart.
So when that night I pray'd
To God, I wept, and said:
Ah, when at last we lie with tranced breath,
Not vexing Thee in death,
And Thou rememberest of what toys
We made our joys,
How weakly understood,
Thy great commanded good,
Then, fatherly not less
Than I whom Thou hast moulded from the clay,
Thou'lt leave Thy wrath, and say,
'I will be sorry for their childishness.'

## John Payne
## From *The Masque of Shadows* (1870)

This is the House of Dreams. Whoso is fain
To enter in this shadow-land of mine,
He must forget the utter Summer's shine
And all the daylight ways of hand and brain:
Here is the white moon ever on the wane,
    And here the air is sad with many a sign
    Of haunting mysteries,—the golden wine
Of June falls never, nor the silver rain
    Of hawthorns pallid with the joy of Spring:
But many a mirage of pale memories
Veils up the sunless aisle: upon the breeze
    A music of waste sighs doth float and sing:
And in the shadow of the sad-flower'd trees,
    The ghosts of men's desire walk wandering.

## From *Lautrec* (1878)

Vocantur mortui *vampiræ* in quibus, aut lunæ luminis
crescentis receptione, aut quæcunque aliæ influentiæ
potentiâ diabolicæ, infusa sit vita impia nocturnaque, vi
cujus sepulcrum frangunt, Dianâque fulgente per
terram errantes, sanguinem dormientium horridè
pascuntur. Fertur etiam nonnunquem ita trucidatos
*vampiras* ipsos vicissim factos esse.

Dead persons are styled *Vampires*, into whom—either
by the absorption of the rays of the waxing moon or
through the potency of some other diabolical
influence—has been infused an unholy and nocturnal
vitality, by dint whereof thy break sepulchre, and
wandering over the earth in the full splendour of the
moon, fearsomely feed on the blood of sleeping folk. It
is of record also that those thus done to death not
seldom in their turn become *Vampires*.
             P. Van Tonynck, *Infernalia* (1533)

The moon comes strangely late tonight,
    And yet meseems the dusk has laid
    On all its woven hands of shade;
Spent is the tall wan altar-light,
    And the last vesper-prayer is pray'd.

The last chimes of the vesper bell
    Along the sighing wind have died;
    And as it were a shadowtide
Rolled upward from the gates of Hell,
    The stern gloom surges far and wide.

I lie close shut within my bier;
    And yet, despite the graven stone,
    I feel the spells the night has strown,
The spells of sorcery and fear,
    Unto me through the air sink down:

The many-mingling influences;
    The viewless throb of awful mights;
    The flutter of the grey-wing'd sprights;
A press of shadowy semblances;
    The dreadful things that fly by nights.

I feel the spells of Fate and Fear
    That hold the empire of the dark;
    Like unseen birds their flight I mark
Athwart the teeming air, and hear
    The ghosts rush past me, as I hark.

Lo! there the charm fled through the night
    That sets the witch's black soul free
    To revel over earth and sea,
Whilst the reft corpse lies stark and white:
    And still the grave grips hold on me.

Ah, there again the hot thrill swept
    Across the dusk brown-breasted air!
    I know it: see, the graves gape bare,
Answering; and one by one, upleapt,
    The hell hounds startle from their lair.

A flash as of a dead man's eyes,
    Blues as the fires that streak the storm!
    And from their dwelling with the worm,
See where the restless spirits rise,
    Each like a vapour in man's form.

The signs begin to thicken fast:
    A noise of horns, as if there blew
    The clarions of all storms that brew
Within the world-womb for the blast
    That bids the earth and sea renew.

And to that call the shapes rouse forth
    That make night weird with wailing ghosts
    Of frightful beasts, whose flamebreath hosts
East unto West and South to North
    Laid waste of old the night's grey coasts.

Until the Christ-god came to bear
    Back with his smile the ages' gloom,—
    And withered back into their doom,
They died: yet, wraiths of what they were,
    Still in the night they cheat the tomb

And wander over hill and dale,
    An awful host, invisible:
    But he, who fares by wood and dell,
Hears their wings rustle, and their wail
    Shrills through him like a wind of hell.

I know them all, ghost, witch and beast;
    I hear them hurtle through the gloom;
    The glad ghosts scatter from their room;
The ghouls fare forth unto the feast:
    Still I lie within the tomb.

For lo! the Queen of my desire,—
    The dreadful Lady of the Night,
    That fills my veins with wine of light,
Scaring me with her cold white fire, —
    Sleeps yet cloud-hidden from my sight.

And here I lie, wrapt in my shroud,
    Moveless and cold upon the bier;
    And all my rage of wish and fear
Unto the hush I cry aloud,
    In tones that only sprights can hear.

And in the fever of my mood,
    The passion of the days of yore
    Swims like a mist of flame before
My haggard eyes, —a mist of blood,
    A meteor play of tears and gore.

And one white face, mark'd out in lines
    And silver characters of fire,
    Flames like a phantom of desire
Against my sight; and through the pines
    The nightwind, screaming nigh and nigh.

Is as a well remember'd voice,
    That once to me was honeysweet
    As that the white soul waits to greet,
When heaven's sight bids the eye rejoice,
    Opening upon the golden street.

Ay, once that visage was to me
    As Christ's face seen upon the rim
    Of heaven, betwixt the cherubim;
That voice was as the melody
    Of angels calling through the dim

Hush'd heart of Death, to him who lies
    And waits the coming of the feet
    Of what white angel stern and sweet
That gives the keys of Paradise,
    Or opens up Hell's sulphur-seat.

There was great love betwixt us twain:
    The memory of the time we kiss'd
    In passionate innocence, nor wist
Of any harm, will never wane,
    Maugre this bloody moonshot mist.

Despite this trance of tears and blood,
    I shall remember it for aye:
    And the warm lovelight in his eye,
When for my answering kiss he sued,
    Will haunt my curst eternity,

Ay, though the fathomless abyss
    Of doom lie gaped our souls between,
    His soul, that walks in Heaven's sheen,
Shall burn for ever with that kiss,
    Though Hell flame 'twixt us for a screen.

Ay, even midst the blaze of stars
    That light the golden city's air,
    My face shall stand out weird and fair
My voice shall reach him through Hell's bars,
    Across the din of harps and prayer.

I was the daughter of a king;
    And he a simple knight that bent
    His knee before my sire and went
About the world, adventuring
    In battle and in tournament.

A simple knight he was: but none
    In all the land was fair to see
    Or glorious in fight as he:
There was no man beneath the sun
    Could match with him in chivalry.

Woe's me, how fierce the anguish is
    Of memory, and how the blue
    Of his two eyes, soft shining through
The year-mists, like twin stars of bliss,
    Prevails my passion to renew!

Those starsoft eyes! And too the red
    Of his clear lips, that on my eyes
    Did shed the dews of Paradise
In kisses, such as stir the dead
    And bid the shrouded ghost arise!

I do remember how he told
    Me first the love he bore to me:
    It was one summer, when the bee
Humm'd through a burning mist of gold,
    And fruit flamed on the orange tree.

The day had been made bright
    With many a noble deed of arms:
    All day the trumpet's shrill alarms
Rang through the golden summer-light;
    And the hush'd noontide's drowsy charms

Of sun and shade were cleft and stirr'd
    By grinding shock of shield and spear;
    And from the banner'd gallery-tier
I looked upon the lists and heard
    The swordplay ring out loud and clear.

Queen of the tourney was I set,
    And watch'd the harness'd spearman dash
    Athwart the mellay, and the flash
Of helmets, as the fair knights met
    And the spears shiver'd in the crash.

Full many a deed of arms was done,
    And many a mighty man that day
    Rode, meteor-like, through the array:
But over all the mellay shone
    One knight's white plume; and through the fray

Rose Lautrec's war-cry, as he clave
    The throng of riders, and the sweep
    Of his broad falchion did reap
The mailclad knights, as some stout knave
    Shears through the cornsheves tall and deep.

So all day long he rode the press,
    And all day long his stout arm held
    The lists, until the curfew knell'd,
And down behind the Westernness
    The gold sun cover'd up his shield.

Wherefore the prize to him was given
    Of that day's tourney, for that he
    Unconquer'd and unfalteringly
Against the press of knights had striven,
    Until the sunset kiss'd the sea.

I set the prize upon his brow—
    A wreath of laurel, fairly chased
    In gold and with rich emeralds graced—
And as he louted him full low,
    Whilst on his uncasqued front I placed

The jewelled cirque, his eyes met mine;
    And from their velvet deeps there shone
    So clear a fire into my own,
That thence my warm soul drank like wine
    An esctasy till then unknown.[1]

<p style="text-align:center">❧</p>

But I, for rapture of new bliss,
    Cared not to sink into the deep
    Delicious lap of that sweet sleep
That follows Love, lest I should miss
    Some ecstasy; or leave to reap

Some delicate delights of thought,
    That spring like flower-flakes of the May
    From Love fulfilled, and fade away
Like blossoms of the sea-foam wrought,
    That melt into the sunny spray.

My eyes stirr'd not from Lautrec's face
    That lay upturn'd towards my own.
    As 'twere some sculptured saint of stone.
With memories of the last embrace
    His rose-red mouth and forehead shone.

How fair he seem'd to me! So fair,    *Sucking blood*
    As I bent over him and fed
    My thirsty sight on him, the dread
Of some vague misery somewhere
    Envying our fortune, in my head

Ran like the tremulous faint fear
    That in full tide of August sun
    Across the scented air doth run,
Foreboding thunders drawing near
    And levins ere the day be done.

And more especially my sight
    Sate on the glory of his throat:
    With fondling fingers did I note
The part where it was left milkwhite,
    And that whereon the full sun smote

And burnt its pallor golden brown.
    Then as my toying hand withdrew
    The coverlet of gold and blue
From off his breast, and creeping down,
    Did nestle in his bosom true.

I saw—whereas the royal line
    Of his fair throat met with the snow
    Of the broad breast, and curving slow,
Blended—a crescent purpurine,
    That on the milky flesh did glow

Like angry birth of harvest moon:
    'Twas where some cruel sword had let
    Well night the life out. But I set
My lips unto it, half a-swoon
    For thinking of the cruel fret

Of pain that there had throbb'd whilere
    And as I kiss'd the scarce heal'd scar,
    A dim foreboding, faint and far,
Rose through my rapture, seeing there
    The image of the midnight star

<p style="text-align:center"></p>

The thought of love was burnt away
    By that fell passion and forgot.
    Fiercelier and faster the moon shot
Upon me ray on lurid ray,
    Until (but how me knoweth not),

1. Lautrec, however, is called to the Crusades and, soon after, false news comes of his death. Overwhelmed with grief, the narrator falls into a death-like trance, and is taken to the church for burial. While in this state, she experiences a powerful vision of blood-stained moon and the rising of the vampiric undead. She longs to join them, when she is awoken by Lautrec's voice and kiss. They marry, and the poem moves on to the honeymoon night after Lautrec has fallen asleep.

All suddenly, my parch'd lips clave
    To Lautrec's throat, and in the scar
    That did its fair perfection mar,
So fiercely delved, that like a wave
    The bright blood spouted, fast and far,

An arch of crimson.—Still he slept;
    For over all the night was strewn
    The curst enchantments of the moon:
And as the hot blood through me swept,
    My sense shook off its leaden swoon;

And with parch'd throat I drank my fill
    Of that fell stream. Then as I stay'd
    My awful hunger, undismay'd,
There rose within me higher still
    That horrid gladness, and there play'd

Full streams of fire through every vein.
    The darkling majesty of Hell
    Within my breast did surge and swell:
The infernal rapture brimm'd my brain
    With ecstasy ineffable.

Each limb and nerve seem'd born anew,
    And every separate faculty
    Retemper'd in that fiery sea:
In baptism of blood there grew
    Another heart and soul in me:

The heart and spirit of a fiend,
    That in all things that live and are
    Seeks but God's handiwork to mar.
At dugs of death my soul was yearn'd,
    Under the magic midnight star.

I trod in thought the flaming shore
    Of that unfathomable sea,
    Wherein both damn'd and demons be;
Stood, crown'd with fire, upon Hell's floor
    And strain'd exultant eyes to see

The damn'd folk writhing in the gloom;
    Whilst, all around me, from the throng
    Arose the immeasurable song
Of fiends exulting in their doom,
    With hideous hymnings, loud and long.

Still the moon glared on me; and still,
    Possessèd of her fatal sway,
    With lips that drain'd his life away
Of Lautrec's blood I took my fill;
    And still immovable he lay.

But life ebb'd fast from him the while:
    His face put on a livid hue;
    And the moon falling on him, drew
His features to a seeming smile,
    Dreadful with death that pierced it through.

Yet I at that unholy feast
    Lay, with tranced sense that could not note
    The ghastly tremors that denote
Death's drawing nigh,—till the moon ceased
    And faded from me, mote by mote.

The vangard banners of the dawn
    Dappled the Eastward. In the sky
    A thin grey line of light grew high;
And gradually all the dark was drawn
    Together, as the stars did die

And night left heaven to the day.
    Then as on me the earliest stroke
    Of sun across the casement broke,
The hellish sorcery drew away
    From off my spirit, and I woke

Into my doom: and as my sight
    Drank in that scene of death and dread
    And the corpse lying on the bed,
Life faded out from me forthright;
    And dead I lay, by Lautrec dead.

No more I knew, until the moon
  Roused me once more within the bier.
  Since then, each night when she shines clear,
My body from the chill corpse-swoon
  Startles; and in the moonlight sheer

Across the sleeping earth I go,
  Seeking anew to sate my thirst
  Upon fresh victims, as at first:
So till the Judgment-trumpets blow,
  To roam the night I am accurst.

But lo! the shimmer in the sky!
  She comes, the Queen of night and hell!
  The grave-grip looses me; the spell
Of death is slackening. Full and high
  She grows. Ah, there her first rays fell

Across the painted window-pane!
  And see, her stern face surges slow,
  And fills the chapel with its glow:
Onward it creeps—onward amain,
  Till on my tomb its full tides flow.

Ah, there at last full on my eyes
  The thaumaturgic splendour shone
  Across the crannies of the stone!
All hail, my mistress! I arise,
  And in my graveclothes stand alone.

Then, as the cold hermetic fire
  Streams in my veins, portal and wall
  Before my rushing footsteps fall;
And ravening with red desire,
  I scatter death in hut and hall.

## Christina Rossetti
### From *Common Place and Other Short Stories* (1870)

### *Nick*

There dwelt in a small village, not a thousand miles from Fairyland, a poor man, who had no family to labour for or friend to assist. When I call him poor, you must not suppose he was a homeless wanderer, trusting to charity for a night's lodging; on the contrary his stone house, with its green verandah and flower-garden, was the prettiest and snuggest in all the place, the doctor's only excepted. Neither was his store of provisions running low: his farm supplied him with milk, eggs, mutton, butter, poultry, and cheese in abundance; his fields with hops and barley for beer, and wheat for bread; his orchard with fruit and cider; and his kitchen-garden with vegetables and wholesome herbs. He had, moreover, health, an appetite to enjoy all these good things, and strength to walk about his possessions. No, I call him poor because, with all these, he was discontented and envious. It was in vain that his apples were the largest for miles around, if his neighbour's vines were the most productive by a single bunch; it was in vain that his lambs were fat and thriving, if some one else's sheep bore twins: so, instead of enjoying his own prosperity, and being glad when his neighbours prospered too, he would sit grumbling and bemoaning himself as if every other man's riches were his poverty. And thus it was that one day our friend Nick leaned over Giles Hodge's gate, counting his cherries.

'Yes,' he muttered, 'I wish I were sparrows to eat them up, or a blight to kill your fine trees altogether.'

The words were scarcely uttered when he felt a tap on his shoulder, and looking round, perceived a little rosy woman, no bigger than a butterfly, who held her tiny fist clenched in a menacing attitude. She looked scornfully at him, and said: 'Now listen, you churl, you! henceforward you shall straightway become

everything you wish; only mind, you must remain under one form for at least an hour.' Then she gave him a slap in the face, which made his cheek tingle as if a bee had stung him, and disappeared with just so much sound as a dewdrop makes in falling.

Nick rubbed his cheek in a pet, pulling wry faces and showing his teeth. He was boiling over with vexation, but dared not vent it in words lest some unlucky wish should escape him. Just then the sun seemed to shine brighter than ever, the wind blew spicy from the south; all Giles's roses looked redder and larger than before, while his cherries seemed to multiply, swell, ripen. He could refrain no longer, but, heedless of the fairy-gift he had just received, exclaimed, 'I wish I were sparrows eating—' No sooner said than done: in a moment he found himself a whole flight of hungry birds, pecking, devouring, and bidding fair to devastate the envied cherry-trees. But honest Giles was on the watch hard by; for that very morning it had struck him he must make nets for the protection of his fine fruit. Forthwith he ran home, and speedily returned with a revolver furnished with quite a marvellous array of barrels. Pop, hang-pop, hang! he made short work of the sparrows, and soon reduced the enemy to one crestfallen biped with broken leg and wing, who limped to hide himself under a holly-hush. But though the fun was over, the hour was not; so Nick must needs sit out his allotted time. Next a pelting shower came down, which soaked him through his torn, ruffled feathers; and then, exactly as the last drops fell and the sun came out with a beautiful rainbow, a tabby cat pounced upon him. Giving himself up for lost, he chirped in desperation, 'O, I wish I were a dog to worry you!' Instantly—for the hour was just passed—in the grip of his horrified adversary, he turned at bay, a savage bull-dog. A shake, a deep bite, and poor puss was out of her pain. Nick, with immense satisfaction, tore her fur to bits, wishing he could in like manner exterminate all her progeny. At last, glutted with vengeance, he lay down beside his victim, relaxed his ears and tail,

and fell asleep.

Now that tabby-cat was the property and special pet of no less a personage than the doctor's lady; so when dinner-time came, and not the cat, a general consternation pervaded the household. The kitchens were searched, the cellars, the attics; every apartment was ransacked; even the watch-dog's kennel was visited. Next the stable was rummaged, then the hay-loft; lastly, the bereaved lady wandered disconsolately through her own private garden into the shrubbery, calling 'Puss, puss', and looking so intently up the trees as not to perceive what lay close before her feet. Thus it was that, unawares, she stumbled over Nick, and trod upon his tail.

Up jumped our hero, snarling, biting, and rushing at her with such blind fury as to miss his aim. She ran, he ran. Gathering up his strength, he took a flying-leap after his victim; her foot caught in the spreading root of an oak tree, she fell, and he went over her head, clear over, into a bed of stinging-nettles. Then she found breath to raise that fatal cry, 'Mad dog!' Nick's blood curdled in his veins; he would have slunk away if he could; but already a stout labouring-man, to whom he had done many an ill turn in the time of his humanity, had spied him, and, bludgeon in hand, was preparing to give chase. However, Nick had the start of him, and used it too; while the lady, far behind, went on vociferating, 'Mad dog, mad dog!' inciting doctor, servants, and vagabonds to the pursuit. Finally, the whole village came pouring out to swell the hue and cry.

The dog kept ahead gallantly, distancing more and more the asthmatic doctor, fat Giles, and, in fact, all his pursuers except the bludgeon-bearing labourer, who was just near enough to persecute his tail. Nick knew the magic hour must be almost over, and so kept forming wish after wish as he ran,—that he were a viper only to get trodden on, a thorn to run into some one's foot, a man-trap in the path, even the detested bludgeon to miss its aim and break. This wish crossed his mind at the propitious moment; the bull-dog vanished, and the labourer, overreaching himself,

fell flat on his face, while his weapon struck deep into the earth, and snapped.

A strict search was instituted after the missing dog, but without success. During two whole days the village children were exhorted to keep indoors and beware of dogs; on the third an inoffensive bull pup was hanged, and the panic subsided.

Meanwhile the labourer, with his shattered stick, walked home in silent wonder, pondering on the mysterious disappearance. But the puzzle was beyond his solution; so he only made up his mind not to tell his wife the whole story till after tea. He found her preparing for that meal, the bread and cheese set out, and the kettle singing softly on the fire. 'Here's something to make the kettle boil, mother,' said he, thrusting our hero between the bars and seating himself; 'for I'm mortal tired and thirsty.'

Nick crackled and blazed away cheerfully, throwing out bright sparks, and lighting up every corner of the little room. He toasted the cheese to a nicety, made the kettle boil without spilling a drop, set the cat purring with comfort, and illuminated the pots and pans into splendour. It was provocation enough to be burned; but to contribute by his misfortune to the well-being of his tormentors was still more aggravating. He heard, too, all their remarks and wonderment about the supposed mad-dog, and saw the doctor's lady's own maid bring the labourer five shillings as a reward for his exertions. Then followed a discussion as to what should be purchased with the gift, till at last it was resolved to have their best window glazed with real glass. The prospect of their grandeur put the finishing stroke to Nick's indignation. Sending up a sudden flare, he wished with all his might that he were fire to burn the cottage.

Forthwith the flame leaped higher than ever flame leaped before. It played for a moment about a ham, and smoked it to a nicety; then, fastening on the woodwork above the chimney-corner, flashed full into a blaze. The labourer ran for help, while his wife, a timid woman, with three small children, overturned two pails of water on the floor, and set the beer-tap running. This done, she hurried, wringing her hands, to the door, and threw it wide open. The sudden draught of air did more mischief than all Nick's malice, and fanned him into quite a conflagration. He danced upon the rafters, melted a pewter-pot and a pat of butter, licked up the beer, and was just making his way towards the bedroom, when through the thatch and down the chimney came a rush of water. This arrested his progress for the moment; and before he could recover himself, a second and a third discharge from the enemy completed his discomfiture. Reduced ere long to one blue flame, and entirely surrounded by a wall of wet ashes, Nick sat and smouldered; while the good-natured neighbours did their best to remedy the mishap,— saved a small remnant of beer, assured the labourer that his landlord was certain to do the repairs, and observed that the ham would eat 'beautiful'.

Our hero now had leisure for reflection. His situation precluded all hope of doing further mischief; and the disagreeable conviction kept forcing itself upon his mind that, after all, he had caused more injury to himself than to any of his neighbours. Remembering, too, how contemptuously the fairy woman had looked and spoken, he began to wonder how he could ever have expected to enjoy her gift. Then it occurred to him, that if he merely studied his own advantage without trying to annoy other people, perhaps his persecutor might be propitiated; so he fell to thinking over all his acquaintances, their fortunes and misfortunes; and, having weighed well their several claims on his preference, ended by wishing himself the rich old man who lived in a handsome house just beyond the turnpike. In this wish he burned out.

The last glimmer had scarcely died away, when Nick found himself in a bed hung round with faded curtains, and occupying the centre of a large room. A night-lamp, burning on the chimney-piece, just enabled him to discern a few shabby old articles of furniture, a scanty carpet,

and some writing materials on a table. These objects looked somewhat dreary; but for his comfort he felt an inward consciousness of a goodly money-chest stowed away under his bed, and of sundry precious documents hidden in a secret cupboard in the wall.

So he lay very cosily, and listened to the clock ticking, the mice squeaking, and the housedog barking down below. This was, however, but a drowsy occupation; and he soon bore witness to its somniferous influence by sinking into a fantastic dream about his money-chest. First, it was broken open, then shipwrecked, then burned; lastly, some men in masks, whom he knew instinctively to be his own servants, began dragging it away. Nick started up, clutched hold of something in the dark, found his last dream true, and the next moment was stretched on the floor—lifeless, yet not insensible—by a heavy blow from a crowbar.

The men now proceeded to secure their booty, leaving our hero where he fell. They carried off the chest, broke open and ransacked the secret closet, overturned the furniture, to make sure that no hiding-place of treasure escaped them, and at length, whispering together, left the room. Nick felt quite discouraged by his ill success, and now entertained only one wish—that he were himself again. Yet even this wish gave him some anxiety; for he feared that if the servants returned and found him in his original shape they might take him for a spy, and murder him in downright earnest. While he lay thus cogitating two of the men reappeared, bearing a shutter and some tools. They lifted him up, laid him on the shutter, and carried him out of the room, down the back-stairs, through a long vaulted passage, into the open air. No word was spoken; but Nick knew they were going to bury him.

An utter horror seized him, while, at the same time, he felt a strange consciousness that his hair would not stand on end because he was dead. The men set him down, and began in silence to dig his grave. It was soon ready to receive him; they threw the body roughly in, and cast upon it the first shovelful of earth.

But the moment of deliverance had arrived. His wish suddenly found vent in a prolonged unearthly yell. Damp with night dew, pale as death, and shivering from head to foot, he sat bolt upright, with starting, staring eyes and chattering teeth. The murderers, in mortal fear, cast down their tools, plunged deep into a wood hard by, and were never heard of more.

Under cover of night Nick made the best of his way home, silent and pondering. Next morning he gave Giles Hodge a rare tulip-root, with full directions for rearing it; he sent the doctor's wife a Persian cat twice the size of her lost pet; the labourer's cottage was repaired, his window glazed, and his beer-barrel replaced by unknown agency; and when a vague rumour reached the village that the miser was dead, that his ghost had been heard bemoaning itself, and that all his treasures had been carried off, our hero was one of the few persons who did not say, 'And served him right, too.'

Finally, Nick was never again heard to utter a wish.

## From *Sing-Song: A Nursery Rhyme Book* (1872)

Hope is like a harebell trembling from its birth,
Love is like a rose the joy of all the earth;
Faith is like a lily lifted high and white,
Love is like a lovely rose the world's delight;
Harebells and sweet lilies show a thornless growth,
But the rose with all its thorns excels them both.

A pin has a head, but has no hair;
A clock has a face, but no mouth there;
Needles have eyes, but they cannot see;
A fly has a trunk without a lock or key;
A timepiece may lose, but cannot win;
A corn-field dimples without a chin;
A hill has no leg, but has a foot;
A wine-glass a stem, but not a root;

A watch has hands, but no thumb or finger;
A boot has a tongue, but is no singer;
Rivers run, though they have no feet;
A saw has teeth, but it does not eat;
Ash-trees have keys, yet never a lock;
And baby crows, without being a cock.

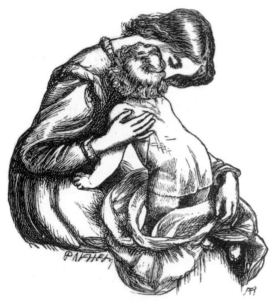

My baby has a mottled fist,
    My baby has a neck in creases;
My baby kisses and is kissed,
    For he's the very thing for kisses.

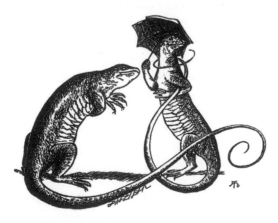

When fishes set umbrellas up
    If the rain-drops run,
Lizards will want their parasols
    To shade them from the sun.

Who has seen the wind?
    Neither I nor you:
But when the leaves hang trembling
    The wind is passing thro'.

Who has seen the wind?
    Neither you nor I:
But when the trees bow down their heads
    The wind is passing by.

Boats sail on the rivers,
    And ships sail on the seas;
But clouds that sail across the sky
    Are prettier than these.

There are bridges on the rivers,
    As pretty as you please;
But the bow that bridges heaven,
    And overtops the trees,
And builds a road from earth to sky,
    Is prettier far than these.

Hurt no living thing:
    Ladybird, nor butterfly,
Nor moth with dusty wing,
    Nor cricket chirping cheerily,
Nor grasshopper so light of leap,
    Nor dancing gnat, nor beetle fat,
Nor harmless worms that creep.

If stars dropped out of heaven,
    And if flowers took their place,
The sky would still look very fair,
    And fair earth's face.

Winged angels might fly down to us
        To pluck the stars,
But we could only long for flowers
        Beyond the cloudy bars.

If the moon came from heaven,
        Talking all the way,
What could she have to tell us,
        And what could she say?

'I've seen a hundred pretty things,
        And seen a hundred gay;
But only think: I peep by night
        And do not peep by day!'

**Dante Rossetti**
**From *Poems* (1870)**

*Jenny*

*Vengeance of Jenny's case! Fie on her!*
*Never name her, child!—(Mrs. Quickly)*

Lazy laughing languid Jenny,
Fond of a kiss and fond of a guinea,
Whose head upon my knee to-night
Rests for a while, as if grown light
With all our dances and the sound

To which the wild tones spun you round
Fair Jenny mine, the thoughtless queen
Of kisses which the blush between
Could hardly make much daintier;
Whose eyes are as the skies, whose hair
Is countless gold incomparable:
Fresh flower, scarce touched with signs that tell
Of Love's exuberant hotbed:—Nay,
Poor flower left torn since yesterday
Until to-morrow leave you bare;
Poor handful of bright spring-water
Flung in the whirlpool's shrieking face;
Poor shameful Jenny, full of grace
Thus with your head upon my knee;—
Whose person or whose purse may be
The lodestar of your reverie?

        This room of yours, my Jenny, looks
A change from mine so full of books,
Whose serried ranks hold fast, forsooth,
So many captive hours of youth,—
The hours they thieve from day and night
To make one's cherished work come right,
And leave it wrong for all their theft,
Even as to-night my work was left:
Until I vowed that since my brain
And eyes of dancing seemed so fain,
My feet should have some dancing too:—
And thus it was I met with you.
Well, I suppose 'twas hard to part,
For here I am. And now, sweetheart,
You seem too tired to get to bed.

        It was a careless life I led
When rooms like this were scarce so strange
Not long ago. What breeds the change,—
The many aims or the few years?
Because to-night it all appears
Something I do not know again.

        The cloud's not danced out of my brain,—
The cloud that made it turn and swim
While hour by hour the books grew dim.
Why, Jenny, as I watch you there,—
For all your wealth of loosened hair,
Your silk ungirdled and unlac'd

And warm sweets open to the waist,
All golden in the lamplight's gleam,—
You know not what a book you seem,
Half-read by lightning in a dream!
How should you know, my Jenny? Nay,
And I should be ashamed to say:—
Poor beauty, so well worth a kiss!
But while my thought runs on like this
With wasteful whims more than enough,
 I wonder what you're thinking of.

If of myself you think at all,
What is the thought?—conjectural
On sorry matters best unsolved?—
Or inly is each grace revolved
To fit me with a lure?—or (sad
To think!) perhaps you're merely glad
That I'm not drunk or ruffianly
And let you rest upon my knee.

For sometimes, were the truth confess'd,
You're thankful for a little rest,—
Glad from the crush to rest within,
From the heart-sickness and the din
Where envy's voice at virtue's pitch
Mocks you because your gown is rich;
And from the pale girl's dumb rebuke,
Whose ill-clad grace and toil-worn look
Proclaim the strength that keeps her weak,
And other nights than yours bespeak;
And from the wise unchildish elf,
To schoolmate lesser than himself
Pointing you out, what thing you are:—
Yes, from the daily jeer and jar,
From shame and shame's outbraving too,
Is rest not sometimes sweet to you?—
But most from the hatefulness of man,
Who spares not to end what he began,
Whose acts are ill and his speech ill,
Who, having used you at his will,
Thrusts you aside, as when I dine
I serve the dishes and the wine.

Well, handsome Jenny mine, sit up:
 I've filled our glasses, let us sup,

And do not let me think of you,
Lest shame of yours suffice for two.
What, still so tired? Well, well then, keep
Your head there, so you do not sleep;
But that the weariness may pass
And leave you merry, take this glass.
Ah! lazy lily hand, more bless'd
If ne'er in rings it had been dress'd
Nor ever by a glove conceal'd!

Behold the lilies of the field,
They toil not neither do they spin;
(So doth the ancient text begin,—
Not of such rest as one of these
Can share.) Another rest and ease
Along each summer-sated path
From its new lord the garden hath,
Than that whose spring in blessings ran
Which praised the bounteous husbandman,
Ere yet, in days of hankering breath,
The lilies sickened unto death.

What, Jenny, are your lilies dead?
Aye, and the snow-white leaves are spread
Like winter on the garden-bed.
But you had roses left in May,—
They were not gone too. Jenny, nay,
But must your roses die, and those
Their purfled buds that should unclose?
Even so; the leaves are curled apart,
Still red as from the broken heart,
And here's the naked stem of thorns.

Nay, nay, mere words. Here nothing warns
As yet of winter. Sickness here
Or want alone could waken fear,—
Nothing but passion wrings a tear.
Except when there may rise unsought
Haply at times a passing thought
Of the old days which seem to be
Much older than any history
That is written in any book;
When she would lie in fields and look
Along the ground through the blown grass,
And wonder where the city was,

Far out of sight, whose broil and bale
They told her then for a child's tale.

Jenny, you know the city now.
A child can tell the tale there, how
Some things which are not yet enroll'd
In market-lists are bought and sold
Even till the early Sunday light,
When Saturday night is market-night
Everywhere, be it dry or wet
And market-night in the Haymarket.
Our learned London children know,
Poor Jenny, all your pride and woe;
Have seen your lifted silken skirt
Advertise dainties through the dirt;
Have seen your coach-wheels splash rebuke
On virtue; and have learned your look
When, wealth and health slipped past, you stare
Along the streets alone, and there,
Round the long park, across the bridge,
The cold lamps at the pavement's edge
Wind on together and apart,
A fiery serpent for your heart.

Let the thoughts pass, an empty cloud!
Suppose I were to think aloud,—
What if to her all this were said?
Why, as a volume seldom read
Being opened halfway shuts again,
So might the pages of her brain
Be parted at such words, and thence
Close back upon the dusty sense.
For is there hue or shape defin'd
In Jenny's desecrated mind,
Where all contagious currents meet,
A Lethe of the middle street?
Nay, it reflects not any face,
Nor sound is in its sluggish pace,
But as they coil those eddies clot,
And night and day remember not.

Why, Jenny, you're asleep at last!—
Asleep, poor Jenny, hard and fast,—
So young and soft and tired; so fair,
With chin thus nestled in your hair,

Mouth quiet, eyelids almost blue
As if some sky of dreams shone through!

Just as another woman sleeps!
Enough to throw one's thoughts in heaps
Of doubt and horror,—what to say
Or think,—this awful secret sway,
The potter's power over the clay!
Of the same lump (it has been said)
For honour and dishonour made,
Two sister vessels. Here is one.

My cousin Nell is fond of fun,
And fond of dress, and change, and praise,
So mere a woman in her ways:
And if her sweet eyes rich in youth
Are like her lips that tell the truth
My cousin Nell is fond of love.
And she's the girl I'm proudest of.
Who does not prize her, guard her well?
The love of change, in cousin Nell,
Shall find the best and hold it dear.
The unconquered mirth turn quieter
Not through her own, through others' woe:
The conscious pride of beauty glow
Beside another's pride in her,
One little part of all they share.
For Love himself shall ripen these
In a kind soil to just increase
Through years of fertilizing peace.

Of the same lump (as it is said)
For honour and dishonour made,
Two sister vessels. Here is one.

It makes a goblin of the sun.

So pure,—so fall'n! How dare to think
Of the first common kindred link?
Yet, Jenny, till the world shall burn
It seems that all things take their turn;
And who shall say but this fair tree
May need, in changes that may be,
Your children's children's charity?
Scorned then, no doubt, as you are scorn'd!

Shall no man hold his pride forewarn'd
Till in the end, the Day of Days,
At Judgment, one of his own race,
As frail and lost as you, shall rise,—
His daughter, with his mother's eyes?

How Jenny's clock ticks on the shelf!
Might not the dial scorn itself
That has such hours to register?
Yet as to me, even so to her
Are golden sun and silver moon,
In daily largesse of earth's boon,
Counted for life-coins to one tune.
And if, as blindfold fates are toss'd,
Through some one man this life be lost,
Shall soul not somehow pay for soul?

Fair shines the gilded aureole
In which our highest painters place
Some living woman's simple face.
And the stilled features thus descried
As Jenny's long throat droops aside,—
The shadows where the cheeks are thin
And pure wide curve from ear to chin,—
With Raffæl's, Leonardo's hand
To show them to men's souls, might stand,
Whole ages long, the whole world through,
For preachings of what God can do.
What has man done here? How atone,
Great God, for this which man has done?
And for the body and soul which by
Man's pitiless doom must now comply
With lifelong hell, what lullaby
Of sweet forgetful second birth
Remains? All dark. No sign on earth
What measure of God's rest endows
The many mansions of his house.

If but a woman's heart might see
Such erring heart unerringly
For once! But that can never be.

Like a rose shut in a book
In which pure women may not look,
For its base pages claim control

To crush the flower within the soul;
Where through each dead rose-leaf that clings,
Pale as transparent Psyche-wings,
To the vile text, are traced such things
As might make lady's cheek indeed
More than a living rose to read;
So nought save foolish foulness may
Watch with hard eyes the sure decay;
And so the life-blood of this rose,
Puddled with shameful knowledge, flows
Through leaves no chaste hand may unclose:
Yet still it keeps such faded show
Of when 'twas gathered long ago,
That the crushed petals' lovely grain,
The sweetness of the sanguine stain,
Seen of a woman's eyes, must make
Her pitiful heart, so prone to ache,
Love roses better for its sake:—
Only that this can never be:—
Even so unto her sex is she.

Yet, Jenny, looking long at you,
The woman almost fades from view.
A cipher of man's changeless sum
Of lust, past, present, and to come,
Is left. A riddle that one shrinks
To challenge from the scornful sphinx.

Like a toad within a stone
Seated while Time crumbles on;
Which sits there since the earth was curs'd
For Man's transgression at the first;
Which, living through all centuries,
Not once has seen the sun arise;
Whose life, to its cold circle charmed,
The earth's whole summers have not warmed;
Which always—whitherso the stone
Be flung—sits there, deaf, blind, alone;—
Aye, and shall not be driven out
Till that which shuts him round about
Break at the very Master's stroke,
And the dust thereof vanish as smoke,
And the seed of Man vanish as dust:—
Even so within this world is Lust.

Come, come, what use in thoughts like this?
Poor little Jenny, good to kiss,—
You'd not believe by what strange roads
Thought travels, when your beauty goads
A man to-night to think of toads!
Jenny, wake up…Why, there's the dawn!

And there's an early waggon drawn
To market, and some sheep that jog
Bleating before a barking dog;
And the old streets come peering through
Another night that London knew;
And all as ghostlike as the lamps.

So on the wings of day decamps
My last night's frolic. Glooms begin
To shiver off as lights creep in
Past the gauze curtains half drawn-to,
And the lamp's doubled shade grows blue,—
Your lamp, my Jenny, kept alight,
Like a wise virgin's, all one night!
And in the alcove coolly spread
Glimmers with dawn your empty bed;
And yonder your fair face I see
Reflected lying on my knee,
Where teems with first foreshadowings
Your pier-glass scrawled with diamond rings:
And on your bosom all night worn
Yesterday's rose now droops forlorn,
But dies not yet this summer morn.

And now without, as if some word
Had called upon them that they heard,
The London sparrows far and nigh
Clamour together suddenly;
And Jenny's cage-bird grown awake
 Here in their song his part must take,
Because here too the day doth break.

And somehow in myself the dawn
Among stirred clouds and veils withdrawn
Strikes greyly on her. Let her sleep.
But will it wake her if I heap
These cushions thus beneath her head
Where my knee was? No,—there's your bed,

My Jenny, while you dream. And there
I lay among your golden hair
Perhaps the subject of your dreams,
These golden coins.

         For still one deems
That Jenny's flattering sleep confers
New magic on the magic purse,—
Grim web, how clogged with shrivelled flies!
Between the threads fine fumes arise
And shape their pictures in the brain.
There roll no streets in glare and rain,
Nor flagrant man-swine whets his tusk;
But delicately sighs in musk
The homage of the dim boudoir;
Or like a palpitating star
Thrilled into song, the opera-night
Breathes faint in the quick pulse of light;
Or at the carriage-window shine
Rich wares for choice; or, free to dine,
Whirls through its hour of health (divine
For her) the concourse of the Park.
And though in the discounted dark
Her functions there and here are one,
Beneath the lamps and in the sun
There reigns at least the acknowledged belle
Apparelled beyond parallel.
Ah Jenny, yes, we know your dreams.

For even the Paphian Venus seems
A goddess o'er the realms of love,
When silver-shrined in shadowy grove:
Aye, or let offerings nicely plac'd
But hide Priapus to the waist,
And whoso looks on him shall see
An eligible deity.

Why, Jenny, waking here alone,
May help you to remember one,
Though all the memory's long outworn
Of many a double-pillowed morn.
I think I see you when you wake,
And rub your eyes for me, and shake
My gold, in rising, from your hair,
A Danæ for a moment there.

Jenny, my love rang true! for still
Love at first sight is vague, until
That tinkling makes him audible.

And must I mock you to the last,
Ashamed of my own shame,—aghast
Because some thoughts not born amiss
Rose at a poor fair face like this?
Well, of such thoughts so much I know:
In my life, as in hers, they show,
By a far gleam which I may near,
A dark path I can strive to clear.

Only one kiss. Good-bye, my dear.

### The Sea-Limits

Consider the sea's listless chime:
        Time's self it is, made audible,—
        The murmur of the earth's own shell.
Secret continuance sublime
        Is the sea's end: our sight may pass
        No furlong further. Since time was,
This sound hath told the lapse of time.

No quiet, which is death's,—it hath
        The mournfulness of ancient life,
        Enduring always at dull strife.
As the world's heart of rest and wrath,
        Its painful pulse is in the sands.
        Last utterly, the whole sky stands,
Grey and not known, along its path.

Listen alone beside the sea,
        Listen alone among the woods;
        Those voices of twin solitudes
Shall have one sound alike to thee:
        Hark where the murmurs of thronged men
        Surge and sink back and surge again,—
Still the one voice of wave and tree.

Gather a shell from the strown beach
        And listen at its lips: they sigh
        The same desire and mystery,

The echo of the whole sea's speech.
        And all mankind is thus at heart
        Not anything but what thou art:
And Earth, Sea, Man, are all in each.

### Sudden Light

I have been here before,
        But when or how I cannot tell:
I know the grass beyond the door,
        The sweet keen smell,
The sighing sound, the lights around the shore.

You have been mine before,—
        How long ago I may not know:
But just when at that swallow's soar
        Your neck turned so,
Some veil did fall,—I knew it all of yore.

Has this been thus before?
        And shall not thus time's edding flight
Still with our lives our love restore
        In death's despite,
And day and night yield one delight once more?

### Even So

So it is, my dear.
All such things touch secret strings
        For heavy hearts to hear.
        So it is, my dear.
        Very like indeed:
Sea and sky, afar, on high,
        Sand and strewn seaweed,—
        Very like indeed.

But the sea stands spread
As one wall with the flat skies,
Where the lean black craft like flies
        Seem well-nigh stagnated,
        Soon to drop off dead.

Seemed it so to us
When I was thine and thou wast mine,
    And all these things were thus,
    But all our world in us?

    Could we be so now?
Not if all beneath heaven's pall
    Lay dead but I and thou,
    Could we be so now!

### The Woodspurge

The wind flapped loose, the wind was still,
Shaken out dead from tree and hill:
I had walked on at the wind's will,—
I sat now, for the wind was still.

Between my knees my forehead was,—
My lips, drawn in, said not Alas!
My hair was over in the grass,
My naked ears heard the day pass.

My eyes, wide open, had the run
Of some ten weeds to fix upon;
Among those few, out of the sun,
The woodspurge flowered, three cups in one.

From perfect grief there need not be
Wisdom or even memory:
One thing then learnt remains to me,—
The woodspurge has a cup of three.

### The Song of the Bower

Say, is it day, is it dusk in thy bower,
    Thou whom I long for, who longest for me?
Oh! be it light, be it night, 'tis Love's hour,
    Love's that is fettered as Love's that is free.
Free Love has leaped to that innermost chamber,
    Oh! the last time, and the hundred before:
Fettered Love, motionless, can but remember,
    Yet something that sighs from him passes the door.
Nay, but my heart when it flies to thy bower,

What does it find there that knows it again?
There it must droop like a shower-beaten flower,
    Red at the rent core and dark with the rain.
Ah! yet what shelter is still shed above it,—
    What waters still image its leaves torn apart?
Thy soul is the shade that clings round it to love it,
    And tears are its mirror deep down in thy heart.

What were my prize, could I enter thy bower,
    This day, to-morrow, at eve or at morn?
Large lovely arms and a neck like a tower,
    Bosom then heaving that now lies forlorn.
Kindled with love-breath, (the sun's kiss is colder!)
    Thy sweetness all near me, so distant to-day;
My hand round thy neck and thy hand on my shoulder
    My mouth to thy mouth as the world melts away.

What is it keeps me afar from thy bower,—
    My spirit, my body, so fain to be there?
Waters engulfing or fires that devour?—
    Earth heaped against me or death in the air?
Nay, but in day-dreams, for terror, for pity,
    The trees wave their heads with an omen to tell;
Nay, but in night-dreams, throughout the dark city,
    The hours, clashed together, lose count in the bell.

Shall I not one day remember thy bower,
    One day when all days are one day to me?—
Thinking, 'I stirred not, and yet had the power!'—
    Yearning, 'Ah God, if again it might be!'
Peace, peace! such a small lamp illumes, on this highway,
    So dimly so few steps in front of my feet,—
Yet shows me that her way is parted from my way...
    Out of sight, beyond light, at what goal may we meet?

## William Bell Scott
### From *Poems* (1875)

### From *The Old Scotch House*

#### 1: *The Bower*

In the old house there is a chamber high,
   Diapered with wind-scattered plane-tree leaves;
   And o'er one corbelled window that receives
The sunrise we've inscribed right daintily,
'Come, O fair Morn, fulfilling prophecy!'
   Over another, western watch doth keep,
   Is writ, 'O Eve, bring thou the nursling Sleep!'
Adorning the old walls as best we may.

For up this bower-stair, in long-vanished years,
   The bridegroom brought his bride and shut the
      door;
Here, too, closed weary eyes with kindred tears,
   While mourners' feet were hushed upon the floor:
And still it seems these old trees and brown hills
Remember also our past joys and ills.

'Penkill, Ayrshire' by William Bell Scott

#### 2: *A Spring Morning*

Vaguely at dawn within the temperate clime
   Of glimmering half-sleep, in this chamber high,
   I heard the jackdaws in their loopholes nigh,
Fitfully stir: as yet it scarce was time
Of dawning, but the nestlings' hungry chime
   Awoke me, and the old birds soon had flown;
   Then was a perfect lull, and I went down
Into deep slumber beneath dreams or rhyme.

But, suddenly renewed, the clamouring grows,
   The callow beaklings clamouring every one,
      The grey-heads had returned with worm and fly;
I looked up and the room was like a rose,
   Above the hill-top was the brave young sun,
      The world was still as in an ecstasy.

#### 7: *In the Garden*

This afterglow of summer wears away:
   Russet and yellowing boughs bend everywhere,
   Languid in noontide, and the rose-trees bear
Buds that will never open; this long day
Hath been so still, so warm, so lucidly
   White, like shadowless days in heaven I ween,
   A moment by God lengthened it hath been,—
As Time shall be no more at last, they say.

Let us sit here! there is no bird to sing;
   Not even the aspen quivers; faintly brown,
The great trees hang around us in a ring;
   Never shall snow or storm again come down,
And never shall we be again footsore,
But live in this enchantment ever more.

#### 8: *In the Garden*

Happiness sometimes hath a tinge of dread,
   Perfection unconditioned, strange indeed,
   As if at once the green leaf, flower, and seed.
Let the sun shine thus on thy nut-brown head,

'The Garden' by William Bell Scott

So lovely flecked with little shadows, shed
  Through the close trellis as I see it now,
  And on thy neck and on thy thoughtful brow:
Look up, so thought by thought be answerèd.
And let the dead leaves fall whene'er they may,
  Dropping like Danæ's gold-shower from on high,
  Rare jewels gathered in thy lap they'll lie:

This day hath been a sacred festa-day,
  We'll lock it fast within our treasure-store,
  And live in its enchantment ever more.

**From *Parted Love***

### 4: *By the Sea-Side*

Rest here, my heart, nor let us further creep;
  Rest for an hour, I shall again be strong,
  And make for thee another little song:
Rest here, and look down on the tremulous deep
Where sea-weeds like dead mænad's long locks sweep
  Over that dreadful floor of stagnant green,
  Stewed with the bones of lovers that have been,
Nor even yet can scarce be said to sleep.

Beyond that sea, far o'er that wasteful sea,
The sunset she so oft hath seen with me
  Flames up with all the arrogances of gold,
Scarlet and purple, while the west-wind falls
  Upon us with its deadliest winter-cold;—
Shall we slide down? I think the dear one calls!

### 5: *Evening*

As in a glass at evening, dusky-grey,
  The faces of those passing through the room
  Seem like ghost-transits thwart reflected gloom,
Thus, darling image! thou, so long away,
Visitest sometimes my darkening day:
  Other friends come; the toy of life turns around,
  The glittering beads change with their tinkling sound,
Whilst thou in endless youth sit'st silently.

How vain to call time back, to think these arms
  Again may touch, may shield, those shoulders soft
  And solid, never more my eyes can see:
But yet, perchance—(*speak low*)—beyond all harms,
  I may walk with thee in God's other croft,
  When this world shall the darkling mirror be.

## Green Cherries

The season had been late: Spring, lagging long,—
Not like the rosy-cheeked lithe Columbine
We see her pictured, but with frost-filled hair,
And sad scared eyes, had cowered beneath the eaves
From the sharp-biting blasts and drifting rains.
Yet in the heart of nature the great change
Had been effected, and one morn in June
Suddenly all the clouds were carol filled,
Every road dried and freckled with sunshine,
Every flower full-blown, both by hedge and garth,
Every tree heavy. So I said, This day
Is the true May-day, and I straight went forth
The nighest way unto the loneliest fields.
Two hours or so it might be from the town,
Before a thriving friend's well-built gateway,
I found myself, and entered, though I knew
That he would not be there; unfortunate
Son of dame Fortune he, who sits all day
With wits repressed and sharp pen, gain and loss
His nether lip developing.
                                            I swung
The gate and entered. All along the edge
Of the bright gravel fallen lilac blooms
Or young leaf-sheaths were scattered, and small groups
Of coming toadstools showed where showers had lain.
Under the wavering shades of trees I turned,
Skirting the garden's boxwood bordered ways,
Its rhododendrons bursting into flower,

'A Study from Nature' by William Bell Scott

Flaming beneath the sunshine, and at length
Rested upon an orchard arbour seat.
        All over bench and table, ground and sward,
The young green cherries lay, yet overhead,
Glittering like beads, they still seemed thick as leaves
Upon the boughs. And young green apples too,
Scattered by prodigal winds, peeped here and there,
Among the clover. Through the black boughs shone
Clouds of a white heat, in the cold blue depths
Poised steadily, and all about them rang
Those songs of skylarks. Other sounds were there:
The click mistimed of hedge-shears; the brave bee
Passing with trumpet gladness; and the leaves
Waving against each other. Soon this way
Along the further hedge-tops came the shears;
Two wielding arms assiduous and a face
The prickly screen disclosed. Far down the line
By slow degrees went shears and arms, while I
Marked the still toppling twigs, until at length
They passed beyond the fruit-trees, and I turned
To other themes. Above the flowering beds
Of jonquil and chill iris rose the house,—
There is the window of my host's small room,
There Harriet's, vacant now, with casements thrown
Wide open, their white curtains driven about;—
And see, within that other tightly closed,
The old dame sits intent on stocking wires.
I sat there; on the seat beside me lay
A cluster of three cherries on one stalk.

        A casual passing picture! strange it bides
Perennial with me yet! This little sprig
Of three green cherries, what may it concern
The universal heart? Why all along
The road of life do I remember still
The three green cherries there?

                        And yet the eye
Sees only what the mind perceives. The heart
Hath its supreme perceptions. We retain
Deepest impressions from most trivial things;
They are the daily food by which we grow;
Some future poet shall find fit airs for them
And touch the nerve of life. For yet shall come
The Poet, such an one as hath not yet

Entered his sickle in those great corn-fields
Whence comes the spiritual bread. Not battle deaths,
Nor mere adventures, nor rank passions moved
By vulgar things shall he sing; nor shall prate
With vague loose phrase of Nature: he shall see
The inexorable step-dame as she is,—
A teacher blind, whose task-work and closed door,
Body and soul, we strive against! O world!
The Poet of the future, welcome him!
When he appears.

        I left my reverie
Within the arbour, threw the green fruit back,
Crossed the scythed lawn and threshold, for the door

Stood hospitably open; none I met,
Nor had I any errand maid or man
Could answer: on the well-known table stood
Bread cut in shrives and wine. Then I put off
My hat before this sacrament and ate,
And called aloud that I might even perforce
Be courteous and give thanks; but no one came.
So thence departing, said I, 'Every home
Is thus enchanted justly understood',
And fared right on for many miles that day,
Picking up thoughts like wild-flowers by the path;
Some of them coarse and prickly, some sweet-breathed,
But none of them were homeward borne save those,
Now half expressed, I have writ here for thee!

## Algernon Charles Swinburne
**From *Songs before Sunrise* (1871)**

### From *Hymn of Man*

…Before the growth was the grower, and the seed ere the plant was sown;
But what was seed of the sower? and the grain of him, whence was it grown?
Foot after foot ye go back and travail and make yourselves mad;
Blind feet that feel for the track where highway is none to be had.
Therefore the God that ye make you is grievous, and give not aid,
Because it is but for your sake that the God of your making is made.
Thou and I and he are not gods made men for a span,
But God, if a God there be, is the substance of men which is a man.
Our lives are as pulses or pores of his manifold body and breath;
As waves of his sea on the shores where birth is the beacon of death.
We men, the multiform features of man, whatsoever we be,
Recreate him of whom we are creatures, and all we only are he.
For each man of all men is God, but God is the fruit of the whole;
Indivisible spirit and blood, indiscernible body from soul.
Not men's but man's is the glory of godhead, the kingdom of time.
The mountainous ages made hoary with snows for the spirit to climb.
A God with the world inwound whose clay to his footsole clings;
A manifold God fast-bound as with iron of adverse things.
A soul that labours and lives, an emotion, a strenuous breath,
From the flame that its own mouth gives illumed and refreshed with death.
In the sea whereof centuries are waves the live God plunges and swims;
His bed is in all men's graves, but the worm hath not hold on his limbs.
Night puts out not his eyes, nor time sheds change on his head;

With such fires as the stars of the skies are the roots of his heart are fed.
Men are the thoughts passing throught it, the veins that fulfil it with blood,
With spirit of sense to renew it as springs fulfilling a flood.
Men are the heartbeats of man, the plumes that feather his wings,
Storm-worn, since being began, with the wind and thunder of things.

Is no heat of him left in the ashes of thousands burnt up for his sake?
Can prayer not rekindle the flashes that shone in his face from the stake?
Cry aloud; for your God is a God and a Saviour; cry, make yourselves lean:
Is he drunk or asleep, that the rod of his wrath is unfelt and unseen?
Is the fire of his old loving-kindness gone out, that his pyres are acold?
Hath he gazed on himself unto blindness, who made men blind to behold?
Cry out, for his kingdom is shaken; cry out, for the people blaspheme;
Cry aloud till his godhead awaken; what doth he to sleep and to dream?
Cry, cut yourslves, gash you with knives and with scourges, heap on to you dust;
Is his life but as other gods' lives? is not this the Lord God of your trust?
Is not this the great God of your sires, that with souls and bodies was fed,
And the world was on flame with his fires? O fools, he was God, and is dead.
He will hear not again the strong crying of earth in his ears as before,
The fume of his multitudes dying shall flatter his nostrils no more.
By the spirit he rules as his slave is he slain who was mighty to slay,
And the stone that is sealed on his grave he shall rise not and roll not away.
Yea, weep to him, lift up your hands; be your eyes as a fountain of tears;
Where he stood there is nothing that stands; if he call, there is no man that hears.
He hath doffed his king's raiment of lies now the wane of his kingdom is come;
Ears hath he, and hears not; and eyes, and he sees not; and mouth, and is dumb.
His red king's raiment is ripped from him naked, his staff broken down:
And the signs of his empire are stripped from him shuddering; and where is his crown?
And in vain by the wellsprings refrozen ye cry for the warmth of his sun—
O God, the Lord God of thy chosen, thy will in thy kingdom be done.
Kingdom and will hath he none in him left him, nor warmth in his breath;
Till his corpse be cast out of the sun will ye know not the truth of his death?
Surely, ye say, he is strong, though the times be against him and men;
Yet a little, ye say, and how long, till he come to show judgement again?
Shall God then die as the beasts die? who is it hath broken his rod?
O God, Lord God of thy priests, rise up now and show thyself God.
They cry out, thine elect, thine aspirants, to heavenward, whose faith is as flame;
O thou the Lord God of our tyrants, they call thee, their God, by thy name.
By thy name that in hell-fire was written, and burned at the point of thy sword.
Thou art smitten, thou God, thou art smitten; thy death is upon thee, O Lord,
And the love-song of earth as thou diest resounds through the wind of her wings—
Glory to Man in the highest! for Man is the master of things.

### Eurydice
To Victor Hugo

Orpheus, the night is full of tears and cries,
   And hardly for the storm and ruin shed
   Can even thine eyes be certain of her head
Who never passed out of thy spirit's eyes,
But stood and shone before them in such wise
   As when with love her lips and hands were fed,
   And with mute mouth out of the dusty dead
Strove to make answer when thou bad'st her rise.

Yet viper-stricken must her lifeblood feel
   The fang that stung her sleeping, the foul germ
   Even when she wakes of hell's most poisonous worm,
Though now it writhe beneath her wounded heel.
   Turn yet, she will not fade nor fly from thee;
Wait, and see hell yield up Eurydice.

### From *Poems and Ballads*, Second Series (1878)
### A Forsaken Garden

In a coign of the cliff between lowland and highland,
    At the sea-down's edge between windward and lee,
Walled round with rocks as an inland island,
    The ghost of a garden fronts the sea.
A girdle of brushwood and thorn encloses
    The steep square slope of the blossomless bed
Where the weeds that grew green from the graves of roses
      Now lie dead.

The fields fall southward, abrupt and broken,
    To the low last edge of the long lone land.
If a step should sound or a word be spoken,
    Would a ghost not rise at the strange guest's hand?
So long have the grey bare walks lain guestless,
    Through branches and briers if a man make way,
He shall find no life but the sea-wind's, restless
      Night and day.

The dense hard passage is blind and stifled
    That crawls by a track none turn to climb
To the strait waste place that the years have rifled
    Of all but the thorns that are touched not of time.

The thorns he spares when the rose is taken;
    The rocks are left when he wastes the plain.
The wind that wanders, the weeds windshaken,
      These remain.

Not a flower to be pressed of the foot that falls not;
    As the heart of a dead man the seed-plots are dry;
From the thicket of thorns whence the nightingale calls not,
    Could she call, there were never a rose to reply.
Over the meadows that blossom and wither
    Rings but the note of a sea-bird's song;
Only the sun and the rain come hither
      All year long.

The sun burns sere and the rain dishevels
    One gaunt bleak blossom of scentless breath.
Only the wind here hovers and revels
     In a round where life seems barren as death.
Here there was laughing of old, there was weeping,
    Haply, of lovers none ever will know,
Whose eyes went seaward a hundred sleeping
      Years ago.

Heart handfast in heart as they stood, 'Look thither,'
    Did he whisper? 'look forth from the flowers to the sea;
For the foam-flowers endure when the rose-blossoms wither,
    And men that love lightly may die—but we?'
And the same wind sang and the same waves whitened,
    And or ever the garden's last petals were shed,
In the lips that had whispered, the eyes that had lightened,
      Love was dead.

Or they loved their life through, and then went whither?
    And were one to the end—but what end who knows?
Love deep as the sea as a rose must wither,
    As the rose-red seaweed that mocks the rose.
Shall the dead take thought for the dead to love them?
    What love was ever as deep as a grave?
They are loveless now as the grass above them
      Or the wave

All are at one now, roses and lovers,
    Not known of the cliffs and the fields and the sea.
Not a breath of the time that has been hovers
    In the air now soft with a summer to be.

Not a breath shall there sweeten the seasons hereafter
    Of the flowers or the lovers that laugh now or weep,
When as they that are free now of weeping and laughter
    We shall sleep.

Here death may deal not again for ever;
    Here change may come not till all change end.
From the graves they have made they shall rise up never,
    Who have left nought living to ravage and rend.
Earth, stones, and thorns of the wild ground growing,
    While the sun and the rain live, these shall be;
Till a last wind's breath upon all these blowing
    Roll the sea.

Till the slow sea rise and the sheer cliff crumble,
    Till terrace and meadow the deep gulfs drink,
Till the strength of the waves of the high tides humble
    The fields that lessen, the rocks that shrink,
Here now in his triumph where all things falter,
    Stretched out on the spoils that his own hand spread,
As a god self-slain on his own strange altar,
    Death lies dead.

## At a Month's End

The night last night was strange and shaken:
    More strange the change of you and me.
Once more, for the old love's love forsaken,
    We went out once more toward the sea.

For the old love's love-sake dead and buried,
    One last time, one more and no more,
We watched the waves set in, the serried
    Spears of the tide storming the shore.

Hardly we saw the high moon hanging,
    Heard hardly through the windy night
Far waters ringing, low reefs clanging,
    Under wan skies and waste white light.

With chafe and change of surges chiming,
    The clashing channels rocked and rang
Large music, wave to wild wave timing,
    And all the choral water sang.

Faint lights fell this way, that way floated,
    Quick sparks of sea-fire keen like eyes
From the rolled surf that flashed, and noted
    Shores and faint cliffs and bays and skies.

The ghost of sea that shrank up sighing
    At the sand's edge, a short sad breath
Trembling to touch the goal, and dying
    With weak heart heaved up once in death—

The rustling sand and shingle shaken
    With light sweet touches and small sound—
These could not move us, could not waken
    Hearts to look forth, eyes to look round.

Silent we went an hour together,
    Under grey skies by waters white.
Our hearts were full of windy weather,
    Clouds and blown stars and broken light.

Full of cold clouds and moonbeams drifted
    And streaming storm and straying fires,
Our souls in us were stirred and shifted
    By doubts and dreams and foiled desires.

Across, aslant, a scudding sea-mew
    Swam, dipped, and dropped, and grazed the sea:
And one with me I could not dream you;
    And one with you I could not be.

As the white wing the white wave's fringes
    Touched and slid over and flashed past—
As a pale cloud a pale flame tinges
    From the moon's lowest light and last—

As a star feels the sun and falters,
    Touched to death by diviner eyes—
As on the old gods' untended altars
    The old fire of withered worship dies—

(Once only, once the shrine relighted
    Sees the last fiery shadow shine,
Last shadow of flame and faith benighted,
    Sees falter and flutter and fail the shrine)

So once with fiery breath and flying
    Your winged heart touched mine and went,
And the swift spirits kissed, and sighing,
    Sundered and smiled and were content.

That only touch, that feeling only,
    Enough we found, we found too much;
For the unlit shrine is hardly lonely
    As one the old fire forgets to touch.

Slight as the sea's sight of the sea-mew,
    Slight as the sun's sight of the star:
Enough to show one must not deem you
    For love's sake other than you are.

Who snares and tames with fear and danger
    A bright beat of a fiery kin,
Only to mar, only to changer her
    Sleek supple soul and splendid skin?

Easy with blows to mar and maim her,
    Easy with bonds to bind and bruise;
What profit, if she yield her tamer
    The limbs to mar, the soul to lose?

Best leave or take the perfect creature,
    Take all she is or leave complete;
Transmute you will not form or feature,
    Change feet for wings or wings for feet.

Strange eyes, new limbs, can no man give her;
    Sweet is the sweet thing as it is.
No soul she hath, we see, to outlive her;
    Hath she for that no lips to kiss?

So may one read his weird, and reason,
    And with vain drugs assuage no pain.
For each man in his loving season
    Fools and is fooled of these in vain.

Charms that allay not any longing,
    Spells that appease not any grief,
Time brings us all by handfuls, wronging
    All hurts with nothing of relief.

Ah, too soon shot, the fool's bolt misses!
    What help? the world is full of loves;
Night after night of running kisses,
    Chirp after chirp of chanting doves.

Should Love disown or disesteem you
    For loving one man more or less?
You can not tame your light white sea-mew,
    Nor I may sleek black pantheress.

For a new soul let whoso please pray,
    We are what life made us, and shall be.
For you the jungle and me the sea-spray,
    And south for you and north for me.

But this one broken foam-white feather
    I throw you off the hither wing,
Splashed stiff with sea-scurf and salt weather,
    This song for sleep to learn and sing—

Sing in your ear when, daytime over,
  You, couched at long length on hot sand
With some sleek sun-discoloured lover,
  Wince from his breath as from a brand:

Till the acrid hour aches out and ceases,
  And the sheathed eyeball sleepier swims,
The deep flank smooths its dimpling creases,
  And passion loosens all the limbs:

Till dreams of sharp gray north-sea weather
  Fall faint upon your fiery sleep,
As on strange sands a strayed bird's feather
  The wind may choose to lose or keep.

But I, who leave my queen of panthers,
  As a tired honey-heavy bee
Gilt with sweet dust from gold-grained anthers
  Leaves the rose-chalice, what for me?

From the ardors of the chaliced centre,
  From the amorous anthers' golden grime,
That scorch and smutch all wings that enter,
  I fly forth hot from honey-time.

But as to a bee's gilt thighs and winglets
  The flower-dust with the flower-smell clings;
As a snake's mobile rampant ringlets
  Leve the sand marked with print of rings;

So to my soul in surer fashion
  Your savage stamp and savour hangs;
The print and perfume of old passion,
  The wild-beast mark of panther's fangs.

## A Wasted Vigil

### 1

Couldst thou not watch with me one hour?
  Behold,
Dawn skims the sea with flying feet of gold,
With sudden feet that graze the gradual sea;
    Couldst thou not watch with me?

### 2

What, not one hour? for star by star the night
Falls, and here thousands world by world take flight;
They die, and day survives, and what of thee?
    Couldst thou not watch with me?

### 3

Lo, far in heaven the web of night undone,
And on the sudden sea the gradual sun;
Wave to wave answers, tree responds to tree;
    Couldst thou not watch with me?

### 4

Sunbeam by sunbeam creeps from line to line,
Foam by foam quickens on the brightening brine;
Sail by sail passes, flower by flower gets free;
    Couldst thou not watch with me?

### 5

Last year, a brief while since, an age ago,
A whole year past, with bud and bloom and snow,
O moon that wast in heaven, what friends were we!
    Couldst thou not watch with me?

### 6

Old moons, and last year's flowers, and last year's snow
Who now saith to thee, moon? or who saith, rose?
O dust and ashes, once found fair to see!
    Couldst thou not watch with me?

### 7

O dust and ashes, once thought sweet to smell!
With me it is not, is it with thee well?
O sea-drift blown from windward back to lee!
    Couldst thou not watch with me?

### 8

The old year's dead hands are full of their dead flowers,
The old days are full of dead old loves of ours,
Born as a rose, and briefer born than she;
    Couldst thou not watch with me?

### 9

Could two days live again of that dead year,
One would say, seeking us and passing here,
*Where is she?* and one answering, *Where is he?*
　　　Couldst thou not watch with me?

### 10

Nay, those two lovers are not anywhere;
If we were they, none knows us what we were,
Nor aught of all their barren grief and glee.
　　　Couldst thou not watch with me?

### 11

Half false, half fair, all feeble, be my verse
Upon thee not for blessing nor for curse
For some must stand, and some must fall or flee;
　　　Couldst thou not watch with me?

### 12

As a new moon above spent stars thou wast;
But stars endure after the moon is past.
Couldst thou not watch one hour, though I watch three?
　　　Couldst thou not watch with me?

### 13

What of the night? The night is full, the tide
Storms inland, the most ancient rocks divide;
Yet some endure, and bow nor head nor knee;
　　　Couldst thou not watch with me?

### 14

Since thou art not as these are, go thy ways,
Thou hast no part in all my nights and days.
Lie still, sleep on, be glad—as such things be;
　　　Thou couldst not watch with me.

## REACTIONS

### Robert Buchanan

#### 'The Fleshly School of Poetry: Mr. D.G. Rossetti' in *The Contemporary Review* (October 1871)

If, on the occasion of any public performance of Shakespere's great tragedy, the actors who perform the parts of Rosencranz and Guildenstern were, by a preconcerted arrangement and by means of what is technically known as 'gagging', to make themselves fully as prominent as the leading character, and to indulge in soliloquies and business strictly belonging to Hamlet himself, the result would be, to say the least of it, astonishing; yet a very similar effect is produced on the unprejudiced mind when the 'walking gentlemen' of the fleshly school of poetry, who bear precisely the same relation to Mr. Tennyson as Rosencranz and Guildenstern do to the Prince of Denmark in the play, obtrude their lesser identities and parade their smaller idiosyncrasies in the front rank of leading performers. In their own place, the gentlemen are interesting and useful. Pursuing still the theatrical analogy, the present drama of poetry might be cast as follows: Mr. Tennyson supporting the part of Hamlet, Mr. Matthew Arnold that of Horatio, Mr. Bailey that of Voltimand, Mr. Buchanan that of Cornelius, Messrs. Swinburne and Morris, the parts of Rosencranz and Guildenstern, Mr. Rossetti that of Osric, and Mr. Robert Lytton that of 'A Gentleman'. It will be seen that we have left no place for Mr. Browning, who may be said, however, to play the leading character in his own peculiar fashion on alternate nights.

This may seem a frivolous and inadequate way of opening our remarks on a school of verse writers which some people regard as possessing great merits; but in good truth, it is scarcely possible to discuss with any seriousness the pretensions with which foolish friends and small critics have surrounded the fleshly school, which, in spite of its spasmodic ramifications in the erotic direction, is merely one of the many sub-Tennysonian schools expanded to supernatural dimensions, and endeavouring by affectations all its own to overshadow its connection with the great original. In the sweep of one single poem, the weird and doubtful 'Vivien', Mr. Tennyson has concentrated all the epicene force which,

wearisomely expanded, constitutes the characteristic of the writers at present under consideration; and if in 'Vivien' he has indicated for them the bounds of sensualism in art, he has in 'Maud', in the dramatic person of the hero, afforded distinct precedent for the hysteric tone and overloaded style which is now so familiar to readers of Mr. Swinburne. The fleshliness of 'Vivien' may indeed be described as the distinct quality held in common by all the members of the last sub-Tennysonian school, and it is a quality which becomes unwholesome when there is no moral or intellectual quality to temper and control it. Fully conscious of this themselves, the fleshly gentlemen have bound themselves by solemn league and covenant to extol fleshliness as the distinct and supreme end of poetic and pictorial art; to aver that poetic expression is greater than poetic thought, and by inference that the body is greater than the soul, and sound superior to sense; and that the poet, properly to develop his poetic faculty, must be an intellectual hermaphrodite, to whom the very facts of day and night are lost in a whirl of æsthetic terminology. After Mr. Tennyson has probed the depths of modern speculation in a series of commanding moods, all right and interesting in him as the reigning personage, the walking gentlemen, knowing that something of the sort is expected from all leading performers, bare their roseate bosoms and aver that they are creedless; the only possible question here being, if any disinterested person cares twopence whether Rosencranz, Guildenstern, and Osric are creedless or not—their self-revelation on that score being so perfectly gratuitous. But having gone so far, it was and is too late to retreat. Rosencranz, Guildenstern, and Osric, finding it impossible to risk an individual bid for the leading business, have arranged all to play leading business together, and mutually to praise, extol, and imitate each other; and although by these measures they have fairly earned for themselves the title of the Mutual Admiration School, they have in a great measure succeeded in their object—to the general stupefaction of a British audience. It is time,

therefore, to ascertain whether any of these gentlemen has actually in himself the making of a leading performer. When the *Athenæum*—once more cautious in such matters—advertised nearly every week some interesting particular about Mr. Swinburne's health, Mr. Morris's holiday-making, or Mr. Rossetti's genealogy, varied with such startling statements as 'We are informed that Mr. Swinburne dashed off his noble ode *at a sitting*', or 'Mr. Swinburne's songs have already reached a second edition', or 'Good poetry seems to be in demand; the first edition of Mr, O'Shaughnessy's poems is exhausted'; when the *Academy* informed us that 'During the past year or two Mr. Swinburne has written several novels' (!) and that some review or other is to be praised for giving Mr. Rossetti's poems 'the attentive study which they demand'—when we read these things we might or might not know pretty well how and where they originated; but to a provincial eye, perhaps, the whole thing really looked like leading business. It would be scarcely worth while, however, to inquire into the pretensions of the writers on merely literary grounds, because sooner or later all literature finds its own level, whatever criticism may say or do in the matter; but it unfortunately happens in the present case that the fleshly school of verse-writers are, so to speak, public offenders, because they are diligently spreading the seeds of disease broadcast wherever they are read and understood. Their complaint too is catching, and carries off many young persons. What the complaint is, and how it works, may be seen on a very slight examination of the works of Mr. Dante Gabriel Rossetti, to whom we shall confine our attention in the present article.

Mr. Rossetti has been known for many years as a painter of exceptional powers, who, for reasons best known to himself, has shrunk from publicly exhibiting his pictures, and from allowing anything like a popular estimate to be formed of their qualities. He belongs, or is said to belong, to the so-called Pre-Raphælite school, a school which is generally considered to exhibit much genius for colour, and great indifference to

perspective. It would be unfair to judge the painter by the glimpses we have had of his works, or by the photographs which are sold of the principal paintings. Judged by the photographs, he is an artist who conceives unpleasantly, and draws ill. Like Mr. Simeon Solomon, however, with whom he seems to have many points in common, he is distinctively a colourist, and of his capabilities in colour we cannot speak, though we should guess that they are great; for if there is any good quality by which his poems are specially marked, it is a great sensitiveness to hues and tints as conveyed in poetic epithet. These qualities, which impress the casual spectator of the photographs from his pictures, are to be found abundantly among his verses. There is the same thinness and transparency of design, the same combination of the simple and the grotesque, the same morbid deviation from healthy forms of life, the same sense of weary, wasting, yet exquisite sensuality; nothing, virile, nothing tender, nothing completely sane; a superfluity of extreme sensibility, of delight in beautiful forms, hues, and tints, and a deep-seated indifference to all agitating forces and agencies, all tumultuous griefs and sorrows, all the thunderous stress of life, and all the straining storm of speculation. Mr. Morris is often pure, fresh, and wholesome as his own great model; Mr. Swinburne startles us more than once by some fine flash of insight; but the mind of Mr. Rossetti is like a glassy mere, broken only by the dive of some water-bird or by the hum of winged insects, and brooded, over by an atmosphere of insufferable closeness, with a light blue sky above it, sultry depths mirrored within it, and a surface so thickly sown with water-lilies that it retains its glassy smoothness even in the strongest wind. Judged relatively to his poetic associates, Mr. Rossetti must be pronounced inferior to either. He cannot tell a pleasant story like Mr. Morris, nor forge alliterative thunderbolts like Mr. Swinburne. It must be conceded, nevertheless, that he is neither so glibly imitative as the one, nor so transcendently superficial as the other.

Although he has been known for many years as a poet as well as a painter—as a painter and poet idolized by his own family and personal associates—and although he has once or twice appeared in print as a contributor to magazines, Mr. Rossetti did not formally appeal to the public until rather more than a year ago, when he published a copious volume of poems, with the announcement that the book, although it contained pieces composed at intervals during a period of many years, 'included nothing which the author believes to be immature.' This work was inscribed to his brother, Mr. William Rossetti, who, having written much both in poetry and criticism, will perhaps be known to bibliographers as the editor of the worst edition of Shelley which has yet seen the light. No sooner had the work appeared than the chorus of eulogy began. 'The book is satisfactory from end to end', wrote Mr. Morris in the Academy; 'I think these lyrics, with all their other merits, the most complete of their time; nor do I know what lyrics of any time are to be called great, if we are to deny the title to these.' On the same subject Mr. Swinburne went into a hysteria of admiration: 'golden affluence', 'jewel-coloured words', 'chastity of form', 'harmonious nakedness', 'consummate fleshly sculpture', and so on in Mr. Swinburne's well-known manner when reviewing his friends. Other critics, with a singular similarity of phrase followed suit. Strange to say, moreover, no one accused Mr. Rossetti of naughtiness. What had been heinous in Mr. Swinburne was majestic exquisiteness in Mr. Rossetti. Yet we question if there is anything in the unfortunate 'Poems and Ballads' quite so questionable on the score of thorough nastiness as many pieces in Mr. Rossetti's collection. Mr. Swinburne was wilder, more outrageous, more blasphemous, and his subjects were more atrocious in themselves; yet the hysterical tone slew the animalism, the furiousness of epithet lowered the sensation; and the first feeling of disgust at such themes as 'Laus Veneris' and 'Anactoria' faded away into comic amazement. It was only a little mad boy letting off squibs; not a great strong man, who might be really dangerous

*[handwritten annotations: 4-17-00 ; ow o ; 4-17-00 ; Buchanan Slamming Rossetti]*

*He's slamming Rossetti.*

to society. 'I *will* be naughty!' screamed the little boy; but, after all, what did it matter? It is quite different, however, when a grown man, with the self-control and easy audacity of actual experience, comes forward to chronicle his amorous sensations, and, first proclaiming in a loud voice his literary maturity, and consequent responsibility, shamelessly prints and publishes such a piece of writing as this sonnet on 'Nuptial Sleep':

At length their long kiss severed, with sweet smart:
    And as the last slow sudden drops are shed
    From sparkling eaves when all the storm has fled,
So singly flagged the pulses of each heart.
Their bosoms sundered, with the opening start
    Of married flowers to either side outspread
    From the knit stem; yet still their mouths, burnt red,
Fawned on each other where they lay apart.

Sleep sank them lower than the tide of dreams,
    And their dreams watched them sink, and slid away.
Slowly their souls swam up again, through gleams
    Of watered light and dull drowned waifs of day;
Till from some wonder of new woods and streams
    He woke, and wondered more: for there she lay.

*4-17-00*

*voice of Victorian conventions*

This, then, is 'the golden affluence of words, the firm outline, the justice and chastity of form'. Here is a full-grown man, presumably intelligent and cultivated, putting on record for other full-grown men to read, the most secret mysteries of sexual connection, and that with so sickening a desire to reproduce the sexual mood, so careful a choice of epithet to convey mere animal sensations, that we merely shudder at the shameless nakedness. We are no purists in such matters. We hold the sensual part of our nature to be as holy as the spiritual or intellectual part, and we believe that such things must find their equivalent in all; but it is neither poetic, nor manly, nor even human, to obtrude such things as the themes of whole poems. It is simply nasty. Nasty as it is, we are very mistaken if many readers do not think it nice. English society of one kind purchases the *Day's Doings*. English society of another kind goes into ecstasy over Mr. Solomon's pictures—pretty

pieces of morality, such as 'Love dying by the breath of Lust'. There is not much to choose between the two objects of admiration, except that painters like Mr. Solomon lend actual genius to worthless subjects, and thereby produce veritable monsters—like the lovely devils that danced round Saint Anthony. Mr. Rossetti owes his so-called success to the same causes. In poems like 'Nuptial Sleep', the man who is too sensitive to exhibit his pictures, and so modest that it takes him years to make up his mind to publish his poems, parades his private sensations before a coarse public, and is gratified by their applause.

It must not be supposed that all Mr. Rossetti's poems are made up of trash like this. Some of them are as noteworthy for delicacy of touch as others are for shamelessness of exposition. They contain some exquisite pictures of nature, occasional passages of real meaning, much beautiful phraseology, lines of peculiar sweetness, and epithets chosen with true literary cunning. But the fleshly feeling is everywhere. Sometimes, as in 'The Stream's Secret', it is deliciously modulated, and adds greatly to our emotion of pleasure at perusing a finely-wrought poem; at other times, as in the 'Last Confession', it is fiercely held in check by the exigencies of a powerful situation and the strength of a dramatic speaker; but it is generally in the foreground, flushing the whole poem with unhealthy rose-colour, stifling the senses with overpowering sickliness, as of too much civet. Mr. Rossetti is never dramatic, never impersonal—always attitudinizing, posturing, and describing his own exquisite emotions. He is the 'Blessed Damozel', leaning over the 'gold bar of heaven', and seeing

    Time like a pulse shake fierce
  Thro' all the worlds;

he is 'heaven-born Helen, Sparta's queen' whose 'each twin breast is an apple sweet'; he is Lilith, the first wife of Adam; he is the rosy Virgin of the poem called 'Ave', and the Queen in the 'Staff and Scrip'; he is 'Sister Helen' melting her waxen man; he is all these, just as surely as he is Mr. Rossetti

soliloquizing over Jenny in her London lodging, or the very nuptial person writing erotic sonnets to his wife. In petticoats or pantaloons, in modern times or in the middle ages, he is just Mr. Rossetti, a fleshly person, with nothing particular to tell us or teach us, with extreme self-control, a strong sense of colour, and a careful choice of diction. Amid all his 'affluence of jewel-coloured words', he has not given us one rounded and noteworthy piece of art, though his verses are all art; not one poem which is memorable for its own sake, and quite separable from the displeasing identity of the composer. The nearest approach to a perfect whole is the 'Blessed Damozel', a peculiar poem, placed first in the book, perhaps by accident, perhaps because it is a key to the poems which follow. This poem appeared in a rough shape many years ago in the *Germ*, an unwholesome periodical started by the Pre-Raphælites, and suffered, after gasping through a few feeble numbers, to die the death of all such publications. In spite of its affected title, and of numberless affectations throughout the text, the 'Blessed Damozel' has great merits of its own, and a few lines of real genius. We have heard it described as the record of actual grief and love, or, in simple words, the apotheosis of one actually lost by the writer; but, without having any private knowledge of the circumstance of its composition, we feel that such an account of the poem is inadmissible. It does not contain one single note of sorrow. It is a 'composition', and a clever one. Read the opening stanzas:

> The blessed damozel leaned out
>     From the gold bar of Heaven;
> Her eyes were deeper than the depth
>     Of water stilled at even;
> She had three lilies in her hand,
>     And the stars in her hair were seven.
>
> Her robe, ungirt from clasp to hem,
>     No wrought flowers did adorn,
> But a white rose of Mary's gift,
>     For service meetly worn;
> Her hair that lay along her back
>     Was yellow like ripe corn.

This is a careful sketch for a picture, which, worked into actual colour by a master, might have been worth seeing. The steadiness of hand lessens as the poem proceeds, and although there are several passages of considerable power, —such as that where, far down the void,

>             this earth
> Spins like a fretful midge,

or that other, describing how

>             the curled moon
> Was like a little feather
> Fluttering far down the gulf,—

the general effect is that of a queer old painting in a missal, very affected and very odd. What moved the British critic to ecstasy in this poem seems to us very sad nonsense indeed, or, if not sad nonsense, very meretricious affectation. Thus, we have seen the following verses quoted with enthusiasm, as italicized—

> And still she bowed herself and stooped
>     Out of the circling charm;
> *Until her bosom must have made*
>     *The bar she leaned on warm,*
> And the lilies lay as if asleep
>     Along her bended arm.
>
> From the fixed place of Heaven she saw
>     *Time like a pulse shake fierce*
> *Thro' all the worlds.* Her gaze still strove
>     Within the gulf to pierce
> Its path; and now she spoke as when
>     The stars sang in their spheres.

It seems to us that all these lines are very bad, with the exception of the two admirable lines ending the first verse, and that the italicized portions are quite without merit, and almost without meaning. On the whole, one feels disheartened and amazed at the poet who, in the nineteenth century, talks about 'damozels', 'citherns', and 'citoles', and addresses the mother of Christ as the 'Lady Mary',—

With her five handmaidens, whose names
    Are five sweet symphonies,
Cecily, Gertrude, Magdalen,
    Margaret and Rosalys.

A suspicion is awakened that the writer is laughing at us. We hover uncertainly between picturesqueness and namby-pamby, and the effect, as Artemus Ward would express it, is 'weakening to the intellect'. The thing would have been almost too much in the shape of a picture, though the workmanship might have made amends. The truth is that literature, and more particularly poetry, is in a very bad way when one art gets hold of another, and imposes upon it its conditions and limitations. In the first few verses of the 'Damozel' we have the subject, or part of the subject, of a picture, and the inventor should either have painted it or left it alone altogether; and had he done the latter, the world would have lost nothing. Poetry is something more than painting; and an idea will not become a poem because it is too smudgy for a picture.

In a short notice from a well-known pen, giving the best estimate we have seen of Mr. Rossetti's powers as a poet, the *North American Review* offers a certain explanation for affectation such as that of Mr. Rossetti. The writer suggests that 'it may probably be the expression of genuine moods of mind in natures too little comprehensive'. We would rather believe that Mr. Rossetti lacks comprehension than that he is deficient in sincerity; yet really, to paraphrase the words which Johnson applied to Thomas Sheridan, Mr. Rossetti is affected, naturally affected, but it must have taken him a great deal of trouble to become what we now see him—such an excess of affectation is not in nature. [*Buchanan's Note*: 'Why, sir, Sherry is dull, naturally dull; but it must have taken him *a great deal of trouble* to become what we now see him—such an excess of stupidity is not in nature'—Boswell's *Life of Dr Johnson*.] There is very little writing in the volume spontaneous in the sense that some of Swinburne's verses are spontaneous; the poems all look as if they had taken a great deal of trouble.

The grotesque mediævalism of 'Stratton Water' and 'Sister Helen', the mediæval classicism of 'Troy Town', the false and shallow mysticism of 'Eden Bower' are one and all essentially imitative and must have cost the writer much pains. It is time, indeed, to point out that Mr. Rossetti is a poet possessing great powers of assimilation and some faculty for concealing the nutriment on which he feeds. Setting aside the 'Vita Nuova' and the early Italian poems, which are familiar to many readers by his own excellent translation, Mr. Rossetti may be described as a writer who has yielded to an unusual extent to the complex influences of the literature surrounding him at the present moment. He has the painter's imitative power developed in proportion to his lack of the poet's conceiving imagination. He reproduces to a nicety the manner of an old ballad, a trick in which Mr. Swinburne is also an adept. Cultivated readers, moreover, will recognize in every one of these poems the tone of Mr. Tennyson broken up by the style of Mr. and Mrs. Browning, and disguised here and there by the eccentricities of the Pre-Raphælites. The 'Burden of Nineveh' is a philosophical edition of 'Recollections of the Arabian Nights'; 'A Last Confession' and 'Dante at Verona' are, in the minutest trick and form of thought, suggestive of Mr. Browning; and that the sonnets have been largely moulded and inspired by Mrs. Browning can be ascertained by any critic who will compare them with the 'Sonnets from the Portuguese'. Much remains, nevertheless, that is Mr. Rossetti's own. We at once recognize as his own property such passages as this:

> I looked up
> And saw where a brown-shouldered harlot leaned
> Half through a tavern window thick with vine.
> Some man had come behind her in the room
> And caught her by her arms, and she had turned
> With that coarse empty laugh on him, as now
> He munched her neck with kisses, while the vine
> Crawled in her back.

Or this:

> As I stopped, her own lips rising there
> Bubbled with brimming kisses at my mouth.

Or this:

> Have you seen your lifted silken skirt
> Advertise dainties through the dirt!

Or this:

> 'What more prize than love to impel thee,
> Grip and lip my limbs as I tell thee!'

*4-17-00*

Passages like these are the common stock of the walking gentlemen of the fleshly school. We cannot forbear expressing our wonder, by the way, at the kind of women whom it seems the unhappy lot of these gentlemen to encounter. We have lived as long in the world as they have, but never yet came across persons of the other sex who conduct themselves in the manner described. Females who bite, scratch, scream, bubble, munch, sweat, writhe, twist, wriggle, foam, and in a general way slaver over their lovers, must surely possess some extraordinary qualities to counteract their otherwise most offensive mode of conducting themselves. It appears, however, on examination, that their poet-lovers conduct themselves in a similar manner. They, too, bite, scratch, scream, bubble, munch, sweat, writhe, twist, wriggle, foam, and slaver, in a style frightful to hear of. Let us hope that it is only their fun, and that they don't mean half they say. At times, in reading such books as this, one cannot help wishing, that things had remained forever in the asexual state described in Mr. Darwin's great chapter on Palingenesis. We get very weary of this protracted hankering after a person of the other sex; it seems meat, drink, thought, sinew, religion for the fleshly school. There is no limit to the fleshliness, and Mr. Rossetti finds in it its own religious justification much in the same way as Holy Willie:

*Buchanan's "it's all the saliva + sweating that grosses me out"*

> Maybe thou let'st this fleshly thorn
> Perplex thy servant night and morn.

*Buchanan is mean-spirited + hardly an objective critic but he does have a point.*

> 'Cause he's so gifted.
> If so, thy hand must e'en be borne,
> Until thou lift it.

Whether he is writing of the holy Damozel, or of the Virgin herself, or of Lilith, or of Helen, or of Dante, or of Jenny the streetwalker, he is fleshly all over, from the roots of his hair to the tip of his toes; never a true lover merging his identity into that of the beloved one; never spiritual, never tender; always self-conscious and æsthetic. 'Nothing', says a modern writer, 'in human life is so utterly remorseless—as the artistic or æsthetic instinct morbidly developed to the suppression of conscience and feeling'; and at no time do we feel more fully impressed with this truth than after the persual of 'Jenny', in some respects the finest poem in the volume, and in all respects the poem best indicative of the true quality of the writer's humanity. It is a production which bears signs of having been suggested by Mr. Buchanan's quasi-lyrical poems, which it copies in the style of title, and particularly by 'Artist and Model'; but certainly Mr. Rossetti cannot be accused, as the Scottish writer has been accused, of maudlin sentiment and affected tenderness. The first two lines are perfect:

> Lazy, laughing languid Jenny,
> Fond of a kiss and fond of a guinea;

And the poem is a soliloquy of the poet—who has been spending the evening in dancing at a casino—over his partner, whom he has accompanied home to the usual style of lodgings occupied by such ladies, and who has fallen asleep with her head upon his knee, while he wonders, in a wretched pun—

> Whose person or whose purse may be
> The lodestar of your reverie?

The soliloquy is long, and in some parts beautiful, despite a very constant suspicion that we are listening to an emasculated Mr. Browning, whose whole tone and gesture, so to speak, is

243

occasionally introduced with startling fidelity; and there are here and there glimpses of actual thought and insight, over and above the picturesque touches which belong to the writer's true profession, such as that where, at daybreak—

> lights creep in
> Past the gauze curtains half drawn-to,
> And the lamp's doubled shade grows blue.

What we object to in this poem is not the subject, which any writer may be fairly left to choose for himself; nor anything particularly vicious in the poetic treatment of it; nor any bad blood bursting through in special passages. But the whole tone, without being more than usually coarse, seems heartless. There is not a drop of piteousness in Mr. Rossetti. He is just to the outcast, even generous; severe to the seducer; sad even at the spectacle of lust in dimity and fine ribbons. Notwithstanding all this, and a certain delicacy and refinement of treatment unusual with this poet, the poem repels and revolts us, and we like Mr. Rossetti least after its perusal. We are angry with the fleshly person at last. The 'Blessed Damozel' puzzled us, the 'Song of the Bower' amused us, the love-sonnet depressed and sickened us, but 'Jenny', though distinguished by less special viciousness of thought and style than any of these, fairly makes us lose patience. We detect its fleshliness at a glance; we perceive that the scene was fascinating less through its human tenderness than because it, like all the others, possessed an inherent quality of animalism. 'The whole work', ('Jenny'), writes Mr. Swinburne, 'is worthy to fill its place forever as one of the most perfect poems of an age or generation. There is just the same lifeblood and breadth of poetic interest in this episode of a London street and lodging as in the song of "Troy Town" and the song of "Eden Bower"; just as much, and no jot more',—to which last statement we cordially assent; for there is bad blood in all, and breadth of poetic interest in none. 'Vengeance of Jenny's case', indeed!—when such a poet as this comes fawning over her, with tender compassion in one

eye and æsthetic enjoyment in the other! It is time that we permitted Mr. Rossetti to speak for himself, which we will do by quoting a fairly representative poem entire:

### Love-Lily

Between the hands, between the brows,
    Between the lips of Love-Lily,
*A spirit is born whose birth endows*
    *My blood with fire to burn through me*;
Who breathes upon my gazing eyes,
    Who laughs and murmurs in mine ear,
At whose least touch my colour flies,
    And whom my life grows faint to hear.

Within the voice, within the heart,
    Within the mind of Love-Lily,
A spirit is born who lifts apart
    His tremulous wings and looks at me;
Who on my mouth his finger lays,
    And shows, while whispering lutes confer,
That Eden of Love's watered ways,
    Whose winds and spirits worship her.

Brows, hands, and lips, heart, mind, and voice,
    Kisses and words of Love-Lily,—
Oh! bid me with your joy rejoice
    Till *riotous longing rest in me!*
Ah! let not hope be still distraught,
    But find in her its gracious goal,
Whose speech Truth knows not from her thought,
    Nor Love her body from her soul.

With the exception of the usual 'riotous longing', which seems to make Mr. Rossetti a burthen to himself, there is nothing to find fault with in the extreme fleshliness of these verses, and to many people who live in the country they may even appear beautiful. Without pausing to criticize a thing so trifling—as well might we dissect a cobweb or anatomize a medusa—let us ask the reader's attention to a peculiarity to which all the students of the fleshly school must sooner or later give their attention—we mean the habit of accenting the last syllable in words which in ordinary speech are accented on the penultimate:

Between the hands, between the brows,
Between the lips of Love-Lil*ee*!

which may be said to give to the speaker's voice a
sort of cooing tenderness just bordering on a
loving whistle. Still better as an illustration are the
lines:

Saturday night is market night
Everywhere, be it dry or wet,
And market night in the Haymar-*ket*!

which the reader may advantageously compare
with Mr. Morris's

Then said the king
Thanked be thou; *neither for nothing*
Shalt thou this good deed do to me;

or Mr. Swinburne's

In either of the twain
Red roses full of rain;
She hath for bondwomen
All kinds of flowers.

It is unnecessary to multiply examples of an
affectation which disfigures all these writers—
Guildenstern, Rosencranz, and Osric; who, in the
same spirit which prompts the ambitious
nobodies that rent London theatres in the 'empty'
season to make up for their dulness by fearfully
original 'new readings', distinguish their attempt
at leading business by affecting the construction of
their grandfathers and great-grandfathers, and the
accentuation of the poets of the court of James I. It
is in all respects a sign of remarkable genius, from
this point of view, to rhyme 'was' with 'grass',
'death' with 'lieth', 'love' with 'of', 'once' with
'suns', and so on *ad nauseam*. We are far from
disputing the value of bad rhymes used
occasionally to break up the monotony of verse,
but the case is hard when such blunders become
the rule and not the exception, when writers
deliberately lay themselves out to be as archaic
and affected as possible. Poetry is perfect human
speech, and these archaisms are the mere

fiddlededeeing of empty heads and hollow heart.
Bad as they are, they are the true indication of
false tricks and affectations which lie far deeper.
They are trifles, light as air, showing how the wind
blows. The soul's speech and the heart's speech
are clear, simple, natural, and beautiful, and reject
the meretricious tricks to which we have drawn
attention.

It is on the score that these tricks and
affectations have procured the professors a
number of imitators, that the fleshly school deliver
their formula that great poets are always to be
known because their manner is immediately
reproduced by small poets, and that a poet who
finds few imitators is probably of inferior rank—by
which they mean to infer that they themselves are
very great poets indeed. It is quite true that they
are imitated. On the stage, twenty provincial 'stars'
copy Charles Kean, while not one copies his
father; there are dozens of actors who reproduce
Mr. Charles Dillon, and not one who attempts to
reproduce Macready. When we take up the poems
of Mr. O'Shaughnessy, we are face to face with a
second-hand Mr. Swinburne; when we read Mr.
Payne's queer allegories, we remember Mr.
Morris's early stage; and every poem of Mr.
Marston's reminds us of Mr. Rossetti. But what is
really most droll and puzzling in the matter is that
these imitators seem to have no difficulty whatever
in writing nearly, if not quite, as well as their
masters. It is not bad imitations they offer us, but
poems which read just like the originals; the fact
being that it is easy to reproduce sound when it
has no strict connection with sense, and simple
enough to cull phraseology not hopelessly
interwoven with thought and spirit. The fact that
these gentlemen are so easily imitated is the most
damning proof of their inferiority. What merits
they have lie with their faults on the surface, and
can be caught by any young gentleman as easily as
the measles, only they are rather more difficult to
get rid of. All young gentlemen have animal
faculties, though few have brains; and if animal
faculties without brains make poems, nothing is
easier in the world. A great and good poet,

however, is great and good irrespective of manner, and often in spite of manner; he is great because he brings great ideas and new light, because his thought is a revelation; and, although it is true that a great manner generally accompanies great matter, the manner of great matter is almost inimitable. The great poet is not Cowley, imitated and idolized and reproduced by every scribbler of this time; nor Pope, whose trick of style was so easily copied that to this day we cannot trace his own hand with any certainty in the *Illiad*; nor Donne, nor Sylvester, nor the Della Cruscans. Shakespere's blank verse is the most difficult, and Jonson's the most easy to imitate, of all the Elizabethan stock; and Shakespere's verse is the best verse, because it combines the great qualities of all contemporary verse, with no individual affectations; and so perfectly does this verse, with all its splendour, intersect with the style of contemporaries *at their best*, that we would undertake to select passage after passage which would puzzle a good judge to tell which of the Elizabethans was the author—Marlowe, Beaumont, Dekker, Marston, Webster, or Shakespere himself. The great poet is Dante, full of the thunder of a great Idea; and Milton, unapproachable in the serene white light of thought and sumptuous wealth of style; and Shakespere, all poets by turns, and all men in succession; and Goethe, always innovating, and ever indifferent to innovation for its own sake; and Wordsworth, clear as crystal and deep as the sea; and Tennyson, with his vivid range, far-piercing sight, and perfect speech; and Browning, great, not by virtue of his eccentricities, but because of his close intellectual grasp. Tell 'Paradise Lost', the 'Divine Comedy', in naked prose; do the same by *Hamlet*, *Macbeth*, and *Lear*; read Mr. Hayward's translation of 'Faust'; take up the 'Excursion', a great poem, though its speech is nearly prose already; turn the 'Guinevere' into a mere story; reproduce Pompilia's last dying speech without a line of rhythm. Reduced to bald English, all these poems, and all great poems lose much; but how much do they not retain? They

are poems to the very roots and depths of being, poems born and delivered from the soul, and treat them as cruelly as you may, poems they will remain. So it is with all good and thorough creations, however low in their rank; so it is with the 'Ballad in a Wedding' and 'Clever Tom Clinch', just as much as with the 'Epistle of Karsheesh', or Goethe's torso of 'Prometheus'; with Shelley's 'Skylark', or Alfred de Musset's 'A la Lune', as well as Racine's 'Athalie', Victor Hugo's 'Parricide', or Hood's 'Last Man.' A poem is a poem first as to the soul, next as to the form. The fleshly persons who wish to create form for its own sake are merely pronouncing their own doom. But such form! If the Pre-Raphælite fervour gains ground, we shall soon have popular songs like this;—

> When winds do roar, and rains do pour,
> Hard is the life of a sail*or*;
> He scarcely as he reels can tell
> The side-lights from the binna*cle*;
> He looketh on the wild wat*er*, etc.,

and so on, till the English speech seems the speech of raving madmen. Of a piece with other affectations is the device of a burthen, of which the fleshly persons are very fond for its own sake, quite apart from its relevancy. Thus Mr. Rossetti sings:

> Why did you melt your waxen man
> > Sister Helen?
> To-day is the third since you began.
> The time was long, yet the time ran,
> > Little brother.
> (*O mother, Mary mother,*
> *Three days to-day between Heaven and Hell.*)

This burthen is repeated, with little or no alteration, through thirty-four verses, and might with as much music, and far more point, run as follows:

> Why did you melt your Waxen man,
> > Sister Helen?
> Today is the third since you began.

The time was long, yet the time ran,
　　Little Brother.
　　(*O Mr. Dante Rossetti*
*What stuff is this about Heaven and Hell?*)

About as much to the point is a burthen of Mr. Swinburne's something to the following effect:

We were three maidens in the green corn
　　*Hey chickaleerie, the red cock and gray,*
Fairer maidens were never born,
　　*One o'clock, two o'clock, off and away.*

We are not quite certain of the words, as we quote from memory, but we are sure our version fairly represents the original and is quite as expressive. Productions of this sort are 'silly sooth' in good earnest, though they delight some newspaper critics of the day, and are copied by young gentlemen with animal faculties morbidly developed by too much tobacco and too little exercise. Such indulgence, however, would ruin the strongest poetical constitution; and it unfortunately happens that neither masters nor pupils were naturally very healthy. In such a poem as 'Eden Bower' there is not one scrap of imagination, properly so-called. It is a clever grotesque in the worst manner of Callot, unredeemed by a gleam of true poetry or humour. No good poet would have wrought into a poem the absurd tradition about Lilith; Goethe was content to glance at it merely, with a grim smile, in the great scene in the Brocken. We may remark here that poems of this unnatural and morbid kind are only tolerable when they embody a profound meaning, as do Coleridge's 'Ancient Mariner' and 'Cristabel.' Not that we would insult the memory of Coleridge by comparing his exquisitely conscientious work with this affected rubbish about 'Eden Bower' and 'Sister Helen', though his influence in their composition is unmistakable. Still more unmistakable is the influence of that most unwholesome poet, Beddoes, who, with all his great powers, treated his subjects in a thoroughly insincere manner, and is now justly forgotten.

The great strong current of English poetry rolls on, ever mirroring in its bosom new prospects of fair and wholesome thought. Morbid deviations are endless and inevitable; there must be marsh and stagnant mere as well as mountain and wood. Glancing backward into the shady places of the obscure, we see the once prosperous nonsense-writers each now consigned to his own little limbo—Skelton and Gower still playing fantastic tricks with the mother-tongue; Gascoigne outlasting the applause of all, and living to see his own works buried before him; Sylvester doomed to oblivion by his own fame as a translator; Carew the idol of courts, and Donne the beloved of schoolmen, both buried in the same oblivion; the fantastic Fletchers winning the wonder of collegians and fading out through sheer poetic impotence; Cowley shaking all England with his pindarics, and perishing with them; Waller, the famous, saved from oblivion by the natural note of one single song—and so on, through league after league of a flat and desolate country, which once was prosperous, till we come again to these fantastic figures of the fleshly school, with their droll mediæval garments, their funny archaic speech, and the fatal marks of literary consumption in every pale and delicate visage. Our judgment on Mr. Rossetti, to whom we in the meantime confine our judgment, is substantially that of the *North American Reviewer*, who believes that 'we have in him another poetical man, and a man markedly poetical, and of a kind apparently, though not radically, different from any of our secondary writers of poetry, but that we have not in him a new poet of any weight'; and that he is 'so affected, sentimental, and painfully self-conscious, that the best to be done in his case is to hope that this book of his, having unpacked his bosom of so much that is unhealthy, may have done him more good than it has given others pleasure'. Such, we say, is our opinion, which might very well be wrong, and have to undergo modification, if Mr. Rossetti was younger and less self-possessed. His 'maturity' is fatal.

Thomas Maitland.

# Dante Rossetti
## 'The Stealthy School of Criticism' in the *Athenæum* (December 1871)

Your paragraph, a fortnight ago, relating to the pseudonymous authorship of an article, violently assailing myself and other writers of poetry, in the *Contemporary Review* for October last, reveals a species of critical masquerade which I have expressed in the heading given to this letter. Since then, Mr. Sidney Colvin's note, qualifying the report that he intends to 'answer' that article, has appeared in your pages; and my own view as to the absolute forfeit, under such conditions, of all claim to honourable reply, is precisely the same as Mr. Colvin's. For here a critical organ, professedly adopting the principle of open signature, would seem, in reality, to assert (by silent practice, however, not by enunciation,) that if the anonymous in criticism was—as itself originally inculcated—but an early caterpillar stage, the nominate too is found to be on better than a homely transitional chrysalis, and that the ultimate butterfly form for a critic who likes to sport in sunlight and yet to elude the grasp, is after all the pseudonymous. But, indeed, what I may call the 'Siamese' aspect of the entertainment provided by the *Review* will elicit but one verdict. Yet I may, perhaps, as the individual chiefly attacked, be excused for asking your assistance now in giving a specific denial to specific charges which, if unrefuted, may still continue, in spite of their author's strategic *fiasco*, to serve his purpose against me to some extent.

The primary accusation, on which this writer grounds all the rest, seems to be that others and myself 'extol fleshliness as the distinct and supreme end of poetic and pictorial art; aver that poetic expression is greater than poetic thought; and, by inference, that the body is greater than the soul, and sound superior to sense'.

As my own writings are alone formally dealt with in the article, I shall confine my answer to myself; and this must first take unavoidably the form of a challenge to prove so broad a statement.

It is true, some fragmentary pretence at proof is put in here and there throughout the attack, and thus far an opportunity is given of contesting the assertion.

A Sonnet entitled *Nuptial Sleep* is quoted and abused at page 338 of the *Review*, and is there dwelt upon as a 'whole poem', describing 'merely animal sensations'. It is no more a whole poem, in reality, than is any single stanza of any poem throughout the book. The poem, written chiefly in sonnets, and of which this is one sonnet-stanza, is entitled *The House of Life*; and even in my first published instalment of the whole work (as contained in the volume under notice) ample evidence is included that no such passing phase of description as the one headed *Nuptial Sleep* could possibly be put forward by the author of *The House of Life* as his own representative view of the subject of love. In proof of this, I will direct attention (among the love-sonnets of this poem) to Nos. 2, 8, 11, 17, 28, and more especially 13, which, indeed, I had better print here.

### LOVE-SWEETNESS

Sweet dimness of her loosened hair's downfall
    About thy face; her sweet hands round thy head
    In gracious fostering union garlanded;
Her tremulous smiles; her glances' sweet recall
Of love; her murmuring sighs memorial;
  Her mouth's culled sweetness by thy kisses shed
  On cheeks and neck and eyelids, and so led
Back to her mouth which answers there for all:—
'What sweeter than these things, except the thing
  In lacking which all these would lose their sweet:
  The confident heart's still fervour; the swift beat
And soft subsidence of the spirit's wing
Then when it feels, in cloud-girt wayfaring,
  The breath of kindred plumes against its feet?'

Any reader may bring any artistic charge he pleases against the above sonnet; but one charge it would be impossible to maintain against the writer of the series in which it occurs, and that is, the wish on his part to assert that the body is greater than the soul. For here all the passionate and just delights of the body are declared—somewhat

figuratively, it is true, but unmistakably—to be as naught if not ennobled by the concurrence of the soul at all times. Moreover, nearly one half of this series of sonnets has nothing to do with love, but treats of quite other life-influences. I would defy any one to couple with fair quotation of Sonnets 29, 30, 31, 39, 40, 41, 43, or others, the slander that their author was not impressed, like all other thinking men, with the responsibilities and higher mysteries of life; while Sonnets 35, 36, and 37, entitled *The Choice*, sum up the general view taken in a manner only to be evaded by conscious insincerity. Thus much for *The House of Life*, of which the sonnet *Nuptial Sleep* is one stanza, embodying, for its small constituent share, a beauty of natural universal function, only to be reprobated in art if dwelt on (as I have shown that it is not here) to the exclusion of those other highest things of which it is the harmonious concomitant.

At page 342, an attempt is made to stigmatize four short quotations as being specially 'my own property', that is, (for the context shows the meaning,) as being grossly sensual; though all guiding reference to any precise page or poem in my book is avoided here. The first of these unspecified quotations is from the *Last Confession*; and is the description referring to the harlot's laugh, the hideous character of which, together with its real or imagined resemblance to the laugh heard soon afterwards from the lips of one long cherished as an ideal, is the immediate cause which makes the maddened hero of the poem a murderer. Assailants may say what they please; but no poet or poetic reader will blame me for making the incident recorded in these seven lines as repulsive to the reader as it was to the hearer and beholder. Without this, the chain of motive and result would remain obviously incomplete. Observe also that these are but seven lines in a poem of some five hundred, not one other of which could be classed with them.

A second quotation gives the last two lines only of the following sonnet, which is the first of four sonnets in *The House of Life* jointly entitled *Willowwood*:

> I sat with Love upon a woodside well,
>     Leaning across the water, I and he;
> Nor ever did he speak nor looked at me,
> But touched his lute wherein was audible
> The certain secret thing he had to tell:
> Only our mirrored eyes met silently
> In the low wave; and that sound seemed to be
> The passionate voice I knew; and my tears fell.
>
> And at their fall, his eyes beneath grew hers;
> And with his foot and with his wing-feathers
>     He swept the spring that watered my
>         heart's drouth.
> Then the dark ripples spread to waving hair,
> And as I stooped, her own lips rising there
> Bubbled with brimming kisses at my mouth.

The critic has quoted (as I said) only the last two lines, and he has italicized the second as something unbearable and ridiculous. Of course the inference would be that this was really my own absurd bubble-and-squeak notion of an actual kiss. The reader will perceive at once, from the whole sonnet transcribed above, how untrue such an inference would be. The sonnet describes a dream or trance of divided love momentarily reunited by the longing fancy; and in the imagery of the dream, the face of the beloved rises through deep dark waters to kiss the lover. Thus the phrase, 'Bubbled with brimming kisses', etc., bears purely on the special symbolism employed, and from that point of view will be found, I believe, perfectly simple and just.

A third quotation is from 'Eden Bower', and says,

> What more prize than love to impel thee?
> Grip and lip my limbs as I tell thee!

Here again no reference is given, and naturally the reader would suppose that a human embrace is described. The embrace, on the contrary, is that of a fabled snake-woman and a snake. It would be possible still, no doubt, to object no other grounds to this conception; but the ground inferred and relied on for full effect by the critic is none the less an absolute misrepresentation. These three

extracts, it will be admitted, are virtually, though not verbally garbled with malicious intention; and the same is the case, as I have shown, with the sonnet called *Nuptial Sleep* when purposely treated as a 'whole poem'.

The last of the four quotations grouped by the critic as conclusive examples consists of two lines from *Jenny*. Neither some thirteen years ago, when I wrote this poem, nor last year when I published it, did I fail to foresee impending charges of recklessness and aggressiveness, or to perceive that even some among those who could really read the poem, and acquit me on these grounds, might still hold that the thought in it had better have dispensed with the situation which serves it for framework. Nor did I omit to consider how far a treatment from without might here be possible. But the motive powers of art reverse the requirement of science, and demand first of all an *inner* standing-point. The heart of such a mystery as this must be plucked from the very world in which it beats or bleeds; and the beauty and pity, the self-questionings and all-questionings which it brings with it, can come with full force only from the mouth of one alive to its whole appeal, such as the speaker put forward in the poem,—that is, of a young and thoughtful man of the world. To such a speaker, many half-cynical revulsions of feeling and reverie, and a recurrent presence of the impressions of beauty (however artificial) which first brought him within such a circle of influence, would be inevitable features of the dramatic relations portrayed. Here again I can give the lie, in hearing of honest readers, to the base or trivial ideas which my critic labours to connect with the poem. There is another little charge, however, which this minstrel in mufti brings against *Jenny*, namely, one of plagiarism from that very poetic self of his which the tutelary prose does but enshroud for the moment. This question can, fortunately, be settled with ease by others who have read my critic's poems; and thus I need the less regret that, not happening myself to be in that position, I must be content to rank with those who cannot pretend to an opinion on the subject.

It would be humiliating, need one come to serious detail, to have to refute such an accusation as that of 'binding oneself by solemn league and covenant to extol fleshliness as the distinct and supreme end of poetic and pictorial art'; and one cannot but feel that here every one will think it allowable merely to pass by with a smile the foolish fellow who has brought a charged thus framed against any reasonable man. Indeed, what I have said already is substantially enough to refute it, even did I not feel sure that a fair balance of my poetry must, of itself, do so in the eyes of every candid reader. I say nothing of my pictures; but those who know them will laugh at the idea. That I may, nevertheless, take a wider view than some poets or critics, of how much, in the material conditions absolutely given to man to deal with as distinct from his spiritual aspirations, is admissible within the limits of Art,—this, I say, is possible enough; nor do I wish to shrink from such responsibility. But to state that I do so to the ignoring or overshadowing of spiritual beauty, is an absolute falsehood, impossible to be put forward except in the indulgence of prejudice or rancour.

I have selected, amid much railing on my critic's part, what seemed the most representative indictment against me, and have, so far, answered it. Its remaining clauses set forth how others and myself 'aver that poetic expression is greater than poetic thought…and sound superior to sense'—an accusation elsewhere, I observe, expressed by saying that we 'wish to create form for its own sake'. If writers of verse are to be listened to in such arraignment of each other, it might be quite competent to me to prove, from the works of my friends in question, that no such thing is the case with them; but my present function is to confine myself to my own defence. This, again, it is difficult to do quite seriously. It is no part of my undertaking to dispute the verdict of any 'contemporary', however contemptuous or contemptible, on my own measure of executive success; but the accusation cited above is not against the poetic value of certain work, but

against its primary and (by assumption) its admitted aim. And to this I must reply that so far, assuredly, not even Shakspeare himself could desire more arduous human tragedy for development in Art than belongs to the themes I venture to embody, however incalculably higher might be his power of dealing with them. What more inspiring for poetic effort than the terrible Love turned to Hate,—perhaps the deadliest of all passion-woven complexities,—which is the theme of *Sister Helen*, and, in a more fantastic form, of *Eden Bower*—the surroundings of both poems being the mere machinery of a central universal meaning? What, again, more so than the savage penalty exacted for a lost ideal, as expressed in the *Last Confession*;—than the outraged love for man and burning compensations in art and memory of *Dante at Verona*;—than the baffling problems which the face of *Jenny* conjures up;—or than the analysis of passion and feeling attempted in *The House of Life*, and others among the more purely lyrical poems? I speak here, as does my critic in the clause adduced, of *aim*, not of *achievement*, and so far, the mere summary is instantly subversive of the preposterous imputation. To assert that the poet whose matter is such as this aims chiefly at 'creating form for its own sake', is, in fact, almost an ingenuous kind of dishonesty; for surely it delivers up the asserter at once, bound hand and foot, to the tender mercies of contradictory proof. Yet this may fairly be taken as an example of the spirit in which a constant effort is here made against me to appeal to those who either are ignorant of what I write, or else belong to the large class too easily influenced by an assumption of authority in addressing them. The false name appended to the article must, as is evident, aid this position vastly; for who, after all, would not be apt to laugh at seeing one poet confessedly come forward as aggressor against another in the field of criticism?

It would not be worth while to lose time and patience in noticing minutely how the system of misrepresentation is carried into points of artistic detail,—giving us, for example,—such statements as that the burthen employed in the ballad of *Sister Helen* 'is repeated with little or no alteration through thirty-four verses', whereas the fact is, that the alteration of it in every verse is the very scheme of the poem. But these are minor matters quite thrown into the shade by the critic's more daring sallies. In addition to the class of attack I have answered above, the article contains, of course, an immense amount of personal paltriness; as, for instance, attributions of my work to this, that, or the other absurd derivative source; or again, pure nonsense (which can have no real meaning even to the writer) about 'one art getting hold of another, and imposing on it its conditions and limitations'; or, indeed, what not besides? However, to such antics as this, no more attention is possible than that which Virgil enjoined Dante to bestow on the meaner phenomena of his pilgrimage.

Thus far, then, let me thank you for the opportunity afforded me to join issue with the Stealthy School of Criticism. As for any literary justice to be done on this particular Mr. Robert Thomas, I will merely ask the reader whether, once identified, he does not become manifestly his own best 'sworn tormentor'? For who will then fail to discern all the palpitations which preceded his final resolve in the great question whether to be or not to be his acknowledged self when he became an assailant? And yet this is he who, from behind his mask, ventures to charge another with 'bad blood', with 'insincerity', and the rest of it (and that where poetic fancies are alone in question); while every word on his own tongue is covert rancour, and every stroke from his pen perversion of truth. Yet, after all, there is nothing wonderful in the lengths to which a fretful poet-critic will carry such grudges as he may bear, while publisher and editor can both be found who are willing to consider such means admissible, even to the clear subversion of first professed tenets in the *Review* which they conduct.

In many phases of outward nature, the principle of chaff and grain holds good,—the base enveloping the precious continually; but an

untruth was never yet the husk of a truth. Thresh and riddle and winnow it as you may,—let it fly in shreds to the four winds,—falsehood only will be that which flies and that which stays. And thus the sheath of deceit which this pseudonymous undertaking presents at the outset insures in fact what will be found to be its real character to the core.

## W.J. Courthope
### From 'The latest development in literary poetry: Swinburne, Rossetti and Morris' in the *Quarterly Review* (January 1872)

[A] double process has long [separated] the English poets from the thought and language of their country. The phase of literary poetry has, we think, received its fullest expression in the school of writers whose works we now propose to examine. We call them a school, because, though differing from each other in their choice of subjects and in their style, a common antipathy to society has produced in them a certain community of perception, and even occasional resemblances of language. An atmosphere of what is called materialistic feeling pervades the poetry of all three. Atheism, which is quietly avowed by one, is passionately professed by another, not as the supplanter of superstition, but as the rival of Christianity. Love is a favourite theme in their works, but the word has an esoteric signification; the objects of their devotion resemble not so much the sainted lady of Dante, or the honoured mistress of Lovelace, as the models of the painter's studio. Finally, the inspiration of all three has a literary source, for while two professedly revive the practice of ancient masters, the third, though dealing with contemporary interests, expresses himself in a borrowed style, which gives his verse all the ring of ancient rhetoric.

Mr. Swinburne is already known as the author of several works, notably 'Atalanta in Calydon', and 'Poems and Ballads'. The former is a reproduction of Greek drama, with ingenious imitations of the original language, and an extraordinary variety of melodious and flowing metres. The latter is even more remarkable for the unprecedented dexterity of its versification. This volume contains many poems marked by an uncleanness of fancy, not the less pernicious because it is exercised on such remote themes as a love-fragment of Sappho, an extinct type of Roman lust, and the statue of the Hermaphrodite in the Louvre. But there are besides a number of pieces framed upon mediæval types, in which the feeling of the originals is caught with a precision that reveals an imitative faculty of the highest order. In his latest work, entitled 'Songs before Sunrise', the author takes a serious farewell of the remote themes which had once attracted him, and announces himself as the poetical apostle of the Universal Republic.

While we are quite prepared to congratulate Mr. Swinburne upon the more manly tone he has adopted, we cannot say that we think he has at present shown the qualities of a great political poet...

We are, therefore, of opinion, on the whole, that Mr. Swinburne has chosen his themes not so much under the influence of political enthusiasm as from a keen literary perception of the advantages they offered to his peculiar rhetoric. And, viewing him as a master of metre alone, it is impossible to admire too much the taste that has led him to perceive, and the tact which which he has applied, the poetical resources of the religion which he so grossly assails. The solemn supplications of the English Litany are transferred to the nations of Europe in the appeal to their mother Earth. Imagery, borrowed from the Crucifixion, the Burial, the Resurrection, is applied to the revival of Italy, while France is represented under the character of the repentent Magdalen. No praise, we think, can be too high for the metrical faculty that has discovered a musical modulation in the simple words—

Therefore thy sins, which are many, are forgiven thee,
Because thou hast loved much.

Of the arts of rhetoric, on the other hand, which extend beyond artifices of style, Mr. Swinburne knows little. He describes himself not inaptly, when he says—

I have no spirit of skill with equal fingers,
At sign to sharpen or to slacken strings.

His verse is always pitched in the highest key. With the use of contrast and relief he is unacquainted, and of exaggeration he knows enough only to abuse it. Exaggeration is, doubtless, a legitimate resource of poetry. Thus it is flattery, but poetical flattery, when Virgil, at the opening of the 'Georgics', raises Augustus by anticipation among the stars. Yet, even when applied to the great and famous, there is danger of such complimentary poetry passing into the ridiculous; and the keen-witted Sylla paid a poet who had composed an ode in his honour not to recite it. Far more perilous is it when it is employed to exalt persons of little distinction, or is exchanged between members of a mutual admiration society. In a poem, called 'Blessed among Women', Mr. Swinburne addresses the Signora Cairoli as the superior of the Virgin Mary. Her claims to this position rest on the fact that four of her sons perished in the revolutionary crusade against Rome:

Four times art thou blest,
On whose most holy breast
Four times a godlike soldier-saviour hung;
And thence a four-fold Christ,
Given to be sacrificed,
To the same cross as the same bosom clung.'

The poem is in a perfectly serious strain; and as Mr. Swinburne seems to have no suspicion that this passage is offensively profane, it is, perhaps, no wonder that he does not see it is ridiculous.

His poems do not aim at terseness, and many of them run to an inexcusable length through their iteration and diffuseness...

The passions of modern life, which appear to Mr. Swinburne so full of sound and fury, die completely away, or at most make themselves but faintly audible, in the poems of Mr. Rossetti. The latter describes himself as a poet of the order that haunt—

The vale of magical dark mysteries.

In one of his sonnets he speaks approvingly of the religious symbolism of ancient art, and advises the moderns to retrace their footsteps to the old starting-point. A similar impulse, we presume, leads him to attempt in poetry a revival of the mystical style of Dante's 'Vita Nuova'. Such, at least, appears to be the intention of his sonnets, which, we think, contain all that is most characteristic of his work.

The objections to such a scheme are not far to seek, and lose none of their force after an examination of Mr. Rossetti's poems. The period for which Dante wrote was theological, learned, and enigmatical. Our own day is scientific and matter-of-fact to excess. The complete body of physical and metaphysical philosophy which Dante compiled throws light upon the otherwise dark enigmas of his style. In the riddles of the modern mystic everything is of private interpretation, and depends upon the kind of communication established between the author and the reader. Lastly, in the 'Vita Nuova' Dante gives us a detailed history of his connection with Beatrice, and explains the occasion and the meaning of each sonnet in turn. Mr. Rossetti affords us no clue to the collection of sonnets which he terms 'contributions towards a work to be entitled "The House of Life".' We fail to find in it any sign of unity or arrangement. We see that some of the sonnets express the feelings of a lover in happy possession of his mistress, and others his despair at the loss of her; others, again, are in a vein of philosophical reflection; but how the philosophical sonnets are connected with the love sonnets, or the love sonnets with each other, there is nothing to declare. The result of all this is that, whether or not the reader of Dante fathoms the depth of the poet's meaning, he finds enough to interest him strongly in an orderly and beautiful work; while the reader of Mr. Rossetti has to

content himself with guessing at mysteries, which often turn out to be nothing but word puzzles or literary conceits…

The practice of looking at everything in an uncommon way extends itself to the commonest objects. A love-letter is thus addressed:

Warmed by her hand and shadowed by her hair,
  As closed she leaned and poured her heart through thee,
Whereof the articulate throbs accompany
  *The smooth black stream that makes thy whiteness fair,*
Sweet fluttering sheet!

Passing over the grammatical looseness of these lines, and making allowance for a lover's enthusiasm, we must say we have never known ink and paper apostrophised in terms of such elaborate and Oriental respect.

Obscurity of thought may sometimes be conditioned in a mystical poet, but wherever his thought is clear in intention he has no excuse for not presenting it in the clearest language, especially when, like Mr. Rossetti, he opens his volume with the notice that nothing is included which is believed to be incomplete. What, then, are we to say of lines like these?—

Because our talk was of the cloud-control
  And moon-track of the journeying face of Fate.
Her tremulous kisses faltered at love's gate,
  And her eyes dreamed against a distant goal.

When translated into English prose we suppose this means, 'Our talk of the uncertainty of events made her kisses falter on her lips, while her eyes appeared to contemplate some distant goal'. We see in fragments the metaphor by which the thought is conveyed, but to extract any clear image from the words in the first two lines is, we venture to say, a sheer impossibility. In the next sonnet, called 'Parted Love', we read—

What shall be said of this embattled day,
  And armed occupation of this night,
  By all thy foes beleaguered,—now when sight
Nor sound denotes the loved one far away?
Of these thy vanquished hours what shalt thou say,—

As every sense to which she dealt delight
  Now labours lonely o'er the stark noon-height
To reach the sunset's desolate disarray?

How can we sympathise with a lonely lover, however weary of the time, who cannot speak more plainly than this?

We have commented severely upon these sonnets because their defects appear to us considerably to exceed their merits. It would be unjust, however, to Mr. Rossetti to deny that his poetical qualities—and they are not mean—sometimes combine to produce a really happy result. The following sonnet entitled 'The Portrait':

O Lord of all compassionate control,
O Love, let this my lady's picture glow
    Under my hand to praise thy name, and show
Even of her inner self the perfect whole;
That he who seeks her beauty's farthest goal,
    Beyond the light that the sweet glances throw,
    And refluent wave of the sweet smile, may know
The very sky and sealine of her soul.
Lo! it is done. Above the long lithe throat
    The mouth's mould testifies of voice and hiss,
    The shadowed eyes remember and foresee.
Her face is reade her shrine. Let all men note
That in all years (O Love, thy gift is this!)
    They that would look on her must come to me.

If 'Lord of all compassionate control' is not one of the author's many affectations, it is, at any rate, not idiomatic English. 'Long lithe throat' has rather too much of the jargon of the studio. But with these exceptions the sonnet seems to us as good as it can be. Appropriate symbolism is united to ingenious fancy, and expressed in language of natural feeling. It is a singular comment on the general tone of Mr. Rossetti's love poems, that as the expression in the portrait appropriately made a revelation of the lady's soul, so the bodily traits of the lady herself are elsewhere exalted as revelations of the supreme and invisible Love. But in the former case, the symbolism represents the glow of natural feeling; in the latter it is an unnatural conceit.

Mr. Rossetti's volume also contains several ballads, which are mostly exercises on remote subjects in a semi-antique style, generally ingenious and complete. One in particular, called 'Sister Helen', deserves the praise due to poems of this class as being forcibly imagined and very dramatically contrived. The effect of the others is a little spoiled by their tiresome and unmeaning burdens.

We purpose to close our remarks on Mr. Rossetti's verse with some reflections on a poem which, we think, reveals the incapacity of the literary poet to deal with contemporary themes in an effective and straightforward manner. 'Jenny' is a poem on the subject of unfortunate women. A man is supposed to have accompanied a girl of this description to her house, where she falls asleep with her head on his knee, while he moralises on her condition. The majority of poets have, as we think wisely, avoided subjects of this sort. But assuming that success might justify its treatment, one of the first elements of success is that the piece should be brief and forcible. 'Jenny' is nearly 400 lines long. The metre at the opening reminds us of one which Mr. Browning uses with characteristic force, but which in Mr. Rossetti's hands soon degenerates into feeble octosyllabic verse. The thought throughout is pretentious but commonplace. The moralist, beginning with something like a rhapsody on the appearance of the girl as she lies asleep, wonders what she is thinking about; he then reflects that her sleep exactly resembles the sleep of a pure woman; her face he feels might serve a painter as the model of a Madonna. We are thus imperceptibly edged on into the author's favourite regions of abstraction:

Yet, Jenny, looking long at you
The woman almost fades from view.
A cipher of man's changeless aura
Of lust past, present and to come Is left.
A riddle that one shrinks
To challenge from the scornful sphinx.

Exactly. So this profound philosopher, whose somewhat particular reflections on the charms of the sleeper have brought him at last face to face with the mystery of evil, coolly remarks,—

Come, come what good in thoughts like this?

packs some gold into the girl's hair, and takes his leave. What good indeed? But why in that case, and if Mr. Rossetti had no power to deal otherwise with so painful a theme could he not have spared us an useless display of affected sentiment and impotent philosophy?

The style of the poem is as bad as the matter. Descriptions repulsively realistic are mixed up with imagery like that in Solomon's Song; the most familiar objects are described by the most unusual paraphrases; a London schoolboy, for instance, being called 'a wise unchildish elf', while the similes are painfully far-fetched…

Without in any way affecting the character of a mystic, Mr. Morris withdraws himself, perhaps, even farther than Mr. Rossetti from all sympathy with the life and interests of his time:

Of Heaven and Hell I have no power to sing,
I cannot ease the burden of your fears,
Or make quick-coming death a little thing,
Or bring again the pleasures of past years,
Nor for my words shall ye forget your tears,
Or hope again for aught that I can say,
The idle singer of an empty day.

But rather, when aweary of your mirth
From full hearts still unsatisfied ye sigh,
And feeling kindly unto all the earth,
Grudge every minute as it passes by,
Made the more mindful that the sweet days die,
Remember me a little then I pray,
The idle singer of an empty day.

The heavy trouble, the bewildering care,
That weigh us down who live and earn our bread,
These idle verses have no power to bear;
So let me sing of names remembered,
Because they, living not, can ne'er be dead,
Or long time take their memories away
From us poor singers of an empty day.

Such is Mr. Morris's apology for taking us back to a kind of mediæval legend for the scheme of his 'Earthly Paradise'. 'Certain gentlemen and mariners of Norway having considered all that they had heard of the "Earthly Paradise" set sail to find it, and, after many troubles, and the lapse of many years, came old men to some western land of which they had never before heard: there they died when they had dwelt there certain years much honoured of the strange people.' The narrative of their wanderings is told with much grace and pathos. A proposal by a priest of the strange people that feasts should be instituted, for the wanderers to hear some of the tales of their Greek ancestors, connects the stories of the poem with the introduction. Mr. Morris ascribes his inspiration to Chaucer, but we think that the design of 'The Earthly Paradise' bears much more resemblance to the 'Decameron' than to 'The Canterbury Tales'. The characters are far more like the colourless ladies and gentlemen who left Florence during the plague, and serve so conveniently as narrators and audience of the Tales in the 'Decameron', than Chaucer's

vivacious company of pilgrims. At the end of each of Boccaccio's stories, his ladies 'praise the tale', or 'laugh very pleasantly', or 'feel their cheeks suffused with blushes'. In like manner Mr. Morris's wanderers 'watch the shades of their dead hopes pass by', sit 'silent, soft-hearted, and compassionate', or are 'wrapped up in soft self pity'. We are never interested in their actions, as in the quarrel between the Frere and the Somnoure; indeed it is clear that the racy incidents of real life would be out of place among his legendary shadows. The symmetrical division of the Tales by periods of time is after the manner of the 'Decameron'; but the institution of monthly feasts for the mere purpose of telling stories is a somewhat clumsy contrivance for connecting the tales with the introduction, and for giving the poet an excuse for a graceful prelude to every month of the year. In spite, however, of small blemishes, there is a beauty and completeness in the design of the 'Earthly Paradise', which gives it a fine distinction among the crowd of chaotic fragments that darken modern literature.

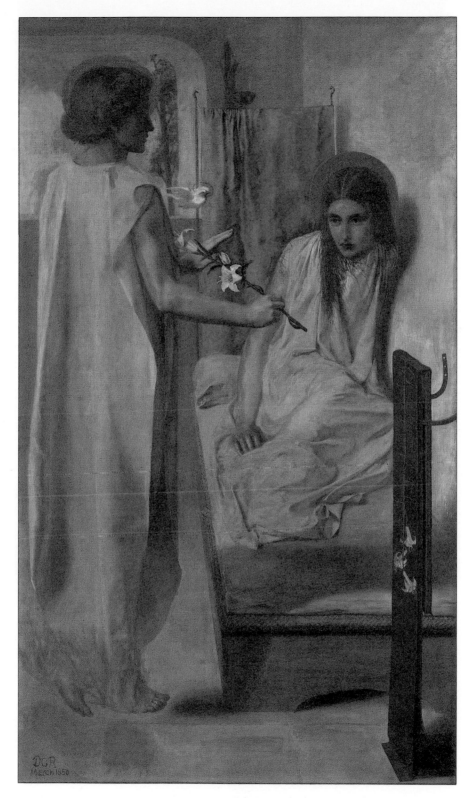

PLATE 1
*Ecce Ancilla Domini* (1849) by Dante Rossetti

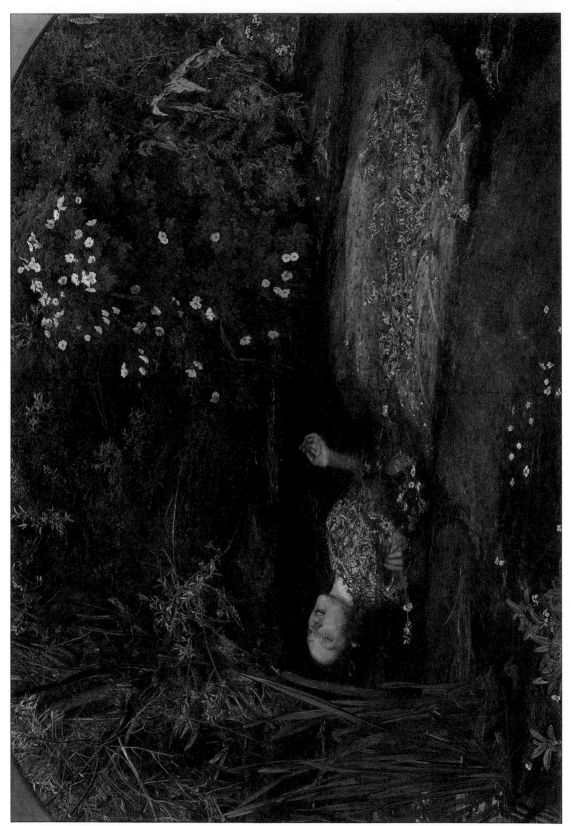

PLATE 2
*Ophelia* (1851) by John Everett Millais

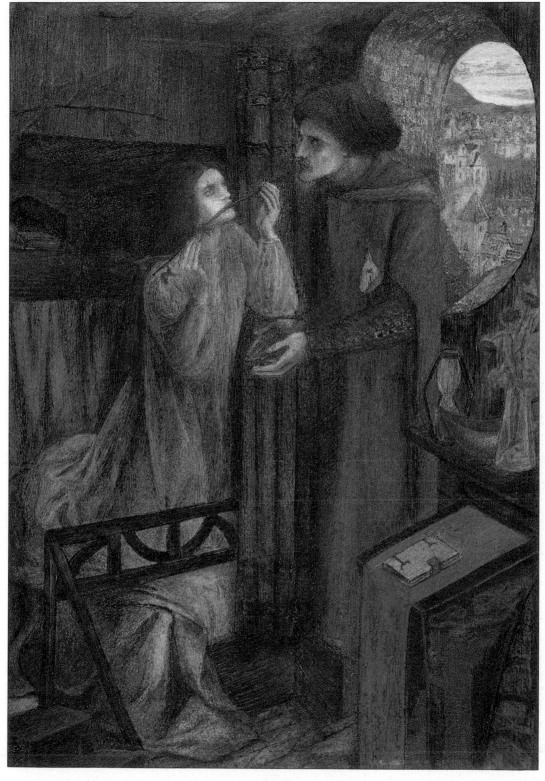

PLATE 3
*Clerk Saunders* (1857) by Elizabeth Siddal

PLATE 4
*The Oxford Union Murals* (1857)

PLATE 6

*The Green Dining Room* (1866) by Morris, Marshall, Faulkner and Company

261

PLATE 5

*The Last of England* (1865) by Ford Madox Brown

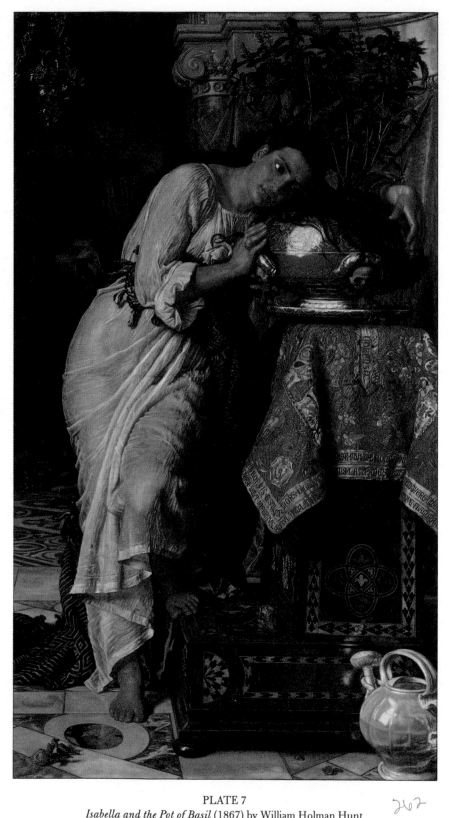

PLATE 7
*Isabella and the Pot of Basil* (1867) by William Holman Hunt

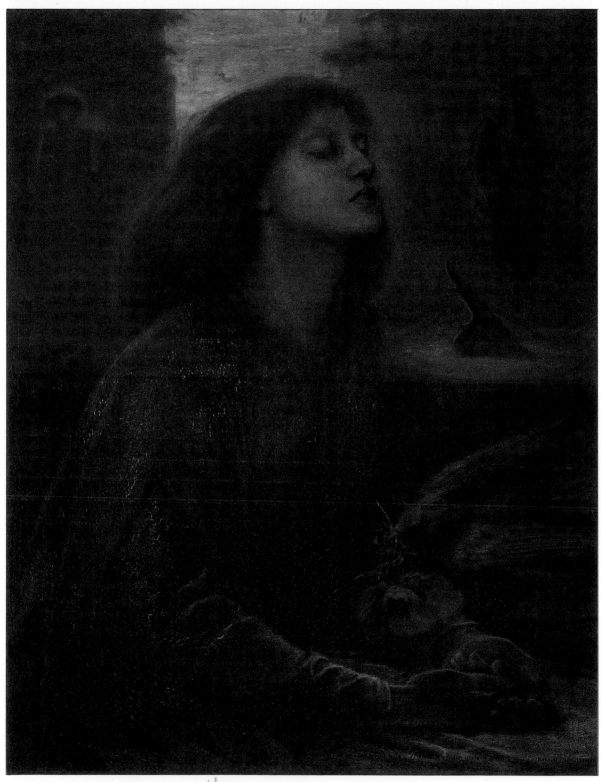

Elizabeth Siddal, model
(p. 30)

PLATE 8
*Beata Beatrix* (1868) by Dante Rossetti

263

## A GARDEN BY THE SEA

I KNOW a little garden-close,
Set thick with lily and red rose,
Where I would wander if I might
From dewy morn to dewy night,
And have one with me wandering.

And though within it no birds sing,
And though no pillared house is there,
And though the apple-boughs are bare
Of fruit and blossom, would to God
Her feet upon the green grass trod,
And I beheld them as before.

There comes a murmur from the shore,
And in the close two fair streams are,
Drawn from the purple hills afar,
Drawn down unto the restless sea:
Dark hills whose heath-bloom feeds no bee,
Dark shore no ship has ever seen,
Tormented by the billows green
Whose murmur comes unceasingly
Unto the place for which I cry.
For which I cry both day and night,

## A GARDEN BY THE SEA

For which I let ship all delight,
Whereby I grow both deaf and blind,
Careless to win, unskilled to find,
And quick to lose what all men seek.

Yet tottering as I am and weak,
Still have I left a little breath
To seek within the jaws of death
An entrance to that happy place,
To seek the unforgotten face,
Once seen, once kissed, once reft from me
Anigh the murmuring of the sea.

PLATE 9

*A Garden by the Sea* (1870)

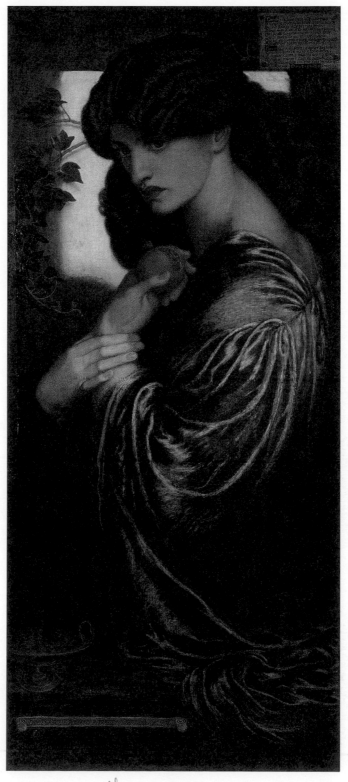

PLATE 10
*Proserpine* (1873) by Dante Rossetti

264

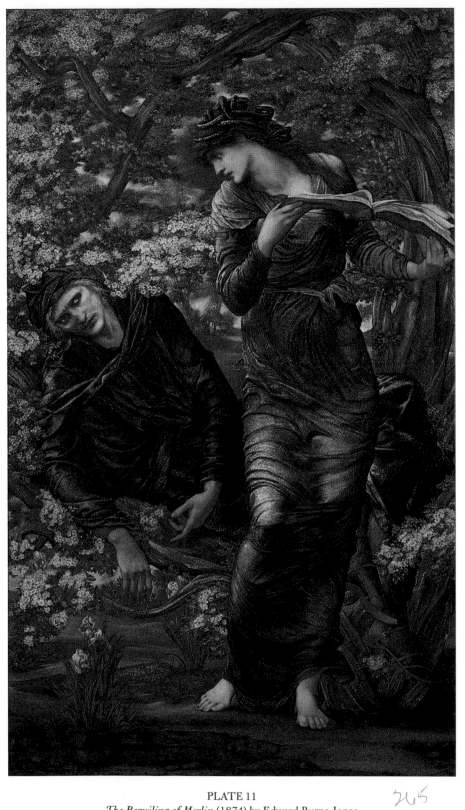

PLATE 11
*The Beguiling of Merlin* (1874) by Edward Burne-Jones

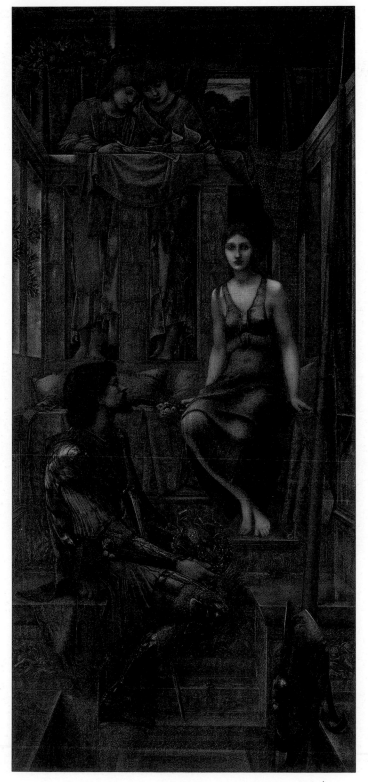

PLATE 12

*King Cophetua and the Beggar Maid* (1884) by Edward Burne-Jones

266

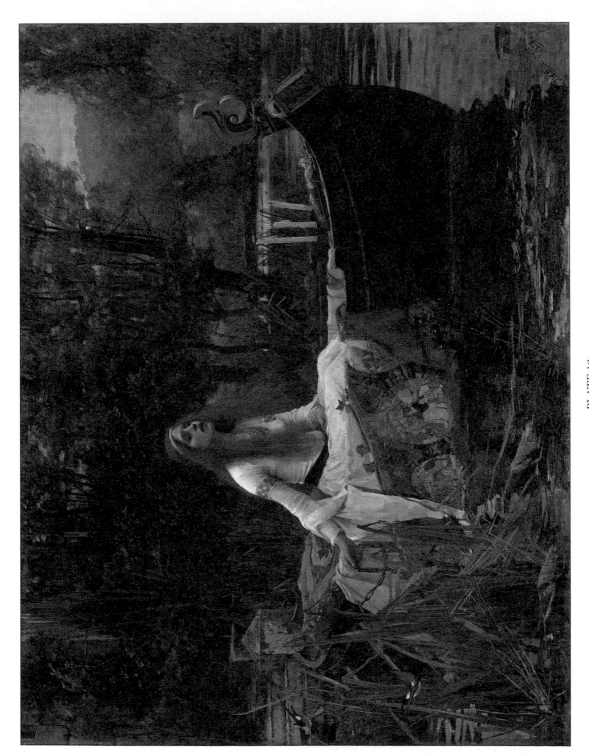

PLATE 13

*The Lady of Shalott* (1888) by J. W. Waterhouse

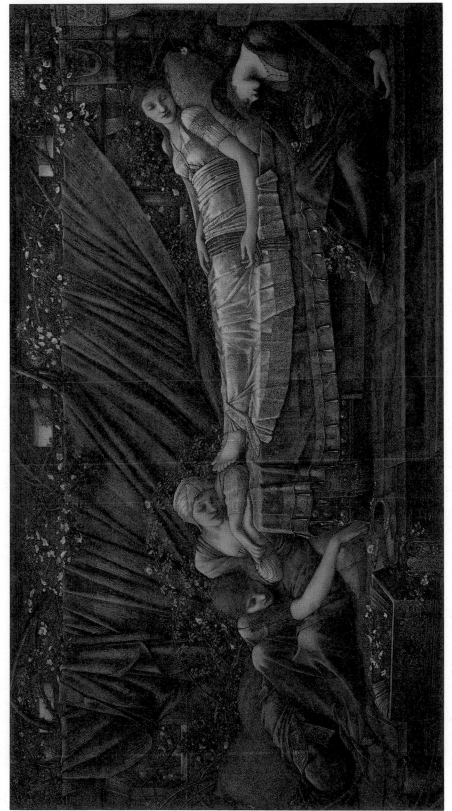

PLATE 14

*The Briar Rose — The Sleeping Princess* (1890) by Edward Burne-Jones

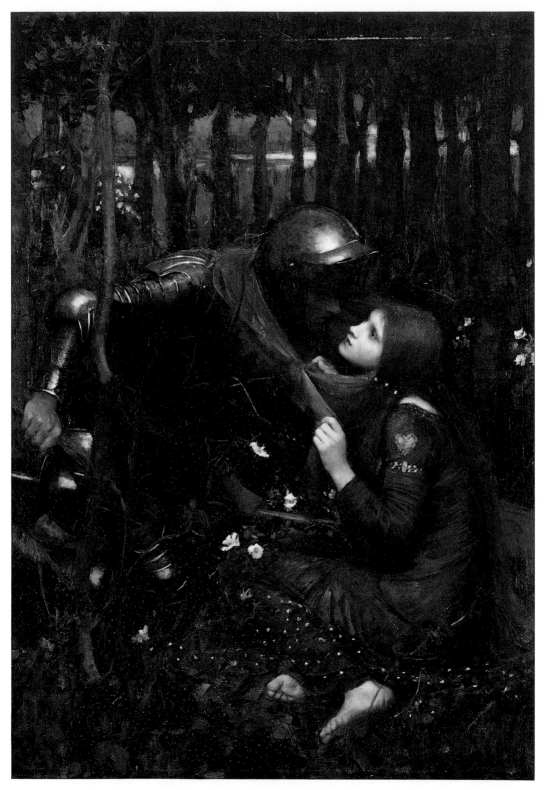

PLATE 15
*La Belle Dame Sans Merci* (1893) by J. W. Waterhouse

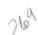

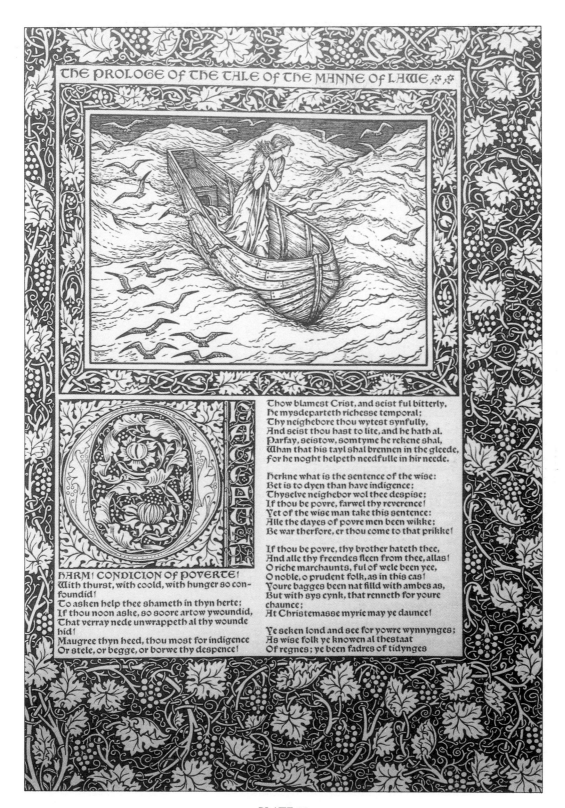

THE PROLOGE OF THE TALE OF THE MANNE OF LAWE

Thow blamest Crist, and seist ful bitterly,
He mysdeparteth richesse temporal;
Thy neighebore thou wytest synfully,
And seist thou hast to lite, and he hath al.
Parfay, seistow, somtyme he rekene shal,
Whan that his tayl shal brennen in the gleede,
for he noght helpeth needfulle in hir neede.

Herkne what is the sentence of the wise:
Bet is to dyen than have indigence;
Thyselve neighebor wol thee despise;
If thou be povre, farwel thy reverence!
Yet of the wise man take this sentence:
Alle the dayes of povre men been wikke;
Be war therfore, er thou come to that prikke!

If thou be povre, thy brother hateth thee,
And alle thy freendes fleen from thee, allas!
O riche marchaunts, ful of wele been yee,
O noble, o prudent folk, as in this cas!
Youre bagges been nat filld with ambes as,
But with sys cynk, that renneth for youre chaunce;
At Christemasse myrie may ye daunce!

Ye seken lond and see for yowre wynnynges;
As wise folk ye knowen al thestaat
Of regnes; ye been fadres of tidynges

HARM! CONDICION OF POVERTE!
With thurst, with coold, with hunger so confoundid!
To asken help thee shameth in thyn herte;
If thou noon aske, so soore artow ywoundid,
That verray nede unwrappeth al thy wounde hid!
Maugree thyn heed, thou most for indigence
Or stele, or begge, or borwe thy despence!

PLATE 16
*The Prologue of the Tale of the Manne of Lawe* (1896) by William Morris & Edward Burne-Jones

270

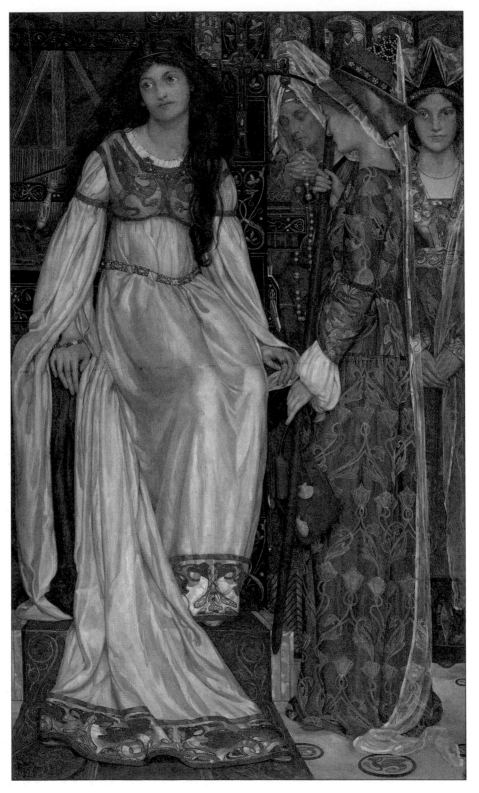

PLATE 17
*The Keepsake* (1901) by Kate E. Bunce

# ◼ The 1880s ◼

## LETTERS, DIARIES AND REFLECTIONS

### Georgiana Macdonald Burne-Jones
### From *Memorials of Edward Burne-Jones*

[1880]

In these days the one great difference between Edward and Morris—which yet did not divide them—was beginning to make itself felt. Morris was growing more and more restless and disturbed in mind by the conditions of modern life, and his conscience was dragging him towards some definite work for its amendment, while Edward held that it was always a mistake, if not a wrong thing for a man to swerve from the exercise of his own special gift, or seek another way of helping the world. Speaking of their difference long afterwards, Edward called it 'the only time when I failed Morris'. Morris, however, was strong enough to pursue his way alone, and their friendship was none the less for it.

Edward always regretted that Morris joined the Socialist body. He said: 'When he went into it I thought he would have subdued the ignorant, conceited, mistaken rancour of it all—that he would teach them some humility and give them some sense of obedience, with his splendid bird's-eye view of all that has happened in the world and his genius for History in the abstract. I had hopes he would affect them. But never a bit—he did them absolutely no good—they got complete possession of him. All the nice men that went into it were never listened to, only noisy, rancorous ones got the ear of the movement.'

Once, when it was urged upon him that, after all, Morris' connection with Socialism was an important part of his life, he would not allow even so much, maintaining that ' it was a parenthesis', and that 'Morris was before all things a poet and an artist'. Yet in a letter written after Morris had formally joined the Democratic Federation he shews a clear understanding of his friend's motive, and the expression of his own feeling proves that they only parted company about the means to be employed for one and the same end.

'Yes, I know "Progress and Poverty" and admire it greatly, its nobility of temper and style...it is a book that couldn't more persuade me of a thing I believed already—and you must have patience with some of us who say things more strongly still. How can some men help having an ideal of the world they want, and feeling for it as for a religion, and sometimes being fanatical for it and unwise—as men are too for the religion that they love? It must be, and Morris is quite right, only for my sake I wish he could be out of it all and busy only for the things he used to be busy about. I shall never again make myself much unhappy about passing events it would be easy to break oneself to bits with fruitless trouble; I shall never try again to leave the world that I can control to my heart's desire—the little world that has the walls of my workroom for its furthest horizon;—and I want Morris back to it, and want him to write divine books and leave the rest. Some day it will all change violently, and I hate and dread it but say beforehand it will thoroughly serve everybody right—but I don't want to see it or foresee it, or dwell upon it.' This seclusion of an artist with his work, sometimes misconceived of as a selfish thing, is in truth as needful a tool as any if a vision is to be made clear to others, and all the men I have known do creative work obtained it; either mechanically, by the walls of a workroom, or by that withdrawal into themselves which is part of their power...

Morris went down to Birmingham and gave, as President of the Society of Artists there, the splendid lecture afterwards published as The Art of the People...

A letter of this summer, to Norton, gives us a vision of Edward himself and Morris and Rossetti.

'If you came in to-day I will tell you what would happen; no, I daren't do that, but if you had come yesterday I will tell you all you would have found. First, it was a lazy day with me, for I get from time to time dregs of an old Italian fever, and have to put by work and so I lay in a hammock under the big hawthorn-tree in the garden and read a book. Margaret came from school—the brightest of bright things is that damsel, half a head taller than her mother, and I sit and chuckle at the sight of her, and nudge my neighbour; also I praise her to her face that she may be used to flattery and be sick of it, and not astonished or touched when it is used by others— that is my way with her. Towards evening Morris came—for it was Georgie's birthday—and you would have found him just as if no time had gone by, only the best talk with him while he is hungry, for meat makes him sad. So it is wise to delay dinner, and get out of him all you can in walks round the garden. He is unchanged—little grey tips to his curly wig—no more; not quite so stout; not one hair less on his head, buttons more off than formerly, never any necktie—more eager if anything than ever, but about just the same things; a rock of defence to us all, and a castle on top of that—before meat—but the banner lowered after that. Then the family—how unchanged all these years and what happy fortune for me, and why? and how long will it be? Alas, I say we are not changed, but how do I know? come and see.

'One night lately I spent the evening with Rossetti—there is change—enough for us all if it had been distributed amongst us, amongst any seven of us. He has given it all up, and will try no more, nor care much more how it all goes. It's nine years since he came to the Grange—now he goes nowhere and will see scarcely any one. Four or five times a year I go to spend a ghostly evening with him, and come back heavy-hearted always, sometimes worse than that—it's all past hope or remedy, I think, and his best work has been done—and I don't know how it has all come about.

'And my rooms are so full of work—too full—

and I have begun so much that if I live to be as old as the oldest inhabitant of Fulham I shall never complete it. And are you sorry they have dragged me out of my quiet? But they haven't and never shall. I read nothing that is said, I shall never be moved out of my plan of life, I shall alter nothing—neither my way of life or thought—nor go out more, nor waste my time in any of their devices, so don't be sorry, my dear. In a year or two they will tire and want a new thing. I am out of the story as they mean it, and you needn't be afraid. But, O me, I want you to see it—when you come (for you will come), I will take you to see every place where my things are. I have worked so hard I feel as if I had lived a hundred years—and when I am well it is still a fresh fountain every day. The old things are dearer and better to think of, nothing else has happened—I am just what you left me, only minding more for the same things and one or two new things—no more change than that.

'I was very ill for a bit last year—and I'm not ever very well. I don't know what could do me more good than seeing you, we might run somewhere together, and renew our youth—say you'll some day come, dear, dear old fellow.'

[1881]
On publication of Rossetti's Ballads and Sonnets in October, Edward wrote enthusiastically to him, calling it a 'blessed and divine book', and saying:

'I have been bad again—physically, not otherwise particularly, and couldn't get out—else I should have been to thank you for it. It only reached me a few days ago, but I had got it already of course, as soon as it was published. Tell me when I may see you, I can go out now on days that are not positively devilish, and I do want to see you—it is eight months since I did.'

The answer to this was a poor trembling note: 'Thanks, but I am very ill, and not well enough to see you. I can hardly write.' Early in 1882 Gabriel went down to Birchington, and, as the world knows, died there on April 9th; but his death, instead of further separating him from

Edward, cleared away the mists in which illness had wrapped him for years past, and he shone out again upon his friend as in the first days.

Nothing written about Rossetti ever satisfied Edward, and some things so much dissatisfied him that as years went on he began to feel that he could not keep silence, but must one day write a monograph himself. 'Yes', he said, 'if no one else will do it, I will display Gabriel — after a time.' A few notes were made for this purpose; on the leaf of a pocket-book is the following memorandum.

'Gabriel. His talk, its sanity and measure of it—his tone of voice—his hands—his charm—his dislike of all big-wig and pompous things—his craze for funny animals—generally his love for animals—his religion—his wife.'

Would that the book had been written.

[1883]
From Rottingham, early in the year, Edward had written to Mr. Norton after a long silence, taking up the thread of correspondence with the ease of perfect faith in his friend:

'It's getting on for a year now since Rossetti died: poor thing, I wonder if any man ever made such a hell out of this little earth for himself as he did. To any who saw his last months the end seemed sure, and desirable—and when the start was over I was glad: the work was done—for a thankless world, at the wrong moment, it seemed—but how solitary I feel in labour now you can easily think. They are shewing his pictures in London but I haven't had courage to go—I haven't the heart to go and see those first things of his that were such miracles to me. What a world it did look then—twenty-seven years ago; and he the centre and light of it all to me.

'And Morris never faileth', he goes on; 'not in the best of spirits now, for his eldest girl is ill and grows weaker and fills him with almost constant alarm.

'And Ruskin flourishes—gave a lecture on Cistercian architecture the other day that was like most ancient times and of his very best, and looks well— really looks stronger than for many a year

past. The hair that he has grown over his mouth hides that often angry feature, and his eyes look gentle and invite the unwary, who could never guess the dragon that lurks in the bush below.'

Mr. Norton's answer to this letter contained the glad news that he was coming over to England, and at the end of June he came. A letter from Edward met him on his arrival, trying to arrange how they could soonest meet:

'This is what happens: on the 1st and 2nd of July I must be in Oxford—Morris and I have just been made Fellows of our old College, and on the 2nd is a dinner where we must make our appearance—but on the 3rd (Tuesday) by the earliest morning train we come back to London and then we must meet and be together every hour that is possible.'

The Honorary Fellowship of his own College was dear to Edward's heart, feeling as he did that its meaning was: 'My child, I know now why you left me'. The conferring of the distinction had been announced in the newspapers of January 12th, but Morris and he had not yet formally taken their places as Fellows; and now they did it together, just as together they entered the University thirty years before…

Until April, 1884, the large oil picture of 'Cophetua' was worked upon, and was then finished and sent to the Grosvenor Gallery. On April 23rd he writes to Mrs. Wyndham: 'This very hour I have ended my work on my picture. I am very tired of it—I can see nothing any more in it, I have stared it out of all countenance and it has no word for me. It is like a child that one watches without ceasing till it grows up, and lo! it is a stranger.'

I have always thought this picture contained more of Edward's own distinctive qualities than any other that he did, and for that reason am glad it has been placed as a memorial of him in our National Collection. It as noteworthy that he designed and carried it out during the divergence of opinion between himself and Morris on the subject of Socialism, bringing it to an end soon after Morris joined the Democratic Federation.

The thought of the King and the Beggar lay deep in both their minds, and the reception of 'Cophetua' in Paris by some who saw it there in 1889 proves how strongly it impressed on them a distinct meaning. M. de la Sizeranne writes that it seemed to himself and his friends as though in standing before it they had 'come forth from the Universal Exhibition of Wealth to see the symbolical expression of the Scorn of Wealth'.

# Hall Caine
**From *Recollections of Rossetti***

### Chapter 5, My First Meeting with Rossetti

It was 1880 that I saw Rossetti for the first time. Being somewhat reduced in health, I had contemplated a visit to one of the South Coast watering-places, and wrote saying that in passing through London I should like to avail myself of his oft-repeated invitation to visit him. By return of post came two letters, the one obviously written and posted within an hour or two of the other. In the first of these he said:

'I will be truly glad to meet you when you come to town. You will recognize the hole-and-cornerest of all existences; but I'll read you a ballad or two, and have Brown's report to back my certainty of liking you.'

In the second letter he said:

'I would propose that you should dine with me on Monday at 8:30, and spend the evening. P.S.— Of course when I speak of your dining with me, I mean tete-a-tete, and without ceremony of any kind. I usually dine in my studio, and in my painting coat. D.G.R.'

Cheyne Walk was unknown to me at the time of my first visit to Rossetti, except as the locality in which men and women eminent in literature were residing. It was not even then as picturesque as it appears to be in certain familiar engravings, for the embankment and the gardens that separated it from the main thoroughfare had already taken

something from its quaint beauty; but it still possessed attractions which it has since lost, among them a look of age, which contrasted agreeably with the spick-and-span newness of neighbouring districts, and the slumbrous atmosphere as of a cathedral close, drowsing in the autumn sun to the murmur of the river which flowed in front, and the rustle of the trees that grew between.

Every foot of the old Walk was sacred ground to me then, for George Eliot, after her marriage with Mr. Cross, had lately come to, I think, No. 5; while at No. 5, in the second street to the westward Carlyle was still living, and a little beyond Cheyne Row stood the modest cottage wherein Turner died. Rossetti's house was No. 16, and I found it answering in external appearance to the frank description he had given of it. It seemed to be the oldest house in the Walk, and the exceptional size of its gate piers and the height and weight of its gate and railings suggested to me, as an architect, that perhaps at some period it had stood alone, commanding as grounds a large part of the space occupied by the houses on either side.

The house itself was a plain Queen Anne erection, much mutilated by the introduction of unsightly bow windows, the brick work falling into decay, the paint in need of renewal, the windows dull with the dust of months, the sills bearing more than the suspicion of cobwebs, the angles of the steps to the porch and the untrodden flags of the little court leading up to them overgrown with moss and weed, while round the walls and up the reveals of door and windows were creeping the tangled branches of the wildest ivy that ever grew untouched by shears.

Such was the exterior of the house of the poet-painter when I walked up to it on the autumn evening of my earliest visit. The interior of the house, when with a trembling heart I first stepped over the threshold, seemed to be at once like and unlike the outside. The hall had a puzzling look of equal nobility and shabbiness, for the floor was paved with white marble, which was partly

covered by a strip of worn out coconut matting. Three doors led out of the hall, one at each side and one in front, and two corridors opened into it, but there was no sign of a staircase; neither was there any daylight, except the little that was borrowed from a fanlight which looked into the porch.

I took note of these things in the few minutes I stood waiting in the hall, and if I had to sum up my first impressions of the home of Rossetti, I should say it looked like a house that no woman had ever dwelt in—a house inhabited by a man who had once felt a vivid interest in life, but was now living from day to day.

Very soon Rossetti came to me through the doorway in front, which proved to be the entrance to his studio. Holding out both hands and crying 'Hulloa!' he gave me that cheery, hearty greeting which I came to recognize as belonging to him alone, perhaps, of all the men I have ever known.

Leading the way into the studio, he introduced me to his brother William, who was there on one of the evening visits which at intervals of a week he made then with unfailing regularity.

I should have described Rossetti, at that time, as a man who looked quite ten years older than his actual age (fifty-two); of full middle height, and inclining to corpulence; with a round face that ought, one thought, to be ruddy, but was pale; with large grey eyes, that had a steady, introspective look, and were surmounted by broad, protrusive brows, and divided by a clearly pencilled ridge over the nose, which was well cut, and had breathing nostrils resembling the nostrils of a high-bred horse.

His mouth and chin were hidden beneath a heavy moustache and an abundant beard, which had once been mixed black-brown and auburn, but were now thickly streaked with grey. His forehead was large, round, without protuberances, and very gently receding to where thin black curls began to roll round to the ears. I though his head and face singularly noble, and from the eyes upward full of beauty.

His dress was not conspicuous, being rather negligent than eccentric, and only remarkable for a straight sack-coat (his 'painting coat') buttoned close to the throat, descending at least to the knees, and having large perpendicular pockets, in which he kept his hands almost constantly while he walked to and fro. His voice, even in the preliminary courtesies of conversation, was, I thought, the richest I had ever heard. It was a deep, full baritone, with easy modulations and undertones of infinite softness and sweetness, yet capable, as I speedily found, of almost illimitable compass, having every gradation of tone at command for the recitation or reading of poetry.

Such was Rossetti as he seemed to me when I saw him first—a noticeable man, indeed; an Englishman in his stolid build, an Italian in the dark fire of his face, a man of genius in the strength and individuality which expressed themselves in his outer personality without singularity or affectation.

The studio was a large, irregular room, measuring, perhaps, thirty feet by twenty, and structurally puzzling to one who saw it for the first time. The fireplace was at one end of the room, and at either side of it hung a number of drawings in chalk, chiefly studies of female heads, all very beautiful, and all by Rossetti himself. Easels of various size, some very large, bearing partly-painted pictures in different stages of progress, stood at irregular angles nearly all over the floor, leaving room only for a few pieces of furniture. There were a large sofa, under a holland cover, somewhat baggy and soiled, two low easy chairs similarly apparelled (now in my own study at Greeba) a large bookcase with a glass front surmounted by a yellow copy of the Stratford bust of Shakespeare—also now in my home. Two carved cabinets, and a little writing-desk and cane-bottomed chair were in the corner, near a small window, which was heavily darkened by the thick foliage of the trees that grew in the garden beyond.

As I had arrived late, and the light was failing, Rossetti immediately drew up an easel containing a picture he wished me to see, and I

recall a large canvas full of the bright sunshine of spring, with a beautiful lady sitting reading in a tree that was heavily laden with pink and white blossom. Remembering the sense of the open air which the picture conveyed, I cannot forget the pallid face of the painter as he stood beside it, or the close atmosphere of his studio, with its smell of paint and the musty odour of accumulated treasures lying long undisturbed in a room that can have been rarely visited by the winds of heaven.

I helped Rossetti to push the big easel out of the way, and then he dropped down on the sofa at full length, letting his head lie low on the cushion, and throwing his feet up on the back. In this attitude, which I afterwards saw was a favourite one with him, he began the conversation by telling me, with various humorous touches, how like I was to what a well-known friend of his (Burne-Jones) had been at my age; and then he bantered me for several minutes on what he called my 'robustious' appearance, compared with that which he had been led to expect from gloomy reports of uncertain health.

It was all done in the easiest conceivable way, and was so playful and so natural, as coming from a great and famous man on his first meeting with a young fellow half his age, who regarded him with a reverence only modified by affection, that it might fairly have conveyed any impression on earth save the right one, that Rossetti was a bungle of nerves, a creature of emotions all compact, and that, at this period, a visit from a new friend, however harmless and insignificant, was an ordeal of almost tragic gravity to him.

Then, one by one, he glanced at certain of the more personal topics that had arisen in the course of our correspondence, and I soon saw that he was a ready, fluent, and graceful talker, with an unusual incisiveness of speech which gave the effect of wit, even when it was not wit. I was struck with a trick he had of snapping his long finger-nails as he talked, and the constant presence of his hands, which were small and smooth and delicate as a young girl's, with tapering fingers, that he

seemed to be always looking at and playing with…

[W]hen William Rossetti rose to go I got up to go with him. Then it was arranged that on returning through London after my holiday on the South Coast I should dine with Rossetti again, and sleep the night at his house. He came into the hall to see us off, and down to the last his high spirits never failed him. I recall some further bantering as I was going out at the door, and the full-chested laugh that followed us over the little paved court between the house and the gate.

Our little night journey, William's and mine, in the hansom cab which was to drop me at the door of the 'hole-and-cornerest' of all hotels, which, as a young countryman ignorant of London, I somehow ferreted out, is made ever memorable to me by a dazed sense I had of having seen and spoken to and spent an evening with what I thought one of the gods of the earth. That is a delicious sensation that only comes once perhaps to any of us, and then in our youth; and it was after my first meeting with Rossetti that it came to me.

## Chapter 10, Rossetti and his Friends

Rossetti was now a changed man. He was distinctly less inclined to corpulence, his eyes were less bright, and when he walked to and fro in the studio, as it was his habit to do at intervals of about an hour, it was with a laboured, side-long motion that I had not previously observed. Half sensible of an anxiety which I found it difficult to conceal, he paused for an instant in the midst of these melancholy perambulations, and asked how he struck me as to health. More frankly than wisely I answered: 'Less well than formerly.' It was an unlucky remark, for Rossetti's secret desire at that moment was to conceal his lowering state even from himself.

Nights of such loneliness were frequently broken, however, by the society of Rossetti's friends, and during the weeks of our waiting I came to know one by one the few men and women who remained of the poet's intimate circle. There was his brother William, a staid and rather silent man, at that time in the Civil Service, growing elderly and apparently encompassed by family cares, but coming to Cheyne Walk every Monday night with unfailing regularity and a brotherly loyalty that never flagged. There was Theodore Watts (afterwards Watts-Dunton), most intimate of Rossetti's friends, a short man, then in the prime of life, with a great head and brilliant eyes. There was Frederic Shields, the painter, on the sunny side of middle age, enthusiastic, spontaneous, almost spasmodic. There was (about once a week) William Bell Scott, poet and painter, very emotional, very sensitive, a little embittered, a tall old man who had lost his hair and wore a wig which somewhat belied his face. There was Ford Madox Brown, a handsome elderly man with a long whitening beard, a solid figure with a firm step, a dignified manner, and a sententious style of speech. Then there was William Sharp (now known as Fiona Macleod), a young fellow in his early twenties, very bright, very winsome, very lively, very lovable, very Scotch, always telling, in what Rossetti called 'the unknown tongue', exaggerated and incredible stories which made him laugh uproariously, but were never intended to be believed. And then (less frequently) there was the blind poet, Philip Bourke Marston, a pathetic figure, slack and untidy, with large lips and pale cheeks, silent, gloomy, and perhaps morbid.

These constituted the inner circle of Rossetti's friends. Outside this inner circle there were various writers and painters who would have joined us, if they had been as welcome as willing. Rossetti's closer friends came at varying intervals: Watts twice or thrice a week, Shields more rarely, Brown on the occasions of his holidays in London from his work on the frescoes in the Town Hall at Manchester: Sharp and Marston now and then. Once or twice during the weeks of our waiting there were visits from the ladies of Rossetti's family, his mother, a gentle, sweet-faced old lady, in a long sealskin coat (the treasured gift of the poet), and his sister Christina, a woman in middle life, with a fine, intellectual face, noticeably large and somewhat protrusive eyes, a pleasant smile and a quiet manner, but a power of clear-cut incisive speech which gave an astonishing effect of mental strength. Finally, there were rare and valued visits from Mrs. William Morris, the subject of many of Rossetti's pictures, no longer young but still wondrously beautiful, with the grand, sad face which the painter has made immortal in those three-quarter-length pictures which, for wealth of sublime and mysterious suggestion, unaided by dramatic design, are probably unique in the art of the world.

I never met her. She was the only intimate friend of Rossetti whom I did not meet. As often as she came he would write a little note and send it out to me, saying: 'The lady I spoke about has arrived and will stay with me to dinner. In these circumstances I will ask you to be good enough to dine in your own room to-night.' Naturally, I respected to the end the sincerity of what I then believed, and still believe, to have been from first to last the most beautiful of friendships, although it deprived me of the acquaintance of the one member of his circle whom, most of all, and for more reasons than I can give, I desired to meet.

Naturally, it could not be altogether a desolate house in which such men and women gathered at intervals around one of the most extraordinary personalities of the age, and notwithstanding the gradual lowering of Rossetti's health, we have our cheerful hours together.

## Chapter 12, Last Weeks in the Vale[1]

…Undoubtedly, there was enough in the circumstances of our return to London to justify the deepest depression. Rossetti had gone to Cumberland solely in the interests of his failing health, and he was returning in far worse condition. The flicker of hope which had come with his first apparent improvement had made the sadness of his relapse more dark. In the light of subsequent events it would be impossible to say that he exaggerated the gravity of his symptoms, but it was only too clear that he thought he was going home to die.

As the hours went on he was full of lamentations, and I was making feeble efforts over the rattling and clanging of the car to sustain the pitiful insincerity of the comforter who has no real faith in his own comforting, for I, too, had begun to believe that the road for Rossetti was all downhill now.

It is not for me, who, by virtue of the closest intimacy, was permitted to see a great and unhappy man in his mood of most vehement sorrow and self-reproach, to uncover his naked soul for any purpose less sacred than that of justifying his character against misinterpretation, or bringing his otherwise wayward conduct and mysterious life within the range of sympathy; and if I go further with the story of this terrible night, it is with the hope of that result and no other—no other in the world.

For what I shall say next there is, so far as I know, no witness except my own memory, and that stands between my soul and the soul of Rossetti alone. But for no lower reason than that of lifting the darkest cloud that hangs over the character of my friend above the common and, I think, vulgar charge that his long enslavement to a pernicious drug was due merely to want of manliness in

meeting the world on its own terms, and for the purpose of indicating my belief that it was more probably the sequel to an event of the most tragic kind that can enter into a man's life, I will no longer hesitate to say that during the painful journey from Cumberland he told me that on the night of his wife's death, when he returned to her room from his walk, he found a letter or message addressed to himself lying on the table by her side. I think he said he had not shown that letter to anyone, and that he had never mentioned it before. Of this last fact I cannot be certain, but sure I am that he said that the message had left such a scar on his heart as would never be healed.

Rossetti's words during the hours that followed I cannot, except in broken passages, recall, and, if I could recall them, I should not set them down, so deep was the distress with which they were spoken and the emotion with which they were heard; but I can at least indicate the impressions they left on me then, as a young man who had known no more down to that moment than a few of his other friends of some of the saddest and darkest chapters of his life.

The first of those impressions was that, while the long indulgence in the drug might have broken up his health and created delusions that had alienated friends, it was not that, nor yet the bitterness of malignant criticism, that had separated him from the world and destroyed the happiness of his life. The next of my impressions was that Rossetti had never forgiven himself for the weakness of yielding to the importunity of friends, and the impulse of literary ambition, which had led him to violate the sanctity of his wife's grave in recovering the manuscripts he had buried in it. And, above all, it was my impression that Rossetti had never ceased to reproach himself with his wife's death, as an event that had been due in some degree to failure of duty on his part, or perhaps to something still graver, although in no wise criminal.

Let me not seem to have forgotten that a generous soul in the hours of deepest contrition will load itself with responsibilities that are far

---

1. Due to Rossetti's failing health, he and Caine retreated to the Lake District. It proved disastrous. There, Caine learned of the 'corroding influence of the drug [chloral] on Rossetti's better nature'. They returned to London, and Caine reports: 'Rossetti's spirits were more disconsolate than I had ever known them to be before'.

beyond its own, and certainly it was not for me to take too literally all the burning words of self-reproach which Rossetti heaped upon himself; but if I had now to reconstruct his life afresh from the impressions of that night, I think it would be a far more human, more touching, more affectionate, more unselfish, more intelligible figure that would emerge than the one hitherto known to the world.

It would be the figure of a man who, after engaging himself to one woman in all honour and good faith, had fallen in love with another, and then gone on to marry the first out of a mistaken sense of loyalty and a fear of giving pain, instead of stopping, as he must have done, if his will had been stronger and his heart sterner, at the door of the church itself. It would be the figure of a man who realized that the good woman he had married was reading his secret in spite of his efforts to conceal it, and thereby losing all joy and interest in life. It would be the figure of a man who, coming home late at night to find his wife dying, probably by her own hand, was overwhelmed with remorse, not perhaps for any unkindness, any want of attention, still less any act of infidelity on his part, but for the far deeper wrong of failure of affection for the one being to whom affection was most due.

Thus the burial of his manuscript in his wife's coffin was plainly saying: 'This was how I loved you once, for these poems were written to and inspired by you; and if I have wronged you since by losing my love for you, the solitary text of them shall go with you to the grave'. Thus the sadness and gloom of later days, after the poet had repented of his sacrifice and the poems had been recovered and published, were clearly showing that Rossetti felt he had won his place among the English poets only by forfeiting the tragic grace and wasting the poignant pathos of his first consuming renunciation. And thus, too, the solitude of his last years—with its sleepless nights and its delusions born of indulgence in the drug—was not wholly, or even mainly, the result of morbid brooding over the insults of pitiful critics, but of a deep-seated, if wholly unnecessary sense as of a curse resting on him and on his work,

whereof the malignancy of criticism was only one of many manifestations.

In this reading of Rossetti's life there is no room at all for any of the gross accusations of ill-treatment or neglect which have been supposed, by some of his less friendly judges, to have burdened his conscience with regard to his wife. There was not one word in his self-reproach which conveyed to my mind a sense of anything so mean as that, and nothing I knew of Rossetti's tenderness of character would have allowed me to believe for a moment that he could be guilty of conscious cruelty. But there was, indeed, something here that was deeper and more terrible, if more spiritual—one of those tragic entanglements from which there is no escape, because fate itself has made them.

All I knew of Rossetti, all he had told me of himself, all he had revealed to me of the troubles of his soul, all that had seemed so mysterious in the conduct of his life and the moods of his mind, became clear and intelligible, and even noble and deeply touching, in the light of his secret as I thought I read it for the first time on that journey from Cumberland to London. It lifted him entirely out of the character of the wayward, weak, uncertain, neurotic person who could put up a blank wall about his existence because his wife had died by the accident of miscalculating a dose of laudanum; who could do a grave act and afterwards repent of it and undo it; who could finally shut himself up as a hermit and encourage a hundred delusions about the world because a rival poet had resented his success. Out of all this it raised him into the place of one of the great tragic figures of literature, one of the great lovers, whose lives as well as their works speak to the depth of their love or the immensity of their remorse.

It has only been with a thrill of the heart and a trembling hand that I have written this, but I have written it; and now I shall let it go to join other such incidents in literary history, because I feel that it is a true reading of the poet's soul, and one that ennobles his memory. I wrote it all, or the substance of it all, with the story of another

incident narrated in this chapter, forty-six years ago, but I did not attempt to publish it then from sheer fear of lowering the temperature of reverence in which I thought Rossetti's name ought to live. But after nearly half a century of conflicting portraiture—much of it very true, some of it very false, all of it incomplete—I feel that the truth of the poet's life as it revealed itself to me (or as I believed it revealed itself to me) can only have the effect of deepening the admiration and affection with which the world regards him. The whole truth that hurts is better than the half truth that kills. And, speaking for myself, I can truly say that out of the memory of that terrible journey only one emotion remained, and that was a greater love than ever for the strong and passionate soul in the depths of its abased penitence.

It was just daylight as we approached London, and when we arrived at Euston it was a rather cold and gloomy morning. Rossetti was much exhausted when we got into the omnibus that was waiting for us, and when we reached Cheyne Walk, where the blinds were still down in all the windows, his Spirits were very low. I did my best to keep a good heart for his sake as well as my own; but well do I remember the pathos of his words as I helped him, now feebler than ever, into his house:

'Thank God! Home at last, and never shall I leave it again!'

## Chapter 15, At Birchington[1]

After a few weeks upstairs, Rossetti was able to get down to his studio; but this strength did not increase; so it was decided that the error of the autumn should, if possible, be repaired, by sending him, late as it was, to the seaside. At that moment a friend of earlier days, Seddon, the architect, offered the use of a bungalow at Birchington, a few miles from Margate, and I was asked to go down and look at the place. I did so,

and, coming back, I reported so favourably of the house and the situation that Rossetti determined to move immediately.

There were the same laborious preparations as before, only they were lightened now by Rossetti's calmer spirits; and towards the end of January the poet left his home for the last time. Whether he had any premonitions that this was the fact I cannot say, but whatever the hopes of his recovery cherished by his friends, it was clear enough to me that the poet himself had no illusions. And though he gave no outward sign of regret, I will not doubt that the day was a sad one on which he turned his back on the house in which he known so much joy and sorrow, the place so full of himself, written all over with the story of his life, the studio, the muffled bedroom, the closed-up drawing room, the little green dining-room, and the garden now ploughed up and lost.

We travelled in ordinary carriages, taking with us the domestic servants from Cheyne Walk, a professional nurse, and my sister, then a little girl. Though so weak, Rossetti was in good spirits, and I remember that, on getting into the compartments, he tried to amuse the child by pretending that the carriage itself had been built expressly in her and his honour.

'Look here', he said, pointing to the initials on the carpet ('London, Chatham, and Dover Railway', as it was then), 'They have even written our names on the floor; L.C. and D.R.—Lily Caine and Dante Rossetti.'

It had been a fine and cheerful day when I went down to Thanet to report on the land, but it was a dark and sullen one when I arrived with Rossetti. Birchington was not a holiday resort in those days, though it was being laid out for its career in that character. It was merely an old-fashioned Kentish settlement on the edge of a hungry coast.

The village, which stood back from the shore the better part of a mile, consisted of a quaint old Gothic church, grey and green, a winding street, a few shops, and a windmill; while the bungalow we

---

1. Sadly, Rossetti did have to leave his home again—This time for Birchington in Kent. He would never return to Cheyne Walk.

were going to live in stood alone on the bare fields to the seaward side, and looked like a scout that had ventured far towards the edge of unseen cliffs. The land around was flat and featureless, unbroken by a tree or a bush, and one felt as if the great sea in front, rising up to the horizon in a vast round hill, dominated and threatened to submerge it. The clouds were low, the sea was loud, the weather was chill, and if Rossetti had been able to act on his first impression of Birchington I think he would have gone back to London immediately…

### Chapter 16, The Last of Rossetti

…Thus February slid into March, and spring began to come with its soft sunshine and the skylarks singing in the morning, but Rossetti's health did not improve. The hours in the drawing-room became shorter every day, and we all knew that the end was drawing on…

One morning, more than usually cheerful with signs of the coming spring, the local doctor made the painful and somewhat belated discovery that Rossetti was in an advanced stage of Bright's disease, and we telegraphed to his brother, to Watts, and to Shields to come down immediately. That night his dear old mother and I remained with him until early morning, and then his sister took our place by his side.

Since the coming of his mother and sister I had seen less of Rossetti than before, feeling a certain delicacy in intruding upon the sacred intimacies of the home circle in these last reunions; but the next morning, after he had received what we believed to be his death warrant, I spent a long hour alone with him.

'Hulloa! Sit down! I thought at one time you were going to leave me', he said as I went into his room.

'You'll have to leave me first, Rossetti', I replied.

'Ah!'…

About nine o'clock Watts left us for a short time, and when he returned he said he had been in Rossetti's room and found him at ease and very bright. Then we three gave way to good spirits, and began to laugh at little things, as is the way with people when a long strain seemed to be relaxed. An instant afterwards we heard a terrible cry, followed by the sound of somebody scurrying down the corridor, and knocking loudly at every door.

We hurried into Rossetti's room and found him in convulsions. Watts raised him on one side, while I raised him on the other. His mother, sister and brother were immediately present (Shields having fled away bareheaded for the doctor); there were a few moments of suspense, and then we saw him pass away in our arms.

Thus, late at night on Easter Day, 1882 at less than fifty-four years of age, Rossetti died. It was all over before we seemed to draw breath. I remember the look of stupefaction in our faces, the sense of being stunned, as we three—Watts, Shields, and I—leaving the two good women murmuring their prayers in the death chamber, returned to the dining-room, and said to each other: 'Gabriel has gone!'

Long as we had foreseen the great asundering it fell at last as a surprise. Each of us no doubt had had his vision of how it was to be with Rossetti at the end. In mine he was to die slowly, body and soul sinking gradually to rest, as the boat, coming out of a tempestuous sea, lets fall its sail and glides into harbour. This was to be Nature's recompense for Rossetti's troubled days and sleepless nights; the end of his fierce joys and stormy sorrows. But Nature knew better the mysteries of the future, and Rossetti was to be the same tragic figure to the end, in sunshine and shadow, in life and death, always tragic.

## William Holman Hunt
### From *Pre-Raphælitism and the Pre-Raphælite Brotherhood*

[1887]

Dante Gabriel Rossetti had died on 9th April 1881. I had not see him since the private view of 'The Shadow of Death', when I had observed him in the room with his brother. My intention was to accost him, but before I could disengage myself to do this, he had left the room. He had kept out of the way of both Millais and myself since 1857. When latterly news had been brought to me of his serious indisposition, I wrote to his brother to ask whether he thought it would be pleasant to Gabriel if I went to visit him. The reply was thoughtful in tone; he decided that Gabriel's health was so uncertain at the time as to make the visit undesirable. Thus I did not see him at the last. I was anxious not to appear in any degree grudging of the reputation which my former friend had won, and when an invitation came to me to write some notes about the origin of our Brotherhood, I determined that no generosity towards his memory should be wanting. In the year 1886 my papers on Pre-Raphælitism were published in the *Contemporary Review*. In the following year I was appealed to by his nearest friends, and as the most appropriate member of the circle, to give an address at the unveiling of the fountain, designed by John Seddon, and ornamented with an alto-relievo bust executed by Madox Brown, erected on the embankment at Chelsea. Accepting the duty, I determined, therefore, to give the fullest measure of admiration possible. May it not have been that, in scribbling some of the sentences of my address in the cab, as I drove to the place of meeting, I was too careless of the construction that might be put upon my words? The manner in which all my ungrudging praises of Dante Gabriel Rossetti have been treated by varying commentators compels me to refer to my past utterances on this subject, and to the date of their delivery. The text here given is that of the *Pall Mall Budget* of the 21st July 1887,

the week after the ceremony of the unveiling of the fountain:

Ladies and Gentlemen—It is fair to assume that all whom I address have an interest, great or small, in Rossetti's genius. Certain may be offended that it expressed itself as it did. They may feel assured that what is called by great authorities 'that fatal gift of originality' had too much to do with it. They may fasten upon some particular phase of his nature, which at a special time he exhibited, and decide from that that he was altogether perverse and mistaken, and they may stop far short of admiration, while they admit he was a genius about whom it is impossible not to feel curiosity. Others will go far beyond this degree of admiration, and they would be offended at anything short of the greatest praise. I don't think that any of the Committee have intention of deciding the point of his exact place among the great. We know that his work in art and poetry will live for exactly what it is worth, without flattery and despite abuse, in future generations in a manner more sure than it has so far done. I will not take up your time with apologies at my shortcomings for the office of speaker. I conclude that I have been chosen to this honour because I was his early companion day after day, at that period in life when he was just feeling strong enough to take independent flight. He was open with me, as boys will be when they know that their comrade is as much in earnest as themselves. We talked much about poetry, but what he said about reducing it to words I will not pretend to remember so well, for life was too much of a storm at the time to have prepared me to justify an independent opinion, or to allow me to put to immediate test the views he approved or opposed. I will leave others to treat of his poetic theories and practice...There is no unfitness in thinking of the incidents of moment in our past companion's life which had a laugh connected with them. It astonished me when I was young to find that very serious men love fun most heartily. They weep

when it is the time to weep, it is true; but they see the fun and absurdity of life. No one did this more than Rossetti. I feel called upon to bring out this phase of his character, because the work he left was uniformly sad. My memory of him is of the heyday of his life, and many of our hours then were spent about this very spot. In 1849 we came here to find a house which we could share together. There were two or three or more to let in Cheyne Walk. We preferred one just vacated by Mr. Dyce, but the rent was £60 per annum, on a lease too; and with taxes the responsibility was too great for me at least. As young painters we had no prospects but of the meanest incomes, and so we found separate lodgings, he in Newman Street, and later one at the foot of Blackfriars Bridge, and I took apartments in Cheyne Walk, where often he was a visitor, sometimes sitting down hour after hour to design or to write. Occasionally we went out on nocturnal expeditions on the river, not often, for he could not swim. He never became an oarsman or a sculler; but I remember his first ambitious effort as a boatman, to the accompaniment of shouts of laughter; but generally we were quieter. The star-checked gloom, the long deep-draggled lamps, making the water into a bottomless pit, the black piles of the timber bridges, the tides empty of all but floating barges, slowly guided with deep-falling, splashing sweeps, the challenged echoes, the ghostly houses on the bank, with windows glaring as the dawn stared in to them as into the wide-opened eyes of a corpse; and last the jocund day uprose, cloud garlanded—these things were worth the seeing, the hearing, and the learning, for they had a voice for each. They should not be forgotten till the last slumber (slumber which has fallen upon him in untimely season), and yet, as I believe, behind my time as I am, even this sleep will not chase away such memories…

…Other painters loved to exaggerate the more 'en-franchised' phase of Rossetti's mind, and with these were joined many, not graphic or plastic artists, but men of literary aims who caricatured the verbal sentiments of Rossetti, who intensified what they represented to be his ideas with obtrusive parade. Talking in mincing affectation and adopting a tone which they stamped as that of extreme 'culture', these busy jackanapes were characterised in a spirit of irony as 'unutterably utter'. Gilbert and Sullivan in the opera of *Patience*, and Du Maurier in *Punch*, held them up to deserved ridicule, without, however, at the time abashing these defiers of all common-sense in the slightest degrees. It had been from the beginning a penalty that if any one of our body provoked hostility, justly or unjustly, each other of the active members had to suffer. Accordingly, the appearance in force of many quattrocentists of different degrees of ability, and the loud exaggerators of Rossetti's defiant sensuousness, led unthinking critics again to say that these quattrocentists and the affected foppery of their frenzied satellites were alike the representatives of Pre-Raphælitism, and so some of the public applied to Pre-Raphælitism itself such ridicule as appeared in the opera, while it was in fact justly directed against what might be considered the alien fringe and reversing mirage of our company. The outrageous sentimentalists in fact distorted every emotion of human sympathy and tore passion to tatters in hysteric grimacings, that would relegate healthy manliness to be a mark of childishness or rudeness, and would deny the name of poetry to all that was not sickly and morbid. The gushing tatterdemalions who paraded their idolatory for this rotten affectation of genius were satirised thus in *Patience*:

If you're anxious to shine in the high æsthetic
    line, as a man of culture rare,
You most get up all the germs of the transcendental
    terms and plant them everywhere.
You must lie on beds of daisies and discant in novel
    phrases of your complicated state of mind.
The reason doesn't matter if the subjects only
    chatter of a transcendental kind.
And every one will say, as you walk your mystic way,
If this young man can understand these things that
    are far too hard for me,

Why, what a very cultivated, clever young man, this
clever young man must be!

And again:

Then a sentimental passion of a vegetable fashion
must excite your languid spleen,
An attachement à la Plato, to a bashful young potato
or a not too French, French bean.
Though the Philistines may jostle you will rank as an
apostle in the high æsthetic band,
If you walk down Piccadilly with a poppy or a lily in
your mediæval hand.

Again:

A Japanese young man—
A blue and white young man—
Francesca di Rimini, niminy piminy,
Je ne sais quoi young man.
A pallid and thin young man—
A haggard and lank young man—
A greenery-yallery, Grosvenor Gallery,
Foot in the grave young man.

This was no mere passing frivolity, it was the
fumes from festering decay; it was the complete
distortion of art which is the highest perfecting
principle of the human mind, expressed by
strenuous labour. The Lord of Misrule had
usurped the throne and was caricaturing beauty
and wisdom into tawdry over-dressed vanity and
folly. The men who thus turned honour into
dishonour, and travestied innocent gladsomeness
into licence and raillery, were equipped with
weapons first made for the hands of virtue.
Pertness was made to pass as wit, and contempt of
common sense as wisdom; it was rioting and
selfishness masked by pretentious learning and
sophistical philosophy alluring weak minds with
the sheen of superficial culture. Many of its
votaries were employed on the press, and as their
sympathies were with false art, so they used their
opportunities to applaud sham sentiment, and to
uphold all artists in letters or in picture images
who mocked rectitude, and who disported
themselves in topsyturveydom or in wild
recklessness of handling…

It was apparent, however, that many who
deluded themselves that they were adopting our
ideals went out to the fields, and sitting down
transcribed chance scenes touch by touch, without
recognising that art is not prosaic reproduction.
Every hour a view, indoors or outdoors, near or
far, changes its phase, and the artist must capture
that which best reflects the heavens. The dull man
does not discern the image of the celestial in
earthly things, and his work accordingly may be
deservedly admired for its care and delicacy, but
the spectator passes by and forgets it. Yet the
painters of such works were often cited as masters
of the purest Pre-Raphælitism. The special
champions of our third member in his later phases
treated Millais and myself as unmoved by the
canonical breath of poetic dogma. When it was
pointed out to them that our pictures had never
attempted quattrocentism, they met this argument
with the conclusion that we two were unable to
reach the exalted heights of the 'arch Pre-
Raphælite'…

A baronetcy was conferred on him [Millais]
in 1885, and he was happy in his exaltation. In
talking to him at about this date I asked, 'Can you
remember what paper it was in 1849 which, in its
art review, spoke of our two pictures at the Royal
Academy as the main feature of the exhibition, and
greeted them with marked respect? I was told of
this, but never saw the article myself.'

'No, I certainly do not remember one
generous word printed of us the first year, and the
second year, when Rossetti had given away our
secret, I remember only treatment that would have
been unwarrantably cruel had we been the vilest
criminals. No, we made a miserable mistake in
accepting others to form a Brotherhood with us,
when we knew little or nothing of their abilities
and dispositions. One condition of our compact
was that we should become helpful to one another,
as a means of making our Body the stronger. The
practical interpretation of this on the part of the
others was amusingly one-sided. You taught
Gabriel to paint at a perilous sacrifice to yourself,
and I kept back no secret from him. We brought

out our very precious guineas to start *The Germ*, so that the writers could publish their poems and articles; and we did etchings in addition, and met other liabilities incurred for their advantage. Did they ever do anything for us? No! Gabriel stole a march on us to get the picture which you had helped him to paint seen in the Hyde Park Exhibition a week before ours appeared in the Royal Academy, and when he found the penalty of public exhibition was to suffer abuse, he left us to bear it all alone, and when he felt that he could stand alone, he studiously kept out of our way. A few years ago, not having seen Rossetti since you were first abroad, I met him one evening at Sandys' studio, and he warmed up somewhat in his mood, and coming out late at night we walked together till he came to my house. As he asked me what I was doing in the old way, I said, if he liked, I would take him into the studio, which I did; and on leaving he pressed me to come and see him. Twice I called and was refused at the door, and he never wrote to me any explanation, and I could see he was determined to indulge his old jealous temper. Why, it was only a month ago that I passed one of the set in a cab, and when I nodded to him he held up his head and looked quite indignant.'

I replied, 'I am sure the man you mean couldn't have done that but from failure to recognise you.'

'Oh no, I am sure he knew me very well. Have you seen a book on Rossetti by Knight? You haven't! Mary read it to me lately, and in the evening afterwards I met him at the Garrick, and went to him saying, 'You've written a very readable and plausible book about Rossetti; but it is altogether a romance. Why, instead of getting your information from the family, didn't you come to me or go to Holman Hunt?' And when I told him the facts of the case he avowed that he would not have published his book as it was had he know it the facts. All this distortion of our real purpose as Pre-Raphælites makes me disposed to repudiate the name.'

## William Morris

### To the Editor of *The Commonweal* (1886)

Of the facts already known to the public I fear I can tell little of the occurrences in Trafalgar Square last November. As to the reason why three men were killed, many sent to prison, three hundred or so arrested and several condemned to penal servitude; the retail trade of the metropolis thrown into disorder, the troops called out; as to why many men and women were beaten and brutalized in the public streets; the wherefore that the powers that be chose to expose their capital to the chance of being sacked and burnt by an angry populace—I confess I am still in the dark. The more I think, the more I cannot tell. It may be that Sir Charles Dogberry had heard of, and wished to imitate, the behaviour of the negro pilot who came aboard a ship in the West Indies, and immediately gave the order, 'Haul um jib up, Mr Mate', and then, amidst the curses of the crew, instantly remarked, 'Haul um jib down, Mr Mate', giving as his reason that he wished to show his authority.

What I can tell you is merely this, that I was in Birmingham and read in the morning papers that a meeting having for its object to petition the Government for the release of Mr William O'Brien, M.P., had suddenly been proclaimed without rhyme or reason. At that time I was a newly-elected Liberal member. I had heard members of my party, men who at that time I respected and believed to be in earnest, talking big at meetings and telling lies about what they intended to do in Ireland that autumn. I had read Mr Gladstone's speech at Nottingham, in which he had expressly said that coercion would not be confined to Ireland, but would also be applied to England if the people were supine. I had read this, and—fool that I was—I believed it; for at that time I did not know that Liberals, Tories, and Unionists were three bands of thimbleriggers. I did not know that the fooleries of Harcourt and the platitudes of Morley were anything else than the utterances of good dull men, who at least

believed in themselves. I was soon to be undeceived.

To return to my meeting. I came up to London, hearing at the meeting was held under the auspices of the Radical clubs of London, in conjunction with the Irish National league. Now one would have thought that I should have met at every political club in London the local Liberal member encouraging his constituents. One would have thought that the boasters and braggers from the country constituencies would have rushed up to town to redeem their vaunts on public platforms. I expected that it would be thought as cruel and tyrannical to break up a meeting at which thousands of Irishmen were to be present, in London as it would be in Ireland. I thought that freedom of speech and the right of public meeting were facts in themselves, about which politicians were agreed. I did not know the meanness of the whole crew even at that time. I was not aware that freedom of speech and public meeting were nothing to them but stalking-horses to hide themselves behind, and under cover of which to crawl into Downing Street. I soon found, however, that the Liberal party was a complete cur, that what they excelled in doing was singing, 'Gloria Gladstone in excelsis', and talking of what they intended to do in Ireland. You see the sea divided them from Ireland, and one is always brave when no danger is at hand. However, no political capital was to be made out of London, it appeared, therefore Mr Shaw Lefevre thought better to vapour and obtain a cheap notoriety in Ireland, where he knew he was quite safe, than to help his fellow townsmen—he is, I think, a Londoner—in London, where there might have been some incurred.

Finding myself deserted by all my colleagues, with the exception of Messrs Conybear and Walter M'Laren, who would have been at the meeting had they been able, and at that time not knowing many of the Radicals, I turned to the Socialists, some of whom I did not know, and hearing their procession was to arrive at St

Martin's Church at a certain time, I determined to join it.

What happened is known to all: how no procession reached the Square; how they were all illegally attacked and broken up, some of them several miles from the Square; how despite of every constitutional right, and without a shadow of pretext, banners and instruments were destroyed, and not a farthing of compensation ever given, though the loss fell on poor people. It will be remembered, too, how the police, acting under the orders of Sir Charles Dogberry, the Christian soldier (sic!), felled men and women, and in some cases little children, to the ground. I wonder if Mr Henry Matthews, the pious Catholic Home Secretary, approved of this, and how he broached the matter to his priest when he went to confession? It will not be forgotten the sort of bloody assize that followed, and how Judge Edlin wrote himself down as by the folly of his sentences. No one will forget the trial and condemnation of George Harrison, and his sentence to five years' penal servitude on the oath of one policeman, eleven independent witnesses being of no avail to save him. Then the pantomimic trial of John Burns and myself, and our condemnation by Mr Justice Charles Shallow, also on the testimony of professional witnesses, and for an obsolete offence. It is still, I think, fresh in the memory of all, how with the help of all the professional perjurers in London, all the arms collected from that vast crowd amounted to three pokers, one piece of wood, and an oyster-knife. How I failed to join the procession, and having met Messrs Burns and Hyndman by accident, proceeded to the Square; how we were assaulted and knocked about and sent to prison, is matter of notoriety in London.

I can tell no more of the incidents of the day than can any other spectator. I walked across the street with Burns, was joined by no one as far as I remember, and found myself a prisoner in the Square with a broken head. Whilst in there though I had ample time to observe a good deal. I watched the crowd and the police pretty carefully;

I saw repeated charges made at a perfectly unarmed and helpless crowd; I saw policemen not of their own accord, but under the express orders of their superiors, repeatedly strike women and children; I saw them invariably choose those for assault who seemed least able to retaliate. One incident struck me with considerable force and disgust. As I was being led out of the crowd a poor woman asked a police inspector (I think) or a sergeant if he had seen a child she had lost. His answer was to tell her she was a 'damned whore', and to knock her down. I never till that time completely realized how utterly servile and cowardly an English crowd is. I venture to say that had it occurred in any other country in the world, the man would have been torn to pieces. But no! in England we are so completely accustomed to bow the knee before wealth and riches, to repeat to ourselves we are a free nation, that in the end we have got to believe it, and the grossest acts of injustice may be perpetrated under our very eyes, and we still slap our manly chests and congratulate ourselves that Britain is the home of Liberty.

Other things I saw that pleased me better than this, I saw that the police were afraid; I saw on more than one occasion that the officials had to strike their free British men to make them obey orders; I saw that the horses were clumsy and badly bitted, and of no use whatever in a stone street; and lastly, I am almost certain I observed several of the police officers to be armed with pistols, which I believe is against the law. I saw much, too, to moralize on. The tops of the houses and hotels were crowded with well-dressed women, who clapped their hands and cheered with delight when some miserable and half-starved working-man was knocked thown and trodden under foot. This I saw as I stood on almost the identical spot where a few weeks ago the Government unveiled the statue of Gordon, not daring to pay honour to the memory of one of our greatest latter-day Englishmen because they feared the assembly of a crowd to do him honour; because, I suppose, for both political parties the comments on the death of a man sacrificed to their petty Modern party broils would have seemed awkward. As I stood there, Socialism as I saw the gross over-fed faces at the club and hotel windows, as I heard the meretricious laughter of the Christian women on the housetops (it is a significant feature of the decadence of England, that not one woman of the upper classes raised her protest by pen or on platform to deprecate the treatment of her unarmed fellow-countrymen; no, all their pity was for the police), I thought yet, still—I have heard that these poor working-men, these Irish and Radicals have votes, and perhaps even souls, and it seemed impossible but that some day these poor deceived, beaten, down-trodden slaves would turn upon their oppressors and demand why they had made their England so hideous, why they ate and drank to repletion, and left nothing but work, starvation, kicks, and curses for their Christian brethren? Somewhat in this style I thought; this I saw as I stood wiping the blood out of my eyes in Trafalgar Square. What I did not see was entirely owing to the quietness of the crowd. I did not see houses burning; I did not hear pistols cracking. I did not see this—not because of any precautions the authorities had taken, for they had taken none, but because it was the first time such a scene had been witnessed in London during this generation.

Now, whilst thanking the *Commonweal* for giving me so much space, I can only say that I do not contemplate the renewal of such a scene with much pleasure. 'You can beat a cow till she is mad', says the old proverb; and even a Londoner may turn at last. I hope that there may be no occasion for him to turn in my lifetime, but I know that if he is not forced to do so he will have only himself to thank for having avoided it. No party will help him, no one cares for him; rich, noble, City; West End, infidels, Turks, and Jews combine to cheat him, and he stands quiet as a tree, helpless as a sheep, bearing it all and paying for it all. This, then, is all I can tell you of the great riots (sic) in Trafalgar Square, where three men were killed, three hundred kicked, wounded, and

arrested, and which had no result, so far as I can see, but to make the Liberal party as odious and as despised as the Tory party in the metropolis. All honour to the Sunday Socialists for being the first body of Englishmen in the metropolis to have determined that the death of three Englishmen, killed by the folly of Sir Charles Dogberry and worthy Mr Verges, the Home Secretary, shall not go unregarded, and I hope unpunished.

I am, Sir, your obedient servant

R.B. Cunninghame Graham.

## William Bell Scott
### From *Autobiographical Notes*

[1882]

When I left off the previous chapter…I laid this MS., such as it is, aside with the feeling that it was closed; but already since then two incidents have unexpectedly transpired of vital importance, such as cause me to add another chapter to my story. The unexpected incidents are—my writing without premeditation and with a quite novel feeling of spontaneity a hundred or more little poems, expressing the mental state of the day in the simplest manner, with the comparatively successful publication of the same under the name of A Poet's Harvest Home; and the death of my dear friend for so many years, whose intercourse has occupied a very considerable space in this manuscript.

With regard to the poems, the novelty of their unplanned production, while it deprived them of recognised form, gave them simplicity of expression, not one elocutionary or unnecessary word being admitted. This has indeed been always more or less characteristic of the advent of my poems, good, indifferent, or bad as they may be judged; but in the present case the poems or rhymes—many of them abrupt as epigrams should be, others, ballads or short narratives or sonnets— came to me fully dressed, as it were, every morning between waking and rising, in the

autumn months of 1881. The motive, with every line to be employed in its development, came to me as if from memory; they were written down in pencil on pieces of paper I had placed under my pillow the night before. Every day I thought, now the good fairy has exhausted himself, I shall have no more! but still it went on till I had a good many over a hundred, some mornings bringing me two or three. The house was full of company, but I found time to make fair copies, and to read them over to AB in the garden bower, where in 1870 I used to read the wonderful war news in the daily paper. Then we threw out or tore up a number, as she objected violently to such as were either satirical or metaphysical.

While this incubation was going on, I was surprised by a letter from Rossetti, whom we had left in a very low state of general health, even suffering from a total loss of the hope of recovery, the greatest loss a sick man can suffer. The letter was dated from an out-of-the-way farmhouse in Cumberland, whither he had passively allowed himself to be carried by a young man to whom he had suddenly become exclusively attached, Mr. T. Hall Caine.

When our time came for returning to town I was shocked to find the dear old Gabriel prostrate on the old sofa we had so often in the earlier times seen filled with the most genial friends. He was, it now appeared to me, going down fast; but I tried to keep up the usual deception we apply to invalids. I had gone alone, thinking it best to make this first visit so; but he was by himself, no one attending or trying to cheer the man whose spirits were down to zero.

When he and I were alone, he wept and complained, and made unkind speeches or showed me things he thought would wound me, as when he made his servant lay before me a large chalk sketch he called 'Questioning the Sphinx'. This wounded me, because it happened that I had made an illustration in my first issue of The Year of the World, that juvenile 'poem with a purpose', of the hero-traveller leaning on an augural staff with his ear to the mouth of a Sphinx, which I

called by that name, and which the beloved D.G.R. of that early time used to make game of, as if I had mistaken the ancient fable in which the Sphinx was the questioner, not the questioned. I had besides written a poem called 'To the Sphinx considered as the symbol of religious mystery'. Lying on the sofa dying, as he was, I saw that singular expression of ferocity that used to take possession of his face if he surmised a quarrel was coming. I laid the sketch aside, but he kept staring at me; I refused to take up the gauntlet, and I could not venture to speak of the sketch itself, the style of drawing being so bad as to show his illness was destroying his work.

As the year drew to a close I was variously harassed and occupied, among other things, with reading my new poems to literary friends, and in trying to find a publisher, as, since the death of Mr. W. Longman, I had no interest in that world. Had it not been for the favourable verdict pronounced on the majority of my poems I would not have published at all; in Rossetti in particular, when very short readings sufficed to tire him, the old enthusiasm in my verse burst out, and the tears that came to his eyes were answered by mine, alas! from a different cause. One or two such effusions of feeling were the last flashes of ancient friendship I have to record.

Professor Marshall's object in sending young Mr. Maudsley and a nurse was to cure, by sub-cutaneous injections of morphia gradually decreased, his consumption of chloral—of late enormously enlarged by his increasing insomnia. The result was a complete success. Maudsley decreased the dose, and gradually diluted it without the knowledge and without the consciousness of the patient, till at last he injected only water, Rossetti actually going to sleep immediately after the operation! Altogether before this treatment, with its surprising result, a new idea had taken possession of his mind which caused us painful agitation. He wanted a priest to give him absolution for his sins! I mention this hallucination as I have related previous ones; for example, that of the chaffinch on the highway, so

long ago as 1869, not loving him the less but the more, sympathising with him almost mesmerically. Italian as he was, he had no living tie to the country, had never visited it, although Italy is conventionally the country of painting. His mother was affectionately attached to the Church of England, and his father's book of poems called Arpa Evangelica was evangelical enough. But the æsthetic side of anything was his exclusive interest; in poetry and in painting the mediæval period of history was necessary to him. Everything he ever did in either art was mediæval in date and in spirit, except his picture called 'Found' and his poem called 'Jenny', which had both one origin and inspiration. I am nearly certain he never entered a Romish church in his life, except to look at some picture that might be there, and that he knew simply nothing of its ritual or its sacraments.

At first no one took any notice of this demand for a confessor. We thought his mind wandering, or that he was dreaming. But on its earnest repetition, with his eyes open, I for one put him in mind of his not being a papist, and of his extreme agnosticism. 'I don't care about that', was his puzzling reply; 'I can make nothing of Christianity, but I only want a confessor to give me absolution for my sins!' This was so truly like a man living or rather dying in A.D. 1300, that it was impossible to do anything but smile. Yet he was serious, and went on: 'I believe in a future life. Have I not had evidence of that often enough? Have I not heard and seen those that died long years ago? What I want now is absolution for my sins, that's all!' 'And very little too', some outsider in the room whispered, as a gloomy joke; none of us, the deeply-interested few who heard him, could answer a word.

Shortly after this he had a slight attack of paralysis, or fancied he had. He was carried upstairs to bed, and never came down again. The difficulty in believing in his sensations made his illness a problem to every one, and I remember William Morris, when he came one evening to hear some of my new poems read, asking me if I really thought Rossetti so ill, or was he only acting

to keep those about him in suspense? I declared I knew him to be very ill, but Morris still hesitated to accept my assurance. He was in fact preparing to die. He became weaker, more natural, without the chloral, perhaps, but less vital; and one morning I was surprised by J.P. Selden, the architect, who had been building houses of the bungalow type at Birchington-on-the-Sea, calling with the information that he had placed one of them at the service of the invalid, who was, at the moment of our conversation, leaving for that place with the young doctor, and others attending. I felt it was too late to see him again, before going; but he never returned, so I saw him no more.

The picture I have drawn had been a painful one to witness in the original, and has been only less so to indicate in narrative, even carefully omitting the most repulsive elements of the scene. At Birchington he lived four months or more, till the 9th of April, but the presence of his mother and sister, Christina, cleared the air of the sickroom, and made the period sacred. I saw him no more.

My Poet's Harvest Home had been issued just the day before. Let me finish my task by my usual method, quoting, or giving entire letters of friends about it. Here is one from Morris himself:

> Kelmscott House, Upper Mall,
> Hammersmith, 27th April 1882.

My Dear Scott—I have never written to thank you for sending me your book, because I have been trying to get round to see you to do so in person, but I must put that off till next week; so I write now.

I have just the same impression on me now I have seen the poems in print, as I had when I heard you read them: that they are original and full of thought, and that their general atmosphere is most delightfully poetical and real; that there is real beauty about them, and I congratulate you heartily on the book, which for the rest is a very pretty little book...

> With best wishes, yours ever,
> William Morris

...[Another] is from Holman Hunt, somewhat autobiographic in its nature, and showing, moreover, that he had in his mind a renewal of the ancient amity and intercourse with D.G.R., which had died out with bitterness many years before. It is dated 17th April 1882.

My Dear Scott—My first thought on getting your little volume is to envy you. I wish so much that I could write poetry! I tried a little in early youth, but then, as with music at a still earlier time, and for somewhat similar reasons, i.e. that I had almost more than I could do to avoid being driven from painting, I was discouraged, and lost the chance, if ever I had one, of training my ear in the melody of sweet sounds. It seems to me that I have been assailed more than most men in attempts to work by obstructing demons, so that it has been impossible to listen duly to angels' lessons. In poetry, I may say, that I try to console myself by fancying out poems without words; but I long for the further power, that I might tell my dreams to others.

Although I have by no means had time to go through your little volume thoroughly, I have read enough to feel that the poems are very dainty and thoughtful, with that tender pitifulness that can only be expressed by an Ancient justified by confidence in the authority he holds, but who would not imitate the defiant neck of men of earlier days; an elder doubtful whether the objects of a holy war have not often been missed by the hectoring spirit of the young who have adopted the confidence in their mission of the enlisting sergeant. Your poems have the ripeness of Age without the loss of faith in effort which is so often a mark of length of days, and I treasure the book in the hope that some day I may talk to my children about its author as one they have desired to know more of.

Rossetti's death is ever in my mind, for all my old thoughts turn up in order to be fresh marked with the painful fact. I had long ago forgiven him, and forgotten the offence, which, in fact, taken altogether, worked me good rather than

harm; indeed, I had intended in recent times to call upon him, but the difficulties arising from this Jerusalem canvas had already humiliated my spirit so much, that when the visit was in question I felt the need of conquering the task before I went, and awakened memories of early days, when, partly by the noisy blundering of followers, we were driven to stand as though we were reckless in our challenge of the whole world of self-seeking fools. Illness of Rossetti hindered our meeting still more, and thus our talk over the past is deferred until our meeting in the Elysian fields, when, if, as you suggest in your little book, he may defer so long to drink the waters of Lethe, and I retain my memory so long, we may talk over back history as having nothing in it not atoned for and wiped out long ago, and as having value only as experience which has done its work in making us both wiser and better. Yours ever affectionately,

W. Holman Hunt.

What this ancient but now forgiven offence was we shall not now inquire…And so my Notes bring themselves to an end, at least as far as we can be sure of anything we say or do ending as long as we live. My work has not been Art for Art's sake, but truth for truth's sake. There is no other writing quite honourable for a man to do; and I shall miss the little task I have always fallen back upon as an occupation in the absence of any other more urgent in this pleasant retirement I enjoy, invalid as I am, waiting till the fatal bell shall call me home. The day is fine, warm day in late September; Miss Boyd and the gardener are among the flowers preparing for the next spring beforehand, by cutting and layering such as are preservable; so the seasons bring their everlasting repetition of interest. I shall go to join them…

## LITERATURE

**William Allingham**
**From *Evil May-Day* (1882)**

> Four ducks on a pond,
> A grass-bank beyond,
> A blue sky of spring,
> White clouds on the wing;
> What a little thing
> To remember for years—
> To remember with tears!

> Everything passes and vanishes;
> Everything leaves its trace;
> And often you see in a footstep
> What you could not see in a face.

**From *Blackberries* (1884)**

*Writing*

> A Man who keep a diary, pays
> Due toll to many tedious days;
> But life becomes eventful—then
> His busy hand forgets the pen.
> Most books, indeed, are records less
> Of fulness than of emptiness.

**From *Life and Phantasy* (1889)**

*Express* **(From Liverpool, Southwards)**

> We move in elephantine row,
>     The faces of our friends retire,
> The roof withdraws, and curtsying flow
>     The message-bearing lines of wire;
>         With doubling, redoubling beat,
>         Smoother we run and more fleet.

By flow'r-knots, shrubs, and slopes of grass,
    Cut walls of rock with ivy-stains,
Thro' winking arches swift we pass,
    And flying, meet the flying trains,
        Whirr-whirr-gone!
        And still we hurry on;

By orchards, kine in pleasant leas,
    A hamlet-lane, a spire, a pond,
Long hedgerows, counter-changing trees,
    With blue and steady hills beyond;
        (House, platform, post,
        Flash—and are lost!)

Smooth-edged canals, and mills on brooks;
    Old farmsteads, busier than they seem,
Rose-crusted or of graver looks,
    Rich with old tile and motley beam;
        Clay-cutting, slope, and ridge,
        The hollow rumbling bridge.

Gray vapour-surges, whirl'd in the wind
    Of roaring tunnels, dark and long,
Then sky and landscape unconfined,
    Then streets again where workers throng
        Come—go. The whistle shrill
        Controls us to its will.

Broad vents, and chimneys tall as masts,
    With heavy flags of streaming smoke;
Brick mazes, fiery furnace-blasts,
    Walls, waggons, gritty heaps of coke;
        Through these our ponderous rank
        Glides in with hiss and clank.

So have we sped our wondrous course
    Amid a peaceful busy land,
Subdued by long and painful force
    Of planning head and plodding hand.
        How much by labour can
        The feeble race of man!

# Philip Bourke Marston
## From *Wind-Voices* (1883)

### *The Old Churchyard of Bonchurch*[1]

The churchyard leans to the sea with its dead,—
It leans to the sea with its dead so long.
Do they hear, I wonder, the first bird's song,
When the winter's anger is all but fled;
The high, sweet voice of the west wind,
The fall of the warm, soft rain,
When the second month of the year
Puts heart in the earth again?

Do they hear, through the glad April weather,
The green grasses waving above them?
Do they think there are none left to love them,
They have lain for so long there, together?
Do they hear the note of the cuckoo,
The cry of gulls on the wing,
The laughter of winds and waters,
The feet of the dancing Spring?

Do they feel the old land slipping seaward,
The old land, with its hills and its graves,
As they gradually slide to the waves,
With the wind blowing on them from leeward?
Do they know of the change that awaits them,
The sepulchre vast and strange?
Do they long for the days to go over,
And bring that miraculous change?

Or love they their night with no moonlight,
With no starlight, no dawn to its gloom?
Do they sigh: "Neath the snow, or the bloom
Of the wild things that wave from our night,
We are warm, through winter and summer;
We hear the winds rave, and we say,—
"The storm-wind blows over our heads,
But we, here, are out of its way" '?

Do they mumble low, one to another,
With a sense that the waters that thunder
Shall ingather them all, draw them under,

---

1. This old churchyard has been for many years slipping toward the
    sea, which it is expected will ultimately engulf it.—Marston's note.

'Ah, how long to our moving, my brother?
How long shall we quietly rest here,
In graves of darkness and ease?
The waves, even now, may be on us,
To draw us down under the seas!'

Do they think 'twill be cold when the waters
That they love not, that neither can love them,
Shall eternally thunder above them?
Have they dread of the sea's shining daughters,
That people the bright sea-regions
And play with the young sea-kings?
Have they dread of their cold embraces,
And dread of all strange sea-things?

But their dread or their joy—it is bootless:
They shall pass from the breast of their mother;
They shall lie low, dead brother by brother,
In a place that is radiant and fruitless;
And the folk that sail over their heads
In violent weather
Shall come down to them, haply, and all
They shall lie there, together.

### The Ballad of Monk Julius

Monk Julius lived in a wild countrie,
And never a purer monk than he
Was vowed and wedded to chastity.

The monk was fair, and the monk was young,
His mouth seemed shaped for kisses and song,
And tender his eyes, and gentle his tongue.

He loved the Virgin, as good monks should,
And counted his beads, and kissed the rood,
But great was the pain of his manlihood.

'Sweet Mary Mother,' the monk would pray,
'Take thou this curse of the flesh away—
Give me not up to the devil's sway.

'Oh, make me pure as thine own pure Son;
My thoughts are fain to be thine, each one,
But body and soul are alike undone.'

And, even while praying, there came between
Himself who prayed and Heaven's own Queen
A delicate presence, more felt than seen—

The sense of woman though none was there,
Her beauty near him, her breath on the air,
Almost the touch of her hand on his hair;

And when night came, and he fell on sleep,
Warm tears in a dream his eyes would weep,
For fair, strange shapes that he might not keep—

The fair dream-girls who leaned o'er his bed,
Who held his hand, and whose kisses were shed
On his lips, for a monk's too full and red.

Oh fair dream-women, with flowing tresses
And loosened vesture! Their soft caresses
Thrilled him through to his soul's recesses.

He woke on fire, with rioting blood,
To scourge himself and to kiss the rood,
And to fear the strength of his manlihood.

One stormy night, when Christ's birth was nigh,
When snow lay thick, and the winds were high
'Twixt the large light land and the large light sky,

Monk Julius knelt in his cell's scant light,
And prayed, 'If any be out to-night,
Oh Mother Mary, guide them aright.'

Then there came to his ears, o'er the wastes of snow,
The dreadest of sounds, now loud, now low,
The cry of the wolves, that howl as they go.

Then followed a light, quick tap at the door;
The monk rose up from the cell's cold floor,
And opened it, crossing himself once more.

A girl stood there, and 'The wolves!' she cried,
'No danger now, daughter,' the monk replied,
And drew the beautiful woman inside,

For fair she was, as few women are fair,
Most tall and shapely; her great gold hair
Crowned her brows, that as ivory were.

Her deep blue eyes were two homes of light,
Soft moons of beauty to his dark night—
What fairness was this to pasture sight?

But the sight was sin, so he turned away
And knelt him down yet again to pray;
But not one prayer could his starved lips say.

And as he knelt he became aware
Of a light hand passing across his hair,
And a sudden fragrance filled the air.

He raised his eyes, and they met her own—
How blue hers were, how they yearned and shone!
Her waist was girt with a jewelled zone,

But aside it slipped from her silken vest,
And the monk's eyes fell on her snowy breast,
Of her marvellous beauty the loveliest.

The monk sprang up, and he cried, 'Oh bliss!'
His lips sought hers in a desperate kiss;
He had given his soul to make her his.

But he clasped no woman—no woman was there,
Only this laughter of fiends on the air;
The monk was snared in the devil's own snare.

## My Life

To me my life seems as a haunted house,
  The ways and passages whereof are dumb,
  Up whose decaying stair no footsteps come;
Lo, this the hall hung with sere laurel boughs,
Where long years back came victors to carouse;
  But none of all that company went home;
  For scarce their lips had quaffed the bright wine's
    foam,
When sudden Death brake dank upon their brows.

Here in this lonely, ruined house I dwell,
While unseen fingers toll the chapel bell;
Sometimes the arras rustles, and I see
  A half-veiled figure through time twilight steal,
Which, when I follow, pauses suddenly
  Before the door whereon is set a seal.

## Haunted Rooms

Must this not be, whate'er the years disclose,
  When I and those in whom my heart has vent,
  From whose dear lives soul-light to mine is sent,
Lie at the last beneath where the grass grows,
Make one, in one interminable repose,
  Not knowing whence we came or whither went,
  Done with regret, with black presentiment
Of greater griefs, yet more victorious foes—

Must this not be that one then dwelling here,
  Where one man and his sorrows dwelt so long,
  Shall feel the pressure of a ghostly throng,
And shall upon some desolate midnight hear
  A sound more sad than is the pine-trees' song,
And thrill with great, inexplicable fear?

## Buried Self

Where side by side we sat, I sit alone,
  But surely hear the absent voice—as one
  Who, playing, when the tune he plays is done,
Hears the spent music through the strings yet moan.
I rove, through places that my soul has known,
  Like the sad ghost of some departed nun
  Who comes between the moonrise and the sun,
To sit beside her monumental stone.

So by my buried self I take my seat,
  And talk with other ghosts of vanished days,
And watch grey shadows through the twilight fleet;
  And half expect to see the buried face
  Of my dead self rise in the silent place,
To look at me with mournful eyes and sweet.

### Late Love

With two who might have loved each other well
  Had they met earlier who meet too late,
  How does it fare? Do they keep separate,
Each one with feelings incommunicable;
Or are they as dear friends content to dwell
  In heart together till they change this state?
  Or may their sad and unaccomplished fate,
Instead of joining, wound them and repel?

As when, unjust, a father wills away
  His land and fortune from his rightful heirs,
They wronged, incensed, come after set of day,
  And thief-like gain the house and scale the stairs,
  And slay the invader, spite his threats and prayers;
Yet there for fear of judgment may not stay.

### Bridal Eve

Half robed, with gold hair drooped o'er shoulders
    white,
  She sits as one entranced, with eyes that gaze
  Upon the mirrored beauties of her face;
And through the distances of dark and light
She hears faint music of the coming night;
  She hears the murmurs of receding days;
  Her future life is veiled in such a haze
As hides, on sultry morns, the sun from sight.

Upon the brink of imminent change she stands,
  Glad, yet afraid to look beyond the verge;
She starts, as at the touch of unseen hands;
  Love's music grows half anthem and half dirge.
Strange sounds and shadows round her spirit fall,
Yet to herself she stranger seems than all.

### No Death

I saw in dreams a mighty multitude—
  Gathered, they seemed, from North, South, East
    and West,
  And in their looks such horror was exprest
As must forever words of mine elude.

As if tranfixed by grief, some silent stood,
  While others wildly smote upon the breast,
  And cried out fearfully, 'No rest, no rest!'
Some fled, as if by shapes unseen pursued.

Some laughed insanely. Others shrieking, said,
  'To think but yesterday we might have died;
For then God had not thundered, "Death is
    dead!"'
  They gashed themselves till all with blood were red.
  'Answer, O God; take back this curse!' they cried—
But 'Death is dead,' was all the voice replied.

### In Memory of D. G. Rossetti

What wreath have I above thy rest to place,
  What worthy song-wreath, Friend—nay, more
    than friend?
  For so thou didst all other men transcend
That the pure, fiery worship of old days—
That of the boy, content to hear, to gaze—
  Burned on most brightly, though as lamps none tend
  The lights on other shrines had made an end,
And darkness reigned where was the vestal blaze.

Far from us now thou art, and never again
  Thy magic voice shall thrill me as one thrills
When noblest music storms his heart and brain.
  The sea remembers thee, the woods, the hills,
  Sunlight and moonlight, and the hurrying rills;
And Love saith, 'Surely this man leads my train!'

## George Meredith
### From *Poems and Lyrics of the Joy of the Earth* (1883)

### The Woods of Westermain

1
Enter these enchanted woods,
    You who dare.
Nothing harms beneath the leaves

More than waves a swimmer cleaves.
Toss your heart up with the lark,
Foot at peace with mouse and worm,
  Fair you fare.
Only at a dread of dark
Quaver, and they quit their form:
Thousand eyeballs under hoods
  Have you by the hair.
Enter these enchanted woods,
  You who dare.

### 2

Here the snake across your path
Stretches in his golden bath:
Mossy-footed squirrels leap
Soft as winnowing plumes of Sleep:
Yaffles on a chuckle skim
Low to laugh from branches dim:
Up the pine, where sits the star,
Rattles deep the moth-winged jar
Each has business of his own;
But should you distrust a tone,
  Then beware.
Shudder all the haunted roods,
All the eyeballs under hoods
  Shroud you in their glare.
Enter these enchanted woods,
  You who dare…

## Lucifer in Starlight

On a starred night Prince Lucifer uprose.
Tired of his dark dominion swung the fiend
Above the rolling ball, in cloud part screened,
Where sinners hugged their spectre of repose.
Poor prey to his hot fit of pride were those.
And now upon his western wing he leaned,
Now his huge bulk o'er Afric's sands careened,
Now the black planet shadowed Arctic snows.
Soaring through wider zones that pricked his scars
With memory of the old revolt from Awe,
He reached a middle height, and at the stars,
Which are the brain of heaven, he looked, and sank.
Around the ancient track marched, rank on rank,
The army of unalterable law.

## The Orchard and the Heath

I chanced upon an early walk to spy
A troop of children through an orchard gate:
  The boughs hung low, the grass was high;
  They had but to lift hands or wait
For fruits to fill them; fruits were all their sky.

They shouted, running on from tree to tree,
And played the game the wind plays, on and round.
  'Twas visible invisible glee
  Pursuing; and a fountain's sound
Of laughter spouted, pattering fresh on me.

I could have watched them till the daylight fled,
Their pretty bower made such a light of day.
  A small one tumbling sang, 'Oh! head!'
  The rest to comfort her straightway
Seized on a branch and thumped down apples red.

The tiny creature flashing through green grass,
And laughing with her feet and eyes among
  Fresh apples, while a little lass
  Over as o'er breeze-ripples hung:
That sight I saw, and passed as aliens pass.

My footpath left the pleasant farms and lanes,
Soft cottage-smoke, straight cocks a-crow, gay flowers;
  Beyond the wheel-ruts of the wains,
  Across a heath I walked for hours,
And met its rival tenants, rays and rains.

Still in my view mile-distant first appeared,
When, under a patched channel-bank enriched
  With foxglove whose late bells dropped seared,
  Behold, a family had pitched
Their camp, and labouring the low tent unreared.

Here, too, were many children, quick to scan
A new thing coming; swarthy cheeks, white teeth;
  In many-coloured rags they ran,
  Like iron runlets of the heath.
Dispersed lay broth-pot, sticks, and drinking-can.

Three girls, with shoulders like a boat at sea
Tipped sideways by the wave (their clothing slid
    From either ridge unequally),
    Lean, swift and voluble, bestrid
A starting-point, unfrocked to the bent knee.

They raced; their brothers yelled them on, and broke
In act to follow, but as one they snuffed
    Wood-fumes, and by the fire that spoke
    Of provender its pale flame puffed,
And rolled athwart dwarf furzes grey-blue smoke.

Soon on the dark edge of a ruddier gleam,
The mother-pot perusing, all, stretched flat,
    Paused for its bubbling-up supreme:
    A dog upright in circle sat,
And oft his nose went with the flying steam.

I turned and looked on heaven awhile, where now
The moor-faced sunset broaden'd with red light;
    Threw high aloft a golden bough,
    And seemed the desert of the night
Far down with mellow orchards to endow.

### From *A Reading of Earth* (1888)

### *Dirge in Woods*

    A wind sways the pines,
        And below
    Not a breath of wild air;
    Still as the mosses that glow
    On the flooring and over the lines
    Of the roots here and there.

    The pine-tree drops its dead;
    They are quiet, as under the sea.
    Overhead, overhead
    Rushes life in a race,
    As the clouds the clouds chase;
        And we go,
    And we drop like the fruits of the tree,
        Even we,
        Even so.

### *Meditation under Stars*

What links are ours with orbs that are
    So resolutely far:
The solitary asks, and they
Give radiance as from a shield:
    Still at the death of day,
    The seen, the unrevealed.
    Implacable they shine
To us who would of Life obtain
An answer for the life we strain
    To nourish with one sign.
Nor can imagination throw
The penetrative shaft: we pass
The breath of thought, who would divine
    If haply they may grow
As Earth; have our desire to know;
If life comes there to grain from grass,
And flowers like ours of toil and pain;
    Has passion to beat bar,
    Win space from cleaving brain;
    The mystic link attain,
    Whereby star holds on star.

Those visible immortals beam
    Allurements to the dream:
Ireful at human hungers brook
    No question in the look.
For ever virgin to our sense,
Remote they wane to gaze intense:
Prolong it, and in ruthlessness they smite
The beating heart behind the ball of sight:
    Till we conceive their heavens hoar,
Those lights they raise but sparkles frore,
And Earth, our blood-warm Earth, a shuddering
        prey
To the frigidity of brainless ray.

Yet space is given for breath of thought
Beyond our bounds when musing: more
When to that musing love is brought,
And love is asked of love's wherefore.
'Tis Earth's, her gift; else have we nought:
Her gift, her secret, here our tie.
And not with her and yonder sky?

Bethink you: were it Earth alone
Breeds love, would not her region be
    The sole delight and throne
    Of generous Deity?

    To deeper than this ball of sight
Appeal the lustrous people of the night.
Fronting yon shoreless, sown with fiery sails,
    It is our ravenous that quails,
Flesh by its craven thirsts and fears distraught.
    The spirit leaps alight,
    Doubts not in them is he,
The binder of his sheaves, the sane, the right:
Of magnitude to magnitude is wrought,
To feel it large of the great life they hold:
In them to come, or vaster intervolved,
The issues known in us, our unsolved solved:
That there with toil Life climbs the self-same
        Tree,
Whose roots enrichment have from ripeness
        dropped.
So may we read and little find them cold:
Let it but be the lord of Mind to guide
Our eyes; no branch of Reason's growing lopped;
Nor dreaming on a dream; but fortified
By day to penetrate black midnight; see,
Hear, feel, outside the senses; even that we,
The specks of dust upon a mound of mould,
We who reflect those rays, though low our place,
    To them are lastingly allied.

So may we read, and little find them cold:
Not frostly lamps illumining dead space,
Not distant aliens, not senseless Powers.
The fire is in them whereof we are born;
The music of their motion may be ours.
Spirit shall deem them beckoning Earth and
        voiced
Sisterly to her, in her beams rejoiced.
Of love, the grand impulsion, we behold
    The love that lends her grace
    Among the starry fold.
Then at new flood of customary morn,
    Look at her through her showers,
    Her mists, her steaming gold,

A wonder edges the familiar face:
She wears no more that robe of printed hours;
Half strange seems Earth, and sweeter than
    her flowers.

### Breath of the Briar

1

O briary-scents, on yon wet wing
Of warm South-west wind brushing by,
You mind me of the sweetest thing
That ever mingled frank and shy:
When she and I, by love enticed,
Beneath the orchard-apples met,
In equal halves a ripe one sliced,
And smelt the juices ere we ate.

2

That apple of the briar-scent,
Among our lost in Britain now,
Was green of rind, and redolent
Of sweetness as a milking cow.
The briar gives it back, well nigh
The damsel with her teeth on it;
Her twinkle between frank and shy.
My thrist to bite where she had bit.

## William Morris

You may hang your walls with tapestry
instead of whitewash or paper; or you may
cover them with mosaic; or have them
frescoed by a great painter: all this is not
luxury, if it be done for beauty's sake, and
not for show: it does not break our golden
rule: Have nothing in your houses which
you do not know to be useful or believe to
be beautiful…

    *The Beauty of Life*, 1880

### *Art and the People: A Socialist's Protest against Capitalist Brutality; Addressed to the Working Class* (1883)

*• Literacy rate went way up in 19ᶜ, so working class could read this*

Fellow citizens,

I wish to say a few plain words to you on the subject of art; and since I address myself chiefly to those who are called the working classes, I know well that the plainer those words are the better, since now for many years, for centuries, the working-class have scarcely been partakers in art of any kind, and the phraseology of men learned in the fine arts will be strange to you. For centuries this slavery has been added to the rest of the oppression under which you lie, that you have been forbidden to have any share in the intelligent production of beautiful things.

Indeed, I think it will be news to many of you who toil to live that you may live to toil, that there either is or has been or can be any connexion between Art and the People. It may seem to you, I can well imagine, that art is concerned only in making luxurious toys for rich and idle persons, and that all the working-classes have to do with it, is that some of them can earn their poor wages by working at it as machines work, without knowing or caring what they are doing; while now and then on holidays those of them that chance to think of it and who live in London may stray into the National Gallery or the British Museum, and see the carefully hoarded works of past ages, and get from them such good as men can get who look on a book in an antiquated dialect of their language without an interpreter between them and the past.

And yet there is a phrase which of late has been much in the mouths of those who have been thought to be interested in the welfare of the Fine Arts; they have talked much of Popular Art: what does that mean? *4-17-00*

The words Popular Art, or Art of the People, have a meaning you may be sure; the thing which they mean has really existed, or you would have little to look at when you stray into the National Gallery and the British Museum: the Art of the

People has in many places and in many times solaced and sustained the people amidst their griefs and troubles.

And a great gift such an art seems to me; an art made intelligently by the whole body of those who live by their labour: instinct with their thoughts and aspirations, moving whither they are moving, changing as they change, the genuine expression of their sense of the beauty and mystery of life: an art born of their joy and outliving their sorrow, though tinged by it: an art leaving to future ages living witness of the existence of deft hands and eager minds not too proud to tell us of their imperfect thoughts and their glimpses of insight into wonders and terrors, as they passed amid the hurry of their daily work through the sunshine and the shadow of their lives…

The sad truth is that there is no popular art to-day, no art which represents the feelings and aspirations of the people at large, as for example the buildings of the Middle Ages represented the feelings and aspirations of the people, gentle and simple, lay and clerk, of that period.

This then is the condition of the fine arts under the rule of Plutocracy: on the one side there remains of the higher intellectual art, the work of poets, painters, and the like, a very small remnant struggling amidst a thicket of pretence and imposture: this remnant is lofty in aim and is not without special skill of its own; but it is quite unregarded by, indeed unknown to the people in general, and is but ill understood even among the cultivated classes by all but a very few.

On the other side of what used to be popular art there remains but a ghastly pretence of ornament which is nothing but a commercial imposture, or at best but a foolish survival of a half-remembered habit.

That I say is all the art we have left us; we in the heyday of civilization, we who, as many people confidently believe, have at last perfected our social system, and arranged for it to endure for ever in that perfect form…

As far as the mass of people is concerned art

is gone or all but gone from the daily life of man in civilized countries, and I say that is no mere accident but a necessary consequence of the rule of plutocratic anarchy: some branches of human invention can live under that tyranny: it allows learned men to seek out the secrets of nature and to subdue her forces because these matters can be turned to the advantage of the profit-market. But in art, the romance of each day's life, there is nothing 'practical' that is convertible into money, so long as it is real: all plutocray can do is to degrade it into an hypocrisy, a sham of real feeling and insight, a set of counters for the picture-dealers; it can do that and in the end kill it, but it cannot use it.

Yes, art is not far from actual death and beauty is fading out of the land before the poison of riches. Green and beautiful places are still left in the countryside of England, but the hand of decay is on them; the life of man is poor and slavish there, and his dwellings, the sure token of the life led in them, which were once sound, trim, and beautiful, are giving place to miserable abortions which it is a pain and grief to look at; mere scrapings from the heaps of filth where you working-men live and which we call great cities.

And those terrible and frightful places; this horror we call London, or those worse because filthier hells the manufacturing districts—if ever the world escapes from the nightmare of riches and poverty which now oppresses us, will people from the midst of order and peace be able to understand what they were like?

And if we choose to consider the matter and face what must be the future unless this living death of Commercialism is swept away, do we not know what it must come to, supposing that national ruin does not overtake us? no rest, no beauty, no leisure anywhere: all England become like the heart of Lancashire is now: a breeding-stye for flesh and blood machines for the production of the profit of capital: machines, yes, but men also who, dimly perhaps, but miserably certainly, will be conscious us of their own degradation.

Yes, it may be that Commercialism will find

for us plenty of food and clothes and house-room, comforts even or luxuries; for us, I say, for most of us. It may be that, though it must have a body of abject poverty to serve it, it will produce so many rich men, and so many well-to-do men down to the class of the well fed prosperous artizan, that the class of the *poor* slaves will not be very numerous and will be powerless: that I know is the ideal of a large body of so-called advanced thinkers; and they may realize it, though I do not think they will, as I fervently hope they will not: for art, or the beauty of life, would be wholly lacking to all these classes, rich, middle-class, and poor; they would pass a wretched bestial degraded existence, and the hope of the progress of the race would have perished.

What is to save us from this misery, this hell? What but a Social Revolution which shall take away from men at once the power and the temptation of accumulating riches or in other words of keeping a body of slaves to do their dirty work for them: a Revolution which by abolishing men's power of making a profit from their fellows' labour will abolish all classes: not the mere arbitrary distinction between lord and commoner, gentleman and worker, but the real and dreadful distinction between rich man and poor, between the cultivated and the ignorant, between the refined and the brutal, which now exists, and is the foundation of plutocratic society.

I know as surely as I know that I breathe, that this Social Revolution would give to each and all of us a fair share of the good and evil of life: we should have our fair share of troublesome work and no more than our fair share: for we should not then be set to work for the sake of working: there would no longer be any need to cumber the world with mountains of useless wares: no need to weary ourselves with making either the idiotic toys of the rich, or the miserable rags of the poor, which form now by far the greater part of the baggage of commerce.

In all our work would be hope, and the greater part of it would be a labour of love, given freely and happily to the commonweal, as the

commonweal would freely and ungrudgingly supply our needs for us: the hours of such work would to most of us be the happiest, but mere rest, time for thought, or dreaming even, would not be lacking to us, nor in any wise be grudged to us.

Then we should have nature beautiful around us again, for surely then no disgrace of foulness in air or water would be suffered, nor would it in anywise need to be, with science set free from the huckster's fetters: and remember once more it is not mere carelessness of beauty as we are now, the serving of our real needs, that has turned half England into a foul and greasy cinderheap, but the insatiable compulsion of commerce on us to make an extra profit from labour we know not for what or for whom.

Doubt it not that from all this art would spring art in all forms, great and glorious, full of hope with eyes always turned towards perfection.

Is it a dream? If so then let us give up all striving for progress: do not let us worry ourselves about politics, but stand by and grin as one knave pushes the other out of the saddle; for one or another will be much the same to us: let us eat and drink for to-morrow we die—or better still let us die to-day.

It is no dream but a cause; men and women have died for it, not in the ancient days but in our own time: they lie in prison for it, work in mines, are exiled, are ruined for it: believe me when such things are suffered for dreams, the dreams come true at last.

But how is the change to be brought about?

The minds and hearts of men must be set on bringing it about; that is clear; no noise of people puffing themselves will do it, no mere electioneering dodges, no mere clattering of fine phrases amongst those who perfectly well agree with each other; it must come from the hearts of men who are resolved on it. Yet do not mistake my meaning; I have heard several people say: This is a thing which must be the gradual birth of opinion; therefore we, though we think the change necessary, must take no active measures to bring it about, but let it grow spontaneously.

Friends, such words may have the appearance of philosophical wisdom and forbearance and tolerance, but I fear their meaning is, *I durst not though I would.*

What other sign can there be of the growth of spontaneous opinion save eager and active attempts to spread that opinion? is the opinion never to result in action? and if ever when? if 'tis too early to-day, will it be late enough to-morrow? Alas! for some of us it will be too late; for every minute while we speak our fellows and friends are living in degradation and dying in despair.

I say it is the plain duty of those who believe in the necessity of social revolution, quite irrespectively of any date they may give to the event, first to express their own discontent and hope when and where they can, striving to impress it on others; secondly to learn from books and from living people who are willing, or I will say, who can be made, to teach them, in as much detail as possible what are the ends and the hopes of Social Revolution; and thirdly to join any body of men which is honestly striving to give means of expression to that discontent and hope, and to teach people the details of the aim of Constructive Revolution. You will understand that although I have numbered these duties first, second, and third, they must be all set about together: you can neither express your discontent nor learn what hopes there are of making it fruitful without union with others who have those aims in view.

And mind you by union I mean a very serious matter: I mean sacrifice to the Cause of leisure, pleasure and money each according to his means: I mean sacrifice of individual whims and vanity, of individual misgivings, even though they may be founded on reason, as to the means which the organizing body may be forced to use: remember without organization the cause *is* but a vague dream, which may lead to revolt, to violence and disorder, but which will be speedily repressed by those who are blindly interested in sustaining the present anarchical tyranny which is misnamed Society: remember also that no organization is possible without the sacrifices I have been

speaking of; without obedience to the necessities of the Cause.

Educate, Agitate, Organize; these words the motto of our Federation do most completely express what is necessary to be done by those who have any hope in the future of the People.

To feel the wrongs which oppress ourselves and our fellows, to learn what remedies there are for them, to declare openly the wrongs and remedies and to band together to make that declaration effective: how can those who wish to call themselves free and honest do less than this?

And the consequences that may come of our action? What can they be in the long run save peace and order? You who fear revolt, you who fear revolution, think what blind revolt and aimless revolution may mean; shake off at least enough of your cowardice and sloth to consider what must be the consequences of blind repression, of aimless upholding of a state of Society where side by side with refinement and cultivation dwell brutality and ignorance; and in which this dreadful contrast is not an accident but a necessity of the existence of your boasted civilized society.

I tell you civilization will begin on the day when we determine that Riches and Poverty shall disappear into one commonweal of happy people. I tell you that civilization, long talked of much boasted of never yet attained, will begin on the day when the organization of the claims of labour is strong enough to force on society the acceptance of those claims: when the necessary and inevitable revolution, the child of all the long centuries of history, which while we speak is being born out of the corruption of the organized anarchy which it is doomed to destroy, when that revolution shall take definite and orderly form, and sweep away for ever the two great foes of humanity, riches and poverty.

It is for you working men to attain this end: learn what you have to claim and unite to claim it: who or what can resist you then?

## Under an Elm-Tree; or, Thoughts in the Countryside (6 July 1889)

Midsummer in the country; here you may walk between the fields and hedges that are as it were one huge nosegay for you, redolent of bean-flowers and clover and sweet hay and elder-blossom. The cottage-gardens are bright with flowers, the Cottages themselves mostly models of architecture in their way. Above them towers here and there the architecture proper of days bygone, when every craftsman was an artist and brought definite intelligence to bear upon his work. Man in the past, nature in the present, seem to be bent on pleasing you and making all things delightful to your senses; even the burning dusty road has a look of luxury as you lie on the strip of roadside green, and listen to the blackbirds singing, surely for your benefit, and, I was going to say, as if they were paid to do it, but I was wrong, for as it is they seem to be doing their best.

And all, or let us say most, things are brilliantly alive. The shadowy bleak in the river down yonder, which—ignorant of the fate that Barking Reach is preparing for its waters—is sapphire blue under this ruffling wind and cloud-less sky, and barred across here and there with the pearly white-flowered waterweeds, every yard of its banks a treasure of delicate design, meadow-sweet and dewberry, and comfrey and bedstraw: from the bleak in the river, among the labyrinth of grasses, to the starlings busy in the new-shorn fields, or about the grey ridges of the hay, all is eager, and I think all is happy that is not anxious.

What is that thought that has come into one's head as one turns round in the shadow of the roadside elm? A countryside worth fighting for, if that were necessary, worth taking trouble to defend its peace. I raise my head, and betwixt the elm-boughs I see far off a grey buttressed down rising over the sea of green and blue-green meadows and fields, and dim on the flank of it over its buttresses I can see a quaint figure made by cutting the short turf away from the chalk of the hillside; a figure which represents a White Horse

according to the heraldry of the period, eleven hundred years ago. Hard by the hillside the country people of the day did verily fight for the peace and loveliness of this very country where I lie, and coming back from their victory scored the image of the White Horse as a token of their valour, and, who knows? perhaps as an example for their descendants to follow.

For a little time it makes the blood stir in me as I think of that; but as I watch the swallows flitting past me betwixt hedge and hedge, or mounting over the hedge in an easy sweep and hawking over the bean-field beyond, another thought comes over me. These live things I have been speaking of, bleak and swallows and starlings and blackbirds, are all after their kind beautiful and graceful, not one of them is lacking in its due grace and beauty; but yesterday as I was passing by a hay-field there was an old red-roan cart-horse looking seriously but good-humouredly at me from a gap in the hedge, and I stopped to make his acquaintance, and I am sorry to say that in spite of his obvious merits he was ugly, Roman-nosed, shambling, ungainly: yet how useful had he been—for others. Also the same day (but not in the same field) I saw some other animals, male and female, with whom also I made acquaintance, for the male ones at least were thirsty. And these animals, both male and female, were ungraceful, unbeautiful, for they were making hay before my eyes. Then I bethought me that as I had seen starlings in Hertfordshire that were of the same race as the Thames-side starlings, so I had seen or heard of featherless, two-legged animals of the same race as the thirsty creatures in the hay-field; they had been sculptured in the frieze of the Parthenon, painted on the ceiling of the Sistine chapel, imagined in literature as the heroes and heroines of romance; nay, when people had created in their minds a god of the universe, creator of all that was, is, or shall be, they were driven to represent him as one of that same race to which the thirsty haymakers belonged; as though supreme intelligence and the greatest measure of gracefulness and beauty and majesty were at their

highest in the race of those ungainly animals.

Under the elm-tree these things puzzle me, and again my thoughts return to the bold men of that very countryside who, coming back from Ashdown field, scored that White Horse to look down for ever on the valley of the Thames; and I thought it likely that they had this much in common with the starlings and the bleak, that there was more equality among them than we are used to now, and that there would have been more models available amongst them for Woden than one would be like to find in the Thames-side meadows.

Under the elm-tree I don't ask myself whether that is owing to the greater average intelligence of men at the present day, and to the progress of humanity made since the time of the only decent official that England ever had: Alfred the Great, to wit; for indeed the place and time are not favourable to such questions, which seem sheer nonsense amidst of all that waste of superabundant beauty and pleasure held out to men who cannot take it or use it, unless some chance rich idler may happen to stray that way. My thoughts turn back to the haymakers and their hopes, and I remember that yesterday morning I said to a bystander, 'Mr So-and-so (the farmer) is late in sending his men into the hay-field.'

Quoth he, 'You see, sir, Mr So-and-so is short-handed.'

'How's that?' said I, pricking up my Socialist ears.

'Well, sir,' said he, 'these men are the old men and women bred in the village, and pretty much past work; and the young men with more work in them, they do think that they ought to have more wages than them and Mr So-and-so he won't pay it. So you see, he be short-handed.'

As I turned away, thinking over all the untold, untellable details of misery that lay within this shabby sordid story, another one met my ears. A labourer of the village comes to a farmer and says to him that he really can't work for 9s. a week any more, but must have 10s. Says the farmer, 'Get your 10s. somewhere else then.' The man turns

away to two months' lack of employment, and then comes back begging for his 9s. slavery.

Commonplace stories of unsupported strikes, you will say. Indeed they are, if not they would be easily remedied; the casual tragedy cut short; the casual wrong-doer branded as a person out of humanity. But since they are so commonplace—

What will happen, say my gloomy thoughts to me under the elm-tree, with all this country beauty so tragically incongruous in its richness with the country misery which cannot feel its existence? Well, if we must still be slaves and slave-holders, it will not last long: the Battle of Ashdown will be forgotten for the last commercial crisis: Alfred's heraldry will yield to the lions on the half crown. The architecture of the crafts-gildsmen will tumble down, or be 'restored' for the benefit of hunters of the picturesque, who, hopeless themselves, are incapable of understanding the hopes of past days, or the expression of them. The beauty of the landscape will be exploited and artificialized for the sake of villa-dwellers' purses where it is striking enough to touch their jaded appetites; but in quiet places like this it will vanish year by year (as indeed it is now doing) under the attacks of the most grovelling commercialism.

Yet think I to myself under the elm-tree, whatever England, once so beautiful, may become, it will be good enough for us if we set no hope before us but the continuance of a population of slaves and slave-holders for the country which we pretend to love, while we use it and our sham love for it as a stalking-horse for robbery of the poor at home and abroad. The worst outward ugliness and vulgarity will be good enough for such sneaks and cowards.

Let me turn the leaf and find a new picture, or my holiday is spoilt; and don't let some of my Socialist friends with whom I have wrangled about the horrors of London say, 'This is all that can come of your country life.' For as the round of the seasons under our system of landlord, farmer and labourer produces in the country pinching parsimony and dulness, so does the 'excitement of intellectual life' in the cities produce the slum under the capitalist system of turning out and selling market wares not for use but for waste. Turn the page, I say. The hay-field is a pretty sight this month seen under the elm, as the work goes forward on the other side of the way opposite to the bean-field, till you look at the haymakers closely. Suppose the haymakers were friends working for friends on land which was theirs, as many as were needed, with leisure and hope ahead of them instead of hopeless toil and anxiety. Need their useful labour for themselves and their neighbours cripple and disfigure them and knock them out of the shape of men fit to represent the Gods and Heroes? If under such conditions a new Ashdown had to be fought (against *capitalist* robbers this time), the new White Horse would look down on the home of men as wise as the starlings, in their *equality*, and so perhaps as happy.

## Arthur O'Shaughnessy
**From *Songs of a Worker* (1881)**

### Song

When the Rose came I loved the Rose,
    And thought of none beside,
Forgetting all the other flowers,
    And all the others died;
And morn and noon, and sun and showers,
And all things loved the Rose,
    Who only half returned my love,
Blooming alike for those.

I was the rival of a score
    Of loves on gaudy wing,
The nightingale I would implore
    For pity not to sing;
Each called her his; still I was glad
    To wait or take my part;
I loved the Rose—who might have had
    The fairest lily's heart.

## Eden

Weary and wandering, hand in hand,
    Through ways and cities rough,
And with a law in every land
    Written against our love,
We set our hearts to seek and find,
Forgotten now and out of mind,
    Lost Eden garden desolate,
Hoping the angel would be kind,
    And let us pass the gate.

We turned into the lawless waste
    Wild outer gardens of the world—
We heard awhile our footsteps chased,
    Men's curses at us hurled;
But safe at length, we came and found,
Open with ruined wall all round,
    Lost Eden garden desolate;
No angel stood to guard the ground
    At Eden garden gate.

We crossed the flower-encumbered floor,
    And wandered up and down the place,
And marvelled at the open door
    And all the desolate grace
And beast and bird with joy and song
That broke man's laws the whole day long;
    For all was free in Eden waste:
There seemed no rule of right and wrong,
    No fruit we might not taste.

Our hearts, o'erwhelmed with many a word
    Of bitter scathing, human blame,
Trembled with what they late had heard,
    And fear upon us came,
Till, finding the forbidden tree,
We ate the fruit, and stayed to see
    If God would chide our wickedness;
No God forbade my love and me
    In Eden wilderness.

The rose has overgrown the bower
    In lawless Eden garden waste,
The eastern flower and western flower

Have met and interlaced;
The trees have joined above and twined
And shut out every cruel wind
    That from the world was blown:
Ah, what a place for love to find
    Is Eden garden grown!

The fair things exiled from the earth
    Have found the way there in a dream;
The phoenix has its fiery birth
    And nests there in the gleam;
Love's self, with draggled rainbow wings,
At rest now form his wanderings,
    In Eden beds and bowers hath lain
So long, no wealth of worldly kings
    Will win him back again.

And now we need not fear to kiss;
    The serpent is our playfellow,
And tempts us on from bliss to bliss,
    No man can see or know.
Loved was turned out of Eden first
By God, and then of man accurst;
    And fleeing long from human hate,
And counting man's hard laws the worst,
    Returned to Eden gate.

Now every creature there obeys
    Exuberantly his lawless power;
The wall is overthrown, the ways
    Ruined by bird and flower;
The nuptial riot of the rose
Runs on for centuries and grows;
    The great heart of the place is strong—
It swells in overmastering throes
    Of passionate sigh and song.

And while we joy in Eden's state,
    Outside men serve a loveless lord;
They think the angel guards the gate
    With burning fiery sword!
Ah, fools! he fled an age ago,
The roses pressed upon him so,
    And all the perfume from within,
And he forgot or did not know:
    Eden must surely win.

## Christina Rossetti
### From *A Pageant and Other Poems* (1881)

### *Pastime*

A boat amid the ripples, drifting, rocking,
    Two idle people, without pause or aim;
While in the ominous west there gathers darkness
    Flushed with flame.

A haycock in a hayfield backing, lapping,
    Two drowsy people pillowed around about;
While in the ominous west across the darkness
    Flames leaps out.

Better a wrecked life than a life so aimless,
    Better a wrecked life than a life so soft;
The ominous west glooms thundering, with its fire
    Lit aloft.

### *A Life's Parallels*

Never on this side of the grave again,
    On this side of the river,
On this side of the garner of the grain,
      Never,—

Ever while time flows on and on and on,
    That narrow noiseless river,
Ever while corn bows heavy-headed, wan,
      Ever,—

Never despairing, often fainting, ruing,
    But looking back, ah never!
Faint yet pursuing, faint yet still pursuing
      Ever.

### *At Last*

Many have sung of love a root of bane:
      While to my mind a root of balm it is,
    For love at length breeds love; sufficient bliss
For life and death and rising up again.

Surely when light of Heaven makes all things plain,
    Love will grow plain with all its mysteries;
    Nor shall we need to fetch from over seas
Wisdom or wealth or pleasure safe from pain.
Love in our borders, love within our heart,
    Love all in all, we then shall bide at rest,
    Ended for ever life's unending quest,
      Ended for ever effort, change and fear:
Love all in all;—no more that better part
    Purchased, but at the cost of all things here.

### *'One Foot on Sea, and One on Shore'*

'Oh tell me once and tell me twice
    And tell me thrice to make it plain,
When we who part this weary day,
    When we who part shall meet again.'

'When windflowers blossom on the sea
    And fishes skim along the plain,
Then we who part this weary day,
    Then you and I shall meet again.'

'Yet tell me once before we part,
    Why need we part who part in pain?
If flowers must blossom on the sea,
    Why, we shall never meet again.

'My cheeks are paler than a rose,
    My tears are salter than the main,
My heart is like a lump of ice
    If we must never meet again.'

### *'Summer is Ended'*

To think that this meaningless thing was ever a rose,
    Scentless, colourless, *this*!
      Will it ever be thus (who knows?)
        Thus with our bliss,
      If we wait till the close?

Tho' we care not to wait for the end, there comes the end
    Sooner, later, at last,
  Which nothing can mar, nothing mend:
    An end locked fast,
    Bent we cannot re-bend.

## Passing and Glassing

    All things that pass
    Are woman's looking-glass;
They show her how her bloom must fade,
And she herself be laid
With withered roses in the shade;
    With withered roses and the fallen peach,
    Unlovely, out of reach
      Of summer joy that was.

    All things that pass
    Are woman's tiring-glass;
The faded lavender is sweet,
Sweet the dead violet
Culled and laid by and cared for yet;
    The dried-up violets and dried lavender
    Still sweet, may comfort her,
      Nor need she cry Alas!

    All things that pass
    Are wisdom's looking-glass;
Being full of hope and fear, and still
Brimful of good or ill,
According to our work and will;
    For there is nothing new beneath the sun;
    Our doings have been done,
      And that which shall be was.

## The Thread of Life

### 1

The irresponsive silence of the land,
  The irresponsive sounding of the sea,
  Speak both one message of one sense to me:—
Aloof, aloof, we stand aloof, so stand
Thou too aloof bound with the flawless band

Of inner solitude; we bind not thee;
  But who from thy self-chain shall set thee free?
What heart shall touch thy heart? what hand
    thy hand?—
And I am sometimes proud and sometimes meek,
  And sometimes I remember days of old
When fellowship seemed not so far to seek
  And all the world and I seemed much less cold,
  And at the rainbow's foot lay surely gold,
And hope felt strong and life itself not weak.

### 2

Thus am I mine own prison. Everything
  Around me free and sunny and at ease:
  Or if in shadow, in a shade of trees
Which the sun kisses, where the gay birds sing
And where all winds make various murmuring;
  Where bees are found, with honey for the bees;
  Where sounds are music, and where silences
Are music of an unlike fashioning.
Then gaze I at the merrymaking crew,
  And smile a moment and a moment sigh
Thinking: Why can I not rejoice with you?
  But soon I put the foolish fancy by:
I am not what I have nor what I do;
  But what I was I am, I am even I.

### 3

Therefore myself is that one only thing
  I hold to use or waste, to keep or give;
  My sole possession every day I live,
And still mine own despite Time's winnowing.
Ever mine own, while moons and seasons bring
  From crudeness ripeness mellow and sanative;
  Ever mine own, till Death shall ply his sieve;
And still mine own, when saints break grave and sing.
And this myself as king unto my King
  I give, to Him Who gave Himself for me;
Who gives Himself to me, and bids me sing
  A sweet new song of His redeemed set free;
He bids me sing: O death, where is thy sting?
  And sing: O grave, where is thy victory?

## From *Monna Innominata*

2

*'Era già l'ora che volge il desio.'*—Dante
*'Ricorro al temp ch'io vi vidi prima.'*—Petrarca

I wish I could remember that first day,
   First hour, first moment of your meeting me,
   If bright or dim the season, it might be
Summer or Winter for aught I can say;
So unrecorded did it slip away,
   So blind was I to see and to forsee,
   So dull to mark the budding of my tree
That would not blossom yet for many a May.
If only I could recollect it, such
   A day of days! I let it come and go
   As traceless as a thaw of bygone snow;
It seemed to mean so little, meant so much;
If only now I could recall that touch,
   First touch of hand in hand—Did one but know!

3

*'O ombre vane, fuor che ne l'aspetto!'*—Dante
*'Immaginata guida la conduce.'*—Petrarca

I dream of you to wake: would that I might
   Dream of you and not wake but slumber on;
   Nor find with dreams the dear companion gone,
As Summer ended Summer birds take flight.
In happy dreams I hold you full in sight,
   I blush again who waking look so wan;
   Brighter than sunniest day that ever shone,
In happy dreams your smile makes day of night.
Thus only in a dream we are at one,
   Thus only in a dream we give and take
The faith that maketh rich who take or give;
   If thus to sleep is sweeter than to wake,
   To die were surely sweeter than to live,
Though there be nothing new beneath the sun.

### 4

'*Poca favilla gran fiamma seconda.*'—Dante
'*Ogni altra cosa, ogni pensier va fore,*
   *E sol ivi con voi rimansi amore.*'—Petrarca

I loved you first: but afterwards your love
   Outsoaring mine; sang such a loftier song
As drowned the friendly cooings of my dove.
   Which owes the other most? my love was long,
   And yours one moment seemed to wax more strong;
I loved and guessed at you, you construed me
And loved me for what might or might not be—
   Nay, weights and measures do us both a wrong.
For verily love knows not 'mine' or 'thine;'
   With separate 'I' and 'thou' free love has done,
   For one is both and both are one in love:
Rich love knows nought of 'thine that is not mine;'
Both have the strength and both the length thereof,
   Both of us of the love which makes us one.

### 11

'*Vien dietro a me e lascia dir le genti.*'—Dante
'*Contando i casi della vita nostra.*'—Petrarca

Many in aftertimes will say of you
'He loved her'— while of me what will they say?
   Not that I loved you more than just in play,
For fashion's sake as idle women do.
Even let them prate; who know not what we knew
   Of love and parting in exceeding pain,
   Of parting hopeless here to meet again,
Hopeless on earth, and heaven is out of view.
But by my heart of love laid bare to you,
   My love that you can make not void nor vain,
Love that foregoes you but to claim anew
   Beyond this passage of the gate of death,
   I charge you at the Judgment make it plain
   My love of you was life and not a breath.

## 12

*'Amor, che ne la mente me ragiona.'*—Dante
*'Amor vien nel bel viso di costei.'*—Petrarca

If there be any one can take my place
　　And make you happy whom I grieve to grieve,
　　Think not that I can grudge it, but believe
I do commend you to that nobler grace,
That readier wit than mine, that sweeter face;
　　Yea, since your riches make me rich, conceive
　　I too am crowned, while bridal crowns I weave,
And thread the bridal dance with jocund pace.
For if I did not love you, it might be
　　That I should grudge you some one dear delight;
But since the heart is yours that was mine own,
　　Your pleasure is my pleasure, right my right,
Your honourable freedom makes me free,
　　And you companioned I am not alone.

## 14

*'E la Sua Volontade è nostra pace.'*—Dante
*'Sol con questi pensier, con altre chiome.'*—Petrarca

Youth gone, and beauty gone if ever there
　　Dwelt beauty in so poor a face as this;
　　Youth gone and beauty, what remains of bliss?
I will not bind fresh roses in my hair,
To shame a cheek at best but little fair,—
　　Leave youth his roses, who can bear a thorn,—
I will not seek for blossoms anywhere,
　　Except such common flowers as blow with corn.
Youth gone and beauty gone, what doth remain?
The longing of a heart pent up forlorn,
　　A silent heart whose silence loves and longs;
　　The silence of a heart which sang its songs
While youth and beauty made a summer morn,
Silence of love that cannot sing again.

**From *Later Life***

### 10

Tread softly! all the earth is holy ground.
  It may be, could we look with seeing eyes,
  This spot we stand on is a Paradise
Where dead have come to life and lost been found,
Where Faith has triumphed, Martyrdom been crowned,
  Where fools have foiled the wisdom of the wise;
  From this same spot the dust of saints may rise,
And the King's prisoners come to light unbound.
O earth, earth, earth, hear thou thy Maker's Word:
  'Thy dead thou shalt give up, nor hide thy slain'—
Some who went weeping forth shall come again
    Rejoicing from the east or from the west,
As doves fly to their windows, love's own bird
    Contented and desirous to the nest.*

    * *Quali columbe dal disio chiamate*
    *Con l'ali aperte e ferme al dolce nido*
    *Volan per l'aer dal voler portate.*

### 17

Something this foggy day, a something which
  Is neither of this fog nor of to-day,
  Has set me dreaming of the winds that play
Past certain cliffs, along one certain beach,
  And turn the topmost edge of waves to spray:
  Ah pleasant pebbly strand so far away,
So out of reach while quite within my reach,
  As out of reach as India or Cathay!
I am sick of where I am and where I am not,
  I am sick of foresight and of memory,
  I am sick of all I have and all I see,
    I am sick of self, and there is nothing new;
Oh weary impatient patience of my lot!—
    Thus with myself: how fares it, Friends, with you?

**From *Time Flies* (1885)**

*A Frog's Fate*

Contemptuous of his home beyond
The village and the village-pond,
A large-souled Frog who spurned each byeway
Hopped along the imperial highway.

Nor grunting pig nor barking dog
Could disconcert so great a Frog.
The morning dew was lingering yet,
His sides to cool, his tongue to wet:
The night-dew, when the night should come,
A travelled Frog would send him home.

Not so, alas! The wayside grass
Sees him no more: not so, alas!
A broad-wheeled waggon unawares
Ran him down, his joys, his cares.
From dying choke one feeble croak
The Frog's perpetual silence broke:—
'Ye buoyant Frogs, ye great and small,
Even I am mortal after all!
My road to fame turns out a wry way;
I perish on the hideous highway;
Oh for my old familiar byeway!'
The choking Frog sobbed and was gone;
The Waggoner strode whistling on.
Unconscious of the carnage done,
Whistling that Waggoner strode on—
Whistling (it may have happened so)
'A froggy would a-wooing go.'
A hypothetic frog trolled he,
Obtuse to a reality.

O rich and poor, O great and small,
Such oversights beset us all.
The mangled Frog abides incog,
The uninteresing actual frog:
The hypothetic frog alone
Is the one frog we dwell upon.

## Dante Rossetti
### From *Ballads and Sonnets* (1881)

*Sunset Wings*

To-night this sunset spreads two golden wings
    Cleaving the western sky;
Winged too with wind it is, and winnowings
Of birds; as if the day's last hour in rings
    Of strenuous flight must die.

Sun-steeped in fire, the homeward pinions sway
    Above the dovecote-tops;
And clouds of starlings, ere they rest with day,
Sink, clamorous like mill-waters, at wild play,
    By turns in every copse:

Each tree heart-deep the wrangling rout receives,—
    Save for the whirr within,
You could not tell the starlings from the leaves;
Then one great puff of wings, and the swarm heaves
    Away with all its din.

Even thus Hope's hours, in every-eddying flight,
    To many a refuge tend;
With the first light she laughed, and the last light
Glows round her still; who natheless in the night
    At length must make an end.

And now the mustering rooks innumerable
    Together sail and soar,
While for the day's death, like a tolling knell,
Until the heart they seem to cry, Farewell,
    No more, farewell, no more!

Is Hope not plumed, as 'twere a fiery dart?
    And oh! thou dying day,
Even as thou goest must she too depart,
And Sorrow fold such pinions on the heart
    As will not fly away?

*Three Shadows*

I looked and saw your eyes
    In the shadow of your hair,
As a traveller sees the stream
    In the shadow of the wood;
And I said, 'My faint heart sighs,
    Ah me! to linger there,
To drink deep and to dream
    In that sweet solitude.'

I looked and saw your heart
    In the shadow of your eyes,
As a seeker sees the gold
    In the shadow of the stream;
And I said, 'Ah me! what art
    Should win the immortal prize,
Whose want must make life cold
    And Heaven a hollow dream?'

I look and saw your love
    In the shadow of your heart,
As a diver sees the pearl
    In the shadow of the sea;
And I murmured, not above
    My breath, but all apart,—
'Ah! you can love, true girl,
    And is your love for me?'

*Alas, So Long!*

Ah! dear one, we were young so long,
    It seemed that youth would never go,
For skies and trees were ever in song
    And water in singing flow
In the days we never again shall know.
    Alas, so long!
    Ah! then was it all Spring weather?
    Nay, but we were young and together.

Ah! dear one, I've been old so long,
    It seems that age is loth to part,
Though days and years have never a song,
    And oh! have they still the art
That warmed the pulses of heart to heart?
            Alas, so long!
        Ah! then was it all Spring weather?
        Nay, but we were young and together.

Ah! dear one, you've been dead so long,—
    How long until we meet again,
Where hours may never lose their song
    Nor flowers forget the rain
In glad noonlight that never shall wane?
            Alas, so long!
        Ah, shall it be then Spring weather,
        And ah! shall we be young together?

## Winter

How large that thrush looks on the bare thorn-tree!
    A swarm of such, three little months ago,
    Had hidden in the leaves and let none know
Save by the outburst of their minstrelsy.
A white flake here and there—a snow-lily
    Of last night's frost—our naked flower-beds hold;
    And for a rose-flower on the darkling mould
The hungry redbreast gleams. No bloom, no bee.

The current shudders to its ice-bound sedge:
    Nipped in their bath, the stark reds one by one
    Flash each its clinging diamond in the sun:
'Neath winds which for this winter's sovereign pledge
Shall curb great king-masts to the ocean's edge
    And leave memorial forest-kings o'erthrown.

## The Church-Porch

Sister, first shake we off the dust we have
    Upon our feet, lest it defile the stones
    Inscriptured, covering their sacred bones
Who lie i' the aisles which keep the names they gave,
Their trust abiding round them in the grave;
    Whom painters paint for visible orisons,
    And to whom sculptors pray in stone and bronze;
Their voices echo still like a spent wave.

Without here, the church-bells are but a tune,
And on the carven church-door this hot noon
    Lays all its heavy sunshine here without:
But having entered in, we shall find there
Silence, and sudden dimness, and deep prayer,
    And faces of crowned angels all about.

## 'Found': (For a Picture)

'There is a budding morrow in midnight:'—
    So sang our Keats, our English nightingale.
    And here, as lamps across the bridge turn pale
In London's smokeless resurrection-light,
Dark breaks to dawn. But o'er the deadly blight
    Of love deflowered and sorrow of none avail
    Which makes this man gasp and this woman quail,
Can day from darkness ever again take flight?

Ah! gave not these two hearts their mutual pledge,
Under one mantle sheltered 'neath the hedge
    In gloaming courtship? And O God! to-day
He only knows he holds her;—but what part
Can life now take? She cries in her locked heart,—
    'Leave me—I do not know you—go away!'

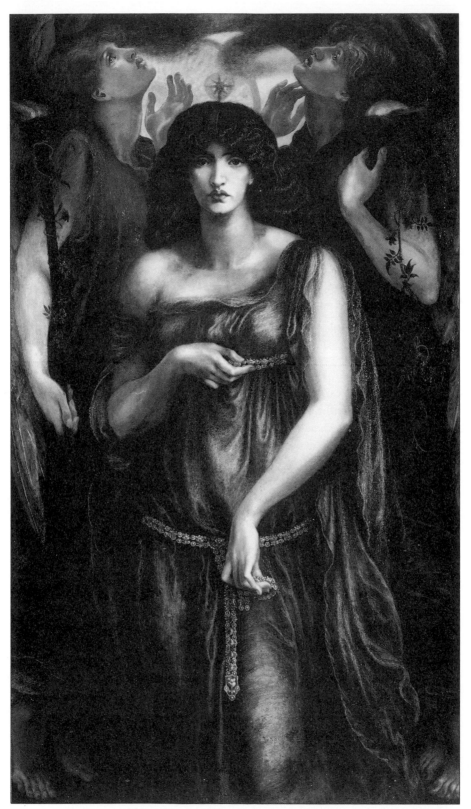

*Astarte Syriaca* by Dante Gabriel Rossetti (1877)

### *Astarte Syriaca*: (For a Picture)

MYSTERY: lo! betwixt the sun and moon
   Astarte of the Syrians: Venus Queen
   Ere Aphrodite was. In silver sheen
Her twofold girdle clasps the infinite boon
Of bliss whereof the heaven and earth commune:
   And from her neck's inclining flower-stem lean
   Love-freighted lips and absolute eyes that wean
The pulse of hearts to the sphere's dominant tune.

Torch-bearing, her sweet ministers compel
   All thrones of light beyond the sky and sea
   The witnesses of Beauty's face to be:
That face, of Love's all-penetrative spell
Amulet, talisman, and oracle,—
   Betwixt the sun and moon a mystery.

### *Proserpina*: (For a Picture)

Afar away the light that brings cold cheer
   Unto this wall,—one instant and no more
   Admitted at my distant palace-door.
Afar the flowers of Enna from this drear
Dire fruit, which, tasted once, must thrall me there.
   Afar those skies from this Tartarean grey
   That chills me: and afar, how far away,
The nights that shall be from the days that were.

Afar from mine own self I see, and wing
   Strange ways in thought, and listen for a sign:
   And still some heart unto some soul doth pine,
(Whose sounds mine inner sense is fain to bring,
Continually together murmuring,)
   'Woe's me for thee! unhappy Proserpine!'

### From *The House of Life: A Sonnet-Sequence*

### Part 1: Youth and Change

*A sonnet is a moment's monument,—*
   *Memorial from the Soul's eternity*
   *To one dealt deathless hour. Look that it be,*
*Whether for lustral rite or dire portent,*

*Of its own arduous fulness reverent:*
   *Carve it in ivory or in ebony,*
   *As Day or Night may rule; and let Time see*
*Its flowering crest impearled and orient.*

*A sonnet is a coin: its face reveals*
   *The soul,—its converse, to what Power 'tis due:—*
*Whether for tribute to the august appeals*
   *Of Life, or dower in Love's high retinue,*
*It serve; or, 'mid the dark wharf's cavernous breath,*
*In Charon's palm it pay the toll to Death.*

### Sonnet 4: *Lovesight*

When do I see thee most, beloved one?
   When in the light the spirits of mine eyes
   Before thy face, their altar, solemnize
The worship of that Love through thee made known?
Or when in the dusk hours, (we two alone,)
   Close-kissed and eloquent of still replies
   Thy twilight-hidden glimmering visage lies,
And my soul only sees thy soul its own?

O love, my love! if I no more should see
Thyself, nor on the earth the shadow of thee,
   Nor image of thine eyes in any spring,—
How then should sound upon Life's darkening slope
The ground-whirl of the perished leaves of Hope,
   The wind of Death's imperishable wing?

### Sonnet 6a: *Nuptial Sleep*

At length their long kiss severed, with sweet smart:
   And as the last slow sudden drops are shed
   From sparkling eaves when all the storm has fled,
So singly flagged the pulses of each heart.
Their bosoms sundered, with the opening start
   Of married flowers to either side outspread
   From the knit stem; yet still their mouths, burnt red,
Fawned on each other where they lay apart.

Sleep sank them lower than the tide of dreams,
   And their dreams watched them sink, and slid away.
Slowly their souls swam up again, through gleams

Of watered light and dull drowned waifs of day;
Till from some wonder of new woods and streams
    He woke, and wondered more: for there she lay.

## Sonnet 10: *The Portrait*

O Lord of all compassionate control,
    O Love! let this my lady's picture glow
    Under my hand to praise her name, and show
Even of her inner self the perfect whole:
That he who seeks her beauty's furthest goal,
    Beyond the light that the sweet glances throw
    And refluent wave of the sweet smile, may know
The very sky and sea-line of her soul.

Lo! it is done. Above the enthroning throat
    The mouth's mould testifies of voice and kiss,
        The shadowed eyes remember and foresee.
Her face is made her shrine. Let all men note
    That in all years (O Love, thy gift is this!)
        They that would look on her must come to me.

## Sonnet 11: *The Love-Letter*

Warmed by her hand and shadowed by her hair
    As close she leaned and poured her heart
        through thee,
    Whereof the articulate throbs accompany
The smooth black stream that makes thy whiteness
        fair,—
Sweet fluttering sheet, even of her breath aware,—
    Oh let thy silent song disclose to me
    That soul wherewith her lips and eyes agree
Like married music in Love's answering air.

Fain had I watched her when, at some fond thought,
    Her bosom to the writing closelier press'd,
    And her breast's secrets peered into her breast;
When, through eyes raised an instant, her soul sought
My soul, and from the sudden confluence caught
    The words that made her love the loveliest.

## Sonnet 14: *Youth's Spring-Tribute*

On this sweet bank your head thrice sweet and dear
    I lay, and spread your hair on either side,
    And see the newborn woodflowers bashful-eyed
Look through the golden tresses here and there.
On these debateable borders of the year
    Spring's foot half falters; scarce she yet may know
    The leafless blackthorn-blossom from the snow;
And through her bowers the wind's way still is clear.

But April's sun strikes down the glades to-day;
    So shut your eyes upturned, and feel my kiss
Creep, as the Spring now thrills through every spray,
    Up your warm throat to your warm lips: for this
    Is even the hour of Love's sworn suitservice,
With whom cold hearts are counted castaway.

## Sonnet 17: *Beauty's Pageant*

What dawn-pulse at the heart of heaven, or last
    Incarnate flower of culminating day,—
    What marshalled marvels on the skirts of May,
Or song full-quired, sweet June's encomiast;
What glory of change by Nature's hand amass'd
    Can vie with all those moods of varying grace
    Which o'er one loveliest woman's form and face
Within this hour, within this room, have pass'd?

Love's very vesture and elect disguise
    Was each fine movement,—wonder new-begot
    Of lily or swan or swan-stemmed galiot;
Joy to his sight who now the sadlier sighs,
Parted again; and sorrow yet for eyes
    Unborn, that read these words and saw her not.

## Sonnet 19: *Silent Noon*

Your hands lie open in the long fresh grass,—
    The finger-points look through like rosy blooms:
    Your eyes smile peace. The pasture gleams and glooms
'Neath billowing skies that scatter and amass.
All round our nest, far as the eye can pass,
    Are golden kingcup-fields with silver edge

Where the cow-parsley skirts the hawthorn-hedge.
'Tis visible silence, still as the hour-glass.

Deep in the sun-searched growths the dragon-fly
Hangs like a blue thread loosened from the sky:—
   So this wing'd hour is dropt to us from above.
Oh! clasp we to our hearts, for deathless dower,
This close-companioned inarticulate hour
   When twofold silence was the song of love.

## Sonnet 31: *Her Gifts*

High grace, the dower of queens; and therewithal
   Some wood-born wonder's sweet simplicity;
   A glance like water brimming with the sky
Or hyacinth-light where forest-shadows fall;
Such thrilling pallor of cheek as doth enthral
   The heart; a mouth whose passionate forms imply
   All music and all silence held thereby;
Deep golden locks, her sovereign coronal;
A round reared neck, meet column of Love's shrine
   To cling to when the heart takes sanctuary;
   Hands which for ever at Love's bidding be,
And soft-stirred feet still answering to his sign:—
These are her gifts, as tongue may tell them o'er.
Breathe low her name, my soul; for that means more.

## Sonnet 36: *Life-in-Love*

Not in thy body is thy life at all,
   But in this lady's lips and hands and eyes;
   Through these she yields thee life that vivifies
What else were sorrow's servant and death's thrall.
Look on thyself without her, and recall
   The waste remembrance and forlorn surmise
   That lived but in a dead-drawn breath of sighs
O'er vanished hours and hours eventual.

Even so much life hath the poor tress of hair
   Which, stored apart, is all love hath to show
   For heart-beats and for fire-heats long ago;
Even so much life endures unknown, even where,
'Mid change the changeless night environeth,
Lies all that golden hair undimmed in death.

## Sonnet 40: *Severed Selves*

Two separate divided silences,
   Which, brought together, would find loving voice;
   Two glances which together would rejoice
In love, now lost like stars beyond dark trees;
Two hands apart whose touch alone gives ease;
   Two bosoms which, heart-shrined with
      mutual flame,
   Would, meeting in one clasp, be made the same;
Two souls, the shores wave-mocked of
      sundering seas:—

Such are we now. Ah! may our hope forecast
   Indeed one hour again, when on this stream
   Of darkened love once more the light shall
      gleam?—
An hour how slow to come, how quickly past,—
Which blooms and fades, and only leaves at last,
   Faint as shed flowers, the attenuated dream.

## Sonnet 47: *Broken Music*

The mother will not turn, who thinks she hears
   Her nursling's speech first grow articulate;
   But breathless with averted eyes elate
She sits, with open lips and open ears,
That it may call her twice. 'Mid doubts and fears
   Thus oft my soul has hearkened; till the song,
   A central moan for days, at length found tongue,
And the sweet music welled and the sweet tears.

But now, whatever while the soul is fain
   To list that wonted murmur, as it were
The speech-hound sea-shell's low
      importunate strain,—
   No breath of song, thy voice alone is there,
O bitterly beloved! and all her gain
   Is but the pang of unpermitted prayer.

## Sonnet 48: *Death-in-Love*

There came an image in Life's retinue
   That had Love's wings and bore his gonfalon:

Fair was the web, and nobly wrought thereon,
O soul-sequestered face, thy form and hue!
Bewildering sounds, such as Spring wakens to,
    Shook in its folds; and through my heart its power
    Sped trackless as the immemorable hour
When birth's dark portal groaned and all was new.

But a veiled woman followed, and she caught
    The banner round its staff, to furl and cling,—
    Then plucked a feather from the bearer's wing,
And held it to his lips that stirred it not,
And said to me, 'Behold, there is no breath:
I and this Love are one, and I am Death.'

### Sonnet 49: *Willowwood—I*

I sat with Love upon a woodside well,
    Leaning across the water, I and he;
    Nor ever did he speak nor looked at me,
But touched his lute wherein was audible
The certain secret thing he had to tell:
    Only our mirrored eyes met silently
    In the low wave; and that sound came to be
The passionate voice I knew; and my tears fell.

And at their fall, his eyes beneath grew hers;
And with his foot and with his wing-feathers
    He swept the spring that watered my heart's drouth.
Then the dark ripples spread to waving hair,
And as I stooped, her own lips rising there
    Bubbled with brimming kisses at my mouth.

### Sonnet 51: *Willowwood—III*

'O ye, all ye that walk in Willowwood,
    That walk with hollow faces burning white;
What fathom-depth of soul-struck widowhood,
    What long, what longer hours, one lifelong night,
Ere ye again, who so in vain have wooed
    Your last hope lost, who so in vain invite
Your lips to that their unforgotten food,
    Ere ye, ere ye again shall see the light!

'Alas! the bitter banks in Willowwood,
    With tear-spurge wan, with blood-wort burning red:
Alas! if ever such a pillow could
    Steep deep the soul in sleep till she were dead,—
Better all life forget her than this thing,
That Willowwood should hold her wandering!'

### Sonnet 53: *Without Her*

What of her glass without her? The blank grey
    There where the pool is blind of the moon's face.
    Her dress without her? The tossed empty space
Of cloud-rack whence the moon has passed away.
Her paths without her? Day's appointed sway
    Usurped by desolate night. Her pillowed place
    Without her? Tears, ah me! for love's good grace,
And cold forgetfulness of night or day.

What of the heart without her? Nay, poor heart,
    Of thee what word remains ere speech be still?
    A wayfarer by barren ways and chill,
Steep ways and weary, without her thou art,
Where the long cloud, the long wood's counterpart,
    Sheds doubled darkness up the labouring hill.

### Part 2: Change and Fate

### Sonnet 63: *Inclusiveness*

The changing guests, each in a different mood,
    Sit at the roadside table and arise:
    And every life among them in likewise
Is a soul's board set daily with new food.
What man has bent o'er his son's sleep, to brood
    How that face shall watch his when cold it lies—
    Or thought, as his own mother kissed his eyes,
Of what her kiss was when his father wooed?

May not this ancient room thou sitt'st in dwell
    In separate living souls for joy or pain?
    Nay, all its corners may be painted plain
Where Heaven shows pictures of some life spent well,
    And may be stamped, a memory all in vain,
Upon the sight of lidless eyes in Hell.

## Sonnet 67: *The Landmark*

Was that the landmark? What,—the foolish well
  Whose wave, low down, I did not stoop to drink,
  But sat and flung the pebbles from its brink
In sport to send its imaged skies pell-mell,
(And mine own image, had I noted well!)—
  Was that my point of turning?—I had thought
  The stations of my course should rise unsought,
As altar-stone or ensigned citadel.

But lo! the path is missed, I must go back,
  And thirst to drink when next I reach the spring
Which once I stained, which since may have
     grown black.
  Yet though no light be left nor bird now sing
  As here I turn, I'll thank God, hastening,
That the same goal is still on the same track.

## Sonnet 77: *Soul's Beauty*

Under the arch of Life, where love and death,
  Terror and mystery, guard her shrine, I saw
  Beauty enthroned; and though her gaze struck awe,
I drew it in as simply as my breath.
Hers are the eyes which, over and beneath,
  The sky and sea bend on thee,—which can draw,
  By sea or sky or woman, to one law,
The allotted bondman of her palm and wreath.

This is that Lady Beauty, in whose praise
  Thy voice and hand shake still,—long known to thee
    By flying hair and fluttering hem,—the beat
    Following her daily of thy heart and feet,
  How passionately and irretrievably,
In what fond flight, how many ways and days!

## Sonnet 78: *Body's Beauty*

Of Adam's first wife, Lilith, it is told
  (The witch he loved before the gift of Eve,)
  That, ere the snake's, her sweet tongue
    could deceive,

And her enchanted hair was the first gold.
And still she sits, young while the earth is old,
  And, subtly of herself contemplative,
  Draws men to watch the bright web she can weave,
Till heart and body and life are in its hold.

The rose and poppy are her flowers; for where
  Is he not found, O Lilith, whom shed scent
And soft-shed kisses and soft sleep shall snare?
  Lo! as that youth's eyes burned at thine, so went
  Thy spell through him, and left his straight
    neck bent
And round his heart one strangling golden hair.

## Sonnet 82: *Hoarded Joy*

I said: 'Nay, pluck not,—let the first fruit be:
  Even as thou sayest, it is sweet and red,
  But let it ripen still. The tree's bent head
Sees in the stream its own fecundity
And bides the day of fulness. Shall not we
  At the sun's hour that day possess the shade,
  And claim our fruit before its ripeness fade,
And eat it from the branch and praise the tree?'

I say: 'Alas! our fruit hath wooed the sun
  Too long,—'tis fallen and floats adown the stream.
Lo, the last clusters! Pluck them every one,
  And let us sup with summer; ere the gleam
Of autumn set the year's pent sorrow free,
And the woods wail like echoes from the sea.'

## Sonnet 83: *Barren Spring*

Once more the changed year's turning wheel returns:
  And as a girl sails balanced in the wind,
  And now before and now again behind
Stoops as it swoops, with cheek that laughs
    and burns,—
So Spring comes merry towards me here, but earns
  No answering smile from me, whose life is twin'd
  With the dead boughs that winter still must bind,
And whom to-day the Spring no more concerns.

Behold, this crocus is a withering flame;
   This snowdrop, snow; this apple-blossom's part
   To breed the fruit that breeds the serpent's art.
Nay, for these Spring-flowers, turn thy face from them,
Nor stay till on the year's last lily-stem
   The white cup shrivels round the golden heart.

## Sonnet 85: *Vain Virtues*

What is the sorriest thing that enters Hell?
   None of the sins,—but this and that fair deed
   Which a soul's sin at length could supersede.
These yet are virgins, whom death's timely knell

Might once have sainted; whom the fiends compel
   Together now, in snake-bound shuddering sheaves
   Of anguish, while the pit's pollution leaves
Their refuse maidenhood abominable.

Night sucks them down, the tribute of the pit,
   Whose names, half entered in the book of Life,
      Were God's desire at noon. And as their hair
And eyes sink last, the Torturer deigns no whit
   To gaze, but, yearning, waits his destined wife,
      The Sin still blithe on earth that sent them there.

## Sonnet 86: *Lost Days*

The lost days of my life until to-day,
   What were they, could I see them on the street
   Lie as they fell? Would they be ears of wheat
Sown once for food but trodden into clay?
Or golden coins squandered and still to pay?
   Or drops of blood dabbling the guilty feet?
   Or such spilt water as in dreams must cheat
The undying throats of Hell, athirst alway?

I do not see them here; but after death
   God knows I know the faces I shall see,
Each one a murdered self, with low last breath.
   'I am thyself,—what hast thou done to me?'
'And I—and I—thyself,' (lo! each one saith,)
   'And thou thyself to all eternity!'

## Sonnet 97: *A Superscription*

Look in my face; my name is Might-have-been;
   I am also called No-more, Too-late, Farewell;
   Unto thine ear I hold the dead-sea shell
Cast up thy Life's foam-fretted feet between;
Unto thine eyes the glass where that is seen
   Which had Life's form and Love's, but by my spell
   Is now a shaken shadow intolerable,
Of ultimate things unuttered the frail screen.

Mark me, how still I am! But should there dart
   One moment through thy soul the soft surprise
   Of that winged Peace which lulls the breath of
      sighs,—
Then shalt thou see me smile, and turn apart
Thy visage to mine ambush at thy heart
   Sleepless with cold commemorative eyes.

## Sonnet 101: *The One Hope*

When vain desire at last and vain regret
   Go hand in hand to death, and all is vain,
   What shall assuage the unforgotten pain
And teach the unforgetful to forget?
Shall Peace be still a sunk stream long unmet,—
   Or may the soul at once in a green plain
   Stoop through the spray of some sweet life-fountain
And cull the dew-drenched flowering amulet?

Ah! when the wan soul in that golden air
   Between the scriptured petals softly blown
   Peers breathless for the gift of grace unknown,—
Ah! let none other alien spell soe'er
But only the one Hope's one name be there,—
   Not less nor more, but even that word alone.

## From *Collected Works* (1866)

### *She Bound her Green Sleeve* (A Fragment)

She bound her green sleeve on my helm,
   Sweet pledge of love's sweet meed;

Warm was her bared arm round my neck
   As well she bade me speed;
And her kiss clings still between my lips,
   Heart's beat and strength at need.

### The Orchard-Pit (A Fragment)

Piled deep below the screening apple branch
   They lie with bitter apples in their hands:
And some are only ancient bones that blanch,
And some had ships that last year's wind did launch,
   And some were yesterday the lords of lands.

In the soft dell, among the apple trees,
   High up above the hidden pit she stands,
And there forever sings, who gave to these,
That lie below, her magic hour of ease,
   And those her apples holden in their hands.

This in my dreams is shown me; and her hair
   Crosses my lips and draws my burning breath;
Her song spreads golden wings upon the air,
Life's eyes are gleaming from her forehead fair,
   And from her breasts the ravishing eyes of Death.

Men say to me that sleep hath many dreams,
   Yet I knew never but this dream alone:
There, from a dried-up channel, once the stream's,
The glen slopes up; even such in sleep it seems
   As to my waking sight the place well known.

---

My love I call her, and she loves me well:
   But I love her as in the mælstrom's cup
The whirled stone loves the leaf inseparable
That clings to it round all the circling swell,
   And that the same last eddy swallows up.

## William Bell Scott
### From *A Poet's Harvest Home* (1882)

### Apple Gathering

The boughs with dark-brown leaves o'erspread,
And crimsoned fruit; the sky pure white,
With dense blue clefts that look so high,
Everything so sharp and bright,
Made up a picture chased outright
My tiresome news; besides, in joy,
The happy household voices too,
That touch the heart, a welcome threw
About me, and the rich dull sound
Of apples dropping on the ground
Brought out the laughter of the boy.
Great piled-up baskets stood about:
'How shall we ever eat all these?'
They seemed to him quite infinite—
'I too would pluck some if I might!'
He clapped his hands, 'Oh let me, please!'
So I raised him over shoulder high,
The reddest, ripest, bunches nigh.
He caught them with a childish shout.
He was much merrier than was I
When I returned to read and write.

### The Sphynx

1

'Tis said that Homer, blind and old,
Wandered round the great lone Sphynx:
I see him blind and all alone,
Grope round that vast misshapen stone
   To discern the sense untold,
The answer from our ear that shrinks,
The mystery no hand can hold.

Did he discover even the shape—
Feel what the giant mass expressed—
Recognise the eyes agape—
Know what the monstrous claws confessed?
Poet of poets, greatest one
Born of the Hellenic sun,

Who made the grand song still we sing,
Groping blindly and alone
Round that arcane misshapen stone;
Did it tell thee anything?

## *Nature*

### 2

On a rock limpet-crusted, one still day
We sat; the sun upon the white sea shone;
Ripples like living arrows came right on
From rock to rock; a mist harmoniously
United earth and heaven in silvery-grey.
    I said, there's noght to wish for more; but she,
    The loved one, my companion, smiled at me;
Yet she too by the charm was borne away.

Alas, this charm was broken by my deed;—
    I strike the limpets off to see them fall,
And by strange instinct drawn from far, crabs speed
Along the water floor, crabs all astir,
    To tear the limpets from their shells! A pall
Was lowered 'tween Nature and our faith in her.

## *A Lowland Witch Ballad*

The old witch-wife beside her door,
    Sat spinning with a watchful ear,
A horse's hoof upon the road
    Is what she waits for, longs to hear.

A mottled gloaming dusky grew,
    Or else we might a furrow trace,
Sowed with small bones and leaves of yew,
    Across the road from place to place.

Hark he comes! The young bridegroom,
    Singing gaily down the hill,
Rides on, rides blindly to his doom,
    His heart that witch hath sworn to kill.

Up to the fosse he rode so free,
    There his steed stumbled and he fell,
He cannot pass, nor turn, nor flee;
    His song is done, he's in the spell.

She dances round him where he stands,
    Her distaff touches both his feet,
She blows upon his eyes and hands,
    He has no power his fate to cheat.

'Ye cannot visit her to-night,
    Nor ever again,' the witch-wife cried;
'But thou shalt do as I think right,
    And do it swift without a guide.

'Upon the top of Tintock hill
    This night there rests the yearly mist,
In silence go, your tongue keep still,
    And find for me the dead man's kist.

'Within the kist there is a cup,
    Thou'lt find it by the dead man's shine,
Take it thus! thus fold it up,—
    It holds for me the wisdom-wine.

'Go to the top of Tintock hill,
    Grope within that eerie mist,
Whatever happens, keep quite still
    Until ye find the dead man's kist.

'The kist will open, take the cup,
    Heed ye not the dead man's shine,
Take it thus, thus fold it up,
    Bring it to me and I am thine.'

He went, he could make answer none,
    He went, he found all as she said,
Before the dawn had well begun
    She had the cup from that strange bed.

Into the hut she fled at once,
    She drank the wine;—forthwith, behold!
A radiant damozel advance
    From that black door in silken fold.

The little Circe flower she held
    Towards the boy with such a smile
Made his heart leap, he was compelled
    To take it gently as a child.

She turned, he followed, passed the door,
    Which closed behind: at noon next day,
    Ambling on his mule that way,
The Abbot found the steed, no more,
    The rest was lost in glamoury.

### Rose-Leaves

Once a rose ever a rose, we say,
    One we loved and who loved us
Remains beloved though gone from day;
To human hearts it must be thus,
The past is sweetly laid away.

Sere and sealed for a day and year,
    Smell them, dear Christina, pray;

So nature treats its children dear,
So memory deals with yesterday,
The past is sweetly laid away.

### Seeking Forgetfulness

And yet I am as one who looks behind,
    A traveller in a shadowed land astray,
Passing and lost upon the boundary
Of actual things, who turns against the wind,
An hundred simulacral ghosts to find
    Close following, an hundred pairs of eyes
    Shining around like phosphorescent flies,—
And all of them himself, yet changed in kind.

Those once I was, which of them now am I?
    Not one, all alien, long-abandoned masks,
    That in some witches' sabbath, long since past,
Did dance awhile in my life's panoply,
    And drank with me from out of the same flasks;
    Am I not rid of these, not even at last?

# REACTIONS

## Walter Hamilton
### From *The Æsthetic Movement in England* (1882)

### From 'The Grosvenor Gallery'

A weird sort of sensation of being carried back into the Middle Ages is engendered by long gazing at these pictures, for in that temple of art of which Burne-Jones is the high priest, one seems to feel the priestly influence stealing over one, as when standing before some pieces of glorious glass-painting in an old Gothic cathedral. Indeed, the resemblance is somewhat more than fanciful, for in these compositions the figures are strongly defined, clearly detached, and transparent in tint, and the effect is very similar to that seen in stained glass windows.

Perspective does not seem to have received the same amount of attention as colour; and this, coupled with the somewhat constrained and angular attitudes of the figures, a peculiar arrangement of closely fitting draperies, and the general tone of colours employed, give the majority of the paintings an appearance which can best be indicated as resembling the Japanese style of art, a resemblance which is also to be found in the furniture and costumes adopted by people of Æsthetic tastes.

But it is the portrayal of female beauty that Æsthetic art is most peculiar, both in conception as to what constitutes female loveliness, and in the treatment of it.

The type most usually found is that of a pale distraught lady with matted dark auburn hair falling in masses over the brow, and shading eyes full of love-lorn languor, or feverish despair; emaciated cheeks and somewhat heavy jaws; protruding upper lip, the lower lip being indrawn, long crane neck, flat breasts, and long thin nervous hands.

**THE SIX-MARK TEA-POT.**

*Æsthetic Bridegroom.* "It is quite consummate, is it not?"
*Intense Bride.* "It is, indeed! Oh, Algernon, let us live up to it!"

It naturally follows that artists having selected this ideal of loveliness, certain ladies should endeavour to attain it, and in not a few cases they have earned the derision of the Philistines, one of whom thus describes:—

A Female Æsthete
'Maiden of the sallow brow,
Listen whilst my love I vow!
By thy kisses which consume;
By thy spikenard-like perfume;
By thy hollow, parboiled eyes;
By thy heart-devouring sighs;
By thy sodden, pasty cheek;
By thy poses, from the Greek;
By thy tongue, like asp which stings;
By thy zither's twangy strings;
By thy dress of stewed-sage green;
By thy idiotic mien;—
By these signs, O æsthete mine,
Thou shalt be my Valentine!'

### From 'Æsthetic Culture'

From the consideration of the painters who are known either as Pre-Raphælites, Impressionists, or Æsthetes, we pass naturally to the poetical division of the Æsthetic School, in which lies its principal strength, in so far as it has affected the general public and the press.

We must pause for a moment to consider what are its most prominent features and general characteristics.

First, and above all other considerations, the leaders of the Æsthetic School in poetry have been styled fleshly poets, delighting in somewhat sensually-suggestive descriptions of the passions, ornamented with hyperbolical metaphor, or told in curious archaic speech; and dressed up in quaint mediæval garments of odd old ballad rhymes and phrases.

The strict Æsthete admires only what in his language is known as *intense*, and what Ruskin somewhat gushingly terms the 'blessed and precious' in art…

In architecture the Queen Anne style is favoured by the Æsthetes; and on the really beautiful Bedford Park Estate, one of the chosen homes of the 'select', only houses built after this manner are permitted to be erected.

Chippendale furniture, dados, old-fashioned brass and wrought iron work, mediæval lamps, stained glass in small squares, and old china are all held to be the outward and visible signs of an inward and spiritual grace and intensity. Let a jaded City man, if he have an eye for the beautiful, only walk three minutes off 'Change, and in Dashwood House, Old Broad Street, he will find a cool, shady retreat, where he can admire at his leisure one of the finest staircases in London, decorated with a charming dado, Minton's tiles, and lit by some stained-glass windows of exquisite colouring, put in by Pitman and Son. Or, if he can only take an hour's ride, let him visit the Sanatorium, recently built, at an enormous expense, by Mr. Thomas Holloway, at Virginia Water, and there study the decorative wall

paintings, by J. Moyr Smith, especially those representing *History*, *Legend*, and *Epic Poetry*, and having studied these, let him ask himself whether such work could have been produced, or would have been appreciated, forty years ago.

Now, it cannot be too strongly insisted on that in much of this there is visible not only a *real love of the beautiful*, but also that the wonderful improvements which have been so eagerly seized upon by the general public during the last few years originated amongst the Æsthetes, whom the vulgar herd think it witty and clever to abuse, or to ridicule. Soft draperies of quiet, sober, yet withal delicate and harmonious tints, have replaced the heavy, gaudy curtains of yore; bevilled mirrors with black frames slightly relieved with gold, have driven out the large old plate glasses, with sham, but expensive gold frames; plain painted walls, of soft tints, show up our pictures far better than the old fashioned papers which, pasted one over another, became the haunt of the agile flea, or still more objectionable but less lively insect abominations. But why the sunflower, the lily, and the peacock's feather have become so closely identified with the movement is not easy to explain; certain it is they appear to be as distinctively the badges of the true Æsthete as the green turban is amongst Mahommedans the sign that the wearer has accomplished a pilgrimage to the holy place. In these minor details, I believe the examples of D.G. Rossetti, and more recently of Oscar Wilde, have had considerable influence.

Oxford, it must be remembered, was the scene of some of the first labours of the P.R. Brotherhood, and the name of nearly every distinguished member of the new school has been associated with that city. Thomas Woolner had placed a statue of Lord Bacon in the Oxford University Museum in 1856, and in 1857 Dante Gabriel Rossetti was employed to paint the frescoes in the Oxford Union Hall. In this work, although he was associated with five other artists, he was the only P.R.B. amongst them. The strange shadowy frescoes around the interior of the Union Cupola are now rapidly fading into nothingness,

for the youths who painted them had no practical training in mural painting; they used no vehicle for their colours, nor did they prepare the walls to receive them, and the result has been that their interesting boyish efforts are now decayed beyond any chance of restoration. 'The Oxford and Cambridge Magazine', which was in progress at the same time, contained many poems and articles by Rossetti and his friends William Morris and Burne-Jones. This magazine ran to twelve monthly numbers; a complete set of it being of course very scarce as all such works become immediately the public learn that they contain the early contributions of men afterwards famous. John Ruskin was a distinguished scholar and prizeman at the University, as were also A.C. Swinburne and Oscar Wilde, beside these already enumerated in preceding notes. Thus E. Burne-Jones and William Morris were undergraduates at Oxford when Rossetti was painting the frescoes in the Union, and it was mainly through his influence that they adopted their respective artistic roles.

Constantly yearning for the intense, the language of the Æsthete is tinged with somewhat exaggerated metaphor, and their adjectives are usually superlative—as supreme, consummate, utter, quite too preciously sublime, &c. For some of this mannerism of speech Mr. Ruskin's writings have to answer; but the words he uses applied to grand works of art sound ludicrous enough when debased by being applied to the petty uses of everyday small talk...

### From 'A Home for the Æsthetes'

The little colony of Bedford Park had no existence, even in the imagination of its enthusiastic proprietor, until within the last six or seven years, before which time the site selected by Mr. Carr for his experiment did not differ from the surrounding country.

The monotony of a continuous prospect of fields and orchards was being gradually invaded and encroached upon by long dreary rows of brick and stucco houses of the Pimlico type, so dear to

the speculative builder, who can build street upon street in this type without any exercise of his ingenuity, except as to how best to utilize his old materials, rejected bricks, mortar destitute of binding power, doors that refuse to open, and windows which it is impossible to shut; roofs which let in the water, and drains which will not carry it away; deep dismal basements, meant only for the home of the beetle and cockroach, and huge flights of pretentious stone steps for people to slip down in frosty weather, and for poor servants to kneel at for hours to white stone over. But here, at Bedford Park, a good fairy seems to have been at work, and the view from the railway is brightened by an oasis amidst the such rounding desert of stereotyped suburban settlements.

This result is due to the enterprise of Mr. Jonathan Carr, who originated the idea, in which he has been ably assisted by his architect, Mr. R. Norman Shaw, and although for a time the scheme was laughed at as Utopian and absurd, it has long since passed into the stage of a recognized success, and fast as the houses are being built, the demand is ahead of the supply.

Whilst admitting the credit due to Mr. Carr for the initiative he has taken in the matter, it must be conceded that he started with several elements of success in his favour.

First of all was the undoubted revival in artistic taste which has been making its way amongst the well-to-do middle class of English people since the Exhibition of 1851; next came the important fact that Mr. Carr was the possessor of a plot of land admirably adapted by nature for such a retreat as he has turned it into, and of all its natural beauties he has taken the fullest advantage, the wide avenues being lined with some of the finest old trees to be found near London.

Again, whilst being sufficiently removed from the noise, smoke, and bustle of London, it is not so far distant as to prevent City men from making it their home, or ladies from taking those pleasant but costly journeys to town, known to husbands as 'going shopping'. And for all these journeys, whether for business or pleasure, every facility of conveyance is near at hand.

So taking all these natural advantages into consideration, Mr. Carr determined that the architecture and arrangements of the colony should be in keeping with its surroundings, and in harmony with the artistic taste of the period.

To have built only a few houses in the exceptional style he had planned out would have been costly beyond all possibility of remunerative return, but by laying out the buildings in groups of detached and semi-detached houses somewhat similar in their *main features*, but exceedingly varied in *matters of detail*, the objection of excessive expense was removed, and the houses, with all their advantages, are let at rents no higher than those of the dreary roads and streets of Pimlico, or Camden-town.

One great charm of the idea is that no two houses are exactly alike, and the picturesque aspect of the whole makes one marvel that the idea is so novel, especially when the feeling will keep rising in one's mind, that it is a little piece of an old English town which has somehow or another escaped the ravages of time, to show us how much more sensible our ancestors were, in some respects, than we who live in this much-vaunted nineteenth century.

This illusion is made all the more perfect from the pains that have been taken not to spoil the rural appearance of the estate—not a tree has been needlessly cut down; each house is sheltered, many are perfectly embowered in jasmine, laburnum, and hawthorn, and the aspect of the avenues, on a sunny day, is full of such old-world repose, colour and sweetness as even Tennyson could describe, or Ruskin could desire.

Healthy air, a gravel soil, the river near enough for those who love boating, charming walks around, Kew Gardens only distant by a ten minutes ride by rail, and the great world of London but half an hour away. And yet what need to wander away; are there not the club and the theatre, the church and the *Tabard*? Even shopping can be done, and comfortably, too, on

the estate, for at the Stores nearly every requisite of civilized life can be obtained, and for all practical purposes Bedford Park is a little world in itself. As one wanders along the avenues, under the gently rustling trees, the sunlight wavers and flickers on the red brick fronts of the houses; many of the doors are open, and the neat halls are visible with their clean cool Indian matting, square old-fashioned brass lamps; comfort and elegance everywhere, lightness and grace abound. Even the names on the door-posts have a touch of poetry and quaintness about them:—Pleasaunce, Elm-dene, Kirk Loss, Ye Denne, for example.

Nearly every house has also a balcony, not the ordinary kind of iron abomination jutting out like a huge wart on the face of the house, and dangerous even for children to stand upon, but a good sized square comfortable arrangement, generally forming the roof of some out-building, surrounded with a low parapet, and affording a pleasant view of the trees and gardens around— the place of all others to sit in the hot summer evenings, to smoke a cigar, and play a quiet game of chess. How Thackeray, with his love for the Queen Anne style, would have delighted in the view to be obtained from any of these balconies; what a 'Round-about Paper' he would have written on the reminiscences it called up of Addison, Steele, and *The Spectator*.

The great charm about the estate is the absence of conventionality; there is none of the usual dull monotony about the exterior of the houses, the roads wind about without any apparent desire to lead anywhere in particular, or of having any intention of returning when they get there. They are sheltered by pleasant trees, and are not bordered by dismal rows of cast iron railings all moulded on the same pattern. Low wooden fences mark the boundaries of the gardens, and allow one to see over and admire the trim parterres full of Nature's brightest jewellery. Wood, brick, or stone show for what they are, and do not make absured and ineffectual attempts to look like ebony, or marble, or terra cotta. There is no stucco, no gilt, no affectation, no monotony;

but there is comfort, cleanliness, taste, green trees, and plenty of fresh air.

Tower House stands at the corner of two charming avenues, and whilst one of the largest residences on the estate, is far more noticeable for the beauty of its internal fittings and furniture, than for its external appearance, which is, in front at least, somewhat more simple than its neighbours, but the garden face and the grounds themselves are very pretty.

Availing myself of the courteous invitation of Mrs. Carr to look over her house, I was delighted with the exquisite taste displayed in it. The hall, dining-room, and drawing-room, all on the entrance floor, are large and well lit, whilst the staircase with its wide stairs and massive banisters remind one of the old-fashioned manor halls still to be found on quiet country estates. The prevailing colours used in the decorations are soft neutral tints, nothing brilliant or startling being seen. The projecting windows are fitted with large square casements, comfortable window seats and cushions. The walls of the dining-room are panelled with fine old carved oak, most of which was obtained by Mr. Carr from the fittings of an old City church, St. Dionysius Backchurch, an edifice which even the fame of its architect, Sir Christopher Wren, could not save from destruction when its site was required for modern street improvements.

In both the dining and drawing-rooms the floors are of polished wood, not covered with regularly fitting carpets complete, but with Persian or Turkey rugs of various sizes and shapes; in the drawing-room the walls are hung round with some fine pieces of very old tapestry brought by Mr. Carr from Spain, and very valuable paintings; then books, flowers, and pottery form an ensemble which it would indeed be hard to match for beauty and originality.

In this style of old English furniture, wall hangings should be largely used, curtains employed in place of folding doors, and the panels of halls and staircases covered with Indian or other matting easily removed and cleansed. For

dining and drawing-rooms, tapestry hangings might be used were it not for the extreme costliness of that material.

In the internal decorations of a new house an incoming tenant at Bedford park has much liberty of selection; the majority of the residents have chosen from the wall-papers and designs furnished by Mr. William Morris, whose establishment at Bloomsbury is extensive enough to supply new and varied patterns without any fear of sameness or monotony in passing from one house in the estate to another. Besides, the changes can so easily be rung when there are dado paper, tiles, or matting, wall-papers, distemper, hangings and tapestry to select from, that the danger of monotony in this new style of decoration is avoided…

## Walter Pater
### From *Appreciations* (1883)

#### 'Æsthetic Poetry'

The 'æsthetic' poetry is neither a mere reproduction of Greek or medieval poetry, nor only an idealisation of modern life and sentiment. The atmosphere on which its effect depends belongs to no simple form of poetry, no actual form of life. Greek poetry, medieval or modern poetry, projects, above the realities of its time, a world in which the forms of things are transfigured. Of that transfigured world this new poetry takes possession, and sublimates beyond it another still fainter and more spectral, which is literally an artificial or 'earthly paradise'. It is a finer ideal, extracted from what in relation to any actual world is already an ideal. Like some strange second flowering after date, it renews on a more delicate type the poetry of a past age, but must not be confounded with it. The secret of the enjoyment of it is that inversion of home-sickness known to some, that incurable thirst for the sense of escape, which no actual form of life satisfies, no poetry even, if it be merely simple and spontaneous.

The writings of the 'romantic school', of which the æsthetic poetry is an afterthought, mark a transition not so much from the pagan to the medieval ideal, as from a lower to a higher degree of passion in literature. The end of the eighteenth century, swept by vast disturbing currents, experienced an excitement of spirit of which one note was a reaction against an outworn classicism severed not more from nature than from the genuine motives of ancient art; and a return to true Hellenism was as much a part of this reaction as the sudden preoccupation with things medieval. The medieval tendency is in Goethe's *Goetz von Berlichingen*, the Hellenic in his *Iphigenie*. At first this medievalism was superficial, or at least external. Adventure, romance in the frankest sense, grotesque individualism—that is one element in medieval poetry, and with it alone Scott and Goethe dealt. Beyond them were the two other elements of the medieval spirit: its mystic religion at its apex in Dante and Saint Louis, and its mystic passion, passing here and there into the great romantic loves of rebellious flesh, of Lancelot and Abelard. That stricter, imaginative medievalism which re-creates the mind of the Middle Age, so that the form, the presentment grows outward from within, came later with Victor Hugo in France, with Heine in Germany.

In the *Defence of Guenevere: and Other Poems*, published by Mr. William Morris now many years ago, the first typical specimen of æsthetic poetry, we have a refinement upon this later, profounder medievalism. The poem which gives its name to the volume is a thing tormented and awry with passion, like the body of Guenevere defending herself from the charge of adultery, and the accent falls in strange, unwonted places with the effect of a great cry. In truth these Arthurian legends, in their origin prior to Christianity, yield all their sweetness only in a Christian atmosphere. What is characteristic in them is the strange suggestion of a deliberate choice between Christ and a rival lover. That religion, monastic religion at any rate, has its sensuous side, a dangerously sensuous side, has been often seen: it is the

experience of Rousseau as well as of the Christian mystics. The Christianity of the Middle Age made way among a people whose loss was in the life of the senses, partly by its æsthetic beauty, a thing so profoundly felt by the Latin hymn-writers, who for one moral or spiritual sentiment have a hundred sensuous images. And so in those imaginative loves, in their highest expression, the Provençal poetry, it is a rival religion with a new rival *cultus* that we see. Coloured through and through with Christian sentiment, they are rebels against it. The rejection of one worship for another is never lost sight of. The jealousy of that other lover, for whom these words and images and refined ways of sentiment were first devised, is the secret here of a borrowed, perhaps factitious colour and heat. It is the mood of the cloister taking a new direction, and winning so a later space of life it never anticipated.

Hereon, as before in the cloister, so now in the *château*, the reign of reverie set in. The devotion of the cloister knew that mood thoroughly, and had sounded all its stops. For the object of this devotion was absent or veiled, not limited to one supreme plastic form like Zeus at Olympia or Athena in the Acropolis, but distracted, as in a fever dream, into a thousand symbols and reflections. But then, the Church, that new Sibyl, had a thousand secrets to make the absent near. Into this kingdom of reverie, and with it into a paradise of ambitious refinements, the earthly love enters, and becomes a prolonged somnambulism. Of religion it learns the art of directing towards an unseen object sentiments whose natural direction is towards objects of sense. Hence a love defined by the absence of the beloved, choosing to be without hope, protesting against all lower uses of love, barren, extravagant, antinomian. It is the love which is incompatible with marriage, for the chevalier who never comes, of the serf for the *châtelaine*, of the rose for the nightingale, of Rudel for the Lady of Tripoli. Another element of extravagance came in with the feudal spirit: Provençal love is full of the very forms of vassalage. To be the servant of love, to

have offended, to taste the subtle luxury of chastisement, of reconciliation—the religious spirit, too, knows that, and meets just there, as in Rousseau, the delicacies of the earthly love. Here, under this strange complex of conditions, as in some medicated air, exotic flowers of sentiment expand, among people of a remote and unaccustomed beauty, somnambulistic, frail, androgynous, the light almost shining through them. Surely, such loves were too fragile and adventurous to last more than for a moment.

That monastic religion of the Middle Age was, in fact, in many of its bearings, like a beautiful disease or disorder of the senses: and a religion which is a disorder of the senses must always be subject to illusions. Reverie, illusion, delirium: they are the three stages of a fatal descent both in the religion and the loves of the Middle Age. Nowhere has the impression of this delirium been conveyed as by Victor Hugo in *Notre Dame de Paris*. The strangest creations of sleep seem here, by some appalling licence, to cross the limit of the dawn. The English poet too has learned the secret. He has diffused through *King Arthur's Tomb* the maddening white glare of the sun, and tyranny of the moon, not tender and far-off, but close down—the sorcerer's moon, large and feverish. The colouring is intricate and delirious, as of 'scarlet lilies'. The influence of summer is like a poison in one's blood, with a sudden bewildered sickening of life and all things. In *Galahad: a Mystery*, the frost of Christmas night on the chapel stones acts as a strong narcotic: a sudden shrill ringing pierces through the numbness: a voice proclaims that the Grail has gone forth through the great forest. It is in the *Blue Closet* that this delirium reaches its height with a singular beauty, reserved perhaps for the enjoyment of the few.

A passion of which the outlets are sealed, begets a tension of nerve, in which the sensible world comes to one with a reinforced brilliancy and relief—all redness is turned into blood, all water into tears. Hence a wild, convulsed sensuousness in the poetry of the Middle Age, in

which the things of nature begin to play a strange delirious part. Of the things of nature the medieval mind had a deep sense; but its sense of them was not objective, no real escape to the world without us. The aspects and motions of nature only reinforced its prevailing mood, and were in conspiracy with one's own brain against one. A single sentiment invaded the world: everything was infused with a motive drawn from the soul. The amorous poetry of Provence, making the starling and the swallow its messengers, illustrates the whole attitude of nature in this electric atmosphere, bent as by miracle or magic to the service of human passion.

The most popular and gracious form of Provençal poetry was the *nocturn*, sung by the lover at night at the door or under the window of his mistress. These songs were of different kinds, according to the hour at which they were intended to be sung. Some were to be sung at midnight—songs inviting to sleep, the *serena*, or *serenade*; others at break of day—waking songs, the *aube* or *aubade*. This waking-song is put sometimes into the mouth of a comrade of the lover, who plays sentinel during the night, to watch for and announce the dawn: sometimes into the mouth of one of the lovers, who are about to separate. A modification of it is familiar to us all in *Romeo and Juliet*, where the lovers debate whether the song they hear is of the nightingale or the lark; the aubade, with the two other great forms of love-poetry then floating in the world, the sonnet and the epithalamium, being here refined, heightened, and inwoven into the structure of the play. Those, in whom what Rousseau calls *les frayeurs nocturnes* are constitutional, know what splendour they give to the things of the morning; and how there comes something of relief from physical pain with the first white film in the sky. The Middle Age knew those terrors in all their forms; and these songs of the morning win hence a strange tenderness and effect. The crown of the English poet's book is one of these appreciations of the dawn:—

Pray but one prayer for me 'twixt thy closed lips,
    Think but one thought of me up in the stars,
The summer-night waneth, the morning light slips,
    Faint and gray 'twixt the leaves of the aspen,
        betwixt the cloud-bars,
That are patiently waiting there for the dawn:
    Patient and colourless, though Heaven's gold
Waits to float through them along with the sun.
Far out in the meadows, above the young corn,
    The heavy elms wait, and restless and cold
The uneasy wind rises; the roses are dun;
Through the long twilight they pray for the dawn,
Round the lone house in the midst of the corn.
    Speak but one word to me over the corn,
    Over the tender, bow'd locks of the corn.
         [*Summer Dawn*, William Morris]

It is the very soul of the bridegroom which goes forth to the bride: inanimate things are longing with him: all the sweetness of the imaginative loves of the Middle Age, with a superadded spirituality of touch all its own, is in that!

The *Defence of Guenevere* was published in 1858, the *Life and Death of Jason* in 1867, to be followed by *The Earthly Paradise*; and the change of manner wrought in the interval, entire, almost a revolt, is characteristic of the æsthetic poetry. Here there is no delirium or illusion, no experiences of mere soul while the body and the bodily sense sleep, or wake with convulsed intensity at the prompting of imaginative love; but rather the great primary passions under broad daylight as of the pagan Veronese. This simplification interests us, not merely for the sake of an individual poet—full of charm as he is—but chiefly because it explains through him a transition which, under many forms, is one law of the life of the human spirit, and of which what we call the Renaissance is only a supreme instance. Just so the monk in his cloister, through the 'open vision', open only to the spirit, divined, aspired to, and at last apprehended, a better daylight, but earthly, open only to the senses. Complex and subtle interests, which the mind spins for itself, may occupy art and poetry or our own spirits for a time; but sooner or later they come back with a sharp

rebound to the simple elementary passions—anger, desire, regret, pity, and fear: and what corresponds to them in the sensuous world—bare, abstract fire, water, air, tears, sleep, silence, and what De Quincey has called the 'glory of motion'.

This reaction from dreamlight to daylight gives, as always happens, a strange power in dealing with morning and the things of the morning. Not less is this Hellenist of the Middle Age master of dreams, of sleep and the desire of sleep, sleep in which no one walks, restorer of childhood to men—dreams, not like Galahad's or Guenevere's, but full of happy, childish wonder as in the earlier world. It is a world in which the centaur and the ram with the fleece of gold are conceivable. The song sung always claims to be sung for the first time. There are hints at a language common to birds and beasts and men. Everywhere there is an impression of surprise, as of people first waking from the golden age, at fire, snow, wine, the touch of water as one swims, the salt taste of the sea. And this simplicity at first hand is a strange contrast to the sought-out simplicity of Wordsworth. Desire here is towards the body of nature for its own sake, not because a soul is divined through it.

And yet it is one of the charming anachronisms of a poet, who, while he handles an ancient subject, never becomes an antiquarian, but animates his subject by keeping it always close to himself, that between whiles we have a sense of English scenery as from an eye well practised under Wordsworth's influence, as from 'the casement half opened on summer-nights', with the song of the brown bird among the willows, the

> Noise of bells, such as in moonlit lanes
> Rings from the grey team on the market night.

Nowhere but in England is there such a 'paradise of birds', the fern-owl, the water-hen, the thrush in a hundred sweet variations, the ger-falcon, the kestrel, the starling, the pea-fowl; birds heard from the field by the townsman down in the streets at dawn; doves everywhere, pink-footed, grey-winged, flitting about the temple, troubled by the temple incense, trapped in the snow. The sea-touches are not less sharp and firm, surest of effect in places where river and sea, salt and fresh waves, conflict.

In handling a subject of Greek's legend, anything in the way of an actual revival must always be impossible. Such vain antiquarianism is a waste of the poet's power. The composite experience of all the ages is part of each one of us: to deduct from that experience, to obliterate any part of it, to come face to face with the people of a past age, as if the Middle Age, the Renaissance, the eighteenth century had not been, is as impossible as to become a little child, or enter again into the womb and be born. But though it is not possible to repress a single phase of that humanity, which, because we live and move and have our being in the life of humanity, makes us what we are, it is possible to isolate such a phase, to throw it into relief, to be divided against ourselves in zeal for it; as we may hark back to some choice space of our own individual life. We cannot truly conceive the age: we can conceive the element it has contributed to our culture: we can treat the subjects of the age bringing that into relief. Such an attitude towards Greece, aspiring to but never actually reaching its way of conceiving life, is what is possible for art.

The modern poet or artist who treats in this way a classical story comes very near, if not to the Hellenism of Homer, yet to the Hellenism of Chaucer, the Hellenism of the Middle Age, or rather of that exquisite first period of the Renaissance within it. Afterwards the Renaissance takes its side, becomes, perhaps, exaggerated or facile. But the choice life of the human spirit is always under mixed lights, and in mixed situations, when it is not too sure of itself, is still expectant, girt up to leap forward to the promise. Such a situation there was in that earliest return from the over-wrought spiritualities of the Middle Age to the earlier, more ancient life of the senses; and for us the most attractive form of classical story is the monk's conception of it, when he escapes from the sombre atmosphere of his

cloister to natural light. The fruits of this mood, which, divining more than it understands, infuses into the scenery and figures of Christian history some subtle reminiscence of older gods, or into the story of Cupid and Psyche that passionate stress of spirit which the world owes to Christianity, constitute a peculiar vein of interest in the art of the fifteenth century.

And so, before we leave *Jason* and *The Earthly Paradise*, a word must be said about their medievalisms, delicate inconsistencies, which, coming in a poem of Greek subject, bring into this white dawn thoughts of the delirious night just over and make one's sense of relief deeper. The opening of the fourth book of *Jason* describes the embarkation of the Argonauts: as in a dream, the scene shifts and we go down from Iolchos to the sea through a pageant of the Middle Age in some French or Italian town. The gilded vanes on the spires, the bells ringing in the towers, the trellis of roses at the window, the close planted with apple-trees, the grotesque undercroft with its close-set pillars, change by a single touch the air of these Greek cities and we are at Glastonbury by the tomb of Arthur. The nymph in furred raiment who seduces Hylas is conceived frankly in the spirit of Teutonic romance; her song is of a garden enclosed, such as that with which the old church glass-stainer surrounds the mystic bride of the song of songs. Medea herself has a hundred touches of the medieval sorceress, the sorceress of the Streckelberg or the Blocksberg: her mystic changes are Christabel's. It is precisely this effect, this grace of Hellenism relieved against the sorrow of the Middle Age, which forms the chief motives of *The Earthly Paradise*: with an exquisite dexterity the two threads of sentiment are here interwoven and contrasted. A band of adventurers sets out from Norway, most northerly of northern lands, where the plague is raging—the bell continually ringing as they carry the Sacrament to the sick. Even in Mr. Morris's earliest poems snatches of the sweet French tongue had always come with something of Hellenic blitheness and grace. And now it is below the very coast of France, through the fleet of Edward the Third, among the gaily painted medieval sails, that we pass to a reserved fragment of Greece, which by some divine good fortune lingers on in the western sea into the Middle Age. There the stories of *The Earthly Paradise* are told, Greek story and romantic alternating; and for the crew of the *Rose Garland*, coming across the sins of the earlier world with the sign of the cross, and drinking Rhine-wine in Greech, the two worlds of sentiment are confronted.

One characteristic of the pagan spirit the æsthetic poetry has, which is on its surface—the continual suggestion, pensive or passionate, of the shortness of life. This is contrasted with the bloom of the world, and gives new seduction to it—the sense of death and the desire of beauty: the desire of beauty quickened by the sense of death. But that complexion of sentiment is at its height in another 'æsthetic' poet of whom I have to speak next, Dante Gabriel Rossetti.

### 'Dante Gabriel Rossetti'

It was characteristic of a poet who had ever something about him of mystic isolation, and will still appeal perhaps, though with a name it may seem now established in English literature, to a special and limited audience, that some of his poems had won a kind of exquisite fame before they were in the full sense published. *The Blessed Damozel*, although actually printed twice before the year 1870, was eagerly circulated in manuscript; and the volume which it now opens came at last to satisfy a long-standing curiosity as to the poet, whose pictures also had become an object of the same peculiar kind of interest. For those poems were the work of a painter, understood to belong to, and to be indeed the leader, of a new school then rising into note; and the reader of today may observe already; in *The Blessed Damozel*, written at the age of eighteen, a prefigurement of the chief characteristics of that school, as he will recognise in it also, in

proportion as he really knows Rossetti, many of the characteristics which are most markedly personal and his own. Common to that school and to him, and in both alike of primary significance, was the quality of sincerity, already felt as one of the charms of that earliest poem—a perfect sincerity, taking effect in the deliberate use of the most direct and unconventional expression, for the conveyance of a poetic sense which recognised no conventional standard of what poetry was called upon to be. At a time when poetic originality in England might seem to have had its utmost play, here was certainly one new poet more, with a structure and music of verse, a vocabulary, an accent, unmistakably novel, yet felt to be no mere tricks of manner adopted with a view to forcing attention—an accent which might rather count as the very seal of reality on one man's own proper speech; as that speech itself was the wholly natural expression of certain wonderful things he really felt and saw. Here was one, who had a matter to present to his readers, to himself at least, in the first instance, so valuable, so real and definite, that his primary aim, as regards form or expression in his verse, would be but its exact equivalence to those data within. That he had this gift of transparency in language—the control of a style which did but obediently shift and shape itself to the mental motion, as a well-trained hand can follow on the tracing-paper the outline of an original drawing below it, was proved afterwards by a volume of typically perfect translations from the delightful but difficult 'early Italian poets': such transparency being indeed the secret of all genuine style, of all such style as can truly belong to one man and not to another. His own meaning was always personal and even recondite, in a certain sense learned and casuistical, sometimes complex or obscure; but the term was always, one could see, deliberately chosen from many competitors, as the just transcript of that peculiar phase of soul which he alone knew, precisely as he knew it.

One of the peculiarities of *The Blessed Damozel* was a definiteness of sensible imagery, which seemed almost grotesque to some, and was strange, above all, in a theme so profoundly visionary. The gold bar of heaven from which she leaned, her hair yellow like ripe corn, are but examples of a general treatment, as naively detailed as the pictures of those early painters contemporary with Dante, who has shown a similar care for minute and definite imagery in his verse; there, too, in the very midst of profoundly mystic vision. Such definition of outline is indeed one among many points in which Rossetti resembles the great Italian poet, of whom, led to him at first by family circumstances, he was ever a lover—a 'servant and singer', faithful as Dante, 'of Florence and of Beatrice'—with some close inward conformities of genius also, independent of any mere circumstances of education. It was said by a critic of the last century, not wisely though agreeably to the practice of his time, that poetry rejoices in abstractions. For Rossetti, as for Dante, without question on his part, the first condition of the poetic way of seeing and presenting things is particularisation. 'Tell me now', he writes, for Villon's

> *Dictes-moy où, n'en quel pays,*
> *Est Flora, la belle Romaine—*

> Tell me now, in what hidden way is
> Lady Flora the lovely Roman;

—'way', in which one might actually chance to meet her; the unmistakably poetic effect of the couplet in English being dependent on the definiteness of that single word (though actually lighted on in the search after a difficult double rhyme) for which every one else would have written, like Villon himself a more general one, just equivalent to place or region.

And this delight in concrete definition is allied with another of his conformities to Dante, the really imaginative vividness, namely, of his personifications—his hold upon them, or rather their hold upon him, with the force of a Frankenstein, when once they have taken life from him. Not Death only and Sleep, for instance, and

the winged spirit of Love, but certain particular aspects of them, a whole 'populace' of special hours and places, 'the hour' even 'which might have been, yet might not be', are living creatures, with hands and eyes and articulate voices.

> Stands it not by the door—
> Love's Hour—till she and I shall meet;
> With bodiless form and unapparent feet
> That cast no shadow yet before,
> Though round its head the dawn begins to pour
> The breath that makes day sweet?—
>
> Nay, why
> Name the dead hours? I mind them well:
> Their ghosts in many darkened doorways dwell
> With desolate eyes to know them by.

Poetry as a *mania*—one of Plato's two higher forms of 'divine' mania—has, in all its species, a mere insanity incidental to it, the 'defect of its quality', into which it may lapse in its moment of weakness; and the insanity which follows a vivid poetic anthropomorphism like that of Rossetti may be noted here and there in his work, in a forced and almost grotesque materialising of abstractions, as Dante also became at times a mere subject of the scholastic realism of the Middle Age.

In *Love's Nocturn* and *The Stream's Secret*, congruously perhaps with a certain feverishness of soul in the moods they present, there is at times a near approach (may it be said?) to such insanity of realism—

> Pity and love shall burn
> In her pressed cheek and cherishing hands;
> And from the living spirit of love that stands
> Between her lips to soothe and yearn,
> Each separate breath shall clasp me round in turn
> And loose my spirit's bands.

But even if we concede this; even if we allow, in the very plan of those two compositions, something of the literary conceit—what exquisite, what novel flowers of poetry, we must admit them to be, as they stand! In the one, what a delight in all the natural beauty of water, all its details for the eye of a painter; in the other, how subtle and fine the imaginative hold upon all the secret ways of sleep and dreams! In both of them, with much the same attitude and tone, Love—sick and doubtful Love—would fain inquire of what lies below the surface of sleep, and below the water; stream or dream being forced to speak by Love's powerful 'control'; and the poet would have it foretell the fortune, issue, and event of his wasting passion. Such artifices, indeed, were not unknown in the old Provençal poetry of which Dante had learned something. Only, in Rossetti at least, they are redeemed by a serious purpose, by that sincerity of his, which allies itself readily to a serious beauty, a sort of grandeur of literary workmanship, to a great style. One seems to hear there a really new kind of poetic utterance, with effects which have nothing else like them; as there is nothing else, for instance, like the narrative of Jacob's Dream in *Genesis*, or Blake's design of the Singing of the Morning Stars, or Addison's Nineteenth Psalm.

With him indeed, as in some revival of the old mythopceic age, common things—dawn, noon, night—are full of human or personal expression, full of sentiment. The lovely little sceneries scattered up and down his poems, glimpses of a landscape, not indeed of broad open-air effects, but rather that of a painter concentrated upon the picturesque effect of one or two selected objects at a time—the 'hollow brimmed with mist', or the 'ruined weir', as he sees it from one of the windows, or reflected in one of the mirrors of his 'house of life' (the vignettes for instance seen by Rose Mary in the magic beryl) attest, by their very freshness and simplicity, to a pictorial or descriptive power in dealing with the inanimate world, which is certainly also one half of the charm, in that other, more remote and mystic, use of it. For with Rossetti this sense of lifeless nature, after all, is translated to a higher service, in which it does but incorporate itself with some phase of strong emotion. Every one understands how this may happen at critical moments of life; what a weirdly

expressive soul may have crept, even in full noonday, into 'the white-flower'd elder-thicket', when Godiva saw it 'gleam through the Gothic archways in the wall', at the end of her terrible ride. To Rossetti it is so always, because to him life is a crisis at every moment. A sustained impressibility towards the mysterious conditions of man's everyday life, towards the very mystery itself in it, gives a singular gravity to all his work: those matters never became trite to him. But throughout, it is the ideal intensity of love—of love based upon a perfect yet peculiar type of physical or material beauty—which is enthroned in the midst of those mysterious powers; Youth and Death, Destiny and Fortune, Fame, poetic Fame, Memory, Oblivion, and the like. Rossetti is one of those who, in the words of Mérimée, *se possionnent pour la passion*, one of Love's lovers.

And yet, again as with Dante, to speak of his ideal type of beauty as material, is partly misleading. Spirit and matter, indeed, have been for the most part opposed, with a false contrast or antagonism by schoolmen, whose artificial creation those abstractions really are. In our actual concrete experience, the two trains of phenomena which the words matter and spirit do but roughly distinguish, play inextricably into each other. Practically, the church of the Middle Age by its æsthetic worship, its sacramentalism, its real faith in the resurrection of the flesh, had set itself against that Manichean opposition of spirit and matter, and its results in men's way of taking life; and in this, Dante is the central representative of its spirit. To him, in the vehement and impassioned heat of his conceptions, the material and the spiritual are fused and blent: if the spiritual attains the definite visibility a crystal, what is material loses its earthiness and impurity... And here again, by force of instinct, Rossetti is one with him. His chosen type of beauty is one,

> Whose speech Truth knows not from her thought,
> Nor Love her body from her soul.

Like Dante, he knows no region of spirit which shall not be sensuous also, or material. The shadowy world, which he realises so powerfully, has still the ways and houses, the land and water, the light and darkness, the fire and flowers, that had so much to do in the moulding of those bodily powers and aspects which counted for so large a part of the soul, here.

For Rossetti, then, the great affections of persons to each other, swayed and determined, in the case of his highly pictorial genius, mainly by that so-called material loveliness, formed the great undeniable reality in things, the solid resisting substance, in a world where all beside might be but shadow. The fortunes of those affections—of the great love so determined; its casuistries, its languor sometimes; above all, its sorrows; its fortunate or unfortunate collisions with those other great matters; how it looks, as the long day of life goes round, in the light and shadow of them: all this, conceived with an abundant imagination, and a deep, a philosophic, reflectiveness, is the matter of his verse, and especially of what he designed as his chief poetic work, 'a work to be called *The House of Life*', towards which the majority of his sonnets and songs were contributions.

The dwelling-place in which one finds oneself by chance or destiny, yet can partly fashion for oneself; never properly one's own at all, if it be changed too lightly; in which every object has its associations—the dim mirrors, the portraits, the lamps, the books, the hair-tresses of the dead and visionary magic crystals in the secret drawers, the names and words scratched on the windows, windows open upon prospects the saddest or the sweetest; the house one must quit, yet taking perhaps, how much of its quietly active light and colour along with us!—grown now to be a kind of raiment to one's body, as the body, according to Swedenborg, is but the raiment of the soul—under that image, the whole of Rossetti's work might count as a *House of Life*, of which he is but the 'Interpreter'. And it is a 'haunted' house. A sense of power in love, defying distance, and those barriers which are so much more than physical

distance, of unutterable desire penetrating into the world of sleep, however 'lead-bound', was one of those anticipative notes obscurely struck in *The Blessed Damozel*, and, in his later work, makes him speak sometimes almost like a believer in mesmerism. Dream-land, as we said, with its 'phantoms of the body', deftly coming and going on love's service, is to him, in no mere fancy or figure of speech, a real country, a veritable expansion of, or addition to, our waking life; and he did well perhaps to wait carefully upon sleep, for the lack of it became mortal disease with him. One may even recognise a sort of morbid and over-hasty making-ready for death itself which increases on him; thoughts concerning it, its imageries, coming with a frequency and importunity, in excess, one might think, of even the very saddest, quite wholesome wisdom.

And indeed the publication of his second volume of *Ballads and Sonnets* preceded his death by scarcely a twelvemonth. That volume bears witness to the reverse of any failure of power, or falling-off from his early standard of literary perfection, in every one of his then accustomed forms of poetry—the song, the sonnet, and the ballad. The newly printed sonnets, now completing *The House of Life*, certainly advanced beyond those earlier ones, in clearness; his dramatic power in the ballad, was here at its height; while one monumental, gnomic piece, *Soothsay*, testifies, more clearly even than the *Nineveh* of his first volume, to the reflective force, the dry reason, always at work behind his imaginative creations, which at no time dispensed with a genuine intellectual structure. For in matters of pure reflection also, Rossetti maintained the painter's sensuous clearness of conception; and this has something to do with the capacity, largely illustrated by his ballads, of telling some red-hearted story of impassioned action with effect.

Have there, in very deed, been ages, in which the external conditions of poetry such as Rossetti's were of more spontaneous growth than in our own?

# ◼ The 1890s and after ◼

## THE SISTERHOOD OF PRE-RAPHÆLITE ARTISTS

Although the anthology offers examples of the writings of women within the Pre-Raphælite movement—Christina Rossetti's prose and poetry Elizabeth Siddal's poetry, Georgiana Burne-Jones's memoirs of her husband—the Pre-Raphælites are still more commonly associated with men. And the perception is not altogether incorrect, because so much of the writing was done by male authors and respondents. Within the world of Pre-Raphælite art, however, such a perception is incorrect. Pre-Raphælite art had always depended heavily upon women as the inspiration and validation of its own particular brand of the æsthetic ideal. Indeed, its art is defined by its adherence to a stylized image of women immortalized by such models, sometimes later wives, as Elizabeth Siddal, Jane Morris, Fanny Cornforth, Alexa Wilding and Maria Zambaco. The impact of women upon the movement was immediate and indelible. As an observer of the year 1851 wrote, 'Girls had now entered the Pre-Raphælite circle, and the close group of young men was breaking up'. Women were acknowledged as vital, but the regret revealed by such a statement could almost be applied to the resentment levied at Yoko Ono for the breakup of the Beatles. Perceived as virtue or vice, women were instrumental in the shaping of Pre-Raphælitism not only as models but as artists also, a fact that is too often overlooked. To quote from Jan Marsh and Pamela Gerrish Nunn's invaluable *Women Artists and the Pre-Raphælite Movement*, 'Today, a general account of Pre-Raphælitism may include more than forty male artists and fewer than five female names, or often none at all. The ambitious exhibition "The Pre-Raphælites" at the Tate Gallery in 1984, for example, covering the years 1848-70, contained work by twenty-eight men and one woman.' As Pre-Raphælitism evolved ever increasingly into the Arts and Crafts movement and the Æsthetic movement, however, women artists were drawn by the style and themes of Pre-Raphælite art, and this section showcases work produced by some of the best of these artists at the turn of the century. I have chosen, therefore, to highlight the art of Evelyn de Morgan née Pickering, Eleanor Fortescue Brickdale, and Frances Macdonald, the designs and embroidery of Jane and May Morris, and the book illustrations of Jessie Marion King. Their work shows obvious signs of influence by the more established and recognized male artists of the movement; and, as Harold Bloom would phrase it for literary endeavors, some 'anxiety of influence' is apparent. One sees, for example, in Evelyn de Morgan's work echoes of Edward Burne-Jones, but whereas Burne-Jones often imbued his women with vacancy, Evelyn de Morgan depicts her subjects with dramatic intensity; in Eleanor Fortescue Brickdale's work, her attention to detail is reminiscent of the early work of Millais and the continuing obsession of Hunt, but, while her subject matter relies heavily on the perennial Pre-Raphælite fare of literary and religious subjects, her interest in women lay in their strength as is evidenced by a compilation of watercolors and texts she did in 1919, *Eleanor Fortescue Brickdale's Golden Book of Famous Women*, highlighting such as Guinevere, Katherine of Aragon, Joan of Arc, Beatrice and Eloise. The illustrations of Jessie Marion King, like the illustrations of Arthur Hughes, are a significant accompanying force to the text, and the delicacy of her drawings for William Morris's *The Defence of Guinevere* (1904) exclude the Froissart-like realism of Morris's work and eschew morbidity in favor of mysticism. Kate E. Bunce, herself a minor poet, depicts Rossetti's 'The Staff and Scrip' in her painting *The Keepsake* (color plate), but almost as a counter to his melancholy narrative of female

frailty she offers a Palace of Art, immutable and dominated by women. In the case of other artists, some license has been taken. Frances Macdonald is more commonly viewed as belonging to the Glasgow School of Art, best known perhaps within the context of the work of Charles R. Mackintosh, but as Marsh and Nunn argue, the roots of such Symbolist art are traceable to Pre-Raphælitism and it is fascinating to compare Frances Macdonald's 'The Choice' to Dante Rossetti's equally 'spooky' pen and brush 'How

They Met Themselves'. Jane Morris and her daughter May Morris have also been included because while art is commonly limited to paintings and drawings, the artistry of design and embroidery should also be included, especially as they embody the philosophy which came to define the Arts and Crafts Movement: the use of raw materials and craftsmanship—kilns, presses, and looms—to create art. The works of this section, therefore, offer some balance to the Brotherhood.

William Morris's bed at Kelmscott, bed curtains and valance worked by Jane Morris and May Morris (1894)

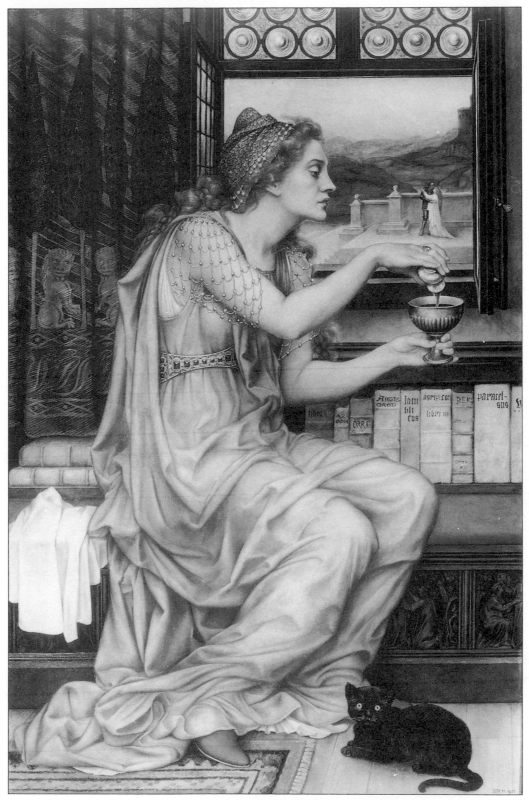

*The Love Potion* by Evelyn de Morgan née Pickering (1903)

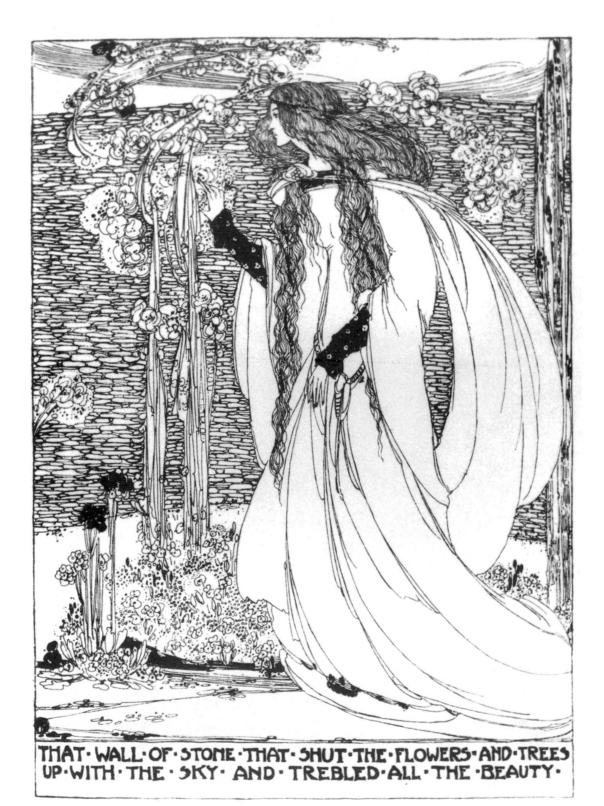

THAT·WALL·OF·STONE·THAT·SHUT·THE·FLOWERS·AND·TREES
UP·WITH·THE·SKY·AND·TREBLED·ALL·THE·BEAUTY·

'That Wall of Stone that Shut the Flowers and Trees up with the Sky' by Jessie Marion King (1905)

326

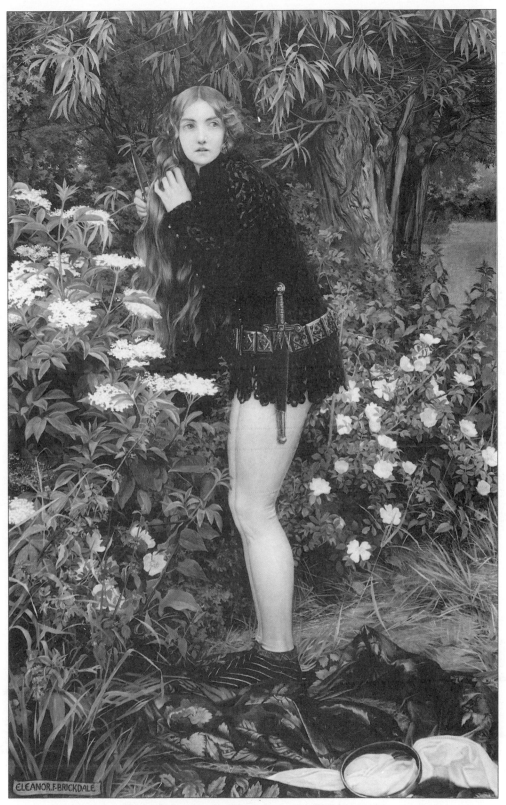

*The Little Foot Page* by Eleanor Fortescue Brickdale (1905)

327

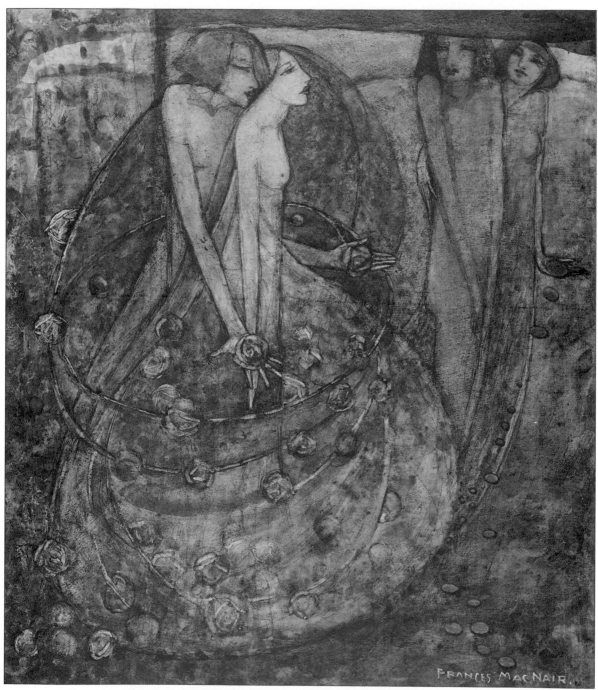

*The Choice* by Frances Macdonald (1910)

328

# LETTERS, DIARIES AND REFLECTIONS

## Wilfrid Scawen Blunt
### From his Diaries and Notebooks

[1890]

May 13  Then to Hammersmith and spent the afternoon with Mrs. Morris. Sitting in the garden on a bench she told me more about Rossetti than I had yet heard from her. She corresponded with him before her marriage, but he never made love to her then, though she used to sit to him as a model. Many of his earlier letters she destroyed but she still has ten years of them—'love letters', she said, 'and very beautiful ones'. I urged her not to destroy them but rather to leave them to me in trust, for she said that she could not leave them in any way that her husband or children could see them. She had thought sometimes of building them into a wall at Kelmscott and leaving it to fate to decide what should become of them. But she has promised to leave them to me, 'for there is nobody now living', she said, 'who knows me as you do'. She described to me her last meeting with Rossetti which was as late as 1881 the year before he died (Note—Their love ended in 1875). She went to spend the afternoon with him at his house in Chelsea and dined with him, and after dinner he took her home in a cab and she had almost persuaded him inside the house to see the children when he turned back. He had already half crossed the little courtyard—'He was in high spirits that day', she said, 'but I never saw him again'. I quite understand her influence over him, for she influences me. In her prime she must have been the most beautiful woman conceivable—I do not mean her face—and she is wholly unselfish and unworldly, though extremely human…

May 7  Next day to Hammersmith and lunched with the Morrises. He has been at death's door through gout but looks well again, she much aged. He is full as ever of his work and took me to see his printing press a few doors off, and sold me across the dining table the first copy of the first

volume printed at the Kelmscott Press, a very wonderful production. [This was 'The Story of the Glittering Plain'. While we were sitting talking this copy was brought in to him by the printer, the first that had been bound and made up, and I asked him 'What do you mean to do with these books?' He said 'To sell them of course'. 'Will you sell this copy to me?' 'Certainly.' 'How much?' 'A pound.' So I paid my pound and took it away having made him write his name thus: 'I sold this book to Wilfrid Scawen Blunt May 7th 1891. William Morris.' A copy of it has since been sold for £39.] My poems are to be in the fourth book printed. I walked with Mrs. Morris in her suburban garden—ours is a very envious [sic] friendship, for we have little really in common on the outside of things, and she is so silent a woman that except through the physical senses we never could have become intimate. As it is, though we have so long been on these terms, we have neither, that I can remember, ever called the other by our Christian names. I wonder whether it was so with Rossetti. The result in any case is a very excellent and worthy friendship, unbroken by a single unkind or impatient word.

[1892]

May 5  To Mrs. Morris at Hammersmith and stopped a couple of hours with her in the gloomy house. We talked about Rossetti, and I asked her whether she had been very much in love with him. She said, 'Yes, at first, but it did not last long. When I found that he was ruining himself with Chloral and that I could do nothing to prevent it, I left off going to him—and on account of the children.' I said, 'I think I loved you for Rossetti's sake. He is the one modern poet who interests me.' 'If you had known him,' she said, 'you would have loved him, and he would have loved you —all were devoted to him who knew him. He was unlike all other men—' She showed me the inside of the cabinet in her drawing room, the one painted by Burne-Jones as a wedding gift for

Morris. There was a picture in it on the door panel of a woman with red hair and bright cheeks, Rossetti's wife. It was not till long after that Rossetti's love for herself began. On the other panel was a figure by Morris, half finished, intended for her. 'He was wise enough', she said, 'to give up painting when he found he could not do it well—'

[1893]
June 9  To Hammersmith. I had written an acrostic for Mrs. Morris and sent it to her. It is this:

> Acrostic to Jane Morris
> Jacinths and jessamines and jonquils sweet,
> All odorous pale flowers from orient lands,
> (No vain red roses) strew I at thy feet,
> Emblems of grief and thee, with reverent hands.
> Mine is no madrigal of passionate joy
> Or orison or aught less chaste than tears.
> Ruth on thy brow sits fairest. Its annoy
> Rends not thy beauty's raiment, nor the years.
> In thy shut lips, what secrets! Who am I
> Should seek a sign at that sad sanctuary?

I had sent her this, and she asked me today whether her face really gave me the impression of being sad, as she had never thought of it as such. The verses, as a matter of fact, were the impression I first had of her ten years ago, but it is the first lines I ever wrote to her.

## Georgiana MacDonald Burne-Jones
### From *The Memorials of Edward Burne-Jones*

[1893]
About the exhibition of his own collected works at the New Gallery this winter he writes: 'It is the kind of thing that should never be done till a man is dead. I dreaded it exceedingly. I feel a little as if a line was drawn across my life now and that the future won't be quite the same thing I meant it to be—I can't tell quite what I mean, and it is a sort of superstition, but there it is. It will be like

looking in a magic mirror, and seeing myself at 25 and 30, and 35 and 40, and 45 and 50, and so on to the hundred and tenth year I have now, and I don't like it one bit. I try to close my ears, and to forget it all. It was a mistake of Nature that we cannot shut our ears as we can our eyes, with firm lids.' But afterwards he said: 'Though I was discouraging always when the exhibitions was first thought of and was loth to have the pictures tried again by the public, yet now that all is over and many were pleased, I am glad'.

A letter from Du Maurier in February, 1893, full of sympathy and remembrance of their youth, was amongst the few papers that Edward preserved. It follows here.

'My dear Burne-Jones, I went yesterday to the New Gallery. It was a peculiar sensation of pleasure—très doux et un peu triste—like opening an old diary. I knew all or very nearly all the pictures there, remembering well where and when I had seen them, and with what impressions. It reminded me of Millais' show at the Grosvenor Gallery, where you were so enthusiastic—do you recollect? We went down Bond Street afterwards in a four-wheeler together and you nearly stamped through the floor! Millais' Autumn Leaves, the Vale of Rest,—at Christie's—what a pleasure it was to see them again after so many years! And in just the same way I can't tell you with what pleasure I saw Merlin and Nimue, the Merciful Knight, Circe and her black panther, and others that I had so loved in the happy days of youths; and found that absence had only made the heart grow fonder!

'I think your special glamour (the Burne-Jonesiness of Burne-Jones, if I may coin such a word), the gift you always had among others of so strangely impressing the imagination and ever after haunting the memory, was almost as fully developed then (when I was young and tender!) as in the later work of greater scope where you had reached your full of mastery of execution and draughtsmanship and design—which you seem to have reached so soon.

'I suppose it is this very marked and peculiar flavour in your work which has made you such

friends among even those who have had no special technical training and can only feel without knowing why—like my wife who was with me and shared in all this delight of walking in a lovely dream-land full of mystery and reminiscence,

> Fair passions and bountiful pities
> And loves without stain!

It is of course a great pity the Briar Rose was absent. But King Cophetua, the Wheel of Fortune, Merlin and Nimue, Laus Veneris, Chant d'Amour, and these later works (that must be so good to live with) I beheld again with a still keener insight and appreciation than in the old Grosvenor Gallery days.

'But I won't bore you any longer with my own sensations; I will only say that I have always loved your work from the beginning and shall no doubt do so to the end. If you had been a stranger to me I should have felt the same. It is only because on more than one occasion you have been good enough to tell me that you have had pleasure from things I have done (and thereby given me very great pleasure indeed) that I venture to try and express myself thus directly to you.'...

The death of Madox Brown this October brought unforgotten kindness to mind more than ever. I was able to join the friends who stood around his grave. Edward could not be there visibly, but a letter written the same day shews how he was thinking of his old friend: 'And to-day they bury Madox Brown. I can't go, but I ought to be there. Little was his luck in this world—less wonderful men have even been famous. At first he was very kind to me, then he wasn't. I know no more why than you do—perhaps chatterers came between. He knew no middle way between loving and hating, and I ought to understand that—a turbulent head, impetuous, unjust—always interesting; but it was more fun for those he liked than those he hated—and to-day they put him out of sight. For the first three or four years he was a great part of my life; and I could have done very well for that mood never to have passed away. He died quite young for an artist. Our first fifty years

pass in mighty mistakes: after that we grow timid, and can scarce put the right foot in front of the left, for self-conscious shame. Then another twenty years of halting, and we get new courage and know what to do, and what must be left undone: and then comes a gleam of hope and a trumpet call—and off we have to go.'...

On January 27th 1894, came the following letter from Mr. Gladstone:

> Dear Mr. Burne-Jones,
>     With the sanction of Her Majesty, I have to propose to you that you should accept the honour of a Baronetcy, in recognition of the high position which you have obtained by your achievement in your noble art.
>     Perhaps I give more pleasure to myself in writing this letter, than I shall give to you on your receiving it. But I hope that it may be agreeable to you to fall in with my views; for, setting aside private satisfactions, their aim is to promote a due distribution of public honour in a great profession, which has not always received in this respect anything approaching to liberal treatment.
>     Believe me most faithfully yours
>             W.E. Gladstone.

The honour was accepted...

[1896]

With the beginning of 1896 came a menace of change. Hear it in this whisper of dismay: 'Last Sunday, in the very middle of breakfast, Morris began leaning his forehead on his hand, as he does so often now. It is a thing I have never seen him do before in all the years I have known him.' And from this time Edward knew that the force which had directed his friend's life was failing.

The day had been when this would have overwhelmed him, but now he was himself a traveller that hasted to his rest, and his first thought was of completing their work. 'I am getting very anxious about Morris and about the Chaucer', he said. 'He has not done the title-page yet, which will be such a rich page of ornament

with all the large lettering. I wish he would not leave it any longer.' By the end of February it was splendidly finished, but on the 23rd of that month I find in my diary, 'No Morris to breakfast', nor did he ever come again in the old way. Before long Edward wrote: 'Morris has been ill again—I am very frightened—better now, but the ground beneath one is shifting, and I travel amongst quicksands.'…

A letter to Mr. Ellis, in reply to one about the completion of the Chaucer, belongs to April 24th:

'What a nice letter to have brought one at breakfast time—the first restful breakfast for months, for work is finished and I am off to the sea. So it came well-timed and gave me real happiness, that you should feel so strongly about my share of the Chaucer. I have worked at it with love, and was almost as sorry as glad when the work was done; but, as you say, what praise shall be given to Morris, and who else could have carried it through, and who else have designed it as he has? A few more weeks now and it will be out, and I almost believe—so childishly hopeful am I—that as many as seven people will be delighted with it. I put it at a high number, but then I feel exhilarated.'

To another friend he said later on: 'When Morris and I were little chaps at Oxford, if such a book had come out then we should have just gone off our heads, but we have made at the end of our days the very thing we would have made then if we could. It does look Beautiful, and why should I deceive you? and I may say it, for my share in it is that of the carver of the images in Amiens, and Morris's that of the Architect and Magister Lapicida. We have given one to Swinburne, between us, and writ his name in it, from us both, and I expect he will be pleased.' He spoke of the book altogether as being a type of the life he should most love, 'a centre of Beauty so surrounded with Beauty that you scarcely notice it—scarcely notice it, take it for granted—where the lowest is as worthy as the highest, and yet the King is there'.

Though the Chaucer was not issued to the public before June 26th, Edward procured a copy, bound in the white pig-skin cover designed by Morris, in time to give it to our daughter upon her birthday, which was the 3rd of the month. The joke of a surprise present was repeated by his packing up the big volume in a parcel of shape so disguised that no one could guess at its contents, and then he carried it triumphantly to her house before breakfast. The anniversary was a double one, our little grandson having been born on the same day as his mother, and we always made some celebration of it at the Grange. This year we had Punch and Judy in the garden, and none of the children who came to see it enjoyed the performance more than did the master of the house. 'I really do think', he said, 'Punch is the noblest play in the whole world. He's such a fine character, so cheerful, he's such a poet, he chirrups and sings whole operas that are not yet written down, till the world breaks in upon him in the shape of domestic life and the neighbours. And then his poor little legs, how pathetic they are, and his ways with his wife, and his dying shudder.' To Morris, coming in the day afterwards, he spoke of this treat: 'I say, old boy, I saw a play yesterday you would have liked—Punch!' 'Yes', said Morris, 'I like Punch'.

The last time the friends went anywhere together was to the Society of Antiquaries, of which Morris was a member, their errand being to look at painted manuscripts. 'We made our little pious pilgrimage together', said Edward, 'and saw the beautiful books: but though he was full of interest and enthusiasm about them, he could not look at them for more than five minutes together without being so fatigued that he had to take a rest.'…

And now that they were done, instead of wanting rest, he [Edward] said: 'I feel that I would like to go at another picture straight away, but I can't, not because of myself, but because of other people. They won't let me. Never mind, when I come back, after next week, we'll begin a new campaign.'

By the time named he was back again, face to

face with the work he had decided to finish next, the large oil picture of 'Love and the Pilgrim'. Looking at it, he said: 'These days are very disappointing: the work done and gone leaves one stranded. I thought of beginning a fresh lot of work with such vigour, and now don't feel the energy to tackle anything. The fact is I am still very tired. And the death of poor Alfred Hunt too is quite upsetting. It seems as though nothing had been happening but deaths of artists. Such a lot of them have been going. Such a lot! Poor Millais is ill again, I hear.' A little later he wrote: 'I grizzle a good deal over Millais. He was such a hero to me when I was young—seemed like one of the celestials—and I did not want to be reminded that he is mortal.'

On October 3rd Morris died—as gently, as quiet as a babe who is satisfied drops from its mother's breast. A letter of mine, written in these days, tells something of how Edward passed through them. 'It is no shock—for we have watched it drawing near for a long time—but we know that the conditions of life are changed for us now. We are not broken, either in body or spirit, by the death of our beloved friend. Edward is slowly but steadily gaining ground, and goes out every day; I need not say that he works through everything. It almost frightened me at first to see how he flew at his work, but now he does it less feverishly. I scarce know how to write of it all, but so far Morris' own vitality seems as if it encompassed us, and added energy instead of any prostration has been the effect of his going. We said to each other directly that it was no weeping matter. The beauty of his funeral nothing can express. The rain ceased for the few minutes we stood by his grave, and there was silence that could be heard, when the last words ceased to break it. I am taking all the care I can of Edward— feeding as far as he will let me—companioning as far as may be.' But his cry was: 'I am quite alone now, quite, quite'. Whilst his friend still lived he said: 'The things that in thought are most of me, most dear and necessary, are dear and necessary to no one except Morris only.'...

[1898]
By the kindness of God we were alone on this last evening: the theatre engagement that hung over our heads had been postponed. We played dominoes on the corner of the dinner table, and as we played he said he was tired and would write to tell Rudyard when he was coming to Rottingdean. I left him at his writing-table, and went into the drawing-room as usual. There a cloud descended upon me, of nameless fear: I had felt none of it while with Edward, but it covered me with darkness in my own familiar room. I turned to the piano and tried to play, but could only lean forward with folded arms upon the music desk and feel a terror around me. Edward joined me before long, and his presence made things natural again, as he lay down on the sofa with his back to the light and I settled by a lamp to find the place we were at in Miss Kingsley's Travels. He listened with the keenest interest to her account of the rapids of the river Ogowé. 'How good her descriptions are', he said; 'some people can't describe a thing at all, but I can see all the places she writes about'. We followed the story as far as her safe descent of the rapids, and I put the marker into the book and closed it at the place where she describes herself as having been in 'the amphitheatre of King Death'.

Alone in my room upstairs, fear came upon me again, still with no warning of the side from which trouble would come. I was not afraid especially for him, nor for myself, but of something, and my sorely-laden spirit found relief in the cry 'O God, help us to bear it!'

A speaking-tube connected Edward's room with mine, and in the night he called me and I went to him. Full and round as ever was the voice in which he spoke, splendid was his strength and courage against mortal pain; but a stronger than he was there, and the first severe shock of angina pectoris took his life.

He lay there, a serene image of restored, unshaken power, when his children came; and amongst us all there was but one thought, of joy that now no other storm of pain could reach him.

We threw open the shutters of his room, and let in the morning light. All things afterwards were done according to arrangements that had been long understood. Fire, not earth, received the body he had done with, and his ashes were laid in the quiet corner of a country churchyard. There was a memorial service in Westminster Abbey, and then the stream of life flowed on.

## Arthur Hughes

### Letters to Alice Boyd

May 1891

Dear Miss Boyd

…I don't think I have much news. I hope you have taken advantage of the long fine spring weather to get strong, that is if it has been the same with you as with us. Until just this Whitsuntide when we have had it has bad as possible with cold and rain—but before, truly, I never remember the Orchards so lovely with bloom and lasting so long uninjured by wind or rain. My morning ride to town has been lovely, at least the beginning of it, as the rail runs across the river and thro' orchards that have been masses of loveliness!

I must tell you how I got into an empty compartment one morning and went to the far side and sat looking at the blooms and bright clouds over them, got dreaming about Japan, and going over and thro' everything I ever heard or knew about it,—and so after a while returning to the common world and looking around thinking what a very long wandering I had taken, found I was not alone. The train had stopped two or three times perhaps, without my being aware of it, and in the corner sat a young Jap quietly reading a letter from Japan! wasn't that rather funny? I have been running against a few old friends too, at Holman Hunt's private view the other day. He looked very well and bright, and Mrs. Hunt wonderfully well and young. Often she seems so tired and worn out one can only feel she must be

tried a great deal, but she looked splendid then and Gladys, oh! so tall. I think taller than her mother. Cyril is tea or coffee planting in Ceylon and they gave a fairly good report of him. The Hipkins is well as ever. The Seddons, with a good report of Mrs. Scott. (I'm horridly ashamed of myself. We have not yet found opportunity to visit her)…Wm. Rossetti seems quite unaltered but his wife's illness seems to tell upon her, and prematurely ages her I think. The young Hueffer aged 17 I think is about to bring out a book! of fairy tales. I saw all the good people at one of Mrs. Rossetti's afternoons, there, and at all the private views…

I have lately read Morris' 'News from Nowhere'. A pretty dream of 2000 AD when England is to be a Mediæval Paradise and all work to be done for the pleasure of it. Every sort. No money. No buying or selling. Every one with plenty of leisure and wearing beautiful clothes richly embroidered by hand. No railways. Every house lovely. No crime. All people beautiful and living to 125 years or so. A pretty dream…

I am filling our Whitsuntide holiday by beginning dear Scotus' picture. Ever so much love from all here—

Affect[ionate]ly yrs
Arthur Hughes

Dec. 7. 92

Dear Miss Boyd

You were quite within the mark when you said you knew 'the book would be full of deep interest' for me.[1] It is indeed inwoven with the strongest threads of my life. I am so glad of it, and grateful to him for it; it is just a confirmation of himself; and as one fell in love with him at first, long ago, knowing blindly, it was so, and could not be otherwise with one's self, and that all further acquaintance only repeated the sensation, so, this seems to sum it all up in his own words at last, and the character is concrete, and one's own affection confirmed. For now, no alteration can be.

1. Hughes here refers to William Bell Scott's *Autobiographical Notes*, which was published posthumously.

I do not wish a word less in the book. I think it is a most truth loving history, so far as human work can be so. I know I feel its value, and feel that it might have been equally truthful, so to speak, and rather seriously unpleasant with less reticence.

I should like someday to read it, with you near by—altho' I say it is complete, a little more sometimes would be welcome, if it could be had. And the good Hunt's letters too—how good they are.

I feel I want to thank Mr. Minto for that epilogue.

I last night met in the Pall Mall Gazette—the cutting I enclose[2]—an answer to some foolishness of Swinburne lately.

With love from all of us. I am, dear Miss Boyd
Affect[ionate]ly yours
Arthur Hughes

Please excuse this hasty scrawl.

Dec. 14. 92

Dear Miss Boyd

I have just had the courage to write a line or two to Mr. Minto, having seen the very perfect answer of his in the Academy to all that wicked stupidity that called it forth!

I only yesterday saw the Fortnightly. What a farrago of wickedness!—But oh! what a diseased mind it represents: of wounded vanity, disturbed to such incomprehensible dimensions, by seemingly quite the smallest of causes. Such unbalanced language only defeats its object, and paints the user ridiculous. The squandering of all adjectives in the dictionary is surely very poor misuse of literary faculty too?

I cannot help contrasting and thinking of dear W.B.'s reflections after taking his early ambitious poem to Walter Scott. He sums up: 'He was not the literary man by profession, but a gentleman'.

2. The cutting Hughes sends Alice Boyd is of 'Tantenæne Animus Cælestibus Iræ' which appeared in the *Pall Mall Gazette* (6 December 1892), a parody of Swinburne's vehement attack on *Autobiographical Notes* in the *Fortnightly*.

How cleverly and quietly Mr. Minto turns Mr. Sharp inside out, passage after passage!

Thank you so much for your kind last letter, and, with the wife's love, believe me
always affect[ionate]ly yrs
Arthur Hughes

Feb. 4. 95

Dear Miss Boyd

As usual I am owing you a letter for a long time, ever since the dear Christina died. My last to you was just before that news was published, and yours to me was just before it reached you. I went to the funeral service, held by her church close to her house, and it was so very lovely with music written & set to her own words and beautifully given, and the church full of most reverent and I hope devoted admirers as ourselves, altho' mostly strange to me. The only ones I knew beyond her family were Stephens & his wife, Shields, and Clayton. Theodore Watts of course came with William and the family principal mourners. I did not go up to the cemetery, learning from Shields that it was rather William's wish that the friends would be contented with the first half of the service at the church.

Well! The most beautiful soul of these latter days is at rest, and we shall not see the like again, and truly we may be very grateful for the privilege we have had.

Now, I should not have been all this time writing but for a piece of work, and which I hope will compel you, to your surprise to buy a poem by HALL CAINE!!!. For three weeks ago that blessed Shields sent the Caine's younger brother to me; he is starting an illustrated magazine, price 3d, not very ruinous, to be called *The London Home Monthly*, and Hall Caine produces in the first number a Manx ballad to start it with a bang! and he wanted me to illustrate it. Now I have been a long long time off that work and pining dreadfully to get some again, for pictures are vain indeed, and very expensive to produce, and not any result follows! Alas! Alas! So it being a most picturesque ballad I agreed enthusiastically, and have done 5

really rather more than they asked for or can afford to pay for, but it seemed to me an opportunity to show I could do that sort of thing still, more or less, and so I have been very busy till just lately and both the Caines are fearfully and wonderfully appreciative of what is done—and the number is to be out about the 15th of the month, and I am only hoping they will come out decently…

Now dear Miss Boyd this is a stop gap and a bait for a letter. So please excuse more just now and believe me, with love from all

affect[ionate]ly yours
Arthur Hughes

Aug. 28. 95

Dear Miss Boyd

It is an immense time since we have heard from you, and I really think it is your turn this time. I *believe* I wrote last but won't be quite too sure of it. I hope all is well at Penkill and that you are having a lovely summer, free of tiresome troubles, and with cheerful associations around. We are getting delicious weather here, after a few summer storms that kept us ever wondering at the grand and lovely changing skies. I never saw such beautiful wild pictures in succession day after day, for so long together: I daresay you have been getting much the same. The other day I saw a tree in Kew Gardens that had been struck, and torn to pieces, but not singed or blackened as I thought lightning always burnt, but clean ripped and torn to pieces by a Giant's hands apparently, much as mine might with a stick of celery: and we hear of a house near where each fireplace, one below another on three floors, was sent forth into the room, the lightning passing in at the chimney top: but hurting nothing else!…

I have lately sold three little Cornish landscapes rather romantically I think. Long ago I used to visit dear friends the Birkbeck Hills whose children then were small, but very great friends. These are now grown into men & woman doing famously in the world, and now & then they one or another, come to see me and buy a very small

picture of Cornwall sketches I made a few years ago. But this last incident crowns all, for one, a Liverpool Solicitor, has such a grateful client, that the said G.C. must needs make my young friend a present, and wished it to be in the form of 60 pounds worth of Electro-Plate!! which so horrified them that by some means they made grateful one to know what they would like most of all would be landscapes by A H!!! and the 60 pounds is to come to Kew in consequence!…

Now for next news. Do you know William Rossetti has found 300 new poems by Christina among her papers? as good as those already in print he considers. And do you know he has sold her little belongings of other kinds, calling one or two friends in to take such memorials of her as they cared for, at a price fixed by him. I did not know of it, but Stephens was one, and he bought several things, and in the most amiable manner and with a charming letter has sent a priceless treasure for me! Gabriel it seems designed and had made a pair of candlesticks of steel, each bearing two candles, and presenting them to Christina; and these wonderful things are now owned by unworthy me! only, I think in one way I may be worthy to hold them, for I don't think anyone could have felt a much greater respect & love for her mind than I have, ever since the dear old day when the first number of the Germ came into my hands (in the Royal Academy Schools). She must have been very young then, and it the first appearance in print I should think…You can see they have quaintness and characteristic Rossetti lines, at bottom resembling the old fashioned things for warming toast & plates at a fire and at top resembling a flower for the candle holding with an odd little handle for finger and thumb to catch it up by, half way down.

Now, for the present Good bye. We are trying to manage to go to Cornwall for a short spell in order to replace the sketches. Best love from everybody to you, & Miss Courtney if [with] you.

Affect[ionate]ly yrs
Arthur Hughes

Oct. 5. 96

Dear Miss Boyd

I hope all this long 'no news is good news' with you, but it, that is, the no news, ought to come to an end I think.

I trust that all is well with you and your belonging, in this very sad year of deaths and disasters. You will know ere you get this of dear Morris' end—so soon and sudden.

I intended to write to tell you of my visit to him about 5 weeks ago, before I went to Pett n[ea]r Winchelsea for a little sketching, where I ought to have written on many a wet day that I had, but somehow didn't. Then he told me he was so weak he could hardly walk across the room. The lungs had all gone wrong and this was much more serious than the former disease of Diabetes. He had taken a voyage to Norway at the recommendation of his doctor and friend he said and this had been most disastrous; he had evidently been so very unfit for it.

He sat in a chair with his feet upon another, and smoked his pipe cheerfully almost between whiles and looked in face very like himself but thinner. Good colour, very; but coughing and spitting sadly, occasionally vigorous in talk, and very delightful as ever, excepting on the subject of Norway and his doctor, and I can leave you to guess the nature of his language then! I sat with him the hour before the expected visit of a new one a specialist to examine him. His secretary Cockerell had asked me to come then to prevent or take him away from dwelling on the subject, and afterwards I was glad to learn that I came in 'just when the Doldrums were beginning'.

The doctor's report was serious, 'but not expecting immediate danger'. I guess he made it as well as he could. It has been terribly rapid it seems to me, but to such a one perhaps all the better at the last, tho' when I saw him he was able to dictate to Cockerell his wonderful prose—all straight off perfect, never needing correction or any change. So I hope that almost to the last he may have been able to keep that wonderful brain at work with good result to himself at the sad time, as well as for others later.

I took tea after with Mrs. Morris who then seemed to be keeping up wonderfully well. She said, 'He says that his patience is quite gone now! poor dear! he never had any'!

It seems only the other day I saw Millais' funeral with his friend Hunt for a Pall bearer! and his great palette & brushes & maul stick tied with crepe on top of the beautiful old Pall and coffin.

We are all pretty well here. Emily just back from a two months stay with Agnes, who with her little girl is also well, and good news from Amy too, whose youngest boy was just christened, and his Godfather an old person much wishing to present him with a cow!

Nov. 25. 96

Dear Miss Boyd,

Many thanks for your letter. I just wanted that for a fillip. I had intended to write to you again just after my last, for I wanted to tell you about the funeral of dear Morris, which I went to, and was glad I did, but things came in the way, and lately I have been very seedy, and so, as usual!! We are sorry to hear of your being so unwell. I am sure you were bad, when you admit so much, who never were a grumbler. I think this sad low Autumn time is more depressing than it usually is. I have been wretched—with cough and plegm to an extent that frightens us. It seemed as if it must mean something much more serious. But I too, am like you, beginning to see daylight again; and am able to do a little work in just the middle of the day...

But I must tell you about Morris: I joined the train at Paddington, and a special portion was set apart there with a guard's van with open doors on the platform side and closed doors on the other, which [had] a little window in, and on the floor lay the plain unvarnished oaken coffin, with numerous large wreaths set on either side and at the head—the coffin foot towards us, looking in, and its head under the little window, in the close doors on the other side—so it made exactly a miniature chapel! There filling the platform in

front was a crowd of all sorts of socialist bodies, who came to take a last look and bring their wreaths, not a sign of an undertaker anywhere! Then we started and at Oxford let the main train go on, and our portion waited awhile and then away for Lechlade which seems to be on a branch. I was put with Mr. Tebbs for companion, and while the rain poured in torrents outside he beguiled the time with the usual flow: Then came Lachlade station and the little Van Chapel gave up its tenant, and there was another surprise, one of the pretty hay carts of that district was waiting: with posts erected at each corner dressed with foliage—and strings across the top hung with vine leaves. The coffin was laid on it, and all the wreaths on it and about it, making one of the prettiest sights, and like a page out of one of his own stories—the rain falling always all the time. Then I was put with Walter Crane in a carriage for the three miles to the Church and I felt myself lucky. I have a sincere respect and great liking for him. There were many following—you will have seen the list—Jones & his wife, Mrs. Morris and the daughters, Richmond and his wife, Mr. Ellis, & Cockerell, Morris's secretary, and most of his people belonging to the Shop, and the Works, and the Press. Jones & Mrs. Morris in chief place at church & grave and in train both families together. Mrs. Morris very broken down, May bearing up well, but poor Jennie weeping piteously. Kelmscott church is very lovely, the simplest barn form with a tiny open arch belfry at one end very very rural on a flat damp land, with hills in view across the river, but we did not see the house—it lay beyond the church and only the families of Morris & Jones went there. Mr. Ellis had arranged all very beautifully for us—to lunch at the Inn at Lechlade & so fill up the hours before the return train late in the afternoon. I forgot to say that T. Armstrong was there too. Mrs. Morris & May have gone to Egypt with the Blunts for the winter I believe, and so ends the chapter; not that there ends the work that Morris has done, I believe. It was delightful to hear from Mr. Ellis how he tried to preserve and make others preserve the old English beauties of Kelmscott, where the barns are thatched and the farms stone roofed with slabs of stone like immense tiles. Nowadays when roofs need renewing they substitute slates, & Morris grieved and begged and finally did their roof for them, thatch or stone at his own cost! did the old church stone & lead, thus; so at last when roofs needed renewal he was looked to for them as a matter of course…

Affect[ionate]ly yrs,
Arthur Hughes

Good+Friday, 97

Dear Miss Boyd—

Can you forgive so bad a correspondent once again? I have been owing you a letter so long, and always about to write it too! but have been dismal sometimes quite unfit and then so very busy with the two pictures I got somehow more or less fit to go to the R.A., and then so many things had to be seen to immediately after that—and—here I am, recruiting for a very few days, to begin the S.K. Exams on the 21st. I did partly delay lately for the better letter I could send after attending & seeing friends at a grand dinner Hunt kindly asked me to, on his birthday on the 2nd and then Jones to a dinner to meet the Mackails on the 9th and to see his picture on Sunday the 11th. You will perceive I have been very grand, and going considerably into Society! which came very pleasantly after the hard work on the pictures, and now in proper order, I am taking my repose in the country after the dissipations thereof—blasé!

…(But, how I wish you could have seen the dinner at Hunts!!!!!)

You will see it was on the lines of a very stately feast—only, with all the stiffness absent—beautifully friendly, and all beautifully done. Hunt and wife so charming, and everybody so natural and quietly gay. Jones was almost Bohemian—it was lovely, when Lushington was telling me had had come up from Bath, to hear him 'Bath! and did you meet Mr. Pickwick there?' and the Judge looked almost hurt! Then at dinner the chairs had

been borrowed all over the house I think for mine was very low, and Kitty has gone on growing since she got married, and Jones across the table said 'Uge! I always thought you were rather a tall man—are you in a very low chair or is it that you are now dwarfed and shrunken with extreme old age?' Then he remembered with such nice pathetic kind of pleasure the old days, and I told him how I first saw him. Morris bought 'April Love', and sent BJ with a letter containing the cheque, and I was out, but returning just as he was a few doors away he stopped me, and said he 'thought I must be Hughes, because Rossetti had described me as a little like Morris, so he knew me'. And he said 'only to think of his having a cheque entrusted to him and that it actually passed thro' his hands to its proper destination'. How different it would be now!!!

It was awfully sweet to hear his pleasure in recollecting the early days and doings and Rossetti's beautiful things, and how 'that was the best time of all times', and I felt more affection for him than I ever quite did before I think. And how that 'that was Rossetti's nicest time when he was best and his work best too'! Sometimes I have fancied Jones a little cold, but I don't mean to anymore. I think we all improve a little at last, don't you? I seem to find most old friends come back to go more naturalness & simplicty. I do wish you had been there. I never saw Hunt so loveable and simply sweet—altho' older, he seems wonderfully well; both do. After the ladies left the dining room Hunt asked all to draw up his end so Jones & Richmond came next him—and then Godfrey Lushington with the characteristic modesty & sweetness of the family begged me 'as a personal favour' to sit by Hunt on his side; so there were four painters all together at top—and the others all below! And then Hunt told nice stories, and everyone smoked, and after the most delightful music & last, Susan's fiddle, so late, that I lost all last trains, and had to walk home to Kew!

Saturday 17th

(Such a wet night & morning—so on goes my letter.)
…Jones & I had to talk over old times, to saturate Mackail with, for the purpose of writing Morris' life, you see—altho' no dear old jokes are to be allowed, such as used to occur when all were working at those Oxford pictures. Dr. Acland you know then took all under his wing and forced his kindness upon all in a most distracting way, especially by dinner parties in the evening, when dress clothes were few, and one suit of mine received honour to which it had not been born. Jones described to me Maurice[1] getting my trousers on with difficulty, being too small in circumference while equally too long! Then he said, 'Uge, do you remember dining at Aclands one evening when you went to sleep?' I said, No— because when I sleep I snore, and I should have been turned out—but he said 'I was there'. It is quite untrue I am sure. Then he said, 'do you remember once when Acland bothered Morris & me dreadfully and we promised to go, and then Morris after all would not', and so Jones went and made some hastily invented excuses for M, saying he was not feeling well—forgetting Acland was a Doctor! who immediately put on his hat and left Jones to run round to the lodgings and find Morris & Charley Faulkner playing cards and as well as possible and quite innocent of what Jones had said to excuse him altogether away! And how Rossetti once went in beautiful evening dress to some other stately feast, and only late in the evening feeling for his handkerchief discovered no pocket, and looking down, many smears of paint, having his trousers & waistcoat correct enough, but in the dark had slipped again his old painting coat on, and how magnificently and like a prince, he passed it off! And how another evening they had accepted to go—and dreaded it so much—that they looked out trains and at the last moment sent word that they had to go suddenly to town; and Jones & Rossetti actually went on to Paddington & slept there, only to get back by first train in the morning.

1. William Fredeman suggests that here 'AH is almost certainly punning on Morris' name'.

Jones says that Swinburne has been to see him lately—that he has lost this hair! and is quite deaf! That he is very sweet and reverent with old persons and young children, but does not remember or being deaf is rather wild in talk before others, does not know that he speaks aloud sometimes matter that should be whispered rather! and that he does not look nice—the bald head being red & bad colour. How very different, to imagine him without that bush of hair!

What a lovely house the Grange is, and how full of lovely things. Jones himself seems very well indeed, but is not able he says to walk much since an illness two years ago; and he groans a little in getting up from his very low easy chair or sofa, as if the legs were weak at the knees, or somewhere; is entirely cheerful on the subject of Morris, and not at all broken up by it I should say—with the deepest sense of Morris's life's work. I hope the book will be good. You will see poor Boyce's lovely things are to be sold at Christie's this summer!

Of ourselves we are keeping quietly well. The wife goes nowhere, but keeps well, and we expect Agnes & her girl up soon for two or three weeks I hope. And now dear Miss Boyd you must send us news of yourself, and I hope it is all well with you, as it can be, and with love from all of us believe me,

Affect[ionate]ly yrs,
Arthur Hughes[1]

## John Guille Millais
### From *The Life and Letters of Sir John Everett Millais*

Draycott Lodge, Fulham, S.W.
February 24th, 1896.

My Dear Millais,—

I don't know whether it is definitely settled yet that you shall be the President of the Royal

Academy, but I have no doubt that it soon will be, for, whatever differences of interests there may be among the members, when once it was known that there was a possibility of your accepting the post, there could have been, and there will be, but one feeling about the surpassing fitness of the choice of yourself...

That you may hold it for some years is my hearty wish, but I trust that you will not make any kind of promise to keep it for life. The post is quite a different thing to fill, in the amount of work required, to what it was in Sir Joshua Reynold's time. London, with six million of inhabitants, and about three-quarters of these calling themselves 'artists', would wear any man to death if he felt there was no escape for him. It would assuredly interfere with his opportunities for work very mischievously. I was sorry that so true an artist as Leighton allowed himself to be hampered with the duties permanently... He did the duties magnificently, but he could have worked magnificently also, and the work would have remained for all generations; and this may the same with you.

Give my felicitations to Lady Millais, who will have to take so large a part in the new honour; and give my love to Mary.

Yours very affectionately,
W. Holman Hunt

Did you ever hear of Lear's pun?—which would be more appropriate now. It was—that the *Millais-nium* of Art had come. You have gone a letter higher—from P.R.B. to P.R.A.

March now set in with a rigour that added greatly to Millais' discomfort.[2] His voice, once so powerful, sank to a whisper, and at times he could hardly make himself heard. There was, however, a great deal to be done in view of the coming exhibition, and with characteristic bravery he devoted his whole time and attention to the work. Specially trying was the month of April, when, day after day, he had to act as Chairman of the Hanging Committee—a task at once so responsible and so exhausting that his health well-

---

1. Sadly, Alice Boyd never did receive Hughes' letter, as she had died a week before he wrote it.

2. Millais had been diagnosed as having a malignant throat tumour.

nigh broke down altogether before it was finished. He recovered himself, however, sufficiently to take a final survey of the exhibition before it was opened to the public, and to welcome, with his usual geniality, the artists whose works had been accepted.

A writer in the *Daily News* of August 14th, 1896, thus describes one of this last visits to the Academy:

'There was something very pathetic in the way Millais lingered round the galleries of the Academy during the last days before it opened for the first time under his presidentship. He was in the rooms of the Saturday before the private view (the last of the members' varnishing days) shaking hands with old friends, and saying, in a hoarse whisper, which told its tale tragically enough, that he was better. He came again on Monday—that was the outsiders' varnishing day. The galleries were full of painters, young and old, hard at their work—much to do and little time to do it in—when someone said, "Millais is in the next room." Young men and old, they all looked in, mournfully realising it might be their last chance to see the greatest of their brethren. There he was, leaning on the Secretary, and slowly going his round. One young painter, perched upon a ladder, varnishing his canvas, felt his leg touched, but was too busy to turn round. Again he was interrupted. It was the President, who, in a scarcely audible whisper, wished to congratulate him on his work. That was on Monday. He came again on Tuesday. There was a discussion amongst a few of the members about a picture that in the hanging had not got so good a place as it deserved. "Take one of my places", he said; and he meant it. It was not the first time he had offered to make way, giving up his own position to an outsider.'...

By the request of the Royal Academy, who undertook the management of his funeral, he was buried in St. Paul's Cathedral on August 20th, 1896, the pall being borne by Mr. Holman Hunt, Mr. Philip Calderon, R.A., Sir Henry Irving, Sir George Reid, P.R.S.A., Viscount Wolseley, the Earl of Roseberry, the Earl of Carlisle, and the Marquis of Granby.

And there he lies in 'Painters' Corner' in the same niche with his friend Leighton, and with his illustrious predecessors Sir Joshua Reynolds, Sir Christopher Wren, Sir Thomas Lawrence, Benjamin West, Opie, Fuseli, and Sir Edgar Boehm...

## LITERATURE

### Hall Caine
### 'Graih My Chree' in *The London Home Monthly* (1895)

1

She was Janey, the rich man's only child,
    He was Juan, a son of the sea.
'Thy father hath cast me forth of his door,
But, poor as I am, to his teeth I swore
    I should wed thee, O graih my chree.'

He broke a ring and gave her the half,
    And she buried it close at her heart.
'I must leave thee, love of my soul,' he said,
'But I vow by our troth that living or dead,

I will come back rich to thine arms and thy bed,
    And fetch thee as sure as we part.'

He sailed to the north, he sailed to the south,
    He sailed to the foreign strand,
But whether he touched on the icy cone
Or the coral reef of the Indian zone
    It turned to a golden land.

And he cried to his crew, 'Hoist sail and about,
    For no more do I need to roam;
I have silks and satins and lace and gold,
I have treasure as deep as my ship will hold
    To win me a wife at home.'

They had not sailed but half of their course
    To the haven where they would be,
When the devil beguiled their barque on a rock,
And down it sank with a woeful shock
    On the banks of Italy.

Then over the roar of the clamorous waves
    The skipper his voice was heard,
'I vowed by our troth that dead or alive
I should come back yet to wed and to wive,
    And by t' Lady I keep my word.

'I will come to thee still, O love of my heart,
    From the arms of the envious sea;
Though the tempest should swallow my choking
      breath,
In the spite of hell and the devil and death
    I will come to thee, graih my chree.'

### 2

'He will come no more to thine arms, my child,
    He is false or lost and dead,
Now wherefore make ye these five years moan,
And wherefore sit by the sea alone?'
    'He will keep his vow,' she said.

She climbed the brows of the cliffs at home,
    She gazed on the false, false sea.
'It comes and it goes for ever,' she cried,
'And tidings it brings to the wife and the bride,
    But never a word to me.'

Then, of lovers, another came wooing the maid,
    But she answered him nay and nay,
The manfullest man and her servant true,
'Give thy hand and thou shalt not rue,'
    She murmured, 'Alack, the day.'

Her father arose in his pride and his wrath,
    He was last of his race and name,
'Because that a daughter will peak and will pine
Must I never have child of my child to my line,
    But die in my childless shame?'

They bore her a bride to the kirkyard gate,
    It was a pitiful sight to see,

Her body they decked in their jewels and gold,
But the heart in her bosom sate silent and cold,
    And she murmured, 'Ah, woe is me.'

### 3

They had not been wedded a year, a year,
    A year but barely two,
When the good wife close to the hearth-stone crept
And rocked her babe while the good man slept
    And the wind in the chimney blew.

Loud was the sea and fierce was the night,
    Gloomy and wild and dour;
From a flying cloud came a lightning flash,
A pane of the window fell in with a crash,
    And something rang on the floor.

O, was it a stone from the waste sea-beach?
    O, was it an earthly thing?
She stirred the peat and stooped to the ground,
And there in the red, red light she found
    The half of a broken ring.

She rose upright in a terror of fright
    As one that hath sinned a sin,
And out of the dark and the wind and rain,
Through the jagged gap of the broken pane,
    A man's white face looked in.

'O, why didst thou stay so long, Juan?
    Five years I waited for thee.'
'I vowed by our troth, that living or dead
I should come back yet to thine arms and thy bed,
    And my vow I have kept, my chree.'

'But I have been false to my troth, Juan;
    Falsely I swore me away.'
'I have silks and satins and lace and gold,
I have treasure as deep as my ship will hold;
    And my barque lies out in the bay.'

'But I have a husband that loves me dear;
    I promised him never to part.'
'Through the salt sea's foam and the earth's
      hot breath,
Through the grapplings of hell and the gates of death
    I have come thee, Janey, my heart.'

'But I have a child of my body so sweet—
  Little Jannie that sleeps in the cot.'
'By the glimpse of the moon, at the top of the tide,
Ere the crow of the cock our vessel must ride,
  Or what will befall us, God wot.'

'Now ever alack, thou must kiss and back;
  As sure as yon ship to the billows that roll,
By the plight of our troth, both body and soul
  You belong to me, graih my chree.'

She followed him forth like to one in a sleep;
  It was a woeful and wondrous sight.
The moon on his face from a rift in a cloud
Showed it white and wan as a face in a shroud,
  And his ship on the sea gleamed white.

<br>

### 4

'Now weigh and away, my merry men all.'
  The crew laughed loud in their glee.
'With the rich man's pride and his sweet daughter,
In the spite of wind and the wild water—
  To the banks of Italy!'

The anchor was weighed, the canvas was spread,
  All in the storm and the dark,
With never a reef in a stitch of sail,
But standing about to burst the gale
  Merrily sped the barque.

The first night out there was fear on the ship,
  For the lady lay in a swoon;
The second night out she awoke from her trance,
And the skipper did laugh and his men would dance.
  But she made a piteous moan.

'O, where is my home and my sweet baby
  My Jannie I nursed on my knee?
He will wake in his cot by the cold hearth-stone
And cry for his mother who left him alone;
  My Jannie, I'm wæ for thee.'

The skipper he shouted for music and song,
  And his crew they answered his call.
He clothed her in silk and satin and lace
But   still through the rout and riot her face
  Showed fit for a funeral.

'As she sank in the water's tomb…' by Arthur Hughes

And ever at night they sailed by the moon,
  Through the wild white foam so fleet,
And ever again at the coming of day,
When the sun rose out of the sea they lay
  In a mist like a winding sheet.

And still the skipper he kissed her and cried,
  'Be merry and let-a-be.'
And still to soothe her he sat through the nights
With his hand in her hand, till they opened the lights
  By the banks of Italy.

Then his face shone green as with ghostly sheen,
  And the moon began to dip.
'O, think not you, I am the lover ye knew;
I am a ghostly man with a ghostly crew,
  And this is a ghostly ship.'

Then he rose upright to a fearsome height,
  And stamped his foot on the deck;
He smote the mast at the topsail yards,
And the rigging fell like a house of cards,
  And the hulk was a splitting wreck.

O, then as she sank in the water's tomb,
  In the churn of the choking sea,
She knew that his arms were about her breast,
  As close as his arms might be.

And he cried o'er the tramp of the champing tide
   On the banks of Italy,
'By the plight of our troth, by the power of our bond,
If not in this world in the world beyond,
   Thou art mine, O graih my chree.'

## Thomas Gordon Hake
### From *The New Day* (1890)

### 1

In the unbroken silence of the mind
   Thoughts creep about us, seeming not to move,
And life is back among the days behind—
   The spectral days of that lamented love—
Days whose romance can never be repeated.
   The sun at Kelmscott through the foliage gleaming,
We see him,[1] life-like, at his easel seated,
   His voice, his brush, with rival wonders teaming.
These vanished hours, where are they stored away?
   Hear we the voice, or but its lingering tone?
Its utterances are swallowed up in day;
   The gabled house, the mighty master gone.
Yet are they ours: the stranger at the hall—
   What dreams he of the days we there recall?

### 2

O, happy days with him who once so loved us!
   We loved as brothers, with a single heart,
The man whose iris-woven pictures moved us
   From Nature to her blazoned shadow—Art.
How often did we trace the nestling Thames
   From humblest waters on his course of might,
Down where the weir the bursting current stems—
   There sat till evening grew to balmy night,
Veiling the weir whose roar recalled the strand
   Where we had listened to the wave-lipped sea,
That seemed to utter plaudits while we planned
   Triumphal labours of the day to be.
The words were his: 'Such love can never die;'
   The grief was ours when he no more was nigh.

### 3

Like some sweet water-bell, the tinkling rill
   Still calls the flowers upon its misty bank
To stoop into the stream and drink their fill.
   And still the shapeless rushes, green and rank,
Seem lounging in their pride round those retreats,
   Watching slim willows dip their thirsty spray.
Slowly a loosened weed another meets;
   They stop, like strangers, neither giving way.
We are here surely if the world, forgot,
   Glides from our sight into the charm, unbidden;
We are here surely at this witching spot,—
   Though Nature in the reverie is hidden.
A spell so holds our captive eyes in thrall,
   It is as if a play pervaded all.

### 4

Sitting with him, his tones as Petrarch's tender,
   With many a speaking vision on the wall,[2]
The fire, a-blaze, flashing the studio fender,
   Closed in from London shouts and ceaseless brawl—
'Twas you brought Nature to the visiting,
   Till she herself seemed breathing in the room,
And Art grew fragrant in the glow of spring
   With homely scents of gorse and heather bloom.
Or sunbeams shone by many an Alpine fountain,
   Fed by the waters of the forest stream;
Or glacier-glories in the rock-girt mountain,
   Where they so often fed the poet's dream;
Or else was mingled the rough billow's glee
With cries of petrels on a sullen sea.

## Philip Bourke Marston
### From *A Last Harvest* (1891)

### *London, from Far*

Afar from all this country peace it lies,
   Tremendous and unscrutable for gloom—
   The dreadful, fateful City of my doom.
I know its lurid, fog-invested skies—

---

1. Dante Gabriel Rossetti

2. Of Rossetti's house in Cheyne Walk— Hake's note.

I know what pestilential odours rise
   From court and alley, each a living tomb—
   I know the tainted flowers, by night that bloom
Along its wayside—flowers men spurn and prize.

I know the strife, and the unceasing din—
   The utmost blackness of its heart I know—
I hear their shrieks and groans who toil within,
   And cries of those it murdered long ago—
Yet mid the twisted growths of Shame and Sin,
   One woodland flower of memory shall grow.

## Her Pity

This is the room to which she came that day—
Came when the dusk was falling cold and grey—
Came with soft step, in delicate array,

And sat beside me in the firelight there:
And like a rose of perfume rich and rare
Thrilled with her sweetness the environing air.

We heard the grind of traffic in the street—
The clamorous calls—the beat of passing feet—
The wail of bells that in the twilight meet.

Then I knelt down, and dared to touch her hand—
Those slender fingers, and the shining band
Of happy gold wherewith her wrist was spanned.

Her radiant beauty made my heart rejoice;
And then she spoke, and her low pitying voice
Was like the soft, pathetic, tender noise

Of winds that come before a summer rain:
Once leaped the blood in every clamorous vein—
Once leaped my heart, then dumb, stood still again.

## Not Only Rooms wherein thy Love Has Been

Not only rooms wherein thy Love has been
   Hold still for thee the memory of her grace,
   The benediction of her blessing face,

But other rooms that never saw thy Queen
Are full of her: Has not thy spirit seen
   A vision of her in this firelit place
   That never knew the witchery of her ways,
The perfect voice, the eyes intense, serene?

Ah, stood she not before the mirror there,
   Her loveliness all clothed in soft attire,
   Then turned to thee, low-kneeling by this fire,
And laid a gracious hand upon thy hair,
   While thy heart leaped to her, thy heart's desire,
And thy kiss praised her, and thy look was prayer?

## Here in this Sunset Splendour Desolate

Here in this sunset splendour desolate,
   As in some Country strange and sad I stand—
   A mighty sadness broods upon the land,
The gloom of some unalterable Fate.
O Thou whose love dost make august my state,
   A little longer leave in mine thy hand—
   Night birds are singing, but the place is banned
By stern gods whom no prayers propitiate.

Seeking for bliss supreme, we lost the track—
Shall we then part, and parted try to reach
   A goal like that we two sought day and night,
   Or shall we sit here, in the sun's low light,
And see, it may be through Death's twilight breach,
A new path to the old way leading back?

## Good-Night and Good-Morrow

The fires are all burned out, the lamps are low,
   The guests are gone, the cups are drained and dry.
   Here there was somewhat once of revelry;
But now no more at all the fires shall glow,
Nor song be heard, nor laughter, nor wine flow.
   Chill is the air; grey gleams the wintry sky:
   Through lifeless boughs drear winds begin to sigh.
'Tis time, my heart, for us to rise and go
Up the steep stair, till that dark room we gain
   Where sleep awaits us, brooding by that bed

On which who lies forgets all joy and pain,

   Nor weeps in dreams for some sweet thing long fled.

'Tis cold and lonely now; set wide the door;

Good-morrow, my heart, and rest thee evermore.

## William Morris
### From *News from Nowhere* (1891)

### Chapter 1: Discussion and Bed

Up at the League, says a friend, there had been one night a brisk conversational discussion, as to what would happen on the Morrow of the Revolution, finally shading off into a vigorous statement by various friends of their views on the future of the fully-developed new society.

   Says our friend: Considering the subject, the discussion was good-tempered; for those presently being used to public meetings and after-lecture debates, if they did not listen to each other's opinions (which could scarcely be expected of them), at all events did not always attempt to speak all together, as is the custom of people in ordinary polite society when conversing on a subject which interests them. For the rest, there were six persons present, and consequently six sections of the party were represented, four of which had strong but divergent Anarchist opinions. One of the sections, says our friend, a man whom he knows very well indeed, sat almost silent at the beginning of the discussion, but at last got drawn into it, and finished by roaring out very loud and damning all the rest for fools; after which befell a period of noise, and then a lull, during which the aforesaid section, having said good-night very amicably, took his way home by himself to a western suburb, using the means of travelling which civilization has forced upon us like a habit. As he sat in that vapour-bath of hurried and discontented humanity, a carriage of the underground railway, he, like others, stewed discontentedly, while in self-reproachful mood he turned over the many excellent and conclusive arguments which, though

they lay at his fingers' ends, he had forgotten in the just past discussion frame of mind he was so wed to, that it didn't last him long, and after a brief discomfort, caused by disgust with himself for having lost his temper (which he was also well used to), he found himself musing on the subject-matter of discussion, but still discontentedly and unhappily. 'If I could but see a day of it', he said to himself; 'if I could but see it!'

   As he formed the words, the train stopped at his station, five minutes' walk from his own house, which stood on the banks of the Thames, a little way above an ugly suspension bridge. He went out of the station, still discontented and unhappy, muttering 'If I could but see it! if I could but see it!' but had not gone many steps towards the river before (says our friend who tells the story) all that discontent and trouble seemed to slip off him.

   It was a beautiful night of early winter, the air just sharp enough to be refreshing after the hot room and the stinking railway carriage. The wind, which had lately turned a point or two north of west, had blown the sky clear of all cloud save a light fleck or two which went swiftly down the heavens. There was a young moon half way up the sky, and as the home-farer caught sight of it, tangled in the branches of a tall old elm, he could scarce bring to his mind the shabby London suburb where he was, and he felt as if he were in a pleasant country place—pleasanter, indeed, than the deep country was as he had known it.

   He came right down to the river-side and lingered a little, looking over the low wall to note the moonlit river, near upon high water, go swirling and glittering up to Chiswick Eyot; as for the ugly bridge below, he did not notice it or think of it, except when for a moment (says our friend) it struck him that he missed the row of lights downstream. Then he turned to his house door and let himself in; and even as he shut the door to, disappeared all remembrance of that brilliant logic and foresight which had so illuminated the recent discussion; and, of the discussion itself there remained no trace, save a vague hope, that was now become a pleasure, for days of peace and rest,

and cleanness and smiling goodwill.

In this mood he tumbled into bed, and fell asleep after his wont, in two minutes' time; but (contrary to his wont) woke up again not long after in that curiously wide-awake condition which sometimes surprises even good sleepers; a condition under which we feel all our wits preternaturally sharpened, while all the miserable muddles we have ever got into, all the disgraces and losses of our lives, will insist on thrusting themselves forward for the consideration of those sharpened wits.

In this state he lay (says our friend) till he had almost begun to enjoy it: till the tale of his stupidities amused him, and the entanglements before him, which he saw so clearly, began to shape themselves into an amusing story for him.

He heard one o'clock strike, then two and then three; after which he fell asleep again. Our friend says that from that sleep he awoke once more, and afterwards went through such surprising adventures that he thinks that they should be told to our comrades and indeed the public in general, and therefore proposes to tell them now. But, says he, I think it would be better if I told them in the first person, as if it were myself who had gone through them; which, indeed will be the easier and more natural to me, since I understand the feelings and desires of the comrade of whom I am telling better than anyone else in the world does.

## Chapter 17: How the Change Came[1]

…'On some comparatively trifling occasion a great meeting was summoned by the workmen leaders to meet in Trafalgar Square (about the right to meet in which place there had for years and years been bickering). The civic bourgeois guard (called the police) attacked the said meeting with bludgeons, according to their custom; many people were hurt in the *mêlée*, of whom five in all died, either trampled to death on the spot, or from the effects of their cudgelling; the meeting was scattered, and some hundred of prisoners cast into gaol. A similar meeting had been treated in the same way a few days before at a place called Manchester, which has now disappeared. Thus the "lesson" began. The whole country was thrown into a ferment by this; meetings were held which attempted some rough organization for the holding of another meeting to retort on the authorities. A huge crowd assembled in Trafalgar Square and the neighbourhood (then a place of crowded streets), and was too big for the bludgeon-armed police to cope with; there was a good deal of dry-blow fighting; three or four of the people were killed, and half a score of policemen were crushed to death in the throng, and the rest got away as they could. This was a victory for the people as far as it went. The next day all London (remember what it was in those days) was in a state of turmoil. Many of the rich fled into the country; the executive got together soldiery, but did not dare to use them; and the police could not be massed in any one place, because riots or threats of riots were everywhere. But in Manchester, where the people were not so courageous or not so desperate as in London, several of the popular leaders were arrested. In London a convention of leaders was got together from the Federation of Combined Workmen, and sat under the old revolutionary name of the Committee of Public Safety; but as they had no drilled and armed body of men to direct, they attempted no aggressive measures, but only placarded the walls with somewhat vague appeals to the workmen not to allow themselves to be trampled upon. However, they called a meeting in Trafalgar Square for the day fortnight of the last mentioned skirmish.

---

1. When the Dreamer, or Guest, awakes he begins an intellectual and literal journey through the utopia of the future in which he finds himself. As in Sir Thomas More's *Utopia* and Jonathan Swift's *Gulliver's Travels*, the stranger learns most from asking questions regarding laws and practices. In this chapter, the Guest asks about the events that shaped the utopian community he sees around him, and the catalyst is described to him, an event much akin to the early Chartist gatherings and to Bloody Sunday, although taken to nightmarish proportions.

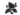 

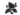

'Well, the Sunday of the meeting came, and great crowds came to Trafalgar Square in procession, the greater part of the Committee amongst them, surrounded by their band of men armed somehow or other. The streets were quite peaceful and quiet, though there were many spectators to see the procession pass. Trafalgar Square had no body of police in it; the people took quiet possession of it, and the meeting began. The armed men stood round the principal platform, and there were a few others armed amidst the general crowd; but by far the greater part were unarmed.

'Most people thought the meeting would go off peaceably; but the members of the Committee had heard from various quarters that something would be attempted against them; but these rumours were vague, and they had no idea of what threatened. They soon found out.

'For before the streets about the Square were filled, a body of soldiers poured into it from the north-west corner and took up their places by the houses that stood on the west side. The people growled at the sight of the red-coats; the armed men of the Committee stood undecided, not knowing what to do; and indeed this new influx so jammed the crowd together that, unorganized as they were, they had little chance of working through it. They had scarcely grasped the fact of their enemies being there, when another column of soldiers, pouring out of the streets which led into the great southern road going down to the Parliament House (still existing, and called the Dung Market), and also from the embankment by the side of the Thames, marched up, pushing the crowd into a denser and denser mass, and formed along the south side of the Square. Then any of those who could see what was going on, knew at once that they were in a trap, and could only wonder what would be done with them.

'The closely-packed crowd would not or could not budge, except under the influence of the height of terror, which was soon to be supplied to them. A few of the armed men struggled to the front, or climbed up the base of the monument which then stood there, that they might face the wall of hidden fire before them; and to most men (there were many women amongst them) it seemed as if the end of the world had come, and to-day seemed strangely different from yesterday. No sooner were the soldiers drawn up aforesaid than, says an eye-witness, "a glittering officer on horseback came prancing out from the ranks on the south, and read something from a paper which he held in his hand; which something, very few heard; but I was told afterwards that it was an order for us to disperse, and a warning that he had legal right to fire on the crowd else, and that he would do so. The crowd rook it as a challenge of some sort, and a hoarse threatening roar went up from them; and after that there was comparative silence for a little, till the officer had got back into the ranks. I was near the edge of the crowd, towards the soldiers," says this eye-witness, "and I saw three little machines being wheeled out in front of the ranks, which I knew for mechanical guns. I cried out, 'Throw yourselves down! they are going to fire!' But no one scarcely could throw himself down, so tight as the crowd were packed. I heard a sharp order given, and wondered where I should be the next minute; and then— It was as if the earth had opened, and hell had come up bodily amidst us. It was no use trying to describe the scene that followed. Deep lanes were mowed amidst the thick crowd; the dead and dying covered the ground, and the shrieks and wails and cries of horror filled all the air, till it seemed as if there was nothing else in the world but murder and death. Those of our armed men who were still unhurt cheered wildly and opened a scattering fire on the soldiers. One or two soldiers fell; and I saw the officers going up and down the ranks urging the men to fire again; but they received the orders in sullen silence, and let the butts of their guns fall. Only one sergeant ran to a machine-gun and began to set it going; but a tall young man, an officer too, ran out of the ranks and dragged him back by the collar, and the soldiers stood there motionless whilst the horror-stricken crowd, nearly wholly unarmed (for most of the armed

men had fallen in that first discharge), drifted out of the Square. I was told afterwards that the soldiers on the west side had fired also, and done their part of the slaughter. How I got out of the Square I scarcely know: I went, not feeling the ground under me, what with rage and terror and despair."

'So says our eye-witness. The number of the slain on the side of the people in that shooting during a minute was prodigious; but it was not easy to come at the truth about it; it was probably between one and two thousand. Of the soldiers, six were killed outright, and a dozen wounded.'

I listened, trembling with excitement. The old man's eyes glittered and his face flushed as he spoke, and told the tale of what I had often thought might happen. Yet I wondered that he should have got so elated about a mere massacre, and I said:

'How fearful! And I suppose that this massacre put an end to the whole revolution for that time?'

'No, no,' cried old Hammond; 'it began it!'...

### Chapter 31: An Old House amongst New Folk[1]

As I stood there Ellen detached herself from our happy friends who still stood on the little strand and came up to me. She took me by the hand, and said softly, 'Take me on to the house at once; we need not wait for the others: I had rather not.'

I had a mind to say that I did not know the way thither, and that the river-side dwellers should lead; but almost without my will my feet moved on along the road they knew. The raised way led us into a little field bounded by a backwater of the river on one side; on the right hand we could see a cluster of small houses and barns, new and old, and before us a grey stone barn and a wall partly overgrown with ivy, over which a few grey gables

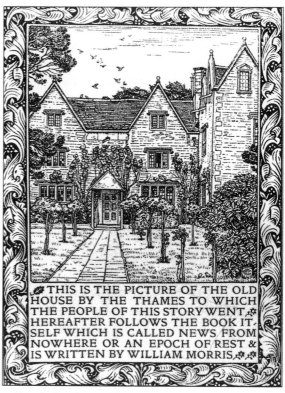

Frontispiece from William Morris's *News from Nowhere*. (It shows the front of Kelmscott Manor in Oxfordshire, the setting for the final chapters of the book.)

showed. The village road ended in the shallow of the aforesaid backwater. We crossed the road, and again almost without my will my hand raised the latch of a door in the wall, and we stood presently on a stone path which led up to the old house to which fate in the shape of Dick had so strangely brought me in this new world of men. My companion gave a sigh of pleased surprise and enjoyment; nor did I wonder, for the garden between the wall and the house was redolent of the June flowers, and the roses were rolling over one another with that delicious super-abundance of small well-tended gardens which at first sight takes away all thought from the beholder save that of beauty. The blackbirds were singing their loudest, the doves were cooing on the roof-ridge, the rooks in the high elm-trees beyond were garrulous among the young leaves, and the swifts wheeled whining about the gables. And the house

---

1. This section, taken from the end of the book, shows the Guest having arrived at an idyllic, many-gabled house, where the utopian dream seems realized—at least temporarily, because shortly the Guest will awake and find himself once more in the dingy Hammersmith of his own times.

itself was a fit guardian for all the beauty of this heart of summer.

Once again Ellen echoed my thoughts as she said: 'Yes, friend, this is what I came out for to see; this many-gabled old house built by the simple country-folk of the long-past times, regardless of all the turmoil that was going on in cities and courts, is lovely still amidst all the beauty which these latter days have created; and I do not wonder at our friends tending it carefully and making much of it. It seems to me as if it had waited for these happy days, and held in it the gathered crumbs of happiness of the confused and turbulent past.'

She led me up close to the house, and laid her shapely sun browned hand and arm on the lichened wall as if to embrace it, and cried out, 'Oh me! Oh me! How I love the earth, and the seasons, and weather, and all things that deal with it, and all that grows out of it, as this has done!'

I could not answer her, or say a word. Her exultation and pleasure was so keen and exquisite, and her beauty, so delicate, yet so interfused with energy, expressed it so fully, that any added word would have been commonplace and futile. I dreaded lest the others should come in suddenly and break the spell she had cast about me; but we stood there a while by the corner of the big gable of the house, and no one came. I heard the merry voices some way off presently, and knew that they were going along the river to the great meadow on the other side of the house and garden.

We drew back a little, and looked up at the house: the door and the windows were open to the fragrant sun-cured air: from the upper window-sills hung festoons of flowers in honour of the festival, as if the others shared in the love for the old house.

'Come in', said Ellen. 'I hope nothing will spoil it inside; but I don't think it will. Come! we must go back presently to the others. They have gone on to the tents; for surely they must have tents pitched for the haymakers —the house would not hold a tithe of the folk, I am sure.'

She led me on to the door, murmuring little above her breath as she did so, 'The earth and the growth of it and the life of it! If I could but say or show how I love it!'

We went in, and found no soul in any room as we wandered from room to room,—from the rose-covered porch to the strange and quaint garrets amongst the great timbers of the roof, where of old time the tillers and herdsmen of the manor slept, but which a-nights seemed now, by the small size of the beds, and the litter of useless and disregarded matters—bunches of dying flowers, feathers of birds, shells of starlings' eggs, caddis worms in mugs, and the like—seemed to be inhabited for the time by children.

Everywhere there was but little furniture, and that only the most necessary, and of the simplest forms. The extravagant love of ornament which I had noted in this people elsewhere seemed here to have given place to the feeling that the house itself and its associations was the ornament of the country life amidst which it had been left stranded from old times, and that to re-ornament it would but take away its use as a piece of natural beauty.

We sat down at last in a room over the wall which Ellen had caressed, and which was still hung with old tapestry, originally of no artistic value, but now faded into pleasant grey tones which harmonized thoroughly well with the quiet of the place, and which would have been ill supplanted by brighter and more striking decoration.

I asked a few random questions of Ellen as we sat there, but scarcely listened to her answers, and presently became silent, and then scarce conscious of anything, but that I was there in that old room, the doves crooning from the roofs of the barn and dovecot beyond the window opposite to me.

I lay in my bed in my house at dingy Hammersmith thinking about it all; and trying to consider if I was overwhelmed with despair at finding I had been dreaming a dream; and strange to say, I found that I was not so despairing.

Or indeed was it a dream? If so, why was I

so conscious all along that I was really seeing all that new life from the outside, still wrapped up in the prejudices, the anxieties, the distrust of this time of doubt and struggle?

All along, though those friends were so real to me, I had been feeling as if I had no business amongst them: as though the time would come when they would reject me, and say, as Ellen's last mournful look seemed to say 'No, it will not do; you cannot be of us; you belong so entirely to the unhappiness of the past that our happiness even would weary you. Go back again, now you have seen us, and your outward eyes have learned that in spite of all the infallible maxims of your day there is yet a time of rest in store for the world, when mastery has changed into fellowship—but not before. Go back again, then, and while you live you will see all round you people engaged in making others live lives which are not their own, while they themselves care nothing for their own real lives—men who hate life though they, fear death. Go back and be the happier for having seen us, for having added a little hope to your struggle. Go on living while you may, striving, with whatsoever pain and labour needs must be, to build up little by little the new day of fellowship, and rest, and happiness.'

Yes, surely! and if others can see it as I have seen it, then it may be called a vision rather than a dream.

## From *Poems by the Way* (1891)

### *Of the Three Seekers*

There met three knights on the woodland way,
And the first was clad in silk array:
The second was dight in iron and steel,
But the third was rags from head to heel.
'Lo, now is the year and the day come round
When we must tell what we have found.'
The first said: 'I have found a king
Who grudgeth no gift of anything.'
The second said: 'I have found a knight
Who hath never turned his back in fight.'

But the third said: 'I have found a love
That Time and the World shall never move.'

Whither away to win good cheer?
'With me,' said the first, 'for my king is near.'
So to the King they went their ways;
But there was a change of times and days.
'What men are ye,' the great King said,
'That ye should eat my children's bread?
My waste has fed full many a store,
And mocking and grudge have I gained therefore.
Whatever waneth as days wax old,
Full worth to win are goods and gold.'

Whither away to win good cheer?
'With me,' said the second, 'my knight is near.'
So to the knight they went their ways,
But there was a change of times and days.
He dwelt in castle sure and strong,
For fear lest aught should do him wrong.
Guards by gate and hall there were,
And folk went in and out in fear.
When he heard the mouse run in the wall,
'Hist!' he said, 'what next shall befall?
Draw not near, speak under your breath,
For all new-comers tell of death.
Bring me no song nor minstrelsy,
Round death it babbleth still,' said he.
'And what is fame and the praise of men,
When lost life cometh not again?'

Whither away to seek good cheer?
'Ah me!' said the third, 'that my love were anear!
Were the world as little as it is wide,
In a happy house should ye abide.
Were the world as kind as it is hard,
Ye should behold a fair reward.'

So far by high and low have they gone,
They have come to a waste was rock and stone,
But lo, from the waste, a company
Full well bedight came riding by;
And in the midst, a queen, so fair,
That god wrought well in making her.
The first and the second knights abode

To gaze upon her as she rode,
Forth passed the third with head down bent,
And stumbling ever as he went.
His shoulder brushed her saddle-bow;
He trembled with his head hung low.
His hand brushed o'er her golden gown,
As on the waste he fell adown.
So swift to earth her feet she set,
It seemed that there her arms he met.
His lips that looked the stone to meet
Were on her trembling lips and sweet.
Softly she kissed him cheek and chin.
His mouth her many tears drank in.
'Where would'st thou wander, love,' she said,
'Now I have drawn thee from the dead?'
'I go my ways,' he said, 'and thine
Have nought to do with grief and pine.'
'All ways are one way now,' she said,
'Since I have drawn thee from the dead.'
Said he, 'But I must seek again
Where first I met thee in thy pain:
I am not clad so fair,' said he,
'But yet the old hurts thou may'st see.
And thou, but for thy gown of gold
A pieteous tale of thee were told.'
'There is no pain on earth,' she said,
'Since I have drawn thee from the dead.'
'And parting waiteth for us there,'
Said he, 'As it was yester-year.'
'Yet first a space of love,' she said,
'Since I have drawn thee from the dead.'
He laughed; said he, 'Has thou a home
Where I and these my friends may come?'
Laughing, 'The world's my home,' she said,
'Now I have drawn thee from the dead.
Yet somewhere is a space thereof
Where I may dwell beside my love.
There clear the river grows for him
Till o'er its stones his keel shall swim.
There faint the thrushes in their song,
And deem he tarrieth overlong.
There summer-tide is waiting now
Until he bids the roses flow.
Come, tell my flowery fields,' she said,
'How I have drawn thee from the dead.'

Whither away to win good cheer?
'With me,' he said, 'for my love is here.
The wealth of my house it waneth not;
No gift it giveth is forgot.
No fear my house may enter in,
For nought is there that death may win.
Now life is little, and death is nought,
Since all is found that erst I sought.'

### Thunder in the Garden

When the boughs of the garden hang heavy with rain
And the blackbird reneweth his song,
And the thunder departeth yet rolleth again,
I remember the ending of wrong.

When the day that was dusk while his death was aloof
Is ending wide-gleaming, and strange
For the clearness of all things beneath the world's roof,
I call back the wild chance and the change.

For once we twain sat through the hot afternoon
While the rain held aloof for a while,
Till she, soft-clad, for the glory of June
Changed all with the change of her smile.

For her smile was of longing, no longer of glee
And her fingers, entwined with mine own,
With the caresses unquiet sought kindness of me
For the gift that I never had known. —

Then down rushed the rain, and the voice of the
        thunder
Smote dumb all the sound of the street,
And I to myself was grown nought but a wonder,
As she leaned down my kisses to meet.

That she craved for my lips that had craved her
        so often,
And the hand that had trembled to touch,
That the tears filled her eyes I had hoped now
        to soften
In this world was a marvel too much.

It was dusk 'mid the thunder, dusk e'en as the night,
When the first brake out our love like the storm,
But no night-hour was it, and back came the light
While our hands with each other were warm.

And her smile killed with kisses, came back as at first
As she rose up and led me along,
And out to the garden, where nought was athirst,
And the blackbird renewing his song.

Earth's fragrance went with her, as in the wet grass,
Her feet little hidden were set;
She bent down her head, 'neath the roses to pass,
And her arm with the lily was wet.

In the garden we wandered while day waned apace
And the thunder was dying aloof;
Till the moon o'er the minster-wall lifted his face,
And grey gleamed out the lead of the roof.

Then we turned from the blossoms, and cold were
    they grown:
In the trees the wind westering moved;
Till over the threshold backfluttered her gown
And in the dark house I was loved.

### Another for the Briar Rose

O treacherous scent, O thorny sight,
O tangle of world's wrong and right,
What art thou 'gainst my armour's gleam
But dusky cobwebs of a dream?

Beat down, deep sunk from every gleam
Of hope, they lie and dully dream;
Men once, but men no more, that Love
Their waste defeated hearts should move.

Here sleeps the world that would not love!
Let it sleep on, but if He move
Their hearts in humble wise to wait
On his new-wakened fair estate.

O won at last is never late!
Thy silence was the voice of fate;
Thy still hands conquered in the strife;
Thine eyes were light; thy lips were life.

### Pomona

I am the ancient Apple-Queen,
As once I was so am I now.
For evermore a hope unseen,
Betwixt the blossom and the bough.

Ah, where's the river's hidden Gold!
And where the windy grave of Troy?
Yet come I as I came of old,
From out the heart of Summer's joy.

## From *The Story of the Glittering Plain* (1891)

### Chapter 1: Of those Three who Came to the House of the Raven

4-17-00 Mon.

It has been told that there was once a young man of free kindred and whose name was Hallblithe: he was fair, strong, and not untried in battle; he was of the House of the Raven of old time.

    This man loved an exceeding fair damsel called the Hostage, who was of the House of the Rose, wherein it was right and due that the men of the Raven should wed.

    She loved him no less, and no man of the kindred gainsaid their love, and they were to be wedded on Midsummer Night.

    But one day of early spring, when the days were yet short and the nights long, Hallblithe sat before the porch of the house smoothing an ash stave for his spear, and he heard the sound of horse-hoofs drawing nigh, and he looked up and saw folk riding toward the house, and so presently they rode through the garth gate; and there was no man but he about the house, so he rose up and went to meet them, and he saw that they were but three in company: they had weapons with them,

*ornamental language*

353

and their horses were of the best; but they were no fellowship for a man to be afraid of; for two of them were old and feeble, and the third was dark and sad, and drooping of aspect: it seemed as if they had ridden far and fast, for their spurs were bloody and their horses all a-sweat.

Hallblithe hailed them kindly and said: 'Ye are way worn, and maybe ye have to ride further; so light down and come into the house, and take bite and sup, and hay and corn also for your horses; and then if ye needs must ride on your way, depart when ye are rested; or else if ye may, then abide here night-long and go your ways tomorrow, and meantime that which is ours shall be yours, and all shall be free to you.'

Then spake the oldest of the elders in a high piping voice and said: 'Young man, we thank thee; but though the days of the springtide are waxing, the hours of our lives are waning; nor may we abide unless thou canst truly tell us that this is the Land of the Glittering Plain: and if that be so, then delay not, lead us to thy lord, and perhaps he will make us content.'

Spake he who was somewhat less stricken in the first: 'Thanks have thou I but we need something more than meat and drink, to wit the Land of Living Men. And Oh! but the time presses.'

Spake the sad and sorry carle: 'We seek the Land where the days are many: so many that he who hath forgotten how to laugh, may learn the craft again, and forget the days of Sorrow.'

Then they all three cried aloud and said: 'Is this the Land? Is this the Land?'

But Hallblithe wondered, and he laughed and said: 'Wayfarers, look under the sun down the plain which lieth betwixt the mountains and the sea, and ye shall behold the meadows all gleaming with the spring lilies; yet do we not call this the Glittering Plain, but Cleveland by the Sea. Here men die when their hour comes, nor know I if the days of their life be long enough for the forgetting of sorrow; for I am young and not yet a yoke-fellow of sorrow; but this I know, that they are long enough for the doing of deeds that shall not

die. And as for Lord, I know not this word, for here dwell we, the sons of the Raven, in good fellowship, with our wives that we have wedded, and our mothers who have borne us, and our sisters who serve us. Again I bid you light down off your horses, and eat and drink, and be merry; and depart when ye will, to seek what land ye will.'

They scarce looked on him, but cried out together mournfully:

'This is not the Land! This is not the Land!'

No more than that they said, but turned about their horses and rode out through the garth gate, and went clattering up the road that led to the pass of the mountains. But Hallblithe hearkened wondering, till the sound of their horse-hoofs died away, and then turned back to his work: and it was then two hours after high-noon.

## Chapter 2: Evil Tidings Come to Hand at Cleveland

Not long had he worked ere he heard the sound of horse-hoofs once more, and he looked not up, but said to himself, 'It is but the lads bringing back the teams from the acres, and riding fast and driving hard for joy of heart and in wantonness of youth.'

But the sound grew nearer and he looked up and saw over the turf wall of the garth the flutter of white raiment; and he said:

'Nay, it is the maidens coming, back from the seashore and the gathering of wrack.'

So he set himself the harder to his work, and laughed, all alone as he was, and said: 'She is with them: now I will not look up again till they have ridden into the garth, and she has come from among them, and leapt off her horse, and cast her arms about my neck as her wont is; and it will rejoice her then to mock me with hard words and kind voice and longing heart; and I shall long for her and kiss her, and sweet shall the coming days seem to us: and the daughters of our folk shall look on and be kind and blithe with us.'

Therewith rode the maidens into the garth,

but he heard no sound of laughter or merriment amongst them, which was contrary to their wont; and his heart fell, and it was as if instead of the maidens' laughter the voices of those wayfarers came back upon the wind crying out, 'Is this the land? Is this the land?'

Then he looked up hastily, and saw the maidens drawing near, ten of the House of the Raven, and three of the House of the Rose; and he beheld them that their faces were pale and woe-begone, and their raiment rent, and there was no joy in them. Hallblithe stood aghast while one who had gotten off her horse (and she was the daughter of his own mother) ran past him into the hall, looking not at him, as if she durst not: and another rode off to the horse-stalls. But the others, leaving their horses, drew round about him, and for a while none durst utter a word; and he stood gazing at them, with the spoke-shave in his hand, he also silent; for he saw that the Hostage was not with them, and he knew that now he was the yoke-fellow of sorrow.

At last he spoke gently and in a kind voice, and said: 'Tell me, sisters, what evil hath befallen us, even if it be the death of a dear friend, and the thing that may not be amended.'

Then spoke a fair woman of the Rose, whose name was Brightling, and said: 'Hallblithe, it is not of death that we have to tell, but of sundering, which may yet be amended. We were on the sand of the sea nigh the Ship-stead and the Rollers of the Raven, and we were gathering the wrack and playing together; and we saw a round-ship nigh to shore lying with her sheet slack, and her sail beating the mast; but we deemed it to be none other than some bark of the Fish-biters, and thought no harm thereof, but went on running and playing amidst the little waves that fell on the sand, and the ripples that curled around our feet. At last there came a small boat from the side of the round-ship, and rowed in toward shore, and still we feared not, though we drew a little aback from the surf and let fall our gown-hems. But the crew of that boat beached her close to where we stood, and came hastily wading the surf towards us; and

we saw that they were twelve weaponed men, great, and grim, and all clad in black raiment.

'Then indeed were we afraid, and we turned about and fled up the beach; but now it was too late, for the tide was at more than half ebb and long was the way over the sand to the place where we had left our horses tied among the tamarisk-bushes. Nevertheless we ran, and had gotten up to the pebble-beach before they ran in amongst us: and they caught us, and cast us down on to the hard stones.

'Then they made us sit in a row on a ridge of the pebbles; and we were sore afraid, yet more for defilement at their hands than for death; for they were evil-looking men exceeding foul of favour. Then said one of them: "Which of all you maidens is the Hostage of the House of the Rose?" Then all we kept silence, for we would not betray her. But the evil man spake again: "Choose ye then whether we shall take one, or all of you across the waters in our black ship." Yet still we others spake not, till arose thy beloved, O Hallblithe, and said: Let it be one then, and not all; for I am the Hostage. How shalt thou make us sure thereof? said the evil carle. She looked on him proudly and said: Because I say it, Wilt thou swear it? said he. Yea, said she, I swear it by the token of the House wherein I shall wed; by the wings of the Fowl that seeketh the Field of Slaying. It is enough, said the man, come thou with us. And ye maidens sit ye there, and move not till we have made way on our ship, unless ye would feel the point of the arrow. For ye are within bow-shot of the ship, and we have shot weapons aboard. So the Hostage departed with them, and she unweeping, but we wept sorely. And we saw the small boat come up to the side of the round-ship, and the Hostage going over the gunwale along with those evil men, and we heard the hale and how of the mariners as they drew up the anchor and sheeted home; and then the sweeps came out and the ship began to move over the sea. And one of those evil-minded men bent his bow and shot a shaft at us, but it fell far short of where we sat, and the laugh of those runagates came over

the sands to us. So we crept up the beach trembling, and then rose to our feet and got to our horses, and rode hither speedily, and our hearts are broken for thy sorrow.'

At that word came Hallblithe's own sister out from the hall; and she bore weapons with her, to wit Hallblithe's sword and shield and helm and hauberk. As for him he turned back silently to his work, and set the steel of the spear on the new ashen shaft, and took the hammer and smote the nail in, and laid the weapon on a round pebble that was nearby, and clenched the nail on the other side. Then he looked about, and saw that the other damsel had brought him his coal-black war-horse ready saddled and bridled; then he did on his armour, and girt his sword to his side and leapt into the saddle, and took his new-shafted spear in hand and shook the rein. But none of all those damsels durst say a word to him or ask him whither he went, for they feared his face, and the sorrow of his heart. So he got him out of the garth and turned toward the sea-shore, and they saw the glitter of his spear-point a minute over the turf-wall, and heard the clatter of his horse-hoofs as he galloped over the hard way; and thus he departed.

## Chapter 9: They Come to the Land of the Glittering Plain

…Hallblithe, though he wondered much what all this betokened, and what the land was whereto he was wending was no man to fear an unboded peril… So wore the day and still the wind held fair, though it was light; and the sun set in a sky nigh cloudless, and there was nowhere any forecast of peril. But when night was come, Hallblithe lay down on a fair bed, which was dight for him in the poop, and he soon fell asleep and dreamed not save such dreams as are but made up of bygone memories, and betoken nought, and are not remembered.

When he awoke, day lay broad on the sea, and the waves were little, the sky had but few

clouds, the sun shone bright, and the air was warm and sweet-breathed.

He looked aside and saw [an] old man sitting up in his bed, as ghastly as a dead man dug up again: his bushy eye-brows were wrinkled over his bleared old eyes, the long white hair dangled forlorn from his gaunt head: yet was his face smiling and he looked as happy as the soul within him could make the half-dead body. He turned now to Hallblithe and said: 'Thou art late awake: hadst thou been waking earlier, the sooner had thine heart been gladdened. Go forward now, and gaze thy fill and come and tell me thereof.'

'Thou art happy, Grandfather,' said Hallblithe, ' what good tidings hath morn brought us?'

'The land! the land!' said the Long-hoary; 'there are no longer tears in this old body, else should I be weeping for joy.'

Said Hallblithe: 'Art thou going to meet some one who shall make thee glad before thou diest, old man?'

'Some one?' said the elder; 'what one? Are they not all gone? burned, and drowned, and slain and died abed? Some one, young man? Yea, forsooth some one indeed! Yea, the great warrior of the Wasters of the Shore; the Sea-eagle who bore the sword and the torch and the terror of the Ravagers over the coal-blue sea. It is myself, MYSELF that I shall find on the Land of the Glittering Plain, O young lover!'

Hallblithe looked on him wondering as he raised his wasted arms toward the bows of the ship pitching down the slope of the sunlit sea, or climbing up it. Then again the old man fell back on his bed and muttered 'What fool's work is this! that thou wilt draw me on to talk loud, and waste my body with lack of patience. I will talk with thee no more, lest my heart swell and break, and quench the little spark of life within me.'

Then Hallblithe arose to his feet, and stood looking at him, wondering so much at his words, that for a while he forgat the land which they were nearing, though he had caught glimpses of it, as the bows of the round-ship fell downward into the

hollow of the sea. The wind was but light, as hath been said, and the waves little under it, but there was still a smooth swell of the sea which came of breezes now dead, and the ship wallowed thereon and sailed but slowly.

In a while the old man opened his eyes again, and said in a low peevish voice: 'Why standest thou staring at me? why hast thou not gone forward to look upon the land? True it is that ye Ravens are short of wits.' Said Hallblithe: 'Be not wrath, chieftain; I was wondering at thy words, which are exceeding marvellous; tell me more of this land of the Glittering Plain.'

Said the Grandfather: 'Why should I tell it thee? ask of the mariners. They all know more than thou dost.'

'Thou knowest,' said Hallblithe, 'that these men speak not to me, and take no more heed of me than if I were an image which they were carrying to sell to the next mighty man they may hap on. Or tell me, thou old man,' said he fiercely, 'is it perchance a thrallmarket whereto they are bringing me? Have they sold her there, and will they sell me also in the same place, but into other hands?'

'Tush!' said the Grandfather somewhat feebly, 'this last word of thine is folly; there is no buying or selling in the land whereto we are bound. As to thine other word, that these men have no fellowship with thee, it is true: thou art my fellow and the fellow of none else aboard. Therefore if I feel might in me, maybe I will tell thee somewhat.'

Then he raised his head a little and said: 'The sun grows hot, the wind faileth us, and slow and slow are we sailing.'

Even as he spoke there was a stir amidships, and Hallblithe looked and beheld the mariners handling the sweeps, and settling themselves on the rowing-benches. Said the elder: 'There is noise amidships, what are they doing?'

The old man raised himself a little again, and cried out in his shrill voice: 'Good lads! brave lads! Thus would we do in the old time when we drew anear some shore, and the beacons were sending up smoke by day, and flame benights; and the shore-abiders did on their helms and trembled. 'Thrust her through lads! Thrust her along!' Then he fell back again, and said in a weak voice: 'Make no more delay, guest, but go forward and look upon the land, and come back and tell me thereof, and then the tale may flow from me. Haste, haste!' So Hallblithe went down from the poop, and into the waist, where now the rowers were bending to their oars, and crying out fiercely as they tugged at the quivering ash; and he clomb on to the forecastle and went forward right to the dragon-head, and gazed long upon the land, while the dashing of the oar-blades made the semblance of a gale about the ship's black sides. Then he came back again to the Sea-eagle, who said to him: 'Son, what hast thou seen?'

'Right ahead lieth the land, and it is still a good way off. High rise the mountains there, but by seeming there is no snow on them; and thou they be blue they are not blue like the mountains of the Isle of Ransom. Also it seemed to me as if fair slopes of woodland and meadow come down to the edge of the sea. But it is yet far away.'

'Yea,' said the elder, ' is it so? Then will I not wear myself with making words for thee. I will rest rather, and gather might. Come again when an hour hath worn, and tell me what thou seest; and may happen then thou shalt have my tale!' And he laid him down therewith and seemed to be asleep at once. And Hallblithe might not amend it; so he waited patiently till the hour had worn, and then went forward again, and looked long and carefully, and came back and said to the Sea-eagle, 'The hour is worn.'

The old chieftain turned himself about and said: 'What hast thou seen?'

Said Hallblithe: 'The mountains are pale and high and below them are hills dark with wood, and betwixt them and the sea is a fair space of meadow-land, and me-thought it was wide.' Said the old man: 'Sawest thou a rocky skerry rising high out of the sea anigh the shore?'

'Nay,' said Hallblithe, 'If there be, it is all blended with the meadows and the hills.' Said the

Sea-eagle: 'Abide the wearing of another hour, and come and tell me again, and then may have a gainful word for thee.' And he fell asleep again. But Hallblithe abided, and when the hour was worn, he went forward and stood on the forecastle. And this was the third shift of the rowers, and the stoutest men in the ship now held the oars in their hands, and the ship shook thro' all her length and breadth as they drave her over the waters.

So Hallblithe came aft to the old man and found him asleep; so he took him by the shoulder, and shook him and said: 'Awake, faring-fellow, for the land is a-nigh.'

So the old man sat up and said: 'What hast thou seen?'

Said Hallblithe: 'I have seen the peaks and cliffs of the far-off mountains; and below them are hills green with grass and dark with woods, and thence stretch soft green meadows down to the sea-strand, which is fair and smooth, and yellow.'

'Sawest thou the skerry?' said the Sea-eagle.

'Yea, I saw it,' said Hallblithe, 'and it rises sheer from out the sea about a mile from the yellow strand; but its rocks are black, like the rocks of the Isle of Ransom.'

'Son,' said the elder, 'give me thine hands and raise me up a little.' So Hallblithe took him and raised him up, so that he sat leaning against the pillows. And he looked not on Hallblithe, but on the bows of the ship, which now pitched but a little up and down, for the sea was laid quiet now. Then he cried in his shrill, piping voice: 'It is the land! It is the land!'

But after a little while he turned to Haliblithe and spake: 'Short is the tale to tell: thou hast wished me youth, and thy wish hath thriven; for to-day, ere the sun goes down thou shalt see me as I was in the days when I reaped the harvest of the sea with sharp sword and hardy heart for this is the land of the Undying King, who is our lord and our gift-giver; and to some he giveth the gift of youth renewed, and life that shall abide here the Gloom of the Gods. But none of us all may come to the Glittering Plain and the King Undying

without turning the back for the last time on the Isle of Ransom: nor may any men of the Isle come hither save those who are of the House of the Sea-eagle, and few of those, save the chieftains of the House, such as are they who sat by thee on the high-seat that even. Of these once in a while is chosen one of us, who is old and bent and past battle, and is borne to this land and the gift of the Undying. Forsooth some of us have no will to take the gift, for they say they are liefer to go to where they shall meet more of our kindred than dwell on the Glittering Plain and the Acre of the Undying; but as for me I was ever an overbearing and masterful man, and meseemeth it is well that I meet as few of our kindred as may be: for they are a strifeful race.'

Hereat Hallblithe marvelled exceedingly, and he said: 'And what am I in all this story? Why am I come hither with thy furtherance?' Said the Sea-eagle: 'We had a charge from the Undying King concerning thee, that we should bring thee hither alive and well, if so be thou camest to the Isle of Ransom. For what cause we had the charge, I know not, nor do I greatly heed.'

Said Hallblithe: 'And shall I also have that gift of undying youth, and life while the world of men and gods endureth?'

'I must needs deem so,' said the Sea-eagle, 'so long as thou abidest on the Glittering Plain; and I see not how thou mayst ever escape thence.'

Now Hallblithe heard him, how he said 'escape,' and thereat he was somewhat ill at ease, and stood and pondered a little. At last he said: 'Is this then all that thou hast to tell me concerning the Glittering Plain?'

'By the Treasure of the Sea!' said the Elder, 'I know no more of it. The living shall learn. But I suppose that thou mayst seek thy troth-plight maiden there all thou wilt. Or thou mayst pray the Undying King to have her thither to thee. What know I? At least, it is like that there shall be no lack of fair women there: or else the promise of youth renewed is nought and vain. Shall this not be enough for thee?'

'Nay,' said Hallblithe.

'What, said the elder, 'must it be one woman only?'

'One only,' said Hallblithe.

The old man laughed his thin mocking laugh, and said: 'I will not assure thee but that the land of the Glittering Plain shall change all that for thee so soon as it touches the soles of thy feet.'

Hallblithe looked at him steadily and smiled, and said: 'Well is it then that I shall find the Hostage there; for then shall we be of one mind, either to sunder or to cleave together. It is well with me this day.'

'And with me it shall be well ere long,' said the Sea-eagle.

But now the rowers ceased rowing and lay on their oars, and the shipmen cast anchor; or they were but a bowshot from the shore, and the ship swung with the tide and lay side-long to the shore. Then said the Sea-eagle: 'Look forth, shipmate, and tell me of the land.'

And Hallblithe looked and said: 'The yellow beach is sandy and shell-strewn, as I deem, and there is no great space of it betwixt the sea and the flowery grass; and a bowshot from the strand I see a little wood amidst which are fair trees blossoming.'

'Seest thou any folk on the shore?' said the old man. 'Yea,' said Hallblithe,' close to the edge of the sea go four; and by seeming three are women, for their long gowns flutter in the wind. And one of these is clad in saffron colour, and another in white, and another in watchet; but the carle is clad in dark red; and their raiment is all listening as with gold and gems; and by seeming they are looking at our ship as though they expected somewhat.'

Said the Sea-eagle: 'Why now do the ship men tarry and have not made ready the skiff? Swillers and belly-gods they be; slothful swine that forget their chieftain.'

But even as he spake came four of the shipmen, and without more ado took him up, bed and all, and bore him down into the waist of the ship, whereunder lay the skiff with four strong rowers lying on their oars. These men made no

sign to Hallblithe, nor took any heed of him; but he caught up his spear, and followed them and stood by as they lowered the old man into the boat. Then he set his foot on the gunwale of the ship and leapt down lightly into the boat, and none hindered or helped him; and he stood upright in the boat, a goodly image of battle with the sun flashing back from his bright helm, his spear in his hand, his white shield at his back, and thereon the image of the Raven; but if he had been but a salt-boiling carle of the sea-side none would have heeded him less.

## Chapter 15: Yet Hallblithe Speaketh with the King

So wore the days and the moons; and now were some six moons worn since first he came to the Glittering Plain; and he was come to Wood-end again, and heard and knew that the King was sitting once more in the door of his pavilion to hearken to the words of his people, and he said to himself: 'I will speak yet again to this man, if indeed he be a man; yea, though he turn me into stone.'

And he went up toward the pavilion; and on the way it came into his mind what the men of the kindred were doing that morning; and he had a vision of them as it were, and saw them yoking the oxen to the plough, and slowly going down the acres, as the shining iron drew the long furrow down the stubble-land, and the light haze hung about the elm-trees in the calm morning, and the smoke rose straight into the air from the roof of the kindred. And he said: 'What is this? am I death- doomed this morning that this sight cometh so clearly upon me amidst the falseness of this unchanging land?'

Thus he came to the pavilion, and folk fell back before him to the right and the left, and he stood before the King, and said to him: 'I cannot find her; she is not in thy land.'

Then spake the King, smiling upon him, as erst: 'What wilt thou then? Is it not time to rest?'

He said: 'Yea, O King; but not in this land.'

Said the King: 'Where else than in this land wilt thou find rest? Without is battle and famine, longing unsatisfied, and heart-burning and fear; within it is plenty and peace and good will and plea, sure without cease. Thy word hath no meaning to me.'

Said Hallblithe: 'Give me leave to depart, and I will bless thee.'

'Is there nought else to do?' said the King.

'Nought else,' said Hallblithe.

Therewith he felt that the King's face changed though he still smiled on him, and again he felt his heart grow cold before the King.

But the King spake and said: 'I hinder not thy departure, nor will any of my folk. No hand will be raised against thee; there is no weapon in all the land, save the deedless sword by my side and the weapons which thou bearest.' Said Hallblithe: 'Dost thou not owe me a joy in return for my beguiling?'

'Yea,' said the King, 'reach out thine hand to take it.'

'One thing only may I take of thee,' said Hallblithe; 'my troth-plight maiden or else the speeding of my departure.'

Then said the King, and his voice was terrible though yet he smiled: 'I will not hinder; I will not hinder; I will not help. Depart in peace!'

Then Hallblithe turned away dizzy and half faint and strayed down the field, scarce knowing where he was and as he went he felt his sleeve plucked at, and turned about, and lo! he was face to face with the Sea-eagle, no less joyous than aforetime. He took Hallblithe in arms and embraced him and kissed him, and said: 'Well met faring-fellow! Whither away?'

'Away out of this land of lies,' said Hallblithe.

The Sea-eagle shook his head, and quoth he: 'Art thou still seeking a dream? And thou so fair that puttest all other men to shame.'

'I seek no dream,' said Hallblithe, 'but rather the end of dreams.'

## From *Collected Works* (ed. May Morris 1910-1915)

### *For the Bed at Kelmscott*

The wind's on the wold
And the night is a-cold,
And the Thames runs chill
'Twixt mead and hill;
But kind and dear
Is the old house here,
And my heart is warm
'Midst winter's harm.
Rest, then, and rest,
And think of the best
'Twixt summer and spring,
When all birds sing
In the town of the tree,
And ye lie in me
And scarce dare move,
Lest the earth and its love
Should fade away
Ere the full of the day.
I am old and have seen
Many things that have been—
Both grief and peace
And wane and increase.
No tale I tell
Of ill or well,
But this I say,
Night treadeth on day.
And for worst and best
Right good is rest.

## John Payne
## From *The Poetical Works of John Payne* (1902)

### *Sibyl*

This is the glamour of the world antique:
The thyme-scents of Hymettus fill the air,
And in the grass narcissus-cups are fair.
The full brook wanders through the ferns to seek
The amber haunts of bees; and on the peak

Of the soft hill, against the gold-marged sky,
She stands, a dream from out the days gone by.
Entreat her not. Indeed, she will not speak!
Her eyes are full of dreams; and in her ears
There is the rustle of immortal wings;
And ever and anon the slow breeze bears
The mystic murmur of the songs she sings.
Entreat her not: she sees thee not, nor hears
Aught but the sights and sounds of bygone springs.

*Love's Autumn*
**(Field's Nocturne in D Minor)**

Yes, love, the Spring shall come again;
    But not as once it came:
Once more in meadow and in lane
    The daffodils shall flame,
The cowslips blow, but all in vain;
    Alike, but not the same.

The roses that we plucked of old
    Were dewed with heart's delight:
Our gladness steeped the primrose-gold
    In half its lovely light:
The hopes are long since dead and cold,
    That flushed the wind-flowers' white.

Ah, who can give us back our Spring?
    What spell can fill the air
With all the birds of painted wing
    That song for us whilere?
What cloth reclothe with blossoming
    Our lives grown blank and bare?

What sun can draw the ruddy bloom
    Back to hope's faded rose?
What stir of summer re-illume
    Our hearts' wrecked garden-close?
What flowers can fill the empty room
    Where now the nightshade grows?

'Tis but the Autumn's chilly sun
    That mocks the glow of May;
'Tis but the pallid bindweeds run

Across our garden way,
Pale orchids, scentless every one
    Ghosts of the summer day.

Yet, if it must be so, 'tis well:
    What part have we in June?
Our hearts have all forgot the spell
    That held the summer noon;
We echo back the cuckoo's knell
    And not the linnet's tune.

What should we do with roses now,
    Whose cheeks no more are red?
What violets should deck our brow,
    Whose hopes are long since fled?
Recalling many a wasted vow
    And many a faith struck dead.

Bring heath and pimpernel and rue,
    The Autumn's somber flowers:
At least their scent will not renew
    The thought of happy hours
Nor drag sad memory back unto
    That lost sweet time of ours.

Faith is no sun of summer-tide,
    Only the pale calm light
That, when the Autumn clouds divide,
    Hangs in the watchet height,
A lamp, wherein we may abide
    The coming of the night.

And yet, beneath its languid ray,
    The moorlands bare and dry
Bethink them of the summer day
    And flower, far and nigh,
With fragile memories of the May,
    Blue as the August sky.

These are our flowers: they have no scent
    To mock our waste desire,
No hint of bygone ravishment
    To stir the faded fire:
The very soul of sad content
    Dwells in each azure spire.

I have no violets: you laid
    Your blight upon them all:
It was your hand, alas! that made
    My roses fade and fall,
Your breath my lilies that forbade
    To come at summer's call.

Yet take these scentless flowers and pale,
    The last of all my year:
Be tender with them; they are frail:
    But, if thou hold them dear,
I'll not their brighter kin bewail,
    That now lie cold and sere.

## Christina Rossetti
### From *The Face of the Deep: A Devotional Commentary on The Apocalypse* (1892)

1. *And there appeared a great wonder in heaven; a woman clothed with the sun, and the moon under her feet, and upon her head a crown of twelve stars.*

'A woman clothed with the sun, and the moon under her feet, and upon her head a crown of twelve stars.'—Whatever else may here be hidden, there stands revealed that 'great wonder', weakness made strong and shame swallowed up in celestial glory. For thus the figure is set before our eyes. Through Eve's lapse, weakness and shame devolved on woman as her characteristics, in a manner special to herself and unlike the corresponding heritage of man.

And as instinctively we personify the sun and moon as *he* and *she*, I trust there is no harm in my considering that her sun-clothing indicates how in that heaven where St. John in vision beheld her, she will be made equal with men and angels; arrayed in all human virtues, and decked with all communicable Divine graces: whilst the moon under her feet portends that her sometime infirmity of purpose and changeableness of mood have, by preventing, assisting, final grace, become immutable; she has done all and stands; from the lowest place she has gone up higher. As love of his Lord enabled St. Peter to tread the sea, so love of the same Lord sets weak woman immovable on the waves of this troublesome world, triumphantly erect, despite her own frailty, made not 'like unto a wheel', amid all the changes and chances of this mortal life.

Eve's temptation and fall suggest the suitableness and safety of much (though by no means of all) ignorance, and the wholesomeness of studying what is open without prying into what is secret. We have no reason to doubt that the forbidden fruit was genuinely 'pleasant to the eyes': as such she might innocently have gazed upon it with delight, and for that delight might profitably have returned thanks to the Author and Giver of all good. Not till she became wise in her own conceit, disregarding the plain obvious meaning of words, and theorizing on her own responsibility as to physical and intellectual results, did she bring sin and death into the world. The Tree of the Knowledge of Good and Evil was as it were a standing prophet ever reiterating the contingent sentence, Thou shalt surely die. This sentence, plain and unmistakable, she connived at explaining away, and being deceived, was undone.

Eve exhibits one extreme of feminine character, the Blessed Virgin the opposite extreme. Eve parleyed with a devil: holy Mary 'was troubled' at the salutation of an Angel. Eve sought knowledge: Mary instruction. Eve aimed at self-indulgence: Mary at self-oblation. Eve, by disbelief and disobedience, brought sin to the birth: Mary, by faith and submission, Righteousness.

And yet, even as at the foot of the Cross, St. Mary Magdalene, out of whom went seven devils, stood beside the 'lily among thorns', the Mother of sorrows: so (I humbly hope and trust) amongst all saints of all time will stand before the Throne, Eve the beloved first Mother of us all. Who that has loved and revered her own immediate dear mother, wilt not echo the hope?

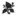

2. *And I John saw the holy city, new Jerusalem, coming down from God out of heaven, prepared as a bride adorned for her husband.*

'For, behold, I create new heavens and a new earth: and the former shall not be remembered, nor come into mind. But be ye glad and rejoice for ever in that which I create: for, behold, I create Jerusalem a rejoicing, and her people a joy. And I will rejoice in Jerusalem, and joy in My people: and the voice of weeping shall be no more heard in her, nor the voice of crying.'

(If I am not mistaken) a double point of likeness here connects St. John with his Adorable Master. Throughout the Gospel record of Christ's sayings whilst on earth He never once calls Himself by His Blessed Name of Jesus; but speaking from heaven first to Saul of Tarsus, afterwards in this Apocalypse (ch. xxii. 16) in reference to the Churches, He nameth Himself by that Name which is above every name, whereat every knee shall bow and which every tongue shall confess. Even so the beloved disciple who in his Gospel enters not his own name so much as once, now speaking as from within the door opened into heaven names himself thrice, and of these times twice in the emphatic form 'I John'.

To ourselves an alluring lesson of present abasement, future exaltation. Thus pearls submerged awhile in deep waters come to light hereafter in the City of God.

I think too that our eager hope of recognition, the craved for 'I am I and you are you' of eternal reunion, is hereby solaced and strengthened; whilst we perceive one such identity as might even have eluded observation on earth proclaimed triumphantly in heaven.

My Lord, my Lord Jesus, Thou art enough, Thou by Thyself art enough. Yet withholdest Thou no good thing from them that live a godly life. And Thou discernest the heart's desire of every man, and Thou hearest the request of all lips. Every heart's desire and request I commend to Thee, most loving Lord. Amen.

What will it be at last to see a 'holy' city! for Londoners, for Parisians, for citizens of all cities upon earth to see a holy city. Truly as yet this also 'eye hath not seen'. Not such is or ever was Jerusalem that now is, or Rome though styled eternal or sacred, or Moscow albeit called holy: neither does any continent or island rear such, nor is any ruin extant of such, nor is so much as one material foundation-stone laid of such.

Nevertheless whoever seeks citizenship at last in that all holy City must now day by day watch, pray, labour, agonize it may be, to sanctify his allotted dwelling in his present mean city; though this be as Babylon awaiting destruction, as an actual city of the plain clamouring for the vengeance of eternal fire.

Art thou as Lazarus? Hold fast godliness and contentment, earnests and precursors of great gain. Art thou as Dives? Heed betimes the voice of Lazarus:

> I, laid beside thy gate, am Lazarus;
> See me or see me not I still am there,
> Hungry and thirsty, sore and sick and bare,
> Dog-comforted and crumbs-solicitous:
> While thou in all thy ways art sumptuous.
> Daintily clothed, with dainties for thy fare:
> Thus a world's wonder thou art quit of care,
> And be I seen or not seen I am thus.
> One day a worm for thee, a worm for me:
> With my worm angel songs and trumpet burst
> And plenitude an end of all desire :
> But what for thee, alas! but what for thee?
> Fire and an unextinguishable thirst,
> Thirst in an unextinguishable fire.

New Jerusalem has been gathered from the uttermost part of the earth to the uttermost part of heaven: stone by stone, soul by soul, here a little and there a little. Laps of luxury, fire of temptation, ease of riches, squalor of destitution, pinnacles of giddy exaltation, mountains of difficulty, valleys of humiliation, each has sent up its prefixed weight, number, measure, nothing lacking, nothing over. Redeemed, called by name, claimed, precious, honourable, beloved, brought from the east and gathered from the west, given up by the north and by the south kept not back,

God's sons have been brought from far and His daughters from the ends of the earth; even every one that is called by the Divine Name, formed of God, created for His glory. Alleluia!

New Jerusalem comes down 'from God out of heaven', not as leaving God, but inasmuch as His Presence goeth with her. As when of old that Adorable Presence led the elder Isræl in the stages of their Exodus, so now that Same Adorable Inalienable Presence leads her out and brings her in, is beneath her for stability, over her for benediction, around her for acceptance. As a chaste virgin espoused she comes down, longed for, toiled for, Self-sacrificed for, bought with a great price by Him Who gave His whole Substance for love.

She has received all and now she gives back all. She is 'adorned for her Husband', for her Beloved, Who is indeed more than another beloved. He loved her first, and now she returns His love. He is the Sun, and now as His moon-mirror she appears clear as the sun. He is the Life, and now she has received life from Him and lives to Him. She is His lily, no longer among thorns because He once wore those thorns that so He might take them out of her way. He is All-Holy: and now, her heart purified by His Blood and sanctified by His Spirit, she sees Him Whom to see beatifies. His graces shed on her form the ornament to her head and the chains about her neck. Beautiful are her feet shod with the preparation of the Gospel of His peace. Behold her in tenderness His dove, in likeness His sister, in union His spouse.

Behold her! yea, also, and behold thyself, O thou called to be a saint. Her perfections are thy birthright; thou art what she was, what she is thou mayest become. That Goodness which is her fountain of good overflows to thee likewise. Covet earnestly gifts such as hers, practise self-adornment for love of Him who loveth thee, Reserve gems and pearls for immortality when thou shalt be flawless as they. Adorn thyself meanwhile with flower-like graces: humility the violet, innocence the snowdrop, purity the lily;

with sweetness for a honeysuckle, with penitence for a fruitful thorn. To-day put on the garments of salvation prepared for thee, that to-morrow thou mayest be promoted to wear the garments of praise. 'Then shall every man have praise of God.'

> A lovely city in a lovely land,
>     Whose citizens are lovely, and whose King
>     Is Very Love; to Whom all angels sing;
> To Whom all saints sing crowned, their sacred band
> Saluting Love with palm-branch in their hand:
>     Thither all doves on gold or silver wing
>     Flock home thro' agate windows glistering
> Set wide, and where pearl gates wide open stand.
> A bower of roses is not half so sweet,
>     A cave of diamonds doth not glitter so,
>       Nor Lebanon is fruitful set thereby:
>       And thither thou, beloved, and thither I
>     May set our heart and set our face, and go
> Faint yet pursuing home on tireless feet.

## From *New Poems by Christina Rossetti Hitherto Unpublished or Uncollected* (ed. William Michael Rossetti, 1896)

### A Pause

> They made the chamber sweet with flowers and leaves,
>     And the bed sweet with flowers on which I lay;
>     While my soul, love-bound, loitered on its way.
> I did not hear the birds about the eaves,
> Nor hear the reapers talk among the sheaves:
>     Only my soul kept watch from day to day,
>     My thirsty soul kept watch for one away:—
> Perhaps he loves, I thought, remembers, grieves.
> At length there came the step upon the stair,
>     Upon the lock the old familiar hand:
> Then first my spirit seemed to scent the air
>     Of Paradise; then first the tardy sand
> Of time ran golden; and I felt my hair
>     Put on a glory, and my soul expand.
>                     10 June 1853

## From the Antique

It's a weary life, it is, she said:—
    Doubly blank in a woman's lot:
I wish and I wish I were a man:
    Or, better than any being, were not:

Were nothing at all in all the world,
    Not a body and not a soul:
Not so much as a grain of dust
    Or drop of water from pole to pole.

Still the world would wag on the same,
    Still the seasons go and come:
Blossoms bloom as in days of old,
    Cherries ripen and wild bees hum.

None would miss me in all the world,
    How much less would care or weep:
I should be nothing, while all the rest
    Would **wake** and weary and fall asleep.

                28 June 1854

## In an Artist's Studio   *[handwritten: 4-17-00 mon.]*

One face looks out from all his canvases,
One selfsame figure sits or walks or leans:
  We found her hidden just behind those screens,
That mirror gave back all her loveliness.
A queen in opal or in ruby dress,
  A nameless girl in freshest summer-greens,
  A saint, an angel—every canvas means
The same one meaning, neither more nor less.
He feeds upon her face by day and night, *[handwritten: interesting]*
  And she with true kind eyes looks back on him,
Fair as the moon and joyful as the light:
  Not wan with waiting, not with sorrow dim;
Not as she is, but was when hope shone bright;
  Not as she is, but as she fills his dream.

             24 December 1856

*[handwritten margin notes: Description of wt gg's on wl / all Pre-Raphaelites — obsession w/ women (as object) / This notion that it's an almost carnivorous relationship; morbid / Emblematic of position of women in Victorian England in general]*

## To-day and To-morrow

### 1

All the world is out in leaf,
    Half the world in flower,
Earth has waited weeks and weeks
    For this special hour:
Faint the rainbow comes and goes
    On a sunny shower.

All the world is making love:
    Bird to bird in bushes,
Beast to beast in glades, and frog
    To frog among the rushes:
Wake, O south wind sweet with spice,
    Wake the rose to blushes.

Life breaks forth to right and left—
    Pipe wild-wood notes cheery.
Nevertheless there are the dead
    Fast asleep and weary—
To-day we live, to-day we love,
    Wake and listen, dreary.

### 2

I wish I were dead, my foe,
My friend, I wish I were dead,
With a stone at my tired feet
And a stone at my tired head.

In the pleasant April days
Half the world will stir and sing,
But half the world will slug and rot
    For all the sap of Spring.

             29 June 1858

## Promises Like Pie-Crust

*[handwritten: Easily broken, flaked ood if it's good pie crust) — Promises too easily broken, too superficial / 4-17-00 (circled) / "I can never really know you, you can never really know me"]*

Promise me no promises,
    So will I not promise you:
Keep we both our liberties,
    Never false and never true:
Let us hold the die uncast,
    Free to come as free to go:
For I cannot know your past,
    And of mine what can you know?

*[handwritten marginalia: why this is women not male? Recognised he might i previous have not only had but slept with them, too. girlfriend]*

*[handwritten marginalia, left margin: poem about someone unwilling to commit Or very aware of how ephemeral (or As life not promised human promised are) at all.]*

You, so warm, may once have been
    Warmer towards another one:
I, so cold, may once have seen
    Sunlight, once have felt the sun:
Who shall show us if it was
    Thus indeed in time of old?
Fades the image from the glass,
    And the fortune is not told.

If you promised, you might grieve *[handwritten: on so many levels]*
    For lost liberty again:
If I promised, I believe
    I should fret to break the chain:
Let us be the friends we were,
    Nothing more but nothing less:
Many thrive on frugal fare
    Who would perish of excess.

<div align="right">20 April 1861</div>

### An Echo from Willow-Wood

'O ye, all ye that walk in willow-wood', D.G. Rossetti.

Two gazed into a pool, he gazed and she,
Not hand in hand, yet heart in heart, I think,
    Pale and reluctant on the water's brink,
As on the brink of parting which must be.
Each eyed the other's aspect, she and he,
    Each felt one hungering heart leap up and sink,
    Each tasted bitterness which both must drink,
There on the brink of life's dividing sea.
Lilies upon the surface, deep below
    Two wistful faces craving each for each,
    Resolute and reluctant without speech:—
A sudden ripple made the faces flow,
    One moment joined, to vanish out of reach:
So those hearts joined, and ah were parted so.

<div align="right">Circa 1870</div>

### Sleeping at Last

Sleeping at last, the trouble and tumult over,
    Sleeping at last, the struggle and horror past,
Cold and white, out of sight of friend and of lover,
    Sleeping at last.

    No more a tired heart downcast or overcast,
No more pangs that wring or shifting fears that hover,
    Sleeping at last in a dreamless sleep locked fast.

Fast asleep. Singing birds in their leafy cover
    Cannot wake her, nor shake her the gusty blast.
Under the purple thyme and the purple clover
    Sleeping at last.

<div align="right">Circa 1893</div>

### How Long?

My life is long—Not so the Angels say
Who watch me waste it, trembling whilst they weigh
Against eternity my lavished day.

My life is long—Not so the Saints in peace
Judge, filled with plenitude that cannot cease:
Oh life was short which bought such large increase!

My life is long—Christ's word is different:
The heat and burden of the day were spent
On Him,—to me refreshing times are sent.

Give me an Angel's heart, that day nor night
Rests not from adoration its delight,
Still crying 'Holy holy' in the height.

Give me the heart of Saints, who, laid at rest
In better Paradise than Abraham's breast,
In the everlasting Rock have made their nest.

Give me Thy heart, O Christ, who thirty-three
Slow years of sorrow countedst short for me,
That where Thou art there Thy beloved might be.

<div align="right">14 April 1856</div>

### *Out of the Deep*

Have mercy, Thou my God—mercy, my God!
  For I can hardly bear life day by day.
    Be I here or there, I fret myself away:
Lo for Thy staff I have but felt Thy rod
Along this tedious desert-path long trod.
    When will Thy judgment judge me, yea or nay?
  I pray for grace: but then my sins unpray
My prayer: on holy ground I fool stand shod—

While still Thou haunt'st me, faint upon the cross,
  A sorrow beyond sorrow in Thy look,
    Unutterable craving for my soul.
  All-faithful Thou, Lord: I, not Thou, forsook
    Myself: I traitor slunk back from the goal:
Lord, I repent—help Thou my helpless loss.
                    17 December 1862

### From *Maude* (written 1850; published 1897)

#### 1

'A penny for your thoughts,' said Mrs. Foster, one bright July morning, as she entered the sitting-room, with a bunch of roses in her hand, and an open letter: 'A penny for your thoughts,' said she, addressing her daughter, who, surrounded by a chaos of stationery, was slipping out of sight some scrawled paper. This observation remaining unanswered, the mother, only too much accustomed to inattention, continued: 'Here is a note from your Aunt Letty; she wants us to go and pass a few days with them. You know, Tuesday is Mary's birthday, so they mean to have some young people, and cannot dispense with your company.'

'Do you think of going?' said Maude at last, having locked her writing-book.

'Yes, dear; even a short stay in the country may do you good, you have looked so pale lately. Don't you feel quite well? tell me.'

'Oh yes; there is not much the matter, only I am tired and have a headache. Indeed there is nothing at all the matter; besides, the country may work wonders.'

Half satisfied, half uneasy, Mrs. Foster asked a few more questions, to have them all answered in the same style: vain questions, put to one who, without telling lies, was determined not to tell the truth.

When once more alone, Maude resumed the occupation which her mother's entrance had interrupted. Her writing-book was neither com-monplace-book, album, scrap-book, nor diary; it was a compound of all these, and contained original compositions not intended for the public eye, pet extracts, extraordinary little sketches, and occasional tracts of journal. This choice collection she now proceeded to enrich with the following sonnet:

Yes, I too could face death and never shrink:
But it is harder to bear hated life;
To strive with hands and knees weary of strife;
To drag the heavy chain whose every link
Galls to the bone; to stand upon the brink
Of the deep grave, nor drowse, though it be rife
With sleep; to hold with steady hand the knife,
Nor strike home: this is courage, as I think.
Surely to suffer is more than to do:
To do is quickly done; to suffer is
Longer and fuller of heart-sicknesses;
Each day's experience testifies of this:
Good deeds are many, but good lives are few;
Thousands taste the full cup; who drains the lees?

having done which she yawned, leaned back in her chair, and wondered how she should fill the time till dinner.

Maude Foster was just fifteen. Small, though not positively short, she might easily be overlooked, but would not easily be forgotten. Her figure was slight and well-made, but appeared almost high-shouldered through a habitual shrugging stoop. Her features were regular and pleasing; as a child she had been very pretty, and might have continued so but for a fixed paleness, and an expression, not exactly of pain, but languid and preoccupied to a painful degree. Yet even now if at any time she became thoroughly aroused and interested, her sleepy eyes would light up with wonderful brilliancy, her cheeks glow with warm colour, her manner become animated, and

drawing herself up to her full height, she would look more beautiful than ever she did as a child. So Mrs. Foster said, and so unhappily Maude knew. She also knew that people thought her clever, and that her little copies of verses were handed about and admired. Touching these same verses, it was the amazement of every one what could make her poetry so broken-hearted, as was mostly the case. Some pronounced that she wrote very foolishly about things she could not possibly understand; some wondered if she really had any secret source of uneasiness; while some simply set her down as affected. Perhaps there was a degree of truth in all these opinions. But I have said enough: the following pages will enable my readers to form their own estimate of Maude's character. Meanwhile let me transport them to another sitting-room; but this time it will be in the country, with a delightful garden look-out. Mary Clifton was arranging her mother's special nosegay when that entered.

'Here, my dear, I will finish doing the flowers. It is time for you to go and meet your aunt and cousin; indeed, if you do not make haste, you will be late.'

'Thank you, mamma; the flowers are nearly done'; and Mary ran out of the room.

Before long she and her sister were hurrying beneath a burning sun towards the railway station. Through having delayed their start to the very last moment, neither had found time to lay hands on a parasol; but this was little heeded by two healthy girls, full of life and spirits, and longing moreover to spy out their friends. Mary wanted one day of fifteen; Agnes was almost a year older: both were well-grown and well-made, with fair hair, blue eyes, and fresh complexions. So far they were alike: what differences existed in other respects remains to be seen.

'How do you do, aunt? How do you do, Maude?' cried Mary, making a sudden dart forward as she discovered our friends, who, having left the station, had already made some progress along the dusty road. Then relinquishing her aunt to Agnes, she seized upon her cousin,

and was soon deep in the description of all the pleasures planned for the auspicious morrow.

'We are to do what we like in the morning: I mean, nothing particular is arranged; so I shall initiate you into all the mysteries of the place; all the cats, dogs, rabbits, pigeons, etc.; above all I must introduce you to a pig, a special protégé of mine: that is, if you are inclined, for you look wretchedly pale; aren't you well, dear?'

'Oh yes, quite well, and you must show me everything. But what are we to do afterwards?'

'Oh! afterwards we are to be intensely grand. All our young friends are coming and we are to play at round games (you were always clever at round games), and I expect to have great fun. Besides, I have stipulated for unlimited strawberries and cream; also, sundry tarts are in course of preparation. By the way, I count on your introducing some new games among us benighted rustics; you who come from dissipated London.'

'I fear I know nothing new, but will do my best. At any rate I can preside at your toilet and assist in making you irresistible.'

Mary coloured and laughed; then thought no more of the pretty speech, which sounded as if carefully prepared by her polite cousin. The two made a strong contrast: one was occupied by a thousand shifting thoughts of herself, her friends, her plans, what she must do, what she would do; the other, whatever might employ her tongue, and to a certain extent her mind, had always an undercurrent of thought intent upon herself.

Arrived at the house, greetings were duly and cordially performed; also an introduction to a new and very fat baby, who received Maude's advances with a howl of intense dismay. The first day of a visit is often no very lively affair; so perhaps all parties heard the clock announce bedtime without much regret.

2

The young people were assembled in Mary's room, deep in the mysteries of the toilet.

'Here is your wreath, Maude; you must wear it for my sake, and forgive a surreptitious sprig of

bay which I have introduced,' said Agnes, adjusting the last white rose, and looking affectionately at her sister and cousin.

Maude was arranging Mary's long fair hair with good-natured anxiety to display it to the utmost advantage.

'One more spray of fuchsia; I was always sure fuchsia would make a beautiful head-dress. There; now you are perfection: only look; look Agnes. Oh, I beg your pardon; thank you; my wreath is very nice, only I have not earned the bay.' Still she did not remove it; and when placed on her hair it well became the really intellectual character of her face. Her dress was entirely white; simple and elegant. Neither she nor Agnes would wear ornaments, but left them to Mary, in whose honour the entertainment was given, and who in all other respects was arrayed like her sister.

In the drawing-room Mary proceeded to set in order the presents received that morning; a handsomely bound Bible from her father, and a small prayer-book with cross and clasp from her mother; a bracelet of Maude's hair from her aunt; a cornelian heart from Agnes, and a pocket-bonbonnière from her cousin, besides pretty trifles from her little brothers. In the midst of arrangements and re-arrangements, the servant entered with a large bunch of lilies from the village school-children, and the announcement that Mr. and Mrs. Savage were just arrived with their six daughters.

Gradually the guests assembled, young and old, pretty and plain; all alike seemingly bent on enjoying themselves; some with gifts, and all with cordial greetings for Mary; for she was a general favourite. There was slim Rosanna Hunt, her scarf arranged with artful negligence to hide a slight protrusion of one shoulder; and sweet Magdalen Ellis habited as usual in quiet colours. Then came Jane and Alice Deverall, twins so much alike that few besides their parents knew them apart with any certainty; and their fair brother Alexis, who, had he been a girl, would have increased the confusion. There was little Ellen Potter, with a round rosy face like an apple, looking as natural

and good-humoured as if, instead of a grand French governess, she had had her own parents with her like most of the other children; and then came three rather haughty-looking Miss Stantons; and pale Hannah Lindley, the orphan; and Harriet Eyre, a thought too showy in her dress.

Mary, all life and spirits, hastened to introduce the new-comers to Maude; who, perfectly unembarrassed, bowed and uttered little speeches with the manner of a practised woman of the world; while the genuine, unobtrusive courtesy of Agnes did more towards making their guests comfortable than the eager good nature of her sister, or the correct breeding of her cousin.

At length the preliminaries were all accomplished, every one having found a seat, or being otherwise satisfactorily disposed of. The elders of the party were grouped here and there talking and looking on: the very small children were accommodated in an adjoining apartment with a gigantic Noah's ark: and the rest of the young people being at liberty to amuse themselves as fancy might prompt, a general appeal was made to Miss Foster for some game, novel, entertaining, and ingenious; or, as some of the more diffident hinted, easy.

'I really know nothing new,' said Maude: 'you must have played at Proverbs, What's my thought like? How do you like it? and Magic music:—or stay, there is one thing we can try:—bouts-rimés.'

'What?' asked Mary.

'Bouts-rimés: it is very easy. Some one gives rhymes, mamma can do that, and then every one fills them up as they think fit. A sonnet is the best form to select; but, if you wish, we could try eight, or even four lines.'

'But I am certain I could not make a couplet,' said Mary, laughing. 'Of course you would get on capitally, and Agnes might manage very well, and Magdalen can do anything; but it is quite beyond me: do pray think of something more suited to my capacity.'

'Indeed I have nothing else to propose. This is very much better than mere common games; but

if you will not try it, that ends the matter': and Maude leaned back in her chair.

'I hope'—began Mary; but Agnes interposed:

'Suppose some of us attempt bouts-rimés, and you meanwhile can settle what we shall do afterwards. Who is ready to test her poetical powers?—What, no one?—Oh, Magdalen, pray join Maude and me.'

This proposal met with universal approbation, and the three girls retreated to a side table; Mary, who supplied the rhymes, exacting a promise that only one sonnet should be composed. Before the next game was fixed upon, the three following productions were submitted for judgment to the discerning public. The first was by Agnes.

> Would that I were a turnip white,
> Or raven black,
> Or miserable hack
>   Dragging a cab from left to right;
>   Or would I were the showman of a sight,
> Or weary donkey with a laden back,
> Or racer in a sack,
>   Or freezing traveller on an Alpine height;
>   Or would I were straw-catching as I drown,
>   (A wretched landsman I, who cannot swim),
> Or watching a lone vessel sink,
> Rather than writing: I would change my pink
>   Gauze for a hideous yellow satin gown
>   With deep-cut scolloped edges and a rim.

'Indeed I had no idea of the sacrifice you were making,' observed Maude; 'you did it with such heroic equanimity. Might I, however, venture to hint that my sympathy with your sorrows would have been greater, had they been expressed in metre?'

'There's gratitude for you,' cried Agnes gaily: 'What have you to expect, Magdalen?' and she went on to read her friend's sonnet:

> I fancy the good fairies dressed in white,
> Glancing like moonbeams through the shadows black;
> Without much work to do for king or hack.
>   Training perhaps some twisted branch aright;
>   Or sweeping faded autumn leaves from sight,
> To foster embryo life; or binding back

> Stray tendrils; or in ample bean-pod sack
>   Bringing wild honey from the rocky height;
> Or fishing for a fly lest it should drown;
>   Or teaching water-lily heads to swim,
> Fearful that sudden rain might make them sink;
> Or dyeing the pale rose a warmer pink;
> Or wrapping lilies in their leafy gown,
>   Yet letting the white peep beyond the rim.—

'Well, Maude?'

'Well, Agnes; Miss Ellis is too kind to feel gratified at hearing that her verses make me tremble for my own: but such as they are, listen:

> Some ladies dress in muslin full and white,
> Some gentlemen in cloth succinct and black;
> Some patronise a dog-cart, some a hack,
>   Some think a painted clarence only right.
>   Youth is not always such a pleasing sight,
> Witness a man with tassels on his back;
> Or woman in a great-coat like a sack
>   Towering above her sex with horrid height.
>   If all the world were water fit to drown
> There are some whom you would not teach to swim,
> Rather enjoying if you saw them sink;
>   Certain old ladies dressed in girlish pink,
>   With roses and geraniums on their gowns:—
> Go to the Basin, poke them o'er the rim.

'What a very odd sonnet': said Mary after a slight pause: 'but surely men don't wear tassels.'

## Algernon Charles Swinburne
## From *Love's Cross-Currents: A Year's Letters* (1905)

### Chapter 25: Reginald Harewood to Edward Audley[1]

Lidcombe, Dec. 15th

...I found her yesterday by herself in the library ...She spoke to me with a sort of sad laugh in her

---

1. Swinburne uses the Pre-Raphælite ideal of beauty to represent the beloved in the following selections.

eyes, not smiling; and her brows winced, as they never do for him, whatever he says. She is so gentle and perfect when he is there; and I feel like getting mad. Well, somehow I let her see I knew what an infernal shame it was, and she said wives were meant for the work. Then I began and told her she had no sort of right to take it in that way, and she couldn't expect any fellow to stand and look on while such things were—and I would as soon have looked on at Haynau any day. I dare say I talked no end of folly, but I was regularly off my head. Unless she throws me over I will never give her up. She never will let her brother know how things are with her. But to see him sit by ought to be enough for a man with eyes and a heart. I know you were a good deal in love last year, but Miss Charnworth couldn't have put anybody into such a tender fever of pity as this one puts me; you can't be sorry for her; and I don't think you can absolutely worship anything you are not a little sorry for. To have to pity what is such a way above you, no one could stand that. It give one the wish to be hurt for her. I think I should let him insult me and strike me if she wanted it. Nothing hurts me now but the look of her. She has sweet heavy eyes, like an angel's in some great strange pain; eyes without fear or fault in them, which look out over coming tears that never come. There is a sort of look about her lips and under the eyelids as if some sorrow had pressed there with his finger, out of love for beauty, and left the mark. I believe she knew I wanted her to come away. If there were only somewhere to take her to and hide her, and let her live in her own way, out of all their sight and reach, that would do for me. I tell you, she took my hands sadly into hers and never said a word… She has a throat like pearl-colour, with flower-colour over that; and a smell of blossom and honey in her hair. No one on earth is so infinitely good a she is. Her fingers leave a taste of violets on the lips. She is greater in her mind and spirit than men with great names. Only she never lets her greatness of heart out in words. I don't think now that her eyes are hazel. She has in her the royal scornful secret of a great silence. Her hair

and eyelashes change colour in the sun. I shall never come to know all she thinks of. I believe she is doing good somewhere with her thoughts. She is a great angel, and has charge of souls. She has clear thick eyebrows that grow well down, coming full upon the upper lid, with no gap such as there is above some women's eyes before you come to the brow. They have an inexplicable beauty of meaning in them, and the shape of the arch of them looks tender. She has charge of me for one. I must have been a beast or a fool if there had not been such a face as that in the world. She has the texture and colour of rose-leaves crushed deep into the palms of her hands. She can forgive and understand and be angry at the right time: things that women never can do…

## Theodore Watts-Dunton
### From *The Coming of Love: Rhona Boswell's Story and Other Poems* (1897)

### *The Language of Love's Fragrancy*

These are the 'Coloured Caves' the sea-maid built;
Her walls are stained beyond that lonely fern,
For she must fly at every tide's return,
And all her sea-tints round the walls are spilt.
Outside behold the bay, each headland gilt
With morning's gold; far off the foam-wreaths burn
Like fiery snakes, while here the sweet waves yearn
On sand more soft than Avon's sacred silt.
And smell the sea! no breath of wood or field,
From lips of may or eglantine,
Comes with the language of a breath benign,
Shuts the dark room where glimmers Fate revealed,
Calms the vext spirit, balms a sorrow unhealed,
Like scent of seaweed rich of morn and brine.

## A Grave by the Sea

### 2

I stand like her who on the glittering Rhine
  Saw that strange swan which drew a faëry boat
  Where shone a knight whose radiant
    fore-head smote
Her soul with light and made her blue eyes shine
For many a day with sights that seemed divine,
  Till that false swan returned and arched his throat
  In pride, and called him, and she saw him float
Adown the stream: I stand like her and pine.

I stand like her, for she, and only she,
Might know my loneliness for want of thee.
  Light swam into her soul, she asked not whence,
Filled it with joy no clouds of life could smother.
  And then, departing like a vision thence,
Left her more lonely than the blind, my brother.

## The Octopus of the Golden Isles[1]

*'What! Will they even strike at me?'*

Round many an Isle of Song, in seas serene,
  With many a swimmer strove the poet-boy,
  Yet strove in love: their strength, I say, was joy
To him, my friend—dear friend of godlike mien!
But soon he felt beneath the billowy green
  A monster moving—moving to destroy:
  Limb after limb became the tortured toy
Of coils that clung and lips that stung unseen.
'And canst thou strike ev'n me?' the swimmer said,
  As rose above the waves the deadly eyes,
  Arms flecked with mouths that kissed in
    hellish wise,
Quivering with hate around a hateful head.—
  I saw him fight old Envy's sorceries:
  I saw him sink: the man I loved is dead!

---

1. The octopus, the swimmer and the attack are veiled allusions to Robert Buchanan, Dante Rossetti and Buchanan's attack on Rossetti's Poems in 'The Fleshly School of Poetry' (1871).

## From *Aylwin* (1898)

## Chapter 5[2]

Next morning, after I had finished my solitary breakfast, I asked the servant if Mr. D'Arcy had yet risen. On being told that he had not, I went downstairs into the studio where I had spent the previous evening. After examining the pictures on the walls and the easels, I walked to the window and looked out at the garden. It was large, and so neglected and untrimmed as to be a veritable wilderness. While I was marvelling why it should have been left in this state, I saw the eyes of some animal staring at me from the distance, and was soon astonished to see that they belonged to a little Indian bull. My curiosity induced me to go into the garden and look at the creature. He seemed rather threatening at first, but after a while allowed me to go up to him and stroke him. Then I left the Indian bull and explored this extraordinary domain. It was full of unkempt trees, including two fine mulberries, and surrounded by a very high wall. Soon I came across an object which, at first, seemed a little mass of black and white oats moving along, but I presently discovered it to be a hedgehog. It was so tame that it did not curl up as I approached it, but allowed me, though with some show of nervousness, to stroke its pretty little black snout. As I walked about the garden, I found it was populated with several kinds of animals such as are never seen except in menageries or in the Zoological Gardens. Wombats, kangaroos and the like, formed a kind of happy family.

My love of animals led me to linger in the garden. When I returned to the house I found D'Arcy in the green dining-room, where we talked, and he read aloud some verses to me. We then went to the studio. He said,

'No doubt you are surprised at my menagerie. Every man has one side of his character where the child remains. I have a love of

---

2. In this chapter Watts-Dunton portrays D.G. Rossetti and his ménagerie in Chelsea using the character of D'Arcy, or Haroun-al-Raschid.

animals which, I suppose, I may call a passion. The kind of amusement they can afford me is like none other. It is the self-consciousness of men and women that makes them, in a general way, intensely unamusing. I turn from them to the unconscious brutes, and often get a world of enjoyment. To watch a kitten or a puppy play, or the funny antics of a parrot or a cockatoo, or the wise movements of a wombat, will keep me for hours from being bored.'

'And children,' I said, 'do you like children?'

'Yes, so long as they remain like the young animals—until they become self-conscious, I mean, and that is very soon. Then their charm goes. Has it ever occurred to you how fascinating a beautiful young girl would be if she were as unconscious as a young animal? What makes you sigh?'

My thoughts had flown to Winifred breakfasting with her 'Prince of the Mist' on Snowdon. And I said to myself, 'How he would have been fascinated by a sight like that!'

My experience of men at that time was so slight that the opinion I then formed of D'Arcy as a talker was not of much account. But since then I have seen very much of men, and I find that I was right in the view I then took of his conversational powers. When his spirits were at their highest he was without an equal as a wit, without an equal as a humourist. He had more than even Cyril Aylwin's quickness of repartee, and it was of an incomparably rarer quality. To define it would be, of course, impossible, but I might perhaps call it poetic fancy suddenly stimulated at moments by animal spirits into rapid movements—so rapid, indeed, that what in slower movement would be merely fancy, in him became wit. Beneath the coruscations of this wit a rare and deep intellect was always perceptible.

His humour was also so fanciful that it seemed poetry at play, but here was the remarkable thing: although he was not unconscious of his other gifts, he did not seem to be in the least aware that he was a humourist of the first order; every jeu d'esprit seemed to leap

from him involuntarily, like the spray from a fountain. A dull man like myself must not attempt to reproduce these qualities here.

While he was talking he kept on painting, and I said to him, 'I can't understand how you can keep up a conversation while you are at work.'

I took care not to tell him that I was an amateur painter.

'It is only when the work that I am on is in some degree mechanical that I can talk while at work. These flowers, which were brought to me this morning for my use in painting this picture, will very soon wither, and I can put them into the picture without being disturbed by talk; but if I were at work upon this face, if I were putting dramatic expression into these eyes, I should have to be silent.'

He then went on talking upon art and poetry, letting fall at every moment gems of criticism that would have made the fortune of a critic.

After a while, however, he threw down the brush and said, 'Sometimes I can paint with another man in the studio; sometimes I can't.'

I rose to go.

'No, no,' he said; 'I don't want you to go, yet I don't like keeping you in this musty studio on such a morning. Suppose we take a stroll together.'

'But you never walk out in the daytime.'

'Not often; indeed, I may say never, unless it is to go to the Zoo, or to Jamrach's, which I do about once in three months.'

'Jamrach's!' I said. 'Why, he's the importer of animals, isn't he? Of all places in London that is the one I should most like to see.' He then took me into a long panelled room with bay windows looking over the Thames, finished with remarkable Chinese chairs and tables. And then we left the house.

In Maud Street a hansom passed us; D'Arcy hailed it.

'We will take this to the Bank,' said he, 'and then walk through the East End to Jamrach's. Jump in.'

As we drove off, the sun was shining brilliantly, and London seemed very animated—

seemed to be enjoying itself. Until we reached the Bank our drive was through all the most cheerful-looking and prosperous streets of London. It acted like a tonic on me, and for the first time since my trouble I felt really exhilarated. As to

D'Arcy, after we had left behind us what he called the 'stucco world' of the West End, his spirits seemed to rise every minute, and by the time we reached the Strand he was as boisterous as a boy on a holiday...

# REACTIONS

## Max Beerbohm
## From 'No. 2. The Pines' in *And Even Now* (1920)

On the day appointed 'I came as one whose feet half linger'. It is but a few steps from the railway-station in Putney High Street to No. 2. The Pines. I had expected a greater distance to the sanctuary—a walk in which to compose my mind and prepare myself for initiation. I laid my hand irresolutely against the gate of the bleak trim front-garden, I withdrew my hand, I went away. Out there were all the aspects of common modern life. In there was Swinburne. A butcher-boy went by, whistling. He was not going to see Swinburne. He could afford to whistle. I pursed my dilatory course up the slope of Putney, but at length it occurred to me that unpunctuality would after all be an imperfect expression of reverence, and I retraced my footsteps.

No. 2—prosaic inscription! But as that front-door closed behind me I had the instant sense of having slipped away from the harsh light of the ordinary and contemporary into the dimness of an odd, august past. Here, in this dark hall, the past was the present. Here loomed vivid and vital on the walls those women of Rossetti whom I had known but as shades. Familiar to me in small reproductions by photogravure, here they *themselves* were, life-sized, 'with curled-up lips and amorous hair' done in the original crayon, all of them intently looking down on me while I took off my overcoat—all wondering who was this intruder from posterity. That they hung in this hall, evidently no more than an overflow, was an earnest of packed plenitude within. The room I was ushered into was a back-room, a dining-room,

looking on to a good garden. It was, in form and 'fixtures', an inalienably Mid-Victorian room, and held its stolid own in the riot of Rossettis. Its proportions, its window-sash bisecting the view of garden, its folding doors (through which I heard the voice of Watts-Dunton booming mysteriously in the front room), its mantel-piece, its gas-brackets, all proclaimed that nothing ever would seduce them from their allegiance to Martin Tupper. 'Nor me from mine', said the sturdy cruet-stand on the long expanse of table-cloth. The voice of Watts-Dunton ceased suddenly, and a few moments later its owner appeared. He had been dictating, he explained. 'A great deal of work on hand just now—a great deal of work.'...
I remember that on my subsequent visits he was always, at the moment of my arrival, dictating, and always greeted me with that phrase, 'A great deal of work on hand just now'. I used to wonder what work it was, for he published little enough. But I never ventured to inquire, and indeed rather cherished the mystery: it was a part of the dear little old man; it went with the something gnome-like about his swarthiness and chubbiness—went with the shaggy hair that fell over the collar of his eternally crumpled frock-coat, the shaggy eye-brows that overhung his bright little brown eyes, the shaggy moustache that hid his small round chin. It was the mystery inherent in the richly-laden atmosphere of The Pines...
While I stood talking to Watts-Dunton—talking as loudly as he, for he was very deaf—I enjoyed the thrill of suspense in watching the door through which would appear—Swinburne. I asked after Mr. Swinburne's health. Watts-Dunton said it was very good: 'He always goes out for his long walk in the morning—wonderfully active. Active in

'Rossetti in his Back Garden' by Max Beerbohm (1904).
The figures are identified in Beerbohm's *The Poets Corner* (1904) — 'Background from left to right: Swinburne, Theodore Watts, Meredith, Hall Caine. In front of the wall on the left: Whistler. With the kangaroo: Burne-Jones. Upright and reciting: William Morris. On the right: Holman Hunt, and in front of him, in profile: Ruskin. In the foreground: Rossetti. The lady is no one in particular, just a vague synthesis. [The various animals—the turtle, the pelican, the snake and the kangaroo—remind us of Rossetti's obsession with exotic animals which he kept at Tudor House.]

'The Introduction' by Max Beerbohm, depicting Dante Rossetti introducing Fanny Cornforth
to John Ruskin, in *Rossetti and his Circle* (1922)

mind, too. But I'm afraid you won't be able to get into touch with him. He's almost stone deaf, poor fellow—almost stone-deaf now.' He changed the subject, and I felt I must be careful not to seem interested in Swinburne exclusively. I spoke of 'Aylwin'. The parlour maid brought in the hot dishes. The great moment was at hand.

Nor was I disappointed. Swinburne's entry was for me a great moment. Here, suddenly visible in the flesh, was the legendary being and divine singer. Here he was, shutting the door behind him as might anybody else, and advancing—a strange small figure in grey, having an air at once noble and roguish, proud and skittish. My name was roared to him. In shaking his hand, I bowed low, of course—a bow *de cœur*; and he, in the old aristocratic manner, bowed equally low, but with such swiftness that we narrowly escaped concussion. You do not usually associate a man of genius, when you see one, with any social class; and, Swinburne being of an aspect so unrelated as it was to any species of human kind, I wondered the more that almost the first impression he made on me, or would make on any one, was that of very great gentleman indeed. Not of an *old* gentleman, either. Sparse and straggling though the grey hair was that fringed the immense pale dome of his head, and venerably haloed though he was for me by his greatness, there was yet about him something—boyish? girlish? childish, rather; something of a beautifully well-bred child. But he had the eyes of a god, and the smile of an elf. In figure, at first glance, he seemed almost fat; but this was merely because of the way he carried himself, with his long neck strained so tightly back that he all receded from the waist upwards. I noticed afterwards that this deportment made the back of his jacket hang quite far away from his legs; and so small and sloping were his shoulders that the jacket seemed ever so likely to slip right off. I became aware, too, that when he bowed he did not unbend his back, but only his neck—the length of the neck accounted for the depth of the bow. His hands were tiny, even for his size, and they fluttered helplessly, touchingly, unceasingly.

Directly after my introduction, we sat down to the meal. Of course I had never hoped to 'get into touch with him' reciprocally. Quite apart from his deafness, I was too modest to suppose he could be interested in anything I might say. But— for I knew he had once been as high and copious a singer in talk as in verse—I had hoped to hear utterances from him. And it did not seem that my hope was to be fulfilled. Watts-Dunton sat at the head of the table, with a huge and very Tupperesque joint of roast mutton in front of him, Swinburne and myself close up to him on either side. He talked only to me. This was the more tantalising because Swinburne seemed as though he were bubbling over with all sorts of notions. Not that he looked at either of us. He smiled only to himself, and to his plateful of meat, and to the small bottle of Bass's pale ale that stood before him—ultimate allowance of one who had erst clashed cymbals in Naxos. This small bottle he eyed often and with enthusiasm, seeming to waver between the rapture of broaching it now and the grandeur of having it to look forward to. It made me unhappy to see what trouble he had in managing his knife and fork. Watts-Dunton told me on another occasion that this infirmity of the hands had been lifelong—had begun before Eton days. The Swinburne family had been alarmed by it and had consulted a specialist, who said that it resulted from 'an excess of electric vitality', and that any attempt to stop it would be harmful. So they had let it be. I have known no man of genius who had not to pay, in some affliction or defect either physical or spiritual, for what the gods had given him. Here, in this fluttering of his tiny hands, was a part of the price that Swinburne had to pay. No doubt he had grown accustomed to it many lustres before I met him, and I need not have felt at all unhappy at what I tried not to see. He, evidently, was quite gay, in his silence—and in the world that was for him silent. I had, however, the maddening suspicion that he would have liked to talk. Why wouldn't Watts-Dunton roar him an opportunity? I felt I had been right perhaps in feeling that the lesser man was—no, not jealous of

the greater whom he had guarded so long and with such love, but anxious that he himself should be as fully impressive to visitors as his fine gifts warranted. Not, indeed, that he monopolised the talk. He seemed to regard me as a source of information about all the latest 'movements', and I had to shout banalities while he munched his mutton—banalities whose one saving grace for me was that they were inaudible to Swinburne. Had I met Swinburne's gaze, I should have faltered. Now and again his shining light-grey eyes roved from the table, darting this way and that—across the room, up at the ceiling, out of the window; only never at us. Somehow this aloofness gave no hint of indifference. It seemed to be, rather, a point of good manners—the good manners of a child 'sitting up to table', not 'staring', not 'asking questions', and reflecting great credit on its invaluable old nurse. The child sat happy in the wealth of its inner life; the child was content not to speak until it were spoken to; but, but, I felt it did want to be spoken to. And, at length, it was.

So soon as the mutton had been replaced by the apple-pie, Watts-Dunton leaned forward and 'Well, Algernon,' he roared, 'how was it on the heath to-day?' Swinburne, who had meekly inclined his ear to the question, now threw back his head uttering a sound that was like the cooing of a dove, and forthwith, rapidly, ever so musically, he spoke to us of his walk; spoke not in the strain of man who had been taking his daily exercise on Putney heath, but rather in that of a Peri who had at long last been suffered to pass through Paradise. And rather than that he spoke would I say that he cooingly and flutingly sang of his experience. The wonders of this morning's wind and sun and clouds were expressed in a flow of words so right and sentences so perfectly balanced that they would have seemed pedantic had they not been clearly as spontaneous and the wordless notes of a bird in song. The frail, sweet voice rose and fell, lingered, quickened, in all manner of trills and roulades. That he himself could not hear it, seemed to me the greatest loss his deafness inflicted on him. One would have expected this

disability to mar the music; but it didn't; save that now and again a note would come out metallic and over-shrill, the tones were under good control. The whole manner and method had certainly a strong element of oddness; but no one incapable of condemning as unmanly the song of a lark would have called it affected. I had met young men of whose enunciation Swinburne's now reminded me. In them the thing had always irritated me very much; and I now became sure that it had been derived from people who had derived it in old Balliol days from Swinburne himself. One of the points familiar to me in such enunciation was the habit of stressing extremely, and lackadaisically dwelling on, some particular syllable. In Swinburne this trick was delightful— because it wasn't a trick, but a need of his heart. Well do I remember his ecstasy of emphasis and immensity of pause when he described how he had seen in a perambulator on the Heath to-day 'the most BEAUT—iful babbie ever beheld by mortal eyes'. For babies, as some of his later volumes testify, he had a sort of idolatry. After Mazzini had followed Landor to Elysium, and Victor Hugo had followed Mazzini, babies were what among live creatures most evoked Swinburne's genius for self-abasement. His rapture about this especial 'babbie' was such as to shake within me my hitherto firm conviction that, whereas the young of the brute creation are already beautiful at the age of five minutes, the human young never begin to be so before the age of three years. I suspect Watts-Dunton of having shared my lack of innate enthusiasm. But it was one of Swinburne's charms, as I was to find, that he took for granted every one's delight in what he himself so fervidly delighted in...

And now, clearlier still, as I write in these after-years, do I see that dining-room of The Pines; the long white stretch of table-cloth, with Swinburne and Watts-Dunton and another at the extreme end of it; Watts-Dunton between us, very low down over his plate, very cosy and hirsute, and rather like the dormouse at that long tea-table which Alice found in Wonderland. I see myself

sitting there wide-eyed, as Alice sat. And, had the hare been a great poet, and the hatter a great gentleman, and neither of them mad but each only very odd and vivacious, I might see Swinburne as a glorified blend of those two.

When the meal was ended—for, alas! it was not, like that meal in Wonderland, unending—Swinburne would dart round the table, proffer his hand to me, bow deeply, bow to Watts-Dunton also, and disappear. 'He always walks in the morning, writes in the afternoon, and reads in the evening', Watts-Dunton would say with a touch of tutorial pride in this regimen.

That parting bow of Swinburne to his old friend was characteristic of his whole relation to him. Cronies though they were, these two, knit together with bonds innumerable, the greater man was always *aux petits soins* for the lesser, treating him as a newly-arrived young guest might treat an

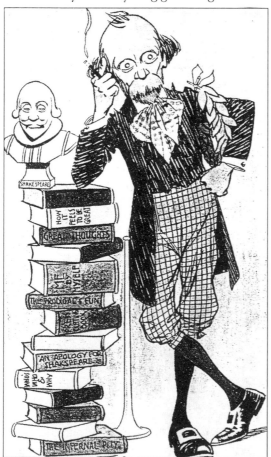

''Tween Inspirations' caricature of Hall Caine by Thorpe

elderly host. Some twenty years had passed since that night when, ailing and broken—thought to be nearly dying, Watts-Dunton told me—Swinburne was brought in a four-wheeler to The Pines. Regular private nursing-homes either did not exist in those days or were less in vogue than they are now. The Pines was to be a sort of private nursing-home for Swinburne. It was a good one. He recovered. He was most grateful to his friend and savior. He made as though to depart, was persuaded to stay a little longer, and then a little longer than that. But I rather fancy that, to the last, he never did, in the fullness of his modesty and good manners, consent to regard his presence as a matter of course, or as anything but a terminable intrusion and obligation. His bow seemed always to convey that.

Swinburne having gone from the room, in would come the parlour maid. The table was cleared, the fire was stirred, two leather arm-chairs were pushed up the hearth. Watts-Dunton wanted gossip of the present. I wanted gossip of the great past. We settled down for a long, comfortable afternoon together…

### Algernon Charles Swinburne
**'W.B. Scott's Autobiographical Notes' in *The Academy* (24 December 1892)[1]**

In the Book of the Prophet Blake, and in the chapter entitled Auguries of Innocence, will be found these words:

> The poison of the snake and the newt
> Is the sweat of envy's foot:
> The poison of the honey-bee
> Is the artist's jealousy.

1. Swinburne's infamous (over)reaction to Scott's *Autobiographical Notes* is the last in a series of letters sent to *The Academy* during December 1892. First, William Sharp had written an unflattering review of the book. Then, W. Minto, the publisher of the book, gleefully felt obliged to respond and defend poor, now dead, Scott and the innocence of his intent to share his memories of the Pre-Raphælites. By Christmas Eve, both William Michael Rossetti and Swinburne themselves wrote to *The Academy*, the tone of the former gently admonishing, the tone of the latter absolutely irate.

It is not this latter poison which exudes from the reopened grave of 'a painter who could not paint'. A humble but early commentator on the sacred text in the first year or so of its ever-blessed revelation may perhaps be permitted to append the following additional couple—apocryphal in the canonical sense, deniable or disputable in none.

> The poison of the parasite
> Is the steam of sewers at night.

[*Complaining of a letter* (*Academy*, December 10) *by W. Minto, Swinburne continues*]...It is impossible that even the reptile rancour, the omnivorous malignity, of Iago himself could have dreamed of trying to cast a slur on the memory of that incomparable lady whose maiden name was Siddal and whose married name was Rossetti. To one at least who knew her better than most of her husband's friends the memory of all her marvellous charms of mind and person—her matchless grace, loveliness, courage, endurance, wit, humour, heroism, and sweetness—is too dear and sacred to be profaned by any attempt at expression. The vilest of the vile could not have dreamed of trying 'to cast a slur on her memory'.

For one thing she did they would not take the life of Sycorax: for one thing apiece they have written I will not bear more heavily than I can help on the writer and the editor of William Bell Scott. I am content to overlook the rather serious provocations and offences of Mr. Minto in consideration of the exquisite drollery, the farcical gravity of his high-toned and pathetic protest against my 'gross and unmeasured' vituperation of 'a dead man' whose posthumous calumnies absolutely seethe and reek with equal and impartial impertinence towards the dead superiors who had preceded and the living superiors who survive him. And towards the worthy Scotus himself I cannot bring myself to feel the due austerity of scorn deserved by such thankless and rancorous conceit, when I read his estimate of his obligation to the eminent artist whose generous kindness condescended to illustrate the text

supplied by him, and the register of his apparent opinion that he was neither poetically nor socially (God save the mark!) inferior to any one of the three persons to whom the volume thus beautified by a better man's genius was inscribed. When we hear a man gratuitously bragging about his social position, we may not feel inclined to exclaim with Charles Lamb, 'Do let me feel that gentleman's humps'; but we must naturally feel disposed to say, 'Do let us look at that gentleman's quarterings'. The House of Malagrowther, for aught I know, may be able to show quarterings with princes—that is a matter for the College of Heralds to decide—but until Garter King-at-Arms has spoken we may surely be permitted to doubt whether a Mac-Malagrowther, by right of the appropriate bar sinister in his shield, can claim precedence as a descendant of Crusaders.

Such revelations of character as abound throughout these two repulsive and amusing volumes are from one point of view as significant as they are insignificant from every other. This sinister old satellite of more or less notable or memorable contemporaries is undoubtedly unworthy of any further commemoration than may be conferred by an epitaph of which I freely make a present to his executors:

> Here lies no envious man! restrain surprise;
> For in this grave incarnate Envy lies.

And, indeed, for my own part, in the teeth of this detestable autobiography, I am fain to believe that his better moods, however transient and untrustworthy, were genuinely cordial and loyal while they lasted. I have had letters from him which I can hardly realise as having been written by the hand which laid bare the nakedness of a soul so mean in its malignity and so graceless in its egotism. But after all it is of no particular importance whether a little more or a little less than justice be done by the few who may remember him to the memory of a far from memorable man. A much more serious question is this: whether it is or is not to be tolerated that the name of any private gentleman who may ever have

had any acquaintance with a secret scribbler or forger of such reminiscences as might be penned from memory in the pantry by an eavesdropping footman should be dragged into such unenviable publicity as must associate it with the name of so discreditable and disagreeable a parasite. I may be told that I have not much to complain of; but I make no personal complaint. I simply desire to enter my protest, futile and fruitless as it may be, against the public violation of privacy and the public prostitution of confidence. Whether this offence be committed by a liar or by a truth-teller, the offence against honour, against courtesy, and against society is the same.

### 'Tantæne Animus Cælestibus Iræ' in the *Pall Mall Gazette* (6 December 1892)[1]

Hearken, gods and little fishes! Here's terrible to-do,
Very wroth is poet Swinburne, and articulately too!
Halting lips will fashion verses when just anger overflows,
But a righteous indignation drives our poet into prose.
For it seems there lived a Scotchman—whom we used to meet at times,
Condescending to his grey hairs, any, coquetted within rhymes,
One whose daubs and driveling doggeral long were dead on dusty shelves
But for parasite acquaintance with such great ones as ourselves;
Would you know the crime that damns him, this most desperate of Scots,
Whose malevolence of slander the *de mortuis* out blots?
He, forsooth,—but language falters at the senile insolence,
At the vitriol and the venom of his posthumous offence—
He, on whose obscure horizon we first dawned an undergrad,
Dared to mount us on a pony, write us down a schoolboy lad!
Dared inanely—but in pity, not in anger, be it spoke—
Very Scot of very Scotchmen, to misunderstand our joke!
Dared, and daring dared record it, to his evermore disgrace,
Dared to criticise our Turner to our very Ruskin's face!
Therefore, though we hymned his friendship while he lived a man with men,
Being dead, we know his stature and we take that back again;
Therefore on our old acquaintance, on the 'giver kingly-souled,'
Be the floods of just invective hyperbolically rolled!
Lest a morbid taste should pasture on such slanderous untruth,
Deem our Pegasus a pony and misread our wondrous youth.
Perish Scott as perished Whitman! We were young who sang their praise,
But we branded Walt with 'muck-rake' in our wiser elder days.—
Thus the wrath of poet Swinburne, beating winds and smiting sands,
While the old man sleeps in silence, and the Muses wring their hands.

1. This anonymously written poem publicly ridiculed Swinburne's overwrought reaction to Scott's *Autobiographical Notes*.

## Lily Hall Caine
### 'A Child's Reminiscences of Rossetti' in *The New Review* (September 1894)

Mr. William Michael Rossetti had suggested that a picture of his brother as viewed by a child would be of great interest. Hall Caine and Rossetti had lived together in a house in Fisher Place, near the 'The Haunted Castle' Rock, in St. John's-in-the-Vale, halfway between Grasmere and Keswick.

Lily made her first visit to London in January 1882. She arrived at Euston, bewildered and amazed at the bustle and excitement of the station.

The house at 16 Cheyne Walk seemed big and heavy and dull. The hall was spacious but dark and forbidding. It had a floor of white and black marble and the whole house had an air of departed grandeur and general neglect. The breakfast room to the left had been taken over as a studio by Hall Caine. The walls were lined with pictures, most of them early works by Rossetti. The corridor was so dark that Lily collided frequently with old oak chairs and cabinets.

In the drawing-room an enormous candelabra suspended from the ceiling was supposed to have been the property of Garrick. The silver was badly tarnished on the candlesticks in the room.

In the breakfast room were several family portraits, one of Christina Rossetti as a child and one of Rossetti's mother painted by himself. Lily had never seen such massive carvings on furniture. The shelves were packed with books.

Over the mantelpiece hung a study of Dante's Beatrice. In the dim light the girl saw a headless woman which had frightened her, as did the black glove on Rossetti's left hand, which was half paralysed and always very cold. Rossetti could not or pretended not to hear when she said her name and had to repeat it several times.

Nurse Abery took charge of her, a kind, good soul.

There was a ghost in the house, a woman who appeared at the top of the second flight of stairs. She retreated to the room overlooking the Embankment. The servants saw her but not Mr. Rossetti but he took it seriously. Hall Caine offered to sleep in the haunted room ('very *un*characteristically') and even to go to bed without a candle, but Lily could not remember if he actually did.

'I had never met a man so full of ideas interesting and attractive to a child. Indeed, now that I look back on it, I feel that Mr. Rossetti was wonderously sweet, tender and even playful with a child…'

At the station Rossetti got nervous and irritated by the turmoil of the busy station and wanted to go back to the quietness of Cheyne Walk and Hall Caine had to use persuasion to get him to mount and take his seat.

At West Cliff Bungalow (now called Rossetti Bungalow) Mr. Rossetti stooped down and whispered in Lily's ear so that Hall Caine would not hear: 'Lily, I don't think this looks like a house. Do you? It's more like another L.C. and D.R. station.' (A joke that Rossetti had made on the train to Lily, indicating the entwined initials of the railways line—London District Railways Company?—saying it was their very own train with their initials.)

The bungalow was very cosy but Rossetti was fretting and wanted home. After dinner he said: 'We must really go back tomorrow, Caine.' But Hall Caine advised him to stay and try the air for at least a week and if still of the same mind they would return, and that seemed to satisfy Rossetti.

Rossetti worked on a painting called 'Joan of Arc kissing the sword'. He did not work much but read a great deal. While at Birchington he eagerly read Miss Braddon's *Dead Men's Shoes*. He had a voracious appetite for oysters. He also like macaroni soup. He drank claret with his dinner but never anything during the day.

One evening Rossetti recited part of Edgar Allan Poe's Raven to Lily and her imagination was stirred by the deep, rich voice. 'The "Nevermore" was so deep and strong that the voice seemed to my childish fancy to come from under the floor. The dramatic vigour he could command was such

as I can never forget.'

One evening when Lily was reading *The Arabian Nights* Rossetti told her to put the book down and he would tell her some of the stories. He sat with his legs crossed, shaking one foot faster than anybody Lily had seen. He also used to crack his thumbnail with his first finger.

Lily grew fond of Christina Rossetti and when adult she and Christina became friends. On the eve of Lily's departure from Birchington Christina gave her a little desk in present, writing her own and Lily's name on the inside lid. Lily still has the desk, much cherished.

## Frederick William Henry Myers
### From 'Rossetti and the Religion of Beauty' in *Essays Modern* (1897)[1]

...For Beauty, as Plato has told us, is all the divine ideas at once most manifest and most loveable to men. When 'Justice and Wisdom and all other things that are held in honour of souls' are hidden from the worshipper's gaze, as finding no avenue of sense by which to reach him through the veil of flesh, Beauty has still some passage an entrance from mortal eyes to eyes, 'And he that gazed so earnestly what things in that holy place were to be seen, he when he discerns on earth some godlike countenance or fashion of body, that counterfeits Beauty well, first of all he trembles, and there comes over him something of fear which erst he knew; but then, looking on that earthly beauty, he worships it as divine, and if he did not fear the reproach of utter madness he would sacrifice to his heart's idol as to the image and presence of a god.'

1. I have chosen to include Myers' essay with these other selections for 'The 1890s and after' even though it was first published in 1883, the year after Dante Rossetti's death, and served as a voice for the Victorian public and scholarly approval of Rossetti's pictures exhibited at Burlington House that same year. Myers' essay went on to be republished again, however, in his collection *Essays Modern* in 1897 and then again in 1908, and 'Rossetti and the Religion of Beauty' can indeed stand as a reflective and academic posture against the general tenor of the decade's decline and the aping parodies of this last phase of the Pre-Raphælite movement.

This is that Lady Beauty, in whose praise
  Thy voice and hand shake still—long known to thee
    By flying hair and fluttering hem—the beat
    Following her daily of thy heart and feet,
  How passionately and irretrievably,
In what fond flight, how many ways and days!

There are some few hearts, no doubt, in which 'sky and sea' and the face of Nature are able to inspire this yearning passion. But with this newer school—with Rossetti especially—we feel at once that Nature is no more than an accessory. The most direct appeals, the most penetrating reminiscences, come to the worshipper of Beauty from a woman's eyes. The steady rise in the status of women; that constant deepening and complication of the commerce between the sexes which is one of the signs of progressive civilisation; all this is perpetually teaching and preaching (if I may say so) the charms of womanhood to all sections of the community. What a difference in this respect has the century since Turner's birth made in England! If another Turner were born now—an eye which gazed, as it were, on a new-created planet from the very bedchamber and outgoing of the sun—can we suppose that such an eye would still find its most attractive feminine type in the bumboats of Wapping? The anomaly, strange enough in Turner's day, is now inconceivable. Our present danger lies in just the opposite direction. We are in danger of losing that direct and straight-forward outlook on human loveliness (of which Mr. Millais may serve as a modern example) which notes and represents the object with a frank enjoyment, and seeks for no further insight into the secret of its charm. All the arts, in fact, are returning now the spirit of Leonardo, to the sense that of all visible objects known to us the human face and form are the complex and mysterious, to the desire to extract the utmost secret, the occult message, from all the phenomena of Life and Being.

Now there is at any rate one obvious explanation of the sense of mystery which attaches to the female form. We may interpret it all as in some way a transformation of the sexual passion. This essentially materialistic view is surrounded

with a kind of glamour by such writes as Gautier and Baudelaire. The tone of sentiment thus generated is repugnant—is sometimes even nauseating—to English feeling; but this tone of sentiment is certainly not Rossetti's. There is no trace in him of this deliberate worship of Baal and Ashtoreth; no touch of the cruelty which is the characteristic note of natures in which the sexual instincts have become haunting and dominant.

It is, indeed, at the opposite end of the scale—among those who meet the mysterious of love and womanhood with a very different interpretation—that Rossetti's nearest affinities are to be found. It must not be forgotten that one of his most exquisite literary achievements consists in a translation of the *Vita Nuova* of Dante. Now, the *Vita Nuova*, to the vulgar reader a childish or meaningless tale, is to those who rightly apprehend it the very gospel and charter of mystical passion. When the child Dante trembles at the first sight of the child Beatrice; when the voice within him cries *Ecce deus fortior me, qui veniens dominabitur mihi*; when that majestic spirit passes, at a look of the beloved one, through all the upward or downward trajectory between heaven and hell; this, indeed, is a love which appertains to the category of reasoned affections no more; its place is with the visions of saints, the intuitions of philosophers, in Plato's ideal world. It is recognised as a secret which none can hope to fathom till we can discern from some mount of unearthly vision what those eternal things were indeed to which somewhat in human nature blindly perceived itself akin.

The parallel between Rossetti and Dante must not be pushed too far. Rossetti is but as a Dante still in the *selva oscura*; he has not sounded hell so profoundly, nor mounted into heaven so high. He is not a prophet but an artist; yet an artist who, both by the very intensity of his artistic vision, and by some inborn bent towards symbol and mysticism, stands on the side of those who see in material things a spiritual significance, and utters words of universal meaning from the fullness of his own heart. Yet he is, it must be

repeated, neither prophet, philosopher, nor saint. The basis of his love is the normal emotion—'the delight in beauty alloyed with appetite, and strengthened by the alloy;'—and although that love has indeed learned, in George Eliot's words, to 'acknowledge an effect from the imagined light of unproven firmaments, and have its scale set to the grander orbit of what hath been and shall be', this transfiguration is effected not so much by any elevation of ethical feeling, as by the mere might and potency of an ardent spirit which projects itself with passionate intensity among things unreachable and unknown. To him his beloved one seems not as herself alone, 'but as the meaning of all things that are'; her voice recalls a prenatal memory, and her eyes 'dream against a distant goal'. We hear little of the intellectual aspects of passion, of the subtle interaction of one character on another, of the modes in which Love possesses himself of the eager or the reluctant heart. In these poems the lovers have lost their idiosyncrasies; they are made at once for ever; the two streams have mingled only to become conscious that they are being drawn together into a boundless sea. Nay, the very passion which serves to unite them, and which is sometimes dwelt on with an Italian emphasis of sensuousness which our English reserve condemns, tends oftener to merge itself in the mystic companionship which holds the two souls together in their enchanted land.

One flame-winged brought a white-winged harp-player
  Even where my lady and I lay all alone;
    Saying: 'Behold, this minstrel is unknown;
Bid him depart, for I am minstrel here;
Only my strains are to Love's dear ones dear.'
    Then said I: 'Through thine haut-boy's rapturous tone
    Unto my lady still this harp makes moan,
And still she deems the cadence deep and clear.'

Then said my lady: 'Thou art Passion of Love,
  And this Love's Worship; both he plights to me
    Thy mastering music walks the sunlit sea;
But where wan water trembles in the grove,
And the wan moon is all the light thereof,
    This harp still makes my name its Voluntary.'

The voluntaries of the white-winged harp-player do not linger long among the accidents of earth; they link with the beloved name all 'the soul's sphere of infinite images', all that she finds of benign or wondrous 'amid the bitterness of things occult'. And as the lover moved amid these mysteries it appears to him that Love is the key which may unlock them all. For the need is not so much of an intellectual insight as of an elevation of the whole being—a rarefaction, as it were, of man's spirit which Love's pure fire effects, and which enables it to penetrate more deeply into the ideal world…

And thus it is that so much of Rossetti's art, in speech or colour, spends itself in the effort to communicate the incommunicable. It is toward 'the vale of magical dark mysteries' that those grave low-hanging brows are bent, and 'vanished hours and hours eventual' brood in the remorseful gaze of Pandora, the yearning gaze of Proserpine. The pictures that perplex us with their obvious incompleteness, their new and haunting beauty, are not the mere caprices of a richly-dowered but wandering spirit. Rather they may be called (and none the less so for their shortcomings) the sacred pictures of a new religion; forms and faces which bear the same relation to that mystical worship of Beauty on which we have dwelt so long, as the forms and faces of a Francia or a Leonardo bear to the mediæval mysteries of the worship of Mary or of Christ. And here it is that in Rossetti's pictures we find ourselves in the midst of a novel symbolism—a symbolism genuine and deeply felt as that of the fifteenth century, and using once more birds and flowers and stars, colours and lights of the evening or the dawn, to tell of beauties impalpable, spaces unfathomed, the setting and resurrection of no measurable or earthly day.

It is chiefly in a series of women's faces that these ideas seek expression. All these have something in common, some union of strange and puissant physical loveliness with depth and remoteness of gaze. They range from demon to angel—as such names may be interpreted in a

Religion of Beauty—from Lilith, whose beauty is destruction, and Astarte, throned between the Sun and Moon in her sinister splendour, to the *Blessed Damozel* and the 'maiden pre-elect', type of the love whose look regenerates and whose assumption lifts to heaven. But all have the look—characteristic of Rossetti's faces as the mystic smile of Leonardo's—the look which bids the spectator murmur—

> What netherworld gulf-whispers doth she hear,
> In answering echoes from what planisphere,
>     Along the wind, along the estuary?

And since these primal impulses, at any rate, will remain to mankind, since Love's pathway will be retrodden by many a generation, and all of faith or knowledge to which that pathway leads will endure, it is no small part of the poet's function to show in how great a measure Love does actually pre-suppose and consist of this exaltation of the mystic element in man; and how the sense of unearthly destinies may give dignity to Love's invasion, and steadfastness to his continuance, and surround his vanishing with the mingled ecstasy of anguish and of hope…

Art and Religion, which no compression could amalgamate, may by Love be expanded and interfused; and thus the poet may not err so wholly who seeks in a woman's eyes 'the meaning of all things that are'; and 'the soul's sphere of infinite images' may be a mere prismatic fringe to reality, but rather those images may be as dark rays made visible by passing through the medium of a mind which is fitted to refract and reflect them.

A faint, a fitful reflex! Whether it be from light of sun or of moon, *sole repercussum aut radiantis imagine lunæ,*—the glimmer of a vivifying or of a phantom day—may scarcely be for us to know. But never yet has the universe been proved smaller than the conceptions of man, whose farthest, deepest speculation has only found *within* him yet profounder abysses,—*without*, a more unfathomable heaven.

## Arthur Clement Hilton
### 'Octopus—A New View of Swinburne's *Dolores*' in *The Works of Arthur Clement Hilton* (1904)

Strange beauty, eight-limbed and eight-handed,
 Whence camest to dazzle our eyes?
With thy bosom bespangled and banded
 With the hues of the seas and the skies;
Is thy home European or Asian,
 O mystical monster marine?
Part molluscous and party crustacean,
 Betwixt and between.

Wast thou born to the song of sea trumpets?
 Hast thou eaten and drunk to excess
Of the sponges—thy muffins and crumpets,
 Of the seaweeds—thy mustard and cress?
Wast thou nurtured in caverns of coral,
 Remote from reproof or restraint?
Art thou innocent, art thou immortal,
 Sinburnian or Saint?

Lithe limbs, curling free, as a creeper
 That creeps in a desolate place,
To enrol and envelop the sleeper
 In a silent and stealthy embrace;
Cruel beak craning forward to bite us,
 Our juices to drain and to drink,
Or to whelm us in waves of Cocytus,
 Indelible ink!

Oh breast, that 'twere rapture to writhe on!
 Oh arms 'twere delicious to feel
Clinging close with the crush of the Python,
 When she maketh her murderous meal!
In thy eight-fold embraces enfolden,
 Let our empty existence escape;
Give us death that is glorious and golden,
 Crushed all out of shape!

Ah thy red lips, lascivious and luscious,
 With death in their amorous kiss!
Cling round us, and clasp us, and crush us,
 With bitings of agonized bliss;

We are sick with the poison of pleasure,
 Dispense us the potion of pain;
Ope thy mouth to its uttermost measure,
 And bite us again!

     Written at the Crystal Palace Aquarium.

## Robert Ross
### From 'Pietistic Ejaculations—A Late Word on Holman Hunt' in *Masques and Phases* (1909)

For the essence of beauty there is nothing of Mr. Holman Hunt's to compare with Rossetti's 'Beloved' or the 'Blue Bower'; and you could name twenty of the poet's water-colours which, for design, invention, devious symbolism, and religious impulse, surpass the finest of Mr. Hunt's most elaborate works. Even in the painter's own special field—the symbolised illustration of Holy Writ—he is overwhelmed by Millais with the superb 'Carpenter's Shop'... In Mr. Holman Hunt we lost another Archdeacon Farrar. Then, in the sublimation of uglitude, Madox-Brown, stepfather of the Pre-Raphælites (my information is derived from a P.R.B. aunt), was an infinitely greater conjurer. Look at the radiant painting of 'Washing of the Feet' in the Tate Gallery; is there anything to equal that masterpiece from the brush of Mr. Holman Hunt? The 'Hireling Shepherd' comes nearest, but the preacher, following his own sheep, has strayed into alien corn, and on the cliffs from which is ebbing a tide of nonconformist conscience. Like his own hireling shepherd, too, he has mistaken a phenomenon of nature for a sermon.

 One of the great little pictures, 'Claudio and Isabella', proves, however, that once he determined to be a painter. In the 'Lady of Shalott' he showed himself a designer with unusual powers akin to those of William Blake. Still, examined at a distance or close at hand, among his canvases do we find a single piece of decoration or a picture in the ordinary sense of the word? My definition of a

religious picture is a painted object in two dimensions destined or suitable for the decoration of an altar or other site in a church, or room devoted to religious purposes; if it fails to satisfy the required conditions, it fails as a work of art. Where is the work of this so-called religious painter which would satisfy the not exacting conditions of a nonconformist or Anglican place of worship? You are not surprised to learn that Keble College mistook the 'Light of the World' for a paten fuel, or that the background of the 'Innocents' was painted in 'the Philistine plain'... What are they if we cannot place them in the category of pictures? They are pietistic ejaculations—ticked-up maxims in pigment of extraordinary durability—counsels of perfection in colour and conduct. Of all the Pre-Raphælites,

Mr. Hunt will remain the most popular. He is artistically the scapegoat of that great movement which gave a new impulse to English art, a scapegoat sent out to wander by the dead seas of popularity...Yes, he has a message for every one... He is a missing link between art and popularity. He symbolises the evangelical attitude of those who would go to German Reed's and the Egyptian Hall, but would not attend a theatre... When modern art, the brilliant world of the 'sixties, was strictly excluded from English homes except in black and white magazines, engravings from the 'Finding of Christ in the Temple' and the 'Light of the World' were allowed to grace the parlour along with 'Bolton Abbey', the 'Stag at Bay', and 'Blücher meeting Wellington'.

# Select Bibliography and Notes

*The author has included key bibliographic information and notes of interest concerning those Pre-Raphælites who saw themselves as primarily writers and who produced a substantive body of work. The 'Works of General Reference' section provides a select bibliography of those sources to which I am most indebted for their useful backgrounds about the Pre-Raphælite Movement, its 'movers and shakers', its art and writings, and its social context.*

WILLIAM ALLINGHAM (1824-89). Married: Helen Allingham. Allingham became sub-editor of *Frazer's Magazine* in 1874. Verse: *Poems*, 1850; *The Music Masters*, 1855; *Songs, Ballads and Stories*, 1877; *Evil May-Day*, 1883; *Ashby Manor*, 1883; *Blackberries*, 1884; *Irish Songs and Poems*, 1887; *By the Way*, 1912. Prose: *Varieties in Prose*, 1893. Biographical and Critical: *Letters of Dante Rossetti to William Allingham*, ed. D.G.B. Hill (1897); *William Allingham: A Diary*, ed. Helen Allingham and D. Radford (1907); *Letters to William Allingham*, ed. Helen Allingham and E.B. Williams (1911); M.S. Lasner, *William Allingham: A Bibliographic Study* (1993).

OLIVER MADOX BROWN (1855-74). The only son of Ford Madox Brown. Prose: *The Black Swan* (1873); Uncompleted: *The Dwale Bluth* and *Hebditch's Legacy*. Biographical and Critical: J.H. Ingram, *Oliver Madox Brown: A Biographical Sketch* (London, 1883); W.E. Fredeman, 'Pre-Raphælite Poet Manque: Oliver Madox Brown', *Bulletin of the John Rylands Library* 51 (1968), pp. 27-72.

HALL CAINE (1853-1931). Knighted in 1918 and retired to the Isle of Man, Greeba Castle. Verse: 'Graih My Chree' (1895). Drama: 'The Christian' *et al.* Prose: *Recollections of Rossetti* (1882); *The Shadow of a Crime* (1884); *The Son of Hagar* (1886); *The Deemster* (1887); *The Bondman: A New Saga* (1890); *The Scapegoat* (1891); *The Manxman* (1895); *The Christian* (1897); *The Eternal City* (1901); *The Prodigal Son* (1904); *King Edward: A Prince and a Great Man* (1910); *The Woman thou Gavest Me* (1913). Biographical and Critical: 'An Afternoon with Hall Caine', *The Young Man* (November 1893).

RICHARD WATSON DIXON (1833-1900). Became Canon of Carlisle Cathedral; had been the teacher of Gerald Manley Hopkins at Highgate School and later a close friend. Verse: *Christ's Company* (1861); *Historical Odes* (1864); *Mano* (1883); *Odes and Eclogues* (1884); *Songs and Odes* (1896); *Last Poems* (1905). Prose: *The Close of the Tenth Century* (1858); *The Life of James Dixon, D.D.* (1874); *The History of the Church in England*, 6 vols. (1878-1902). Biographical and Critical: R. Bridges, *Three Friends* (1832); C.C. Abbott, *The Correspondence of Gerald Manley Hopkins and Richard Watson Dixon* (1955); A.J. Sambrook, *Poet Hidden: The Life of Richard Watson Dixon* (1962); R.J. White, 'Pre-Raphælite Imagery in the Christ's Company Poems of Richard Watson Dixon', *Pre-Raphælite Review* (Nov. 1981), pp. 70-89.

SEBASTIAN EVANS (1830-1909). A one time manager of the art department of a glass works in Birmingham, editor of *Birmingham Daily Gazette* and *The People*, member of Parliament in 1868. Verse: *Brother Fabian's Manuscript and Other Poems* (1865); *Songs and Etchings* (1871); *In the Studio* (1875). Prose: *The High History of the Holy Grail* (1898-1903); *In the Quest of the Holy Grail* (1898).

THOMAS GORDON HAKE (1809-95). For the last twelve years of Rossetti's life, Hake was his physician. Verse: *Poetic Lucubrations* (1828); *The World's Epitaph* (1869); *Madeline: With Other Poems and Parables* (1871); *New Symbols* (1876); *The New Day* (1890). Prose: *The Piromides: A Tragedy* (1838); *A Treatise on Varicose Capillaries* (1838); *Vates: or, The Philosophy of Madness* (1840). Biographical and critical: *Thomas Gordon Hake, Memoirs of Eighty Years* (1892).

PHILIP BOURKE MARSTON (1850-87). Verse: *Song-Tide* (1871); *All in All* (1874); *Wind-Voices* (1883); *A Last Harvest* (1891); *Collected Poems* (1892). Biographical and critical: W. Sharp, 'Introduction', *Song-Tide* (1888); C.C. Osborne, *P.B. Marston* (1926); E. Gosse, 'A Blind Poet', *Leaves and Fruit* (1927); F. Fennell, 'Rossetti and Philip Bourke Marston', *The Pre-Raphælite Review* (May 1983), pp. 19-24.

GEORGE MEREDITH (1828-1909). Verse: *Poems* (1881); *Modern Love* (1862); *Poems and Lyrics of the Joy of Earth* (1883). Prose: *The Shaving of Shagpat* (1855); *Farina* (1857); *The Ordeal of Richard Feverel* (1859); *Evan Harrington* (1861); *Emilia in England* (1864). Biographical and critical: L. Stevenson, *The Ordeal of George Meredith* (1953); C.L. Cline, *The Letters of George Meredith*, 3 vols. (1970); C.K. Hyder, *The Critical Heritage* (1970); *Swinburne as Critic* (1972); G. Beer and M. Harris, *The Notebooks of George Meredith* (1983); C. Comstock, ' "Speak and I See the Side-Lie of Truth": The Problems of Truth in Meredith's Modern Love', *Victorian Poetry* (Summer 1987), pp. 129-41; H. Kozicki, 'The "Unholy Battle" with the Other in George Meredith's Modern Love', *Papers on Language and Literature* (Spring 1987), pp. 142-60.

WILLIAM MORRIS (1834-96). The *Kelmscott Chaucer* was completed just four months before Morris died. Married: Jane Burden. Verse: *The Defence of Guinevere* (1858); *The Life and Death of Jason* (1867); *The Earthly Paradise* (1868-70); *Love is Enough* (1872); *The Story of Sigurd the Volsung* (1876); *Chants for Socialists* (1884); *The Pilgrims of Hope* (1886); *The Collected Works of William Morris*, 24 vols., ed. May Morris (1910-15). Prose: (Romances) *A Dream of John Ball* (1888); *The Roots of the Mountains* (1890); *The Story of the Glittering Plain* (1891); *The Tale of the House of the Wolfings* (1896); *The Well at the World's End* (1896); *The Sundering Flood* (1897); *The Water of the Wondrous Isles* (1897); (Translations) *Grettir Saga* (1869); *Volsunga Saga* (1870); *Æneid* (1875); *Three Northern Love Stories* (1875); *Odyssey* (1887); *The Saga Library* (1891-5); *The Tale of Beowulf* (1895); (Social, Political, Commentary) *The Lesser Arts* (1878); *The Beauty of Life* (1880); *Art and the People* (1883); *The Aims of Art* (1887); *Gothic Architecture* (1889); *News from Nowhere* (1891). Biographical and critical: J.W. Mackail, *The Life of William Morris* (1899); M. Morris, *William Morris: Artist, Writer, Socialist* (1936); P. Henderson, ed., *The Letters of William Morris to his Family and Friends* (1950); E.P. Thompson, *William Morris: Romantic to Revolutionary* (1955, 1977); P. Henderson, *William Morris: His Life, Work, and Friends* (1967); J. Lindsay, *William Morris: His Life and Work* (1979); J. Acheson, *William Morris and Kelmscott* (1981); C. Silver, *Romance of William Morris and The Golden Chain: Essays on William Morris* (1982); J. Harris, *William Morris and the Middle Ages*

(1984); W. Peterson, *A Bibliography of the Kelmscott Press* (1984); N. Kelvin, *The Collected Letters of William Morris* (1987); F. MacCarthy, *William Morris: A Life for our Time* (1994).

COVENTRY PATMORE (1823-96). Verse: *The Woodsman's Daughter* (?); *Tamerton Church Tower and Other Poems* (1853); *The Betrothal* (1854); *The Espousals* (1856) [thereafter the two books are combined under the title *The Angel in the House*]; *Faithful for Ever* (1860); *Victories of Love* (1861); *The Unknown Eros* (1877). Biographical and critical: O. Burdett, *The Idea of Coventry Patmore* (1921); B. Champneys, *Memoirs and Correspondence of Coventry Patmore*, 2 vols. (1900-1901); F. Page, *Coventry Patmore: A Study in Poetry* (1933); D. Patmore, *The Life and Times of Coventry Patmore* (1949); E.J. Oliver, *Coventry Patmore* (1956); J.G. Reid, *The Mind and Art of Coventry Patmore* (1957).

JOHN PAYNE (1842-1916). Along with his best friends, the poet Arthur O'Shaughnessy and the painter John Trivett Nettleship, the three became known as the Triumvirate. The inspiration for many of his poems seems to have been a woman he described as the 'loveliest and most gifted woman of her age', Mrs. Helen Snee. Verse: *The Masque of Shadows* (1870); *Intaglios* (1871); *Songs of Life and Death* (1872); *Lautrec* (1878); *New Poems* (1880); *Collected Poems* (1902); *Songs of Consolation* (1904); *Flower o' the Thorn* (1909); *The Way of the Winepress* (1920). Translations: *Villon* (1878-92); *The Thousand and One Nights* (1882-84); *The Decameron* (1886); *The Novels of Matteo Bandetto* (1890); *The Poems of Hafiz* (1901). Biographical and critical: B.I. Evans, in *English Poetry in the Later Nineteenth Century* (1933); T. Wright, *The Life of John Payne* (1919).

ARTHUR O'SHAUGHNESSY (1844-81). Verse: *An Epic of Women* (1870); *Lays of France* (1872); *Songs of a Worker* (1881). Biographical and critical: L.C. Moulton, *Arthur O'Shaughnessy: His Life and His Work with Selections from his Poems* (1894); S. Kunitz, ed., *British Authors of the Nineteenth Century* (1936); W.D. Paden, 'Arthur O'Shaughnessy in the British Museum', *Victorian Studies* 8 (1964), pp. 7-30.

CHRISTINA ROSSETTI (1830-94). Younger sister to Dante Gabriel and William Michael Rossetti; engaged twice, first to James Collinson and then to Charles Bagot Cayley, and in both instances she broke off the engagement: William Michael wrote, 'her life had two motive powers—religion and affection—hardly a third.' Verse: *The Prince's Progress and Other Poems* (1866); *Sing-Song* (1872); *A Pageant and Other Poems* (1881); *Verses* (1893); *New Poems* (1896); *Poems* (1910); Prose: (Fiction) *Commonplace, and Other Short Stories* (1870); *Speaking Likenesses* (1874); *Maud* (1897); (Devotional) *Annus Domini: A Prayer for each Day of the Year* (1874); *Seek and Find* (1879); *Called to be Saints* (1881); *Letter and Spirit* (1883); *Time Flies* (1885); *The Face of the Deep: A Devotional Commentary on the Apocalypse* (1892). Biographical and critical: E. Procter, *Brief Memoir* (1895); W.M. Rossetti, ed., *Family Letters of Christina Rossetti* (1908); M.F. Sandars, *The Life of Christina Rossetti* (1930); E. Birkhead, *C. Rossetti and her Poetry* (1931); V. Woolf, 'Christina Rossetti', *The Common Reader*, Second Series (1932); L.M. Packer, *Christina Rossetti* (1963); G. Battiscombe, *Christina Rossetti: A Divided Life* (1981); D. Kent, *The Achievement of Christina Rossetti* (1987); J. Marsh, *Christina Rossetti* (1995).

DANTE GABRIEL ROSSETTI (1828-82). Married: Elizabeth Siddal. Verse: *The Early Italian Poets* (1861); *Poems* (1870); *Ballads and Sonnets* (1881); Prose and Verse: *Collected Works* (1886). Biographical and critical: H. Caine, *Recollections of Rossetti* (1882); W. Sharp, *Rossetti* (1882); W.M. Rossetti, *Dante Gabriel Rossetti as Designer and Writer* (1889); W.M. Rossetti, ed., *Dante Gabriel Rossetti: His Family Letters* (1895); O. Doughty, *A Victorian Romantic: Dante Gabriel Rossetti* (1960 [1949]); O. Doughty and J.R. Wahl, *Letters of Dante Gabriel Rossetti* (1965-68); R.G. Grylls, *Portrait of Rossetti* (1969); D. Sonstroem, *Rossetti and the Fair Lady* (1970); R.R. Howard, *The Dark Glass: Vision and Technique in the Poetry of Rossetti* (1972); B. Dobbs and J. Dobbs, *Rossetti: An Alien Victorian* (1977). Art: V. Surtees, *Paintings and Drawings of Dante Gabriel Rossetti* (1971); M. Henderson, *Dante Gabriel Rossetti* (1973).

WILLIAM MICHAEL ROSSETTI (1829-1919). Married: Lucy Madox Brown. Worked for the Inland Revenue from 1845 to 1894; the younger brother of Dante Rossetti, William Michael Rossetti was the unofficial but invaluable archivist of the Rossetti family letters and documents and of the Pre-Raphælite Movement in general; he was a successful biographer, reviewer, critic and editor. Verse: collection of poems and prose in *The Germ*; *Democratic Sonnets* (1907); Prose: *Fine Art, Chiefly Contemporary* (1867); *Lives of Famous Poets* (1878); *Life of Keats* (1887); *Dante and his Convito—A Study* (1910); *Letters about Shelley* (1917); *Letters concerning Whitman, Blake and Shelley to Anne Gilchrist* (1934). Biographical and critical: W.M. Rossetti, *Some Reminiscences of William Michael Rossetti* (1906); J.C. Troxell, ed., *The Family of Rossetti: Three Rossettis* (1937); L.M. Packer, ed., *The Rossetti-Macmillan Letters, 1861-89* (1963); L.M. Arinshtein and W.E. Fredeman, 'William Michael Rossetti's "Democratic Sonnets" ', *Victorian Studies* 14 (1971), pp. 241-74; W. Fredeman, 'A Shadow of Dante: Rossetti in the Final Years (Extracts from W.M. Rossetti's Unpublished Diaries, 1876-1882)', *Victorian Poetry* (Autumn-Winter 1982), pp. 217-45; R. Peattie, *Selected Letters of William Michael Rossetti* (1990).

JOHN RUSKIN (1819-1900). Married: Effie Gray, who later married J.E. Millais. Prose: *Modern Painters* (1843); *The Seven Lamps of Architecture* (1849); *Pre-Raphælitism* (1850); *The Stones of Venice* (1851-53); *Lectures on Architecture and Painting* (1854); *Frondes Agrestes* (1875); *Arrows of the Chace* (1880); *The Art of England and the Pleasures of England*, lecture series (1883-1885); *Præterita*, autobiography (1885-89). Biographical and critical: T.J. Wise, ed., *Letters* (1894); J. Evans and J.H. Whitehouse, eds., *The Diaries of John Ruskin* (1956-59); H.I. Shapiro, *Ruskin in Italy: Letters to his Parents, 1845* (1972); W.J. Collinwood, *The Life and Works of John Ruskin* (1893); R.H. Wilenski, *John Ruskin* (1923); W. James, *The Order of Release* (1948); J. Evans, *John Ruskin* (1954); J.D. Rosenber, *The Darkening Glass: A Portrait of Ruskin's Genius* (1954); J. Abse, *John Ruskin: The Passionate Moralist* (1981); R. Hewison, *Approaches to Ruskin: Thirteen Essays* (1981); T. Hilton, *John Ruskin: The Early Years 1819-59* (1985).

WILLIAM BELL SCOTT (1811-90). Although Scott was married, the relationship of enduring significance was that with Alice Boyd of Penkill Castle, Scotland. Verse: *Hades; or The Transit* (1838); *The Year of the World* (1846); *Poems of a Painter* (1854); *Poems* (1875); *A Poet's Harvest Home* (1882); Prose: *Half-hour lectures on the History and Practice of the Fine and Ornamental Arts* (1867); *Autobiographical Notes* (1892). Biographical and critical: W.E. Fredeman, *Letters of Pictor Ignotus* (1976).

ELIZABETH SIDDAL (1862-83). Note: her watercolours are held in the Victoria and Albert Museum and the Fitzwilliam Museum, Cambridge; her sketches held at Wightwick Manor, Wolverhampton. Verse: most of her poems were published in three of William Michael Rossetti's family compilations: *Ruskin: Rossetti: Pre-Raphælitism* (1899); *Dante Gabriel Rossetti: His Family Letters* (1895); *Some Reminiscences* (1906). Biographical and critical: W.M. Rossetti, 'Dante Rossetti and Elizabeth Siddal', *Burlington Magazine* (June 1903); V. Hunt, *The Wife of Rossetti* (1932); R.C. Lewis and M.S. Lasner, eds., *Poems and Drawing of Elizabeth Siddal* (1978); D. Cherry and G. Pollock, 'Woman as Sign in Pre-Raphælite Literature: A Study of the Representation of Elizabeth Siddal', *Art History* 7 (June 1984), pp. 206-27; J. Marsh, *Pre-Raphælite Sisterhood* (1985); J. Marsh, *The Legendary Elizabeth Siddal* (1989).

ALGERNON CHARLES SWINBURNE (1837-1909). Verse: *The Queen Mother* (1860); *Rosamund* (1860); *Atalanta in Calydon* (1865); *Chastelard* (1865); *Poems and Ballads* (1866); *A Song of Italy* (1867); *Songs before Sunrise* (1871); *Bothwell* (1874); *Songs of Two Nations* (1875); *Erechteus* (1876); *Poems and Ballads,* Second Series (1878); *Songs of the Springtides* (1880); *Studies in Song* (1880); *Mary Stuart* (1881); *Tristram of Lyonesse* (1882); *A Century of Rondels* (1883); *A Midsummer Holiday* (1884); *Marino Faliero* (1885); *Locrine* (1887); *Poems and Ballads,* Third Series (1889); *The Sisters* (1892); *Astrophel* (1894); *A Channel Passage and Other Poems* (1894); *The Tale of Balen* (1896); *Rosamund Queen of the Lombards* (1899); *The Duke of Grandia* (1908); Prose: *William Blake* (1867); *Notes on the Royal Academy Exhibition,* written with

W.M. Rossetti (1868); *Under the Microscope* (1872); *Essays and Studies* (1875); *George Chapman* (1875); *A Note on Charlotte Brontë* (1877); *Shakespeare* (1880); *Victor Hugo* (1886); *Miscellanies* (1886); *Ben Johnson* (1889); *Studies in Prose and Poetry* (1894). Biographical and critical: E. Gosse, *The Life of Algernon Charles Swinburne* (1917); E. Gosse and T.J. Wise, eds., *Letters,* 2 vols. (1928); G. Lafourcade, *Swinburne: A Literary Biography* (1932); H. Hare, *Swinburne: A Biographical Approach* (1949); C.V. Lang, *The Swinburne Letters,* 6 vols. (1959-62); J.O. Fuller, *Swinburne: A Critical Biography* (1968); C.K. Hyder, ed., *Swinburne: The Critical Heritage* (1971); P. Henderson, *Swinburne: Portrait of a Poet* (1974); K. Beetz, *Algernon Charles Swinburne: A Bibliography of Secondary Sources* (1982); J. Jordan, 'Closer than a Brother: Swinburne and Watts-Dunton', in R. Perry and M.W. Brownley, eds., *Mothering the Mind: Twelve Studies of Writers and their Silent Partners* (1984).

THEODORE WATTS-DUNTON (1832-1914). By profession Watts-Dunton was a solicitor in London; from 1876 on, he was the chief poetry critic for the *Athenæum.* From 1879 Watts-Dunton shared his house, No. 2, The Pines, at the foot of Putney Hill with Swinburne, thus rescuing Swinburne from his dissolute way of life. Verse: *The Coming of Love, Rhona Boswell's Story, and Other Poems* (1897); Prose: *The Truth about Rossetti* (1883); *Aylwin* (1898); *Poetry and the Renaissance of Wonder* (1903); *Studies of Shakespeare* (1910); *Old Familiar Faces* (1915). Biographical and critical: J. Douglas, *Theodore Watts-Dunton: Poet, Critic, Novelist* (1904); T.S. Hake and A. Compton-Rickett, *The Life and Letters of Theodore Watts-Dunton,* 2 vols. (1916); M. Panter-Downes, *At the Pines* (1971).

THOMAS WOOLNER (1825-92). He made his fame and fortune from creating portrait medallions; later, he fell under Tennyson's influence and mentoring, abandoning the bohemian Pre-Raphælites of his earlier, poorer, days. Verse: contributions to *The Germ; My Beautiful Lady* (1863); *Pygmalion* (1881); *Silenus* (1884); *Tiresias* (1886). Biographical and critical: A. Woolner, *Thomas Woolner, R.A.: Sculptor and Poet* (1917); E. Glasgow, 'Thomas Woolner: Art and Literature', *Victorians Institute Journal* 21 (1993), pp. 257-63.

# Works of General Reference

*This select bibliography lists significant works not already mentioned within the individual bibliographic and critical entries. One should also refer to such journals as* Victorian Poetry, The Journal of Pre-Raphælite Studies, The Pre-Raphælite Review, The Journal of the William Morris Society, The Bulletin of the John Rylands Library of Manchester, *and* Victorian Studies, *which contain treasure hoards of articles on the Pre-Raphælites.*

F.M. Hueffer, *The Pre-Raphælite Brotherhood* (1907); M. Beerbohm, *Rossetti and his Circle* (1922); T.E. Welby, *The Victorian Romantics, 1850-70* (1929); F.L. Bickley, *The Pre-Raphælite Comedy* (1932); W. Gaunt, *The Pre-Raphælite Tragedy* (1942); G. Hough, *The Last Romantics* (1949); W.E. Fredeman, *Pre-Raphælitism: A Bibliocritical Study* (1965); I. Evans, *English Poetry in the Later Nineteenth Century* (rev. 1966); F.E. Faverty, *The Victorian Poets: A Guide to Research* (rev. 1968); J.D. Hunt, *The Pre-Raphælite Imagination* (1968); G.H. Fleming, *Rossetti and the Pre-Raphælite Brotherhood* (1969); J. Mass, *Victorian Painters* (1969); T. Hilton, *The Pre-Raphælites* (1970); J. Nicol, *The Pre-Raphælites* (1970); R. Watkinson, *Pre-Raphælite Art and Design* (1970); G.H. Fleming, *That Ne'er Shall Meet Again* (1971); V. Surtees, *The Paintings and Drawings of Dante Gabriel Rossetti (1828-82): A Catalogue Raisonné*, 2 vols. (1971); D. Johnson, *Lesser Lives* (1972); L. Stevenson, *The Pre-Raphælite Poets* (1972); P. Faulkner, *The Critical Heritage* (1973); A. Staley, *The Pre-Raphælite Landscape* (1973); J. Sambrook, ed., *Pre-Raphælitism: A Collection of Critical Essays* (1974); F. Watson, *The Year of the Wombat. England: 1857* (1974); J. Harding, *The Pre-Raphælites* (1977); R. Trevelyan, *The Pre-Raphælite Circle* (1978); S. Weintraub, *The Four Rossettis* (1978); J. Treuherz, *Pre-Raphælite Painters* (1980); C. Wood, *The Pre-Raphælites* (1981); K. Hickok, *Representations of Women: Nineteenth-Century British Women's Poetry* (1984); A. Lambert, *Unquiet Souls* (1984); *The Pre-Raphælites*, Tate Gallery exhibition catalogue (1984); S. Casteras, *Images of Womanhood in Victorian Art* (1987); J. Marsh, *Pre-Raphælite Women* (1987); G. Daly, *Pre-Raphælites in Love* (1989); J. Marsh and P.G. Nunn, *Women Artists and the Pre-Raphælite Movement* (1989); W. Fredeman, *Victorian Connections* (1989); L. Pearce, *Woman-Text-Image: Readings in Pre-Raphælite Art and Literature* (1991); L.D.G. Cheney, *Pre-Raphælitism and Medievalism in the Arts* (1992); J. McGann, *The Pre-Raphælites in Context* (1992); B. Garlick, *Virginal Sexuality and Textuality in Victorian Literature* (1993).